The
EASTER SEPULCHRE
in
ENGLAND

by
Pamela Sheingorn

Early Drama, Art and Music
Reference Series, 5

MEDIEVAL INSTITUTE PUBLICATIONS
Western Michigan University
Kalamazoo, MI 49008
1987

CONTENTS

ILLUSTRATIONS

1. *Regularis Concordia*: beginning of *Depositio*.
2. *Regularis Concordia*: conclusion of *Depositio*.
3. *Regularis Concordia*: *Elevatio* and beginning of *Visitatio Sepulchri*.
4. *Regularis Concordia*: conclusion of *Visitatio Sepulchri*.
5. *Ordinale Exoniensis*: *Elevatio*.
6. *Ordinale Exoniensis*: rubrics for Easter Sepulchre.
7. *Ordinale Exoniensis*: *Depositio*.
8. *Missale Dunelmense*: beginning of *Depositio*.
9. *Missale Dunelmense*: conclusion of *Depositio*.
10. *Ordinale Berkingense*: beginning of *Depositio*.
11. *Ordinale Berkingense*: conclusion of *Depositio*.
12. *Ordinale Berkingense*: beginning of *Elevatio*.
13. *Ordinale Berkingense*: continuation of *Elevatio*.
14. *Ordinale Berkingense*: conclusion of *Elevatio* and beginning of *Visitatio Sepulchri*.
15. *Ordinale Berkingense*: continuation of *Visitatio Sepulchri*.
16. *Ordinale Berkingense*: continuation of *Visitatio Sepulchri*.
17. *Ordinale Berkingense*: conclusion of *Visitatio Sepulchri*.
18. *Hereford Ordinal*: *Depositio*.
19. *Norwich Customary*: *Depositio*.
20. *Norwich Customary*: *Elevatio* and *Visitatio Sepulchri*.
21. *Oxford Missal*: *Depositio*.
22. *Sarum Missal*: *Depositio*.

ACKNOWLEDGEMENTS

This project began as a doctoral dissertation in art his-
tory under the supervision of Professor Frank R. Horlbeck at
the University of Wisconsin, Madison, for whose expertise I
shall always be grateful. Although I devoted some study to
liturgical texts in preparing the dissertation, it was through
subsequent apprenticeship to Professors Jerome Taylor of the
University of Wisconsin, Madison, and David Bevington of the
University of Chicago, under the auspices of the National
Endowment for the Humanities in each case, that I became fully
cognizant of the central role of the liturgy in medieval reli-
gious life and of the complex interconnections between the lit-
urgy and the drama in this period. Through acquaintance with
the Records of Early English Drama project, I became increas-
ingly aware of the riches to be found in records, though the
scope of my own work has made it impossible to treat records
with the thoroughness of a REED editor. The tireless Editor
of Early Drama, Art, and Music, Clifford Davidson, has seen
me through the years devoted to this project with advice,
encouragement, and enthusiasm.
 In addition, I owe thanks to colleagues, friends, and
institutions that have supplied much valued assistance in the
various stages of my project. Richard K. Emmerson read an
earlier draft of the introductory chapters and offered the in-
cisive criticism that I have come to expect from him; he did
not, however, read the final draft and bears no responsibility
for the use to which I put his comments. The medieval history
group of the Institute for Research in History also read and
commented helpfully on an earlier draft. I have learned much
from conversations with Diane Dolan Bennett and C. Clifford
Flanigan as well as from their published work, and I have re-
lied, as always, on the wise counsel of Martin Stevens. Jen-
nifer Alexander, Clifford Davidson, and Sally-Beth MacLean
were kind enough to share work in progress. Martha W.
Driver helped me to decipher Latin and Middle English abbrevi-
ations, and Clyde W. Brockett provided paleographic assistance
in kindly checking my transcriptions of Latin texts. Al Gray-
son supplied technical assistance with photographs. Many li-
brarians have spent much time helping me to gain access to
needed materials, among whom I especially thank Eric Neu-
bacher of the Baruch College Library and the patient staff of
the New York Public Library. Constance Nehil of the Medieval
Institute prepared the camera-ready copy.
 For permission to reproduce photographs which form the
basis for the plates in this book, as well as for transcriptions
of the relevant texts, I am grateful to various libraries and
organizations. I am also grateful to the Rev. Roger J. Chap-
man, vicar of St. Mary's, Beverley; the Rev. Canon Peter G.
S. Harrison, vicar of Beverley Minster; Canon M. S. Mac-
Donald, Ely Cathedral; the Rev. H. J. Theodosius, vicar of
Horbling; Canon P. Walpole Wigginton, rector of East Kirkby;

the Rev. Michael Freeman, vicar of St. Mary's, Warwick; the
Rev. Raymond J. Pearson, Patrick Brompton; the Rev. N. A.
Thorp, rector of Lillingstone Dayrell; the Rev. John A. Steg-
gall, St. Agatha, Easby; the Rev. Christopher Burdon, Priest-
in-charge, Olney; and the Rev. Richard Mapplebeckpalmer,
vicar of Merton and Piddington. Extracts from *London
Churches at the Reformation* by H. B. Walters are reprinted by
the permission of the publishers, SPCK (London), and extracts
from *The Collegiate Church of Ottery St. Mary* by John Neale
Dalton are used by permission of the Cambridge University
Press. Quotations from "An Inventory of Gifts to the Holy
Sepulchre that was at Edington," which originally appeared in
the *Wiltshire Archaeological and Natural History Magazine*,
appear with the permission of the Wiltshire Archaeological and
Natural History Society, England.

Finally, I can only acknowledge, but never measure or
repay, the debt of gratitude that I owe to my husband, Mark
Sheingorn, not only for his concrete assistance in matters such
as negotiating country lanes to reach parish churches and
putting the text of the book in computer-readable form com-
patible with the facilities at Medieval Institute Publications, but
most of all for his unshakeable conviction that the author of
this project was worthy of the sustained and sustaining emo-
tional support that so crucially fosters endeavors of this kind.

Pamela Sheingorn

The Easter Sepulchre in England

INTRODUCTION

The English Easter Sepulchre stands at the intersection of several important aspects of medieval culture: its study impinges upon the fields of drama, liturgy, art history, and social history. The Easter Sepulchre represented--i.e., stood in the place of--Christ's tomb in Jerusalem, recreated in hundreds of churches in England for Holy Week and Easter each year. The most solemn and joyous moments of the liturgical year, the celebration through re-enactment of the events surrounding the death, burial, and resurrection of Christ, focused on the Easter Sepulchre. This re-enactment, as it tended toward the mimetic, stimulated the growth of the drama in England; the Easter Sepulchre is, then, one prototype for the theater's stage. Permanent Easter Sepulchres in stone, a small fraction of the whole, preserve beautiful and complex sculptural ensembles, the province of the art historian. One element in the fabric of social life in late medieval England, the Easter Sepulchre brings into focus a significant aspect of medieval religion as understood and experienced by ordinary people. The presence of an Easter Sepulchre in so many parish and monastic churches and even in hospital chapels speaks of a local devotion that is amply illustrated by bequests in wills to the Easter Sepulchre ranging from wax for candles to "my best over-see bed" (1526; Beverley, Yorkshire). One particular aspect of this devotion created the combination of an Easter Sepulchre with a donor's tomb--a combination that both intensified the meaning of the resulting monument to the community and effectively insured that the donor would be remembered in prayers. As Daniel Rock observes, "the owner of the soil, or the lord of the manor, only sought to avail himself best of those opportunities for getting his soul remembered, afforded him by those highest and therefore rare but impressive solemnities of the ritual, which once in every year were sure to bring all the people in crowds to the parish-church, as they mingled in its heart-stirring celebrations."[1] The Easter Sepulchre, which had great symbolic significance for the English Christian community from the tenth century well into the sixteenth, served not only as a reminder of mortality but also as a promise of resurrection after the example of Christ's own Resurrection which was re-enacted--i.e., which re-occurred in this very place every year. The Easter Sepulchre is thus the appropriate locus for the rebirth of Western drama, since the rites associated with it celebrate that most dramatic of events, the return from death to life, the Resurrection of Christ.

The Easter Sepulchre is the English form of a monument known throughout Western Europe in the Middle Ages as the *sepulchrum Domini*. The term *sepulchrum Domini*, the tomb of the Lord, refers to the monument specifically associated with

3

the commemorative Easter rites. The monument in Jerusalem, now part of the Church of the Holy Sepulchre, identified as the tomb of Christ and usually called the "Holy Sepulchre," stands as the ultimate source both for all *sepulchra Domini* and for the terms employed to describe them. 'Anastasis,' meaning "resurrection," is also a common term for this tomb, since it refers to the event traditionally believed to have occurred there. However, 'Anastasis' and 'Holy Sepulchre' are not interchangeable terms; the former refers specifically to the unique structure in Jerusalem (rebuilt and altered many times), whereas 'Holy Sepulchre' has also been used to describe architectural copies of the original. One way to commemorate the events that took place at the Holy Sepulchre in Jerusalem was to reproduce its form; another was to repeat in ritual the events of Christ's burial and resurrection, as well as the visit of the holy women that happened there. These rites, called the *Depositio, Elevatio,* and *Visitatio,* were interwoven with the liturgy of Good Friday and Easter Sunday in churches throughout Western Europe; they have been referred to collectively as "paraliturgical" or "extra-liturgical," terms that will be avoided here because they imply a concept of liturgy as a rigidly fixed body of material that is not consonant with medieval practice. When not referred to specifically by name, these rites are here called "the commemorative Holy Week and Easter rites." The place in a church where the rites were enacted is referred to here as the *sepulchrum Domini,* a term that implies nothing about either the form of a monument or its location within a particular church. Although medieval texts often use the term *monumentum* (its meaning is clear in context) or the term *sepulchrum* to refer to the Holy Sepulchre in Jerusalem, to its copies, and to the sites of the commemorative Easter rites, these terms are employed here only with reference to the *sepulchrum Domini.* The specific type of *sepulchrum Domini* that began to appear in Germany in the thirteenth century and that gave the monument symbolizing Christ's tomb the form of a canopied sarcophagus is called the "Holy Grave" (*heiliges Grab*). The specifically English type, which has a rather wide range of forms and which is the focus of this study, is called the "Easter Sepulchre."

The documents in Latin that serve as the major primary sources for this study usually call the Easter Sepulchre the *sepulchrum,* only rarely using the full term *sepulchrum Domini.* English documents employ a wider range of terms; although "sepulchre" is most frequent, we also read of "the grawe of resurreccion gylde" (1463; Bury St. Edmunds, Suffolk) and "the sepulcher howse" (c.1526; Hellidon, Northamptonshire). As well as referring to the Easter Sepulchre, the terms *sepulchrum* and 'sepulchre' have the related meanings of an individual place of burial and of a small box such as a reliquary. The desired meaning must be determined by context. Thus the "sepulcre of goldsmythes worke the grounde rede and blew pale" (1517; Arundel, Sussex) must have been a box or coffer

of metalwork made to contain the Host and probably to be placed inside the Easter Sepulchre as well as carried in the Corpus Christi procession. This study is organized so as to trace individual threads--the representations of the Holy Sepulchre in art, the development of the commemorative Easter rites, and the form and iconography of the Easter Sepulchre--before describing the pattern that results when they are interwoven. The first chapter surveys material from the early Christian and early medieval periods: representations of the Holy Sepulchre in the pictorial arts in such scenes as the holy women at the tomb and architectural imitations of the structure in Jerusalem. These small buildings, often erected by returning pilgrims, may have had some function in stational liturgy--i.e., liturgy that moves from place to place or from station to station. Next it describes the origins of the commemorative Easter rites and suggests how these rites and their setting at the *sepulchrum Domini* may first have come together. This will involve an examination of Carol Heitz's thesis concerning the locus of the Easter celebration at the western end of the church in the westwork. The rites in England are the subject of the second chapter, which includes comparative material from the continent to clarify regional differences. Chapter III describes the varied forms of the Easter Sepulchre and Chapter IV examines its iconography. The themes of resurrection preferred in the iconography of the Easter Sepulchre both reflect the content of the commemorative Easter rites and suggest a rationale for the frequent combination of Easter Sepulchre and tomb. The final chapter reconstructs the activity at the Easter Sepulchre from the erection of a temporary structure enclosing it to the dismantling of that structure. All of this material is prefatory to the catalogue of Easter Sepulchres in England that completes this volume.

A number of scholars have studied the Easter Sepulchre, prominent among them Neil C. Brooks, H. Philibert Feasey, Alfred Heales, and Karl Young, whose publications are of continuing value, as are the enthusiastic if not always careful descriptions by local antiquaries. The purpose of this study is both to examine carefully in its own right and to place in context a monument, the English Easter Sepulchre, that stands at a point of intersection in the developments of art, liturgy, drama, and popular religion.

I

THE HOLY SEPULCHRE, THE LITURGY, AND THE RITES: QUESTIONS OF DEVELOPMENT

During the Middle Ages the many monuments that commemorated the tomb of Christ served as potent reminders of his Resurrection, of the tomb that could not hold him. Often they functioned as settings for ritual activity that re-enacted the earthly events of this central Christian mystery. What can be said about the origins of these monuments and rites? In the beginning their developments were separate and parallel; at some point they coalesced and the meanings associated with the one reinforced those of the other. The outline of these developments offered here is sketchy and necessarily speculative; it seeks to establish a historical context from which it is clear that drama was the next logical step. This chapter follows two threads of development: that of the physical monuments, Holy Sepulchres, and that of the ritual re-enactments, the commemorative rites. In each case, it begins with the early Christian period; one thread will be dropped from time to time in order to pick up the other. In the pre-Romanesque period the threads are, for the most part, not yet tied together.

Like other sites in the Holy Land, the Holy Sepulchre in Jerusalem was venerated by Christians because of its direct physical association with crucial events in the life of Christ. In the fourth century, when Christians uncovered the monument known as the Holy Sepulchre, they found a cave cut into a sloping wall of rock. Constantine ordered it reshaped and enshrined: the inside remained unchanged, but the outer rock was cut away, leaving a small free-standing structure surrounded by columns. Probably somewhat later in the same century this rock-cut tomb, called the the cave of the Anastasis, or simply the Anastasis, was completely enclosed within a rotunda.[1] Richard Krautheimer finds it likely that as early as 340-50 this structure had a circular form and was surrounded by an ambulatory with a gallery above it.[2] The resulting centralized building was in the pre-Christian tradition of funerary architecture: Roman tombs were often circular, as, for example, the tomb of Hadrian in Rome now known as the Castel Sant'Angelo. The centralized form of the Anastasis may also have been influential in the design of baptistries, an early and influential a figure as St. Paul having described Christian baptism as symbolic of death and rebirth.[3]

Pilgrims' visits to Jerusalem insured that some knowledge of the appearance of the Holy Sepulchre became available in the West.[4] The first surviving report, that of a pilgrim from Bordeaux who had traveled in the Holy Land in 333 A.D., suggests that at that time the tomb had not yet been enclosed.[5] The account of the pilgrim Egeria (381-84), especially

valuable for her descriptions of liturgy, refers frequently to
the cave of the Anastasis, which clearly played a central role
in the liturgy at Jerusalem, though she shows no interest in
architectural details.[6] By this time, according to Eusebius' *Life
of Constantine*, the Emperor Constantine had "adorned the holy
Cave where the bright angel once announced good news of a
new birth for all men, revealed through the Saviour. This
principal feature the munificent Emperor adorned with choice
columns and much ornament, sparing no art to make it beauti-
ful."[7] Apparently the cave stood in an open cloister which was
attached to a church. Jerome, writing in 404 of Paula's pilgrim-
age in 385, provides additional details: "On entering the Tomb
of the Resurrection she kissed the stone which the angel
removed from the sepulchre door; then like a thirsty man who
has waited long, and at last comes to water, she faithfully
kissed the very shelf on which the Lord's body had lain."[8] An
anonymous pilgrim from Piacenza (c.570) left a particularly
vivid account:

> After we had prostrated ourselves and kissed the
> ground, we entered the Holy City and venerated the
> Lord's Tomb. The Tomb is hewn out of living rock, or
> rather in the rock itself . . . and in the place where
> the Lord's body was laid, at the head, has been placed
> a bronze lamp. It burns there day and night, and we
> took a blessing from it, and then put it back. Earth is
> brought to the tomb and put inside, and those who go
> in take some as a blessing. The stone which closed the
> Tomb is in front of the tomb door, and is made of the
> same coloured rock as the rock hewn from Golgotha.
> This stone is decorated with gold and precious stones,
> but the rock of the tomb is like a millstone. There are
> ornaments in vast numbers, which hang from iron
> rods: armlets, bracelets, necklaces, rings, tiaras,
> plaited girdles, belts, emperors' crowns of gold and
> precious stones, and the insignia of an empress. The
> Tomb is roofed with a cone which is silver, with added
> beams of gold. In front of the Tomb stands an altar.[9]

The first of several periods of destruction in Jerusalem
took place with the Persian invasion in 614, followed by
surrender to the Muslims in 634. In spite of these changes in
political authority, the pilgrim Arculf, who was in the Holy
Land sometime between 679 and 688 and visited the Holy
Sepulchre, reported seeing a structure very similar to what
had been described by earlier pilgrims. Perhaps the Persians
confined their depredations to the looting of precious metals,
restored soon thereafter, whereas the Muslim conquest seems to
have changed little and to have allowed pilgrimages to resume.
Arculf described his experiences to Adomnan of Iona, who
recorded them in a book he called *On the Holy Places*. With

Arculf's description, including plans redrawn by Adomnan, we encounter the first clear statement that the courtyard containing the cave of the Anastasis was roofed over, for he refers to "a very large church, entirely made of stone, and built on a remarkable round plan. . . . In the centre of the round space enclosed by this church there is a small building hewn from a single rock. . . . This small building contains the Lord's Sepulchre. . . ."[10] Some scholars believe that this structure may have been built much earlier, perhaps as early as the time of Constantine.

The last descriptive account from the period before the Crusades (after which, of course, the number of pilgrims increased dramatically) was written by a monk from France named Bernard in about 870. He saw the Holy Sepulchre inside the church and noted that "Round the sepulchre are nine columns, and the walls between them are made of excellent stone. Four of the nine columns are in front of the actual tomb, and these (with the walls between them) surround the stone, placed by the tomb, which the angel rolled back, and on which he sat after the Lord had risen."[11]

Some pilgrims, returning home from the Holy Land, found it appropriate to memorialize their pilgrimages by building architectural copies of the Holy Sepulchre, possibly in order to house relics (e.g., the oil from the lamp and the piece of earth mentioned by the Piacenza pilgrim).[12] The final form of such a copy depended on several factors, including, first, the date at which the pilgrim had been in Jerusalem and, therefore, the state of the Holy Sepulchre at the time of the visit. Pilgrims might vary as well in their ability to reconstruct an accurate copy of what they had seen. Of fundamental importance, as Richard Krautheimer observes, is the fact that the concept of an architectural copy differed in the Middle Ages from that of modern times. Copies displayed some of the features of the original considered important in conveying its religious meaning; they did not necessarily reproduce either the general outlines or particular details of the model. Specifically in the case of an architectural copy of the Holy Sepulchre, as Krautheimer comments, "to be recognizable it has to be 'round' and it has either to contain a reproduction of the tomb or to be dedicated to it. These essential outstanding elements may be elaborated by adding to them other features such as the ambulatory, the chapels, the gallery, the clerestory, the vault, a certain number of supports and some measurements. These also are typical features of the prototype and therefore may be carried over into the copies. The model contains, as it were, a repertory of uncommon elements from which very few have to be chosen whereas others may or may not be selected."[13] The earliest such copy known, an architectural fragment in white marble dated to the fifth century,[14] reproduces details such as the stone bench on which the body of Christ lay.

Returning pilgrims displayed a preference for erecting

their architectural copies of the Holy Sepulchre in cemeteries, presumably because in this context Christianity's understanding of the parallel between Christ's Resurrection and future resurrection for believers became especially meaningful. Victor Elbern has identified one such monument, the seventh-century Mellebaudis Memorial in Poitiers.[15] Square in shape, this monument seems to be a model of the actual rock containing the tomb rather than of the surrounding rotunda. A grave under an arch, an arcosolium grave, was empty when the memorial was excavated. Since the lower stories of several representations of the Holy Sepulchre in the pictorial arts appear to be square, Elbern's thesis that this memorial is a deliberate imitation of the Holy Sepulchre in Jerusalem may well be correct. This would introduce at an early date an association that continues to be important for the tomb of Christ throughout the history of such monuments--i.e., its association with a donor's tomb. As Elbern suggests, "The donor *intentionally* sought to find his last resting-place at the location of the life-bestowing grave of Christ."[16]

The chapel of St. Michael at Fulda--a clear imitation of the Holy Sepulchre--also stood in a cemetery.[17] The crypt served as an ossuary for the monks and the rotunda with ambulatory above centered on a tomb of Christ, although nothing is known of the form of the tomb. The verse written by Rhabanus Maurus for the dedication in 822 establishes the relevance of the funerary context: "This altar to God is dedicated most especially to Christ, whose tomb here helps our graves."[18]

If the motivation for giving the chapel of St. Michael at Fulda the form of a Holy Sepulchre sprang from understanding of the relevance of Christ's Resurrection to the future resurrection of the monks, other Holy Sepulchres received inspiration directly from contact with the Holy Land. Bishop Conrad founded the cemetery chapel of St. Maurice at Constance, dated c.960, after returning from a pilgrimage to the Holy Land. Conrad was also buried in his chapel which was "made a *sepulchrum Domini* in imitation of the one in Jerusalem [and] which [Conrad] decorated with work of marvelous artifice throughout its circumference. . . ."[19] Other monuments inspired by direct contact with the original in Jerusalem include the rotunda at Neuvy-Saint-Sépulchre which housed relics--a fragment of Christ's tombstone and earth from Calvary[20]--and the octagonal Holy Sepulchre at Paderborn, built after the abbot Wino had returned from Jerusalem with the measurements of the original tomb.[21]

Thus, a number of architectural imitations of the Holy Sepulchre were in existence by the end of the eleventh century: in addition to those discussed, they include buildings at the Krukenburg, St. Hubert, Lanleff (near Caen), St. Gall, and Mittelzell at Reichenau. In each case such a structure could have become a local center of pilgrimage, especially if it enshrined relics. For those to whom a journey to the Holy Land

seemed impossible, a much shorter journey to a structure built in commemoration of the Holy Sepulchre, and reproducing some of its features, must have been attractive. To summarize what we have said about these Holy Sepulchres built from the fifth into the eleventh centuries, the evidence is consistent with the following conclusions: They were conscious copies of the Holy Sepulchre in Jerusalem, as revealed by their form and by documentary evidence. Free-standing structures and often elements in multi-building monastic complexes, they frequently enshrined relics from Jerusalem, though their primary function for the religious communities that built them was probably funerary.

In another variation on the theme of the Holy Sepulchre as model, whole churches were built as replicas of its form as early as the eleventh century. For example, the first church of St. Fides at Schlettstadt, founded in 1094, reproduced both the outer form of the Holy Sepulchre and the two-room grave complex within. Placed in the crypt of the church,[22] the grave complex stood as a visible sign of promised resurrection. At Eichstätt in Bavaria the church dedicated to the Holy Cross and the Holy Sepulchre centered on a two-room grave complex like that in Jerusalem.[23] In the case of Eichstätt, a venerable tradition connected the monastery to the Holy Land, for an eighth-century bishop, Willibald, had visited there. The present structure was probably built to enshrine a relic of the cross brought back from the Crusades; the outer form of the building suggests a reliquary within which was enclosed the model of the Holy Sepulchre. Other buildings, such as the Church of the Holy Sepulchre in Cambridge, reproduced the rotunda form of the Holy Sepulchre but not the tomb within.[24]

The form of the Holy Sepulchre was familiar to Western Christians not only through architectural copies but also through representations in the pictorial arts. Beginning in the fourth century, artists often showed scenes from the life of Christ as taking place in the Holy Land at locations by then recognized and enshrined as pilgrimage sites. This move toward specificity of location represents, according to William Loerke, a critical turning point in the history of Christian art.[25] Artists represented these settings in the Holy Land not as they were in the first century A.D. but rather according to the most recent information. Thus the Gospel accounts of the Resurrection that describe a sepulchre cut in the rock do not determine the form of the tomb shown in scenes such as the visit of the holy women. Instead, architectural elements define the setting. Works of art produced in the West portray a structure that generally resembles Roman tombs: a small two-story building, square below and circular above, with a cupola and some classical detail.[26] Works that were produced either in the Holy Land or with some knowledge of the archi- tecture of the Anastasis attempt to render that architecture. However, a number of features make it difficult for a modern viewer to glean much precise information about the Holy

Sepulchre in Jerusalem from these representations in art. First, because of its architectural complexity, artists were unable to show all of the features of the structure--features which included the rotunda, the rock with its tomb, and the empty tomb itself. Also, since the focus was on the human figures participating in the scene, they received more of the artist's attention than did the architectural detail. Further, late antique and early medieval style in the pictorial arts increasingly distorted the relative proportions of human figures to architecture so that architectural elements became smaller and it is difficult to reconstruct the proper scale. In general, works associated with the Holy Land represent the rotunda--a circular roof, either pointed or domed, which was supported on columns. Beneath it stands a small more or less square structure with its door either removed or ajar. This type of representation appears on ampullae used to preserve oil removed from the lamps burning in the Anastasis and brought back to the West by pilgrims[27] (cf. the Piacenza pilgrim: "we took a blessing"). In the West these early Christian models continued into the Carolingian period to be copied faithfully by artists. In the Byzantine East, the tomb appeared without a surrounding rotunda or canopy and had the form of a slender vertical structure with a pointed roof; its appearance, as Neil C. Brooks observes, is reminiscent of a sentry box.[28] After the Iconoclastic Controversy of the eighth and ninth centuries, Byzantine art replaced this "sentry box" with a horizontal sarcophagus.

Both architectural Holy Sepulchres and representations of the Holy Sepulchre in the pictorial arts reflect the centrality for medieval Christians of belief in the Resurrection of Christ, but it is primarily through the Easter liturgy that the Church commemorates and celebrates that event. As early as the fourth-century visit of the pilgrim Egeria to Jerusalem, we hear of elements in that liturgy that suggest a context within which the commemorative Holy Week and Easter rites developed. One of these is its stational character. Egeria describes the Palm Sunday procession as it moves from the Mount of Olives to the Anastasis and forms an escort for the bishop who, for the people, represents Jesus: "Everyone is carrying branches, either palm or olive, and they accompany the bishop in the very way the people did when once they went down with the Lord."[29] This re-enactment of the original Palm Sunday, in the very places where Jesus had walked, powerfully suggests the way that ritual dissolves time by making past events present for the participants. The Anastasis, at which some part of the liturgy was celebrated virtually every day, became especially resonant with meaning in the Easter season. On the evening of Good Friday, Egeria reports, the people go to the Anastasis "where, once inside, they read the Gospel passage about Joseph asking Pilate for the Lord's body and placing it in a new tomb,"[30] and on Easter Sunday the Resurrection Gospel is read in the Anastasis.[31]

The Church in Rome also developed a way of integrating its holy sites into the liturgy, perhaps in imitation of the practices in Jerusalem, but most directly in honor of its martyrs. The *Calendar of the Fourth Century* describes the stational character of the celebrations of the feasts of martyrs. The pope or a cleric delegated by him celebrated Mass on a saint's day at the burial place of that saint. According to Gregory Dix, "The clergy were all there at the cemetery chapel around their bishop, along with the Papal choir and such of the laity as felt disposed to attend."[32] Just as the Anastasis played an important role in the celebration of the anniversary of Christ's death and Resurrection, so the tomb was the focal point for celebrating the anniversary of the saint's death, viewed as a birth into eternal life.

This practice of celebrating the liturgy at the tomb of a saint was preceded by other activity of a stational character. As John Baldovin observes, "If Christianity were to survive as a social religion and not merely one of individualistic piety alone, it was necessary for the bishop of one group to unify all the diverse communities. This seems to have been a major aim of Roman bishops from Victor (180) to Callistus (217). One of the ways to do this was for the bishop to go from community to community to celebrate the eucharist. Another was to send portions of the eucharist out to the *tituli* to signify the unity of celebration and hence the unity of the church at Rome. These practices may well date to the end of the second century."[33] Later Mass books indicate that the pope himself conducted a service for the community in the church designated as the day's *statio*, or place of assembly. The early Church viewed the celebration of the Eucharist as a communal action and insisted that the bishop perform this celebration for his whole diocese, even after that diocese was housed in many separate buildings. Some of these services involved processions to the stational church. Nor was this kind of activity confined to Rome; as Josef Jungmann notes, "Stational worship of a similar sort is mentioned also in connection with other episcopal churches of the early Middle Ages."[34] He cites the examples of Antioch, Oxyrhynchus, Tours, and, after the sixth century, Augsburg, Mainz, Trier, Cologne, Metz, and Angers. In Rome the pope's stational Mass endured until the fourteenth century.

The examples of Rome and Jerusalem and of nearby episcopal cities may have influenced the monasteries in which architectural Holy Sepulchres were built. It was apparently not unusual for monasteries in the early medieval period to include several churches, some of them rather (or even very) small and for liturgical processions to move from church to church. If such a monastic complex contained a Holy Sepulchre, stational processions could have included that Holy Sepulchre on days when such a station was meaningful, as, for example, on the anniversaries of the deaths of members of the community who were buried in or near the Holy Sepulchre. There could

also have been a procession on Good Friday to bring the Host to an altar in the Holy Sepulchre for the celebration of the Mass--i.e., the Host which had been sanctified the day before and had then been kept during the night at a Place of Repose. It is easy to see how such a procession, escorting the consecrated body of Christ, could be intepreted as a deposition or burial rite for Christ, especially if funeral processions usually went to the Holy Sepulchre for the funerals of monks. In this context it is relevant to note that later Easter rituals sometimes include a procession to the cemetery,[35] suggesting a possible reminiscence of the time when the Holy Sepulchre had been in the cemetery. Perhaps, where a Holy Sepulchre existed, it was incorporated into the celebration of Easter just as the Easter liturgy at Jerusalem had incorporated the first Holy Sepulchre.

Another rite described by Egeria also contributes to the climate that fostered the development of the commemorative Holy Week and Easter rites. She describes a rite of Good Friday, the Adoration of the Cross, in which fragments of the True Cross were venerated. Although the Palm Sunday procession and the *Adoratio Crucis* both centered on the physical reality of past event, the Palm Sunday procession was a re-enactment, whereas the *Adoratio* could view the Cross as an emblem of triumph worthy of veneration only when seen from the vantage point of the Resurrection. Nonetheless, the impact of the *Adoratio* arose from from physical contact with the actual wood used in the Crucifixion at the same season of the year and in the very place in which the Crucifixion was believed to have occurred. The *Adoratio Crucis* was known in the West by the seventh century. Karl Young suggests that the *Adoratio* would have led naturally to the development of the *Depositio,* the rite of burying the cross in commemoration of the burial of Christ's body.[36]

Thus both the *Adoratio* and the concept of stational liturgy may have helped to create a context favorable to the rise of the Easter rites. One way to examine this context more closely is to look at the liturgy within which these rites developed. The Gallican liturgy, which had been in use in Frankish lands in the early Middle Ages, has been the focus of scholarly attention because the areas with the earliest Easter dramas seem to correspond to those in which the Gallican rite flourished. Distinct in character from other liturgies, the Gallican liturgy, according to Jungmann, "shows a magnificent independence and exclusiveness."[37] C. Clifford Flanigan finds that the Gallican rite successfully communicated cultic experience: "Its dramatic nature, the immense flexibility which allowed it to emphasize the cultic significance of any occasion, its ability to absorb poetic elements and expressions of individual piety without losing its sense of cultic community--all these enabled it to function in the manner that the history of religions has taught us to expect."[38] By about 750, however, the Gallican rite was suppressed and replaced, at the order of Pepin, by the liturgy of Rome. Imposition of the Roman Rite--

characterized by "clear logical orderliness," "laconic brevity," and "stark realism," according to Jungmann[39]--created, Flanigan suggests, a feeling of deprivation that stimulated the development of religious drama "to reassert the cultic nature of liturgical celebration." Thus embellishments to the austere Roman rite were invented, among them the *Quem quaeritis* dialogue for Easter:

> INTERROGATIO: Quem quaeritis in sepulchro,
> Christicolae?
> RESPONSIO: Jhesum Nazarenum cruxifixum, o
> caelicolae.
> Non est hic; surrexit sicut
> praedixerat,
> Ite nunciate quia surrexit de
> sepulchro.[40]

The exact location of this dialogue within the Easter liturgy has been the subject of much debate, summarized and analyzed by David A. Bjork, who adds the remarkable insight that the differences are regional rather than chronological. What is clear to Bjork is that the dialogue was written by a Frankish monk sometime in the ninth century and that the "*Quem quaeritis* enjoyed nearly universal circulation within the Frankish realm."[41] Referring to the liturgy that now included these interpolated Frankish elements--in effect, a Romano-Frankish rite--Flanigan concludes that "stimulated by Gallican practices now repressed, new dramatic features appeared in the liturgical life of Europe which sought to make explicit the significance of Christian rituals. These new practices sought above all to make dramatically clear the manner in which past time is rendered present again in cultic acts. The emergence of the liturgical drama should be seen as part of these developments."[42]

Whereas it is difficult enough to generalize about the nature of the Gallican rite, which still awaits full scholarly study, it is even more difficult to speak to the architectural setting of that rite. Carol Heitz suggests an association between the celebration of Easter in the Gallican rite and the westwork,[43] which is a massing of architectural elements at the western end of a church: an entrance porch, vaulted, at ground level, gives access to the nave of the main church and the main altar to the east; above this porch one or more galleries form a separate church with its own altar(s); towers flanking or capping this central mass create a monumental western façade. Although the function of the westwork, a phenomenon of northern European church architecture of this period, is not yet definitively understood, westworks seem to have associations with tombs of saints, with cults of relics, and with ruling houses. Heitz's suggestion that the westwork housed the Easter celebration in the Gallican liturgy is largely based on his reading of documents associated with St. Riquier

in Picardy and attributed to Angilbert, the eighth-century reformer of that monastery. Specifically Heitz and others read these texts to indicate that the principal Mass of Easter day was celebrated at St. Riquier in the westwork dedicated to St. Savior--a building which is no longer extant. If this were true, it would imply that St. Savior was a large and also important church. From this early example Heitz has traced the later performance of the commemorative Holy Week and Easter rites at a locus toward the western end of the church--or, at least, west of the eastern choir. Heitz seems thus to demonstrate that the documented Romanesque association between the Easter celebration and the western end of the church had its roots as far back as the eighth century. David Parsons, who has recently shown that Angilbert's documents have been misread, proposes a reading that severs this association. Parsons concludes that "Since the use and the importance of St Saviour's were less than Heitz thought, it seems proper to resist any 'contamination' of the Carolingian history of the westwork with notions of embryonic Easter drama taking place in them."[44]

Other evidence supports this association, however. There is a general correlation between monastic communities in which dramatic rites developed and those that had a major church with a westwork.[45] If the church in a westwork was dedicated to Christ the Savior (as at St. Riquier) and if, as Verdier notes, the appropriate day for observing the patronal celebration of a church dedicated to the Savior is Easter,[46] then it is even more likely that the locus for the celebrations of Easter was the westwork. Further, in an article published more than a decade after his book, Heitz establishes a related change in the setting for the scene of the holy women at the tomb as it appeared in the pictorial arts. Some Carolingian renderings of this scene show it taking place not at the familiar centralized structure recognizable as the Holy Sepulchre in Jerusalem but instead at a Carolingian tower often at the western end of a church. As Heitz observes, "The Holy Sepulchre which figures in these scenes frequently presents the form of a Carolingian *turris*, simple or with more complex details, but always in imitation of actual architecture."[47] There is no doubt that these towers imitate westworks. Further, the angel's gesture leads the eye to the interior of the structure where the bunched grave cloth lies discarded, a feature which reinforces the idea that this is where the rites repeating the events of the first Easter morning took place. Heitz is able to demonstrate that Romanesque celebrations of the Easter rites on the Continent at specific locations frequently take place west of the choir. He suggests that this is a survival of the tradition of performance in the westwork; as the architectural practice of erecting a westwork disappeared, the rites were forced into nave, aisles, or chapels. This correlates roughly with the next phase of the chronological development of the Holy Sepulchre, namely its assimilation into a larger church structure.

The Holy Sepulchres built in northern Europe up until the eleventh century were part of monastic complexes. Early medieval monasteries favored "the primitive form of a number of comparatively small churches"[48] on a single site. These were aligned as at St. Augustine, Canterbury, or placed on the perimeter of an open space as at St. Riquier. The Holy Sepulchre, where it existed, was one of those small buildings and, as suggested above, may have been included in stational liturgy. Advances in architectural techniques, in particular the ability to erect stone vaulting, contributed to the construction by the eleventh century of significantly larger and higher churches. As larger churches with multiple chapels (and an altar in each chapel) became the norm in monasteries, these churches assimilated the Holy Sepulchre; it was no longer a separate free-standing structure, but was inside a new, more spacious church. These new "interior" structures are the first Holy Sepulchres to which the Easter rites can be firmly attached.

The change in the placement of the Holy Sepulchre also changed its relationship to its "host" church. In the examples discussed previously, the model of the Holy Sepulchre in Jerusalem had impressed some of its features either on an architectural copy or on a church containing in replica the interior rooms of the Holy Sepulchre. All of these were centralized structures, like the Holy Sepulchre in Jerusalem, but the new type of Holy Sepulchre that begins in the eleventh century is usually housed in a basilican church. Although such a Holy Sepulchre still replicates the architecture of the Holy Sepulchre in Jerusalem, its architectural form loses its functional meaning when it is seen inside another building. The object begins to strike the eye more like a large piece of sculpture than a small piece of architecture. It is as if the entire Holy Sepulchre had been reduced in size, shrunk to a model, and given the precious quality of a shrine or reliquary. An example of a Holy Sepulchre of this type from the second half of the eleventh century stands in the cathedral at Aquileia, in the north aisle, second bay from the west.[49] A round marble building, it is large enough to enter--3.8 meters in diameter and two meters high. The replica of the grave inside is set into the wall under an arch and accompanied by a niche. This structure may correctly by called a *sepulchrum Domini*, for there are surviving texts of the corresponding Easter rites from the fifteenth and sixteenth centuries.[50] These call for the Host and a crucifix to be buried separately, and thus strongly indicate that the structure was intended for use as a *sepulchrum Domini* from the time it was built since the grave and niche are suited to these purposes.

The thirteenth-century Holy Sepulchre at Magdeburg is an example from northern Europe of this same type.[51] Polygonal and originally located in the nave, it approximates the size of the Holy Sepulchre at Aquileia--under four meters in diameter--and thus was large enough for the performance of

the rites; however, neither a replica of a grave nor texts
survive.

It was perhaps inevitable that, deprived of its function
as a work of architecture, the Holy Sepulchre inside a church
would come to be viewed as existing less to commemorate the
original Holy Sepulchre than to call to mind those events which
had happened at the Holy Sepulchre in Jerusalem and which
were re-enacted in the Holy Week and Easter rites. Thus,
although the late eleventh-century Holy Sepulchre at Gernrode
reproduces elements of the architecture of the Holy Sepulchre
in Jerusalem, it also contains narrative sculpture.[52] A two-
roomed structure in the two eastern bays of the south aisle of
the church, the Holy Sepulchre at Gernrode had an octopartite
vault over the grave room, giving it the centralized quality
associated with other Holy Sepulchres. However, inside the
grave room, which contains on its north wall the remains of a
sarcophagus, two angels, carved in relief, sit at the head and
foot of the grave. One of the angels, pointing toward the
grave with one hand, holds in the other the staff of the Res-
urrection and a banderole with the words from the *Quem
quaeritis* dialogue: "SURREXIT NON EST" The three
holy women originally stood on the inner south wall where they
formed an audience for the angel's words and gesture. Two
other scenes related to Christ's Resurrection are sculpted on
the outer walls of this Holy Sepulchre: the *Hortulanus*, and
Peter and John running to the tomb. The presence of all three
of these scenes in the *Visitatio* rite suggests not only that
such rites were performed here but also that the role of the
Holy Sepulchre as locus for the rites had assumed major impor-
tance. This is apparently the first time that any of these three
subjects--holy women at the tomb, *Hortulanus*, and the race of
Peter and John--had appeared in art either on a monumental
scale (i.e., approximately life-sized rather than miniaturized as
on a manuscript page) or in relation to architecture. Thus the
interdependence of the pictorial arts and the Easter rites seems
to have served as a stimulus to artists.

In the cathedral at Constance, a later Holy Sepulchre
which almost certainly functioned as a *sepulchrum Domini*
expands the content of the narrative[53] and thus further
de-emphasizes the role of the Holy Sepulchre as a copy of the
one in Jerusalem. Standing in the chapel of St. Maurice, the
Holy Sepulchre at Constance is a centralized polygon with a
steeply pointed roof and is decorated with sculpture both
inside and out. On the interior are the scenes of the holy
women with the apothecary and then at the grave with an
angel and three soldiers. As at Gernrode, these scenes directly
represent the events around the Resurrection, whereas an
architectural copy of the Holy Sepulchre alone could only evoke
such happenings. The twelve apostles and scenes from the life
of Mary adorn the exterior and expand the narrative content
beyond the specific events that happened at the Holy
Sepulchre in Jerusalem. This tends to reduce the meaning of

the polygonal structure and to move it toward a neutral background for the sculpture.

Architectural copies such as these Holy Sepulchres at Gernrode and Constance as well as the earlier ones which go back to the fifth century indicate that veneration for the Holy Sepulchre in Jerusalem was both strong and persistent; this veneration formed part of the context within which the commemorative Holy Week and Easter rites developed. Other important elements include processional movement and stational liturgy, linked, at least in Jerusalem--and elsewhere through imaginative replication of Jerusalem--with the re-enactment of sacred events. Added to these was a feeling for the dramatic that could not be suppressed even when its manifestation, the Gallican rite, was supplanted. Holy Week observance and Easter celebrations brought large congregations to the church, and there were possibly some associations between these occasions and the western portion of the church, the west-work, containing a separate church often dedicated to Christ the Savior. We cannot say at precisely what point all of this coalesced into rite, although that feat had certainly been accomplished by the middle of the tenth century; the earliest surviving texts have a satisfying completeness that supposes earlier stages of development. But we can say that, given this rich and fertile context, the appearance of drama is not surprising.

The earliest surviving texts of the commemorative Holy Week and Easter rites are English, introducing the problem of the relationship of the context established above to develop-ments in England. Devotion to the Holy Sepulchre was part of the English religious experience as well as of the continental. But none of the four rotundas known to have been built before the twelfth century in England can be linked to the desire of returning pilgrims to replicate the Holy Sepulchre.[54] Monastic complexes with several small buildings were typical and suggest that liturgy could have been stational in nature. From the time that Augustine reintroduced Christianity into Britain after the barbarian invasions, the Roman rite had been used. The Celtic rite brought by Irish monks to the north--the only local rite that could have influenced the Roman--does not seem to have had dramatic tendencies. Thus, conditions in the British isles were significantly different from those which prevailed on the Continent.

By the tenth century the reforming spirit, which among other things had swept away the Gallican rite, also had led to widespread monastic reform. This reform reached England through the efforts of Dunstan, Aethelwold, and Oswald and received strong support from King Edgar, who, probably in 973, summoned a Synodal Council at Winchester. Bishops, abbots, and abbesses gathered, and, in consultation with monks from Fleury and Ghent who had been invited to the council, they compiled a monastic code, the *Regularis Con-cordia*, which all promised to obey.[55] The precise source of

any one of the specific guidelines set forth in the *Regularis Concordia* cannot now be determined. Dom Thomas Symons, its modern editor, who finds more influence from Ghent than from Fleury in the document, comments: "It may be that the customs of Ghent, indirectly discernible in the *Regularis Concordia* through Lotharingian parallels, had specially commended themselves to the English."[56] On the other hand, Richard B. Donovan suggests that influence from Fleury is more probable.[57] What can be concluded, though not proved, is that the custom of enacting the Holy Week and Easter rites, and thus of the necessity of having a *sepulchrum Domini*, entered England in the late tenth century as part of a general monastic reform from one or both of the two main streams of reform on the Continent. In this view, the fact that the earliest surviving texts of the commemorative Holy Week and Easter rites are English is an anomaly, as they must have existed earlier on the Continent in order to have influenced the *Regularis Concordia*.

The texts of the commemorative Holy Week and Easter rites from the *Regularis Concordia* deserve to be presented in full along with translations:[58]

<Depositio crucis>

Nam quia ea die depositionem corporis saluatoris nostri celebramus usum quorundam religiosorum imitabilem ad fidem indocti uulgi ac neofitorum corroborandam equiperando sequi si ita cui uisum fuerit uel sibi taliter placuerit hoc modo decreuimus. Sit autem in una parte altaris qua uacuum fuerit quedam assimilatio sepulchri uelamenque quoddam in gyro tensum. quod dum sancta crux adorata fuerit deponatur hoc ordine. Veniant diaconi qui prius portauerunt eam. & inuoluant eam sindone in loco ubi adorata est. Tunc reportent eam canentes antiphonas.

In pace in idipsum <dormiam et requiescam>.
Habitabit <in tabernaculo tuo, requiescet in monte sancto tuo>.
ITEM.
Cara mea requiescet in spe.
Donec ueniant ad locum monumento. depositaque cruce. ac si domini nostri ihesu Christi corpore sepulto. dicant antiphonam.
Sepulto domino signatum est monumentum ponentes milites qui custodirent eum.
In eodem loco sancta crux cum omni reuerentia custodiatur usque dominica noctem resurrectionis. Nocte uero ordinentur duo fratres aut tres aut plures si tanta fuerint congregatio. qui ibidem | psalmos decantando excubias fideles exerceant. [ff. 19^v-20^r; figs. 1-2]

<Elevatio>

Eiusdem tempore noctis antequam matutinorum signa
moueantur. sumant editui crucem. & ponant in loco sibi
congruo. [f. 21r; fig. 3]

<Visitatio>

Dum tertia recitatur lectio .iiii. fratres induant se
quorum unus a<l>ba indutus. ac si ad aliud agendum
ingrediatur. atque latenter sepulchri locum adeat. ibique
manu tenens palmam quietus sedeat. Dumque tertium
percelebratur reponsorium. residui tres succedant.
Omnes quidem cappis induti. turribula cum incensu
manibus gestantes. ac pedetemptim ad similitudinem
querentium. quid ueniant. ante locum sepulchri. Aguntur
enim hec ad imitationem angeli sedentis in monumento.
atque mulierum cum aromatibus uenientium ut ungerent
corpus ihesu. Cum ergo ille residens. tres uelut erraneos
ac aliquid querentes. uiderit sibi adpromixare. incipiat
mediocri uoce dulcisone ß cantare.
 Quem queritis <in sepulchro, o Christicole?>
Quo decantato fine tenus. respondeant. hi tres uno ore.
 Ihesum nazarenum <crucifixum, o celicola>.
Quibus ille.
 Non est hic surrexit sicut predixerat. Ite nuntiate
 quia surrexit a mortuis.
Cuius iussi<oni>s uoce uertant se illi tres ad chorum
dicentes.
 Alleluia. resurrexit dominus <hodie, leo fortis.
 Christus, filius Dei. Deo gratias, dicite eia>.
Dicto hoc rursus ille residens. uelut reuocans illos. dicat
antiphonam
 Venite & uidete locum <ubi positus erat Dominus,
 alleluia, alleluia>.
hec uero dicens. surgat & erigat uelum. ostendatque eis
locum cruce nudatum. Sed tantum linteamina posita.
quibus crux inuoluta erat. Quo uiso: deponant turribula
que gestauerant in eodem sepulchro. Sumantque linteum.
& extendant contra clerum: ac ueluti ostendentes quod
surrexerit dominus etiam non sit illo inuolutus. hanc
canant antiphonam.
 Surrexit dominus de sepulchro <qui pro nobis
 pependit in ligno, alleluia>.
Superponantque linteum altari. Finita antiphona prior
congaudens pro triumpho regis nostri. quod deuicta
morte surrexit. incipiat hymnum.
 Te deum laudamus.
Quo incepto: una pulsantur omnia signa. [f. 21r-21v;
figs. 3-4]

The Burial of the Cross

For since on that day we celebrate the burial of the body of our Savior, if it should be considered or seem pleasing to anyone to follow, by similar undertaking, the practice of certain religious men who are worthy of imitation in order to strengthen the faith of the unlearned multitude and of neophytes, we have decided [that it should be done] in this manner. Let there be on one part of the altar, where there is space, a likeness of a sepulchre, and a curtain stretched around it which should be placed in this manner while the holy cross had been venerated. The deacons who earlier carried [the cross] should come forward and wrap it in a linen cloth in the place where it had been adored. Then they should carry it back, singing the antiphons *In peace, in this very place, [I shall sleep and I shall rest]; He shall dwell [in your tabernacle; he shall rest in your holy mountain]*; and *My flesh shall rest in hope*, until they come to the place of the sepulchre; and when the cross has been placed in it, as if the body of our Lord Jesus Christ had been buried, they should say the antiphon:

After the Lord was buried, the sepulchre was sealed; the soldiers are placed who are to keep watch over him.

In the same place the holy cross should be kept watch over with every reverence up to the night of the Lord's Resurrection. At night two or three brothers, or more if the community is of such a size, should be appointed, who should diligently keep watch there, chanting psalms.

The Raising of the Cross

At the same time of night, before the bells should be rung for Matins, the sacristans should take up the cross and put it in an appropriate place.

The Visit to the Sepulchre

While the third lesson is being read aloud, four brothers should put on garments; one of them, who has put on an alb, should come in as if he is doing something else, and should surreptitiously go to the place of the sepulchre and should sit there quietly, holding a palm in his hand. And while the third responsory is being sung through, the other three should follow after, all of them wearing copes, carrying thuribles with incense in their hands, and hesitantly, in imitation of those seeking for something, they should come to the place of the sepulchre.

For these things are done in order to imitate the angel
seated in the tomb and the women coming with spices in
order to anoint the body of Jesus. Therefore, when the
one seated has seen that the three are behaving as if
they were wandering about and looking for something
have drawn near to himself, he should begin to sing in a
mellifluous, moderate voice:
"Whom do you seek [in the sepulchre, oh followers of
Christ?]"
After this has been completely finished, these
three should answer in one voice, "Jesus of Nazareth
[who was crucified, O heaven-dweller]."
He replies to them: "He is not here, he has risen just as
he had prophesied; go, report that he has risen from
the dead."
When they have heard this command the three should
turn themselves toward the choir, saying:
"Alleluia, the Lord has risen, [today the mighty lion,
Christ, the son of God]."
When this has been said, he, seating himself again,
should say an antiphon as if he were calling them back:
"Come and see the place where the Lord had been laid,
alleluia."
While he is saying this he should stand up and
lift the curtain and show them the place which is empty
of the cross. Only the linen cloth, in which the cross
had been wrapped, has been put there. When they have
seen this, they should put down in the same sepulchre
the thuribles which they had been carrying, and take up
the shroud, and stretch it out in the direction of the
clergy, and, as if they were showing that the Lord had
risen and was no longer wrapped in it, they should sing
this antiphon:
"The Lord has risen from the sepulchre, [he who hung
on the cross for us, alleluia]."
They should place the cloth over the altar. After the
completion of the antiphon, the prior, rejoicing with them
because of the triumph of our king, because he conquer-
ed death and rose, should begin the hymn, "We praise
you, O God." After this has been started, all the bells
should ring together.[59]

The relevant rites in the *Regularis Concordia* thus call
for the ritual burial of a cross on Good Friday in a re-enact-
ment of Christ's burial (*Depositio*), a ritual raising of the same
cross early Easter morning in a re-enactment of the Resurrec-
tion (*Elevatio*), and a dramatization of the visit of the holy
women to the tomb later on Easter Day (*Visitatio*). The last is
the only ceremony in which roles are assigned and lines are
spoken as if the speaker were playing a part. All of this is to
take place at an altar. The altar, which usually contained one
or more relics, had long been seen as a reminder of Christ's

tomb, a *sepulchrum*. Using an altar as the *sepulchrum Domini* would only serve to bring such resonances more sharply to mind.

Whereas envisioning the performance of the rites at a *sepulchrum Domini* temporarily erected on an altar seems fairly easy, difficulties arise in trying to locate this altar in the space of a church. It has generally been assumed that the altar chosen for the *sepulchrum Domini* would have been the high altar, which would thus fix the locus for the rites in the choir, at the east end of most churches. This does not fit with Heitz's theory that the celebration of Holy Week and Easter in the Gallican rite was in the westwork and that this use of western parts of the church carried over into the setting of the commemorative Holy Week and Easter rites as they developed. If the rites came to England from the Continent, why would this association not have come with them as well? A possible solution is offered by Elie Konigson's reading of the *Regularis Concordia* text, a reading which favors Heitz's interpretation.[60] Konigson argues that since in the *Visitatio* a rubric directs the holy women to display the cloth from the grave "contra clerum," the women must be in the western end of the church at this time and, to follow the rubric, would turn toward the east where the clergy would be standing in the choir. At the conclusion of the rite they would move in procession from the west back to the choir. To buttress his argument, Konigson examines later plays in which use is made of the longitudinal axis of the building, with its poles to east and west, and concludes: "Finally sacred space is always oriented: the officiants and the place of the dramatized liturgy are situated and move themselves along an axis, sometimes from west to east, sometimes from east to west, sometimes, starting from these two poles, towards the center marked by the crossing of the transept or the middle of the nave. In that oriented space the faithful, when they are admitted to participate in the dramatized office, are situated between the extreme poles. There again their participation in the office is marked by their integration into the sacred space, itself oriented according to the axis of the world."[61]

Konigson's vision of religious space that is cosmologically oriented and activated by ritual is very appealing. It seems to fit well with what we know about later religious drama--e.g., the Fleury plays or the Benediktbeuren plays. Further, it reminds us that in the Byzantine East, always an influential model for the West, the entire space of the nave was reserved for the clergy and their processional movements. And it helps us understand why secular drama developed a very different kind of theater: without the orientation along the axis of the world that a church interior provided, secular drama had no conceptual framework around which to structure its action. The interior space of the church was a microcosm--all the world, and heaven too.

But is Konigson's interpretation consistent with the

remaining evidence? Applied to the Continent, his view is fairly
convincing. Most texts of the Holy Week and Easter rites place
the action outside of the choir and to the west of it--in the
crypt, in the transepts, at the altar of the Holy Cross in the
nave. Locations of *sepulchra Domini* still in existence are
virtually always outside the choir. Even in France where an
altar, assumed to be the high altar, is usually stipulated as
the place for the erection of a temporary *sepulchrum Domini*,
the recent discovery of twelfth-century wall painting of Easter
subjects in the north transept of St. Sernin at Toulouse
suggests to Thomas Lyman that the *sepulchrum Domini* at this
important pilgrimage church was in this location, not in the
choir.[62]

Problems arise in applying Konigson's theory to England,
even though the text on which he bases it, the *Regularis
Concordia*, is an English text. The first problem is that the
number of surviving texts from the centuries immediately
following the *Regularis Concordia* is so small that it is difficult
to generalize from them to support any theory. There is,
however, little evidence of commemorative Holy Week and Easter
rites that utilize processional movement along an east-west
axis. Another problem is that surviving *sepulchra Domini* in
England are virtually always in the choir or chancel, not to
the west of it. A further problem concerns the westwork in
England. The council that drew up the *Regularis Concordia*
may well have met in the Old Minster at Winchester, which was
rebuilt immediately thereafter. The rebuilding featured the
addition of a westwork; in the same period the New Minster at
Winchester was given a large western tower. David Parsons
suggests that renovation was undertaken in order to bring the
Old Minster into conformity with the new liturgical require-
ments of the *Concordia*, and he sees it as part of a general
pattern: "it looks as though the story of English architectural
development in the tenth century is one of buildings being
adapted to keep pace with liturgical needs."[63] However,
Parsons does not see a relationship between the westwork and
Easter drama. Rather he assumes that the open space in front
of the chancel, perhaps in the form of a continuous transept,
was provided in order to accommodate the performance of the
new Easter rites, and he bases that assumption on later
English practice.

There seem to be only two certain sources of information
about the locus of the Holy Week and Easter rites when they
were first introduced in England: the texts themselves and
later practice. Konigson and Parsons each consider one of
these sources and reach opposite conclusions. The problem is
that we know so little about how the text of the *Regularis
Concordia* was compiled or interpreted. Symons, its editor,
suggests that the language of the passage introducing the
Easter rites is "suggestive of something in the nature of
compromise resulting from synodal discussion."[64] Perhaps there
was an undercurrent of unease about these rites from the very

beginning. Had any of the bishops, abbots, and abbesses who swore to uphold the *Concordia* ever seen one of the rites performed? Did they think about or discuss the issue of how it could be incorporated into the liturgical space they had available? In the absence of a tradition associating the celebration of Easter with the western end of the church, would they assume that the rites were to be performed in the choir, the center of most liturgical activity? If we could answer these questions we would be closer to an understanding of the first *sepulchra Domini* in England.

THE RITES IN ENGLAND

The *Regularis Concordia*, in all probability, represents the introduction of the *Depositio, Elevatio*, and *Visitatio* rites into England. This chapter focuses on other manuscripts containing those rites in medieval England and provides comparison with the corresponding rites on the Continent. Manuscripts recording the rites are not available in equal numbers for each geographical area; many manuscripts survive from Germany and a moderate number from France, but from England they are relatively few.[1] Nonetheless the latter are important—the *Regularis Concordia* because of its early date, and those reflecting the Use of Sarum because that use was widely followed in England. In fact, a discussion of the Use of Sarum which was frequently consulted by clergy in the fifteenth and early sixteenth centuries identifies having a sepulchre as one of the practices found in the Use of Sarum that ought generally to be observed in all churches and as a rite not properly to be omitted.[2]

The *Depositio*, conducted on Good Friday either after the Adoration of the Cross or after Vespers, was the first ceremony to take place at the *sepulchrum Domini*. The *Regularis Concordia* directs the execution of the *Depositio* immediately after the *Adoratio* as do the texts from Durham, Hereford, Norwich, and York. The alternative time, after Vespers, was followed at Exeter, at Oxford, and in the Use of Sarum. There are no English texts directing the re-enactment of the *Depositio* after the Mass of the Presanctified, although such practice was fairly common in Germany.

In the *Depositio* a cross, in some cases with a detachable *corpus*, was enclosed in the *sepulchrum Domini* to represent the body of Christ. Frequently, as in the Use of Sarum, a Host was included as well. The use of these two items suggests two possible origins for the *Depositio*. First, burial of the cross extends logically the symbolism of the *Adoratio*, in which a cross is venerated as if it were the broken body of Christ.[3] The York *Depositio* printed in 1509 moves from the *Adoratio* to *Depositio* at the *sepulchrum*, but the content of the opening antiphon, sung by a priest, continues the adoration of the cross:

> Super omnia ligna cedrorum tu sola excelsior in qua vita mundi pependit in qua christus triumphauit et mors mortem superauit in eternum.

Burial of the Host could also have arisen from the unusual circumstances surrounding the Mass of the Presanctified on

Good Friday. As no Host is consecrated that day, consecration for Good Friday's Mass takes place on Thursday, and the Host thus needs to be specially reserved until the time when it is required.[4] This practice may have introduced the idea of reservation of the Host in the context of the Good Friday's liturgy, which itself surely provided a heightened awareness that the elements of the Mass were to be identified with the body of Christ. Thus, after the Mass of the Presanctified, at which, in northern Europe, there was usually a general communion,[5] the remaining fragments of the sanctified Host may have been placed then in the *sepulchrum Domini* with the cross. Some combination of these factors probably served as stimulus for the development of the *Depositio*, of which more texts survive in England than of the *Elevatio* or *Visitatio*.

The *Depositio* enacts a simple series of events, beginning with a procession in which monks, deacons, or priests carry the cross and/or host to the *sepulchrum Domini*. Embellishments in some texts reinforce the mimetic content of the rite. In the fourteenth-century text from the convent at Barking in Essex, the procession moves directly from the *Adoratio* and pauses at the high altar, where *in specie ioseph et nichodemi* priests remove the *corpus* from the cross and wash its wounds with wine and water in imitation of the washing of Christ's body in preparation for burial; a fourteenth-century Hereford text directs that this be done at the door of the sepulchre (*ante hostium Sepulchri*). Most texts do not mention the location of the sepulchre which, to judge from surviving examples, was almost always on the north side of the chancel. The 1509 *Depositio* from York supports this evidence, strongly suggesting that the Easter Sepulchre was north of the altar: "Finally, after the cross has been adored, two priests ascending through the northern part of the choir, carry it to the sepulchre." The singing of antiphons accompanied the procession and laying down of the cross and/or Host, which may have been censed before the door of the Easter Sepulchre was closed. Curtains were drawn about the Easter Sepulchre, and lights placed in front of it burned at least until Easter morning.

The *Depositio* in the *Regularis Concordia* ends with a directive that watch be kept at the *sepulchrum*, a custom that was widely followed in England and that reflects funerary practice. Continental manuscripts add some further details from the Gospel accounts which underscore the desire to re-enact and thus to re-experience the burial of Christ. The closing of the *sepulchrum Domini* with a stone is mentioned in a fifteenth-century breviary from Chiemsee.[6] A stone in the parish church at Bleidenstatt inscribed "...m fecit hunc lapidem in sepulturam crucis dominice in parasceve"[7] may have been used for this purpose. Other attempts to close the *sepulchrum Domini* securely must have been based on Gospel reports that Roman soldiers sealed the Holy Sepulchre. At Strasbourg cords were tied to close the *sepulchrum Domini* after the cross was placed

inside.[8]

Although a will of 1546 leaves a sum of money to the church of St. John Baptist in Tunstall, Kent, "for the making of a new frame for the Sepulchre, and a stone to lie upon it," this kind of mimetic detail is most unusual in English Sepulchres. Rather than reproducing features such as the sealing stone that were appropriate to the tomb of the Gospel accounts, some *sepulchra Domini*, especially in England, treated the tomb of Christ as if it were the funerary bier or tomb of a contemporary person of means. The coffer or chest for enclosing cross and/or Host sometimes rested on a "bier," a term also used for the wooden frame on which a coffin rested during a funeral. Enclosing the chest might be a hearse, a wooden or metal framework commonly placed over coffins or funerary effigies to support lights and drapery. The churchwardens at Walberswick in Suffolk in 1463 purchased "ye hearse a bowt ye sepulcre." And the cloths draped over the herse were sometimes called palls, as in an inventory of 1470 from St. John Baptist, Bristol: "a pall of cloth of gold for the Sepulcre." Just as tombs were carved with coats of arms to honor the deceased, the tomb of Christ or Easter Sepulchre at the church of St. Mary, Berry Pomeroy, Devon, has shields with emblems of the Passion, Christ's heraldry, carved on its side. Further underscoring the close relationship between funerary practice and *Depositio*, many of the details in this rite recur in a document recording minutes of a council in which preparations for the funeral of Katherine of Aragon were determined: "Item a sumptuous herce with ix principalls and lights accordingly to be set in the Churche or Monastery where the Corps shalbe buried. . . . Item order to be taken for watche to be had nightly aboute the Corps during the tyme the same shal remayn unburied. . . . The corps must be covered with a pall of black riche clothe of gold. . . ."[9]

The duties of the watchers at the Easter Sepulchre came to an end before the *Elevatio* of Easter morning, a ritual that re-enacted the Resurrection. Developing a procedure for this ceremony must have been somewhat difficult for the same reason that artists refrained for many centuries from depicting the Resurrection: no one had been present to record the original event. The Gospels do not describe the Resurrection and provide no cast of characters as they do for both the *Depositio* and the *Visitatio*. To complete the action begun by the *Depositio* in the places where no *Elevatio* text survives, cross and/or Host must have been removed from the *sepulchrum Domini* as secretly and mysteriously as Christ had risen from his tomb. The *Regularis Concordia* prescribes this kind of *Elevatio*. During the night, before the call to Matins that begins the next liturgical day, sacristans were to remove the cross from the *sepulchrum Domini* and put it in an appropriate place (*in loco sibi congruo*). This text thus instructs the performance of the one essential task, the removal of the cross so that the "tomb" might be found empty, but it gives no

accompanying ritual. The cross is to be taken to a suitable place, but there is unfortunately no suggestion as to where this might be.

Even though the rubric given in the *Regularis Concordia* was in accordance with the scriptural accounts, inevitably the necessary task was elaborated into a colorful ritual. No *Elevatio* appears in early Sarum manuscripts, but by the late fourteenth century a precise ordering of events was given. The time was to be before Matins on Easter morning; it was necessary to enact the *Elevatio* before the morning of Easter Sunday, a new liturgical day, as had been recognized in the *Regularis Concordia*. At this time the clergy convened and, carrying candles, entered the church. Two priests wearing surplices approached the *sepulchrum Domini* and reverently censed the door. The Host was removed and placed on an altar; the cross was carried, accompanied by the singing of an antiphon and preceded by incense and lights, to the altar of St. Martin. Bells rang, and the normal liturgical day then began with the singing of Matins. Since the Sarum Use was widely followed in England, it may be assumed with some degree of certainty that this rite or a variant on it was presented in a great many churches.[10]

In later versions of the *Elevatio*, a larger group, often consisting of all the clergy and the laity as well, moved in procession to the *sepulchrum Domini*. Thus the secrecy of the *Regularis Concordia* was completely abandoned. In the fourteenth century at Exeter, after the opening of the *sepulchrum Domini*, cross and Host received sharply differing treatment. Transferring the Host secretly to an altar (*cum magna ueneracione corpus dominicum accipientes priuatim super altare deponant*) preserved the core of the mystery of the resurrection. The cross, on the other hand, was borne about the church in procession while bells pealed and then was venerated. Sarum service books are not consistent on this point. A printed Breviary of 1531 repeats the Exeter formula: the Host is taken secretly to an altar while *choro et populo* genuflect in veneration of the cross. This is followed by a carefully described procession. But in a Sarum breviary printed in Venice in 1483 and in other texts the Host is not hidden but is displayed at the climax of the ceremony. In these cases either a monstrance or a piece of crystal in the breast of an image of Christ protected the Host, as at Durham Cathedral: "throughe the which christall the blessed host was conspicuous, to the behoulders." At Barking, where abbess Katherine de Sutton had revised the *Elevatio* in the fourteenth century in order to increase the devotion of the faithful (*fidelium deuocionem ad tam celeb<r>em celebracionem magis excitare*), the ceremony began with a re-enactment of Christ's Descent into Limbo in which the nuns themselves acted the parts of the captive souls released by the command *Tollite portas*. Then all go in procession to the *sepulchrum*, which the priest entered. He emerged with the Host exposed through a crystal and then

turned his face toward the people (*uerso uultu ad populum, tenendo corpus dominicum in manibus suis inclusum cristallo*). Such an interest in display and visual witness speaks to the wish on the part of the Church to satisfy the demands of the people. Other details suggest the same motivation--e.g., leaving open the door of the *sepulchrum Domini* "in testimony of the Resurrection" (Hereford Breviary, 1505) and kissing the chalice that held the Host (York Processional, 1530). Thus the *Elevatio* in England took on the nature of an emotionally engaging communal celebration.[11]

What of the situation on the Continent? Here early *Elevatio* texts insist on the secret nature of this rite, and later, though some do include a congregation, others explicitly forbid their presence. The laity could even be excluded from the *Depositio*, as was the case at Breslau: "With the Office having been finished after Mass, let the sepulchre be prepared, the people having previously been excluded."[12] But the *Elevatio* was much more consistent in enforcing this practice. In effect many of the clergy were excluded as well, since only a few had awakened before the others and had gone secretly to the *sepulchrum Domini*. If there were antiphons, they were sung *submissa voce*; both cross and Host, having been removed from the *sepulchrum Domini*, were carried to altars where they could be seen as evidence of the Resurrection. Then, when all had been prepared for them, the laity was allowed to enter: "Meanwhile let the bell be rung for Matins, and the clergy and people coming together to the church."[13] Even if the laity were in the church, as they might have been to participate in the Easter Vigil, they could be forced to leave when it was time to enact the *Elevatio*--"with all the laity having been expelled before."[14] Explicit exclusion of the laity speaks, of course, to their persistent attempts to witness the *Elevatio*. A synod held at Worms firmly excluded the laity because of a superstition that had arisen that anyone witnessing the raising of the cross on Easter morning would not die that year.[15] Some texts, however, do include the laity-- and these increase in numbers in later centuries--but generally there is a tendency on the continent to separate the re- enactment of the Resurrection from the public celebration of the event.

Just as the empty tomb verified the truth of the Resurrection for the original witnesses--the holy women--so did the empty *sepulchrum Domini* provide certification that Christ is indeed risen for medieval Christians. For this reason the door might be left standing open, with one or more statues of angels, mentioned in a number of churchwardens' accounts, placed in or near the *sepulchrum Domini*, as at St. Margaret's church, Southwark, where a 1485 inventory notes "vj angelles of tre gylt with a tombe to stande in the sepulture at Ester." In continental texts the cloth or napkin in which the cross had been wrapped was explicitly to be left in the *sepulchrum*. A fourteenth-century *Elevatio* from St. George's Church in

Prague reads, in its entirety, "But as for the cross itself, let priests carry it away before the call to Matins is rung, nevertheless, with the cloth being left behind, until night, let the sepulchre be visited by the sisters."[16] The cloth was left in the *sepulchrum Domini* because the nuns should be able to see it there. It was the physical evidence of the reality of the Resurrection, demonstrating that a body had been buried but was no longer present in its grave.

The cloth left after the Resurrection also played an important role in another commemorative Easter rite, the *Visitatio*, which returned to an event firmly, though not fully, described in scriptural accounts--the event of the visit of the holy women to the tomb. Certainly the *Visitatio*, a dramatic re-enactment of the post-Resurrection events of Easter morning, is related to the *Quem quaeritis* dialogue containing the words exchanged between the angel and the holy women at the tomb on Easter morning, but, in spite of the attention focused on its history, that relationship is unclear.[17] By far more popular on the Continent than either the *Depositio* or *Elevatio*, the *Visitatio* has usually been categorized according to three types--Type I: confined to the dialogue between the holy women and the angel; Type II: adding two apostles, Peter and John; and Type III: adding as well the appearance of the risen Christ.

The *Visitatio* in its Type I form makes a strong first appearance in England in the authoritative *Regularis Concordia*. Although many continental versions of the *Visitatio* are not preceded by either *Depositio* or *Elevatio*--and thus there is no indication as to whether an actual *sepulchrum Domini* was called for or whether the *Visitatio* made use of an altar as its *sepulchrum*--the *Regularis Concordia* includes a clear directive for the construction of a *sepulchrum Domini* while the text places emphasis on the monument. The angel insists that the holy women should examine the empty tomb for themselves, and, singing *Venite et uidete locum*, lifts the curtain (presumably the enclosing curtain mentioned in the *Depositio*) to display the cloth that represents Christ's winding sheet. Surprisingly, the *Visitatio* does not appear in the Use of Sarum. There is little evidence that the *Visitatio* play was much performed in England, but a newly identified subject on an eleventh or early twelfth century ivory pyx, probably English, suggests some continuity after the *Regularis Concordia*.[18]

The oval pyx, now in the Victoria and Albert Museum, directly associates *Elevatio* and *Visitatio*, for on its two long sides it is carved in relief with two scenes, the first identified by T. A. Heslop as an illustration of the *Elevatio*: a monk (fig. 26) approaches an altar on which stands a large candle, possibly the Paschal candle, and carries the Host in a ciborium (reminiscent of the much later York text: *cuppa in qua est Sacramentum*). On the other side a male figure lies prostrate at the feet of another (fig. 25). The prostrate figure, who clutches a cloth in one hand, may have emerged from the small

building with sloping roof and round-arched entrance just behind him. Out of sight at one small end of the pyx two monks stand fearfully. Heslop sees this as a *Hortulanus* scene from a Type III *Visitatio* in which the holy women were played by monks as in numerous continental manuscripts made to be used in monasteries. If the pyx is English, it not only strengthens the case for the *Visitatio* in England but also helps bridge the gap between the *Regularis Concordia* and the only other English text with a *Visitatio*, the Barking Ordinal of the fourteenth century.[19] Further, the *Hortulanus* scene in the Barking *Visitatio*, as Heslop notes, corresponds rather closely to the *Hortulanus* scene on the pyx. The *Visitatio* from Barking, a lengthy and well-developed play, is most closely related to texts from Rouen and is also similar to the Dublin play of the same period (Lipphardt, Nos. 772 and 772a). Diane Dolan sees Winchester influence at Rouen, which enables her to trace a line of influence from Winchester to Rouen to Barking and Dublin, and hence she is able to speak of an English type of *Visitatio*.[20] But in England it is confined to these examples.

Beyond this, it is difficult to produce positive evidence for the *Visitatio* in England. There are several references to the *Quem quaeritis* or Resurrection plays, but their texts are lost. *Quem quaeritis* might refer to an undeveloped dialogue such as the one that appears, for example, in the tenth-century Winchester Troper rather than to a *Visitatio*, likewise a record of a Resurrection play might refer to an enactment of the actual Resurrection rather than to the *Visitatio*. The telling fact is that the *Visitatio* was not a part of the Use of Sarum, by far the most widely followed liturgical model in England; neither is it a part of extant liturgies of York, Hereford, Exeter, or Durham in which the *Depositio* and/or *Elevatio* are found. Churchwardens' accounts and church inventories, which supply ample evidence for the existence of Easter Sepulchres, do not include information that would unambiguously point to the performance of the *Visitatio*. We finally come to agree with Karl Young's conclusion that the *Visitatio* was rare in England[21] even though on the Continent it was more widespread than the *Depositio* or *Elevatio*.[22] It is therefore entirely logical that it should have been the *Elevatio* that influenced the subjects represented at the Easter Sepulchre.

THE FORM OF THE EASTER SEPULCHRE

The rites of the *Depositio, Elevatio*, and *Visitatio* took place at a locus within a church that functioned in the role of the Holy Sepulchre in Jerusalem. Although the early architect- ural copies of the Holy Sepulchre discussed above in Chapter I may have been used for these rites, later *sepulchra Domini* do not replicate the form of the Holy Sepulchre. Instead they adopt new forms which express in varying ways the later medieval emphasis on Christ's humanity and consequently on the relationship between Christ's death and Resurrection as well as the death and resurrection to eternal life of his followers.

Originating in the thirteenth century, the Germanic *sepulchrum Domini*, called the Holy Grave, assimilates the tomb of Christ to the tomb of the believer, taking the form of a Gothic sarcophagus with a canopy.[1] The sculptural elaboration of the Holy Grave fuses two traditions, that of tomb sculpture and that of narrative scenes associated with Holy Sepulchres such as the one at Gernrode. Tomb sculpture establishes the idea of representing the deceased as a life-sized figure laid out on top of the sarcophagus as if on a funerary bier with the mourners as statues grouped around the grave. Narrative sculpture of the Holy Sepulchre determines the identity of these figures, usually as those present at the Deposition and Entombment of Christ. This large sculptural group usually stands in a side aisle or chapel.[2]

Because the custom neither of erecting Holy Sepulchres nor of celebrating the rites of *Depositio, Elevatio*, and *Visi- tatio* was native to England, the Easter Sepulchre as it developed did not follow Continental patterns. First introduced at the end of the tenth century, as we have seen, by the authoritative text of the *Regularis Concordia*, these rites could not have had a traditional locus in English churches before that time. The *sepulchrum Domini* described in the *Regularis Concordia* is of a make-shift nature—one is to find space on an altar and hang a curtain around it. Was such a practice indicative, we may ask, of the inability of the monks from Fleury and Ghent who attended the synod at Winchester to impress upon their English colleagues the need for a more impressive monument? Failing to motivate the construction of full-scale Holy Sepulchres, they could at least describe the required minimum: designated space at an altar. More likely is the hypothesis that many continental churches which never possessed Holy Sepulchres performed the rites at altars, drawing both on the equation altar=*sepulchrum* and on the fact that there was an altar in the Holy Sepulchre in Jerusalem.

The monks from Fleury and Ghent who participated in the synod at Winchester probably came from monasteries where an altar functioned as the *sepulchrum Domini*.[3]

The next documentation for the presentation of the *Depositio, Elevatio*, and *Visitatio* in England after the *Regularis Concordia* is the ivory pyx of the late eleventh or early twelfth century to which reference has been made above in the previous chapter, but the small rectangular structure with sloping roof and arched opening that represents the Holy Sepulchre on this pyx appears to be modeled after early Christian renditions of the Holy Sepulchre in Jerusalem or possibly after a Holy Sepulchre chapel in England. It certainly does not illustrate either an Easter Sepulchre of the type described in the *Regularis Concordia* or one of the several types that developed later in England. Thirteenth-century service books of the Use of Sarum refer to the *Depositio* and to lights about the Easter Sepulchre. Its form was at least partly temporary, as it was to be removed before Mass on Friday of Easter week. A treasurer's inventory of c.1214-22 from Salisbury Cathedral includes a cloth for the Easter Sepulchre--*velum unum de serico supra sepulchrum*--as does an inventory dated 1245 from St. Paul's Cathedral: *Casula bendata rubeo et purpura ponitur per annum ad Pascha super sepulchrum*. Simple recesses in churches of this period, described below, could have been used as Easter Sepulchres, but neither iconography nor documentation exists to prove this.

Virtually all texts and monuments agree that by the time the Easter Sepulchre unambiguously surfaced as a physical monument in the fourteenth century, it had already found a consistent location not at but near an altar--on the north wall of the chancel, usually just a few feet from the high altar of the church. In such proximity to the high altar, the Easter Sepulchre enjoyed much more prominence than continental *sepulchra Domini*, but its possibilities for development were correspondingly restricted. The chancel does not provide space for the full complement of life-sized figures associated with the German Holy Grave. It is easy to point out the limitations of the English Easter Sepulchre,[4] but one should also note the compensating advantage of its extraordinarily prominent location.

In its place to the north of the high altar, the Easter Sepulchre had one of two basic forms: the first, wholly temporary, was set up for the Easter season, then put away and stored until the next year; the other had some permanent features, to which temporary embellishments could be added. Both forms functioned as enclosures for receptacles to contain the cross and/or Host symbolically buried in the Easter Sepulchre on Good Friday.

By far the largest number of Easter Sepulchres in England were temporary structures, as entries in churchwardens' accounts and inventories testify. A wooden frame--presumably placed against the north wall of the chancel, hung

with richly colored cloths, frequently painted or embroidered--created an enclosure, possibly large enough for a person to enter. Permanent features in a church might indicate the placement of the temporary Easter Sepulchre. At the church of SS. Peter and Paul, Dorchester, Oxfordshire, the subject of Christ's Resurrection, complete with the guarding soldiers, is carved on the main boss on the window at the east end of the north aisle. Joan Evans suggests that the altar below this window was used as the base for the Easter Sepulchre.[5] The arrangement of wall and floor paneling at the church at Lutton, Northamptonshire, suggests that a permanent location was planned here for the temporary Easter Sepulchre, and this is attested to by bequests of barley to defray the costs of the Easter Sepulchre in early sixteenth-century wills. The paneling on the north wall of the chancel, east of the priest's doorway (six cinquefoiled arches, gathered under one containing arch) enframes an 18-inch square formed out of the lower parts of the two center panels. A bier or chest probably stood in front of the undecorated plinth below the paneling where it supported a coffer that filled the framed square. The wall treatment thus created a permanent and decorative setting for the temporary Easter Sepulchre.

Inside the temporary frame, some base for the coffer was necessary. It was, in effect, a bier, and might have been the same object employed to support the coffin of the deceased at a Requiem Mass. Alternatively, a wooden chest might have been used as the base of the Easter Sepulchre. Only one such chest is known to survive; it is in the church at Cowthorpe, in Yorkshire (West Riding) (fig. 27). About five feet long and half that wide, the chest at Cowthorpe supports a gabled roof or canopy, embellished with a pierced cresting along the ridge and crocketed gables. No symbols substantiate the traditional view that this is an Easter Sepulchre, but the restriction of decorative carving to the left end and front suggests that it was meant to stand in a northeast corner. Either the chest itself could have enclosed the Host and/or cross, or a coffer for them could have rested on top of the wooden chest under the canopy.

In addition to Easter Sepulchres erected only for the Holy Week and Easter season, there is a large number of permanent Easter Sepulchres, made up of several distinct groups:

1. A simple small recess in the north chancel wall, possibly entirely plain, with or without a door.
2. A large arched recess in the north chancel wall that could have contained an effigy.
3. An elaborate structure set in the north wall with figural sculpture, usually with a small niche, possibly associated with a tomb.
4. A table or chest tomb, with or without a canopy, standing against or near the north wall of the chancel.

5. A stone chest of the same form as the temporary chests.

6. A separate chapel with Easter associations.

7. A crypt beneath the chancel of the church.

The Small Recess (Figs. 28, 29)

Small rectangular recesses set in the north wall of the chancel near the northeast corner are to be found in many churches in England. Most are without any sculptural decoration; some are rebated for a door and may have grooves to accomodate shelving. Most descriptions simply call them "recesses" and make no suggestion as to function unless a recess has or appears to have had a door, in which case it is called an "aumbry." The aumbry, or cupboard, stored the vessels used in the Mass and housed relics, unless special provision had been made for them elsewhere.[6] Given that the location of this recess is the same as that of an Easter Sepulchre and that its function in general centered on the safekeeping of sacred objects, Alfred Heales is surely correct in suggesting that such a recess could well have been used as an Easter Sepulchre.[7] The ability to close the aumbry securely would have made it more desirable as a place for the Host and/or cross during the Easter rites. Possibly some of these recesses were used as Sacrament Houses throughout the year. Many examples survive, from plain rectangular recesses such as the one below a thirteenth-century lancet in the church of SS. Peter and Paul, Tring, Hertfordshire, to those with elaborately carved heads, such as the early fourteenth-century recess with a trefoiled ogee head capped by a finial in the church at Alphamstone, Essex. Rebuilding of such a recess suggests possible conversion to an Easter Sepulchre. A fourteenth-century recess with rebated jambs in the church at Stokenchurch, Buckinghamshire, received a new head in the form of a trefoiled ogee in the early fifteenth century, perhaps an indication of its conversion to an Easter Sepulchre. Unobtrusive during the rest of the church year, a small recess could even be multi-functional; of course, for this very reason, except when iconographic or documentary evidence is present, it is not possible to make assumptions about one particular function in the instance of such a multi-functional recess.

The Large, Low, Arched Recess (Figs. 31-33)

It is fairly common to find, in the north wall of the chancel, an arched recess set rather low in the wall and large enough to contain a life-sized effigy. Both because of their size and because they frequently contain effigies, these are often called tomb recesses, but their original function may have been different. Lawrance and Routh suggest that such recesses functioned as biers, providing a suitable place for the

body of the deceased during the Requiem Mass, and were later used to house effigies simply because they provided convenient places.[8] Drawing on the analogy of the wooden funerary bier to the framework of the Easter Sepulchre, it would be logical to suggest that such a "tomb recess" could also have been used as an Easter Sepulchre. Recesses of this type are found from all periods of the late Middle Ages; simple, functional structures have a permanent appeal. Some of these recesses feature rich carving, such as the early fourteenth-century recess in the church at Hawstead, Suffolk, which has foliate carving along the arch molding; it now contains the cross-legged effigy of a late-thirteenth-century knight. Another recess, from the fifteenth century in the church at Ivinghoe in Buckinghamshire, displays molded jambs and a cinquefoiled subcusped arch. A will of 1522 from Yalding, Kent, contains a bequest to rebuild such a sepulchre so that its top would extend over the existing window, which therefore would have to be filled in: "I will that the wyndow ouer the sepulture be dampned and a blynde arche to be made rising ouer the same sepulture and the wudwarke of the same sepulture to be made according to good wurmanship and afterwarde to be gilded with the Resurrexion of our Lorde." Iconography identifying the arch as an Easter Sepulchre was ordered for the woodwork, possibly a wooden tympanum fitted under the new blind arch. At Yalding the gilded Resurrection does not survive, but at East Bergholt in Suffolk a painting of the Resurrection under a recess with an arched top in the north wall of the chancel identifies its function as an Easter Sepulchre.

Simple in form and function, the large, low recess and the small recess were the earliest to appear. Where large and small recesses appear together on the north wall of the chancel, one may be intended for a tomb recess and the other for the cross and/or Host of the Holy Week and Easter rites. At St. Mary's church, Garthorpe, Leicestershire, a low tomb recess in the north wall of the chancel sits directly below a smaller niche with elaborately carved head in the Decorated style. An inscription identifies another example of a large low recess combined with a small one in the church at Tarrant Hinton in Dorset as an Easter Sepulchre. Above the large recess, early Tudor in style, is a niche flanked by angels carved in relief. The inscription band which includes the words of the Resurrection angel has, from west to east, the initials T. W., the head of a cherub, VENITE ET VIDETE LOCUM UBI POSITUS ERAT DOMINUS, another cherub's head, and the initials T. T.

Elaborate Structure with Figural Sculpture (Figs. 36-43)

The unexplained initials accompanying the Latin inscription on the Easter Sepulchre at Tarrant Hinton could be those of a donor who wished to combine his own tomb with the Easter Sepulchre. Such a combination, which characterizes several

groups of Easter Sepulchres, provided both a permanent Easter Sepulchre for the church and a prominent place of burial for the donor. The earliest is that in which the niche or recess for the cross and/or Host becomes part of a grand monument, completely dominating the north wall of the chancel and including both figural sculpture based on Holy Week and Easter subjects and a donor's tomb. These monuments, appearing toward the end of the thirteenth century, are the first monuments that can be clearly identified as Easter Sepulchres. Veronica Sekules suggests that these Easter Sepulchres "are related to zeilige Gräbe in Germany and the Low Countries; their sudden appearance in England is perhaps connected with rising interest in the feast of Corpus Christi."[9] However, differences in iconography between English and German *sepulchra Domini* weaken the possibility of direct influence. Both the Easter Sepulchre and the feast of Corpus Christi reflect increased emphasis on the visual experience of religious truth that seems to characterize the late Middle Ages, one focus of which was the Sacrament. Many wills associate devotion to the Easter Sepulchre and the Eucharist, one of the earliest being that of Sir William Tawk, who in his will of 6 July 1375 left three cows and twenty sheep to St. Peter's church in Westhampnett, Sussex, to sustain *ij torticia* burning daily in the church at the elevation of the body of Christ and one candle of two pounds of wax yearly burning *ad sepulcrum de hora sepulture domini in diem boni veneris usque horam resurrectionis domini in die paschali.* Easter Sepulchre and elevation of the Host are presumably singled out because both center on the living body of Christ. Veronica Sekules argues that this led to monuments combining the functions of Easter Sepulchre and Sacrament House and that the early Easter Sepulchres discussed in this section were conceived primarily as Sacrament Houses.[10]

It seems more likely that combination of tomb and Easter Sepulchre was partially motivated by the introduction in the late thirteenth century of the Decorated Style, with its tendency to gather all the isolated units in the chancel--sedilia, piscina, doorways, tombs, and Easter Sepulchre--into one grand ornamental composition. This afforded an unparalleled opportunity for a donor to memorialize himself through his building program. Not only did an entire renovated chancel speak to the generosity of a donor, therefore deserving of intercessory prayers, but further the presence of the Easter Sepulchre in proximity to a donor's tomb allowed some of the "spiritual power" of this place of resurrection to pass to the donor. The earliest will expressing this desire comes later in the fourteenth century than any of this first group of monuments. Luke Poynings, Lord St. John, in his will of 5 June 1376 left his body to be buried *in ecclesia conventuali Prioratus de Boxgrave Cicestrensis Diocesis in sinistra parte ejusdem ecclesie ubi sepulchrum Domini die pascensi solet.* Just as early Christians desired to be buried *ad sanctos,* near the

graves of the martyrs, medieval Englishmen desired burial *ad sepulchrum Domini*, near the grave of Christ.

Some of the most beautiful Easter Sepulchres come from the earliest group, localized in the East Midlands. That in Lincoln Cathedral, from the 1290's, synthesizes tomb and Easter Sepulchre in a total composition forming six free-standing canopied bays in the choir just to the north of the high altar: the three to the west make up a tomb and the three to the east the Easter Sepulchre, but to the eye they are one unified whole. The front of the tomb chest bears decorative quatrefoils and an identifying inscription, while that of the Easter Sepulchre has relief carvings of three sleeping soldiers that identify it as Christ's tomb.

In parish churches, where, in contrast to Lincoln Cathedral, there is no ambulatory passage giving access to chapels behind the choir, the Easter Sepulchre stands against or is built into the north wall of the chancel. Several Easter Sepulchres of this type are stylistically related and must be the products of a workshop or workshops centered in the area of Lincoln.[11] At Hawton, Nottinghamshire, one horizontal cornice gathers the Easter Sepulchre, the donor's tomb, and a doorway into one composition. The donor, possibly Sir Robert de Compton (d. 1330), whose effigy lies in the recess, may also have funded the sedilia on the south chancel wall, which are in the same style. Similarly at Navenby, Lincolnshire, the Decorated Style, through the lavish use of canopies, pinnacles, and rich foliate carving, characterizes the furnishings of the chancel--a donor's tomb, Easter Sepulchre, piscina, and sedilia--as it also does at Heckington, Lincolnshire. The Easter Sepulchres at Arnold and Sibthorpe, both in Nottinghamshire, also belong in this group.

This group of Easter Sepulchres is unified not only by style but also by the inclusion of figural sculpture which is found in every example except at Arnold, which is very badly damaged. Arrangements vary from the sleeping soldiers at Lincoln to the elaborate scene at Hawton, where there are four soldiers, three holy women, Christ rising, the apostles witnessing the ascension, and angels descending with bande-roles as well as a profusion of decorative sculpture. The emphasis on figural sculpture carries over to fifteenth-century Easter Sepulchres such as those at Northwold, Norfolk, and Withybrook, Warwickshire, which are most closely related to this group, although in their present form the latter do not reveal any associations with donors' tombs.

The Table Tomb as Easter Sepulchre (Figs. 52, 54)

Although the group of monumental Easter Sepulchres just discussed contains some of the most beautiful and most impressive sculpture surviving from medieval England, the form they exhibit remains unusual. Until the late fifteenth century most churches either erected temporary Easter Sepulchres or

made use of multi-functional recesses--large or small--in the north wall of the chancel. However, the group of monumental Easter Sepulchres offers clear evidence for the combination of donor's tomb and Easter Sepulchre, a combination that characterizes the next group of Easter Sepulchres, in which the two forms become one monument with two overlapping functions. Such a monument was either recessed in the wall of the north chancel under an arched canopy or stood free of the wall, either with or without a canopy. Use of a donor's table tomb for the Easter Sepulchre created a monument rich in meaning for the donor and economical in its use of space for the church.

Although no surviving fourteenth-century wills stipulate this combination, a mid fourteenth-century relief from Holy Trinity, Burrington, Somerset, which shows the resurrected Christ adored by censing angels and kneeling donors, is likely to have been part of a tomb *cum* Easter Sepulchre. Both the size of the relief and its round-arched top suggest that it was placed under an arch and above a chest tomb recessed into the wall. By the later fifteenth century, wills calling for combination monuments occur frequently. The will of John Bobbe (d. 1484) stipulates that he was to be buried in the church of St. Margaret, Horsmonden, Kent, in front of the image of St. Margaret. As the statue of a patron saint usually stood to the north of the high altar, Bobbe's burial was to be in the usual place for the Easter Sepulchre, and he asks that over his body, *ad decus ecclesie . . . vna tumba construatur super quamquid tumbam sepulcrum dominicum preparari velim.* The will of John Isly (d. 1494) of Sundridge, Kent, concisely expresses his wish that he be "bured in the high chauncell before oure lady in a tombe in the wall for to sett the sepulcur vpon." The Perpendicular tomb chest now in the north wall of the chancel is presumably Isly's. Edward Markwyck of Hamsey, Sussex, who made his will in 1534, included these instructions: "my body to be buried in the Parishe Church of Hampsey before the Image of Saint Peter in the Chauncell there. . . . I will that my executours shall ordeyn and make one Tombe of Stone to be leyde uppon me with an Image and scripture there graven, whereuppon the Sepulchre may be sett." A canopied table tomb richly carved with vines and Tudor flowers now standing in the chancel of the church may be Markwyck's; if so, his executors did not follow his instructions to include "an Image and scripture."

Such a monument must have taken the form of a flat-topped or table tomb placed near or against the north wall of the chancel. By making the tomb a devout gift of a desired item of church furniture, the deceased gained burial not only inside the church but also in a prominent position near the altar, where the monument would be more likely to evoke the prayers of the living on behalf of the soul of the deceased. In return for this privilege, the tomb form had to accommodate the Easter Sepulchre, presumably with a flat top on which a

wooden frame, to be hung with cloths, could be erected.
Elizabeth Reed's will of 1531, asking to be buried in the church
of St. John Zachary, London, succinctly recognizes this need.
Her tomb is to be "at the north ende of the highe awter there
before the Image of saint John in a tombe by me thereto
ordeyned, which tombe doth serve at Esther tyme for the botom
of the Sepulcre of our Lorde Jesu Criste." John Pympe of
Nettlestead, Kent, in his will of 1496, went into greater detail
in asking to be buried "before the Image of our blessed lady in
the selfe place where as the Sepulture of oure lorde is wount
to stonde at the Fest of Ester and so to be leyde there in a
tombe of stone made under suche forme as the blessed
sacremente and the holy crosse may be leide upon the stone of
the said tombe in maner of sepulture at the Feeste aboue-
saide."

In order to leave the top surface flat so that it could be
used as an Easter Sepulchre, the donors of these monuments
had to forego the form of funerary monument in which a
life-sized effigy sculpted in stone lay on top of the tomb.
However, a number of other ways were found to commemorate
donors. If the effigy were made of wood rather than stone,
then it could be removed from the flat top of the tomb chest to
make way for the erection of the Easter Sepulchre. A mid-
fourteenth-century oak effigy of a priest in the church at
Little Leighs, Essex, may have been made with this function in
mind. Nearly one hundred wooden effigies survive, indicating
that a much larger number once existed, so this may have been
a fairly common solution. The tomb of Sir William de Quinton
and his wife in the church of St. John of Beverley, Harpham,
Yorkshire, has figures of Sir John and his wife incised into
the flat tomb top. Although these tombs date to the fourteenth
century, earlier than any will requesting a combination form
for use as an Easter Sepulchre, they may still have been
intended for that purpose. The monument to Ralph Woodford
(d. 1485) in St. Mary's church, Ashby-Folville, Leicestershire,
is more clearly an Easter Sepulchre: the incised slab is set in
the floor in front of the monument; the inscriptions on the
slab, though not at all inappropriate for a tomb, refer to the
Resurrection, and the wall behind the slab enframes a large
blank panel beneath a lintel frieze of half-length angels,
providing a space against which an Easter Sepulchre might
have been erected. Another form that preserves both an effigy
and a flat tomb top appears in the early sixteenth-century
tomb of Sir John Peche in St. Botolph's church, Lullingstone,
Kent, where the sculpted effigy lies *under* a flat stone slab
and is visible through arches supporting the slab.

More commonly, the desired effigy was engraved in
brass. Use of brasses in this way became especially popular in
the later fifteenth and early sixteenth centuries; many survive
as indents, the brass having been removed either as an act of
vandalism or for another use, as is the case with the tomb of
Sir John Hopton (d. 1489) in the church at Blythburgh,

Suffolk, where brasses were inlaid on the top of the Purbeck marble table tomb. Of course, the brasses were more visible if they were placed vertically. This placement could be in a space on the wall above the flat top of the tomb and below its canopy, as in the tomb of Joan Norton in the parish church at Faversham, Kent, where a brass of Dame Norton, kneeling, faced another of Christ rising from the tomb. Her will of 1535 specified that her tomb "be used for a sepulcre place in the same churche to the honour of God and the blessed Sacrement." Even more visible to those gathered in the nave of the church for services was the vertical slab at the east end of the flat-topped tomb for Sir Walter Luke and his wife in All Saints Church at Cople, Bedfordshire, inlaid with brasses that were enriched with colored enameling.

Every flat-topped tomb in the north chancel may have been meant to function as an Easter Sepulchre, but the probability is increased if the form of the monument itself offers additional evidence, as with the tomb of Gregory Lovell in the church at Harlington, Middlesex. Two indents in the back wall of the canopy that stood over the tomb held brass images of Lovell and his wife; they faced a small wall recess that must have been intended for use as an Easter Sepulchre. Even a tomb with a sculptural effigy might be associated with such a recess; a late fourteenth-century canopied tomb against the north chancel wall of the church in Haversham, Buckinghamshire, supports an alabaster effigy, but in the back wall is a cinquefoiled niche that was surely meant for the deposit of the Host. With the integration of Easter Sepulchre and tomb into one monument, the Easter Sepulchre had no identity of its own; rather it was submerged in the individual tomb, to which it thereby imparted additional benefits. Only in the Easter season did the role of the tomb as an Easter Sepulchre stand out clearly.

Chest Type Easter Sepulchres

The fifth group appears in one region of England, the western part of Somerset, in the late fifteenth and early sixteenth centuries. Their form resembles the table tomb, but they seem to have been especially intended for use as Easter Sepulchres, for they are not funerary monuments. These chest-shaped Easter Sepulchres stand in the northeast corner of the chancel, free of the wall but pushed into the corner so that the only ornamentation is on the south and west sides.[12] Carved paneling ornaments the exposed sides of these chests; at Porlock, the quatrefoil panels frame the sacred heart, the pierced hands and feet of Christ, and a Tudor rose. The iconography of the chest from Porlock is similar to that on a wooden chest from Coity, Glamorganshire, suggesting that these stone Easter Sepulchres may be a local variant of a widely distributed wooden type. Other examples include chests at Luccombe, Monksilver, Milverton, Selworthy, and Winsford.

The Chapel as Easter Sepulchre

Especially in cathedral and monastic churches, the more complex design of the building offered other possible locations for the Easter Sepulchre--e.g., specially designated chapels. There is, however, no firmly documented case of such a use. On the other hand, either the name of the chapel or its iconography suggests Easter Sepulchre associations. For the Chapel of St. Mary and All Angels, formerly at York Minster, the popular name of the chapel, St. Sepulchre's, suggests some connection with Holy Sepulchre, Easter Sepulchre, or both. We know nothing of the form of the chapel, which was founded in the late 1170's and stood in the precincts of the Archbishop's Palace. Its door opened into the north aisle of the Minster.

More information survives in regard to the Chapel of the Holy Sepulchre at the Monastery of the Bonhommes in Edington, Wiltshire. William Wey (d. 1476) made generous gifts to the chapel; an inventory of his gifts refers to "the chapel made to the lykenes of the sepulkyr of owre Lord at Jerusalem." The bewilderingly rich array of items begins with altar clothes, including one with "owre Lorde wyth a spade in hys Hande," vestments, corporal cloths, curtains, and "a clothe stayned wyth the tempyl of Jerusalem, the Movnte of Olyvete, and Bethleem" designed "æffor the hangying of the sepulkyr wythowte and whythyn," liturgical vessels, a reliquary containing relics from the Holy Land, miscellaneous other goods including cloths, one "stayned wyth thre Maryes and thre pilgremys," and "[a]nother wythe the aperyng of owre Lord Cryste Jhesu vnto hys moder," a world map ("mappa Mundy"), a map of the Holy Land, some books, "a stone in the whech ys the depyne of the morteyse of ovre Lordys crosse," and "iiij qwystenes [?cushions] ordeyned to the sepukyr." The final group is of "Other thyngys of the Holy Lond mad in bordys" and apparently consists of pieces of wood marked with the measurements of various structures in the Holy Land.

The exact location of the chapel at Edington is not known, so we cannot judge the extent to which it replicated the Holy Sepulchre in the fifteenth century. It is also impossible to say whether this chapel was used for the Easter Sepulchre at Edington, although it seems likely that it was, or whether it stood simply as a memorial to the indefatigable tourism of the medieval pilgrim.

Chapels may serve a variety of functions; when they are located to the north of the chancel use as an Easter Sepulchre could have been one of those functions. Appropriate decoration increases the probability of such use, as at the chapel of the Holy Sepulchre in Winchester Cathedral. Here both vault and walls of the two-bay chapel display paintings of the life of Christ from the Annunciation to the Resurrection. Scenes occurring at the tomb of Christ, the Entombment and *Hortulanus*, are included. However there is no evidence that an

Easter Sepulchre was ever erected here; the chapel may simply
have taken its name from the subject of the wall paintings.[13]
Another north chapel, at the church in Yaxley, Huntingdon-
shire, has four post-Resurrection scenes painted on the south
wall--the resurrected Christ; Christ with Mary Magdalene; the
road to Emmaus; and the incredulity of Thomas--all of which
are of the fourteenth century. This narrative of events after
the resurrection strongly suggests the presence of the Easter
Sepulchre that would have provided the foundation for the
narrative by introducing a physical reminder of the Resurrec-
tion and, by extension, the sequence of events leading up to
it. There is a recess in the east wall of the chapel that could
have served as the Easter Sepulchre.

The Crypt as Easter Sepulchre

Texts of the *Depositio*, *Elevatio*, and *Visitatio* from the
Continent, especially Germany, occasionally call for the
placement of the *sepulchrum Domini* in a crypt, calling on an
association between Holy Sepulchre and crypt that goes back
as early as St. Fides in Schlettstadt (founded 1094). No
documentary evidence for such use in England survives, but
two crypts suggest the possibility of such use. The vaulted
crypt at All Saints, Shillington, Bedfordshire, is under the
east bay of the chancel and was originally approached by
means of a stair from the north chapel. Medieval wills indicate
that All Saints had an Easter Sepulchre. Another fourteenth-
century crypt, at St. Elphin, Warrington, Lancashire, has the
same features as well as four windows, an indication that it
served some function other than the usual use as an ossuary.

In summarizing the forms of the permanent Easter
Sepulchre in England, it is possible to hypothesize a certain
amount of chronological development along with much overlap-
ping of the various types. The earliest forms, appearing in the
twelfth and thirteenth centuries, are the small recess and the
tomb recess. The small recess, similar in form to an aumbry,
may have been exactly that. When it was given more elaborate
decoration, this may have been due to its role as an Easter
Sepulchre. The tomb recess, common from the thirteenth
century, may have developed as a replacement for the wooden
frame used to support the body of the deceased at a Requiem
Mass. Both types of recess are characteristically multi-func-
tional.

Late in the thirteenth century in the East Midlands a
group of Easter Sepulchres began to appear that combined
these two recesses into a grand composition in the Decorated
Style: the small recess became a niche surrounded by figural
sculpture, and the tomb recess served as the grave for the
donor who commissioned the entire composition. Totally satis-
factory explanations have been found neither for the appear-
ance nor for the disappearance of this group, but it should be

noted that no more Easter Sepulchres of this type appear after the devastations of the Black Death, though the sculptural style survives. Perhaps by this time the complete combination of Easter Sepulchre with tomb had been developed and had come to seem more appealing than the juxtaposed forms. By the later fifteenth and sixteenth centuries, the table or chest tomb intended by its owner to be used as as Easter Sepulchre was a widespread form. The stone chest type Easter Sepulchre may derive from the model of the table tomb, but is more likely to be based on wooden chests used as Easter Sepulchres. Even the separate chapel used as an Easter Sepulchre was likely to have had funerary associations since these chapels, usually to the north of the chancel, could serve the special function of chantry chapels, while the function of the crypt was primarily funerary due to its use as a charnel.

Although the veneration involving an Easter Sepulchre at the appropriate time of year was a nearly ubiquitous practice in England, temporary structures usually satisfied this need; there was no demand--and probably no space--in most churches for a separate permanent Easter Sepulchre. Consistently located in the chancel to the north of the high altar, the Easter Sepulchre displayed a tendency to imitate the form of--and even to assimilate to--funerary monuments. Its explicit statement of relationship between Christ's tomb and the tombs of humankind, as well as its prominent location and the content of the rites performed there, determined the nature of the iconography assigned to the Easter Sepulchre.

IV

THE ICONOGRAPHY OF THE EASTER SEPULCHRE

Based on the evidence that remains, the iconography of the Easter Sepulchre has a consistency paralleling that of its form; as its formal associations are funerary, its iconographic focus is the Resurrection. This choice of subject hardly seems surprising, except that it differs distinctly from the iconography of the Germanic Holy Grave and the devotional monument that grew out of it--i.e., the Entombment.[1] The iconography of the Easter Sepulchre reflects its function at the Easter season, as a funerary monument, and as a year-long reminder of the celebration of the Resurrection taking place there.

Medieval Christian art contained several scenes forming a kind of Resurrection "cycle." In narrative sequence the cycle begins with the actual Resurrection, set at the tomb and made up of the figures of Christ rising, soldiers sleeping, and possibly one or more angels. This scene did not appear in the pictorial arts before the tenth century;[2] until that time, the next scene in the narrative functioned as the standard Resurrection image--i.e., the holy women at the tomb, a scene which includes three or four women and one or more angels. Soldiers, often sleeping, are frequently present, and the setting is the empty tomb. Subsequent to this scene are the encounter of the risen Christ with Mary Magdalene--the *Hortulanus*--and Peter and John racing to the tomb, the pilgrims on the road to Emmaus, Thomas doubting, and other post-Resurrection appearances, culminating in the Ascension of Christ. Some elements from this sequence appear on virtually every Easter Sepulchre with figural sculpture.

Information about the iconography of the Easter Sepulchre comes from two sources: documents and existing monuments. From documents we learn of cloths for the sepulchre. Many documents offer no details, listing simply color or type of fabric, but others name or describe the subjects painted on the cloth that rendered it appropriate for use at the Easter Sepulchre. Several cloths illustrated the Passion with no further details given, as in the inventory of 1549 from Leatherhead, Surrey: "Item, a staned cloth of the passion of Christ for the sepulture." A 1546 inventory of "Clothes for the sepulchre" from St. Peter-upon-Cornhill, London, includes two cloths of the crucifixion: "a steyned cloth with a crucyfix, mary and John with mary magdalyn and St. James" and "a steyned white clothe with a crucifix mary and John spotted with bloudde with the holy gost ouer his hed." For the same sepulchre there was a cloth with the Entombment, its icono-

46

graphy reminiscent of the Holy Grave: "Item a steyned clothe of the burying of our lorde with Image of three maryes." But the Resurrection, as in the iconography of permanent Easter Sepulchres, was the most popular subject by far. In 1452-53, the Priory of St. Leonard, Norwich, owned *diversi panni pro sepulcro steyned cum hystoria resurrectionis*. The handsomely carved Easter Sepulchre in Lincoln Cathedral was embellished with "a whyte stenyd cloth of damaske sylke for the sepullcour with ye passyon and the Ressurrecion of owr lord."

Although they are hardly central characters in the story, the sleeping soldiers are perhaps the most consistent feature of the iconography of the Easter Sepulchre. They appear on the earliest surviving Easter Sepulchre with figural sculpture in Lincoln Cathedral, where they are its only figural decoration. This restrained composition has its own inner logic: the top of the canopied tomb is empty, as the tomb of Christ ought to be, and the presence of soldiers on the front of the tomb chest, where coats of arms might normally identify the owner of a tomb, is sufficient to state that this is Christ's tomb. The soldiers, subsidiary figures, do not intrude upon the sacred space of the choir, but rather their attitudes of undisturbed sleep serve to reinforce the mystery of the Resurrection. The group of Easter Sepulchres from the East Midlands, monumental compositions that usually include a donor's tomb, characteristically has soldiers carved in relief on the front of the tomb chest, where they function as attributes of the tomb in the same way that keys invariably identify St. Peter. In fact, the consistent presence of soldiers on these monuments would seem to argue against their use as Sacrament Houses. In the fifteenth century the back wall of an Easter Sepulchre recess could be painted with a resurrection scene, with the soldiers, freed from their niches on the front of the tomb chest, being incorporated in the same landscape as the other figures. Presumably, soldiers appeared in the painted cloths of the Resurrection. For the Easter Sepulchre at All Saints, Bristol, an inventory of 1396 lists a separate cloth devoted to them: "Item I pannum tinctum de quatuor militibus." Soldiers do not appear on tomb chests of donors, even if such a chest was designated for use as the Easter Sepulchre. The paneled front of a tomb chest instead tended to feature coats of arms of the deceased.

Like the soldiers, the holy women generally belong to monuments used only as Easter Sepulchres, not to those assimilated to tombs. Both soldiers and holy women refer to the historicity of the Resurrection; they attest that it happened as part of a sequence of events which took place in the past. Standing or kneeling and carrying their jars of spices to anoint Christ's body, the holy women appear in proximity to the niche or recess designed to hold the cross and/or Host in the Easter rites, as at Heckington and Hawton. There they witness to the fact that the niche is empty, that the Resurrection has occurred. Their role as witnesses also gives them the

leading roles in the *Visitatio* in which they visit Christ's tomb and learn from an angel or angels that Christ has risen. The fact that this rite was apparently seldom performed in England may help to explain why the holy women seldom appear on Easter Sepulchres except in the most elaborate compositions and only rarely on tombs when they are part of a narrative sequence.

The Resurrection angel or angels usually accompany the holy women; they are necessary intermediaries, providing the women with the correct explanation of what they see. The "ij Aungelles and twoo scriptures" on a sepulchre cloth listed in a sixteenth-century inventory from St. Peter-upon-Cornhill were probably the Resurrection angels with the texts *Non est hic* and *Surrexit sicut dixerat.* Some permanent Easter Sepulchres include one or more angels carved in relief near the niche which contained the Host and/or cross; they gesture toward it to emphasize its emptiness. Easter Sepulchres without permanent sculpture achieved the same iconography with wooden angels which, after the enactment of the Resurrection, were placed at or near it to remain there until the sepulchre was dismantled. Apocryphal texts suggest that angels may also have assisted with the Resurrection itself or have been present to glorify Christ as he emerged from the tomb. In the English cycle plays, angels sing a Resurrection antiphon to Christ, and many works of art portray angels kneeling at either side of the tomb and censing it.[3] The use of censers may reflect actual practice. The procession to the Easter Sepulchre for the *Elevatio* often includes a thurifer, who censes the sepulchre immediately before it is opened. Some Easter Sepulchres include flanking angels who cense Christ as he emerges from the tomb.

Angels also participate in the Ascension scene in the few instances in which it is included in the Easter Sepulchre, and were probably included in the scene on the cloth that belonged to the parish church of St. Nicholas Cole Abbey, London, in 1552: "Item a clothe of red wyth the assencyon on yt to lay on the sepulture." The permanent Easter Sepulchre at Hawton treats the Ascension as a subsidiary scene placed above the gable over the tomb chest. The finial of the gable is indented with two footprints, while the feet of Christ disappear into the clouds at the top of the monument. As the apostles, gathered below to either side of the finial, gaze upward, four angels appear in the clouds: two cense the ascending Christ and two carry banderoles to explain the event to the apostles.[4]

The one figure most frequently associated with Easter Sepulchres is the risen Christ. Some representations emphasize the physical action of stepping out of the tomb. At Hawton the figure of Christ, carved in relief on the back wall above the actual tomb chest, faces frontally and raises his right knee so that he seems to be rising from the chest itself; the shadows created by the overhanging canopy contribute to the verisimilitude. The atmosphere of sacred mystery so effective at Hawton is totally absent in the Easter Sepulchre at Patrington,

Yorkshire, where the Resurrection is also in progress (fig. 47). Here Christ has just raised himself to a sitting position in his tomb, pushing aside the lid of the coffin, which falls behind him at an angle. He throws one leg over the edge of the coffin as he prepares to climb out of the tomb. It will clearly be with physical, not spiritual energy that he does so. Whereas representations of the Resurrection as a physical activity stress the process of the event, other Easter Sepulchres portray the resurrected Christ in ways that seem to make a statement true for all eternity. Most frequently Christ stands serenely above his tomb, where he is adored by angels. Thus at Sibthorpe, Nottinghamshire, four relief panels of sleeping soldiers flank a small recess with a pointed canopy. The resurrected Christ stands in the canopy on the finial of the recess below and holds a cross-staff with a banner in his left hand while he blesses with his right. Angels in the lower corners of the canopy swing censers, adoring Christ, who dominates the entire composition. This position directly above the recess used for the Easter rites emphasizes the way in which those rites recreate past time. The recess does not simply represent but actually becomes the Holy Sepulchre in Jerusalem in which Christ's body was placed and from which it rose.

Donors of Easter Sepulchres wished to associate themselves directly with this spiritually powerful monument for the benefit of their souls. John Hamond, whose will dates to 10 February 1485, left twenty shillings to the church at Ticehurst, Sussex, "toward the making of the sepulture." But if the sepulchre were not finished by Easter of 1487, the money was to be given to the house of canons at Combewell "to pray for my sowle." If Hamond could not evoke prayers in one way, then he would do so in another! Edmund Talbot of East Retford, Nottinghamshire, had the same goal in 1496 when he left "To the same church, for the sepulcre, the covering that they have there of grene velvett with myne armes theruppon, and a paynted clothe to be above it." The cloth with his arms would serve as a reminder of his generosity to the church and evoke prayers on his behalf.

The association with triumph over death that the iconography of the Easter Sepulchres celebrates was best achieved through the assimilation of the Easter Sepulchre to a donor's tomb. A stone relief of the middle of the fourteenth century, once probably the back wall of a combined tomb and Easter Sepulchre at Holy Trinity, Burrington, Somerset, presents the essence of the Resurrection scene--Christ with his cross-staff between censing angels. Just below the censers kneel two praying figures, presumably the donors. Later tombs at Racton and Slaugham, Sussex, have similar scenes in brass. Others add inscriptions, such as those in All Saints, Narburgh, Norfolk, where Christ, stepping from his tomb is addressed by a male donor praying: *Jesu, fili Dei, miserere me*. At the same time his wife, facing him, asks: *Salvator*

. . . *memento me.* These inscriptions state explicitly the
relationship between Christ's Resurrection and the hopes of the
deceased. A typical example from the early sixteenth century
was in the church at Cranleigh, Surrey. A brass of Christ
stepping from his tomb, guarded by four soldiers, dominated
the wall under the canopy of the tomb. Brass figures of a
man, woman, and child, all kneeling in veneration of the
resurrected Christ, expressed their prayers in the scrolls
issuing from their mouths: "Have mercy Jhesu in honour of thy
gloriovs resvrreccion"; "And grant vs the merite of thy bytter
Passion"; *Accipe parentes, et infantem, bone Christe.*

Other tombs presumably meant to be used as Easter
Sepulchres present a narrative sequence. Relief panels
decorate the front and sides of the tomb of Dean Thomas
Balshall in Holy Trinity, Stratford-upon-Avon--a tomb placed,
at his request, on the north side of the chancel. The series
begins with Christ taken prisoner in the garden of Gethsemane
and includes a Crucifixion, Entombment, and the holy women
at the tomb. The figure of the deceased was represented in
brass on the top of the tomb. Another example, the tomb of
Thomas Smith in the church at Woodleigh, Devon, stands in a
recess carved on the back wall with reliefs of the Pietà,
Resurrection, and holy women with angel. An inscription
around the cresting seeks prayers for the soul of the de-
ceased.

The basic theme of Easter Sepulchre iconography is,
then, Christ's Resurrection, seen as his triumph over death.
That choice reflected both the content of the Holy Week and
Easter rituals performed at the sepulchre and the close re-
lationship of the Easter Sepulchre to donors' tombs; it also was
well suited to the physical location of the Easter Sepulchre in
the church.

Of the Holy Week and Easter rites--*Depositio, Elevatio,*
and *Visitatio*--the *Elevatio* stood in the strongest position to
influence the iconography of the Easter Sepulchre because
English versions of the rites indicate that the *Elevatio* served
as the communal celebration of the Resurrection. Often a
congregation was present for at least part of this service to
witness the removing of the cross from the Easter Sepulchre in
symbolic re-enactment of Christ's Resurrection. Thus the
figural decoration of the Easter Sepulchre reminded parish-
ioners of the Easter celebrations most directly if it represented
the actual Resurrection and if the Easter Sepulchre became a
year-long commemoration of the Easter rites.

The adoption of the tomb form for the Easter Sepulchre
and the close association--often identification--of Christ's tomb
and donor's tomb also influenced the iconography of the Easter
Sepulchre. If the Easter Sepulchre was a separate monument,
standing next to a donor's tomb, its iconography tended to
include more narrative, extending to events such as the
Ascension, and to be more historical, including figures such as
the soldiers. But even then the triumphant aspect of Christ's

Resurrection most appropriately spoke to the hopes of the donor. When Easter Sepulchre and donor's tomb actually became one monument, narrative and historical aspects of the Resurrection tended to be suppressed in favor of an emphasis on its continuing relevance to the eternal lives of Christians. This must be one of the reasons that the permanent Easter Sepulchre rarely shows influence of the late medieval obsession with the Passion. An unusual example, a wall painting on the north wall of the north chapel of the Church of St. Michael in Aston, Devon, probably part of an Easter Sepulchre, shows Christ rising and surrounded by emblems of the passion--the scourge, ladder, spear, nails, cross. The subject thus becomes the Man of Sorrows, a devotional image outside of historical time, similar in its impact to the long speech that the resurrected Christ delivers to the audience in some of the cycle plays. The focus in each case is not on the triumph of the Resurrection but on the pain which that triumph has cost and on mankind's indifference to it.

Triumphal imagery is also best suited to a monument permanently placed in the chancel near the high altar, where it formed part of a series of images summarizing Christ's actions on behalf of mankind. The suffering Christ had a prominent place on top of the screen separating nave from chancel. There the rood or Crucifixion reminded those gathered in the nave of Christ's sacrifice, celebrated in the Eucharist. But the promise of resurrection won for mankind by means of that sacrifice is what made it meaningful, and the Easter Sepulchre spoke of that promise. Finally the Doom often painted behind the rood in the chancel arch charged each Christian to mend a sinful life in order to receive the benefits that Christ has bought with his suffering.

The Easter Sepulchre gave visual evidence of its functions only if it represented the empty tomb. It may have been the promise of resurrection so clearly stated by the Easter Sepulchre and its rites that motivated popular devotion.

THE EASTER SEPULCHRE IN ENGLISH RELIGIOUS LIFE

The Easter Sepulchre occupied a secure place in late medieval English religious life, yet details of its distribution remain obscure. The monks and nuns of Anglo-Saxon England agreed to follow the *Regularis Concordia,* and it was surely in monastic communities and cathedrals that the first Easter Sepulchres were erected. The rites of *Elevatio, Depositio,* and *Visitatio* were developed for and in communities of religious, and their celebration required the participation of the members of such communities. The earliest documents attesting to the existence of Easter Sepulchres are from such communities--Salisbury, London, and possibly Winchester--and Easter Sepulchres continued to be popular in cathedral and monastic settings until the dissolution of the monasteries and the Reformation. Most frequently documented in Benedictine settings--both monasteries and convents--Easter Sepulchres were also to be found among Augustinian Canons, Carmelites, Cluniacs, Dominicans, and Franciscans. Not surprisingly in view of its association with death and resurrection, the Easter Sepulchre appeared with regularity in hospital chapels.

By the end of the Middle Ages, the Easter Sepulchre had found a secure place in a great many parish churches as well. It was common but not ubiquitous. Geographic distribution suggests roughly that the Easter Sepulchre appeared more frequently in the south and east and was quite usual in London but possibly was less common in the north and west. Many factors, primary among them the uneven preservation of documentation, make it impossible to be more precise. Although entries pertaining to Easter Sepulchres seem to occur in most preserved churchwardens' accounts, only a tiny fraction of such accounts survive. Peacock's publication of the 1566 Commissioners' inventories for Lincolnshire included 170 churches, fifty of which state that they had had Easter Sepulchres, but, in spite of the fact that the Commissioners seem to have expressly asked each set of churchwardens whether they now possessed a sepulchre, only two explicitly answered to say they did not. The others could have assumed that, since the Easter Sepulchre had been previously disposed of, they need not mention it now in an inventory of goods. Equally inconclusive is the statement in the will of Robert Beckwith of Stillingfleet, Yorkshire, dated 19 June 1529: "my body to be beried in suche place as my executours herafter shall thinke convenient to be named. . . . Also I bequeath to the sepulcre light of the churche therewhere my body shalbe beried, xijd."[1] Was the sepulchre so ubiquitous in his part of Yorkshire that Beckwith could assume there would be one in

52

any church where his executors would bury him?

Much evidence, however, exists to assist in forming a picture of activities at the Easter Sepulchre and of its place in the religious and social life of late medieval England. This chapter examines that evidence.

In monastic communities, the Easter Sepulchre was funded from the income of the community, disbursed by the treasurer, cellerer, or other responsible official. At the cathedral church and monastery of St. Andrew, Rochester, the Dean and Chapter in 1545 were leasing lodgings to a priest named Nicholas Arnold for "a rent of a taper of one pound of wax, to be offered on Good Friday to the sepulchre of Our Lord." In addition, gifts such as cloths and bequests of income for maintaining lights were regularly received. The Archbishop of Canterbury supported the sepulchre lights in his cathedral in the late fourteenth century. Gifts came from lay people as well. In 1479, Thebaude Evyas gave to the Abbey of the Holy Saviour at Faversham, Kent, "my great cloth of tapestry work, to do worship to God in their presbitery, and on the Sepulchre next the high altar on high days."

A variety of funding methods supported the Easter Sepulchre in the parish church. In most cases, churches maintained the sepulchre out of their regular sources of income or used that income to supplement funds collected for or donated to the sepulchre. At Wing in Buckinghamshire in 1541, the rather common fund-raising device of a church ale was devoted to the sepulchre (the "sepulker alle"), an event which raised more than twenty shillings. Specific persons might be designated through an elaborate selection process to collect money for the sepulchre (usually for its light or lights) and to keep their own accounts. The sepulchre light was one of several lights in the church that were maintained in this way. In 1516, the "boke of acomtt of Sepulcure light" was placed in a new aumbry in the roodloft of St. James, Louth, along with other church books. At St. Martin's, Leicester, in the early sixteenth century two "gatherers for the sepulcars light" were chosen regularly. The "lytemen to the blesyd sepulkur lytte" at Wing, Buckinghamshire, turned over five shillings to the churchwardens in 1527. In 1539 at Morebath, Devon, two women, "Annys at More & Johanna Webber beyng maydyn Wardyns for ye getheryng of ye sepulture ly3th," rendered their accounts to the churchwardens. The "maydens" and "bachellers" of Heybridge, Essex, each had responsibility for sepulchre lights in 1529-30, while in 1552 at Goldhanger, Essex, the "churche wardyns solde vnto the saide Edward one trydyll of wax the whyche was the bachelars and the maydyns sepulkar lyght."

Bequests of money or goods to the Easter Sepulchre or its lights appear frequently in wills, in some areas appearing to be virtually a part of the standard language of the will. Rectors, who had responsibility for maintaining the chancels of their churches, often included the sepulchre in their bequests.

The rector at Boddington, Northamptonshire, left the rather large sum of £10 in 1506 *pro le selyng chori et fabricacioni sepulchri*. Gifts ranged from very small sums to the fashioning and furnishing of an entire new sepulchre, as in the will of John Asten of Rolvenden, Kent (1533): "Also £6 to the making at his proper cost an honest Sepulchre for the Blessed Body of Our Lord to be laid in at Easter in the Church; and to the buying of one holy cloth there to hang on the Sepulchre at the holy time of Easter, and to do service in the Church there at other times." Donors frequently shared their goods with the sepulchre in the form of the produce of the land: "one quarter of barley" (1523; Helmdon, Northamptonshire), "half a quarter of malt" (1510; Overstone, Northamptonshire), "j combe wete and on combe malte" (1491; Cheveley, Cambridgeshire). Other gifts were of continuing value but required upkeep, such as a parson's bequest of "x bee hyvys to meynteyn the sepulture lyght, which x bee hyves shall be in custody of ye chyrch wardens" (1519; Luddington, Northamptonshire). In 1517 John Garyngton of Mundon, Essex, left the unusually large gift of "xxx ewes of iij yeres of age for ij Tapurs brennyng yerely afore the sepulchre at the fest of Easter as long as the worlde doth stonde." Sometimes donors made arrangements for the care of the animals which they gave to the sepulchre: "I gyve unto the sepulker lyght a browne cowe of the value of xijs. the whych cowe I wyll schulde be sett unto one pore man my nebur and he to pay yerely for the same cowe and callffe unto the churchewardyns apon mydlent Sunday yerely xxd." (1543; Bradden, Northamptonshire). In other places, the church had devised a system of maintaining what was in effect the church herd; there were kye (cow) wardens at Pilton, Somerset, and at Bethersden, Kent, individual farmers kept church cows in return for an annual fee. Each cow supported a specific light, and the rent of the cow (*ferme*) was due in time to prepare the light for that feast. Benefactors also gave real estate to the sepulchre: "v rodes of medow" (1504; Denford, Northamptonshire); while Joan Wede of Mears Ashby, Northamptonshire (1539) made the Easter Sepulchre one of her beneficiaries: "I wyll that yf Thomas Croxon do injoye my house called Brownes house to hys owne use that than the sayed Thomas Croxton shall paye to the mayntayng of the sepulcre lyght xxs."

Frequently a guild maintained the sepulchre and its lights. This might be one among several of the responsibilities of the guild, as at Bardwell, Suffolk (1513-14), where the guild of St. Peter appointed "wax men of the sepulker lyte." Or the guild might be devoted specifically to the sepulchre, as at Chesterton, Cambridgeshire, where in 1389 it was reported that the brothers and sisters of the Guild of the Resurrection had purchased a new sepulchre for the church. Northamptonshire was especially rich in sepulchre guilds, variously known as "Gilde sepulchri Domini" (1496; Stoke Doyle), "fraternitas sepulchri" (1521; Wellingborough), "gyld of the sepulcr lyght" and "sepulkar gyld" (1522; c.1529; Weekley), "fraternitas

resurrectionis" (1496; Raunds), and "bretherhed of the
sepulcre" (1530; Cransley).

Most of the funds for the Easter Sepulchre were
expended in the few weeks surrounding Easter. Preparations
began with an inspection to see that the parts of the sepulchre
were in good order; if not, the necessary repairs were made
("Item paid for the Repacion of the Sepulker ageynst goode
fryday. xd." æ1523; Bungay, Suffolk£; "Paid to John Carver
for a day and di. mendyng of Seynt Pulcure Howse and for
helping of ye Angells' Wyngys. . ." æ1545; York, St Michael
Spurriergate£). Candles had to be purchased ("to the wax
chandeler for strykyng the sepulcre lyght agenst Ester ijs."
æ1527; Great Hallingbury, Essex£) or made ("Item paid for
meate and drynke to Robt Webster, Robt Worseley and Elsabeth
Latham when the light was in castyng, fascyonyng and makyng
iiijs. vjd." æ1546-47; Prescot, Lancashire£). The supports for
the lights might need mending ("Item payd to Leowe for
mendyng of the Beme of the sepelker leyte" æ1529-30; Lewes,
Sussex£). Sepulchre cloths were washed ("Item on to Wylliam
Bode for waschyng the sepulker clothes iijd." æ1537; Bungay,
Suffolk£) and repaired ("Payd a Reward to Ambros Barkars
servant for mendyng of the clothe that henge abowte the
sepulcre by consent was droppyd with candyll ijs. iiijd."
æ1527; Devizes, Wiltshire£). Usually Good Friday was the day
for setting up the sepulchre, but at St. Michael in Bedwar-
dine, Worcester, it seems to have been in place by Palm
Sunday. Setting up required the purchase of nails, pins, and
wire for fastening together the parts of the frame and
suspending the hangings and curtains ("Item payde for pynnes
and poyntes for the sepulcre ijd." æ1537-38; St. Martin-in-
the-Fields, Westminster£). This was often one of the duties of
the clerk and is so described in a document of 1481 from St.
Nicholas, Bristol, entitled "Howe the Clerke And the Suffrigann
of Seynt Nicholas Churche Aught to do." An especially
elaborate sepulchre might require as much as three days to set
up (1556-57; St. Lawrence, Ludlow, Shropshire).

Setting up presumably began with the frame or bier
which supported the coffer ("Item, payd to Thomas Hunt for
mendynge of the crofer for ye sepulcre vjd. Item, payd for
borde nayle and lathe neale for the same cofer ijd." æ1540; St.
Lawrence, Ludlow, Shropshire£), which apparently could be
locked ("Item payd for makyng of A key to the Coffer of ye
Sepulcre ijd." æ1505-06; St. John Baptist, Peterborough£). If a
tomb was to be used as the sepulchre, the frame stood on top
of it; otherwise it must have stood on the floor. A wooden
frame presumably for this purpose was found in St. Michael's
church, Smarden, Kent, in the 1860's, when restorers opened
a small arched recess in the north wall of the chancel.
Unfortunately, the frame disintegrated on exposure to air.
Both wills and churchwardens' accounts refer to painting and
gilding of the sepulchre ("To the giltyng of the Sepulchre
which I wold be payntyd and giltyd before the feaste of Eastre

xxs." [1538 will of John Absolon, Cuxton, Kent]). It is hard
to know whether this item refers to the wooden frame or
possibly to a wooden panel painted with appropriate figural
scenes that fit under the arch.

Various textiles decorated the sepulchre. A cloth might
hang behind it ("Item A payntyd clothe the which hanges
behynde the sepukur" [1536; St. Alphege, London Wall]). A
carpet ("A charpett to the crose for to lye on the sepulcur"
[1518; Woodford Halse, Northamptonshire]), pillows or cushions
rested on the base of the sepulchre to receive the coffer ("ij
pilowes oon blacke and another White for the Sepulcre" [1470;
St. John the Baptist, Bristol]). A pall ("a pall of cloth of gold
for the Sepulcre" [1470; St. John the Baptist, Bristol]) or
other painted cloths hung from the frame presumably to form
an enclosure. Colors mentioned most frequently are green and
red ("one Hanging of red silk for ye Sepulcher" [1545;
Hadleigh, Suffolk]), but clearly any rich fabric would do
("Syx peces of blew damaske for the same, of the gowne of a
gentlewoman" [1547; Long Melford, Suffolk]), and for this
purpose the hangings of a bed served quite well ("a grene
couerlete of the yifte of Mawde Core that was wond to be sette
aboute the Sepulcre" [1471-72; St. Ewen, Bristol]). Smaller
cloths may have served to wrap the Host ("a fine linen cloth
for wrapping the body of our Lord" [1416; Runcton Holme,
Norfolk]) and cross ("a fyne napkyn of Calico cloth trelyd with
silk to Cover the Crosse in ye sepulcre" [1535; Holy Trinity,
Chester]) in imitation of grave cloths. A canopy supported on
painted or gilded staves enshrined the sepulchre ("j canape
steyned with a sonne of golde to henge ouer the sepulcure at
estir" [1466; St. Stephen, Coleman Street, London]). Curtains
on wire or cord suggest that the front of the temporary
enclosure may have been kept closed until Easter morning and
opened at the resurrection ("ij blev cortyns [to] draw afore
the sepulture" and "iij Cortyns of lavnde to draw afore the
sepulture on the ester halydays" [1485; St. Margaret,
Southwark, Surrey]).

Lights were usually placed on a metal candlestick ("j
candylstycke of yrne afore ye sepulchre" [1552; Bonsall,
Derbyshire]) or frame that stood in front of the sepulchre ("A
frame of Irron for the sepulker" [1552; St. Mary Colechurch,
London]; "a frame to sett tapers yn afore the sepulker" [1530;
Stratton, Cornwall]), or in taper dishes of laton ("Item paid
for the mendyng of the brason bolls whiche stondyth uppon
the sepulker whiche were brokyn vjd." [1530-31; Sherborne,
Dorset]). One light was required, but many more were
provided in wealthier churches. The lighting of these lights on
Good Friday coincided with the beginning of ritual activity at
the sepulchre.

Mass on Good Friday ended with the "Creeping to the
Cross," a variation of the *Adoratio* that might include the
presentation of an offering and was followed by the placing of
cross and/or Host in the Easter Sepulchre. In 1501, a London

grocer gave the church of St. Leonard in Eastcheap a silver
gilt cross that contained a relic of the True Cross. The donor
stipulated that the cross was to be used at the creeping to the
cross and "also that the said cross shall yearly be laid by and
with the blessed sacrament in the sepulchere on every Good-
friday, to the great honour of God, and for the great dignity
and preciositie of the same cross." In the *Rites of Durham*,
written in 1593 but describing pre-Reformation practices, the
cross from the *Adoratio* was joined by "another picture of our
saviour Christ, in whose breast they did enclose with great
reuerence the most holy and blessed sacrament of the altar."
The use of both cross and Host seems to have been the
standard practice. As part of this Deposition, the lights in
front of the sepulchre were lit. In 1493 Stephen Glover of
Bethersden, Kent, left a parcel of land to the church, its
income to support "a taper of 3 lbs. of wax to burn in the
church afore the Sepulchre, from the time of divine service
done afore noon on Good Friday. . . ." At Saltwood, Kent, a
taper endowed in 1481 was to burn "before the Sepulchre in
the quire from the ninth hour on Good Friday. . . ."

From this point until Easter morning the lights burned,
and the sepulchre was watched through both Friday and
Saturday nights. At Holy Trinity, Coventry, the second deacon
watched on Friday night and yielded his place to the first
deacon who watched on Easter eve. In parish churches,
watching the sepulchre was one of the innumerable tasks of the
clerk or sexton, who was often joined by one or two others
("Item For brede and drynke for the ij men' that' watched' the
sepulcre and for Wylliam sexton' for ij nyghttes vjd. Item For a
quartter off Coolles for the men that' watched' the sepulcre'
vjd." [1521-22; Lambeth, Surrey]). Sepulchre watching is one
of the most frequently recurring charges in churchwardens'
accounts, which also indicate that food, drink, and coal for
maintaining a fire were frequently provided for the watchers
("Also peyd for Colys brede and Ale for Watchyng of the
Sepulcre vjd." [1450; St. Margaret, Southwark, Surrey]). One
reason for watching was the practical one of keeping the lights
burning while preventing them from starting a fire ("Item for
Watchyng of the Tapers in ester, nyth viijd." [1454; Walbers-
wick, Suffolk]). But though the setting of lights is part of the
watch, it does not explain its purpose. Several more plausible
reasons may be offered. Feasey suggests that this custom may
have some overtones of reparation for the watching of the
Roman soldiers at the Holy Sepulchre and may also reflect a
belief that the Second Advent would take place at Easter, but
the practice was probably largely motivated by the custom of
watching with the dead.[2] The parable of the Wise and Foolish
Virgins, which was understood as referring to the Second
Advent, puts great emphasis upon watching through the night
for the arrival of the Bridegroom. The analogy between
funerary bier and Easter Sepulchre would also require watching
at the sepulchre as one watched at night in the church with

the dead.

Lights burned and watching continued, as various wills and accounts stipulate, "to Ester day morning that Resureccon be done" [1524; Little Steeping, Lincolnshire]. Then, cloths might be changed ("Item a sepulcre of dyverse peces of the same sewte of the whiche oon pece is enbrowdid with a close tombe and an other with the resurrection" [1517; Holy Trinity, Arundel, Sussex]) and curtains opened. By the fifteenth and sixteenth centuries (the period from which documents survive), the *Elevatio* had become the public celebration of the Resurrection. Thus the emphasis focused on *seeing* the object raised from the Easter Sepulchre. Just as the body of Christ often appears transfigured in paintings of the Resurrection in order that the theme of triumph can dominate the theme of sorrow evoked by images of the broken, bleeding body, so also the object removed from the Easter Sepulchre was often a "transfigured" version of that which had been placed in it on Good Friday. Many accounts refer to images for the Resurrection (in 1370 Coldingham Priory purchased one image "pro Resurreccione") and some specify that this image is used on Easter morning ("Item a grene crose with iiij evangelistes gilte for ester morow in the resurrection" [early sixteenth-century; St. Peter Mancroft, Norwich]). The green cross, the living cross, emphasized the message of resurrection. Many of these objects seem to have been of the same specific type and were designed so as to display the sacrament. Thus at Durham an image of Christ crucified had been buried in the *Depositio*. In the *Elevatio*, the officiants removed from the Easter Sepulchre the image of the living Christ with the Host in its breast, supporting in its outstretched hands a cross. At Lincoln, a fifteenth-century inventory lists "j ymago Christi de argento deaurato aperta seu vacua in pectore pro sacramento imponendo tempore resurreccionis stans super vj leones et habet unum birellum et unum diadema in posteriore parte capitis et Crucem in manu. . . ." This image, a figure of Christ with a cross in his hands, possibly quite similar to the object described in the *Rites of Durham*, suggests that there may have been a standard type of image for this purpose. In the sixteenth century, St. Peter-upon-Cornhill, London, owned "a picture for the resurrection on ester day with an owche of siluer and guilt in the brest." It is not clear when this image or other images of this type were introduced into the Easter Sepulchre. Use of words such as "resurrection" and "for Easter Day" in describing them suggests that they played no role in the *Depositio* but rather must have been secretly inserted into the Easter Sepulchre so as to be raised from it on Easter morning. Certainly the "miraculous" appearance of an image of the resurrected Christ displaying a consecrated Host in its breast would have increased the impact of the *Elevatio*.

Other Resurrection images suggest more dramatic possibilities. The image used in the Resurrection at St. Alphege, London Wall, by 1536 not only had "a thing which stands in

God Amyty's brest at Ester," presumably to display the
sacrament, but also wore "a cotte for the resurexione at ester
of rede sylke," "God Amyty's Cotte." Many statues in late
medieval English churches had wardrobes of clothing and
jewelry in which the figures were dressed for feast days. This
"God Amyty" was purchased from a coppersmith and was
presumably made entirely of metal or of sheet metal over wood.
To be portable, it would need to have been small or light in
weight, as was presumably the image purchased by the
churchwardens of St. Lawrence, Ludlow, Shropshire, in
1556-57: "Item to hym for makynge and kervinge the image for
the resurrexcion xvijd." In 1511 St. Mary the Great, Cam-
bridge, was in possession of "the ymage of Jhesus for the
Resurreccion" and in 1537 paid for "Mendyng of the vice for
the Resurrexcion." The image might have been a wooden
statue, in effect a puppet, and the "vice" a mechanism for
raising it from the tomb. The "rosyn to the resurreccyon pley"
purchased by the churchwardens of St. Lawrence, Reading,
Berkshire, in 1507 may have been intended to keep such a
"vice" operating smoothly. A puppet like this was displayed for
purposes of ridicule at an anti-Catholic sermon preached in
1547: "The xxviith daie of November, being the first Soundaie
of Aduent, preched at Poules Crosse Doctor Barlowe, Bishopp
of Sainct Davides, where he shewed a picture of the resurrec-
tion of our Lord made with vices, which putt out his legges of
sepulchree and blessed with his hand, and turned his
heade. . . ."3 The sepulchre given to St. Mary Redcliffe,
Bristol, in 1470 contained a puppet of this type: "Item An
ymage of god almyghty Risyng oute of the same Sepulchre with
all the Ordynance that longeth therto. That is to say A lath
made of Tymbre And the yren worke there to & cetera."
Puppets of this type may also have been used at Witney,
Oxfordshire, "for the which Purpose, and the more lyvely
thearby to exhibit to the Eye the hole Action of the Resurrec-
tion. . . ." No such puppets have survived in England, but
the representation of the resurrected Christ carved in relief on
the Easter Sepulchre at Patrington, Yorkshire, strongly
resembles a puppet figure. Christ is both lively and
stiff--i.e., ungainly as if a jointed puppet. His appearance
replicates the description of the puppet displayed by Dr.
Barlow: sitting up in his tomb, he turns his head to face
outward, blesses with one hand, and throws one leg over the
edge of the coffin. Perhaps, after the resurrection, such a
figure was left suspended so as to stand upright, flanked by
wooden statues of adoring and censing angels, as represented
in several Easter Sepulchres.
 Where churches owned a full set of sepulchre figures, as
at St. Mary Redcliffe, Bristol, a complete tableau of the
resurrection could be displayed, complete with moving parts
and wooden figures decked out in such mimetic elements as
wigs, coats, beards, and spears. These may have been quite
similar to (and perhaps identical with) tableaux which some

scholars believe were employed in Corpus Christi processions
and which may have helped to motivate the writing and
production of cycle plays. At some churches the Resurrection
apparently became a full-fledged play ("Item payed to Christ-
ofer Myxbury for keping of the yarnaments and chevelers for
the Resurrection played in the Church of Thame xvjd." [1523;
St. Mary, Thame, Oxfordshire]). We cannot say with certainty
that such plays took place at the Easter Sepulchre.

The sepulchre taper at Bethersden, Kent, was to burn
"unto 'Christus Resurgens' be sung and procession be done in
the morning upon Easter day. And from that time the taper to
burn in divine service until Wednesday in Easter week be
done." This statement implies that the sepulchre remained set
up until that time. A will of 1509 from Chelsfield, Kent, left a
taper to burn until Thursday in Easter week. A fourteenth-
century Sarum Customary directs that the sepulchre be censed
during this time. Then it would be taken down and carefully
stored until the next Holy Week, when the whole cycle would
be repeated.

The Easter Sepulchre was thus one of the standard
appurtenances of the medieval English church. Although a
target of Protestant reformers, it continued to receive the
devotion of the populace, as the evidence of wills indicates. In
fact, it would appear that the Easter Sepulchre had never been
more popular than when it was about to be suppressed. The
Easter Sepulchre was singled out for continued veneration in
Cromwell's Injunctions of 1538, which stipulated that no lights
were to be placed before images, but allowed lights by the
rood loft, the sacrament at the altar, and the Easter Sepul-
chre. But reformers continued to agitate against images in
general--"it is thabuse and prophanacion of the temple to
suffre them"[4]--and against the Easter Sepulchre in particular.
Cranmer's Articles of Inquiry issued in 1547 asked: "Whether
they had, upon Good Friday last past, the sepulchres with
their lights, having the Sacrament therein." In a tract
published in 1547 Bishop John Hooper of Gloucester fulminated
against the mimetic ritual that took place at the Easter
Sepulchre:

[Christ] hankyd not the picture of his body upon the
crosse to theache them his deathe as our late lernyd men
hathe donne. The plowghman be he never so unlernyd,
shalle better be instructyd of Christes deathe and
passion by the corn that he sowithe in the fyld and
likwyce of Christes resurrextion, then be all the ded
postes that hang in the churche or pullyd out of the
sepulchre withe, Christus resurgens. What resemblaynce
hathe the takyng of the crosse out of the sepulchre and
goying à prossession withe it withe the resurrexcion of
Christ: none at all, the ded post is as ded, when they
sing, iam non moritur, as it was, when they buryd it,
withe, in pace factus est locus eius. If ony precher

would manifest the resurrexion of Christe unto the
sences. Why doothe not he teache tem by the grayne of
the fyld, that is rysyn out of the Erthe, and commithe
of the ded corn, that he sawid in the winter.[5]

Also in 1547, Dr. Barlow, preaching at Paul's Cross, had
displayed a resurrection puppet to the crowd. The chronicler
described the content of the sermon and the reaction of the
audience: "And in his sermon he declared the great abhomina-
tion of idolatrie in images, with other fayned ceremonies
contrarie to scripture, to the extolling of Godes glorie, and to
the great compfort of the awdience. After the sermon the
boyes brooke the idolls in peaces."[6] By 1548 it behooved the
curate at Sandhurst, Kent, to depose to the Consistory Court
that "touching the setting up of the Paschall candle and
sepulchre he was not of knowledge of the settyng up of them."
Easter Sepulchres and their ceremonies were rapidly dis-
appearing under pressure from Edward's churchmen. Bishop
Blandford of Worcester, who had noted in his diary that in 1548
"On Easter day the pix, with the sacrament in it, was taken
out of the sepulchre, they singing Christ is risen'," made the
following terse entry in 1549: "No sepulchre, or service of
sepulchre, on Good Friday." Churchwardens' accounts suddenly
become silent, omitting the annual entries for receipt of
offerings for the sepulchre and expenditures in setting up and
watching. Instead receipts indicate sale of sepulchres, cloths,
and many other items necessary to Catholic ritual (1550-51:
"Item received of Bryane Cole for ye tymber of the ij syde
alters & sepulker ixs. Item received of George Swetnaham for a
sepulker clothe vs." [Sherborne, Dorset]). In May of 1552 the
Privy Council appointed commissioners for each county to
inventory church possessions, preliminary to the seizure
shortly thereafter of all but the bare minimum required for the
new ritual.

The accession of Mary in 1553, accompanied by the
reintroduction of Catholic ritual, brought back the Easter
Sepulchre. Wriothesley notes in his chronicle entry for 1554:
"The same Palme Sunday the old service after the use of Sarum
in Latyn was begone agayne and kept in Paules and other
parishes within the Cittie of London, with allso bearinge of
Palmes, and creeping to the Crosse on Good Fridaye, with the
Sepulcher lights and the Resurrection on Easter daye."[7] In the
same year the church of St. Mary the Great, Cambridge,
appointed two men "Masters of ye sepullter lyght & Rood lyght
accordyng to ye old costom of ye parysh." Churchwardens'
accounts record expenditures for new sepulchres and cloths
and payments to watchers. Now Consistory Courts dealt with
cases such as that of John Parker of Stodmarsh, Kent,
presented because "he had awayd the sepulchre there." And an
archdeacon's visitation to St. Mary's, Lydden, Kent, in 1557
resulted in an injunction "To provide a Sepulchre this side
Easter."

The bewildering sequence of changes came to an end when Elizabeth took the throne in 1559 and Easter Sepulchres, along with other "popish" practices, disappeared from the Church of England for almost three hundred years. In 1559, funds at Stanford-in-the-Vale, Berkshire, were smoothly diverted from the old purpose to the new: "recuyd towards ye charges of ye communion ye wiche monay before this yere was geuen to meyntayne ye sepulchre & paschall lyghtts iijs. xd." Permanent sepulchres that survived earlier iconoclasm were now targeted for destruction. The church at Bearsted, Kent, was presented at Consistory Court in 1562 because "the hole where the sepulchre was wont to lie is undefaced." Many sepulchres discovered in modern restorations must have been blocked up at this time--e.g., the sepulchre at Purleigh, Essex, where the hood mold had been hacked away in order to leave a smooth wall. In an expedient use of available resources, some sepulchres were converted to tombs, as is probably the case with the Forster tomb at Cumnor and the Ward tomb at Hurst, both in Berkshire. In Lincolnshire, royal commissioners took inventory of churches in 1565 and 1566, and upon each occasion they extracted from churchwardens statements such as that signed by the churchwardens of Billingborough: "all the tromperie and popishe Ornamentes is sold and defaced so that ther remaynethe no supersticious monumente with in our parish churche of Billingborowe."

As Keith Thomas observes in speaking of the "iconoclasm and deliberate fouling of holy objects" that characterizes the sixteenth century, "Distasteful though all this violence and invective was intended to be, it exemplified a thoroughly changed attitude to the apparatus of the medieval Church. The decline of old Catholic beliefs was not the result of persecu-tion; it reflected a change in the popular conception of religion."[8] A new sensibility had won the day, one that rejected any notion of the spiritual efficacy of mimetic ritual. Bishop Hooper exemplifes that sensibility in his dismissal of the meaning of the *Elevatio*: "à ded post caryd à prosession as mouch resemblyth the resurrextion of Christ As uery deathe resemblyth lief. . . ."[9] The Easter Sepulchre and its cere-monies had no place in this new world.

Only in the nineteenth century, with the efforts of the Cambridge Camden Society and the Oxford Movement, did the rich treasures of medieval English churches begin to be appreciated. Many of the early restorations carried out under the impact of this new attitude destroyed as much as they saved, yet the change in attitude ultimately has led to careful and intelligent preservation of medieval churches. In more recent years, the Council for the Care of Churches has played an especially important role in the preservation of the fabric of various churches. Without such efforts, many of the Easter Sepulchres described in this catalogue would long ago have disappeared.

NOTES

INTRODUCTION

[1]Daniel Rock, *The Church of our Fathers* (London: John Hodges, 1903), III, 77.

I. THE HOLY SEPULCHRE, THE LITURGY, AND THE RITES: QUESTIONS OF DEVELOPMENT

[1]Kenneth J. Conant and Glanville Downey, "The Original Buildings at the Holy Sepulchre in Jerusalem," *Speculum*, 31 (1956), 1-48. See also E. Wistrand, *Konstantins Kirche am heiligen Grab in Jerusalem*, Acta Univ. Gotobergensis, 1 (1952).

[2]Richard Krautheimer, "Introduction to an 'Iconography of Mediaeval Architecture'," *Journal of the Warburg and Courtauld Institutes*, 5 (1942), 5.

[3]See especially Jean Daniélou, *The Bible and the Liturgy* (Notre Dame: Notre Dame Univ. Press, 1956), pp. 70-113.

[4]For a general study of early pilgrimages to the Holy Land, see Bernhard Kötting, *Peregrinatio Religiosa* (Regensburg: Forschungen zu Volkskunde, 1950). For translations of the two earliest texts along with extensive interpretative commentary, see John Wilkinson, *Egeria's Travels* (London: S.P.C.K., 1971). Wilkinson's *Jerusalem Pilgrims before the Crusades* (Warminster, England: Aris and Phillips, 1977) offers translations of texts written between 385 and 1099, with a gazeteer, maps, and commentary. These books are extremely helpful both in bringing together the relevant materials and in placing them in context.

[5]Wilkinson, *Egeria's Travels*, p. 158.

[6]Ibid., esp. Additional Note D, "The Cave of the Anastasis," pp. 242-52.

[7]I quote from the translation of extracts from Eusebius in Wilkinson, *Egeria's Travels*, p. 167.

[8]St. Jerome, Letter 108 to Eustochium, trans. by Wilkinson in *Jerusalem Pilgrims*, p. 49.

63

[9]Wilkinson, *Jerusalem Pilgrims*, p. 83. This account was formerly thought to have been written by Antoninus the Martyr.

[10]Wilkinson, *Jerusalem Pilgrims*, pp. 95-96; see also "Arculf's Plans of the Holy Places" (ibid., pp. 193-97, esp. pp. 195-96).

[11]Wilkinson, *Jerusalem Pilgrims*, p. 142.

[12]Architectural copies of the Holy Sepulchre have been studied by D. G. Dalman, *Das Grab Christi in Deutschland* (Leipzig: Dieterich, 1922), though much new information has been uncovered since this study, confined to German examples, was written. A new treatment of the subject is needed.

[13]Krautheimer, p. 15.

[14]Jules Formigé, "Un plan du Saint-Sépulchre découvert à la basilique de Saint-Denis," *Academie des Inscriptions et Belles Lettres, Paris, Fondation E. Piot, Monuments et Memoires*, 48 (1956), 107-30.

[15]Victor H. Elbern, "Das Relief des Gekreuzigten in der Mellebaudis-Memorie zu Poitiers: Über eine vorkarolingische Nachbildung des Heiligen Grabes zu Jerusalem," *Jahrbuch der Berliner Museen*, 3 (1961), 149-89.

[16]Ibid., p. 187.

[17]Annemarie Schwarzweber, *Das heilige Grab in der deutschen Bildnerei des Mittelalters* (Freiburg-im-Breisgau: Eberhard Albert, 1940), p. 2.

[18]"Hoc altare deo dedicatum est maxime Christo/ cujus hic tumulus nostra sepulchra juvat" (quoted by Dalman, p. 26).

[19]Schwarzweber, p. 2, from the Life of Conrad (translation mine).

[20]Elbern, p. 177; see also Jean Hubert, "Le Saint-Sépulchre de Neuvy et les pelerinages de Terre Sainte au XI siécle," *Bulletin Monumental*, 90 (1931), 91-100.

[21]Rudolph Wesenberg, "Wino von Helmarshausen und das kreuzförmige Oktagon," *Zeitschrift für Kunstgeschichte*, 12 (1949), 30-40.

[22]Schwarzweber, p. 4; the present St. Fides at Schlettstadt is a twelfth-century building. This description of the former church is based on excavations done in 1892.

[23]Dalman, pp. 56-65.

[24]Michael Gervers, "Rotundae Anglicanae," *International Congress of the History of Art* (Budapest, 1969), I, 359-80.

[25]William Loerke, "'Real Presence' in Early Christian Art," in *Monasticism and the Arts*, ed. Timothy Gregory Verdon (Syracuse: Syracuse Univ. Press, 1984), pp. 29-51.

[26]Phillipe Verdier, "Deux plaques d'ivoire de la Résurrection avec la représentation d'un Westwerk," *Zeitschrift für Schweizerische Archäologie und Kunstgeschichte*, 22 (1962), 5. For the scene of the holy women at the tomb, see Gertrud Schiller, *Ikonographie der christlichen Kunst, III: Der Auferstehung Christi* (Gütersloh: G. Mohn, 1972), Pls. 1-53, and Jeanne Villette, *La Résurrection du Christ dans l'art chrétien du II^e au VII^e siècle* (Paris: H. Laurens, 1957).

[27]André Grabar, *Ampoules de Terre Sainte* (Paris: Klincksieck, 1958).

[28]Neil C. Brooks, *The Sepulchre of Christ in Art and Liturgy*, University of Illinois Studies in Language and Literature, 7, No. 2 (Urbana, 1921), p. 17.

[29]Wilkinson, *Egeria's Travels*, p. 133. For a definition of stational liturgy, see John Francis Baldovin, "The Urban Character of Christian Worship in Jerusalem, Rome, and Constantinople from the Fourth to the Tenth Centuries: The Origins, Development, and Meaning of Stational Liturgy," Ph.D. diss. (Yale Univ., 1982), p. 5, and for a survey of the stational liturgy see ibid., Chapts. I-II.

[30]Wilkinson, *Egeria's Travels*, p. 138.

[31]Ibid., p. 139.

[32]Gregory Dix, *The Shape of the Liturgy*, 2nd ed. (London: Dacre Press, 1945), p. 372. For an excellent discussion of stational liturgy in Rome, see Baldovin, Chapts. III-IV.

[33]Baldovin, pp. 253-54; Josef A. Jungmann, *The Early Liturgy to the Time of Gregory the Great* (1959; rpt. London: Darton, Longman, and Todd, 1980), pp. 256-57. On stational churches and the relevance of their locations, see Richard Krautheimer, *Rome: Profile of a City, 312-1308* (Princeton: Princeton Univ. Press, 1980), p. 58.

[34]Josef A. Jungmann, *The Mass of the Roman Rite: Its Origins and Development* (New York: Benziger, 1951), I, 59.

[35]Richard Stapper, "Mittelalterliche Osterbräuche der Stiftsherren zu Kleve," *Römische Quartelschrift für christliche Altertumskunde und für Kirchengeschichte*, 35 (1927), 180-81.

[36]Karl Young, "The Dramatic Associations of the Easter Sepulchre," *University of Wisconsin Studies in Language and Literature*, 10 (1920), 26.

[37]Jungmann, *Mass of the Roman Rite*, I, 45.

[38]C. Clifford Flanigan, "The Roman Rite and the Origins of Liturgical Drama," *University of Toronto Quarterly*, 43 (1974), 279.

[39]Jungmann, *Mass of the Roman Rite*, I, 76.

[40]After St. Gall, Stiftsbibliothek, MS. 484, p. 111, as cited by David A. Bjork, "On the Dissemination of *Quem quaeritis* and the *Visitatio sepulchri* and the Chronology of Their Early Sources, *Comparative Drama*, 15 (1981), 46.

[41]Bjork, "On the Dissemination," p. 51.

[42]Flanigan, "Roman Rite and the Origins of Liturgical Drama," p. 280.

[43]Carol Heitz, *Recherches sur les rapports entre architecture et liturgie à l'époque carolingienne* (Paris: SEVPEN, 1963).

[44]David Parsons, "The Pre-Romanesque Church of St-Riquier: The Documentary Evidence," *Journal of the British Archaeological Association*, 130 (1977), 50.

[45]R. P. Kassius Hallinger, "Gorze-Kluny. Studien zu den monastischen Lebensformen und Gegensätzen im Hochmittelalter," *Studia Anselmiana*, 24-25 (1950-51), 909-10, shows that most so-called paraliturgical drama had a monastic setting. Elie Konigson, *L'Espace théâtral médiéval* (Paris: Centre National de la Recherche Scientifique, 1975), observes that most of these monasteries (except in Italy) had some form of westwork. Konigson supports Heitz's westwork thesis and adds corroborative evidence.

[46]Verdier, "Deux plaques," p. 6.

[47]Carol Heitz, "Architecture et liturgie processionnelle à l'époque préromane," *Revue de l'Art*, 24 (1974), 43.

[48]H. M. Taylor, "Tenth-Century Church Building in England and on the Continent," in *Tenth-Century Studies*, ed.

David Parsons (London and Chichester: Phillimore, 1975), p. 154.

[49]Karl Lanckoronski-Brzezie, George Niemann, and Heinrich Swoboda, *Der Dom von Aquileia* (Vienna, 1906); see also P. L. Zovatto, *Il Santo Sepulchro di Aquileia e il Dramma Liturgico Medievale* (Udine: Accademia di Scienze, Lettere e Arte di Udine, 1956).

[50]Lipphardt Nos. 495-98.

[51]Dalman, p. 35.

[52]Günter W. Vorbrodt, "Die Stiftskirche in Gernrode," in *Das Stift Gernrode*, ed. Hans K. Schulze (Cologne, 1965). As possible evidence on the relationship between westwork, celebration of the Easter rites, and Holy Sepulchre, it is interesting to note that Gernrode had a westwork with gallery that was destroyed in the twelfth century in order to build the western apse. Could it have been easier to dispense with the westwork because the Easter rites had been shifted to the new Holy Sepulchre in the south aisle?

[53]Schwarzweber, pp. 9ff. See also Siegfried Lauterwasser and Georg Poensgen, *Das Heilige Grab zu Konstanz* (Überlingen: W. Wulff, 1948).

[54]Gervers, pp. 360-62.

[55]*The Monastic Agreement of the Monks and Nuns of the English Nation: Regularis Concordia*, ed. and trans. Thomas Symons (New York: Oxford Univ. Press, 1953).

[56]Thomas Symons, "*Regularis Concordia*: History and Derivation," in *Tenth-Century Studies*, ed. Parsons, p. 59.

[57]Richard B. Donovan, "Two Celebrated Centers of Medieval Liturgical Drama: Fleury and Ripoll," in *The Medieval Drama and Its Claudelian Revival*, ed. E. Catherine Dunn, Tatiana Fotitch, and Bernard M. Peebles (Washington, D.C.: Catholic Univ. of America Press, 1970), pp. 41-51.

[58]Transcribed from British Library MS. Cotton Tiberius A. III, fols. 19v-20r and 21r-21v.

[59]Translation mine.

[60]Konigson, pp. 24-25.

[61]Ibid., p. 37 (translation mine).

[62]Thomas W. Lyman, "Theophanic Iconography and the Easter Liturgy: the Romanesque Painted Program at Saint-Sernin in Toulouse," in *Festschrift für Otto von Simson zum 65. Geburtstag,* ed. Lucius Grisebach and Konrad Renger (Berlin: Propyläen, n.d.), pp. 72-93.

[63]Parsons, ed., *Tenth-Century Studies,* p. 6. One extant church built in the tenth century, Deerhurst Priory in Gloucestershire, has been shown to have architectural features that meet specific liturgical requirements set out in the *Regularis Concordia.* Arnold Klukas, who has examined the building in this light, does not speculate as to the locus of the commemorative Holy Week and Easter rites at Deerhurst, except to suggest "houses connected with the Gorze liturgical reforms as the appropriate source for architectural parallels" (p. 92). He cites as an example the collegiate church at Essen where a fourteenth-century *Visitatio* was performed at the western end of the church. At Deerhurst, the axial western tower contains a room at the upper level with rich architectural decoration (Arnold William Klukas, "Liturgy and Architecture: Deerhurst Priory as an Expression of the Regularis Concordia," *Viator,* 15 [1984], 81-106).

[64]Thomas Symons, "The Regularis Concordia and the Council of Winchester," *Downside Review,* 80 (1962), 144. Symons refers to paragraph 46 of the *Regularis Concordia* which he translates as follows: "if anyone should care or think fit (si ita cui uisum fuerit uel sibi taliter placuerit) to follow . . . certain religious men in a practice [the Good Friday 'sepulchre' custom] worthy to be imitated . . . we have decreed this only (hoc modo decreuimus). . . ."

II. THE RITES IN ENGLAND

[1]Many texts with helpful summaries and commentaries are found in Karl Young's classic edition, *The Drama of the Medieval Church* (Oxford: Clarendon Press, 1933), 2 vols. A much larger collection of texts is to be found in Walther Lipphardt's *Lateinische Osterfeiern und Osterspiele* (Berlin and New York: Walter de Gruyter, 1975-81), 6 vols. Lipphardt includes a total of 832 texts, of which 28 are from the British Isles. However, he does not list separately manuscripts of the Sarum Consuetudinary and Customary collated by Walter H. Frere (*The Use of Sarum* [Cambridge, 1898], 2 vols.), nor does he indicate that texts of the commemorative Holy Week and Easter rites appear in many Sarum service books. Had he done so, it would have been apparent that there are many more English texts and that the vast majority of them represent the Use of Sarum.

[2]". . . de sepulchro habendo sunt generaliter obser-
vanda in omnibus ecclesiis que non possunt de congruo omitti"
(*Defensorium directorii* [Antwerp: G. Leeu, 1488, fol. 292; STC
17721]). Clement Maydeston (1390-c.1456), a Brigittine monk,
certainly wrote the *Directorium sacerdotum*, a widely-used
handbook which appeared before the middle of the fifeenth
century. He presumably also wrote the *Defensorium*, which was
printed with the *Directorium* by William Caxton and Wynkyn de
Worde.

[3]Young, "Dramatic Associations," p. 26.

[4]Ibid., p. 10.

[5]Ludwig Eisenhofer and Joseph Lechner, *The Liturgy of
the Roman Rite* (Freiburg and London, 1961), p. 201;
Schwarzweber, *Das heilige Grab*, p. 61.

[6]"Responsorio finito collocetur in Sepulchro et lin-
theaminibus et sudario cooperiatur. Deinde lapis superponatur"
(Lipphardt, No. 544).

[7]Schwarzweber, *Das heilige Grab*, p. 62.

[8]Lipphardt, No. 341.

[9]William Illingsworth, "Copy of an original Minute of
Council for Preparations for the Ceremonial of the Funeral of
Queen Catherine, the divorced wife of King Henry the Eighth,"
Archaeologia, 16 (1812), 23-24.

[10]For example, see the *Elevatio* in the Wells Ordinal.
Wells adopted the Use of Sarum in the thirteenth century.
Lipphardt does not include this text, which is printed by
Herbert E. Reynolds in *Wells Cathedral: Its Foundations,
Constitutional History and Statutes* (1880), p. 32, from
Lambeth MS. 729. Reynolds says that it is based on an early
fourteenth-century original.

[11]For a discussion of the distinctive nature of the
English celebration of the Resurrection and its correlation with
the iconography of the Easter Sepulchre, see Pamela Shein-
gorn, "The *Sepulchrum Domini*: A Study in Art and Liturgy,"
Studies in Iconography, 4 (1978), 37-60.

[12]Lipphardt, No. 536c (1350-1400: "Finito Officio post
Missam paretur Sepulchrum prius excluso Populo. . . ."

[13]Lipphardt, No. 492, Aquileia Cathedral (1230-60):
"Interim pulsetur ad Matutinum [et] Clerus et Populus con-
veniens ad ecclesiam. . . ."

[14]Lipphardt, No. 796, Regensburg-Obermünster (1567-87): "In die sancto Pasce ante pulsum Matutinarum Plebanus una cum Duabus devote accedant Sepulchrum Domini prius tamen omnibus expulsis Laicis."

[15]Heinrich Alt, *Theater und Kirche* (Berlin, 1846), p. 348.

[16]Lipphardt, No. 802: "Ipso vero Crux, antequam pulsentur Matutine Sacerdotes auferent eam, relicto tamen lintheo usque dum ipsa nocte Sepulchrum a sororibus visitetur."

[17]Young, *The Drama of the Medieval Church*, Vol. I; O. B. Hardison, Jr.; *Christian Rite and Christian Drama in the Middle Ages* (Baltimore: Johns Hopkins Press, 1965); C. Clifford Flanigan, "The Liturgical Drama and its Tradition: A Review of Scholarship 1965-1975," *Research Opportunities in Renaissance Drama*, 18 (1975), 81-102, and 19 (1976), 109-36; Bjork, "On the Dissemination of *Quem quaeritis* and the *Visitatio sepulchri* and the Chronology of Their Early Sources," pp. 46-69.

[18]T. A. Heslop, "A Walrus Ivory Pyx and the *Visitatio Sepulchri*," *Journal of the Warburg and Courtauld Institutes*, 44 (1981), 157-60 and Pl. 19.

[19]The Norwich Customary (1277-1370) seems to call for a *Visitatio (eant se preparare Tres Marie)*, but there are no further rubrics and no dialogue.

[20]Diane Dolan, *Le Drame liturgique de Pâques en Normandie et en Angleterre au Moyen-Age* (Paris: Presses Universitaires de France, 1975).

[21]Young, "Dramatic Associations," p. 130.

[22]Helmut A. De Boor, *Die Textgeschichte der lateinische Osterfeiern* (Tübingen: Niemayer, 1967).

III. THE FORM OF THE EASTER SEPULCHRE

[1]The Holy Grave, the Germanic *sepulchrum Domini*, has been studied by Dalman (*Das Grab Christi in Deutschland*) and Schwarzweber (*Das heilige Grab in der Deutschen Bildnerei des Mittelalters*). The latter work is especially helpful for its treatment of formal and iconographic changes.

[2]Schwarzweber, *Das heilige Grab*, p. 67.

[3]Brooks, *The Sepulchre of Christ*, Chapt. 7, "The Nature of the Sepulchre in Continental Churches," pp. 59-70.

[4]Schwarzweber, *Das heilige Grab*, p. 67.

[5]Joan Evans, *English Art 1307-1461* (1949; rpt. New York: Hacker, 1981), p. 170.

[6]G. H. Cook, *The English Mediaeval Parish Church* (London: Phoenix House, 1954), p. 169.

[7]Alfred Heales, "Easter Sepulchres," *Archaeologia*, 42 (1869), 296.

[8]Henry Lawrance and T. E. Routh, "Military Effigies in Nottinghamshire before the Black Death," *Thoroton Society Transactions*, 28 (1924), 123.

[9]Veronica Sekules, "A Group of Masons in Early Four- teenth-Century Lincolnshire: Research in Progress," in *Studies in Medieval Sculpture*, ed. F. H. Thompson, Occasional Papers, n.s. 3 (London: Society of Antiquaries, 1983), p. 164.

[10]Veronica Sekules, "The Holy Grave at Lincoln and the Development of the Sacrament Shrine: Easter Sepulchres Reconsidered," *British Archaeological Association Conference Transactions, VIII: Lincoln* (forthcoming).

[11]Edward S. Prior and Arthur Gardner, *An Account of Medieval Figure Sculpture in England* (Cambridge: Cambridge Univ. Press, 1912), p. 370. For recent work on this subject, see Sekules, "A Group of Masons," pp. 151-64; the same author's dissertation on fourteenth-century sculpture in Lincolnshire promises to unravel many of the problems assoc- iated with this local style.

[12]On this group, see Charles J. Cox, "Some Somerset Easter Sepulchres and Sacristies," *Downside Review*, n.s. 23 (1924), 84-88.

[13]H. Philibert Feasey, "The Easter Sepulchre," *The Ecclesiastical Review*, 32 (1905), 350, suggests this possibility.

IV. *THE ICONOGRAPHY OF THE EASTER SEPULCHRE*

[1]The transition from the Holy Grave--holy women and angels standing around the body of Christ lying on his tomb--to the Entombment--Mary, John, Joseph of Arimathea, Nicodemus, Mary Magdalene, and others grouped around the body in the same manner as in the Holy Grave--can be traced in a group of portable wooden Holy Graves in the Rhineland.

The Entombment, especially popular in France, was not the locus for the enactment of *Depositio, Elevatio,* and *Visitatio* as was the Holy Grave. See also William H. Forsyth, *The Entombment of Christ* (Cambridge, Mass.: Harvard Univ. Press, 1970).

[2]Franz Rademacher, "Zu den frühesten Darstellungen der Auferstehung Christi," *Zeitschrift für Kunstgeschichte,* 28 (1965), 195-224.

[3]For a visual analysis of the Resurrection scene in the English cycle plays see Pamela Sheingorn, "The Moment of Resurrection in the Corpus Christi Plays," *Medievalia et Humanistica,* n.s. 11 (1982), 111-29.

[4]For the iconography of the Ascension in English art, see Meyer Schapiro, "The Image of the Disappearing Christ," in *Selected Papers, III: Late Antique, Early Christian, and Mediaeval Art* (New York: Braziller, 1979), pp. 266-87.

V. THE EASTER SEPULCHRE IN ENGLISH RELIGIOUS LIFE

[1]*Testamenta Eboracensia,* V, ed. James Raine and John W. Clay, Surtees Society, 79 (1884), p. 273.

[2]Feasey, "Easter Sepulchre," p. 491.

[3]Charles Wriothesley, *A Chronicle of England during the Reigns of the Tudors,* II, ed. William Douglas Hamilton, Camden Society, n.s. 20 (1877), p. 1. On puppets see George Speaight, *The History of the English Puppet Theatre* (New York: de Graff, 1955), and, in response, John W. Robinson, "On the Evidence for Puppets in Late Medieval England," *Theatre Survey,* 14 (1973), 112-17. Robinson disputes Speaight's assumption that puppets and human actors played together in the mystery plays, but does not speak of the Easter morning rite where, I suggest, a puppet many have been used alone.

[4]John Hooper, *A Declaration of Christe and of his offyce* (Zurich: A. Fries, 1547; STC 13745), sig. Eiv. For a discussion of this period that "seeks to clarify the various patterns and interactions of men over the role of images," see John Phillips, *The Reformation of Images: Destruction of Art in England, 1535-1660* (Berkeley: Univ. of California Press, 1973), p. 9 and passim.

[5]Hooper, *A Declaration,* sig. Evi.

[6]Wriothesley, *Chronicle,* II, 1.

[7]Ibid., II, 113

[8]Keith Thomas, *Religion and the Decline of Magic* (New York: Scribner's, 1971), p. 75.

[9]Hooper, *A Declaration*, sig. Evi[v].

CATALOGUE OF EASTER SEPULCHRES

CATALOGUE OF EASTER SEPULCHRES

This catalogue makes no claim to completeness. It includes extant Easter Sepulchres, extant structures that are likely to have been used as Easter Sepulchres, and records pertaining to Easter Sepulchres, including those monuments no longer in existence. A number of Easter sepulchres, especially those with figural sculpture, have been examined at first hand. Descriptions in this catalogue are of necessity based on published accounts in archaeological, antiquarian, and county journals as well as in comprehensive surveys such as the Victoria County Histories, Royal Commission on Historical Monuments, and Buildings of England series. Medieval references to Easter Sepulchres in particular churches have been mostly found in liturgical manuscripts, wills, churchwardens' accounts and inventories, and Commissioners' inventories. Both the random nature of preservation of documents and the wide range of specificity in such documents preclude any suggestion that a complete record could be made. Some entries are highly repetitive. For written records, it has usually only been possible to consult printed sources; these transcriptions have generally not been checked against the original records. Those who consult this book should be aware that such transcriptions vary somewhat in accuracy and in methods of expanding abbreviations. Ideally, each record should have been checked against its original, to the extent that the original records are preserved and accessible. However, the task is so large as to be impossible for a single person to carry through, and therefore the necessity of presenting the records in this catalogue from the available secondary sources has been reluctantly recognized, and also abbreviations have been silently expanded for such documents. However, in all instances where this has been possible the texts of the English *Depositio, Elevatio,* and *Visitatio* have been newly edited from the manuscripts and early printed editions.

The Easter Sepulchre was so widespread in England that the absence of an entry here should not be taken to indicate that a particular church had no such monument. EDAM and REED research currently in progress will undoubtedly find many monuments not cited here. Organization is alphabetical by county, and by city, town, or village. The old county boundaries, immediately prior to the recent reorganization, have been observed. Ascriptions to county and dedications of churches generally follow Arnold-Forster. The notation ESp* in the descriptions indicates either that no monument in an existing church can be identified as the Easter Sepulchre or that there is documentary evidence as to the destruction either of church or of Easter sepulchre. If there is no documentary evidence, figural sculpture, or inscription to identify an example unambiguously as an Easter Sepulchre, but its location, size, and shape make use as an Easter Sepulchre likely, it appears in the list as ?ESp. Dimensions are in feet and inches. References to printed sources are given in brackets at the end

of each entry (for full citations, see Bibliography); they are not necessarily exhaustive. Abbreviated references to multi-volume series--i.e., RCHM (Royal Commission on Historical Monuments), Pevsner (The Buildings of England), VCH (Victoria County Histories)--are understood to refer to the volume in the series covering the relevant county.

LIST OF ABBREVIATIONS

accts	accounts	kt	knight
ch	chapel	L	left
Comm	Commissioners'	N	north
Dec	Decorated	Perp	Perpendicular
E	east	R	right
ESp	Easter Sepulchre	S	south
fig	figure	W	west
inv	inventory	Win	window

BEDFORDSHIRE (Bd)

ARLESEY, St Peter
> ?ESp/tomb; several 14c elements apparently dislocated in widening of Win 1 (E Win) in 15c; now 3 recesses in N wall of chancel; in NE angle, niche with trefoil head; to W of it, larger cinquefoiled niche; each has bracket for support of statue; below these, square recess, perhaps for tomb, with roll molding around head & jambs; projecting sill of this recess carved with 14c diaper pattern, incomplete, which suggests this piece of stone reused; below sill, front paneled with 4 quatrefoils; recess probably assembled in 15c from partly older elements; this complex suitable for use as ESp. [Mee, *Bd & Hu*; Jos E. Morris, "ESp"; VCH 2]
> ESp ntd 1501 will of Jn Cooper leaving 11 quarters of barley to ESp light. [McGregor]
> Also ntd 1506 will of Sir Jn Walcar, perpetual vicar of Arlesey, leaving 2 measures of barley toward upkeep of ESp lights. [Bell]
> Ntd 1508 will of Tho Hockoll:
> I bequeth . . . to the lygt of the sepulcre *dimidiam quarteriam* of barley. [Cirket]

ASPLEY-GUISE, St Botolph
> ESp* ntd 1540 will of Jn Hardyng leaving 3s. 4d. to bells, torches, & ESp light in Aspley Church. [McGregor]

BARTON-LE-CLAY, St Nicholas
 ?ESp/tomb recess at E end of N wall of chancel; recess
 has molded segmental head & double-shafted jambs with
 molded capitals & bases; mid to late 13c. [Pevsner;
 VCH 2]

BEDFORD, new chapel in churchyard
 ESp ntd 1413 will of Sir Jn Cheyne of Bedford:
 And oo taper atte myn heued and an oother atte my
 feet . . . and the tapers that that [sic] leuen there
 of to brenne to fore the sepulcre from good freiday in
 to Esterday by the morowen. [Page-Turner]

BEDFORD, St Paul
 ESp* ntd 1515 will of Robt Smyth leaving 6s. 8d. to ESp
 light. [McGregor]
 Also ntd 1516 will of Sir Wm Gold, priest:
 Item I bequeath to the Sepulaire Lyght of Powls
 Church aforesaid iijs. iiijd. [Cirket]

BEDFORD, St Peter (Merton)
 ESp* ntd 1501 will of Jn Denes leaving 12d. to ESp
 light. [Bell]

BILLINGTON, St Michael
 ?ESp; square unmolded recess in N wall of 13c chancel
 rebuilt in modern times. [VCH 3]

BLETSOE, St Mary
 ?ESp without sculpture; 14c. [Cox & Harvey]
 ESp ntd 1505 will of Jn Lane leaving 2s. to ESp light.
 [Bell]

BLUNHAM, St Edmund
 ESp/tomb recess with canopy in N chancel; cinquefoiled
 ogee arch has crocketed label & large foliate finial;
 leaf carving in spandrels; front of tomb chest paneled
 with quatrefoils enclosing shields; Purbeck marble
 slab; c.1350. [Pevsner; VCH 2]
 ESp ntd 1501 will of Edw Cowper leaving 12d. to ESp
 light. [Bell]
 Also ntd 1509 will of Wm Moore leaving 8d. to ESp
 light; 1512 will of Wm Osburne leaving one quarter of
 malt to ESp light; 1517 will of Tho Cooper leaving 2
 bushels of barley to ESp light. [Cirket]

BOLNHURST, St Dunstan
 ?ESp; rectangular recess, 14" high x 8" wide x 5"
 deep, under Win N2 in N wall of chancel; ?13c. [VCH
 3]
 ESp ntd 1501 will of Jn Lam leaving 12d. to ESp light.
 [Cirket]

Also ntd 1506 will [name of testator missing] leaving 20d. to ESp light. [Bell]

BROMHAM, St Owen
ESp* ntd 1512 will of Tho Brownseld leaving, after death of wife Lucy, one rod of meadow to ESp. [Cirket]

CARDINGTON, St Mary
ESp* ntd 1504 will of Tho Judde leaving 12d. to ESp light. [Bell]

CARLTON, St Mary
ESp* ntd 1514 will of Tho Hyne leaving one bushel of barley to ESp light; also 1517 will of Tho Amowr leaving "20 ft. meadow lying in Widney meadow" to ESp light. [Cirket]

COLMWORTH, St Denis
ESp* ntd 1439 will of Roger Benetheton: Item lego ad lumen sepulcri iijs. [Serjeantson, "Benetheton"]
Also ntd 1500 will of Jn Crawe leaving 6d. to ESp light. [Bell]
Ntd 1514 will of Tho Wytt leaving 6d. to ESp light. [Cirket]

COPLE, All Saints
?ESp/tomb; chest tomb of Purbeck marble in E bay of N chancel has vertical panel at E end with brasses of Sir Walt Luke (d. 1544), justice of King's Bench, & wife Anne Launcelyn (d. 1538); brasses, which show both figs kneeling, have considerable remains of inlaid color. [Pevsner; VCH 3]

DEAN (NETHER), All Saints
?ESp/locker in N wall of 13c chancel. [VCH 3]

DUNTON, St Mary
ESp* ntd 1506 will of Jn Balla leaving 6d. to ESp light. [Bell]
Also ntd 1509 will of Tho Barbor leaving 2 bushels of barley to ESp light; 1521 will of Jn Caryngton leaving one-half quarter of barley to ESp light. [Cirket]

EATON-BRAY, St Mary Virgin
ESp* ntd 1515 will of Jn Rudde leaving 6d. to ESp light; also 1519 will of Eliz Fox leaving 4d. to ESp light; 1521 will of Cuthbert Cutlat leaving 12d. to ESp lights. [Cirket]

EVERTON, St Mary
ESp* ntd 1506 will of Jn Bendow leaving 20d. to ESp
light. [McGregor]

FELMERSHAM, St Mary
ESp* ntd 1505 will of Wm Grendon leaving "dyvydable"
one-half quarter of barley to ESp light. [Cirket]
Also ntd 1508 will of Jn Reysley leaving one measure
of barley to ESp. [Bell]
Ntd 1508 will of Wm Leche leaving 3s. 4d. to ESp
"leyrth" (?light); 1513 will of Jn Gardyner leaving one
bushel of barley to ESp light. [Cirket]

HAYNES or HAWNES, St Mary
ESp* ntd 1501 will of Jn Gogeun leaving one bushel of
barley to ESp light. [Cirket]

HENLOW, St Mary
ESp* ntd 1499 will of Jn Edward leaving 2 quarters of
malt to ESp light & other lights in church; also 1508
will of Jn Sandon leaving one measure of barley to ESp
light. [Bell]

HOUGHTON-CONQUEST, All Saints
?ESp/tomb; brick chest with Purbeck marble top in N
chancel; brasses on top of Jn Conquest, wife Isabel, &
son Rich; Isabel's date of death given as 1493, those
of husband & son left blank; beneath these 3 figs,
smaller brasses of 9 sons & 5 daughters; corners of
slab have evangelist symbols, of which only Matthew &
Luke remain; brasses il Pevsner, p. 102. [VCH 3]
ESp ntd 1509 will of Jn Edwords leaving 2 sheep "to
be contained for ever more" to ESp light. [Cirket]
Also ntd 1509 will of Jn Woodeward:
Item lego dominico sepulcro ecclesie predicte viijd.
[Bell]

HUSBORNE-CRAWLEY, St Mary Magdalene
ESp* ntd 1499 will of Rich Maleherbe leaving one pound
of wax to ESp light. [Bell]

KEMPSTON, All Saints
ESp* ntd 1500 will of Tho Amse leaving 9d. to ESp
light; also 1501 will of Wm Carter leaving 20d. to ESp
light. [Bell]
Ntd 1513 will of Rich Newold leaving 2 year old bullock
to ESp light; 1516 will of Barth Jordan leaving 20d. to
ESp light. [Cirket]

KNOTTING, St Margaret
ESp* ntd 1504 will of Jn Browne leaving 2 measures of
barley for ESp light. [Bell]

LUTON, St Mary
> ESp/tomb recess; early 14c recess with ogee arch,
> crockets, & finial in N wall of chancel below & W of
> Win N3 (now blocked because of vestry); recess, 5'7"
> in length, apparently moved to this location from far-
> ther W when Wenlock (N) Chapel built in 1461, as
> recess now partly blocks later doorway. [Cobbe; Pevs-
> ner; VCH 3]
> ESp ntd ?1516 will of Tho Wynche leaving one pound
> wax to ESp light. [Cirket]

MARSTON-MORTAIN, St Mary
> ESp* ntd 1498 will of Tho Wells leaving one bushel of
> barley to ESp light. [Cirket]

MEPPERSHALL, St Mary
> ESp/tomb recess; wide, shallow recess in N wall of
> chancel immediately to W of Win N3; recess has 4-
> centered head & molded jambs; to E of recess, small
> lamp niche of same period with flue in its head; 15c; S
> wall has recess like one on N, all part of general re-
> fitting of chancel in 15c. [VCH 2]
> ESp ntd 1500 will of Wm Strynger leaving 20d. to ESp
> light; also 1501 will of Agnes Rawlynge leaving 20d. to
> ESp light. [Bell]

MILLBROOK, St Michael
> ESp* ntd 1499 will of Jn Lord leaving cow to ESp light.
> [Bell]

MILTON-ERNEST, All Saints
> ESp* ntd 1501 will of Rich Trayte leaving 2s. to ESp
> light. [Bell]
> Also ntd 1506 will of Tho Gylmyn leaving 6d. to ESp
> light. [Cirket]

NEWNHAM, Augustinian Monastery
> ESp* ntd cellarer's accounts 1519-20 listing payment of
> 4d. for ESp light. [Gilmore]

NORTHILL, St Mary
> ESp*; traces of wide recess in wall between priest's
> vestry & chancel where ESp might have been.
> ESp* ntd churchwardens' accts 1564:
> More recayved of Thomas Tychmar for the sepoulke
> and 2 cruetes 14d. [Farmiloe & Nixseaman]

OAKLEY, St Mary
> ESp* ntd 1505 will of Jn Bays leaving 4d. to ESp light;
> also 1505 will of Wm Necus leaving 12d. to ESp. [Bell]
> Ntd 1505 will of Jn Skott:

[I bequeath] my tapur to the sepulcur.
Ntd 1505 will of Jn Stokes leaving 20d. to ESp light;
1509 will of Jn Clarke leaving 40d. to ESp light; 1516
will of Margery Edwards leaving 2 bushels of barley to
ESp light; 1521 will of Jn Stoke leaving 12d. to ESp
light. [Cirket]

PAVENHAM, St Peter
ESp* ntd 1504 will of Isabella Chirche leaving 12d. to
ESp light. [Bell]
Also ntd 1509 will of Sir Tho Habraham leaving 2s. to
ESp light. [Cirket]

PERTENHALL, SS Peter & Paul
ESp* ntd 1506 will of Alice Wade leaving 8d. to ESp
light. [Bell]
Also ntd 1506 will of Wm Browne:
to the Resurrection of our Lord a measure of barley;
. . . to the fraternity of the Resurrection of our Lord
a measure of barley. [Bell]
Ntd 1508 will of Wm Slade leaving 20d. to ESp light.
[Bell]

PODDINGTON or PUDDINGTON, St Mary
?ESp; 2 low recesses with pointed arches in N wall of
chancel; 14c. [VCH 2]
ESp ntd 1511 will of Rich Rabett leaving half a quarter
of barley to ESp light. [Bell]
Also ntd 1517 will of Jn Heywood leaving 40d. to ESp
light. [Cirket]

POTSGROVE, St Mary
?ESp/tomb; recessed tomb chest in N wall of chancel; 2
lockers in spandrels of its arch; 14c; detail lost due
to 1881 restoration. [VCH 3]

POTTON, St Mary
?ESp/aumbry*; part of sill of 3-light late 15c Win in N
chancel (Win N2) cut down to within 2'6" of floor,
perhaps to accomodate locker or ESp*. [VCH 2]
ESp* ntd 1498 will of Tho Dukkes leaving 4d. to ESp
light; also 1499 will of Walt Clerke leaving 12d. to ESp
light; 1500 will of Tho Bryche leaving 20d. to ESp
light provided that a light is lit at his funeral.
Ntd 1500 will of Bartholomew Atkyn:
Item lego lumini sepulcri xld.
Ntd 1500 will of Joan Best leaving 4d. to ESp light;
1500 will of Rich Cotes leaving 8d. to ESp light. [Bell]
Ntd 1503 will of Rich Raynold leaving 3s. 4d. to ESp;
1503 will of Tho Clerk leaving 3s. 4d. to ESp light;
will of Jn Worelich proved 1504 leaving 3s. 4d. to ESp
light. [McGregor]

Ntd 1505 will of Tho Clay leaving 8d. to ESp light.
[Bell]
Ntd 1505 will of Robt Whyttesyde leaving 12d. to ESp
light. [Cirket]
Ntd 1506 will of Walt Worlych leaving 3s. 4d. to ESp
light & to torches. [McGregor]
Ntd 1509 will of Jn Buttler leaving 8d. each to ESp
light & to torches; 1515 will of Robt Furthowe leaving
12d. to ESp light. [Cirket]
Ntd 1529 will of Tho Cowper leaving 4s. to ESp.
[McGregor]

RAVENSDEN, All Saints
ESp* ntd 1519 will of Tho Lavender leaving 12d. to ESp
light. [Cirket]

SANDY, St Swithin
ESp* ntd 1500 will of Walter Simond leaving 12d. for
upkeep of ESp light; also 1504 will of Ralph Brunsale
leaving half a quarter of malt to upkeep of ESp lights.
[Bell]
Ntd 1505 will of Walter Everad leaving 8d. to ESp
light; 1505 will of Tho Walcot leaving 12d. to ESp
light; 1505 will of Wm Breton leaving one bushel of
malt to ESp light; 1505 will of Tho Maluarn leaving 4d.
to ESp light; 1514 will of Wm Alderyche leaving 4d. to
ESp light. [Cirket]

SHARNBROOK, St Peter
ESp* ntd 1409 will of Wm Gere leaving 12d. to ESp
light; also 1506 will of Wm Basse leaving 12d. to ESp
light; 1506 will of Jn Bower leaving 4d. to ESp light.
[Bell]
Ntd 1508 will of Wm Wyllymot leaving 12d. to ESp.
[Cirket]
Ntd 1510 will of Simon Basse leaving measure of barley
to ESp light. [Bell]

SHELTON, St Mary
?ESp; triangular-arched recess in N wall of chancel; W
half of sill has rectangular sinking; 13-14c. [VCH 3]

SHILLINGTON, All Saints
?ESp; vaulted crypt under E bay of chancel, necessary
due to nature of site; crypt, 19' square, approached
from NE by passage which formerly led from base of
turret stair in SE corner of N chapel; ?used as ESp;
early 14c; il VCH 2, opp. p. 296.
ESp ntd 1500 will of Wm Lawrans leaving 2 bushels of
barley to ESp light; also 1504 will of Rich Grene
leaving measure of malt to ESp. [Bell]

SOULDROP, All Saints
ESp* ntd 1505 will of Jn Lane, Sr, leaving one bushel
of barley to ESp light. [Cirket]

STAGSDEN, St Leonard
?ESp/aumbry; shoulder-arched recess in wall of N chan-
cel near E end; 13c. [VCH 2]
ESp ntd 1507 will of Goditha Wodyll leaving 2 measures
of malt to ESp light. [Bell]

STEVINGTON, St Mary
ESp* ntd 1501 will of [blank] Fyssher leaving 2s. to
ESp lights. [Bell]
Also ntd 1506 will of Rich Whyght leaving 6d. to ESp
light. [Cirket]

STOTFOLD, St Mary
ESp* ntd 1499 will of Jn Breteyn leaving measure of
barley to upkeep of ESp light; also 1503 will of Jn
Lylly leaving measure of barley to upkeep of ESp
light. [Bell]

SUTTON, All Saints
ESp* ntd 1504 will of Robt Mychell leaving 3s. 4d. to
ESp light. [McGregor]

TEMPSFORD, St Peter
ESp* ntd 1499 will of Agnes Cowper leaving 12d. to ESp
light; also 1500 will of Jn Fyscher leaving 12d. to ESp
light; 1500 wills of Margery Norman leaving cow to ESp
light, Jn Stapyllow leaving 20d. to ESp light, and Jn
Boteler leaving 4d. to ESp light; 1503 will of Jn Par-
kyn leaving 5 measures of malt to ESp light. [Bell]
Ntd 1504 will of Jn Hawes leaving 20d. each to lights
of ESp & to torch; 1505 will of Tho Fage leaving 20d.
each to ESp, torches, & bells; 1507 will of Jn Mytton,
clerk, leaving 12d. to ESp light. [Cirket]

TILBROOK, All Saints
ESp* ntd 1502 will of Jn Notte leaving 6d. to ESp light.
[Bell]

TILSWORTH, All Saints
Sculptural fragments from ESp*; 3 small statues of sol-
diers & part of 4th; lower portion of seated fig,
draped; all 13c. [Pevsner]
ESp* ntd 1500 will of Wm Huett leaving measure of
barley to ESp light. [Bell]

TINGRITH, St Nicholas
?ESp; small cinquefoiled opening in N wall of chancel
blocked by buttress; 1450-1500. [VCH 3]

ESp ntd 1515 will of Roger Bunker leaving one pound of wax to ESp light. [Cirket]

WILDEN, St Nicholas
Esp* ntd 1504 will of Jn Luffe leaving 12d. to ESp of Wilden. [Cirket]

WILSHAMSTEAD or WILSTEAD, All Saints
ESp* ntd 1510 will of Nich Church leaving 2 bushels of barley to ESp light of Wilstead; also 1517 will of George Purcer leaving one-half quarter of malt to ESp light. [Cirket]

WOOTTON, St Mary
ESp* ntd 1506 will of Tho Francis leaving 4 strikes (bushels) of barley to ESp; also 1522 will of Harry Goditot leaving one sheep to ESp light. [Cirket]

YELDEN, St Mary
ESp in N wall of chancel; recess with trefoiled arch that has 2 pinholes in cusps; 14c. [VCH 3]
Sepulchre Guild ntd 1501 will of Tho Erle leaving 2 measures of barley to fraternity of Sepulchre. [Bell]

BERKSHIRE (Bk)

ABINGDON, St Helen
ESp* ntd churchwardens' accts 1557:
To the sextin for watching the sepulter two nyghtes 8d.
1558-9:
Payde for making the sepulture 10s.
For peynting the same sepulture 3s.
For stones & other charges about it 4s. 6d.
To the sexten for meat and drink and watching the sepulture according to custom 22d.
To the bellman for meat, drink and coales, watching the sepulture 19d. [J. Ward]

ASTON TIRROLD, St Michael
?ESp/aumbry; plain recess under W jamb of Win N2; c.1200-50. [VCH 3]

AVINGTON, Church (dedication unknown, possibly St Mary)
?ESp/aumbry; plain oblong recess in N chancel; 12c. [VCH 4]

BOXFORD, St Andrew
?ESp/tomb; wide, low, arched recess in N wall next to

chancel arch; 6'11" in height x 5'6" in width; 15c.
[VCH 4]

BUCKLAND, St Mary Virgin
ESp/tomb recess in N wall of chancel; molded ogee
arched canopy with large stops in form of female
heads; large ballflowers in hollow molding; inner side
of arch cinquecusped; 14c; il Keyser, "Buckland," Pl.
5. [VCH 4]
ESp ntd will of Sir Nich Latimer (d. 1505):
Ego Dominus Nicholaus Latimer lego corpus meum
sepeliri in Ecclesia Sancte Marie de Bockland juxta
altare summum & in loco ubi solet sepulchrum Domini
scituari. [Keyser, "Buckland"]

CHILDREY, St Mary
?ESp/tomb recess in N wall of chancel; front of chest
has 6 panels, each with trefoil-headed arch; shallow
trough in stone top of shelf; over chest, nearly semi-
circular arch, cusped & subcusped; enclosing arch,
crocketed ogee-headed canopy with finial; oak leaf,
dogs, & hedgehog in spandrels; center of canopy
pierced with circular medallion enclosing 4 quatrefoils;
canopy enclosed in paneling with cusps and pinnacles;
back wall of recess also paneled; traces of original
coloring; c.1370; il Keyser, "Childrey," Pl. 5. [Pevs-
ner; VCH 4]

COOKHAM, Holy Trinity
?ESp/tomb; Purbeck marble chest tomb with canopy in N
wall of chancel; plaster canopy of 3 arches stands on
twisted columns; underside of canopy imitates fan
vaulting; top of tomb chest has brasses, 18" in
length, of R. Peake (d. 13 Jan 1517) in plate armor &
wife Agnes, with inscribed labels issuing from their
mouths; also brass of Trinity & shields. [Pevsner;
VCH 3]

CUMNOR, St Michael
?ESp/tomb; canopied tomb chest of early 16c type near
E end of N wall of chancel; monument to Anthony
Forster (d. 1572) & wife Ann (Williams); either reuse
of ?ESp of c.1500 already in chancel or new monument
in old style; Purbeck marble chest with paneled front,
topped by flat canopy with quatrefoiled frieze & crest-
ing of Tudor flowers; canopy rests on 4 Ionic col-
umns; brasses of Forster family on back wall: man in
armor kneeling, woman kneeling, 3 sons, inscription, &
coats of arms; il Keyser, "Cumnor," fig. 52. [Pevs-
ner; VCH 4]

EAST HAGBOURNE, St Andrew
?ESp/aumbry; plain, square recess of 13c with modern door in N wall of chancel. [VCH 3]

EAST ILSLEY or MARKET ILSLEY, St Mary
?ESp/aumbry; small recess in N wall of chancel at NE; pointed head with dog-tooth carving. [VCH 4]

ENGLEFIELD, St Mark
?ESp/tomb; canopied table tomb in N chancel under E arch of arcade separating chancel from Englefield chapel for Sir Tho Englefield (d. 1514); tomb chest paneled with quatrefoils covered with 3-arched canopy, underside treated in imitation of fan vaulting; E end of canopy supported on slab that once held brasses of man & wife kneeling with scrolls issuing from their mouths, children, coats of arms, inscription, & perhaps Trinity; placement of brasses suggests use as ESp; il Keyser, "Englefield," fig. 28. [Pevsner; VCH 3]

FYFIELD, St Nicholas
?ESp/tomb; canopied table tomb against N chancel wall for Lady Katherine Gordon (d. 1527) & husband Christopher Ashton (d. 1537); front of chest has cusped paneling; canopy arched below with pierced spandrels & flat top crested with Tudor flowers; boss of canopy has carved sacred initials; back wall of tomb had brasses of family: man in armor with wife & children, all kneeling, inscription, scrolls, & shields; upper part of monument had dark blue coloring. [VCH 4]

HAMPSTEAD NORRIS, St Mary
?ESp/aumbry; large, deep, square-headed recess in N chancel near E end has central mullion & jambs rebated for door; il Keyser, "Hampstead Norris," fig. 27. [VCH 4]

HATFORD, St George or Holy Trinity
?ESp/tomb recess of 13-14c in N wall of chancel has pointed arch with molded label; church disused. [Pevsner; VCH 4]

HURST, St Nicholas
?ESp/tomb now in N wall of N chapel; front of chest paneled with shields in quatrefoils; plain marble slab; shafts support crested canopy with quatrefoil cornice; early 16c style; appropriated after Reformation by Ward family; brasses inserted in back wall of Rich & Colubra Ward (d. 1574); cf. Forster tomb at Cumnor.

[Keyser, "Hurst"]

KINTBURY, Nativity of B V Mary or St Mary
 ?ESp/aumbry in N chancel; 12c; modern door. [VCH 4]

LAMBOURN, St Michael
 ?ESp; low recess E of N chancel arcade; 15c. [VCH 4]

LITTLE (or EAST) SHEFFORD, Church (dedication unknown)
 ?ESp/tomb in N chancel wall; Purbeck chest has
 shields with arms on front and plain slab; Purbeck
 marble canopy, partly recessed in wall, rests on angle
 shafts; paneling on underside of canopy and sides;
 back wall has brasses: in center shield of Jn Fetti-
 place (d. 1524) impaling that of his wife Dorothy
 Danvers; above probably Trinity; to E lady kneeling,
 with 4 daughters kneeling behind her, scroll from her
 mouth: "Deus misereatur nostri, benedicat nobis"; to
 W, Jn Fettiplace in armor, kneeling, indent of 2 sons
 behind him; his scroll reads, "Illuminet vultum suum
 super nos"; brass plate below has inscription reading:
 "Here under this tombe liethe buryed John ffetyplace
 esquyer & Dorothe his wife . . . for whos souls of
 your charite say a pater noster & an ave." Late Perp;
 il Keyser, "Lambourn Valley," fig. 16. [VCH 4]

LITTLE WITTENHAM, All Saints or St Peter
 ?ESp/tomb; tomb chest which has shields on front in
 recess in N wall of chancel; 2'6" brass of Geoffrey
 Kidwelly (d. 1483) in civilian clothing on Purbeck
 marble slab of tomb chest; 4 quatrefoils enclosing
 blank shields on paneled back & ends of recess; flat
 canopy with cusping on inner side has flanking pin-
 nacles with iron prickets for candles; above canopy &
 between pinnacles, stone scroll on which inscription
 formerly painted; 15c; church rebuilt 1863; il Keyser,
 "Little Wittenham," fig. 27; brass il fig. 28a. [Pevs-
 ner; VCH 4]

LYFORD, St Mary
 ?ESp/aumbry in N wall of chancel; shoulder-arched
 recess with hinges; contemporary with Early English
 chancel; il Keyser, "Lyford," fig. 28b.

READING, St Giles
 ESp* ntd churchwardens' accts in which payments for
 watching of ESp recorded from 1519 to 1546.
 Also ntd churchwardens' accts 1520-1:
 Item for nayles cord & sope for the resurrexion.
 [Nash]

READING, St Lawrence
ESp* ntd churchwardens' accts 1498:
In primis payed for wakyng of the sepulcr viijd. [Kerry adds: "Similar entries occur yearly until the Reformation."]
1507:
Item paied to Sybel Derling for nayles for the sepulcre & for rosyn to the resurreccyon pley ijd. ob.
1512:
Item payed to Water Barton to the new Sepulcur iiij li. xiijs. xd.
1513:
Item payd to Harry Horthorne for settyng upp of the frame aboute the sepulcre & for closyng of the dore in Seynt Johns chauncell to the quyre, vjd.
1513-4:
Item payd to Harry Horthorne for ij pecis to hang the sepulcre cloth on, ijd.
Item payd for ale at Removyng of the sepulcre to the carpenters iijd. ob.
1516:
Item paid for makying of the lofte for the sepulcre light lis ijd.
1517 inv:
Item an awlter cloth of Crymson & tawney velwett ymbrowdred with ffloures of gold & for the nether parte of the same Crymson saten & cloth of bawdekyn for the Sepulcr Awter.
Item a sepulcre Cloth of right Crymson Satten imbrowdered with Imagerye with a frontaill of panys conteyning in length iiij yards of the gifte of Mr. Richard Smyth with ij clothes of lawnde for the sepulcre.
1523 inv [added in later hand]:
Item xviij silver aglotts gilt for the sepulcre.
1524:
The Ornaments belongyng to the sepulcre Awlter in the same Church.
In primis a vestemente of Crymson veluet with a crose of rych tyssew.
Item a vestemente of Russet satten with a crose of cloth of gold.
Item a vestemente of whyt brydges satten with a Crose of grene brydges satten.
[Altar cloth of crimson & tawny velvet repeated from 1517 inv.]
Item an awlter cloth of crymson satten & blew bawdkyn with ij Curteyns to the same of grene.
Item iij Curteyns of Russete & blew sarssenete with an awlter cloth of whytte & grene.
Item ij small kanstykks of latten.

1538-9:
Paid for makeyng the beam lights ouer the sepulcre
ayenst easter xxjd.
1544-5:
Paid for sylk poynts for the Sepulcre ijd.
1549:
Received of Mr. Bell for the sepulcre & the frame for
tapers thereto annexid xxs.
1554, in inquiry after alienation, sale, & confiscation
of church goods in reign of previous monarch:
Item for the valence about the sepulcre to know who
hath it in kepyng.
Another entry from mid-1550's records:
Item to enquire for the valence & ffrenge about the
sepulcre.
1561:
Item receyved of Mathew Reynoldes and Water Sawyer
for the sepulcre they bought, xxs. viijd.
1562:
The fframe where the sepulcher Lighte dyd stand
[taken down]. [Kerry]

READING, St Mary Virgin
ESp in chancel with 2 trefoiled arches & gables crock-
eted & finialed; 13c; restored; present chancel rebuilt
1863. [VCH 3]
ESp ntd churchwardens' accts (c.1550-3) [sold by the
churchwardens]:
Item to the same John the Canabye of crymson velvett,
the Alter clothe of whyt Damaske, and Sepulker clothe
of redde and grene satten of Bridges xls.
[1553-4]:
Receyvid of Henry More for the Sepulker xiijs. iiijd.
1557:
paide to Roger Brocke for waching of the Sepulker
viijd.
paide more to the said Roger for Syses and Colles iijd.
1558:
payed to Robert Broke for wachinge the sepulcher
viijd.
1559:
Item payd for Wachynge of the sepulker iiijd. [Garry]

SHILLINGFORD, St Faith
?ESp/tomb recess in N wall of chancel at E end; large
grooved arch with circles down sides which enclose
quatrefoils with roses; under arch, but not filling all
available space, 3-light Perp window (Win N2) which
once had glass of Jn Bleobury (d. 1372) kneeling in
red gown & purple hood; arch once had stone with
brass of Bleobury; il Keyser, "Shellingford," fig. 34.

SPARSHOLT, Holy Rood or Holy Cross
>?ESp/tomb recess; large, arched recess to W of door to sacristy in N wall of chancel; ogee-headed canopy with crocketing & foliate finial; arch cusped & subcusped with heads on center cusps, foliage on others; recess flanked by pilaster shafts capped by pinnacles; traces of red coloring; in S wall opposite, tomb recess like this one for Sir Robt Achard; sedilia & piscina in same style; c.1330; il Keyser, "Sparsholt," Pl. 6. [Pevsner; VCH 4]

STANFORD-IN-THE-VALE, St Denys
>?ESp/aumbry in N wall of chancel; recess had 2 openings & groove in front for doors; Dec. [Keyser, "Stanford-in-the-Vale"]
>ESp ntd churchwardens' accts 1553:
>Item to bottrell for watching ye sepulture iiijd.
>1559:
>Item recuyd towards ye charges of ye communion ye wiche monay before this yere was geuen to meyntayne ye sepulchre & paschall lyghtts iijs. xd. [Haines]

SUNNINGHILL, St Michael
>ESp* ntd inv c.1550:
>sepulchre of timber. [Heales, "ESp"]

SUTTON COURTENAY, All Saints
>?ESp/tomb; recess in N wall of chancel W of recess moved from S wall of chancel in 1903; ?ESp has large pointed arch, trefoil-cusped & subcusped, with hood mold; contains effigy of priest; late 13c to early 14c; il Keyser, "Sutton Courtenay," fig. 4. [Pevsner; VCH 4]

WARFIELD, St Michael & All Angels
>ESp, between E end of chancel arcade & Win N2, had canopy with vaulted soffit, now hacked off flush with wall; part of ensemble including sedilia & piscina, all Dec & 1350-1400. [Pevsner; VCH 3]

WINDSOR, St George's Chapel
>ESp* ntd inv 1384-5:
>Item unus pannus de panno adaurato palliatus rubro et blodio coloribus pro sepulchro Domini.
>Item unus pannus de blodio serico radiato, pouderato cum diversis avibus et floribus, pro celetura sepulchri Domini. [Dugdale, *Mon Angl* 6]

BUCKINGHAMSHIRE (Bu)

AMERSHAM, St Mary
ESp* ntd churchwardens' accts 1539-40:
payd for wachyng of the sepulker in bred and alle
ixd.
1540-1:
Item for breede and drynke for theem that dyd watch
the sepulture.
Also ntd Comm inv 1552:
Item a covyring of silke for the sepulture a valens of
silke a linen clothe to the sepulture a valens for the
same of peynted clothe. [Eeles, *Bu*]

ASHENDON, St Mary
?ESp; long, low recess in N wall of chancel near sanc-
tuary steps; ogee arch with foliated crockets & finial;
contains effigy of knight not meant for it; 15c; il
engraving Lee, "St Mary's," opp. p. 137; Kelke, opp.
p. 16. [RCHM 1; VCH 4]

ASTON CLINTON, St Michael & All Angels
?ESp; small niche (2'2" in width x 10" in depth) in N
wall of chancel with trefoiled ogee head; engraving
before restoration shows figs on small side buttresses,
that on W broken, on E female; these restored as
angels; also knights' head corbels added in restora-
tion; late 14c; il engraving P., [Letter], fig. 2, opp.
p. 841. [Pevsner; RCHM 1; VCH 2]

AYLESBURY, St Mary
?ESp/tomb recess in N wall of chancel near E end;
2-centered arch, molded, on short attached shafts with
capitals & bases; late 13c; much restored; il Kelke,
opp. p. 9. [Pevsner; RCHM 1; VCH 3]

BEACONSFIELD, St Mary & All Saints or All Saints
?ESp/tomb; canopied table tomb of Purbeck marble in N
chancel; shields in paneling on chest; slab has indent
of shield; 2 round columns at front support cusped
4-centered arch of canopy, flat-topped with cornice;
recess, lined with Purbeck marble, has paneling on
sides & back, indents of brasses: man in armor &
woman in butterfly headdress, both kneeling; sons
with him & daughters with her; above these another
indent, possibly Trinity or Virgin & Child; late 15c;
tomb of ?Jn Butler (d. 1477); il RCHM 1, p. xxiv.
[Pevsner; VCH 3]

BIERTON, St James
?ESp; rather large niche in N wall of chancel; molded
jambs & trefoiled head; early 14c. [RCHM 1; VCH 2]

BLEDLOW, Holy Trinity
?ESp; small trefoiled niche low in N chancel wall; 15c; probably copy of 13c piscina opposite; now contains brass of Wm Herne (d. 1525) as priest in chasuble. [RCHM 1; VCH 2]

BLETCHLEY, St Mary
?ESp; small ogee-headed niche with rebated jambs in N chancel, W of door to N chapel; late 13c; at some point cut through to piscina in chapel; now blocked. [VCH 4]

CHALFONT ST GILES, St Giles
ESp/aumbry in N wall of chancel; formed of 13c arch found in wall in 1861-3 when modern vestry built; arch has 2-centered head & rebated jambs; 18c tomb slab forms base.
ESp ntd Comm inv 1552:
a olde clothe of sylke for the sepulker. [Clarke]

CHETWODE, SS Mary & Nicholas
?ESp; pointed recess in N wall of chancel E of chapel arch; recess has corbels carved as crowned heads; on back wall, foliage painted in red & yellow; 13c; nave & chancel formerly chancel of priory church; used as parish church from c.1480. [RCHM 2; VCH 4]

ETON, College, Chapel of St Mary
ESp* ntd reports of ESp watching by 3 or 4 elder scholars taking turns.
Also ntd audit rolls 1479:
Et iijs. iiijd. solutis Thomae Halle pro cetis instrumentis ferreis ponderantibus x li--pro sepulchro Domini erga diem Parasceve. [A. S. Barnes]

GREAT MARLOW, All Saints
Brass, no longer extant, part of tomb and ?ESp*, to 4 sons of Sir Jn & Dame Joan Salesbury (d. 1383-8); Resurrection above with kneeling sons, shield, & symbols of Evangelists below; 14c; rubbings in Craven Ord Collection at British Museum & Franks Collection, Society of Antiquaries. [VCH 3]

HADDENHAM, St Mary
?ESp; large rectangular recess in E wall of chancel flanked by smaller recesses with arched heads; date uncertain. [RCHM 1; VCH 2]

HAMBLEDEN, St Mary
?ESp/tomb; recess in N wall of chancel; flat 4-centered arch under square head with carved spandrels; in

recess, table tomb with 3 front panels containing
shields in cusped quatrefoils; both tomb & recess of
gray limestone; back of recess, also panelled, has
inscriptions: "Liberaeme Domine de Morte Aeternae";
"I believe in the resurrection of life/ To see you again
at the last day/ And now farewell Elizabeth my wife/
Teach my three children God to obeye." VCH 3 sug-
gests this may be tomb of Henry (d. c.1555), son of
2nd Lord Sandys. [Pevsner; RCHM 1]

HAVERSHAM, St Mary
?ESp/tomb against N wall of chancel; canopied table
tomb with effigy of woman, possibly Lady Clinton (d.
1423); S side of tomb chest has 6 trefoiled panels, 2
in middle with figs of male weepers & other 4 with
angels; molded edge of slab has roses, one above each
fig; tomb & effigy of alabaster; stone canopy has
pointed arch with crockets & finial; back wall of re-
cess carved with cinquefoiled panels flanking niche in
center also cinquefoiled & elaborately carved; Lady
Clinton asked to be buried before image of BVM, so
this niche may be for statue or for use in Easter ritu-
al; late 14c; il Kelke, opp. p. 14. [RCHM 2; VCH 4]

HIGH WYCOMBE, All Saints
ESp* ntd inv 1475:
A staynid clothe of gold powderid with gold & sylver
for the sepulcur with a lynnyn clothe therto. A
sepulcur of Tymber with a stole therto.
Inv 1503:
Item ij sepulcre clothis leyd with gold & sylver.
[Eeles, Bu; Jn Parker]

IVINGHOE, St Mary Virgin
?ESp/tomb; recess, approximately 7' in length, low in N
wall of chancel, has pointed arch & cinquefoiled,
subcusped head; hood mold of arch rests on head
stops; some restoration; contains priest effigy; 15c;
il engraving Anon., "Ivinghoe," opp. p. 77. [RCHM
2; VCH 3]

KINGSEY, St Nicholas
ESp* ntd Comm inv 1552:
a sepullcre clothe. [Eeles, Bu]

LILLINGSTONE DAYRELL, St Nicholas
?ESp; long recess (over 6') in N wall of chancel W of
Win N2; under one depressed arch, 2 arches spring
from corbel in center rather than shaft, with result
that recess not subdivided; this design, which looks
clumsy, may have facilitated use of recess as deposi-
tory for life-sized fig of Christ in Easter rites or for

corpse in funeral services; workmanship rough;
late 13c. **Fig. 31.**

LITTLE MISSENDEN, St John Baptist
?ESp/tomb; recessed tomb in N wall of N chapel has
moldings painted red & yellow; arch, with back wall
painted greenish-blue, frames fig of Christ in red
mantle & with white cross displaying wounds in uplifted
hands; Christ seated on white throne; mid 14c. [Mee,
Bu; Pevsner]

LITTLE WOOLSTONE, Holy Trinity
ESp* ntd chantry certificate 1545:
A quiet rent going oute of a tenement and certeine
landes of John Warrens geven for the mainteinyng of
the sepulchre light within the saide parishe worth by
yere--xijd. [Eeles, *Bu*]

MEDMENHAM, SS Peter & Paul
ESp* ntd 1537 inv:
a sepulchre cloth. [Plaisted]

MONKS RISBROUGH, St Dunstan
ESp* ntd Comm inv 1552:
Item ij paynted clothes for the sepulcher. [Eeles, *Bu*]

NEWNTON LONGVILLE, St Faith
?ESp/aumbry; large, oak-lined locker low in N wall of
chancel; original oak doors; 15c. [RCHM 2; VCH 4]

OLNEY, SS Peter & Paul
?ESp; shallow recess in N wall of chancel, partly under
Win N2, contains tomb chest carved on front with
quatrefoil panels; recess has molded jambs & pointed
head; outer molding ends at either side in head stops,
both of women, one young & one old; 14c. **Fig. 33.**

QUAINTON, Holy Cross & St Mary
ESp* ntd Chantry Certificate 1545:
A rent goinge oute of certeine landes of the
auncestres of one Taillour geven for maintenyng of ij
tapers before the sepulchre within the said parishe
worth by yere--iij pounde of wax. [Eeles, *Bu*]

SOULBURY, All Saints
?ESp/tomb; recess low in N wall of chancel beneath Win
N2 has molded ogee head; early 14c; finial modern.
[Pevsner; RCHM 2; VCH 3]

STOKE POGES, St Giles
?ESp/tomb; recess in N wall of chancel, between vestry

doorway & blocked 12c window; 2-centered arch with crockets & finials; flanked by pilasters & pinnacles with finials; mid 14c. [RCHM 1; VCH 3]

STOKENCHURCH, SS Peter & Paul
?ESp/aumbry; 14c recess with rebated jambs in N wall of chancel; trefoiled ogee head added in 15c suggests conversion to ESp. [RCHM 1; VCH 3]

SWANBOURNE, St Swithin
ESp* ntd Comm inv 1552:
a sepulchre solde to the reparacon of the seytes in the churche [entry struck through]. [Eeles, *Bu*]

TOWERSEY, St Catherine
?ESp; small recess in N wall of chancel; height 11" x width 8" x depth 5". [Lee]

WESTON TURVILLE, St Mary
?ESp*; fragments of sculpture, now built into S chancel wall, may be from ESp; include 2 blocks, each 17" in height x 12" in width & each with fig of soldier 13" in height; one sheathing sword, other raising one; defaced; 12-13c; il drawings, Isham, figs. 2 & 3. [RCHM 1; VCH 2]

WEXHAM, St Mary
ESp* ntd Comm inv 1552:
a sepolker clothe of lenande. [Eeles, *Bu*]

WING, All Saints
ESp* ntd inv 1527:
Item a pavlle for the Sepulcher off brauncheyde worke.
Item a gyrdeyll off neiddle worke for the sepulcher. [Loyd]
Churchwardens' accts 1527:
Item Reseuyd of thomas Wynchester & Wyllyam hause lytemen to the blesyd sepulkur lytte xs.
1528:
Item receuyed of Wyllyam lukase & Rafe a burro lyghtmen to the blessed sepulkur ixs.
1529:
Item Reseuyd of thomas Sandurs & Roberd Korker lytemen to the blessyde Sepvlkur xijs. iiijd. ob.
Item payde for mendyng of the sepvlkur vid. [Loyd]
1532:
Memorandum there remaynyth in the hands of Robert Hythe and Robert Skrowgges lxxxiii li. of wexe of the Sepulker lyte, to be delyveryd the thursday next before palm Sonday next ensuyng to the Chyrchwardeyns aforesayde.

1541:
Item, reseyved of the sepulker alle xxs. iiiid. ob.
1542:
Item, for the sepoulker ale xxs. vd.
1553:
Item payde to Edwarde Warde for makyng of the frame
about the sepulcre xd.
1554:
Recevyde of Thomas Bennet for the sepulcre ale for
the last yere xxiis.
Item payde for makynge of the sepulcre xd.
1555:
Received of burcot for sepulcre ale viiis. vd.
Recevyd of Wynge for the sepulcre ale xvis. iiiid.
Received of Ascot for the sepulcre ale xvis. viiid.
Item payde to ye sexten for makynge of a laddre, &
for breade & ale for watchynge of the sepulcre xiid.
[Ouvry]

WOUGHTON-ON-THE-GREEN, St Mary
 ?ESp/tomb; recess at E end of N wall of chancel; molded
 ogee arch with 2 heads in imposts, one of knight in
 mail; effigy of priest in recess, but slab beneath
 carved with tracery; 14c. [RCHM 2; VCH 4]

CAMBRIDGESHIRE (Cs)

BARTON, St Peter
 ?ESp/aumbry; rectangular recess rebated for door
 under Win N2; c.1300. [RCHM 1]

BASSINGBOURNE, SS Peter & Paul
 ?ESp/aumbry in chancel; 14c. [Evelyn-White; VCH 8]
 ESp ntd 1518 will of Sir Jn Hubard, priest of Trinity
 Guild in Bassingbourne:
 for the hearse tapers, & for 4 tapers of the rood &
 sepulchre lights 3s. 4d. [W. M. Palmer, "Village
 Gilds"]

BOTTISHAM, Holy Trinity or Holy Cross or St Mary
 ESp* ntd 1569 sale of forfeited lands by Eliz I; one &
 1/2 acre in Bottisham sold that had been given to
 support ESp light. [W. M. Palmer, "Village Gilds"]

BURWELL, St Mary
 ?ESp; brass, possibly of Jn Lawrence de Wardeboys,
 last abbot of Ramsey (d. 1542); palimpsest; original,
 made during lifetime of abbot, showed man in full
 pontificals; after suppression of abbey in 1539, brass

reversed; new image shows priest in cassock & sur-
plice; finial of canopy over priest supports Resurrec-
tion of Man of Sorrows type: half-length Christ in
tomb wearing crown of thorns within halo; L hand
raised in ?blessing; R hand indicates ?wound in side;
brass now on floor of chancel; original location un-
known; iconography suggests possible association with
ESp; il RCHM 2, Pl. 43, obverse & reverse of brass;
Pl. 44, detail of Resurrection. [Pevsner; Heales,
"ESp"]
?ESp; niche with finial N of Win 1 in mid-15c chancel.
?ESp; crypt with altar recess below chancel & ap-
proached by flight of stairs on N of chancel possibly
associated with ESp. [RCHM 2]
ESp ntd 1569 sale of forfeited lands by Eliz I:
1/2 acre sold that had been given by Rich Hancock for
maintaining of ESp light. [W. M. Palmer, "Village
Gilds"]

CAMBRIDGE, Christ's College Chapel
ESp ntd college accts:
The ymage of Christe's ressurrection . . . with the
iiii. knyghtes and the sepulchre.
ESp found c.1896; described as cupboard-like recep-
tacle with figs representing Christ's Resurrection,
angels, & sleeping soldiers. [Jos Barker]

CAMBRIDGE, Great St Mary
ESp/tomb; table tomb in N wall of chancel possibly for
Sir Jn de Cantebrig (d. 1335) as indicated by 1361
will of Tho, son of Sir Jn, leaving money to high altar
on condition that he be buried in chancel near his
father; no effigy or inscription; chancel & tomb re-
stored 1857. [Bushell; Sandars]
ESp ntd 1511 inv:
Bona dicte Ecclesie in Custodia Johannis Nele.
Item the ymage of Jhesus for the Resurreccion.
1515-6:
In officio Gardianorum luminum sepulcri Johannem
Martyn [&] Robertum Cobbe
Item of Robert Smyth wexchaundeler & william fflory
wardeyns of the sepulcre & Roode lightes for v yers
Resceytes of the same in a grose summe xliijs. iijd.
[To 1534, accts regularly record election of 2 wardens
for ESp light & handing over to churchwardens of
sums collected by them.]
1523:
vij. li wex payed to the sepulcre lighte.
1535:
The receytes by the Masters of the supolkars lyght
Nycolas prime & Arther leche
In primis for the qwartereges xxiijs.

receyvyd for the doreges xjs. xjd.
receyvyd at ester of the hoslyng pepole xijs. xjd.
receyvyd of the drynkers of at the makyng of the
lyght xd.

Sum xlixs. vd.

The allouans of ther expences
Inprimis for wax & the makyng xxiijs. vd.
Item for the expenses at the makyng iijs. vjd.
Item for Jhons cappers wages ijs.

Sum xxviiijs. xjd.

Soo remaynyth xxs. vjd. whych payd the day and
yere above wrytton
1536:
Inprimis payed for a peece of Tymber for the sepulcer
xd.
Item payed for Sawyng of the same Tymber ijd.
Item payed to the yoyner for workyng of the Tymber
in the sepulcer xiijd.
Item payed To Thomas Grene for payntyng the
sepulcer xijd.
1537:
Thaccompt of Mr. John pykerell & william Gryffyn
wardeyns of the Sepulcre lyght
In primis they Chargyn ther sylffes with Resceytes for
Dyrrygies this yer as apperith by a bill seen &
Examyned xiiijs. xd.
Item they also haue Resceyued for quarterages of the
parochianers for the Roode lyght as also apperith by a
byll seen & examyned xxiiijs. viijd. ob.
Item they also haue Resceyued of the people that were
hosylled atte Ester as also apperith by a byll sen &
Examyned xiijs. viijd.
Summa totales Recepte liijs. jd. ob. vnde petunt
allocari
Item payed for xxxv li. wex for the sepulcre & the
Roode lightes price of a li. vijd. ob. summa xxjs. xd.
ob.
Item payd for the makyng of the sayd Wex vs.
Item payed for a Dyner at the makyng of the sayd wex
ijs. iijd. ob.
Item payed to John Capper ffor settyng vp the hyrst
& kepyng of the Sepulcre lyght ijs.
Summa totalis allocationis xxxjs. ijd.
Et sic in arreragiis Et remanet in manibus suis xxijs.
Quos soluerunt pre manibus
Summa totalis Recepte tam pro Gardianis Ecclesie quam
pro Gardianis luminis sancti Sepulcri xxxvs. ob. vnde
deductis pro Reparacione veteris ffenystre xvs.
Et sic Remanet Ecclesie in Clara pecunia xxs.
Item for Mendyng of the vice for the Resurrexcion

iiijd.
[Similarly full accts follow for most years until 1548.]
1539:
In primis payed to Mr. Rust for xxxi li wex & the
makyng all the yere xviijs. vijd.
Item at dyner at the makyng of the wex xvjd.
Item to John Capper for wachyng the sepulcre & hys
meate ijs. xd.
Item for holye ijd.
Item for pynnes spent abought the sepulcre ob.
1540:
Item to John Capper for watchyng of ye sepulker &
settyng up & takyng downe of the same ijs.
Item for hys meat & drynke xd.
1543:
Item for makyng of the vyce of the sepulcre xiiijd.
1551:
Item sold wylliam borwell ij deskt clothes of blew
chamblet & j vallantes yat was of ye sepulter xjs.
Item sold ye clothe yat went over ye quyer in lent &
iij paynted clothes yat was of ye sepulter to Mr. veysy
vjs.
1554:
and for Masters of ye sepullter lyght & Rood lyght
accordyng to ye old costom of ye parysh william grey
[&] peter shers.
Item payd for colles for wechyne of ye Sepulker iijd.
1555:
Item for clothes for the sepulker gyven by mr. Rust
[blank]
Reseyved of the sepulcar lyght xjs. ijd.
1556:
And for the Masters of ye sepulcer lytt & Rood lytte a
cordyng to the olde custome of ye paryche petter
sheres & william graye.
[Inventory:]
Item a frame to the Sepulcar with clothes to the same.
1557:
coles for watcheing ye sepulcre iijd.
1558:
The Masters of ye Roode lyght and ye sepulcar lyght
wylliam gylbert [&] Jorge Jugge. [J. E. Foster]

CAMBRIDGE, Holy Trinity
ESp; niche in N wall of chancel. [Evelyn-White]
ESp ntd churchwardens' accts 1507-8:
To a warkeman for makyng of a Cofer to the Sepulcur
vjs. viijd.
Item paied to Richard Rolfe for two waynskottes to the
same Cofer iijd.
Item paied to George Foyster for nailes and claspys to
the same Cofer iijd.

To the clerk for kepyng of the sepulcr light ijs.
1514-5:
The sepulkyr lyght weyd when yt was taken down
nyne skorre and xviij pound the vij yere of King
Henre viijth. [J. Cox, *Churchwardens' Accts*]

CASTLE-CAMPS, All Saints
ESp* ntd 1552 inv:
a cloth for the Sepulker. [Muskett, "Cs Church
Goods"]

CHAŤTERIS, SS Peter & Paul
ESp* ntd guild certificate 1389 stating Guild of Holy
Trinity (founded 1346-7) had responsibility for 30
tapers of 2 lb. each to burn:
before the sepulchre from the ninth hour of the day
which is called Good Friday, until the morning of
Easter day, the time of the resurrection of our Lord.
[W. M. Palmer, "Village Gilds"]

CHESTERTON, St Andrew
?ESp; small, square opening between chancel & (N)
sacristy; when discovered had socket, so that it could
be stopped; quatrefoil on inner side. [Evelyn-White]
ESp ntd guild certificate 1389 for Guild of Resurrec-
tion:
Quiquidem aldermannus fratres et sorores de bonis
dicti gilde a deo collatis ob reverentiam et honorem
resurrectionis predicti dederunt ad fabricandum unum
novum sepulchrum pro eadem resurrectione in ecclesia
predicta x li.
Also ntd reply of curate & churchwardens to Comm in-
quiry regarding guilds ?1546:
the revenues and profytts of the lands conteyned in
the saide Rentall be converted and employed to the
Releve of the poor peple of the saide parishe, and to
the kepinge of a light about the sepulcre. [W. M.
Palmer, "Village Gilds"]

CHEVELEY, St Mary & Holy Host
ESp* ntd 1457 will of Jn Sybly:
Item lego Sepulturam domini nostri Jhesu Christi ij
modii frumenti et iiij modii brasii.
Also ntd 1491 will of Wm Sybely:
Also I beqwythe . . . to ye Sepulcer j combe wete and
on combe malte. And I wyll that the seyd Jone my
wyff have duryng hyr lyffe iiij shepe ffor to fynde a
leyght a besight ye Sepulcer and after hyr desease I
wyll that the seyd iiij shepe shall for aye remayne with
ye chyrche garde of Chevele beforseyd for the tyme
shall be to ffynde a lyght; and I wyll that who soever

from hencefothe shall occupie of the seyd place which
was mine fadyers have iiij shepe goyng within ye seyd
place to ffynde a lyght a besight ye Sepulcre in ye
chyrche beforseyd for my modyr with outen ende.
Also ntd will of Jn Norbery:
Ye Sepulcre lyghte, iij wetherys ffor to ffynde a
tapyre. [Bennet]

ELSWORTH, Holy Trinity
?ESp; 2 recesses; one in chancel at E end of N wall;
other at N end of E wall; each has stone shelf under
depressed head; chancel 14c. [RCHM 1]

ELY, Cathedral, SS Peter & Etheldreda (now Sacred & Un-
divided Trinity)
ESp ntd inv 20 Nov 1540, mentioning red pall for ESp;
Bishop Alcock's Chantry Chapel, in NE corner of ca-
thedral, suitable for use as ESp, begun in 1488; Al-
cock d. 1501; carved in clunch, entire chantry has
lavish decoration in Perp style, including fan vaulted
ceiling; bishop buried beneath floor, but has monu-
ment on N wall which Pevsner describes as "high up,
with the top of the tomb chest below left vacant, as if
for an Easter Sepulchre." Alcock's device, cock stand-
ing on globe, appears frequently in decoration & could
be interpreted as reference to Resurrection as well.
Fig. 53.

FOWLMERE (FOULMIRE), All Saints
?ESp*; monument in N wall of chancel for Wm Mitchell
(d. 1745) replaced earlier monument, perhaps ESp.
[VCH 8]

GRANTCHESTER, SS Mary & Andrew
?ESp/tomb recess low in N chancel wall under NE win-
dow (Win N2); ogee arch has deep moldings; 1350-
1400; il RCHM 1, Pl. 71. [Evelyn-White; Pevsner]

GREAT EVERSDEN, St Mary
ESp* ntd 1521 will of Jn Curtis:
I bequeath one cow to the sustentation of one taper to
burn yearly before the sepulchre in the said church,
and I will that my executors make the aforesaid taper
of wax containing two pounds, and I will the aforesaid
cow remain in the hands of my children so long as it
pleaseth God they live, and so save the stock and so
to leave it in the churchwardens' hands, and they for
to do the same perpetually. [W. M. Palmer, "Village
Gilds"]

HADDENHAM, Holy Trinity
?ESp/tomb; recess in N wall of chancel has trefoiled

arch with crocketed canopy & pinnacles; squint at
back opens into vestry; 13c. [Evelyn-White; VCH 4]

HASLINGFIELD, All Saints
ESp* ntd 15c will of Jn Sterkyn:
to the light of the Holy Sepulchre 3s. 4d. [Feasey,
"ESp"]
Also ntd 1519 will of Jn Arkin leaving 10s. to make a
new ESp. [W. M. Palmer, "Village Gilds"]

HILDERSHAM, Holy Trinity
ESp/tomb; chest tomb in recess low in N wall of chan-
cel; canopy has rich moldings & crocketing; 14c.
[Evelyn-White; Pevsner]
ESp ntd Comm inv 1552:
one sepulker cloth. [Muskett, "Cs Church Goods"]

ISLEHAM, St Andrew
?ESp/tomb; recess in N wall of chancel; 4-centered arch
with leafy carving in spandrels of crocketed canopy;
contains tomb chest with brasses to Tho Peyton (d.
1484) in armor & with canopy & 2 wives, Margaret
Bernard & Margaret Francis, all with inscriptions;
brasses, 23" in height; 15c. [Evelyn-White; Pevsner]

KINGSTON, All Saints & St Andrew
?ESp; arched recess, consisting of 2 arches meeting at
central corbel, in western half of N wall of chancel;
western arch contains trefoil-headed low-side window,
blocked; 13c. [RCHM 1]

LANDBEACH, All Saints
ESp* notd wills of Jn Lane (1518), Tho Lane (1519), &
Edw Lane (1530), who contributed to sepulchre light.
[Clay, Landbeach]

MELBOURNE, All Saints
?ESp/aumbry; small rectangular recess in N wall of
chancel E of doorway; rebated; il A. H. Lloyd, Pl. IIa.

MILTON, All Saints
ESp* ntd 1521 will of Rose Cokh:
to the churchwardens of Milton an acre of land for
ever to pay yearly to the sepulchre light jd.
Also ntd 1538 will of Wm Edwards:
to the sepulchre light ij bushels of barley. [Clay,
Milton]

PAPWORTH ST. AGNES, St John Baptist
ESp* ntd Comm inv 1552:
one Sepulter clothe. [Muskett, "Cs Church Goods"]

SHEPRETH, All Saints
?ESp/sacrament house* ntd churchwardens' bills or
returns for Michaelmas 1554:
a canebe for ye sacrement sepulcher. [W. M. Palmer,
"Barton"]

SHUDY CAMPS, St Mary
ESp* ntd Comm inv 1552:
Item one clothe yat went about the sepulchre. [Mus-
kett, "Cs Church Goods"]

SNAILWELL, St Peter
?ESp/tomb; recess in N wall of chancel; cusped &
crocketed ogee arch & pinnacles; contains tomb chest;
?14c. [Pevsner]

STETCHWORTH, St Peter
ESp* ntd will of Tho Burrell, 18 Nov 1559:
My boddie to be buried in the holly sepulcre in the
churche of Sainte Peeter of Stetchwourthe. [Heales,
"ESp"]

STRETHAM, St James
?ESp/tomb; recess with steeply pointed arch low in N
wall of chancel W of aumbry; contains tomb lid in-
scribed to Nich de Kingston, rector in late 13c; recess
early 14c. [VCH 4]

TEVERSHAM, All Saints
ESp* ntd 1522 will of Robt Battell leaving money to
lights of All Saints, ESp, Our Lady, & Sacrament. [W.
M. Palmer, "Village Gilds"]

WATERBEACH, St John Baptist or St John
ESp* ntd 1509 will of Henry Lane leaving 3s. 4d. to ESp
light.
Also ntd 1522 will of Jn Warde, vicar:
for to make iiij great tapers of iiij li. a pece for the
Sepulcre this yere in Beche, xiijs. iiijd: the hangings
of [my] bed to the saide Sepulchre.
Ntd 1533-4 will of Wm Rolff, husbandman:
to the reparacons of the bells and to the Sepulchre
lyght a cowe and calfe each. [Clay, *Waterbeach*]

WEST WICKHAM, St Mary
ESp* ntd Comm inv 1552:
one Shete for the Sepulker. [Muskett, "Cs Church
Goods"]

WHITTLESEY, St Mary
?ESp/aumbry; plain rectangular recess in N wall of
chancel; 14-15c. [VCH 4]

WILLINGHAM, St Mary & All Saints
?ESp/tomb; recess in N wall of chancel; molding hacked off prior to restoration of 1890's. [Watkins]

CHESHIRE (Chs)

BUNBURY, St Boniface
?ESp/tomb; ogee-headed recess in N wall of chancel; head of recess has continuous molding, no crocketing or finial; recess flanked by crocketed pinnacles; Dec; end of 14c. [Crossley, "14c"; Glynne, Chs]

CHESTER, Holy Trinity
ESp* ntd churchwardens' accts 1535 (28 March): received of mr. bomvell of the gift of his wife a fyne napkyn of Calico cloth trelyd with silk to Cover the Crosse in ye sepulcre.
1545-6 (25 April):
for pyns & thred to make the sepulcre ijd.
1552-3 (2 April):
to the clarke for wachinge the sepulcre ixd.
1554-5 (14 April):
to the clarke for washinge the Sepulcre 4d.
1555-6 (5 April):
for wachinge the sepulcre one night to the clarke iijd.
for charcole & franconsens agaynst ester: for dressinge the sepulcure & after in herrage ijd. for takinge downe the clothes about the sepulcar ijd.
1556-7 (18 April):
for nayles & pynns at seurall tymes for the sepulcar & Alter clothes etc.
for Settinge vp & takinge downe the sepulcar 4d.
for francomsence & charcole agaynst easter 4d.
watching the sepulcar 2 nightes 4d.
payd a wright for a frame for lightes vnto the Sepulcre 4d.
1557-8 (10 April):
for wyer candles wax candles etc. Scouring candlesticks wachinge the Sepulcre at Ester etc.
1558-9 (26 March):
for wax to make tapers 18d wachinge the Sepulcre at ester viijd. [Beresford; Clopper; MacLean, Chester]

CHESTER, St John
ESp* ntd 1518 will of Nich Deykyn who left his best bed covering:
to be hanged about the Easter sepulchre there.
[MacLean, Chester]

CHESTER, St Mary-on-the-Hill
ESp* ntd churchwardens' accts 1536 (16 April):

Item payd for naylys pynes and [the thred] Thred to
Heng the sepulcur ijd.
1536-7 (1 April):
Item for naylis thred And pynnys Agaynist Ester jd ob.
1537-8 (21 April):
Item for Naylis & pynnys to the sepulcer jd.
1538-9:
Item for naylis & pynnis to the sepulcer jd.
1539-40 (28 March):
Item paide for pynnys & naylis to the sepulcur jd. ob.
1540-1 (17 April):
Item for pyns & nayles to the sepulcre jd.
1541-2 (9 April):
Item to Richard leche for make the sepulcre lightes xd.
1546-7 (10 April):
Item payde for ij burdes to mend the sepulcher. [Clop-
per; MacLean, *Chester*]

CHESTER, St Michael
ESp* ntd inv 1560:
Item a fframe [of] yat was the sepultere.
1560-1:
Item a fframe yat was the sepulkar.
1562-3:
Item a frame that was the sepulcre.
1563-4:
Ittem a frame that was the Sepulchre.
1598-9:
Item a table & a frame. [Clopper; MacLean, *Chester*]

CHESTER, St Olave
ESp* ntd will of Margaret Hawarden of Chester proved 17
Jan 1521:
Item, unto the parish churche of Saynt Olave a small
flaxen shete ij towells of twill for the sepultur in tyme
of Estur. [Piccope]

CHESTER, White Friars
ESp* ntd inv of goods in vestry made at Dissolution:
A cloth for ye sepulchre. [MacLean, *Chester*]

OVER (near WINSFORD), St Chad
?ESp/tomb; tomb chest under flat arch in N chancel;
chest & canopy both of white stone; slab of dark
polished marble has brass of Hugh Starkey, who rebuilt
church c.1543; brass, 39" in length, shows Starkey in
ornamental plate armor over mail shirt; he has sword &
dagger & wears spurs; head with long hair rests on
helmet; grass & flowers beneath feet; brass surrounded
by brass shields at corners & inscription: "Off your
charite pray for the soule of Hugh Starky of Olton,
esquier, gentilman usher [to] Kyng Henry ye VIII and

son to Hugh Starky of Olton esquier which Hugh ye son decessyd the yere of our lord God Mvo . . . on his soule Ihesu haue mercy"; Starkey died 1577; date of death never filled in; back of recess has initials "H. S." & "et Gloria Soli Deo Honor"; triangular crocketed canopy; c.1543; il Crossley, "Effigies," Pl. 45; brass il Angus-Butterworth, Pl. xix. [Glynne, *Chs*; Pevsner]

PRESTBURY, St Peter
?ESp/founder's tomb in N wall of chancel; 14c.
[Crossley, "14c"]

STOCKPORT, St Mary
?ESp/tomb; recess with flattened arch in N wall of chancel; underside of arch paneled; 15c or 16c; restored & recarved in 1689 by Edward Warren as memorial to himself & his wife, as initials E. M. W. on scroll in center of arch indicate; effigy of Rich de Vernon placed there late in 19c; recess 8' in length, 18" in depth; 5'6" in height; 7'6" from floor to top; il *LaCsAnt*, 32 (1914), frontispiece. [Brickhill]

CORNWALL (Co)

CARDINHAM, St Mewbred
?ESp; tomb recess low in N wall of chancel; 13c.
[Pevsner]

DUNHEVED, Chapel of St Mary Magdalene
ESp* ntd borough accts under church costs 1477-8:
for making of le sepulchre 2d.
nails & expenses about the same 1 1/2d.
1479-80:
for making of a sepulchre 2d. [Peter & Peter]

NORTH HILL, St Torney
?ESp; crocketed ogee niche in N wall of chancel; much restored; 14c. [Pevsner]

ST. IVES, St Ia
?ESp/tomb; recess in N wall of chancel holds chest tomb; piscina & triple sedilia in same style; Dec; late 14c-early 15c. [Brickhill; Pevsner]

STRATTON, St Andrew
ESp* ntd churchwardens' accts 1514:
Paid for a cord for the sepulcher cloth jd.
1530:
payd for makyn of a frame to sett tapers yn afore the sepulker xijd.

1551:
Ressevyd of Nicholas yeo for the great sepulcre clothe
iiijs.
1554:
paid for corde to hang the sepulcar jd.
1558:
[paid] for poyntes yn makyn vp of the sepulker jd.
1559:
[paid] for poyntes & pynnes yn maken of the sepulker
jd.
payd to the aforesayd John drome for maken of the
sepulker ijd. [Peacock, "Stratton"]

CUMBERLAND (Cu)

BROMFIELD, St Mungo
?ESp; tomb recess in N wall of chancel; contains 17c
tomb chest. [Pevsner]

CARLISLE, Cathedral, St Mary (now Holy Trinity)
ESp possibly to be identified with double tomb recess in
N chancel aisle; segmental arch decorated with thorns
or short branch stumps; one recess contains mid 13c
effigy of bishop moved to this location in restoration of
1856, other empty; il Ferguson, opp. p. 259. [Pevsner;
VCH 2]
ESp ntd will of Wm Barrow, bishop of Carlisle, 1 Sept
1429:
Item, lego ecclesie cathedrale Beate Marie Karleoli unam
ymaginem resurreccionis de argento. [J. W. Clay]

LANERCOST, St Mary's Priory (Augustinian Canons)
ESp; plain tomb chest at E end of N wall of chancel;
another canopied tomb chest paneled with coats of arms;
canopy has segmental head with dog-tooth molding;
Perp. [Pevsner]

DERBYSHIRE (Db)

ASHBOURNE, St Oswald
?ESp/tomb; recess with broad ogee arch & crocketed pin-
nacles in N wall of chancel opposite sedilia; inscription
on slab in tomb disappeared in 19c; said to be tomb of
Robert de Kniveton (d. 1471). [J. Cox, Notes Db 2]

ASHOVER, All Saints
?ESp; 2 large, shallow recesses in N wall of chancel;
each with ogee arch; each about 6' in width & 5' in

height; one or both ?ESp; brackets in center of each
may have held sculpture or had some other function in
Easter ritual, such as supporting lights; brackets 18"
in length, project about 6"; ?14c. [J. Cox, *Notes Db* 1]

BARLOW, St Lawrence
?ESp; alabaster slab from tomb chest that once stood in
NE corner of chancel; slab incised with life-sized figs
of man in plate armor & woman in horned headdress,
gown, & mantle; border inscription names Robt Barley
(d. 1467) & wife Margaret; original location & flatness
of tomb top suggest dual use as tomb & ESp. [J. Cox,
Notes Db 1]

BONSALL, St James Apostle
ESp* ntd Comm inv 1552:
j candylstycke of yrne afore ye sepulchre. [Walcott,
"Church Goods Db"]

BOYLESTONE, St John Baptist
?ESp/ founder's tomb; arched recess in N wall of chan-
cel; possibly intended for monument to Walter de
Waldeshef, who rebuilt church, but apparently never
contained effigy; 14c. [J. Cox, *Notes Db* 3]

DERBY, All Saints
ESp* ntd inv 1465:
Item one veyle for lente. And one Sepulcre clothe with
one Crisom cloth wroght with ye nylde to henge att
the hoele of ye said sepulcre clothe.
Item one Resurreccon.
Sepulcur serges
In primis one Sepulcre Serge upholden by John Hardyng
And after upholden and kepte by Richerde Stryngar.
[7 more "serges" listed before final entry.]
And lyke wyse of oder sepulcre serges sustened of
charite by oder of the parishe whose names shulde
lykewyse be here expressed botte that som wyked
creature hath kytte the lefe furthe of the olde boke.
Inv 1483:
Sepulcre serges
[26 lights listed, each supported by an individual.]
[Cox & Hope]

DOVERIDGE, St Cuthbert
?ESp/tomb; arched recess near 2 square aumbries in N
wall of chancel. [J. Cox, *Notes Db* 3]

DUFFIELD, St Alkmund
?ESp/ founder's tomb; broad, low ogee-arched recess
with finial in N wall of chancel; blocked up until
c.1850, when stone coffin was found beneath it. [J.

Cox, *Notes Db* 3; Pevsner]

ETWALL, St Helen
?ESp/tomb; stone tomb chest under arched opening from chancel to Port Chapel (N aisle); slab has remains of brasses of Sir Jn Port & his 2 wives: Jane (Fitzherbert) & Margaret (Trafford); c.1527. [Jeavons]

FINDERN, All Saints
?ESp*; recess for founder's tomb in N wall of chancel; contained priest's effigy, not made for it; recess, which had been blocked up, found when church was pulled down in 1862. [J. Cox, *Notes Db* 4]

HATHERSAGE, St Michael
?ESp/tomb in N chancel; chest under canopy; top of chest has brasses of Robt Eyre (d. 1459), wife Joan (d. 1463), & 14 children; Cox describes man as "bareheaded, with his hair cropped close, in plate armour, having a gorget of chain mail covering the throat, armed with a long sword suspended diagonally in front of the body and a dagger, and having a lion under his feet." Woman "wears a double-peaked head dress with falling lappets, and a close-fitting gown trimmed with fur at neck and wrists." Recess with ogee arch and tracery may date from restoration in 1852. [J. Cox, *Notes Db* 2; Pevsner]

LONGFORD, St Chad
?ESp; arched recess low in N wall of chancel; contains effigy of ecclesiastic; 14c. [J. Cox, *Notes Db* 3; Pevsner]

RISLEY, All Saints
ESp* ntd 1504 will of Walt Etun leaving 4d. to ESp light; also 1506 will of Jn Fyshe leaving 4d. to ESp light. [Bell]
Ntd 1509 will of Wm Gamman leaving 6s. to making of ESp & 6s. to "pantyng" of same; 1512 will of Simon Sakwyle leaving 3s. 4d. to ESp; 1517 will of Tho Bromald leaving 4d. to ESp light; 1518 will of Robt Percell leaving 6s. 8d. to ESp; 1519 will of Wm Lord leaving 8d. to ESp. [Cirket]

SAWLEY, All Saints
?ESp; ogee-headed recess with crocketed pinnacles & finial in N wall of chancel between Win N2 & N3; contains tomb chest with brasses on top: Roger Boothe (d. 1467) wearing plate armor, his wife Katherine Hatton, 7 sons, & 10 daughters. [J. Cox, *Notes Db* 4; Pevsner]

SPONDON, St Werburgh (now St Mary)

?ESp/founder's tomb; low arched recess in N wall of
chancel between Win N2 & N3; 14c. [J. Cox, *Notes Db*
3; Pevsner]

STAVELEY, St John Baptist
?ESp; ogee-arched recess in N aisle; formerly in N wall
of nave; width 5' x height 5' at highest point; 2 flank-
ing buttresses with crocketed pinnacles each have small
figs in panels, one above the other; those on R, men,
one crowned & with shield & sword; on L, 2 women,
one with crowned headdress & book; back wall of recess
painted with nimbed fig of ?Christ flanked by angels
holding ?cloak; badly faded; if this is Resurrection,
then recess may well have been ESp, though location in
nave unusual; ?15c.
?ESp/table tomb in N chancel has flat top with brasses:
effigy of Peter Frecheville (d. 1503) in plate armor; 2
scrolls issuing from mouth read "Sta Trinitas unus Deus
miserere nobis," & "Deus propicius esto mihi peccatori."
Above, Throne of Grace type Trinity in brass; sides of
chest have traceried panels with brass shields; in wall
recess behind table tomb, brasses of Frecheville & wife
Matilda (Wortley) kneeling, 8 boys behind him, 7 girls
behind her; all face brass image, above them, of Virgin
& Child; inscription identifies Frecheville as "sume tyme
squier unto the noble and excellent prince King Henry
the VI. and lord and patron of this chirche." [J. Cox,
Notes Db 1; Jeavons; Pevsner]

TIDESWELL, St John Baptist
?ESp; 2 ogee-arched recesses project slightly from N
wall of chancel opposite sedilia; brass in front of one to
founder, Jn Fojambe (d. 1383); other probably used as
ESp; late 14c. [J. Cox, *Notes Db* 2; Pevsner]

WHITWELL, St Lawrence
?ESp; elaborately carved niche in N wall of chancel
opposite sedilia; much cusping & crocketing; style re-
miniscent of Hawton; 14c. [Pevsner]

DEVON (Dv)

ASHBURTON, St Andrew
ESp* ntd churchwardens' accts 1483-4:
Paid William Derte for mending the sepulchre 1d.
1491-2:
For gemeys & naylis to ye sepulker 6d.
I-paide to Richard Col . . . for makyng of the sepulker
5s. 9d.
1511-2:

paid for le sepilcur cloth 66s.
1512-3:
And with 34s. in the hands of Robert Erell besides 66s.
paid by him for le sepulcre cloth.
1537-8:
for a new cord and nails for le sepulcre against Easter
2 1/2d. [Hanham]

ASHTON, St Michael or St John Baptist
?ESp; wall painting on N wall of N (Lady) chapel; 3/4
fig of Christ crowned with thorns; behind him cross &
to his R Instruments of Passion: scourge, basin, lad-
der, spear, nails, pincers; R arm bent with hand
touching side; L hand holds spear & reed; scroll with-
out inscription near head; blank wall below suggests
possibility that temporary ESp, probably wooden,
erected here; 8' in height x 4' in width; black & white
on red ground, faded; 15c; il G. LeBlanc Smith, fig.
8. [Pevsner]

BERRY-POMEROY, St Mary
?ESp/founder's tomb; chest in N wall of chancel under
very depressed 4-centered arch; front of chest carved
with 2 bands of quatrefoils enclosing shields, 4 with
emblems of Passion; indents of brasses on back wall of
recess; canopy vaulted; above arch, course of vine
foliage & Tudor flower cresting; tomb of Sir Rich
Pomeroy (d. 1501) & wife. [Cornelius; Pevsner; Thomp-
son, "Church Arch in Devon"]

BISHOPS-NYMPTON, St Mary
?ESp/tomb; recess with depressed pointed arch under
square head in N wall of chancel; jambs & arch foli-
ated; tomb chest in recess carved with 2 rows of
quatrefoils; 15c; il Pevsner, Pl. 32.

DARTMOUTH, St Saviour
ESp* ntd churchwardens' accts 1494:
for Kepyng of the Sepultur, 12d.
1495:
watchyng of ye sepulker lyght, 10d.
1496:
twyne, pynnys and naylys abowt ye sepulker, 2d.
for waechyng of ye Sepulker lyght, 12d.
1497:
for naylis and pynnes for ye sepulker, 1 1/2d.
for wacchyng of ye Sepulker lyght, 12d.
1498:
for kepyng of ye sepulker lyght, 10d.
1499:
watching of ye sepulker lyght, 12d.
1500:

for watchyng of ye sepulker, 12d.
1503:
for the watchyng of the Sepultur, 12d.
1525:
Laurens [the sexton] for waisheyng of the sepulker,
1s.
1527:
for wacheyng of the sepulkur, 1s.
1528:
Laurens for waycheyng of the Sepulcre, 1s.
1529:
to Jelys mendyng of the sepulcre, 3d.
to Jelis for wacheyng of the Sepulcrowe, 1s.
1530:
settyng uppe of the sepulker, 2d.
for waycheyng of ye sepulker, 1s.
1531:
wacheyng of the sepulcrowe at Ester, 1s.
1532:
wacheyng of the Sepulcre, 1s.
1533:
wachyn of the sepulcure, 1s.
1534:
Laurens for dressyng upp of the sepulture, 2d.
1535:
Laurens Jamys for watchyng the sepulture at Ester, 1s.
1538:
for pynnes and nayls for the sepultur at Ester, 2d.
for settyng up of the coverletts about the sepulcre, 2d.
1539:
hanging up of the Coverletts and dressyng the
sepulchre, 3d.
pyns and nayls to same 3 1/2 d.
to Lawrens for watchyng of the sepulchre at Ester, 1s.
[Hugh R. Watkin]

DENBURY, St Mary
ESp* ntd accts of receivers of Court of Augmentations
1547-9 indicating annual income of 8d. for ESp light &
name of Jesus. [Orme]

EAST OGWELL, St Bartholomew
ESp* ntd accts of receivers of Court of Augmentations
1547-9 indicating annual income of 9s. for obit & candle
burning before ESp at Easter. [Orme]

EXETER, Cathedral, St Peter
ESp; canopy of 14c with crocketed gables & angel cor-
bels, now in St Andrew's Chapel; because of same width
as sedilia, & very similar in design, Percy Morris con-
jectures that it "formed part of some structure on the
north side of the sanctuary before Stapledon's tomb was

added. This position suggests an Easter sepulchre."
ESp ntd *Ordinale Exoniensis*, Corpus Christi College
Parker MS. 93 (end of 14c). Ordinal issued 1337 by
Bishop Grandisson for use in cathedral & diocese,
contains instructions for consecrating Host, setting up
ESp, *Depositio,* and *Elevatio.*

Ponantur a diacono tres hostie ad sacrandum, quarum
due reseruantur usque in crastinum, vna ad
percipiendum a sacerdote. reliqua vt ponatur cum
cruce in sepulcro. [f. 115r; fig. 6]
 Ferie vj in die parasceues summo mane ornetur
sepulchrum a sinistra parte altaris et ammoueatur eadem
hora in feria vj sequente. [f. 115v; fig. 7]

<Depositio>

Deinde exuat sacerdos casulam tantum et in alba
assistens assumat vnum de prelatis in superpellicio et
reponat crucem pariter cum corpore dominico in sepulcro
incipiens hoc Responsorium.
 Estimatus sum.
chorus prosequatur.
 cum descendentibus. et cetera <in lacum, factus sum
 sicut homo sine adjutorio, inter mortuos liber>.
Deinde incensato sepulcro et clauso hostio eiusdem
incipiat ipse sacerdos Responsorium.
 Sepulto Domino.
chorus prosequatur.
 signatum. et cetera <est monumentum, volventes
 lapidem ad hostium monumenti; ponentes milites qui
 custodirent illud>.
Item, idem sacerdos incipiat. antiphonam.
 In pace in idipsum.
chorus
 Dormiam <et requiescam>.
Idem sacerdos incipiat. antiphonam.
 In pace factus est.
chorus.
 Locus eius <et in Sion habitatio ejus>.
Item, sacerdos antiphonam.
 Caro mea.
chorus
 requiescet in spe.
Tunc omnes cum deuocione genuflectant. et adorata
cruce recedant. [f. 116r; fig. 7]

<Elevatio>

In die pasche in aurora ante pulsacionem campanarum et
ante eciam matutinas. conueniant omnes clerici et laici
ad ecclesiam et accendantur omnia luminaria per

ecclesiam. Episcopus et Decanus vel alie due digniores
persone presentes in superpelliciis cum ceroferariis et
thuribulariis albis indutis ad sepulchrum vna cum toto
choro circumstante accedant. et facta deuota
genuflexione. incensatoque prius sepulcro. cum magna
ueneracione corpus dominicum accipientes priuatim
super altare deponant. Item accipientes cum
genuflexione crucem de sepulcro. inchoent episcopus et
decanus alta voce hanc antiphonam.
 Christus resurgens <ex mortuis iam non moritur,
 mors illi ultra non dominabitur. Quod enim vivet,
 vivet Deo, alleluia, alleluia>.
cum qua eat processio choro canente totam antiphonam
cum versu. Et tunc pulsentur omnes campane in
classicum. et sic cum magna ueneracione deportetur
crux solemniter inter eos super brachia et thuribulariis
et ceroferariis precedentibus per hostium australe
presbyterii incedentes. et circumeundo per medium
chori regredientes. choro sequente habitu non mutato
scilicet in cappis nigris ad locum vbi prouisum fuerit
excellencioribus personis incipientibus. ffinita
antiphona cum suo uersu a toto choro dicat excellencior
persona in ipsa stacione ante altare ad clerum conuersus
hunc versum.
 Surrexit dominus de sepulcro.
Responsum
 Qui pro nobis pependit in ligno alleluia.
cum oracione
 Deus qui pro nobis <filium tuum Crucis patibulum
 subire voluisti, ut inimici a nobis expelleres potes-
 tatem concede nobis famulis tuis ut resurrectionis
 eius graciam consequamur>.
nec precedat nec subsequatur Dominus vobiscum. sed
sic finiatur. Per christum dominum nostrum.
ffinita oracione omnes cum gaudio genua flectant ibidem
et ipsam crucem adorent in primis a dignioribus
personis. Interim pulsetur ad matutinas. [f. 57V; fig.
5; cf. Dalton, Ordinale Exon.; Lipphardt, No. 403]

Also ntd 1506 inv in list of gifts of Bishop Grandisson
(1292-1369):
Cross with the four Evangelists and four shields of
arms, of the Bishop and of others, with an enameled
Crucifix, images of the Virgin, SS Peter and Paul
decorated with seventy-eight precious stones and nine
pearls and containing part of the True Cross "for plac-
ing in the Sepulchre." [Rose-Troup]

EXETER, St Kieran or Kerrian
 ESp* ntd 1417 inv:
 Item a chest for the sepulchre of the Lord. [Whitley,
 "St Kieran's"]

EXETER, St Mary Arches
ESp* ntd Comm inv 1552:
Item a sepulchre cloth of bridge sattyn. [Cresswell,
Edw Inv . . . Exeter]

EXETER, St Mary Steps
ESp* ntd churchwardens' accts 1554:
Et soluti pro candelis sepulture vjd.
Et soluti pro faccione alterius altaris et sepulture xd.
Et soluti pro duobus ceriis pro summo altare et cerie
sepulture tres libris iijs. vjd.
1556:
Et soluti pro cerio Paschali cereo Fontis et Cereo
Sepulture iiijs.
1557:
Item payd for the Sepulture Tapper iijs. id. ob.
[Cresswell, *Exeter Churches*]

EXETER, St Paul
ESp* ntd Comm inv 1552:
Item a cloth to hang down the sepulchre.
Item a cloth that hangeth before the sepulchre. [Cress-
well, *Edw Inv . . . Exeter*]

EXETER, St Petrock
ESp* ntd churchwardens' accts 1425-6:
Two pounds of sepulchre candles, 3d.
1427-8:
For making of paschal tapers, sepulchre tapers and 2
processional tapers weighing 7 lbs, 6d.
1433-4:
pynns pro sepulcro 1d.
1452-3:
Item in pynnys pro sepulcro 1d.
1453-7:
Splyntris pro sepulcro 1d.
Splintris & le charcole pro le sepulcro & pro le sensa
1 1/2d.
1471-2:
For 5 lbs. of wax for "ceres sepulcri" at 8d. per lb.,
3s. 4d.
1483-4 inv:
vj lent clothys with a cloth of the sepulcor and other
dyvers pieces of silke and sarcenet to cover ymages in
lent.
1492-3:
For 8 yards of linen cloth "pro sepulcro," 4s.
For sawyng [sewing] the same, 1d.
For stayning the same, 20d.
For making "le valance sepulcri & aris" for the same,
2s. 6d.
1497-8:

For hanging a cloth called "le sepulker cloth," 1d.
1512-3:
For making 3 lbs. of sepulchre candles, 3d.
1540-1:
Solutus vigilatoribus in nocte p'apsid', 1d.
1541-2:
vigilatoribus sepulturae ijd. [Dymond]

HOLCOMBE-BURNELL, St John Baptist
ESp/tomb; recess with ogee arch in N wall of chancel
near altar; contains tomb chest, paneled with 4 blank
shields; back wall of recess has high relief of Christ
rising from tomb & soldiers watching; whole relief much
restored; Perp ornament on cornice & arch; composition
similar to Gosberton, Ls, & Arnold, Ns; Renaissance
detail, including mermaids supporting shields that flank
relief of Resurrection & 2 kneeling ladies in Elizabethan
dress, added in 16c, presumably when ESp converted to
tomb of local family, Dennis; 2 ladies removed & relief
restored in 1843. [Cresswell, *Kenn*; Pevsner; Prior &
Gardener; Thompson, "Church Arch in Devon"]

HOLSWORTHY, SS Peter & Paul
ESp* ntd will of Tho Raymond, 3 August 1418:
To the store of St. Peter of Holsworthy 43s. 4d., to
provide there yearly for ever, two wax lights of three
pounds weight to be burnt before the Sepulchre at
Easter. [W. I. L. Day]

MOLLAND, St Mary
ESp* ntd churchwardens' accts 1562:
 Stowfe Solke of the Churchys
Item for a Sepoulker of Mr Iohn Courtenay 2s. 4d.
[Phear]

MOREBATH, St George
ESp* ntd churchwardens' accts 1526:
Item for iiij yerdes of lyne clothe for ye sepulture with
ye hemyng of ye same xvd.
Item for ye paynten of ye sepulture cloth xxd.
1531 list of gifts to church during vicariate of Sir
Christopher Trychay:
[In 1526] John Holcum gave to ys churche a lent
cloythe y payntyd; a rood cloth y payntyd & a
sepulture clothe y paynted prise of all xs.
1534:
Item ys for ye ijs. yat Richard Robyns was yn debz to
ys churche at ye laste a cowmte he hath payd ixd. of
for lyn clothe: to be payntyd to hong over ye sepulture
& ye rest he wyll pay when ye clothe ys come home
acordyng to hys faders wyll.
Item for yre gere for ye sepulture & for ye ledde & for

makyn of ye tymber to hong ye sepulture clothe yn
mette & drenke & wagis xijd.
1536:
Sir Edward Nicoll gave un to ys churche a sepulture
clothe y staynyd to ley upon ye sepulture prise of vs.
& jd. ye whyche ys no thyng spokyn of a pon ys men a
cownt.
1538:
Item to Stebbe for varnyssyng of ye yre gere for ye
window: & for ij hokis a fore ye figar of our Lady with
ye yre gere for ye sepulture clothe ijs.
1539:
The cownte of Annys at More & Johanna Webber beyng
maydyn Wardyns for ye getheryng of ye sepulture lyzth
with wother lyzth a fore ye hye crosse . . . ye 2
Sonday yn clene Lent madyn.
Item they getheryd of devocon ijd. & for ye sepulture
lyzth they resseuyd xxijd.
Item for wex & for wyke & for makyn for ye hole ere
(by sydis ye sepulture lyzth) & for ye ij tapers a fore
ye hye crosse vijd.
1540:
The cownte of Jone Norman at Courte & Jone Borrage
beyng maydyn Wardyns for ye getheryn of ye sepulture
lyzth with wother lyzth a fore ye hye crosse . . . ye 2
Sonday yn Lent madyn.
Item of devocion nought but for ye sepulture lyzth they
resseuyd xvjd.
Item for makyn of ye sepulture lyzth 2 tymys & ye ij
tapers a fore ye hye crosse for xiij pownde of wex vjs.
& vjd.
1541:
Item a gayn there was lefth of ye sepulture ys mony
vijd.
Item for liij pownde & halfe of wex for ye hole ere for
ye sepulture & hye crosse & all xvijs. & jd. where of
there ys a ij pownde lefth.
Item for makyn of wex to Jone Morsse for ye hole ere
(with ye sepulture lyzth & all) xvjd.
1542:
Item ys for ye sepulture ys mony for ye lyzth Margyt
isac hadde all quod esset ijs. & viijd. ob.
Item for xxxix pownde of wex for ye hole ere for ye
sepulture lyzth & all xixs. & vijd.
Item to here [Jone Morsse] a gayn for makyn of wex
for ye hole ere (with ye sepulture lyzth & all) xvjd.
1543:
Item ys for ye devocion of ye sepulture ys lyzth hyt
was delyveryd all for Margytt Isac & xd. more at
Rogacion wyke of ye mony yat was then lefth at
churche howsse.
Item for xxxviij pownde of wex for ye hole ere (with ye

sepulture lyzth & all) xixs. iiijd.
Item for makyn of wex to William Morsse for ye hole ere
(with ye sepulture lyzt & all) xvjd.
1544:
Also ys for devocion of ye sepulture lyzth hyt was
dysposyd for Margyt Isac quod restat cum Harry Hayle
viijd.
Item for lj pownde of wex for ye hole ere (with ye
sepulture lyzth & all) xxiiijs. & vjd.
Item to William Morsse for makyn of wex for ye hole ere
sepulture lyzth & all xvjd.
1545:
Item to ye sepulture lyzth at Ester William Morsse
reseuyd ijd.
Item to Jone Morsse for makyn of wex for ye hole ere
(with ye sepulture lyzth) xvjd.
1546:
Item no hony hoc anno neque sepulture lyzth non esset.
Item to Jone Morsse for makyn of wex for ye hole ere
with ye sepulture lyzth xvjd.
1548:
The cownte of Luce Scely wydow beyng hye Wardyng of
ye gooddis of sent iorge of Morebath. . . .
Item a gayn sche resseuyd of Rychard Tywell for ye
lente cloythe & for ye 3 clothers of ye sepulture & for
sent iorge awter clothe & for Sent Sydwyllis auter
cloythe he hath payd her yn part of payment vs. &
iiijd. & ye iiijs. more he wyll pay at cristismas or a
fore at your plesure dicit.
1554:
Item for mendyg of ye sepulture & for standyng of ye
tapers ijd. [Binney]

OTTERY ST. MARY, St Mary (Collegiate Church)
ESp remains on N side of altar, now converted to tomb
for Jn Haydon (d. 1587) & wife Jane (d. 1592). Origi-
nal had Purbeck marble slab & may have been similar to
Bishop Stapledon's tomb at Exeter; both decorated with
large quatrefoils inside circles; both would have been
erected under Bishop Grandisson; 14c; il Dalton, Pl.
XVII.
ESp ntd Statutes given by Bishop Grandisson in 1338 &
1339 to his Collegiate Church of St Mary, St Edward
the Confessor, and All Saints, Ottery:
Statute xlviij. *De ymaginibus custodiendis.*
Item, volumus quod duo angeli stantes super collumpnas
ante altare magnum, in principio quadragesime portentur
ad vestibulum, et honeste serventur usque ad
resurreccionem, et tunc ad loca sua reportentur. Tunc
eciam primo discooperiantur cetere ymagines per
ecclesiam, excepto quod magna crux, et illa super
magnum altare in dominica palmarum a processione usque

post vesperas denudentur.
Statutes on Lights
lxxvij. 9. *De die pasche.*
In die eciam Pasche ad resurreccionem ardeant usque
post tunc processionem.
lxxvij. 21. *De festis trium leccionum et ferijs.*
In omnibus autem festis trium leccionum, et ferijs,
quando chorus non regitur, ille tantum cereus in pelui
coram magno altari continue ardeat, ad matutinas et ad
vesperas. Set et tunc ad missam semper duo ceroferaria
accendantur; alio in pelui extincto.
Eodem modo fiat in die Parasceves, ad officium; et
deinceps ad sepulchrum usque ad resurreccionem in die
Pasche ardeat unus cereus, nisi dum paschalis cereus
ardet, quod erit ex quo benedicitur, usque post magnam
missam in die Pasche, ut infra dicetur. [Dalton, *Ottery*]
ESp ntd will (1 April 1499) of Wm Holcomb, Precentor &
Canon:
meas tres virides cortinas sericas sic quod ordinentur
quolibit anno ad ornamentum Sepulcri per subsacristam
melius quo sibi videbitur ex consilio custodis et
canonicorum. [Dalton, *Ottery*]

PLYMPTON, St Thomas
?ESp*; remains of large opening found in N wall of 14c
chancel in restoration of 1865. [Rowe]

SOUTH POOL, St Cyriacus
ESp/tomb; recess in N wall of chancel contains tomb
chest paneled with figs of mourners, damaged; top of
chest has effigy of Tho Bryant, rector of South Pool &
Portlemouth from 1525-50; effigy appears to be short-
ened to fit recess, therefore probably not originally
intended for it; back wall of recess has traceried pan-
eling and, in center, relief of Resurrection showing
Christ stepping from tomb chest paneled with quatre-
foils & soldier sleeping at either end; traces of red &
blue paint on relief; canopy has 4-centered arch
decorated with bands of twisted foliage & tracery in
spandrels; inscription on cornice; battlemented cresting
pierced with quatrefoils in squared; 16c; il Rendall, p.
5; Thompson, "Church Arch in Devon," Pl. XIII. [Key-
ser, *List*; Pevsner]

SOUTH THROWLEIGH, St Mary
ESp; arched recess in N wall of chancel, discovered
1938; base of recess closed with slab covering ashlar
grave; recess originally flanked with broad pinnacled
buttresses; 4 holes near top of recess suggest wooden
panel had been affixed here, perhaps of Resurrection;
just above recess, base of another of same width, its
upper parts entirely missing; lower recess had been

blocked up in 19c, upper much earlier, possibly in 16c
with disuse of ESp; all of granite; monument has been
restored; il Everett, opp. p. 268.

STOKE-IN-TEIGNHEAD, St Andrew
ESp/tomb* formerly in chancel N of high altar; destroyed
or lost in rebuilding of chancel in 1865; edge of slab
had inscription to Jn Symon, rector (d. 1497).
[Whittemore]

TAVISTOCK, St Eustachius
ESp* ntd churchwardens' accts 1543-4:
Item paid vnto george ffisher for ix dayes worke
makyng the Sepulcre & for mete & Drink.
Item paid vnto mr Servyngton for wenskot for the
Sepulcre xxd.
Item paid vnto peter Eggecomb for [Deale] bords for
the same xvjd.
Item paid vnto Richard ffoster for bords xiijd.
Item paid for nayles for the same ijd. [Worth]

WEST ALVINGTON, All Saints
?ESp/tomb; recess with Renaissance detail in N wall of
chancel contains black marble tomb chest carved with
quatrefoils; back wall of recess has indents of brasses;
16c. [Pevsner; Thompson, "Church Arch in Devon"]

WHITCHURCH, St Andrew
?ESp/tomb; recess of 13c in N wall of chancel, now con-
tains 17c effigy. [Pevsner]

WOODBURY, St Swithin
ESp; paneled depressed arch between chancel & N chap-
el; no monument beneath it; combined with squint; early
16c. [Pevsner]
ESp ntd inv 1546-7:
a pyllow ffor the Sepulture.
thre olde sepulcure clothers whyte & rede . stolen.
[Brushfield]

WOODLEIGH, St Mary
ESp/tomb of Tho Smith (d. 1526-7); recess with ogee
arch under square head in N wall of chancel; tomb
chest carved in 2 registers: below 6 square quatrefoils
containing roses & above, large quatrefoil in circular
frame supporting shield; flanking this, 2 figs of ss
standing under arches &, beside these, square quatre-
foils with shields, one with initial T, other with S; top
of chest plain; back of recess has 3 reliefs separated
by thick arches: Pietà with female fig supporting
Christ's head & cross in background; in center, Resur-
rection with 2 soldiers & frontal Christ stepping out of

paneled tomb chest; & 3 Marys with angel; inscription
on folded scroll running across cornice reads, "Orate
pro anima Thome Smyth, quondam rectoris istius
ecclesie"; il Crossley, *ECM*, p. 93. [Pevsner; Thomp-
son, "Church Arch in Devon"]

DORSET (Do)

BRIDPORT, St Mary
ESp* ntd churchwardens' accts 1556:
Item to John Skynner for watchynge of the Sepulchre
iiijd. [Wainwright]

BUCKLAND NEWTON, Holy Cross
ESp* ntd will of Sir Nich Latimer who ordered his body
to be buried in the Church of St Mary, Buckland New-
ton:
near the high altar where the sepulchre of our Lord
used to be placed. [Hutchins 3]

CRANBORNE, SS Mary & Bartholomew
?ESp/tomb; recess with molded segmental-pointed head;
contains tomb chest with Purbeck marble slab; front of
chest has relief of plain shield in quatrefoil; pierced
quatrefoil in back of recess; reset in N wall of modern
chancel; 15c; il RCHM 5, Pl. 12. [Pevsner]

DORCHESTER, Holy Trinity
ESp* ntd Comm inv 1552:
A Sepulcher clothe of canvas paynted. [W. M. Barnes,
"Church Goods"]

DORCHESTER, St Peter
?ESp/founder's tomb; recess in N wall of chancel contains
tomb chest; sides & front of chest paneled; ogee arch
of recess trefoiled & each foil trefoiled; trefoils carved
with initials JW & merchant's mark as on roof of adjoin-
ing N chapel; may refer to Jn Williams of Herrington,
benefactor of church; 1360-90; il W. M. Barnes, "Rural
Deanery," Pl. 1. [Moule; RCHM 2]

EAST STAFFORD, Church (dedication unknown)
ESp* ntd Comm inv 1552:
A sepulcre clothe of canvas. [W. M. Barnes, "Church
Goods"]

GUSSAGE (ALL SAINTS), All Saints
?ESp; shallow recess now in N wall of nave; formerly in
N wall of chancel; crocketed ogee head with pierced
cusping & sub-cusping; ball-flower ornament; flanking

pinnacles with gabled & crocketed finials; recess prob-
ably reset when vestry added N of chancel in 1864;
Dec; il RCHM 5, Pl. 12. [J. H. Ward]

HOLWELL, St Lawrence
ESp* ntd Comm inv 1552:
a sepulcer clothe. [W. M. Barnes, "Church Goods"]

HOOK, St Giles
?ESp; recess in N wall of chancel near E end has molded
jambs & 4-centered arch under square head; 15c.
[RCHM 1]

LODERS, St Mary Magdalene
?ESp/founder's tomb; arched recess (7'2" in width x 2'9"
in depth) in N wall of chancel; arch molded & slightly
ogee at top; jambs of arch begin about 12" above chan-
cel floor; beneath recess, grave with bones of founder;
when recess discovered in restoration of 1900, white-
washed top of arch was smoke-blackened; c.1300-20.
[Broadley; RCHM 1]

LONG CRITCHELL, St Mary
ESp* ntd Comm inv 1552:
j sepulcre cloth of grene sylke. [W. M. Barnes,
"Church Goods"]

MOOR CRITCHELL, All Saints
ESp* ntd Comm inv 1552:
j sepulcre clothe with branches. [W. M. Barnes,
"Church Goods"]

OSMINGTON, St Osmond
ESp* ntd Comm inv 1552:
ij clothes for the Sepulcher of Saten of Bridges. [W. M.
Barnes, "Church Goods"]

POOLE, St James
ESp* ntd inv 30 Nov 1545:
Item iij schetts fyne for to dress the sepulcore on good
fryday.
Item a tewell to couer the crosse & the pelow in ye
sepulcor ye good fryday. [Sydenham]

PURSE CAUNDLE or CAUNDLE-PURSE, St Peter
?ESp/tomb; canopied table tomb between chancel & N
chapel; N face of tomb chest paneled with quatrefoils &
blank shields, S face replaced later; slab Purbeck
marble; arched canopy rests on shafts at corners; ends
closed; some half-length figs of angels with shields;
tomb of Wm Long (d. 1524). [RCHM 3]

SHERBORNE, All Hallows (later St Mary)
ESp* ntd churchwardens' accts 1512-3:
Item colis and wacchyng off ye sepullcre viijd.
1514-5:
Et solutum pro escuracione et mundacione candelabri et la penacls Sepulcri hoc anno vjd.
Et in uno homine conducto vigilante Sepulcrum hoc anno vjd.
1515-6:
Et solutum Bedemano pro custodia sepulcri et escuracione diuersarum rerum et sepulcri hoc anno xijd.
1517-8:
Et in hominibus conductis vigilantibus Sepulcrum hoc anno xijd.
1523-4:
Item payd to Rychard Payne for the tendyng off the sepultur xijd.
1524-5:
Item for a lyne to the sepulcre jd.
Item payd for kepyng the sepulcre xijd.
1525-6:
Item for mendyng of ye Iren in ye sepulker ijs. viijd.
Item for wachyn of ye sepulkar xijd.
1526-7:
Item paid for the kepyng of the sepulker xijd.
1527-8:
Item paid for corde for the sepulker ijd.
1530-1:
Item paid for kepyng of the sepulker xijd.
Item paid for the mendyng of the brason bolls whiche stondyth uppon the sepulker whiche were brokyn vjd.
1533-4:
Item payd to the bedemen for kepyng of ye sepulkere at ester xijd.
1534-5:
Item payd to Wyllyam Rawlens for a loke & a kay to ye sepulkere towme iiijd.
to the bede men for kapyng of ye sepulkere xijd.
1535-6:
Item payde a ester day to the beddemen for keppeng of the sepoulker xijd.
payde for hanggeng upe of the lente clothe & mackyng of the sepowlker iiijd.
[Parishioners abandoned & demolished All Hallows & moved to St Mary's abbey church sold to them in 1540.]
1542:
Item paid to the bellmen for watchyng of the Sepulcre xijd.
1543-4:
Item paid to the bede men for watchyng of the supulcre xijd.
Item paid for iij peces of whipcorde for the sepulcre

and for the lent cloth vjd.
1544-5:
Item payd to the bedmen ffor wacheyng the sepulcer
xijd.
1546-7:
Item paid to the bedemen for watchyng of the Sepulcre
xijd.
1548-9:
paid to the bedemen for watchyng of the sepulker 12d.
1550-1:
Item received of Bryane Cole for ye tymber of the ij
syde alters & sepulker ixs.
Item received of George Swetnaham for a sepulcre
clothe vs.
1554-5:
Item payd to Forcett ffor framyng the Sepulcre ageynst
Ester iiijd.
Item payd to Gullocke ffor nayles ffor the Sepulcre & a
thyng to sett up the paschall taper vd.
Item payd to Robert Blowbolls ffor the sepulcre cloth
iijs. iiijd.
Inv 1555-6:
sepulker cloth.
[Payments:] the sepulchre 5s. 4d.
dressing the sepulchre 4d.
1556-7 inv:
Item the Sepulker clothe.
Item paid to the bedemen for watchynge of the sepulker
xijd.
Item paid for dressynge of the sepulker iiijd. & for
pynes ob. [Jos Fowler, "Sherborne"]
1558:
Item payd ffor settyng up the Sepulcre ijd.
Item payd to the bedmen ffor watchyng the Sepulcre
xijd. [Mills]
1558 inv:
Item the sepulchre clothe.
1559 inv:
Item the sepulker clothe. [Jos Fowler, "Sherborne"]
1559:
Item paide to the bedemen for watchyng of the
Sepulkere xijd. [Mills]
1562:
Item solde to Richarde Damper the Sepulker cloth with
ij Banner clothes xvjd. [Jos Fowler, "Sherborne"]

STALBRIDGE, St Mary
?ESp/tomb; chest tomb in E bay of N chancel arcade;
paneled sides with quatrefoils & blank shields; E of
tomb in N wall of chancel, canopied recess with cusped
& crocketed ogee-headed arcading; rib vaulting in cano-
py; early 16c. [RCHM 3]

TARRANT HINTON, St Mary
 ESp in N wall of chancel; 7' in width & full height of
 wall; Italian Renaissance style; 2 recesses, one above
 the other; lower has molded 4-centered head; flanking
 half-columns support entablature; spandrels with scroll-
 like ribbons, illusionistically carved &, in corners,
 medallions; that to W contains bust of angel, to E 3
 figs, ?Marys, one with vase; half-columns have heads
 of cherubs on pedestals, shafts fluted on lower half,
 upper half carved with arabesques, composite capitals;
 frieze of entablature carved, from W to E, with initials
 T. W., head of cherub, "VENITE ET VIDETE LOCUM
 UBI POSITUS ERAT DOMINUS," head of cherub, initials
 T. T. Initials probably refer to donor: doorway of
 former rectory had inscription, "DA GLORIAM DEO.
 THOMAS TROTTESWELL ALIAS WEVER HUNC PORTICUM
 FECIT ANNO MDXXVII. Tho Wever, rector of church
 1514-36, probably buried beneath ESp; above entabla-
 ture of lower recess, second recess with 4-centered
 head; niches with 4-centered heads in splayed sides of
 recess; rear wall of recess paneled; all 3 panels ?origi-
 nally blind; 2 side panels now with windows of early
 19c; angel carved in high relief flanks upper recess to
 either side; each kneels, one foot on short corbel, &
 raises arms in salutation; entrance to N chapel to W of
 ESp has same moldings as ESp; chapel, remodeled in
 19c, apparently once extended E so that one bay ad-
 joined ESp; lower recess of ESp was open to this chap-
 el; c.1536; il RCHM 4, Pls. 77-78. [J. H. Ward]

WAREHAM, St Peter
 ESp* ntd Comm inv 1552:
 j sepulcre cloth of Dornex, ij shetes to the same.
 [W. M. Barnes, "Church Goods"]

WAREHAM LADY ST. MARY, St Martin
 ?ESp; wall painting on N wall of 11c chancel: IHS with
 crown; 15c. [RCHM 2]

WIMBORNE MINSTER, St. Cuthberga
 ESp* ntd churchwardens' accts 1527-9:
 Paid for ij grete tapers byfore the sepulker and other
 lyghtis for the quere, vjs. vd.
 Paid for wax for paschall taper, a faut taper, 14 tapers
 in the quear, and ij sepultur tapers.
 1542:
 for ryngs and points to the sepulture, ivd. ob.
 [Mayo, *Wimborne*]

WINTERBORNE STEEPLETON, St Michael
 ESp* ntd Comm inv 1552:
 j sepurker clothe steyned. [W. M. Barnes, "Church

Goods"]

WOOTTON GLANVILLE, St Mary
ESp*, mutilated & bricked up, found in N wall of chancel during restoration of 1875-6; fragments removed to rectory garden. [Mayo, "Wooton Glanville"]

DURHAM (Du)

COLDINGHAM PRIORY (dependency of Durham; now in Scotland)
?ESp*; possible ref in acct roll for 1370:
In empcione unius ymaginis pro Resurreccione, et alterius ymaginis sancti Blasii, cum aliis operacionibus pictoris, xviijs. xd. [J. Raine, *Coldingham*]

DARLINGTON, St Cuthbert
ESp to N of altar in chancel; 4-centered arch; Perp; c.1509. [Longstaffe; Pevsner]

DURHAM Cathedral, Blessed Mary Virgin and Cuthbert, Bishop (now Christ & Blessed Mary Virgin)
ESp* ntd *Depositio* in Durham Missal of 14c, British Library MS. Harl. 5289, f. 177r-177v:

<Depositio Crucis>

Et sciendum q*uod* du*m* crux portatur & reportatur p*er* me|dium chori. adorari debet ab omnib*us* flexis genib*us*. Cu*m* uero p*er*uenerint ad gradus pauimenti: p*ro*cedant duo fr*atr*es cu*m* candelabris & tertius cu*m* thuribulo p*re*cedentes crucis portitores. & ep*is*copu*m* uel p*ri*orem q*ui* cu*m* portitorib*us* crucis cruce*m* in sepul<c>ro collocatur*us* est. finita. *Antiphona.*
 Super omnia <ligna cedrorum tu sola excelsior, in
 qua vita mundi pependit, in qua Christus trium-
 phavit, et mors mortem superavit in eternum>.
incipiat cantor *Responsorium.*
 Tenebre <facte sunt dum crucifixissent Jesum
 Judei, et circa horam nonam exclamavit Jesus voce
 magna, Deus meus, ut quid me dereliquisti? Et
 inclinato capite, emisit Spiritum. Tunc unus ex
 militibus lancea latus eius perforavit, et continuo
 exivit sanguis et aqua>.
quo decantato collocet*ur* crux in sepulcro incensato loco ante posicione*m* & post. Dum hec agunt*ur*: incipiat cantor. has *Antiphonas.*
 Proprio filio suo non pep*er*cit deus p*ro* nobis
 omnib*us* tradidit illum.
Antiphonam.

Caro mea requiescet in spe.
Antiphonam.
 Dominus tamquam ouis ad uictimam ductus est &
 non aperuit os suum.
Antiphonam.
 Oblatus est quia ipse uoluit & peccata nostra ipse
 portabit.
Antiphonam.
 In pace in idipsum dormiam & requiescam.
deinde duo uertentes uultum ad conuentum canant hanc
Antiphonam:
 Ioseph ab arimathia petiit corpus ihesu & sepelliuit
 eum in sepulcro suo.
eaque percantata descendat in reuestiarium qui officium
celebrat. [figs. 8-9; cf. Lipphardt, No. 398]

Also ntd *Depositio* & *Elevatio* in 1593 *Rites of Durham*,
description by anonymous commentator:

The Passion

 Within the Abbye Church of Durham uppon good
friday theire was maruelous solemne seruice, in the
which seruice time after the passion was sung two of
the eldest monkes did take a goodly large crucifix all of
gold of the picture of our sauiour Christ nailed uppon
the crosse lyinge uppon a ueluett cushion, hauinge St.
Cuthberts armes uppon it all imbroydered with gold
bringinge that betwixt them uppon the said cushion to
the lowest stepps in the quire, and there betwixt them
did hold the said picture of our sauiour sittinge of
euery side [on ther knees] of that, and then one of the
said monkes did rise and went a prettye way from it
sittinge downe uppon his knees with his shooes put of
uerye reuerently did creepe away uppon his knees unto
the said crosse and most reuerently did kisse it, and
after him the other monke did so likewise and then they
did sitt them downe on euery side of the said crosse
and holdinge it betwixt them, and after that the prior
came forth of his stall, and did sitt him downe of his
knees with his shooes of and in like sort did creepe
also unto the said crosse [and all the monkes after him
one after an nother, in the same order, and] in the
meane time all the whole quire singinge an Himne, the
seruice beinge ended the two monkes did carrye it to
the sepulchre with great reuerence, which sepulchre
was sett upp in the morninge on the north side of the
quire nigh to the high altar before the seruice time and
there did lay it within the said sepulchre, with great
deuotion with another picture of our sauiour Christ, in
whose breast they did enclose with great reuerence the
most holy and blessed sacrament of the altar senceinge

and prayinge vnto it uppon theire knees a great space
settinge two taper lighted before it, which tapers did
burne unto Easter day in the morninge that it was
taken forth.

The resurrection

There was in the abbye church of duresme uerye
solemne seruice uppon easter day betweene 3 and 4 of
the clocke in the morninge in honour of the
resurrection where 2 of the oldest monkes of the quire
came to the sepulchre, beinge sett vpp upon good
friday after the passion all couered with redd ueulett
and embrodered with gold, and then did sence it either
monke with a paire of siluer sencors sittinge on theire
knees before the sepulchre, then they both risinge
came to the sepulchre, out of the which with great
reverence they tooke a maruelous beautifull Image of
our sauiour representinge the resurrection with a
crosse in his hand in the breast whereof was enclosed
in bright Christall the holy sacrament of the altar,
throughe the which christall the blessed host was
conspicuous, to the behoulders, then after the eleuation
of the said picture carryed by the said 2 monkes uppon
a fair ueluett cushion all embrodered singinge the
anthem of christus resurgens they brought to the high
altar settinge that on the midst therof whereon it stood
the two monkes kneelinge on theire knees before the
altar, and senceinge it all the time that the rest of the
whole quire was in singinge the foresaid anthem of
Christus resurgens, the which anthem beinge ended the
2 monkes tooke up the cushines and the picture from
the altar supportinge it betwixt them, proceeding in
procession from the high altar to the south quire dore
where there was 4 antient gentlemen belonginge to the
prior appointed to attend theire comminge holdinge upp
a most rich cannopye of purple ueluett tached round
about with redd silke, and gold fringe, and at euerye
corner did stand one of theise ancient gentlemen to
beare it ouer the said Image, with the holy sacrament
carried by two monkes round about the church the
whole quire waitinge uppon it with goodly torches and
great store of other lights, all singinge reioyceinge and
praising god most deuoutly till they came to the high
altar againe, wheron they did place the said Image
there to remaine untill the assencion day. [Fowler, ed.,
Rites of Durham; cf. Lipphardt, No. 399]

Ntd acct rolls 1536:
Et de 46s. 8d. de terr. nuper Johannis Trotter in
Estmeryngton ex novo impetrat. per magistrum Thomam
Castell, Priorem, una cum 4s. de terra nuper Willelmi
Boyth in Wolveston per eundem impetrata et assignata

officio Sacriste pro celebracione misse et antiphone de
Jhesu coram magno Crucifixo singulis diebus Veneris,
ac pro candelis inveniendis ibidem, pro pulsacione
campane temporibus predictis, una cum 4 cereis coram
Sacramento illuminandis omni tempore trium dierum et
noctium prox. ante Pascha.
1541-c.1548:
Item payd for ye mendyng of ye ymage of Crist for ye
resurrection, 4d.
1547:
Item in tackettes to sett vp ye sepulcre, jd.
26 March 1558:
Pro sarracione 4 waynscott et aliorum meremii pro
operibus in vestibulo et circa le sepulcre (per diem
8d), 4s. 8d. [Fowler, *Acct Rolls*]

REDMARSHALL, St. Cuthbert
?ESp/tomb in N wall of chancel opposite sedilia; same
style as piscina; flat slab of priest on floor in very low
relief; over it, segmental arch with hood mold; 15c.
[Hodgson; VCH 3]

ESSEX (Es)

ALDHAM, Church (dedication unknown)
ESp* ntd Comm inv 1552:
Item sole to John Serle a cloth yat was beffore ye
sepulker viijd. [King, "Inv"]

ALPHAMSTONE, Church (dedication unknown)
?ESp; recess in N wall of chancel; trefoiled ogee head
with finial; now fitted with door; early 14c; church
much restored. [RCHM 3]

ALTHORNE, St Andrew
ESp* ntd Comm inv 1552:
oone sepulker cloth. [King, "Inv"]

BARKING, St Margaret
ESp* ntd Comm inv 1552:
Item a hanginge for the Sepulture of red chamlet and
white. [King, "Inv"]

BARKING ABBEY (Benedictine Convent)
ESp* ntd in *Depositio, Elevatio,* & *Visitatio* in Barking
Ordinal 1373-6, Oxford University College, MS. 169,
15c.

<Depositio>

Cum autem sancta crux fuerit adorata: sacerdotes de loco
predicto crucem eleuantes incipiant antiphonam.
 Super omnia ligna <cedrorum tu sola excelsior, in
 qua vita mundi pependit, in qua Christus trium-
 phavit, et mors mortem superavit in eternum>
& choro illo subsequente totam concinant. cantrice
incipiente deferant crucem ad magnum altare. ibique in
specie ioseph & nichodemi de ligno deponentes
ymaginem uulnera crucifixi vino abluant & aqua. Dum
autem hec fiunt: concinat conuentus Responsorium
 Ecce quomodo moritur iustus <et nemo percipit
 corde, et viri justi tolluntur et nemo considerat;
 a facie iniquitatis sublatus est iustus. Et erit in
 pace memoris ejus>.
sacerdote incipiente & cantrice respondente & conuentu
succinente. post uulnerum ablutionem cum candelabris &
turribulo deferant illam ad sepulcrum hac canentes
antiphonas
 In pace in idipsum <dormiam et requiescam>.
antiphona
 Habitabit <in tabernaculo tuo, requiescet in monte
 sancto tuo>.
antiphona
 Caro mea <requiescet in spe>.
Cumque in predictum locum tapetum palleo auriculari
quoque & lintheis nitidissimis decenter ornatum illam
cum reuerencia locauerint claudat sacerdos sepulchrum &
incipiat Responsorium
 Sepulto domino <signatum est monumentum, vol-
 ventes lapidem ad hostium monumenti; ponentes
 milites qui custodirent illud>.
& tunc abbatissa offerat cereum qui iugiter ardeat ante
sepulcrum nec extinguatur donec ymago in nocte pasche
post matutinas de sepulcro cum cereis & thure &
processione resumpta: suo reponatur in loco. Hiis
itaque gestis: redeat conuentus in chorum | & sacerdos
in uestiarium. [pp. 108-9; figs. 10-11]

<Elevatio>

Nota quod secundum antiquam consuetudinem
ecclesiasticam resurexio dominica celebrata fuit ante
matutinas & ante aliquam campane pulsacionem in die
pasche & quoniam populorum concursus temporibus illis
videbatur deuocione frigessere. & torpor humanus
maxime accrescens. venerabilis domina katerina de
Suttone tunc pastoralis cure gerens vicem. desiderans
dictum torporem penitus exstirpare. & fidelium
deuocionem ad tam celeb<r>em celebracionem magis
excitare: vnanimi consororum consensu instituit. ut

statim post iii. Responsorium matutinarum die pasche
fieret dominice resurexionis celebracio & hoc modo
statuetur processio. In primis eat domina abbatissa cum
toto conuentu & quibusdam sacerdotibus & clericis capis
indutis quolibet sacerdote & clerico palmam & candelam
extinctam manu deferentem intrent capellam sancte marie
magdalene. ffigurantes animas sanctorum patrum ante |
aduentum christi ad inferos descendentes & claudant
sibi ostium dicte capelle. deinde superueniens sacerdos
ebdomadarius ad dictam capellam appropians alba
indutus & capa cum duobus diaconis. vno crucem
deferente cum uexillo dominico desuper pendente
al<ter>o cum turibulo manu sua baiulante & aliis
sacerdotibus & clericis cum duobus pueris cereos
deferentibus ad ostium dicte capelle incipiens ter hanc
antiphonam

> Tollite portas <principes, vestras, et elevamini,
> porte eternales, et introibit rex glorie>.

qui quidem sacerdos representabit personam christi ad
inferos descensuram & portas inferni dirupturam. &
predicta antiphona vnaquaque uice in altiori uoce
incipiatur quam clerici tociens eandem repetant & ad
quamquam incepcionem pulset cum cruce ad predictum
ostium. figurans dirupcionem portarum inferni. & tercia
pulsacione ostium aperiat. deinde ingrediatur ille cum
ministris suis interim incipiat quidam sacerdos in capella
existente antiphonam

> A porta inferi

quam subinferat cantrix cum toto conuentu.

> Erue domine & cetera <animam meam>.

Deinde extrahet sacerdos ebdomadarius omnes essentes
in capella predicta. & interim incipiat sacerdos
antiphonam

> Domine abstraxisti.

& cantrix subsequatur.

> ab inferis <animam meam>.

Tunc omnes exeant de capella id est de limbo patrum. &
cantent sacerdotes & clerici antiphonam

> Cum rex glorie <Christus infernum debellaturus
> intraret, et chorus angelicus ante faciem eius
> portas principium tolli preciperet, sanctorum
> populus, qui tenebatur in morte captivus, voce
> lacrimabili clamaverat: Advenisti desiderabilis,
> quem expectabamus in tenebris, ut educeres hac
> nocte vinculatos de claustris. Te nostra vocabant
> suspira; te larga requirebant lamenta; tu factus
> es spes desolatis, magna consolatio in tormentis,
> alleluia>.

processionaliter per medium chori ad sepulcrum
portantes singuli palmam & candelam designantes
victoriam de hoste recuperatam subsequentibus domina
abbatissa priorissa & toto conuentu sicit sunt priores. &

cum ad sepulcrum peruenerint: sacerdos | ebdomadarius
sepulcrum thurificet & intret sepulcrum incipiendo
versum
Consurgit.
deinde subsequatur cantrix.
Christus tumulo <victor redit de baratro, tyrannum
trudens vinculo, et reserans paradisum>.
versus
Quesumus auctor <omnium, in hoc paschali gaudio
ab omni mortis impetu tuum defende populum>.
versus
Gloria tibi domine <qui surrexisti a mortuis, cum
Patre et Sancto Spiritu in sempiterna secula>.
& interim asportabit corpus dominicum de sepulcro
incipiendo antiphonam.
Christus resurgens
coram altari verso uultu ad populum tenendo corpus
dominicum in manibus suis inclusum cristallo. deinde
sugiungat cantrix.
ex mortuis <iam non moritur, mors illi ultra non
dominabitur. Quod enim vivet, vivet Deo, alleluia,
alleluia>.
& cum dicta antiphona faciant processionem ad altare
sancte trinitatis cum solenni apparatu videlicet cum
turibulis & cereis conuentus sequatur cantando
predictam antiphonam cum versu
Dicant nunc <Judei, quomodo milites custodientes
sepulchrum perdiderunt Regem ad lapidis posi-
tionem. Quare non servabant petram justitie? Aut
sepultum reddant, aut resurgentem adorant,
nobiscum dicentes, Alleluia>.
& versiculo
Dicite in nacionibus <quia Dominus regnavit in
ligno, alleluia>.
Oratio
Deus qui pro nobis filium tuum <Crucis patibulum
subire voluisti, ut inimici a nobis expelleres
potestatem, concede nobis famulis tuis ut in
resurrectionis eius graciam consequamur>.
& hec processio figuratur per hoc quomodo christus
procedit post resurexionem in galileam: sequentibus
discipulis. [pp. 119-21; figs. 12-14]

<Visitatio Sepulchri>

Quibus peractis: procedant tres sorores a domina
abbatissa preelecte et nigris vestibus in capella beate
marie magdalene exute: nitidissimis superpellicijs
induantur niueis velis a domina abbatissa capitibus
earum superpositis. sic igitur preparate & in manibus
ampullas tenentes argenteas dicant. Confiteor ad
abbatissam & ab ea absolute. in loco statuto cum

candelabris consistant. Tunc illa que speciem pretendit
marie magdalene. canat hunc versum.
> Quondam dei.
quo finito: secunda que mariam iacobi prefigurat.
alterum respondeat versum.
> Appropinquans ergo sola.
Tercia maria vicem optinens salomee. tercium canat
versum.
> Licet mihi vobiscum ire.
Post hec chorum incedentes flebili uoce & submissa hos
pariter canant versus.
> Heu nobis internas men|tes <quanti pulsant gemitus
> pro nostra consolatore, quo privamur misere;
> Quem crudelis Judeorum morti dedit populus>.
Hijs versibus finitis. magdalena sola dicat hunc versum.
> Heu misere <cur contigit videre mortem Salva-
> toris?>
Iacobi respondeat.
> Heu consolacio nostra <ut quid mortem sustinuit>.
Salome
> Heu redempcio israel <ut quid taliter agere
> voluit>.
Quartum uero uersum omnes simul concinant scilicet
> Iam iam ecce <iam properemus ad tumulum,
> unguentes dilecti corpus sanctissimum>.
Tunc marie exeuntes a choro: simul dicant
> Eya quis reuoluet <nobis lapidem ab ostio
> monumenti>.
Cum autem uenerint ad sepulcrum. clericus alba stola
indutus. sedeat ante sepulcrum illius angeli gerens
figuram qui ab ostio monumenti lapidem reuoluit. &
super eum sedit. Qui dicat illis.
> Quem queritis in sepulcro o cristicole.
Respondeant mulieres.
> Ihesum nazarenum querimus.
Angelus uero subinferat.
> Non est hic surrexit <sicut predixerat; ite,
> nuntiate quia surrexit de sepulchro. Venite et
> videre locum ubi positus erat Dominus, alleluia,
> alleluia>.
Cumque dixerit
> venite & videte: ingrediantur sepulcrum &
> deosculentur locum vbi positus erat crucifixus.
Maria uero magdalene interim accipiat sudarium quod
fuerat super caput eius: & secum deferat. Tunc alius
clericus in Specie alterius angeli in sepulcro residens:
dicat ad magdalenam.
> mulier quid ploras
Illa autem subiungat.
> Quia tulerunt dominum meum <et nescio ubi
> posuerunt eum>.
deinde duo angeli simul concinentes dicant mulieribus.

Quid queritis viuentem cum mortuis & cetera <Non
est hic, surrexit enim sicut dixit; venite et videte
locum ubi positus fuerat, et euntes dicite disci-
pulis ejus et Petro quia surrexit>.
Tunc ille de resurexcione domini adhuc dubitantes:
plangendo dicant ad inuicem.

Heu dolor & cetera <[Orléans MS. 201 continues:]
heu quam dira doloris angustia, quod dilecti sum
orbata magistri presencia! Heu, quis corpus tam
dilectum sustulit e tumulo?>
Postea maria magdalene suspirando concinant

Te suspiro & cetera.
Tunc in sinistra parte altaris appareat persona dicens
illi.

mulier quid ploras. quem queris.
Illa uero putans eum esse ortolanum respondeat.

Domine si tu sustulisti eum & cetera <dicito mihi
ubi posuisti eum, et ego eum tollam>.
persona subiungat.

maria.
Tunc <i>lla agnoscens eum pedibus eius prosternatur
dicens

Raboni
Persona | autem se subtrahens: dicat

noli me tangere & cetera <nondum enim ascendi ad
Patrem meum, vade autem ad fratres meos, et dic
eis: Ascendo ad Patrem meum, et Patrem vestrum,
Deum meum, et Deum vestrum>.
Cum persona disparuerit: maria gaudium suum
consociabus communicet uoce letabunda: hos concinendo
versus.

Gratulari & letari & cetera.
Quibus finitis: persona in dextera parte altaris tribus
simil occurrat mulieribus dicens.

Auete nolite timere & cetera <vos ite, nuntiate
fratribus meis ut eant in Galileam; ibi me
videbunt sicut predixi eis>.
Tunc ille humi prostrate: teneant pedes eius &
deosculentur. Quo facto: Alternis modulacionibus. hos
versus decantent. maria magdalene incipiente.

Ihesus ille nazarenus & cetera.
ffinitis hijs versibus. Tunc marie stantes super gradus
ante altare uertentes se ad populum canant hoc
Responsum.

alleluia surrexit dominus de sepulcro.
choro eis respondente ffinitis hijs sacerdotes & clerici in
figuram discipulorum christi procedant dicentes.

O gens dira.
Tunc vnus illorum accedat & dicat marie magdalene.

Di<c> nobis maria & cetera <quid vidisti in via?>
Illa autem respondeat.

Sepulcrum christi <viventis, et gloriam vidi

resurgentis>. angelicos testes <sudarium et
vestes>.
digito indicet locum vbi angelus sedebat. & sudarium
probeat illis ad deosculandum hunc adicientes versum.
 Surrexit christus spes nostra <precedet suos in
 Galilea>.
Tunc subiungatur a discipulis & a choro hij ultimi
versus.
 Credendum est <magis soli Marie veraci quam
 Judeorum turbe fallaci>
&
 Scimus christum <surrexisse a mortuis vere; tu
 nobis, victor rex, miserere>.
Postea incipiat magdalena.
 Christus resurgens <ex mortuis iam non moritur,
 mors illi ultra non dominabitur. Quod enim vivet,
 vivet Deo, alleluia, alleluia>.
clero et choro pariter succinente. Hijs itaque peractis:
solenniter decantetur a sacerdote incipiente ymnus.
 Te deum laudamus.
& interim predicte sacerdotes in capellam proprijs
vestibus reinduentes cum candelabris per chorum
transeuntes orandi gratia sepulcrum adeant: & ibi
breuem orationem faciant. tunc redeant in stacionem
suam usque abbatissa | eas iubeat exire ad
quiescendum. [pp. 121-4; figs. 14-17; Lipphardt, No.
770]

BIRCHANGER, St Mary
 ESp* ntd Comm inv 1552:
 A lynnen clothe paynted for the sepulchre. [Waller,
 "Inv"]

BRADWELL (-JUXTA-COGGESHALL), Holy Trinity
 ?ESp*; Win N2 has paintings on splays & soffit; on E
 splay, Throne of Grace Trinity: God Father holds small
 crucifix, dove virtually obliterated; in W splay Christ
 rising from tomb holding cross-staff; above in soffit
 Christ in majesty flanked by angels holding Instruments
 of Passion; subjects & location suggest temporary ESp
 could have been erected here; c.1320. [Pevsner; RCHM
 3; Tristram, 14c]

CASTLE HEDINGHAM, Priory of St Mary, St James, & Holy
Cross (Benedictine)
 ESp* ntd Comm inv 1538:
 In the Dorter
 Item a cloth for the sepulture with the ffrontlett of
 redd sylke at vjd.
 Item iiii. sepulcre clothes of sylke for the sepulcre at
 xxd.
 Item a payer of shetes for the sepulcre at ijs. [Fowler,

"Inv Es Monasteries"]

CHELMSFORD, St Mary Virgin
ESp* ntd churchwardens' accts 1557-8:
Item, payd for watching the sepulcre from good friday
none till Ester daye mornyng, and for breade and
drinke, xijd.
Item, payd Roger Webbe for streykyng xvj lb of wax
for the pascall and sepulcre light, xvjd.
1558-9:
Item, payd to James Harvye, for iiij lb wex to make the
sepulcre lyght, iiijs.
Item, payd to Roger Webbe for strykynge of ye
sepulcer lyght ageynst Ester, and for iij quarters wex
of his own to make beetyngs ijs.
Item, payd for meate and drynck for them that dyd
watch at the sepulcre, xviijd. [Pressey, "Chelmsford"]

COLCHESTER, St Andrew Greenstead
ESp/tomb; recess with segmental-pointed arch & cham-
fered jambs in N wall of chancel; 14c. [RCHM 3]
ESp ntd Comm inv 1552:
Item . . . a sepulcre with the frame. [King, "Inv"]

COLCHESTER, St Leonard (at the Hythe)
?ESp; cinquefoil-headed niche in N wall of chancel; 15c.
[RCHM 3]

COLCHESTER, St Martin
?ESp; recess in N wall of chancel with trefoiled sub-
cusped ogee head; 14c; il RCHM 3, opp. p. 39.

COLCHESTER, St Michael (Mile End)
ESp* ntd certificate of goods sold by 1548:
A paynted clothe belonginge to the sepulchre viijd.
[Dickin]

DAGENHAM, SS Peter & Paul
?ESp; plain tomb chest on N side of chancel with brasses
on molded slab; man in judicial robes, Sir Tho Urswyk
(d. 1479), chief Baron of Exchequer & Recorder of
London; woman in butterfly headdress, feet on dog; 9
daughters, 2 in butterfly headdress; one a nun; 4
sons; shields; figs 27" in height. [Pevsner; RCHM 2]

DEDHAM, St Mary
?ESp/tomb; chest tomb with battlemented cornice in N
aisle; aisle built as family memorial by Webbes, owners
of Dedham cloth mill; tomb on N wall of NE corner in
chantry chapel; chest paneled with 5 square trefoiled
cusped quatrefoils; 2 ends have merchant's marks &
initials J.W. for Jn Webbe (d. 1506); Purbeck marble

slab plain, around rim was inscription & sockets, pos-
sibly for candles; above this, deep recess with de-
pressed pointed arch, all covered with tracery; above
recess, front of canopy has indents for brasses of 2
kneeling figs, each with children behind, facing rec-
tangular panel; cornice has crowned heads, restored;
presence of recess and location of brasses suggests use
as ESp; il Chancellor, *Ancient 2*, Pl. CXIX; Pevsner,
Pl. 34; Rendall, p. 3. [RCHM 3]
ESp ntd 1510 will of Robt Halke, who left £20 for fin-
ishing of steeple & "a Sepulchre to be made after the
pattern of that at Stoke in carving and in painting"; he
asks to rest under this canopy. [Rendall]

EARLS COLNE, St Andrew
ESp* ntd will of Rich Butler, 13 Dec 1500:
To the sepulchre of Erlys Colne, my best redde
couerlet. [Benton]

EAST HORNDON, All Saints
ESp; deep brick-paneled recess in N wall of chancel
contains 19c tomb chest with medieval brass to Dame
Anne Marney & indent of 2nd fig, presumably her
husband, Sir Tho Tyrell (d. 1476). [Pevsner; RCHM 4]
ESp ntd Tyrell's will, dated 16 May 1475:
my body to be buried in the chancell of the church of
Esthornedon in Essex aforesaide, under the place where
the sepulchre is wont to stonde their, and I wolle that
their be a tombe of tymber or of stone for me and my
wif according honestly for our degree. . . . Item,
where as there hath been gadred of me and of myn
houshold many yeres, certain money, whereof parte
hath gone yerely to the fynding of the sepulchre light,
I woll that myn Executours, to thentent that a gode
Rule be hadde hereafter to the pleasure of god and for
the soule that any thyng have given thereto, shall give
and deliver of my godes to the fynding and
contynuance of the saide light, v li. sterling. and I
woll that all other somes of money bilongyng to the
saide light, and being in other mennes handes, shalbe
gadred and be delivered unto humfrey Tyrrell, and the
others, they to se that it may from henceforth be
employed to the wele of the said light. [King, "Ancient
Wills (No. 3)"]

EASTHORPE, St Mary
?ESp; plain plastered recess of uncertain date in N wall
of chancel. [RCHM 3]
ESp ntd Comm inv 1552:
Item A sepulcure xijd. [Muskett, "Church Goods Sf"]

EASTWOOD, St Lawrence & All Saints
ESp* ntd Comm inv including certificate of goods sold before 1548:
Also they [churchwardens] sould in the same yere A sepulcker of wood gylt to Thomas Tyler, of Rotcheford, xs. [King, "Inv"]

FEERING, All Saints
ESp* ntd certificate of ?1552:
Item solde to ye same haygate a sepulker iiijs. [Muskett, "Church Goods Sf"]

FELSTED, Holy Cross
ESp; recess with two-centered ogee molded arch in N wall of chancel; probably refixed W of original position; arch rests of shafts with molded & carved capitals; flanking them, buttresses with gabled & crocketed pinnacles & carved finials; arch has cinquefoiled cusping, the middle cusp on each side sub-cusped; label molded & crocketed, with finial; mid 14c; much restored; il RCHM 2, opp. p. 85.

FRATING, Church (dedication unknown)
?ESp; recess in N wall of chancel; 4-centered arch with molded jambs under square head; leafy carving in spandrels & flowers on arch; early 16c. [Pevsner; RCHM 3]

GESTINGTHORPE, St Mary
ESp* ntd will of Jn Coo, 3 Sept 1520; proved 13 Feb 1521:
Item I bequeth to the makyng a tapour weyinge x lb. to be set before the sepulchre of our lord, euery yere 1 lb, or els xd. in redy money. [King, "Excerpts"]

GOLDHANGER, St Peter
ESp* ntd Comm inv 1552:
Item the same churche wardyns solde vnto the saide Edward one trydyll of wax the whyche was the bachelars and the maydyns sepulkar lyght xs. [King, "Inv"]

GREAT BENTLEY, St Mary
ESp* ntd Comm inv 1552:
also a sepulchre sold to William Harris ijs. [King, "Inv"]

GREAT BROMLEY, St George
?ESp; molded cornice carved with flowers in N wall of chancel may be blocked recess; 15c. [RCHM 3]
ESp ntd Comm inv 1552:
Item ij olde clothes paynted that covered the sepulker. [King, "Inv"]

GREAT DUNMOW, St Mary
ESp* ntd churchwardens' accts ?1526:
[for a] pascall lyne and for pyns and nayles for the
sepoltre 2d.
?1527:
for pynnes and nayles for the canape and for the
sepoltre 4d. [Majendie]
1529:
for nayle for the sepoltre and pynnys for the canape,
iiiid.
1533:
for pynes for the sepoultre, obolus.
1534:
for thred, pynnes, and nayles for the sepoultre, iid.
1541:
payd for charcole to watche the sepulcar, vid.
1543:
for pynnys and nayles for the sepulker, id. obolus.
payd to Wylliam George for tendyng the sepulker lyght,
iiiid.
payd to John Bykener for iiii li and halff of wex, iis.
iiid., and for strykyng the rode-lyhgt and the sepulker
lyhgte at Ester, vs. id.
1544:
payd to John Bykener for wex and for strykyng the
sepulker lyght and the rode lyght att Ester viiis. iid.
payd to Harry Tomson for ii busshells of coles to
watche the sepulker, iiiid.
1545:
payd to Harry Tomson for ii bushell colys to watche the
sepulker at Ester withall, iiiid.
1551:
to George for wacchyng the sepulkyr, iiiid.
1551-8:
payed to Thomas Stewerd for iii. crestes and vi.
transumes, viii. brases and viii. or ix sparrs and ii.
postes for the sepulcre, iiis.
layd owte for nayles and viii. staples for the same,
vid. obolus.
payed to Robert Parker, tyler, to sett in too staples
into the wall, iiiid.
1558:
payd for nayeles and pynnes for the sepulcre, id.
obolus. [Clark, "Great Dunmow"]

GREAT HALLINGBURY, Church (dedication unknown)
ESp* ntd churchwardens' accts 1527-48 in which first
entry each year usually records payment for purchase
of wax and, until 1543, for "strykyng the sepulcre
lyght."
c.1550:
[received] for ye fram of ye sepulcre with other old

stuffe abought ye particons in ye chauncell 6s.
c.1553: [2s. paid for new ESp frame].
1555:
receyved of serten of ye parisheners of charyte agenst
Ester laste, to make ye sepulcre light, vjs. iiijd.
[Williams, "Great Hallingbury"]

GREAT HORKESLEY, All Saints
 ESp* ntd Comm inv 1552:
 Item resayved of John Onywen for a albe a clothe of
 cruel and thred draw with branches for the sepulcar
 xiid. [Fowler, "Church Goods Es"]

GREAT LEIGHS, St Margaret or St Mary
 ?ESp/founder's tomb; canopied recess in N wall of
 chancel; Purbeck marble slab, level with pavement, has
 skeleton beneath it; pointed arch, cusped & sub-
 cusped, rests on short, semi-detached shafts; crocketed
 gable with finial encloses very naturalistic carving of
 vines with leaves & grapes; foliated spandrels have
 rose, oak, marsh mallow; much restored; early 14c; il
 Chancellor, "Es Church VII," fig. 6; RCHM 2, opp. p.
 103; gable of recess in Pevsner, Pl. 18b.

GREAT STAMBRIDGE, St Mary & All Saints
 ESp* ntd Comm inv 1552:
 Item solde to the same rycharde a paynted clothe for
 the sepulchre iijs. [King, "Inv"]

GREAT WARLEY, St Mary
 ESp* ntd Comm inv 1552:
 Item a sepulkar sold to Robert Pake thelder for iijs.
 iiijd.
 all which last somes of money were gyven to the pore
 of the same parishe. [King, "Inv"]

HATFIELD PEVEREL, Priory of St Mary Magdalene (Bene-
dictine)
 ESp* ntd Comm inv 1538:
 Item ix. stayned alter clothes v. for Lent and iiii. for
 the sepulture at iiis. iiiid. [Fowler, "Inv Es Monas-
 teries"]

HAVERING ATTE BOWER, St John Evangelist
 ESp* ntd Comm inv 1552:
 These be the passells that was sold in the presens of
 all those that doth pertayne to the chappell. Item an old
 sepulker clothe xvjd. [King, "Inv"]

HAWKWELL, St Mary
 ESp* ntd Comm inv 1552:
 Item Wyllyam Sutton, Wyllyam Barnystre haythe in ther

custody ij tunnyclys, on grett chestt, a sepulcher and a holy water stocke of latyn. [King, "Inv"]

HEYBRIDGE, St Andrew
?ESp/aumbry; plain square recess with wood lintel in N wall of 12c chancel. [RCHM 3]
ESp ntd churchwardens' accts 1529-30:
Memorandum: Thatt in the 21st yere of Kynge Henrye VIII, the bachellers of the paryshe of Heybryge have delyvarede the 9 tapers belongynge to the sepulker, at the feste of Ester, each taper contaynynge 5 pownde of waxe.
 Sum, 45 pownde of waxe.
Also in the seid yere the maydens of the seid parishe have delyverede on to the 9 tapers belongynge to the seid sepulkre, at the feste of Ester, every taper contaynynge 5 pownde of waxe.
 Sum 45 pownde of waxe. [Pressey, "Heybridge"]
Also ntd Comm inv 1552:
Item a clothe that was at ye Sepulcre.
Item the sepulckre was solde for. . . . [King, "Inv"]
Also ntd churchwardens' accts 1554-5:
Item, payd to Cowben ffor gyldyng of the . . . beme a bowght the sepulker, and for iiij colued stastys payntyed vijs.
Item, for makynge of the sepulker iijs. [Pressey, "Heybridge"]

HORNCHURCH, St Andrew
ESp/tomb; chest in chancel under N arcade; sides & W end have paneling of cusped quatrefoils with shields; slab had brass fillet around edge with inscription; tomb for Wm Ayloffe (d. 1517) & Audrey Shaa, his wife; il Chancellor, "Es Church XVI," fig. 7. [RCHM 4]
ESp ntd Comm inv 1552:
Item a sepulcre clorthe of Rede and blewe satten with a frynge. [King, "Inv"]

LATTON, St Mary Virgin
?ESp/tomb chest with slab of Purbeck marble in recess between chancel & N chapel for Sir Peter Arderne (d. 1467), Chief Baron of Exchequer & Justice of Common Pleas, & wife Katherine Bohun; chest paneled with quatrefoils & shields; slab has brasses, each 3' in length, of man in judicial robes & woman in horned headdress; marginal inscription missing; chest sits in archway closed with iron grill; on chapel side arch has 3-centered head & on chancel side canopy of 3 arches with embattled cornice; oak & vine leaf bosses contain letters P, A, & K; il RCHM 2, opp. p. 103. [Pevsner]

LAYER DE LA HAY, Church (dedication unknown)
?ESp; Purbeck marble tomb chest with canopy in N wall

of chancel; no effigy or brasses; chest paneled; above
very flat arch of canopy resting on 2 octagonal shafts,
frieze of quatrefoils & cresting; soffit of arch has
quatrefoils; similar to Webbe monument at Dedham; late
15c to early 16c; il Chancellor, *Ancient 2*, Pl. CXXX.
[Pevsner; RCHM 3]

LITTLE BENTLEY, St Mary
ESp* ntd Comm inv 1552:
Item iij coshyns for the Sepulker.
Item viij lytell stayned cloths for the Sepulker.
Item vi seuerale peces of lyn, for the same.
Item iij peces of lawnes for the same. [King, "Inv"]

LITTLE CHESTERFORD, St Mary
ESp* ntd Comm inv 1552:
ij. olde paynted clothes, which hanged abowte the
Sepulcre. [Wm Waller, "Inv"]

LITTLE LEIGHS, St John Evangelist
?ESp; ogee-arched canopy of clunch over recess in N
wall of chancel; cusped and subcusped arch rests on
shafts with foliate capitals; E spandrels carved with oak
leaves & acorns; W with leaves; upper 2 spandrels have
heads surrounded by foliage; canopy terminates in large
foliate finial; flanking pinnacles rise to height of finial;
recess contains oak effigy of priest that may be
contemporary with it; was such an effigy removed for
Easter rituals? Mid 14c; il Box, between pp. 64 & 65;
Chancellor, "Es Church XIV," fig. 3; RCHM 2, opp. p.
173.

LITTLE SAMPFORD, St Mary
?ESp; outline of blocked recess with 4-centered arch
visible on N wall of chancel may be walled-up ESp; 15c.
[RCHM 1]
ESp ntd Comm inv 1552:
ij. shetes that served the sepulcre. [Wm Waller, "Inv"]

LITTLE TOTHAM, All Saints
ESp* ntd Comm inv 1552:
Item a stoke of mony to the sum of viijs. which ys in
ye hands of John Whylok that was ye mayeing mony ye
which was certefied to ye mayntenynyng of ye sipulcre
lyght. [King, "Inv"]

LITTLE WALTHAM, St Martin
ESp* ntd inv c.1400:
Wyllyam Massyngham hath y gove iiij ken to systeyne
with the torches, & the same Willyam, hath gove a cow
for to susteyne a lygt be fore the sepulcre. . . .
Thomas Sewell gaf a cow for to susteyne a lygt be fore

the sepulcre. . . . John Osebarn gaf a cow to susteyne
two tapores be fore ye sepulcre. [Brian S. Smith]

LITTLE WARLEY, St Peter
ESp* ntd will of Sir Jn Tyrell, 20 Feb 1541:
I give to the said church all the clothes that be usyd
about the sepulcar every year. [King, "Ancient Wills
(No. 3)"]
Also ntd Comm inv 1552:
Imprimis to Mr. John Tyrrell, esquyer, ij vestments,
one albe, one hangyng for the sepulker xls. [King,
"Inv"]

MARGARET RODING, St Margaret
?ESp/founder's tomb; recess with low ogee arch in N
wall of chancel; crockets & finial; stop in form of
woman's head; late 14c. [Pevsner; RCHM 2]

MUCH HORKESLEY
*ESp ntd Comm Inv 1552:
Item a clothe of Counterfet gold for the sepulcar. [Mus-
kett, "Church Goods"]

MUNDON, St Mary
ESp* ntd 1517 will of Jn Garyngton:
I geve and bequeth to the churche of Mundon xxx ewes
of iij yeres of age for ij Tapurs brennyng yerely afore
the sepulchre at the fest of Easter as long as the
worlde doth stonde. [King, "Excerpts"]

PLESHEY, Holy Trinity
ESp* ntd College inv 1527:
j Coverynge of Cloth of Golde lyned with lynnyn Cloth
for the Sepulcour. [Hope & Atchley]

PRITTLEWELL, Priory of St Mary (Cluniac)
ESp* ntd Comm inv 1538:
 In the Vestry
Sold. Item a cloth of bawdekyne for the sepulcure at
xxd. [Fowler, "Inv Es Monasteries"]

PURLEIGH, All Saints
?ESp/founder's tomb; recess in N wall of chancel at
pavement level; segmental pointed arch on stilted jambs;
whole arch molded; hood mold hacked off; width 6'6" x
height 5' x depth 1'4"; 14c; il Chancellor, "Es Church
V," fig. 3. [RCHM 4]

RAINHAM, SS Helen & Giles
ESp* ntd Comm inv 1552:
Item sold to Thomas Keys lately dycessed, ij paynted
clothes for ye sepulcre non solutus. [King, "Inv"]

RAMSEY, St Michael
?ESp; recess in N wall of chancel; cinquefoiled head
rests on shafted jambs with capitals & bases; 14c.
[RCHM 3]

RICKLING, All Saints
?ESp; large recess at E end of N wall of chancel; ogee
arch with finial; recess contains 2 slabs, one of
Totternhoe stone, other of Purbeck marble; some
restoration; 14c. [Pevsner; RCHM 1]

ROMFORD, Virgin Mary & St Edward Confessor or St Edward
Confessor
ESp* ntd Comm inv 1552:
Item ij peces for the sepulcre, of damaske embrodered
with clothe of gold frenged with sylke. [King, "Inv"]

SAFFRON WALDEN, St Mary
ESp* ntd churchwardens' accts 1445:
Recepti ex moneta collecta in die Pasche pro collectores
pro cera mortarioli propter sepulcrum domini vijs. jd.
In primis solutus pro remocione sepulcri domini nostri
&c. jd.
Item soluti pro panno lineo propter sepulcrum predictum
ijs. jd.
Item soluti Roberto Stystede pro pictura vnius panni
linei propter sepulcrum domini xvjd.
1470:
Payed to ye ofyseres of ye scherche for setyng up of
sepewker ijd.
1474:
Hec sunt Nomina hominum qui habent & receperunt
lumina vocantes Tapres pertinentes ad communem lumen
sepulcri erga festum Pasche in Walden anno regni regis
Edwardi iiijti xvmo. [List of names follows, each person
with a 3 1/2 lb. taper.] [Braybrooke]

SHELLEY, St Peter
ESp* ntd Comm inv 1552:
Item a sepulcre with a paynted clothe. [King, "Inv"]

SOUTHCHURCH, Holy Trinity
ESp & tomb recess; 2 recesses in N wall of chancel
below, low segmental cusped & sub-cusped arch in
square head containing tomb chest with 7 cinquefoil-
headed panels & modern slab; above this, 2nd recess,
presumably ESp, with molded jambs & cusped &
sub-cusped flat segmental arch; late 14c. [Pevsner;
RCHM 4]

STANFORD-LE-HOPE, St Margaret
?ESp/tomb; ogee-headed recess in N wall of chancel

contains tomb chest paneled with quatrefoils & shields; above, cinquefoiled arch, crocketed gable with finial, & flanking paneled buttresses with finials; on back wall of recess indent for brass of fig with scroll; recess 14c; tomb chest c.1500; il RCHM 4, opp. p. 105; Chancellor, *Ancient ?*, Pl. CLVI.

STRETHALL, St Mary
ESp/tomb; canopied tomb chest in N wall of chancel near E end has panels with quatrefoils; partly recessed canopy with molded 4-centered arch; brass inscription at back of recess; engaged shafts flanking recess support richly molded cornice; tomb to Jn Gardyner (d. 1508), lord of manor & patron of church, wife Johane Wodecok, & their son Henry; il RCHM 1, opp. p. 296. [Pevsner]

THEYDON GARNON, All Saints
ESp/tomb; chest with canopy set in N wall of chancel; chest of gray marble paneled with 2 cusped lozenges & blank shields formerly filled with brasses, & 3 cinque-foil-headed panels; canopy has flat arch, horizontal in center with quadrant curves, & frieze of quatrefoils above; brasses at back of recess: kneeling figs of man & wife facing each other; he in armor, with 2 sons behind him; 3 daughters behind her; indents of inscriptions, shields, Trinity; c.1520. [RCHM 2; VCH 4]

TOLLESHUNT D'ARCY, St Nicholas
?ESp/tomb; chest in recess in S wall of chancel; chest cut down to form sedilia; canopy has flat arch & quatrefoil frieze; back of recess with indents for brasses of cross, inscription, & shields; front of chest now in N wall of chancel; slab in S porch; perhaps used as ESp in spite of unusual location; early 16c. [Pevsner; RCHM 3]

UPMINSTER, St Lawrence
ESp* ntd Comm inv 1552:
John Swane bought of Master Holyngworth ij Kene, the wyche fownde ij tapers a bought the sepulker. [King, "Inv"]

WALTHAM HOLY CROSS, Holy Cross & St Lawrence
ESp* ntd churchwardens' accts 1542:
payde for watching the sepulchre 4d. [said to recur in every yearly account]. [J. Ward]

WENNINGTON, St Peter or SS Mary & Peter
ESp* ntd Comm inv 1552:
Item our churche was Robbit iij tymes & sartyn

Implements takyn a way as . . . a sylken cloth yat dyd
hanke a fore the sepulker. . . . [King, "Inv"]

WEST THURROCK, St Clement
ESp* ntd Comm inv 1552:
Item a sepeter clothe. [King, "Inv"]

WETHERSFIELD, St Mary Magdalene or St Mary Virgin
ESp* ntd chantry certificate 1546 indicating a rood of
meadow left to church, yearly value of 12d. to be used
for ESp light & another rood of meadow yielding same
sum for same purpose given by Jn Pecoke. [Redstone,
"Chapels"]

WHITE COLNE, All Saints or St Andrew
?ESp; trefoil-headed recess with hollow-chamfered jambs
in N wall of chancel; 14c. [RCHM 3]

WICKHAM BISHOPS, St Bartholomew (formerly St ?Peter)
?ESp; rough rectangular recess of uncertain date in N
wall of chancel. [RCHM 2]
ESp ntd Comm inv 1552:
Fynally ther was other thyngs wych did perteyne and
belonge to ower church as . . . a veile cloth and other
clothes belongyng to ye sepulture . . . and diverse
other thyngs wych were stollen a wey when ower
church was robbedd and by whom we can nott tell.
[Fowler, "Church Goods Es"]

WITHAM, St Nicholas
?ESp; trefoil-headed niche with molded jambs in N wall
of chancel; 14c. [RCHM 2]

WIVENHOE, St Mary
ESp* ntd Comm inv 1552:
Item solde & delyuered to Wylliam Adams the sepulcre
cloth of course dyaper, Receyued therefore xs. [King,
"Inv"]

WOODHAM MORTIMER, St Margaret
ESp* ntd Comm inv 1552:
Church detts . . . Richard Chamberlayne for the
service of sepulcre viijd. ha. [King, "Inv"]

WRITTLE, All Saints
?ESp/tomb; recess in N wall of chancel with chest tomb
of Purbeck marble; chest has paneled front with brass
shields; tomb said to be of Rich Weston, Justice of
Common Pleas (d. 1572); recess appears to have been
altered, may be earlier. Il RCHM 2, opp. p. 273.

GLOUCESTERSHIRE (G) AND BRISTOL (Bl)

ASHLEWORTH, St Andrew & St Bartholomew
ESp* ntd will of Elenor Marshall, 26 Nov 1544:
To the forsaid churche a coew for this use, that the churchwardens and their successors shall put hur to hyre and the increase of the same cowe all way to contynue to fynde twoo tapers of 2 lb. of waxe to brune all way and from good fryday tyll Estur Day before the sepulcre in the said churche and for not so doynge the vicar nowe beynge and his successors vicars ther shall put the increase of the said cowe to any other use at ther discrecion for my sole helthe. [Hockaday]

ASTON BLANK, St Andrew
?ESp; deep rectangular recess with heavy canopy in N wall of chancel; crocketed gable; 14c. [Pevsner 2]

BERKELEY, St Mary Virgin
?ESp; recess on N side of chancel; 14c. [Pevsner 2]

BRISTOL, All Saints
ESp* ntd inv 5 March 1396:
Item I pannum de auro tincto pro sepulcro.
Item I pannum tinctum de quatuor militibus.
Also ntd inv c.1469 indicating items still in church from inv of 1396:
Item ij Steynyd cloths for the Sepulchre with iiij knyghtys & Mary magdalen.
Churchwardens' accts 1422:
Paymentes for makyng of the Sepulchre
for I ffrontell and I ffrange, ixs.
bread & ale 8 1/2d.
[other items]
total cost 47s. 2d.
Ntd inv 1 March 1470:
Item I Sepulchre.
Item .v. Battyllmentys y-gulte.
Item ij Crucyfyxys guld for the ij Endys of the Sepulchre.
Item iiij Boltys of Iren with ij Batyllmentes of Red.
Item I Clothe of Mary magdalen and iiij knyghtes for the Sepulchre.
Item I Clothe of staynyd werke powdryd with bryddes of gold for the same.
Item I Staynyd clothe powdryd with flowres of gold for the same.
Ntd inv 1496:
Item I ffrontell off Grene and blacke selke for the Sepulchre.
Item I ffrontell of Red and blakke Bokeram for the Sepulchre. [Atchley, "Some More Bl Inv"]

BRISTOL, Christ Church (formerly Holy Trinity)
ESp* ntd churchwardens' accts ?1534:
Item for waching the sepolkyr and coles xiijd.
1547:
Item paid to John Lewys ffor the wachyng of the sepulker xijd.
1554:
For watchyng the sepulcre iiijd.
1555:
To poyntts and rochetts for the sepulchre iijd.
Watching 4d.
1557:
Item for a corde to hange ye pascall and for a small corde to staye ye canabye over ye sepulcre vd. ob.
[Nicholls & Taylor]

BRISTOL, St Augustine the Less
?ESp*; chantry at altar of Holy Sepulchre founded in time of Edward III. [Nicholls & Taylor]

BRISTOL, St Ewen
ESp* ntd Church Book with records 1454-1584 in which payments for watching of ESp occur regularly from 1454-5 to 1517-8.
1455 inv:
Item the apparail of tre and Ire made for the Sepulcre. with the cloths steyned ther to ordeyned.
1458-9:
In primis for .a. batylment to hong a clothe ouer the sepulcre yn the chauncel ixd. ob.
Item for naylys ther to ob.
Item for tynned rek hokys ther to ob.
1463-4:
Item for colys at kepyng of the Sepulcre ijd.
1471-2:
Other Receytes
Also a grene couerlete of the yifte of Mawde Core that was wond to be sette aboute the Sepulcre.
1482-3:
Item For colys wachyng off the sepulcure id.
Item for bred and alle for wachyng of the sepulcre jd.
1484-5:
Item for wacchynge of the Sepulcure and brede and ale ixd.
1490-1:
Item for wacchyng of the sepulcre viijd.
Item for Colys the same tyme jd.
1501:
Item payd for waxing of the Sepolcor and for franc and Sens xd.
1514-5:
Item For wachynge off the sepulcure lyght viijd.

1517-8:
Item For wachen off the sepulker and colys ixd.
[remaining accounts survive only in 17c copies]
1547-8:
Item for watchinge the sepulcre viijd.
Item for dressinge of the sepulcar and nayles iiijd.
1555:
Item paid for Welsh burde to the sepulker vjd.
Item nayles to the sepulker iijd.
Item paid for paintinge the Cover of the sepulker xd.
[Masters & Ralph]

BRISTOL, St John Baptist
ESp* ntd inv 1470:
Item ij stoles and a pall of cloth of gold for the
Sepulcre.
Item ij pilowes oon blacke and another White for the
Sepulcre.
Item ij steyned clothes Damaske werk for the Sepulcre.
Also ntd churchwardens' accts 1542:
Item paid for the Sepullcur light ix tapers xij li. of
newe waxe at vjd. the li. mounte in monnay vjs.
[Atchley, "Some More Bl Invs"]
Churchwardens' accts 1558:
Item paid to William Sexton for watching the sepulker
is. ob. [Nicholls & Taylor]

BRISTOL, St Mary Redcliffe
ESp* ntd 1470 memorandum in parish records:
Memorandum that Mayster Canynges hath delyuered the
iiijth day of Iule in the yere of our lorde j Mille CCCC
lxx to Maister Nicholas Pyttes vicary of Redclif Moyses
Couteryn Phelip Bertlemewe & Iohn Browne procuratores
of Redclif bi foreseid A New Sepulchre well gilte with
fyne golde and a kever therto.
Item An ymage of god almyghty Risyng oute of the same
Sepulchre with all the Ordynance that longeth therto.
That is to sey A lath made of Tymbre And the yren
worke there to & cetera.
Item there to longeth hevyn made of Tymber & steyned
clothes.
Item hell made of Tymbue (& yren worke) with deuellz
the nombre of xiij.
Item iiij knyghtes Armed kepynge the Sepulchre with
hes wepyns in hare handes that is to sey ij speris ij
Axes with ij pavyes.
Item iiij peyre of Angelis whyingez for iiij Angellz made
of Tymber & well peynted // Item the ffader the
Crowne And visage The Ball with A Crosse vppon well
gilte with fine golde.
Item the holygoste Comynge oute of hevyn In to the
Sepulchre.

Item longynge to [Angeliz] the iiij Angellz iiij
Chevelers. [Pilkinton]
Also ntd churchwardens' accts 1549:
Item Received of John West and George Millet for
sepulchre lights vis.
1559:
Item payde unto the waxmaker for the making of the
sepullcar lyght the pascall the saunt taper the tapars
for the hye aweter And to xii li. of new waxe for the
makyng of the saide tapers xvs. [Nicholls & Taylor]

BRISTOL, St Nicholas
ESp* ntd inv 1433:
Jtem j cloth of Rede y-bete with gold for the sepulcur.
Also ntd 1481 document entitled "Howe the Clerke And
the Suffrigann of Seynt Nicholas Churche Aught to do":
The Clerke and the suffrygann to Dress vppe the
sepulcure takyng for a Soper vjd.
The Clerke and the suffrygann to se the lyght ouer
Estere evynn a-boute the Sepulcure takyng for ther
dyner--iiijd.
Ntd churchwardens' accts 1520-48 in which 2 "tapers for
the angels" or "angel-tapers" weighing 3 lb. mentioned
every year; ESp light, setting up, & watching ESp
mentioned regularly; 4d. for 2 lb. frankincense paid in
connection with ESp every year, with last mention on 23
April 1548.
Also ntd churchwardens' accts 1530:
Paid to the Clerkes to sett uppe the sepulcur, xd.
1532:
Jtem payd for pynnys & the mendyng of that the
sepulcre lyght hangyth on, ijd.
1534:
Paid at the makyng of the Sepulcre lyght in the Crowde
ffor wood and Collys, vd.
1540-1:
paid ffor vj yardes canwas to make a clothe to covyre
the sepullkere lyght, xxjd.
1541-2:
39s. 8d. paid for new frame of ESp & wax frame. Also:
paid to W tyler ffor setyng of ij postes yn the hy
awtyre to fastyn the frame, ijd.
1542-3:
Jtem ffor setyng vp & takeyng downe off the fframe of
the Sepulker when yt was showyd ffor to be gyllt,
iiijd.
1543-4:
Jtem paid to fyngall ffor hys hondy worke to ley the
gold apon viij Smale stremereys ffor the Sepulker, viijs;
ffor viij sperys ffor the flages, vjd; ffor bokeram to
make hosys ffor the sperys, ijd; ffor viij levys of
paper to Rowle the flages ynn, jd.

1553-4:
paid ffor makeyng of the Judas crose & the Judas ffor
the pascall & fformys ffor the sepulcur, vjd. [Atchley,
"Mediaeval Parish-Clerks"; Atchley, "St Nicholas"]

BRISTOL, St Philip
ESp* ntd chantry certificate 1548:
The land given to & for the mayntenance of ij Tapers to
burne abowte the Sepulchre in the same Church for
euer in the tenure of Henrye Jeffreys. [Maclean,
"Chantry Cert"]

BRISTOL, St Stephen
ESp* ntd inv 1494:
Jtem more a ffyne Shette ffor the Sepillcowre y-garnysd
with grenne Sylke.
[in a different & later hand] Jtem j silkyn towell for
the sepulcure and ij pewlus of silk of the gyft of
anassy hory. [Atchley, "St Stephen"]

BRISTOL, St Werbergh
ESp* ntd churchwardens' accts 1554:
Item for setting up the sepulcer xiid. [Nicholls &
Taylor]

BRISTOL, Trinity Hospital Chapel
ESp* ntd baliff's statement 1512:
Item paid to the waxmaker for x lb of new waxe for the
Sepulcre light at viid. a lb mot vs xd.
Item for a wachyng Tapir for the Sepulcre I lb and
quartr of new wax at viid. the lb mot viiid. [Leighton]

COLNE-ROGERS, St Andrew
?ESp/founder's tomb; round-headed recess in N wall of
chancel near E end cuts off part of splay of Saxon
window (N2); hood mold with stop in form of female
head on W; 13c; il Keyser, "Barnsley," fig. 81.

COWLEY, St Michael (now St Mary)
?ESp/tomb; ogee-arched recess in N wall of chancel below
small stone bracket for light; effigy of priest in recess;
14c. [VCH 7; Pevsner 1]

GLOUCESTER, Diocese of
ESp ntd both in Articles & in Injunctions of Bishop
Hooper for Gloucester & Worcester dioceses 1551-2:
that none of you maintain . . . sepulchres pascal.
that you exhort your parishioners and such as be
under your cure and charge for the ministry of the
church, to take down and remove out of their churches
and chapels, all places, tabernacles, tombs, sepulchres,
tables, footstools, rood-lofts, and other monuments,

signs, tokens, relics, leavings, and remembrances,
where such superstition, idols, images, or other
provocation of idolatry have been used. [Frere, *Visitation* 3]

GLOUCESTER, St Mary de Crypt
ESp; high recess in N wall of chancel; before restoration
of 1845 back of recess had painting of Christ stepping
from tomb with sleeping guards, & in 4 niches above
recess 4 holy women [possibly 3 holy women & angel?];
stonework described as "once gilt and painted"; squint
in opposite wall allows ESp to be watched from south
chapel; late 15c. [Cook, *EMPC*; Tristram, *14c*]

HAWKESBURY, St Mary
?ESp/tomb; wide recess with cinquefoiled canopy in N
wall of chancel; 14c. [Bethell; Pevsner 1]

LONGNEY, St Lawrence
?ESp; ogee-headed tomb recess in N wall of chancel with
medieval tiles; 14c. [VCH 10; Pevsner 2]

MINCHINHAMPTON, Holy Trinity
ESp* ntd churchwardens' accts 1555:
to Spennell for makyng off the sepulkyer, xijd.
to Rychard Rysley for watchyng the sepulker, xijd.
to Jhon Long for watchyng, vjd.
1556:
for mayng [sic] off the sepulkeyer, xijd.
for watchyng off the same, xijd.
1558:
for ye makeyng of ye sepulkar, xijd.
for pynes and nayelles for the sepulkar, ijd.
1559:
for poyntes, pynnes, and packe thredde for the
sepulture, ijd.
for makynge of the sayd sepulture and wacchynge of
the same, ijs. viijd. [Bruce]

SOUTHROP, St Peter
?ESp/tomb. [Brickhill]

STANLEY ST LEONARD or LEONARD STANLEY, St Swithin
(formerly Priory Church of St Leonard)
?ESp/aumbry; round-headed niche with zigzag molding &
vaulted soffit in N wall of chancel; ?12c. [VCH 10;
Pevsner 1]

STOWELL, St Peter (now St Leonard)
?ESp; deep niche in N wall of chancel; now mutilated;
14c. [Pevsner 1]

UPPER SLAUGHTER, St Peter
 ?ESp/tomb; arched recess with canopy in N wall of
 chancel; marked with a consecration cross; 14c; now
 contains late 17c tomb for Wanley family. [VCH 6;
 Pevsner 1]

HAMPSHIRE (Ha)

ALVERSTOKE, St Mary
 ESp* ntd Comm inv 1549:
 Item j hollon Shete . . . for ye sepulcre. [Craib,
 "1549"]

ANDOVER, St Mary
 ESp* ntd churchwardens' accts 1471. [Clutterbuck]

ANDWELL, Chapel of Priory dependent on Tiron Abbey (Bene-
dictine)
 ?ESp/founder's tomb; wide arched recess in N wall;
 possibly dated to eastward extension of chapel in 13c.
 [Cox, Ha]

ARRETON (ISLE OF WIGHT), St George
 2 chancels, with arcade between them, were maintained
 separately; aumbry in N wall of N chancel has recess 9"
 square & 5" deep cut in sill; also recess below E window
 of S chancel; either could have functioned as ESp.
 [VCH 5]

BISHOPSTOKE, St Mary
 ESp* ntd Comm inv 1552:
 ij coverynges of ye sepulcre. [Craib, "1552"]

CRONDALL, All Saints
 ?ESp/tomb; recess in N chancel contains tomb chest for
 Sir George Paulet (d. 1532); recess has depressed,
 straight-sided arch and flanking buttress shafts.
 [Pevsner]
 ESp ntd churchwardens' accts 1556 noting charge for 2
 tapers before ESp. [Stooks, Crondall]

EAST TISTED, St James
 ESp/tomb; canopied chest tomb with brass of Resur-
 rection for Rich Norton (d. 1556) & wife Eliz, erected
 1530-40; dates of death left blank in black letter
 inscriptions; chest paneled with shields & early
 Renaissance ornament; back of recess has brasses:
 Resurrection of Christ in center, Robt Norton kneeling
 to R with 8 sons, wife to L with 10 daughters; scroll
 reads "JESU CHRISTI FILI DEI MISERERE ME"; canopy

156 HAMPSHIRE

has 4-centered arch with tracery in soffit & plain cornice; monument now in church dated 1846; il Pevsner, Pl. 47. [VCH 3]

ELING, St Mary
ESp* ntd Comm inv 1552:
j old clothe for ye sepulchre. [Craib, "1552"]

ELLINGHAM, St Mary
ESp* ntd Comm inv 1552:
one shete for the sepulcher.
ij steyned clothes for the sepulcher. [Craib, "1552"]

FAREHAM, SS Peter & Paul
ESp* ntd Comm inv 1552:
a sepulcher clothe. [Craib, "1552"]

FORDINGBRIDGE, St Mary Virgin
ESp/aumbry; segmental-headed recess in N wall of chancel below blocked lancet win; rebated for door; width 2'8" & height 1'9"; early 13c. [VCH 4]
ESp ntd Comm inv 1552:
one sepulcre clothe yelow and blew saten of brydges. [Craib, "1552"]

FROYLE, St Mary
?ESp; N wall of chancel has pointed aumbry & broad, low tomb recess with segmental arch, under westernmost window; early 14c. [Pevsner; VCH 2]

HAMBLEDON, SS Peter & Paul
ESp* ntd Comm inv 1552:
vj painted clothes for the sepulcher. [Craib, "1552"]

KIMPTON, Church (dedication unknown)
?ESp/tomb; front of tomb recess remains in N wall of chancel; recess filled in so that present depth only 7"; round arch with 7 cusps; bases of jambs below present floor level; early 14c. [VCH 4]

KING'S-SOMBORNE, SS Peter & Paul
?ESp/tomb; recess in N wall of chancel with ogee head, molded & septfoiled; 14c; contains earlier effigy of priest. [Pevsner; VCH 4]

MEON-STOKE, St Mary or St Andrew
?ESp/tomb; 2 tomb recesses with segmental arches on opposite sides of chancel between windows; each contains marble coffin lid; 14c. [VCH 4]

MILFORD (-ON-SEA), All Saints
ESp* ntd Comm inv 1552:

ij sepulcre clothes. [Craib, "1552"]

OWLESBURY, St Andrew
?ESp/tomb; recess below window in N chancel; early 14c.
[VCH 3]

PORTSEA, St Mary
ESp* ntd Comm inv 1552:
a paynted clothe for the sepulcre. [Craib, "1552"]

QUARLEY, St Michael
?ESp/tomb; low recess with pointed segmental arch in N
wall of chancel near E end; length 7'; mid 14c. [VCH 4]

SILCHESTER, St Mary
?ESp/aumbry; small recess with pointed arch in N wall of
chancel near E end; 13c; il Adams, Pl. 18.

SOUTH WARNBOROUGH, St Andrew
?ESp/tomb; Perp tomb recess in N wall of chancel; small
kneeling figs of Sir Tho White (d. 1566) & family
against back wall of recess; 4-centered arch with Tudor
cresting above; lack of Renaissance detail in archi-
tecture, unusual for this date, suggests recess is
pre-Reformation & figs added to ESp reused as tomb
monument after Reformation. [Pevsner; VCH 3]

STOKE CHARITY, St Michael
?ESp/tomb; chest tomb in N wall of chancel under arch
open to N (Hampton) Chapel; tomb chest plain; Purbeck
marble slab set with brasses of Tho Hampton (d. 1483)
in armor, wife Eliz Dodington, 2 sons, & 6 daughters;
Trinity above figs; inscriptions & shields. [Pevsner;
VCH 3]

WINCHESTER, Cathedral, Holy Trinity, SS Peter, Paul, Swithin
Chapel of Holy Sepulchre under crossing may have been
used for ESp; chapel, entered from N, built in 2
rib-vaulted bays in late 12c; vaults painted in dis-
temper with series of paintings of c.1230 from An-
nunciation to Last Judgment; beneath these, earlier
series; cycle begins in vaults with roundels of Christ
with evangelist symbols, Annunciation, Nativity, &
Annunciation to Shepherds; below bust of Christ, who
holds book with "Salus populi ego sum" & is enclosed by
arch of vault, Deposition from Cross, & (further down)
Lamentation; these from earlier series, later paintings
of same subjects having been removed from wall & now
displayed against W wall of chapel; in Deposition, large
cross dominates composition, standing directly below
bust of Christ above (3'4" high); below, altar; side
walls have Entry into Jerusalem, Harrowing of Hell,

Hortulanus & perhaps Last Judgment with sts & martyrs below; W wall, mutilated by installation of organ, presumed to have had Crucifixion; emphasis on Deposition & Lamentation, as well as traditional name of chapel, & location on N side of crossing, suggest ESp erected here; il Rickert, Pls. 113a & b; Tristram, *13c*, Pls. 28-54; Borenius & Tristram, Pls. 7-10.
ESp ntd in charges against Bishop Gardiner, when he appeared before Council in 1548, that he had allowed certain ceremonies in past Holy Week, among them ESp. [Feasey, "ESp"]

WINCHESTER, College Chapel
ESp* ntd chapel acct rolls ?15c:
In cordulis et splintris emptis pro sepulchro dominico vid. obol.
1453-4:
Et in solutis pro v tabulis de Waynyscote emptis pro Rotis campanarum predictarum et pro novo sepulchro fiendis, precium tabule cum cariagio ixd., iiis. ixd. [Chitty]

WINCHESTER, Kingsgate, St Swithin
ESp* ntd Comm inv 1552:
a lynnen clothe thatt servyd for the sepulcre payntyd. [Craib, "1552"]

WINCHESTER, St George
ESp* ntd Comm inv 1552:
Here foloeth the bestowynge and destrubuttynge of the money that was reseyvyd for the churche goodes afore wrytton yn this inventory. . . .
Payd wacheing of sepulker at Easter iiid. [Craib, "1552"]

WINCHESTER, St John
?ESp/tomb; recess formerly near E end of N wall of N aisle possibly used for ESp; recess taken down in mid 19c restoration; contained paneled chest tomb now in NE angle of chancel; front has 3 shields, 2 with initials TS; center shield has 5 wounds & shield at end has emblems of Passion; edges of plain slab once had fillet of brass with inscription. [Baignent]
ESp ntd churchwardens' accts 1554-7:
for watching the Seculpre [sic] 8d.
Paid to Maistress Alin for a Sepulcre Cloth 10s. 4d.
1557-9:
Paid for watchying the Sepulcre for 2 years & for Prayers 2s. 2d. [I. C. Collier]

WINCHESTER, St Lawrence
ESp* ntd Comm inv 1552:

Goodes of the churche solde by the parishenars yn the fourth yere of Kynge Edwarde ye vj[th]: Solde a olde coverlett, a olde canopie, and ye sepulchre clothe. [Craib, "1552"]

WYKE or WEEKE, St Anastasius (now St Mary)
?ESp; recess with pointed arch on N side of chancel; 13c. [Cox, *Ha*]

HEREFORDSHIRE (He)

ALMELEY, St Mary
?ESp/tomb recess in N wall of chancel; round arch, cusped & subcusped, under ogee label; in back wall, squint from vestry; much restored; early 14c; il RCHM 3, Pl. 78. [Pevsner]

DILWYN, St Mary
?ESp/tomb recess & ?ESp/aumbry in N wall of chancel; rebated late 13c aumbry has cinquefoiled head; tomb recess, containing effigy of cross-legged knight in mail, has segmental pointed head with ballflower ornament & crocketed gable; early 14c; tomb recess il RCHM 3, Pl. 78.

FOWNHOPE, St Mary
?ESp/tomb recess in N wall of chancel with high, segmental pointed arch; also plain square recess in N wall of chancel against E corner; 14c. [RCHM 2]

HEREFORD, Cathedral, St Ethelbert
ESp* ntd *Depositio* in Hereford Ordinal of 14c, London. British Library MS. Harl. 2983:

<Depositio>

postea a sacerdotibus *sancta crux ante hostium* sepulchri *deportetur.* & *lauetur cum* vino & aqua & *lintheo* *tergatur choro interim submissa uoce cantante uel potius* lamentante. *hoc Responsorium.*
 Tenebre *facte* sunt <dum crucifixissent Jesum Judei, et circa horam nonam exclamavit Jesus voce magna, Deus meus, ut quid me dereliquisti? Et inclinato capite, emisit Spiritum. Tunc unus ex militibus lancea latus eius perforavit, et continuo exivit sanguis et aqua>.
cum versu.
Responsorium.
 Ecce uidimus <eum non habentem speciem, neque decorem: aspectus eius in eo non est: hic peccata nostra portavit, et pro nobis dolens: ipse autem

vulneratus est propter iniquitates nostras. Cuius
livore sanati sumus>.
Antiphonam.
Proprio filio <suo non pepercit Deus, sed pro
nobis omnibus tradidit illum>.
Antiphonam.
Dominus tanquam <ovis ad victimam ductus est et
non aperuit os suum>.
Antiphonam.
Oblatus <est, quia ipse voluit, et peccata nostra
ipse portabit>.
Responsorium.
Ecce quomodo <moritur iustus et nemo percipit
corde, et viri iusti toluntur et nemo considerat; a
facie iniquitatis sublatus est iustus. Et erit in
pace memoria eius>.
dum ponitur in sepulchro. cantent. *Antiphonam.*
In pace in idipsum <dormiam et requiescam>.
Antiphonam.
Caro mea <requiescet in spe>.
episcopus thurificet sepulchrum & crucem. & accenso
intus cereo. claudat sepulchrum. chorus humiliter
prosequatur. *Responsorium.*
Sepulto domino <signatum est monumentum,
volventes lapidem ad hostium monumenti; ponentes
milites qui custodirent illud>.
episcopus stans ante sepulchrum solus cantet
Antiphonam.
Memento mei <Domine Deus, dum veneris in regnum
tuum> finetenus.
[f. 30; fig. 18; cf. Lipphardt, No. 405]
Also ntd *Elevatio* in Hereford Breviary printed in Rouen
in 1505:
Post mediam noctem ante matutinas et ante campanarum
pulsationem conveniant omnes clerici in capitulum, et ibi
ordinata processione precedant ceroferarii et
thuribularii cum cruce, episcopo et decano in albis
revestitis, dictis episcopo et decano et omnibus aliis
canonicis cereos extinctos in manibus gestantibus,
omnibusque luminaribus ecclesie preter cereum paschalem
et preter cereum infra sepulcrum extinctis, incipit
cantor antiphonam
Cum rex glorie <Christus infernum debellaturus
intraret, et chorus angelicus ante faciem eius
portas principum tolli preciperet, sanctorum
populus, qui tenebatur in morte captivus, voce
lacrimabili clamaverat: Advenisti desiderabilis,
quem expectabamus in tenebris, ut educeres hac
nocte vinculatos de claustris. Te nostra vocabant
suspiria; te larga requirebant lamenta; tu factus
es spes desolatis, magna consolatio in tormentis,
alleluia>.

submissa voce ut magis lamentationem et suspiria
representet quam cantum, et sic progrediantur ante
sepulchrum. Finita antiphona, episcopus et decanus
accedant ad ostium sepulchri, episcopus humili voce
antiphonam
 Elevamini <porte eternales, et introibit rex glorie>
fine tenus cantet; chorus respondeat
 Quis est iste rex glorie? dominus virtutum, ipse
 est rex glorie.
Episcopus vel executor officii paulo altius cantet
antiphonam
 Elevamini
ut supra. Chorus similiter
 Quis est iste rex glorie? dominus fortis et potens,
 dominus potens in prelio.
Episcopus tercio altius cantet *Elevamini* ut supra.
Chorus similiter
 Quis est iste rex glorie? dominus virtutum
ut supra.
Tunc aperto sepulchro epyscopus vel executor officii
ingrediatur sepulchrum et ablato amictu crucem et
sacramentum thurificet, inde cereum quem tenet
accendat a cereo infra sepulchrum, ex quo omnes alii
cerei accendantur.
Postea epyscopus vel executor officii elevans crucem et
sacramentum coniunctim de sepulchro, incipiat
antiphonam
 Domine abstraxisti <ab inferis animam meam>,
et fine tenus cantet chorus psalmum
 Exaltabo te, Domine <quonian susceptisti me>.
prosequatur, et in fine post unumquemque versum
psalmi fiat repetitio antiphone, scilicet
 Domine abstraxisti <ab inferis animam meam>,
quousque sancta crux ab epyscopo vel executore officii
super altare offeratur, et quousque vexilum sancte
crucis appositum fuerit; et vexilo apposito epyscopus
vel executor officii incipiat hunc versum
 Consurgit Christus tumulo,
choro prosequente
 victor redit de baratro <tyrannum trudens vinculo,
 et reserans paradisum>;
deinde episcopus vel executor officii
 Quesumus, auctor omnium,
chorus
 in hoc paschali gaudio <ab omni mortis impetu tuum
 defende populum>,
epyscopus vel executor officii
 Gloria tibi, Domine.
Hic omnes genuflectant, et pulsentur omnia signa, choro
prosequente
 Qui surrexisti a mortuis <cum Patre et Sancto
 Spiritu in sempiterna secula>.

Tunc epyscopus alta voce incipiat antiphonam
Surrexit dominus de sepulchro qui pro nobis
pependit in ligno, alleluya, alleluya, alleluya.
Epyscopus vel executor officii dicat versiculum
Dicite in nationibus,
Responsio
Quia dominus regnavit in ligno, alleluya.
Oratio.
Deus qui pro nobis <filium tuum Crucis patibulum
subire voluisti, ut inimici a nobis expelleres
potestatem, concede nobis> famulis tuis, ut
resurreccionis eius gratiam consequamur;
que terminetur sic
Per eundum Cristum Dominum nostrum.
Chorus respondeat
amen.
Ne precedat nec sequatur Dominus vobiscum nec
Benedicamus domino.
Tunc accendantur duo cerei, et ponantur a dextris et a
sinistris crucis, non amoueantur usque ad processionem.
Sepulchro vero stet ostio aperto vacuum usque post
vesperas hac die in testimonium resurrectionis.
Postea redeant in Capitulum eodem ordine quo venerunt.
Epyscopus vero hac die post debitam campanarum
pulsationem assumptis pontificibus ascendat ad sedem
suum: et ibi incipiat matutinas hoc modo. [Frere &
Brown, pp. 324-5; cf. Lipphardt, No. 406]

KINNERSLEY, St James
?ESp; as at Dilwyn & Fownhope, 2 recesses in N wall of
chancel, one large, as for tomb recess, other aumbry
with trefoiled head, rebated for door & grooved for
shelves; late 13c. [RCHM 3]

LEDBURY, St Michael & All Angels
?ESp; recess in N wall of chancel with 4-centered head;
late 15c or early 16c. [RCHM 2]

LETTON, St John Baptist or St Peter
?ESp; wide tomb recess in N wall of chancel with
segmental arch; pierced cusping & sub-cusping;
discovered walled up in late 19c; some restoration; late
13c or early 14c. [Pevsner]

LITTLE HEREFORD, St Mary Magdalene
?ESp/tomb; pair of recesses in N wall of chancel; each
has ogee gables with crockets over segmental pointed
arches; each flanked by paneled pedestals; E recess
contains slab incised with fig of woman in veiled
headdress, her feet on lion; mid 14c; perhaps pairing
of tomb & ESp; chancel il RCHM 3, Pl. 78.

MADLEY, Nativity of B V Mary or St Mary
?ESp/aumbry; top of middle light of E window has
panel of Women at Tomb; below window, rectangular
aumbry, now with modern door, ?ESp; 14c. [RCHM 1]

PUDLESTON, St Peter
?ESp; recess in N wall of chancel, probably tomb recess,
mostly destroyed by arch to organ chamber; 14c.
[RCHM 3]

ROSS-ON-WYE, St Mary
?ESp/tomb; recess in N wall of chancel with 2-centered
head; late 13c. [RCHM 2]

STRETTON GRANDISON, St Lawrence
?ESp; recess in N wall of chancel with segmental pointed
arch; also rectangular aumbry rebated for doors; late
14c. [RCHM 2]

TARRINGTON, SS Philip & James or St James
?ESp/tomb; recess in N wall of chancel with ogee arch,
dog-tooth & ballflower ornament, gable above with
crockets, foliate carving in spandrels; contains later
effigy; early 14c; il RCHM 2, Pl. 181.

UPPER SAPEY, St Michael
?ESp; small, trefoil-headed recess in N wall of 12c chan-
cel. [RCHM 2]

WALFORD-ON-WYE, St Leonard or St Michael & All Angels
?ESp; trefoil-headed recess in N wall of chancel, re-
bated for doors; modern sill; early 14c. [RCHM 2]

WESTON BEGGARD, All Saints or St John Baptist
?ESp/tomb; recess in N wall of chancel with 2-centered
arch, cusped & sub-cusped; ballflower ornament &
head-stops; early 14c; il RCHM 2, Pl. 188; also rec-
tangular aumbry with iron hooks for doors & modern
head.

HERTFORDSHIRE (Ht)

ARDELEY, St Lawrence
?ESp/tomb; recess in N wall of chancel near E end with
dogtooth ornament; jambs have short shafts; 13c. [VCH
3]

ASPENDEN, St Mary
?ESp/tomb; wide recess in N wall of chancel under 13c
lancet near E end; pointed arch under ogee gable with
finial; traceried spandrels; crenellations at top; flanking

164 HERTFORDSHIRE

recess, buttresses with crocketed gables; early 15c but
restored. [Pevsner]

BISHOPS STORTFORD, St Michael
ESp* ntd churchwardens' accts 1431-40:
Et in custis circa elevationem et depositionem sepulcri in
primo anno hujus compoti cum obolo in clavis pro eodem
sepulcro iijd. ob.
Et in expensis circa elevationem et depositionem
sepulcri ij^o anno hujus compoti iijd.
Et circa elevationem et depositionem sepulcri iij^o anno
hujus compoti iijd.
Et circa elevationem et depositionem sepulcri $iiij^{to}$anno
infra compotum cum clavis pro eodem ijd. ob.
Et circa erectionem et depositionem sepulcri v^{to} anno
infra tempus compoti cum ob. in clavis et ob. in filo
iiijd.
Et circa erectionem et depositionem sepulcri vj^{to} anno
infra tempus compoti ijd.
Et circa elevationem et depositionem sepulcri anno vij^{mo}
infra tempus hujus compoti ijd.
Et circa elevationem et depositionem sepulcri anno $viij^{vo}$
infra tempus compoti--cum ob. in filo ijd. ob.
Et circa erectionem et depositionem sepulcri ix^{no} anno
infra tempus hujus compoti cum ijd. sacristae pro
custodia luminum vd.
Et de viijd. per annum per aliam cartam sic oneratis in
rentali pro j pecia terrae dicti Walteri Blankes in
Aptonfeld juxta Goodwynesstyle et hic allocantur qia non
solvit istis computantibus nec debet ut dicit sed invenit
annuatim unum cereum ardentem coram sepulcro pro
eodem redditu prout sibi fuit injunctum per Ricardum
Bregge nuper vicarium ut dicit Ideo allocantur pro ix
annis vjs.
1482:
payd for settyng up of the sepulcur and takyng downe
iijs. vjd.
1499 [trans. from Latin by Glasscock]:
Receipts:
The issues of drinkings made for a new sepulchre 14s.
Collected of various parishioners for the new Sepulchre
11s. 5d.
[Paid] For making the new sepulchre 46s. 8d.
1505:
Item for settyng up and taking downe the sepulcre and
nayles to the same vd.
1532:
Item paid to Joobe for makyng of the ffunt and
sepulker xs.
1537 inventory:
Item a sepulker of bourde.
1542:

Item paid for naylis for the orgons and Sepulker jd.
1547:
Item paid to Roger Trenham for settyng up and takyng
downe of the sepulker at Ester iiijd.
Comm inv 1548:
Item a sepulker of bourde.
Left owte of this Inventory at the makyng of yt that is
caryed away bysydis the thyngs that they left forth of
ther inventory at Ware that they have caried away in
lyke maner with owte the assent of the parisshoners
ther.
ffyrst the frame belongyng to the sepulker.
Goods sold 1552:
Item the sepulker sold to Thomas Westwood for vs.
Item the tymber and bourds of the schreevyng howse of
the old orgons and of the sepulker price vjs. vjd.
[Glasscock]

BROXBOURNE, St Augustine
?ESp/tomb; canopied chest tomb of Sir Wm Say (d.
1529), donor of N chapel, on N wall of chancel; chest
paneled with cusped squares set diagonally, in each,
shield & indent of fig, brasses now missing; slab Pur-
beck marble; underside of crested canopy has fan
vaulting with pendants; under E end of canopy slab
with indents of man in armor & woman; early 16c.
[VCH 3]

BYGRAVE, Church (dedication unknown)
?ESp/tomb: recess in N wall of chancel under flattened
arch; chancel late 14c. [RCHM; VCH 3]

CHESHUNT, St Mary (Benedictine Nunnery)
ESp* ntd Comm inv 1538:
A sepulchre of waynscott vjs. viijd. [Walcott, "Dis-
solution"]

DIGSWELL, St John Evangelist
?ESp; deep recess in N wall of chancel E of arch into N
chapel; recess, which has 4-centered head, may orig-
inally have opened into chapel; 15c. [RCHM; VCH 3]

FLAMSTEAD, St Leonard
?ESp; shallow, arched recess in N wall of chancel near E
end; presumably part of remodeling of chancel c.1330-
40; NE corner of N aisle has series of Passion scenes:
Last Supper, Christ before Pilate, Mocking of Christ,
Crucifixion, Entombment, & Resurrection; 14c. [RCHM]

FURNEUX PELHAM, St Mary
?ESp; small recess in N wall of 13c chancel with modern
trefoil-arched head. [RCHM; VCH 4]

HUNSDON, Church (dedication unknown)
?ESp/tomb; arched recess in N wall of chancel; splayed arch with Perp paneling; above arch, 3 shields with coats of arms; Latin inscription for Francis Poynz (d. 1528), said to be later than monument. [E. Morris]

KNEBWORTH, St Mary
?ESp; small, low, arched recess with Perp moldings in N wall of chancel E of arch to N chapel; 16c. [A. Anderson; RCHM; VCH 3]

MUCH HADHAM, St Andrew
?ESp/tomb recess in N wall of chancel between 2 door-ways; height about 4'; recess has ogee gable, carved finial, & stops with shields; il Gregory, opp. p. 138; VCH 4, opp. p. 58.

REDBOURN, St Mary
ESp; ogee-headed recess in N wall of chancel; early 14c; ntd medieval bequest for ESp light. [VCH 2]

SAINT ALBANS, Cathedral, St Alban
ESp* ntd 1460 donation of Abbot Jn Wheathamstead of money for 12 candles "ardere circa sepulchrum Domini." [Heales, "ESp," citing *Vetusta Monumenta* 3]

SANDON, All Saints
?ESp in form of small recess between Win N2 & N3, both of late 14c; recess 2' in length, has depressed arch; like sedilia & piscina, recess has ogee gable, crocketed; formerly had door; il VCH 3, opp. p. 270.

SARRATT, Holy Cross
ESp & square-headed aumbry in N wall of chancel both date from 14c when chancel was lengthened; ESp has modern trefoiled head. [VCH 2]
ESp ntd 1502 will of Jn Rowe referring to ESp light. [VCH 2]
Also ntd medieval inv:
a cloth for the Sepulchre. [A. Anderson]

TRING, SS Peter & Paul
?ESp; rectangular recess in N wall of chancel below 13c lancet window (Win N2). [Evans, *1307-1461*; VCH 2]

HUNTINGDONSHIRE (Hu)

ALWALTON, St Andrew
?ESp/tomb; recess beneath Win N2 in chancel opposite sedilia; recess has arch with segmental, pointed head & molded label with head stops; late 13c. [RCHM; VCH 3]

BLUNTISHAM, St Mary
?ESp; round-headed recess in N wall of chancel at W
end; date uncertain. [RCHM; VCH 2]
ESp ntd 1512 will of Jn Coke leaving one quarter of
barley to ESp guild. [Cirket]
Also ntd as sold by churchwardens in list of goods sold
or lost between 15 February 1549 & Comm inv 1552:
a sepulchre and a vaile for viijs. [Lomas]

BRINGTON, All Saints
ESp* ntd Comm inv 1552:
Item one sepulchre hanging of lynnen. [Lomas]

EASTON, St Peter
ESp* ntd as sold by churchwardens in list of goods sold
or stolen between 15 February 1549 & Comm inv 1552:
a sepulchre clothe for iijs. [Lomas]

HUNTINGDON, All Saints
ESp* ntd 1528 will referring to ESp light. [VCH 2]

KIMBOLTON, St Andrew
ESp* ntd Comm inv 1552:
Item . . . ij painted clothes for the sepulchre. [Lomas]

LEIGHTON BROMSWOLD, St Mary
?ESp/aumbry; recess with trefoiled head, stone shelf, &
rebated jambs in N wall of chancel opposite double pis-
cina; late 13c. [Pevsner; VCH 3]

ORTON LONGUEVILLE, Holy Trinity
?ESp; steeply-pointed recess in N wall of chancel just
outside altar rails; width 7" x height 2' 10" at highest
point; 1320-30. [Royston]

PIDLEY, All Saints
ESp* ntd 1512 will of Wm Hye leaving 12d. to ESp light.
[Cirket]

ST IVES, Bridge Chapel of St Leger or St Lawrence
?ESp*; small niche at E end of N wall; 15c. [VCH 2]

ST IVES, St Ivo or All Saints
ESp* ntd list of goods sold or stolen between 15 Febru-
ary 1549 & Comm inv of 1552:
Solde by Thomas Sisson and Thomas Pallmer, church-
wardenes ther, with the assent of the most parte of the
parochineres, a pillowe of vellvett, a sepulchre of
woodde and one handebell for iiijs. viijd. [Lomas]

SOMERSHAM, St John Baptist
ESp* ntd 1527 will of Agnes Bell leaving bequest for
gilding high altar & ESp. [VCH 2]

SOUTHOE, St Leonard
> ESp* ntd as sold by churchwardens in list of goods sold or stolen between 15 February 1549 & Comm inv 1552: a painted sepulchre. [Lomas]

STANDGROUND, St John Baptist
> ?ESp; plain rectangular recess in N wall of chancel; early 14c. [RCHM; VCH 3]

SWINESHEAD, St Nicholas
> ?ESp/tomb; recess in N chancel; 2-centered molded arch, cinquefoil cusped & sub-cusped; spandrels have leafy carving; through W end of recess, shouldered doorway opens on passage to former vestry at E end of N aisle; 14c. [Pevsner; VCH 3]

UPTON, St Margaret
> ESp/tomb; recess with segmental, pointed arch & foliated stops low in N wall of chancel; 14c.
> ESp ntd 1538 will of Agnes Day leaving 2 bushels of wheat to ESp. [VCH 3]

WYTON, All Saints
> ESp* ntd Comm inv 1552:
> Item . . . a sepulchre of wood with a lynnen clothe paynted. [Lomas]

YAXLEY, St Peter
> ?ESp; N chapel has 4 post-Resurrection scenes painted on S wall in spandrels above arcade; from E to W, standing Christ with long hair & beard; next Hortulanus: Christ with cross-staff wearing pink cloak with white collar & Mary Magdalene kneeling in black cloak; Road to Emmaus, with 3 male figs; Doubting Thomas, with Thomas kneeling before Christ with cross & vexillum; aumbry in E wall of N chapel, & another in N wall of chancel; Road to Emmaus il VCH 3, opp. p. 245.

KENT (K)

ACRISE, St Martin
> ESp* ntd 1513 will of Js Mawger:
> A cow of the value of 8s., to keep a taper to burn every year about the Sepulchre, the time of Easter. [Hussey, *Test Ct*]

ASHFORD, St Mary Virgin
> ?ESp/tomb; large tomb chest of Sir Jn Fogge (d. 1490) N of high altar; sides of chest carved with alternating niches & quatrefoils; of his brass, only head with helmet survives; also brass of angel holding inscription.

[Pevsner, *W K*]
ESp ntd 1493 will of Tho Wilmott, vicar:
To the Light of the Resurrection, 6s. 8d. [Hussey,
Test Ct]
Also ntd Comm inv 1552:
Item j whit clothe of sarcenet for the sepulcre.
Item ij grene sylke clothes of . . . for the sepulcre.
[Walcott, Coates, & Robertson]

BEARSTED, Holy Cross
ESp* ntd extract from *Comperta et Detecta* books of Con-
sistory Court, 1562:
It is presented that the hole where the sepulchre was
wont to lie is undefaced. [Woodruff, "Progress"]

BECKENHAM, St. George
ESp* ntd numerous bequests to ESp light, including 1543
will of Ralph Langle:
every year during seven years one taper of wax of the
weight of 3 lbs. to the Sepulchre light in the said
Church. [Borrowman]
Also ntd Comm inv 1552:
Item ij sepulcre clothes with thapparells paynted of
lynnen clothe. [Walcott, Coates, & Robertson]

BETHERSDEN, St Margaret
ESp* ntd will of Stephen Glover (d. 1493):
the Feoffees of his lands and tenements shall enfeoff 12
honest persons of the parish, in his land called
Wosbriggs to them and their assigns for ever, that with
the yearly profits they shall find a taper of 3 lbs. of
wax to burn in the church afore the Sepulchre, from
the time of divine service done afore noon on Good
Friday unto Christus Resurgens' be sung and
procession be done in the morning upon Easter day.
And from that time the taper to burn in divine service
until Wednesday in Easter week be done. [Hussey, *K
Obit*]
Also ntd churchwardens' accts 1524-5:
and from hense furght the substanse of the parissh
bene accordid and aggreed that every man that hath a
cherche cow to ferm shall yerly paye the ferme to the
cherche wardennys that is to say for every cow xiid. to
be paid yerly at the fests as to every man here unther
wretyn as to hym shall be appoyntid. . . . And every
man that hath a cherche cow to ferm shall fynde suerte
that the said cow shall be furght cummynge when the
parish doth requere here and also for the ferm that it
be truly payd at the fests assynenyd. ffirst one William
Sandyr orden fyve kene to the cherche and every man
that had a cow of the said fyve kene sholde yerly for
ever orden a tapyr price of xiid. to set up before a

emage in the cherche as to hym was assyneyd by the
last wylle of the said William Sandyr, the whiche said
fyve kene be now in the custody of John Chapman,
William Glover senior, German Glover, leonard holnest
and Nicholas lodar, where as now from hense furght
every man that hath a cow in his custody of them that
the said Sandyr orden shall yerly paye the ferme of
them to the cherche wardennys at the fests here unther
wretyn as to every of them shall be appoynted ffirst
the said John Chapman to paye the ferme for his cow
the thursdaye before gud frydaye or els to delyvere a
tapyr uppon gudfryday to the cherchewardenns to the
full value of xiid. and the said tapyr to be set up
before the sepulcure and there to bren at all Divyne
servyce all the Easter holidayes and then to be take up
and set up before the emage of oure lady in the hye
chauncell and ther to bren as longe as he wylle indure,
if so be the said John Chapman be disposyd to the
delivere up his cow and no longer have her to ferm
then he to geve the cherche wardenns a quarterys
warnenynge before gudfriday for the whiche cow and
ferme William Glover the elther hath promysid &
grauntid to be suerte for the said John Chapman that
the cow shall be furght cummynge or xs. for here.
1530:
makyng of the nyw work for the sepulcur iiiis. iiiid.
[Mercer]

BEXLEY, St Mary Virgin
ESp* ntd Comm inv 1552:
Item j candlestick of latten, one olde painted clothe for
the sepulcre. [Walcott, Coates, & Robertson]

BOBBING, St Bartholomew
ESp* ntd 1533 will of Alex Braknoke:
That wife Marion during her life find a taper of 3 lbs.
of wax to burn before the Sepulchre. [Hussey,
Test Ct]

BORDEN, SS Peter & Paul
ESp* ntd 1474 will of Jn Strangbowe:
Light of the Sepulchre in the Church, one bushel of
barley. [Hussey, Test Ct]

BRABOURNE, St Mary
ESp/tomb; canopied tomb of Caen stone for Sir Jn Scott
(d. 1485) in N wall of chancel; no effigy or brass;
chest, paneled with quatrefoils, sits under 4-centered
arch with vaulted soffit; quatrefoils in circles decorate
spandrels of arch; above arch, tracery in panels under
embattled cornice; il Scott, "Brabourne," fig. 5. [Pevs-
ner, NE & E K]

ESp ntd Comm inv 1552:
Item a cloth of silk that was used to be laid uppon the
sepulcre. [Walcott, Coates, & Robertson]

BRASTED, St Martin
ESp* ntd 1431 will of Jn Chaundeler, Rector of Brasted:
[Corpus meum ad] Sepeliendum infra cancellum ecclesie
mee loco scilicet vhi sepulcrum dominicum tempore
pascali stare consuetum est. [Duncan, "Shoreham"]

BRIDGE, St Peter
ESp* ntd 1535 will of Wm Aleyn:
To the Sepulchre at Easter for ten years one taper of 6
lbs. [Hussey, *Test Ct*]

BURMARSH, All Saints
ESp* ntd 1541 will of Jn Chamber:
To the Sepulchre Light, 4d. [Hussey, *Test Ct*]

CANTERBURY, All Saints
ESp* ntd Comm inv 1552:
Item a litill monstros of sylver clene gylte for the
resurrection.
Item ij pyllers for to bere the sepulcre lyght.
Item a sepulcre cloth of red & blew chamlett. [Walcott,
Coates, & Robertson]

CANTERBURY, Christ Church (Cathedral & Benedictine
Priory)
?ESp* ntd ?*Depositio* in Decretals of Lanfranc (d.
1089), Durham, Cathedral Chapter Library, MS. B iv.
24:
Quod si conuenerint aliqui vel clerici, vel laici
uolentes adorare crucem, portetur eis crux in alium
locum ubi aptius adorent eam. Quae si per chorum
transierit, flexis ad terram genibus adoretur a
fratribus, non simul omnibus, sed sicut portabitur coram
eis. Adorata ab omnibus cruce, portitores eius eleuantes
eam incipiant antiphonam
 Super omnia ligna cedrorum <tu sola excelsior, in
 qua vita mundi pependit, in qua Christus trium-
 phavit, et mors mortem superavit in eternam>,
et sic uadant ad locum ubi eam collocare debent. Tunc
omnes petant ueniam flexis ad terram genibus.
[Knowles, *Monastic Constitutions of Lanfranc*, p. 41;
cf. Lipphardt, No. 396]
Also ntd Sacrist's Rolls 1392-3:
Also from the lord William, Archbishop, for the lights
of the sepulchre, in the last and present year, £1. 6s.
8d.
1394-5:
From the lord Archbishop for the lights of the Easter

Sepulchre 13s. 4d.
1398-9:
From the lord Roger Walden, late Archbishop, for the
Easter Sepulchre 20s. [Woodruff, "Sacrist's"]
Ntd treasurers' accts 1553:
Item, for paynting the Sepulchre and other necessaries
iiijs. [Woodruff, "Progress"]

CANTERBURY, Diocese of
ESp ntd Article 57 of Archbishop Cranmer's Articles of
1548 for Canterbury Diocese:
Whether they had upon Good Friday last past the
sepulchres with their lights, having the Sacrament
therein. [Frere, *Visitation* 3]

CANTERBURY, St Alphege
ESp* ntd 1486 will of Margareta Chirche:
Light of the Sepulchre in the Church, a taper of 5 lbs.
of wax, so that it remain for five years next after my
death. [Hussey, *Test Ct*]
Also ntd Comm inv 1552:
Item a sepulcre with a frame wherof the parson hath
the one syde.
Item ij chaunge of hangyngs to the same sepulcre.
[Walcott, Coates, & Robertson]

CANTERBURY, St Andrew
ESp* ntd inv 1485:
Item v yerdds of gren towl for ye sepuclker.
Watching of ESp ntd churchwardens' accts from 1507-8
to 1547-8 & 1554-5 to 1557-8; early payments for ESp
watching to clerk; from 1522-3, 2 men watched.
1507-8:
Item in pryk for the sepulture ob.
1509-10:
Item for mendyng of the sepulture tymber ijd.
1517-8:
Item payed for coolis in washyng ye sepultyr ijd.
1518-9:
Item paied to Johan Copyn for nayle and pynnys for
the sepulcure id.
Item paied for cools for them that wacchyd the
sepulture and for brede and drynk iijd.
1521-2:
Item payd for wachyng the sepulkere ij nytys kepyng
the lyte and colys to weche with and haloyng fe xd.
1524-5:
Item payed to ij men watchyng the sepulture and for
coolys viiid.
1526-7:
Item payd for wachyng of the sepulcwre and for bred
and drynke for the wachers xd.

1527-8:
Item paied to ij men wacheyng the sepulcre viiid.
Item paied for collys ijd.
Item paied for Bred and Drynke for that ij men id. ob.
1538-9:
Item paide to barns and his sonne ffor ij nyghts
watcheyng abowte the sepulture viiid.
Item yn bred and drynk ffor them ijd.
1545-6:
Item payd to ij men for wachyng of ye sepulture viiid.
Payd for bred and drynk for them ijd.
1546-7:
Item payd to ij men for wachyn of the sepulture viiid.
And for bred and drynk for them ijd.
1547-8:
Item paid to ij men for watchynge of the sepulcre and
for bred dryng and coles xiiiid.
1554-5:
Item paide for goodman Wood for makinge clene of the
churche dore and for watchynge of the sepulcher and
for coles and for a kee for the steple dore ijs. jd.
Item paide toe toe men for one nights watchinge of the
sepulcher viiid.
Item for coles vid.
Item for drinke id.
1555-6:
Item a c of nayles for ye sepulcher ijd.
Item unto goodman absle ande goodman Bekerstaffe for
wachynge of ye sepulcher viiid.
1556-7:
Item paid for setting uppe the seputure and neyles for
the same iiijd.
1558-9:
Payed to goodman lawncelot for takyng downe ye
sepullture and ye Imagys under ye clowthe iiijd. [Cotton, "St Andrew"]

CANTERBURY, St Dunstan
ESp* ntd churchwardens' accts 1491:
Item payde for nayles for the chest and to the sepulcre
ijd.
1492:
Item payde for colis at Ester and nayles for the
sepulcre iiijd.
1498:
Item payde to them that whacched the sepulcre for ij
yeres iiijd.
1500:
Item payde for ij yeres for settyng vppe of the
sepulcre wacchyng and colis vjd.
Item payde to the Clarke for wacchyng of the sepulcre
and colis in ij yeres vjd.

Ntd inv 1 May 1500:
A clothe staynyd off the resurreccion for the sepulcre.
1504-8:
Item for wecchyng of the sepulcre for iij yere ixd.
Item for nayles to set vppe the sepulcre for iij yere ijd.
1508-14:
Item for wacchers aboute the sepulcre iij yere iiij ob.
Item for ij men to wache the sepulcre ijd.
Item to Wellar and to his fellow for wacchyng aboute the sepulcre iijd.
1522-4:
Item for wacchyng of the sepulcur and brede and drynke for ij yeres ixd.
1525:
Item for wacching the sepulcur at Ester iiijd. ob.
Item for charcoles then iiijd. ob.
Item for prigs and nayll for the sepulcure and the rodeloft jd. ob.
1526:
Item for charecoles at Ester iiijd.
Item for wacchyng of the sepulcur then iiijd. ob.
1527-8:
Item for wacchyng of the sepulcre for ij yeres and drynk ixd.
1533:
Item for wacchyng of the sepulcre iijd.
Item for brede and drynke for the seid wacchers jd. ob.
1538:
Item for wacchyng of the sepulcre iijd.
Item for brede and drynke for the wacchers jd. ob.
1539-40:
Item for wachyng and for brede and drynk iiijd. ob.
Item for bred for those yat watched jd.
1540-4:
Item for wasshyng of the Churche clothes for iij yeres for coles for scowryng of the candlestyckes iij yeres for watchyng of ye sepulcher and for brede and drynke viijs. jd. ob.
1545:
Item for collys and wachyng at Ester for ij yere ixd.
1546:
Item for wachyng of ye sepulcar and for brede and drynke iiijd. ob.
Item for wachyng ye sepulker thys yere iijd.
1548:
Item layd owt for wachynge of the sepulker and for bred and drynke iiijd. [Cowper, *St Dunstan's*]

CANTERBURY, St John's Hospital without Northgate
ESp* ntd Comm inv 1546:

xiiii peices for the Adorninge of the Sepulcher. [Cotton, *Canterbury*]

CANTERBURY, St Martin
?ESp/founder's tomb; arched recess in N wall of chancel with chamfered slab over sarcophagus; called "Queen Bertha's tomb"; probably tomb of restorer of church in 12c. [Routledge]
?ESp/aumbry; recess with linen-pattern door in N wall of chancel; end 15c. [Heales, "ESp"]

CANTERBURY, St Mildred
ESp* ntd 1472 will of Roger Rydle:
Light of the Sepulchre of the Saviour, 40s. [Hussey, *Test Ct*]

CANTERBURY, St Peter
?ESp; recess in N wall of chancel with depressed ogee arch. [Pevsner, *NE & E K*]

CANTERBURY, Priory of the Holy Sepulchre
?ESp* ntd 1522 will of Joan Ridar:
Buried in the Church of Holy Sepulchre, that is to say, within the part before the Sepulchre. [Hussey, *Test Ct*]

CHALK, St Mary
ESp* ntd 1439 will of Isabella Tebold:
Item coram sepulcro domini in ecclesia de Chalk. [Duncan, "W K"]

CHALLOCK, SS Cosmas & Damian
?ESp; opening in N chancel to chapel.
ESp ntd 1503 will of Joan, widow of Robt Thurston:
A taper of 1 lb. before the Sepulchre at Easter. [Hussey, *Test Ct*]

CHARTHAM, St Mary
?ESp/tomb; chest in N wall of chancel has trefoiled arches with foliate cusping; after 1200. [Pevsner, *NE & E K*]

CHELSFIELD, St Mary
?ESp; coped marble tomb chest in recess in N wall of chancel for Robt de Brun, rector (d. 1417); has indents for brasses of crucifix with Mary & John. [Pevsner, *W K*]
ESp ntd 1468 will of Wm Whythed:
Item I wille that William Whythed the yenger shall fynde a taper brennyng by fore the sepulker at Ester of iij li wex duryng hys lyue.
ESp ntd 1509 will of Alice Bray (her brass in church):
A taper iij li wax to bren before the sepulture of ouer

lorde within the said church at the tyme of Easter that
is to saye from goode fridaye to thursdaye in the Ester
weke to be brennyng at tymes conuenyant according as
other ligthes be wonte and used to be kept there about
the sepulture. [Duncan "W K"]

CHISLEHURST, St Nicholas
ESp/tomb; arched recess of c.1470 in N wall of chancel
near E end; slab has brass of Alan Porter, rector (d.
1482); Steele's notes from 1732:
against the east end of the north wall there was for-
merly an altar tomb before an arch then filled up; the
top stone was remaining and projecting forward from
the wall without any support beneath, and upon it was
the Alan Porter brass.
ESp ntd Comm inv 1552:
Item ij stayned lynnen clothes, on for the sepulcre,
thother for the roode. [Webb]

CLIFFE, St Helen
?ESp/tomb; recess in N wall of chancel opposite sedilia
has wide cinquefoil-cusped & subcusped arch under
square head; above, row of lion's heads & leaves, then
crenellated cornice resting on head stops supported on
narrow buttressed shafts; late 14c; il Martin, opp. p.
77. [I. Lloyd; Pevsner, W K]

COBHAM, St Mary Magdalene (Collegiate)
ESp* ntd inv 1479:
j pannus rubeus aureus pro sepulchro.
j pannus albus de serico pro sepulchro cum frontello de
nigro velvett.
j frontellus de viridi pro sepulchro. [Hope, "Colours"]

COWDEN, St Mary Magdalene
ESp* ntd 1510 will of Rich Wiggenden the Elder:
I bequethe 4 Kyne to be delivered to the
Churchwardens of the Churche of Cowden, that is to
say one of v lb. wax to bren before the Sepulture
uppon Good fridaye and in the tyme of Easter, and that
taper and 2 tapers more every of them 2 lb 1/2 to be
set before the image of our Lady. [Leveson-Gower]

CRANBROOK, St Dunstan
ESp* ntd inv 13 April 1509:
Also ij paynted clothis for ye sepulker & a fronte to
hang under ye taperrs. [Vallance, "Cranbrook"]

CRAY (ST MARY CRAY), St Mary
ESp* ntd 1508 will of Rich Bery:
To be buried in the high Chaunsell of Seynt Mary Cray
bifore the sepulcre ther. [Duncan, "Shoreham"]

CUDHAM, SS Peter & Paul
?ESp/tomb; paneled chest in chancel ?N; canopied niche
above its E end; Perp. [Pevsner, W K]

CUXTON, St Michael
ESp* ntd 1538 will of Jn Absolon:
To the giltyng of the Sepulchre which I wold be
payntyd and giltyd before the feaste of Eastre xxs.
[Duncan, "W K"]

DARTFORD, Holy Trinity
ESp* ntd 1533 will of Jn Morley:
My feoffy Robert Derby to cause a taper of iiij li. wax
standing in the church of Dertford before the sepulcre
at Easter everi yere.
ESp ntd 1530 will of Wm Lownde:
[I will] that the lamp afore Sainte Clement and fyve
tapers at the high awters end and the sepulcre tapre
and a square taper before the Rode be kept and
maynteyned by myn executors for oon yere. [Duncan,
"W K"]

DEAL (UPPER), St Leonard
?ESp/aumbry; recess in N wall of chancel with stilted
segmental head & rebated for door. [Woolaston et al.]

DEPTFORD, St Nicholas
ESp* ntd 1471 will of Jn Baines & other wills mentioning
ESp light. [Duncan, "W K"]

DOVER, St John Baptist
ESp* ntd 1514 will of Jn Bingham:
To the Light of the Sepulchre, three tapers each of 6
lbs. of wax. [Hussey, Test Ct]

DOWNE, Church (now St Mary the Virgin)
ESp* ntd Comm inv 1552:
on sepulcre of wood. [Walcott, Coates, & Robertson]

EASTLING, St Mary
?ESp; row of trefoiled arches on caryatids in N wall of
chancel; ?date. [Pevsner, NE & E K]
ESp ntd 1475 will of Jn Cherch:
The Sepulchre Light have a cow or 6s. 8d. [Hussey,
Test Ct]

EDENBRIDGE, SS Peter & Paul
ESp* ntd inv 1510:
4 clothys for the sepulcer. [Leveson-Gower, "Inven-
tory"]
Also ntd will of Barnard Creke, dated 16 July 1513:
I will that Thomas Medehurst shall do for my soull and

all Christen soulles yerly xiid. of the house of
Lynhurst in dirige masse and ryngeing and he shall
find yearly a taper before the Sepulcre v li wex.
[Leveson-Gower, "Notes"]

ELMSTONE, Church (dedication unknown)
ESp* ntd 1529 will of Alex Stonard:
A cow to the maintaining of two tapers for ever, one
before the Image of Our Lady and the other before the
Image of St. Peter; and the taper before St. Peter
shall be stricken at two times in the year, that is,
against Easter to burn at the Sepulchre, and against
the Feast of St Peter next after midsummer day. [Hus-
sey, *Test Ct*]

ELTHAM, St John Baptist
ESp* ntd Comm inv 1552:
Item j sepulcre with paynted clothes to cover the same.
[Walcott, Coates, & Robertson]
Also ntd churchwardens' accts 1554:
Item paid for Settinge vp of ye Sepullchere iiijd.
Item paid for Takenge doune of the same iiijd.
Item paid for watchenge the same ij nightes viijd.
1555:
Item paid for Seattinge upe of the Sepulchere and
takenge downe the same viijd.
Item paid for watchinge the Sepulcher for ij nights
viijd.
1556-7:
Item paid for xvj li. of onewe waxe for the pascall and
for the tapers about the zepulcher and the roud lofte
with the iiij tapers and Judas lighte at xijd. by amounts
xvjs.
Item paid for setting vp and takinge doune the
zepulcher viijd.
Item paid for watchinge the Sepulchar ij night viijd.
1557-8:
Item paid for watcinge the Sepulcher ij night viijd.
Item paid for settinge vp of ye sepulcher and takinge
doun the Same viijd.
1559:
Item paid for settinge vpe the Sepulcher iijd.
Item paid for takinge downe the same iiijd.
Item paid for watchinge the Sepulchre ij nithes xvjd.
[Vallance, "Eltham"]

FAVERSHAM, Abbey of Holy Saviour (Benedictine)
ESp* ntd will of Thebaude Evyas, proved 8 April 1479:
To the monastery my great cloth of tapestry work, to
do worship to God in their presbitery, and on the
Sepulchre next the high altar on high days. [Hussey,
"Faversham Abbey"]

FAVERSHAM, St Mary of Charity
ESp/tomb; canopied chest of Caen stone in N wall of
chancel under Win N2 for Lady Joan Norton; chest, on
7" ashlar step, has front paneled with shields, marble
slab on top; above chest, set 1' into wall, indents for
brasses of kneeling woman with scroll connecting her to
representation of Christ with cross-staff rising from
tomb & inscription; openwork canopy resting on 2 oc-
tagonal shafts, height 6', divided into 3 bays with imi-
tation tierceron vaulting underneath & 3 crocketed ogee
gables above; entire monument width 7'6" x height 11' x
depth 2'6"; Lady Norton not buried here; il F. Lam-
barde, opp. p. 109; shields & indent of brass, p. 109.
[Pevsner, *NE & E K*]
ESp ntd inv 1512:
Item, a steyned clothe of red with clowdys for the
sepulcre.
Item, xxxvij lytell baner clothes of sylke for the
sepulcre & the pascall. [Giraud]
Also ntd 1523 will of Elis Overton, widow:
To the Blessed Resurrection in the Parish Church, a
dozen taper dishes of laton, price 14d. the pece. [Hus-
sey, *Test Ct*]
ESp/tomb commissioned by Lady Joan Norton of Faver-
sham in 1535 will:
Item I will that myn executours shall fynyshe upp my
tombe in ffeversham churche according to the bargeyn
that I have made with oon Alen a mason of Bersted in
Kent. And it to be used for a sepulcre place in the
same churche to the honour of God and the blessed
Sacrement. [F. Lambarde]

FRINDSBURY, All Saints
ESp* ntd 1441 will of Roger Lorkyn:
Ad lumen Sancti Sepulcri vjd.
Also ntd 1526 will of Alice Langley:
To the sepulcre ligth of Frendesbury a cow for a taper
of iiij li wex before the sepulcre the ester tyme. [Dun-
can, "W K"]

FRINSTEAD, St Dunstan
?ESp; arched recess in N chapel; 14c. [Pevsner, *NE & E
K*]
ESp ntd 1481 will of Vincent Keneworth:
To the Light of the Sepulchre, a wax taper of 3 lbs.
[Hussey, *Test Ct*]

GRAVESEND, St Mary or St George
ESp* ntd 1491 will of Alis Flower:
To the lyte a boute the sepulcre att Easter a taper of
viij li. [Duncan, "W K"]

GUSTON, St Martin
ESp* ntd 1499 will of Wm Page:
To the Light of the Sepulchre, 3 lbs. of wax, and 3s.
4d. in money.
Also ntd 1525 will of Jn Bewysfield:
To the Pascal Light, and a taper before the Sepulchre,
a cow.
Ntd 1531 will of Edward Prescote:
For a taper of 4 lbs. of wax to burn before the
Sepulchre of Our Lord in the Church every Easter for
ever, and maintaining of the Pascal, a cow. [Hussey,
Test Ct]

HALSTEAD, St Margaret
ESp* ntd 1528 will of Wm Petley:
To the mayntenance of the Sepulcre light in Halsted
Church a Taper of wax iiij lb. weight for euer to be
contynued and yerely ayenst Ester to be made of the
weight of iiij lb. of wax with the weight of the olde
stock of the said Taper, and after the light of the holy
sepulcre be taken down yerely in the Ester weke I will
the stock of the said sepulcre taper be sett before the
forsaid ymage of our lady, and it there to be light and
brent at conuenient tymes. [Duncan, "Shoreham"]

HALSTOW (LOWER), St Margaret
ESp* ntd will of Jn Oseborne (d. 1480) stipulating that
after death of his wife Joan:
his croft of 4 acres in Halstow at the common way
leading to North Wodesdown, was to go to the use of
the Sepulchre light in Halstow church for evermore.
[Hussey, *K Obit*]
Also ntd 1502 will of Tho Love:
Also I wul that halsto church shal haue a cowe to
maynten a taper to bren a fore the Sepulcr for
euermore.
Ntd 1534 will of Tho Love:
To the Sepulcre ligtht viijd. [Duncan, "W K"]

HAWKHURST, St Lawrence
ESp* ntd churchwardens' accts 1548:
Item, of William Smyth for an olde sepulcre Frame iiijd.
[Lightfoot]

HEADCORN, SS Peter & Paul
ESp* ntd 1476 will of Tho Fuller:
To the Light upon the Sepulchre, 3s. 4d.
Also ntd 1498 will of Wm Blechinden:
Light of the Sepulchre, 4d.
Ntd 1499 will of Stephen Boycott. [Hussey, *Test Ct*]

HIGH HALDEN, St Mary
ESp* ntd 1504 will of Tho Harlakinden:
Light of Holy Sepulchre in the Church of Halden, 2
lbs. of wax. [Hussey, *Test Ct*]

HIGHAM, St Mary
ESp* ntd 1441 will of Js Falk:
Lumen Sancti Sepulcri ijd. [Duncan, "W K"]

HOO (ALL HALLOWS), All Hallows
ESp* ntd 1503 will of Tho Plott.
Also ntd 1514 will of Raffe Graves:
To the bachilars light before the Sepulcre ij moder
schepe.
Ntd 1533 will of Jn Andrewe:
To ye sepulture lyght on moder [c]ow. [Duncan,
"W K"]
Ntd churchwardens' accts 1557:
Item to Wylliam Bozer for makyng the sepolcar ijd.
[Buckland]

HOO (ST MARY'S HOO), St Mary
ESp* ntd 1525 will of Jn Hall:
To ve sepulcre light a mother shepe. [Duncan, "W K"]

HORSMONDEN, St Mary or St Margaret
ESp* ntd 1484 will of Jn Bobbe alias Toty, clerk:
Corpus meum ad sepeliendum in cancella ecclesie de
Horsmonden coram ymagine beate Margarete virginis
super quod corpus ad decus ecclesie volo vt vna tumba
construatur super quamquid tumbam sepulcrum
dominicum preparari velim. Lego Sancto Sepulcro aliud
linthiamen. [Duncan, *Test Ct*]

HUNTON, St Mary
?Esp/tomb; recess with cusped ogee arch in N wall of
chancel; Dec; 13c. [Pevsner, *W K*]

HYTHE, St Leonard
?ESp; recess in N wall. [Evans, *1307-1461*]
ESp ntd churchwardens' accts 1412-3:
Item . . . in clavis pro sepulcro. [Mackson &
Robertson]

KINGSDOWN, St Catherine
ESp* ntd 1451 will of Jn Medehurst:
Lego ad faciendum unius panni honesti pro ornamento
sepulchri in dicta ecclesia xld. [Duncan, *Test Ct*]

KINGSNORTH, St Michael
ESp* ntd 1524 will of Jn Meryett, rector:
To the Church, three kine to find three tapers, one to

burn at Easter about the Sepulchre, another before Our Lady, and the third before St. Katherine. [Hussey, *Test Ct*]

LEWISHAM, St Mary
ESp* ntd Comm inv 1552:
Item iij sepulcre clothes of lynnen.
Item one clothe for the same of sylke. [Walcott, Coates, & Robertson]

LEYBOURNE CASTLE, Chapel
?ESp; remains of recess in N wall of chapel at E end; recess projected 8" from wall, depth 2' & width 4'8"; 12c. [Fielding]

LITTLEBOURNE, St Vincent
ESp* ntd 1509 will of Robt Kenton:
A taper of 5 lbs. of wax to be kept and maintained to burn before the Sepulchre. [Hussey, *Test Ct*]

LUDDENHAM, St Mary
ESp* ntd 1474 will of Jn Wode:
Two tapers of wax to burn about the Sepulchre in the Church. [Hussey, *Test Ct*]

LULLINGSTONE, St Botolph
?ESp/tomb of Sir Jn Peche (d. Jan 1522) in N wall between chancel & N chapel, open to both; Peche was Constable of Dover & Warden of Cinque Ports; canopied tomb with extremely elaborate carving by ?Torregiano; effigy of Peche in plate armor lies under plain slab visible through 3 arches; canopy has low pointed arch under high, elaborate cornice; decorative carving includes peaches for Peche, pomegranates for Katherine of Aragon, & Tudor rose; il Robertson, "Lullingstone," opp. p. 103. [Pevsner, *W K*]

LYDD, All Saints
ESp* ntd churchwardens' accts 1519-20 to 1546-7, during which time payments for watching of ESp occur regularly.
1521:
Item paid for makyng of the sepulcre, 3s. 6d.
1527:
Item paide for mendyng of Sepulture and mendyng of the Case of the best Crosse, 4d.
1540-1:
Item paid for pynnys for the Sepulcre and mendyng the Stoppe of the churche, 1d.
1543:
Item for pynnys & nailes to the Sepulcre, 3d.
1544:

Item paid for nayles and pynnys for the Sepulcre, 1d.
1546-7:
Item paid for nayles for the Sepulcre and for makyng
clene the Censers agenst Ester, 2d.
1553:
Item payde to Aton for 4 dayes worke he and his man
makynge ye sepulcre ye Judas and ye churche style eny
day 2s. 6d., 10s.
Item paid to Aton for tymber to make ye sepulcre, 16d.
Item paid to bennes for watchynge ye sepulcre and
helpynge ye sexten at ester, 12d.
Item paid to him [William Hever] for watchinge ye
Sepulcre at ester and mendynge ye Albes, 8d.
1554:
Item payde to hever for makynge ye lent clothe and
trymmynge the fframe aboute ye Sepulker, 18d.
Item payde to william hever for watchynge ye Sepulker
and helpynge ye sexten, 12d.
Item payde to wylliam hever for watchynge ye sepulker
lykewyse, 8d.
1555:
Item payde to beames for watchinge ye Sepulcre,
Item payde to hever ye same tyme, 8d.
1556:
Item payed to Willyam bennes for watchinge in the
churche at Ester, 12d.
Item payed for bredde and drinke ye same tyme, 2d.
Item payed to heuer also for watchinge ye same nighte,
8d. [Finn]

LYDDEN, St Mary
ESp* ntd visitation of Archdeacon Harpesfield 1557:
To provide a Sepulchre this side Easter. [Vallance,
"Lydden"]

LYMINGE, SS Mary & Ethelburga or St Eadburg
ESp* ntd 1464 will of Jn Fetell:
Light of the Resurrection, 2d.
Also ntd 1465 will of Wm Wodhill.
Ntd 1478 will of Wm Brokeman:
Light of the Resurrection, a lb. of wax.
Ntd 1481 will of Robt Dene & 1490 will of Henry Rand.
Ntd 1497 will of Js Deryng:
Light of the Holy Sepulchre, one bushel of barley.
[Hussey, *Test Ct*]

LYMPNE, St Stephen
ESp* ntd 1479 will of Jn Harryson:
Light of the Sepulchre, 8d. [Hussey, *Test Ct*]

MAIDSTONE, All Saints (Collegiate)
ESp* ntd Comm inv 1548:

Item ix peces of garnyshing whyche served to the sepulchre some be smale and all be narro. [Woodruff, "Maidstone"]

MARGATE, St John Baptist
ESp* ntd 1480 will of Js Jordan:
Light of the Holy Sepulchre, 4d. [Hussey, *Test Ct*]

MILTON REGIS, Holy Trinity
ESp* ntd will of Jn Wulford, 28 June 1484:
To the parish-clerk for the Sepulchre of Christ a taper of 10 lbs. of wax, and for maintenance a cow.
Also ntd will of Rich Underwode, 11 Dec 1534:
That my Executors find my taper in the church before Our Lady, yearly to be renewed at Easter and to burn before the Sepulchre, all times after before Our Lady in St John's Chapel upon Our Lady Feasts, and after the death of my wife 10 lbs. of wax to the same.
Ntd will of Elisabeth Snelling, 22 May 1538:
Executor make against my burying five tapers each of 3 lbs. of wax to burn about my herse at my burial and month's mind. . . . After the month's day . . . two be new striken and made one taper, to burn about the Sepulchre and maintained by Executor for seven years. [Hussey, "Milton"]

MINSTER-IN-SHEPPEY, Convent of St Sexburga
ESp* ntd Comm inv 1536:
ij stoles embroderyd and one of red sendall for the sepulchre. [Walcott, "Inv Shepey"]

MINSTER-IN-THANET, St Mary
ESp/aumbry; tall, narrow opening with pointed arch in N wall of chancel; height nearly 5'. [Robertson, "Minster Church"]

NETTLESTEAD, St Mary
ESp* ntd will of Jn Pympe, 7 August 1496:
my body to be buried in the quere of the parishe churche of Nettilsted aforesaid before the Image of oure blessed lady in the selfe place where as the Sepulture of oure lorde is wounte to stonde at the Fest of Ester and so to be leyde there in a tombe of stone made under suche forme as the blessed sacremente and the holy crosse may be leide upon the stone of the said tombe in maner of sepulture at the Feeste abouesaide. [Livett]

NEW ROMNEY, St Martin (church removed 1550)
ESp* ntd receipts of goods of St Martin's Church, 1550:
Item Receyved of thomas belomie ffor the sepulcre fframe viijd.

Item Receyved of Christoffer cowcheman ffor the tombe
of ye sepulcre xijd. [Walker & Rutton]

NEW ROMNEY, St Nicholas
 ?ESp/tomb; recess with pointed arch in N wall of chapel;
 arch had semi-circular cusping in relief on attached
 columns with capitals; above cusping, continuous band
 of large square flowers along straight & slanted sides
 of arch; above this, molding resting on head corbels at
 upper corners; when stone slab and masonry removed in
 1837, cavity was revealed (length 36" x width 10")
 containing man's bones; 14c; il Robertson, "Romney
 Marsh," p. 474.

NEWINGTON, St Mary
 ESp* ntd 1472 will of Robt Beresforth:
 Light of the Sepulchre of the Lord, 3 bushels of barley.
 Also ntd 1500 will of Jn Sawyar:
 To the Sepulchre Light, 6s. 8d.
 Ntd 1502 will of Alice Sayer:
 Light of the Sepulchre to the maintaining of four
 tapers, every taper of 6 lbs. of wax, four quarters of
 malt. [Hussey, *Test Ct*]

NONINGTON, St Mary
 ?ESp/tomb; recess with arched molding in N chapel;
 pierced by later window; ?date. [Pevsner, *NE & E K*]
 ESp ntd Chantry Certificate 1548:
 The chapelle of Nonyngton annexed to the College of
 Wingham. Light lands geven to the churche of
 Nonyngton by whom it is not known for the
 mayntenaunce of towe tapers to burne yerelye at Ester
 upon the Sepulcre there for ever. [Hussey, *K Obits*]

NORTHBOURNE, St Augustine
 ESp* ntd 1484 will of Jn Grigge of Fyngelesham:
 Buried in the Church of St. Augustine of Norborne, in
 the Chancel where the Sepulchre of the Lord on Easter
 Day is situated, or before the Image of Blessed Mary in
 the same Church. [Hussey, *Test Ct*]

NORTH-CRAY, St James
 ESp* ntd 1527 will of Wm Swetesyre:
 I will that Petir Strodyll of North Craye shall kepe
 yerely two tapers of fyue pounds wax burnyng before
 the sepulcre within the said church foreuermore for
 which he hath a certayn parcell of lond of me called
 Williams londe in the parishe of Northcray. [Duncan,
 "W K"]

NORTHFLEET, St Botolph
 ?ESp; recess in N wall of chancel. [Heales, "ESp"]

ORPINGTON, All Saints
ESp; recess in N wall of chancel. [Young, *Drama* 2]
ESp ntd 1468-9 will of Wm Whythed of Chellesfelde:
Item, y wille that William Whythed the yenger shall
fynde a taper at Orpyngton brennyng by fore the
sepulker at Ester of iij li. wex during hys lyue. [Dun-
can, *Test Ct*]

OSPRINGE, SS Peter & Paul
ESp* ntd will of Jn Underwode (d. 1508) who left an
acre of land in Paynter's field to maintain a taper to
burn yearly in the church before the Sepulchre at
Easter time perpetually. [Hussey, *K Obits*]
Also ntd 1510 will of Lawrence Alice:
A taper of 4 lbs. of wax before the Sepulchre. [Hus-
sey, *Test Ct*]

OTFORD, St Bartholomew
?ESp/tomb; canopied chest in N wall of chancel; chest
has shields in cusped quatrefoils; back of recess pan-
eled; canopy with cresting; late Perp. [Pevsner, *W K*]

PRESTON-NEXT-FAVERSHAM, St Catherine
ESp/tomb in N wall of chancel about halfway between E
end & chancel arch, reset according to Pevsner, *NE &
E K.*
ESp ntd will of Wm de Macknade, proved 18 May 1407,
who left 10 cows in care of churchwardens; money they
produced to supply taper for ESp to be kept burning in
church:
from Good Friday morning to the hour of the
Resurrection of our Lord. [Robertson, "Preston"]

QUEENBOROUGH, Holy Trinity
ESp* ntd visitation of Archbishop Wareham, 1511:
That William Clerk, now of Sittyngborn, witholdeth xls.
of the chapel light afore the Sepulchre. ["Wareham"]

RAINHAM, St Margaret
ESp* ntd 1479 will of Tho Cornell:
To the maintenance of one taper before the Sepulchre,
one acre of land for ever. [Hussey, *Test Ct*]

RECULVER, St Mary
ESp* ntd will of Wm Germyn, 31 May 1475:
To the Light of St Mary, Pentecost, St James, and the
Holy Sepulchre, one bushel of barley to each.
Also ntd will of Tho Yong, 12 Jan 1484:
To the six Lights in the church six ewes, viz., Light
of Holy Cross, Holy Sepulchre, St Mary, St John, St
James, and St Katherine.
Ntd will of Jn Jermin, 14 March 1540:

To the Sepulcour Light which the bachillours do keep
4d. [Hussey, "Reculver Wills"]

ROCHESTER, Cathedral Church & Monastery of St Andrew
ESp* ntd lease for lodgings from Dean & Chapter to
Nich Arnold, priest, 7 April 1545:
at a rent of a taper of one pound of wax, to be offered
on Good Friday to the sepulchre of Our Lord. [Hope,
"Rochester"]

ROCHESTER, St Margaret
ESp* ntd 1494 will of Jn Darvall of Borstall:
a taper of v li wex before ye sepulcre in the church of
Saynt Margaret and di li wex yerely to the stok of
Saynt Margarets lyght in the seide church and this to
be doon al so longe as hit shall please god that the
encress of my hives in Borstall shalbe abull to mayntene
the saide charges. [Duncan, "W K"]

RODMERSHAM, St Nicholas
ESp* ntd 1530 will of Tho Skott:
To the Sepulchre Light, a taper of two lbs. of wax,
and one ewe sheep to maintain that Light. [Hussey,
Test Ct]

ROLVENDEN, St Mary
ESp* ntd 1478 will of Nich a Berne:
A taper of one and a half lbs. of wax to burn at the
Sepulchre of Our Lord Jesus Christ in the Church
during Easter for two years.
Also ntd 1533 will of Jn Asten:
Also £6 to the making at his proper cost an honest
Sepulchre for the Blessed Body of Our Lord to be laid
in at Easter in the Church; and to the buying of one
holy cloth there to hang on the Sepulchre at the holy
time of Easter, and to do service in the Church there
at other times. [Hussey, *Test Ct*]

RUCKINGE, St Mary Magdalene
ESp* ntd 1473 will of Wm Hunt:
John my sone shall kepe a taper of waxe before Seynte
Katheryns, and a taper of iiij lbs. waxe before the
sepulchre brenyng yerely, so long as he shall lyve.
[Oliver]

RYARSH, St Martin
ESp* ntd 1519 will of Tho Estland:
A taper to bren a fore the Sepulcer at Easter. [Duncan, "W K"]

ST. LAWRENCE IN THANET, St Lawrence
ESp* ntd 1473 will of Wm Taylour:

To the Light of Holy Sepulchre, 4d.
Also ntd 1479 will of Tho Taylor:
Light of Holy Sepulchre, a bushel of barley.
Ntd 1479 will of Henry at Booke. [Hussey, *Test Ct*]

SALMESTONE GRANGE, Chapel (grange of St Augustine's
Abbey, Canterbury)
ESp in N wall chancel near E end has septfoiled arch
with roll molding; damaged. [Feasey, "Salmestone"]

SALTWOOD, SS Peter & Paul
ESp* ntd will of Jn White (d. 1481) leaving 6 acres of
land in Hosse croft:
to provide 5 tapers of 7 1/2 lb. of wax, next the lower
step of the altar within the quire of the church on the
north side, standing before the Body of the Lord on
Sundays and solemn Festivals during divine service
yearly. And one of the tapers before the Sepulchre in
the quire from the ninth hour on Good Friday (dies
Parasceues) until the same hour on the day of the
Resurrection. [Hussey, *K Obit*]

SANDHURST, St Nicholas
?ESp/aumbry in chancel; 14c. [Pevsner, *W K*]
ESp ntd in deposition of Peter Hall, curate of Sand-
hurst, for Consistory Court, 29 May 1548:
touching the setting up of the Paschall candle and
sepulchre he was not of knowledge of the settyng up of
them. [Woodruff, "Progress"]

SANDWICH, St Peter
ESp* ntd 1522 will of Rich Broke:
Light of the Resurrection, 2d. [Hussey, *Test Ct*]

SEASALTER, St Alphege
ESp* ntd 1472 will of Wm Smelt:
Also [from the revenues of 4 acres called Martinesdown]
the Wardens yearly provide one taper of pure wax of 5
lbs. for the Sepulchre of the Church for ever; but
after my death my wife Margaret during her life shall
give one taper of 5 lbs. yearly for the Sepulchre for
ever. [Hussey, *Test Ct*]

SHOREHAM, SS Peter & Paul
ESp* ntd 1532 will of Tho Wiborne:
Lumini sepulture resurrectionis dominice in eadem
ecclesie xijd. [Duncan, "Shoreham"]

SIBERTSWOLD or SHEPHERDSWELL, St Andrew
ESp ntd 1484 will of Hen. Pyers:
One cow to the maintenance of a taper of the Holy
Sepulchre in the Church for two years.

Also ntd 1487 will of Rich Meryweather:
To the support of 8 tapers burning before the
Sepulchre at Easter, until the last Mass on Easter Day,
two sheep. [Hussey, *Test Ct*]

SITTINGBOURNE, St Michael
ESp/tomb; 2 recesses, one above the other; lower square
recess has effigy of shrouded woman who died in child-
birth; upper has very low pointed arch outlined with
wide band of square flowers like those at St Nicholas,
New Romney; after restoration in 18c, ESp in Bayford
aisle; il Grayling, "Sittingbourne," opp. p. 153.
ESp ntd 1502 will of Agnes Garard, 8 March 1502:
to the Sepulchre Light, 10 lbs. of wax.
Also ntd will of Jn Bowdon, 18 Dec 1515:
To the Sepulchre Light a taper of 10 lbs. of wax, and
my wife maintain it during her life, and at her death
leave 10 lbs. of wax to the same.
Ntd will of Jn Noke, 11 April 1540:
To the Sepulchre Light a taper of 10 lbs. of wax which
shall be striken ready at the charge of Jane my wife
during her life, after her death the stock of wax remain
to the Light for ever. [Hussey, "Sittingbourne Wills"]

SMARDEN, St Michael
ESp; small arched recess in N wall of chancel; Hasle-
wood, who opened recess in 1860's, found in it wooden
framework which disintegrated & some carved embattled
stones, painted, possibly from the sedilia; 14c; Instru-
ments of Passion were painted on either side of E win-
dow and twice more on side walls; N of chancel arch,
on reredos in nave, was painting of Entombment; paint-
ing il Haslewood, "Smarden Church," p. 31.
ESp ntd churchwardens' accts 1556:
Item to Christophor Mills ffor makinge the sepulcre and
other things against Ester iijs. viijd. [Haslewood,
"Notes Smarden"]

SNODLAND, All Saints
ESp* ntd 1513 will of Wm Langcaster of Halling:
Lumeni sepulcri in ecclesia de Snodland tres libras
cere. [Duncan, "W K"]

STAPLE, St James
ESp* ntd 1472 will of Tho Kele:
To the Light of Holy Sepulchre in the Church, two
quarters of malt.
Also ntd 1507 will of Jn Alyn:
A taper of 3 lbs. of wax shall burn before the
Sepulchre of Our Lord, and after Easter before the
Image of St. Mary, yearly during the life of my wife.
[Hussey, *Test Ct*]

STODMARSH, St Mary
ESp* ntd presentment made to Consistory Court, temp.
Queen Mary:
John Parker of Stodmarsh for withholding of a vestment
of blewe sattyn, and that he had awayd the sepulchre
there. [Woodruff, "Progress"]

STOKE, St Peter
ESp* ntd 1474 will of Robt à Barton:
Lumeni Sancti Sepulcri xijd.
Also ntd 1511 will of Tho Iden, Esq.:
To the light of the Sepulcre vjs. viijd.
Ntd wills of most other parishioners until 1548. [Dun-
can, "W K"]

STROOD, St Nicholas
ESp* ntd 1536 will of Jn Goldoke:
To ye sepulcre light 4d. [Duncan, "W K"]
Also ntd churchwardens' accts 1555:
Item For watchyng of the sepulcar mett & drynk xxd.
Inv 1555:
Item a sepulcar, a presse, a chest with iij lokes & an
old chest in the vestre.
1556:
Item For watchyng the sepulcur xiijd.
Item For watchyng the sepulcur xijd.
1557:
item paid for watchyng the sepulcar at ester xvjd.
[Plomer]

SUNDRIDGE, Church (modern dedication to St Mary the
Virgin)
?ESp; part of Perp tomb chest in N wall of chancel, with
half-length angel supporting shield. [Pevsner, W K]
ESp ntd 1494 will of Jn Isly:
To be bured in the high chauncell before oure lady in a
tombe in the wall for to sett the sepulcur vpon. [Dun-
can, "Shoreham"]

SUTTON (near Dover), SS Peter & Paul
ESp* ntd 1483 will of Nich Raynold:
To the wardens of the Church, one cow to maintain for
ever one taper burning before the Sepulchre in the
Church. [Hussey, *Test Ct*]

SUTTON-AT-HONE, St John Baptist
ESp* ntd Comm inv 1552:
Item a sepulcre cloth of red tuke. [Walcott, Coates, &
Robertson]

SUTTON VALENCE, St Mary
ESp* ntd 1477 will of Tho Bovinden:

Light of the Sepulchre, 2d. [Hussey, *Test Ct*]

SWANSCOMBE, SS Peter & Paul
 ESp* ntd Comm inv 1552:
 Item ij surplesses of lynnen cloth and iij clothes for the
 sepulcre of red and yelowe saye. [Walcott, Coates, &
 Robertson]

SWINGFIELD, SS Peter & Paul
 ESp* ntd 1488 will of Jn Simon:
 A cow to maintain a taper of 2 lbs. of wax, to burn
 yearly in the Church for ever before the Sepulchre of
 Christ at Easter. [Hussey, *Test Ct*]

THORNHAM or THURNHAM, St Mary
 ?ESp/aumbry; recess in N wall of chancel. [Pevsner, NE
 & E K]
 ESp ntd visitation of Archbishop Wareham, 1511:
 That Nicholas Cole witholdeth viiid. by year from the
 light of the Sepulchre, and hath done these xxx. years
 and more. ["Wareham"]
 Also ntd 1511 will of Juliana Schernden:
 Light of the Sepulchre, 12d. [Hussey, *Test Ct*]
 Also ntd Chantry Certificate 1548:
 Light landes geven and bequeth by [*blank*] Culture by
 his last will for the mayntenaunce of a light called the
 Sepulcre light within the said parishe churche there for
 ever. [Hussey, *K Obit*]

TILMANSTONE, St Andrew
 ESp* ntd will of Rich Knott, 10 April 1480 (proved 12
 June 1498), who left 3 ewes & 3 pounds of wax:
 to the entent that the iij li. wex may be maynteyned
 and light yerely over the sepulchre of our Lord at
 Estertyme. [Feasey, "ESp"]

TONBRIDGE, SS Peter & Paul
 ESp ntd 1518 will of Godlyne Adams:
 To maintenaunce of the Sepulcar lyght iijs. iiijd. [Duncan, "W K"]
 ESp ntd 1529 will of Wm Borowgh, vicar:
 Two of my best couerletts, the oon to hang behynde
 the sepulchre and the other afore the high awter.
 [Duncan, *Test Ct*]

TROTTISCLIFFE, SS Peter & Paul
 ESp* ntd 1523 will of Johan Osbarne:
 A pownd of wax to repare the Sepulcurre lyght. [Duncan, "W K"]

TUNSTALL, St John Baptist
 ESp* ntd 1546 will of Wm Cromer, kt.:

Buried before the high altar where the Sepulchre
standeth. For the making of a new frame for the
Sepulchre, and a stone to lie upon it, £6 13s. 4d.; and
as many Estriche birdes as shall make it. [Hussey,
Test Ct]
Bond, *Chancel*, p. 233, notes that term 'estriche
bordes' was used for deals imported from East Anglia;
'birdes' is probably scribal error.

ULCOMBE, All Saints
ESp* ntd 1473 will of Tho Turnour:
Light of the Sepulchre, 2d. [Hussey, *Test Ct*]

UPCHURCH, St Mary
?ESp/tomb in wall of N chapel; ogee arch with crocket-
ing, cusping, & leafy finial [Pevsner, *NE & E K*]
ESp ntd will of Jn Oseborne (d. 1480) leaving:
his messuage with all lands in Upchurch and Halstow to
his wife Joan and her assigns for life, then to his son
Thomas and his heirs for ever, under condition that
Thomas and his heirs find in the church of Upchurch
every year at Easter, 13 Tapers afore the Sepulchre
there to burn after the form and manner used, every
taper of 4 lbs.
If Thomas or his heirs were to make default any year
contrary to the Will, then his Feoffees were to deprive
him or them and deliver the messuage and lands to them
that will perform the Will and maintain the Tapers for
ever. [Hussey, *K Obit*]

WAREHORNE, St. Matthew
ESp* ntd 1442 will of Rich Fawkener:
Item for newe clothis I-steynyd to be bought and
ordeynyd for the sepulcre in the Church of Wherhorn
xxs. [Greenstreet, "K Wills"]

WESTCLIFFE, St Peter
ESp* ntd 1521 will of Jn Bere:
To the Holy Sepulchre, one ewe and lamb. [Hussey,
Test Ct]

WEST MALLING, Abbey of Our Lady
ESp ntd 1527 will of Wm Hunt of Cobham:
My grete brass pott to the Abbey of Mallyng and I gif
to the mayntenaunce of the sepultures ligth in the saide
abbey ijs. [Duncan, *Test Ct*]

WEST WICKHAM, St John Baptist
?ESp; recess in N wall of chancel. [Heales, "ESp"]
ESp ntd 1450 will of Jn Wilet:
Lumeni circa Sepulcrum domini.
Also ntd 1521 will of Wm Crowland:

To the same church of Wykham to mayntayne the light
at Ester x ewe shepe. [Dûncan, "W K"]

WESTERHAM, St Mary
ESp* ntd 1499 will of Jn Bettesham:
Volo quod Alicia uxor mea supportabit meum paschal.
cereum cremendem coram Sepulchro in die parasives et
eius mortis. [Duncan, "W K"]

WHITSTABLF, All Saints
ESp* ntd 1464 will of Jn Parker & 1474 will of Jn Bred-
ford leaving sums of money to ESp light.
Ntd 1528 will of Wm Gilmin:
My land at Pikindens and two acres called Bosfield in
Seasalter, to the Church of Whitstaple for ever, to
maintain a yearly Obit of 6s. 8d. and a taper of 2 lbs.
of wax. . . . The taper of wax to burn before the
Sepulchre of Christ at Easter, and all the year after to
burn before Our Lady of Pity in the Church of
Whitstaple. [Hussey, *Test Ct*]

WILMINGTON, St Michael
ESp* ntd Comm inv 1552:
Item one sepulcre cloth of whit silke lyned with lynnen
cloth. [Walcott, Coates, & Robertson]

WOMENSWOLD, St Margaret
?ESp/tomb; recess in N wall of Early English chancel.
[Pevsner, *NE & E K*]
ESp ntd 1528 will of Rich Nethersole of Kingston:
To the maintenance of a taper to burn before the
Sepulchre for ever in St. Margaret's Church of
Wymyngewold, a cow. And I will that one within the
parish shall ever have to farm and the profit of the
cow, so that he maintain the foresaid taper to burn
before the foresaid Sepulchre during the Easter
Holydays.
If the Wardens of the Church of Wymyngeweld will not
see and cause this to be done, then the churchwardens
of Kingeston shall have the cow and do for me in like
manner. To the finding of the aforesaid Taper, 3s.,
and the stock of the same taper be 4 lbs. of wax at the
least yearly, to the honor of the Holy Resurrection of
Our Lord. [Hussey, *Test Ct*]

WOOTTON, St Martin
ESp* ntd 1538 will of Elisabeth, widow of Tho Harsefeld:
To the Sepulchre, a cow to find a taper of 3 lbs. of
wax. [Hussey, *Test Ct*]

WORMSHILL, St Giles
ESp* ntd 1460 will of Tho Pepyr:

Light of the Sepulchre, 20d. [Hussey, *Test Ct*]

YALDING, SS Peter & Paul
ESp* ntd 1522 will of Wm Astyn:
I will that the wyndow ouer the sepulture be dampned
and a blynde arche to be made rising ouer the same
sepulture and the wudwarke of the same sepulture to be
made according to good wurmanship and afterwarde to
be gilded with the Resurrexion of our Lorde. [Duncan,
"W K"]

LANCASHIRE (La)

CARTMEL, St Mary (Priory of Canons Regular of St Augustine)
?ESp/tomb; recess with pointed arch in N wall of chan-
cel, E of main arcade; contains slab with inscription:
"Hic jacet frater Wilelmus de Waltona Prior de Kartmel."
[Glynne, *La*; VCH 8]

CHIPPING, St Bartholomew
?ESp; recess with pointed head in N wall of chancel; now
blocked up but originally open; width 16". [VCH 7]

DEANE, St Mary Virgin
ESp* ntd Comm inv 1552:
xvj peces off olde lynnen vsed abowte ye Sepulcre. [J.
Bailey, *Inv*]

HALSALL, St Cuthbert
?ESp/tomb; recess in N wall of chancel with plain paneled
tomb; cinquefoiled, cusped arch under triangular crock-
eted canopy flanked by crocketed pinnacles; arch not
constructed of voussoirs, but of stone blocks with hori-
zontal & vertical joints; pierced trefoil in point of cano-
py; both canopy & pinnacles terminate about 17' above
floor with flattened foliate finials that seem designed to
support statues; to W of recess & contemporary with it,
masonry projection 4'8" in length with maximum depth of
12" possibly to support frame of ESp although it has no
holes for dowels; recess width 6'6" & depth 14"; 14c;
now contains later effigy shortened to fit this recess;
probably effigy of Rich Halsall, rector of Halsall 1513-
63, who asks, in his will of 14 October 1563, that his
body be:
buryed in the chancell of the pariche churche of Halsall
afore sayd in the towmbe made in the wall uppon the
north syde of the same churche. [E. Cox, "Halsall";
Glynne, *La*; Pevsner; Taylor & Radcliffe; VCH 3]

MANCHESTER, St Mary, St George of England, & St Denis
(Collegiate; Cathedral since 1847)
ESp* ntd inv of chantries 1545:
Item certen ornaments for the sepulchre. [Raines,
Chantries]
Also ntd Comm inv 1552:
Item certayn ornamentes for the Sepulchre. [J. Bailey,
Inv]

PRESCOT, St Mary
ESp* ntd churchwardens' accts 1523-4:
Item, paid to the same Jamys [Page], for payntyng the
pascall Cryst and trayle iiijs.
Item, paid to Rauff Holland, for wurchyng three peces
about the sepulcre, by the space of three dayes ixd.
Item, in burd, vjd.
1538-9:
Item, to sir Rychard Potter, for a payntyd [?cloth]
to the sepulcre viijd.
1546-7:
Item, paid for makyng the churche light and the
sepulcre light vjs.
Item paid for meate and drynke to Robt Webster, Robt
Worseley and Elsabeth Latham when the light was in
castyng, fascyonyng and makyng iiijs. vjd.
Item, paid to the said Elsabeth for temperyng of the
waxe vjd.
Item, payd for fetchyng a calfe gyven by Mestres
Pemberton of Halsenett [Halsnead] towardes the light of
the sepulcre ijd.
1547-8
Item paid for the makyng of the churche light and the
sepulcre light, vjs.
1553-4:
Item, for neyls to meynd the church dowre and the
sepulcoure ijd. ob.
1555-6:
Item, to Robart Webster, for makyng the sepullcre
lyghtes and the pas[cal and] other lyghtes to sett vpon
the he allter.
Item, for meate and drynke att the makyng of the same
lyghtes and castyng.
1556-7:
Item, for wyke yorne . . . and naylys to the sepuker
iijd.
1557-8:
Item, for makyng the sepulker lyght and the pascall
and parowche lyght beffore the rode and Sancte
Antonye and [sm]all candylles for the apostelles lyght
and for meate and dryngke and fyre and gresse and for
temperyng the same lyght vijs.
1558-9:

Item, for makyng the sepulker lyghtes, the passecall
and the parishe lvghtes, and x surges for to serve the
heye awter with, and mete and dryngk, with fyre and
greesse vijd. iiijd. ob. [Bailey, "Prescot"; Bailey,
Prescott]

PRESTON, St John (formerly St Wilfrid)
ESp* ntd Comm inv 1552:
Item one painted Cloth wych was aboute the sepulcre.
[Fishwick]

ST. MICHAEL'S-ON-WYRE, St Michael
?ESp*; painting of Ascension on N wall of chancel; dis-
covered in 1956; early 14c. [Pevsner]

WARRINGTON, St Elphin or St Helen
?ESp in crypt; stair in buttress on N side of chancel
leads to crypt beneath altar; crypt has 4 2-light win-
dows that reach to floor; ribs on head corbels; con-
tained many bones, but VCH says too well lit to serve
exclusively as charnel; stair on S not medieval; chancel
from 1354; opening to crypt sealed in time of Eliz I,
discovered 1824. [Glynne, *La*; VCH 3]

WINWICK, St Oswald
?ESp; ogee niche on N side of Dec chancel entirely re-
built 1847-8. [Glynne, *La*; VCH 4]

LEICESTERSHIRE (Le)

ARNESBY, St Peter
?ESp; recess with segmental arch in N wall of chancel;
c.1330; much restored in 19c. [Pevsner]

ASHBY FOLVILLE, St Mary
?ESp/tomb; rectangular monument against N wall of chan-
cel with incised slab on floor directly below; monument
topped by relief carving of arms of Woodford & Folville
flanked by wild man each side; below, lintel with frieze
of 1/2 length angels; at either side, larger, standing
angels; large center panel blank; slab on floor incised
with fig in ?shroud; inscription to Ralph Woodford (d.
1485); 2 scrolls: "Credo quod Redemptor meus vivit" &
"et in novissimo die de terra resurrecturus sum"; il
engraving, Nichols, *Le* 3, Pt. 1, Pl. V, fig. B. [Pevs-
ner]

BLASTON, St Giles
?ESp/door; recess with segmental arch in N wall of chan-
cel. [Bellairs]

BUCKMINSTER, St John Baptist
ESp in chancel, part of ensemble including sedilia &
double piscina, all before 1300. [Pevsner]

CLAYBROOKE or LITTLE CLAYBROOKE, St. Peter
?ESp/founder's tomb; recess in N wall of chancel near E
end; 14c. [Albert Herbert]

COSSINGTON, All Saints
?ESp/tomb in center of N wall of chancel; recess has
cusped & subcusped ogee head within straight-sided
gable with crockets & finial; 1375-1400; contains smaller
alabaster tomb chest with incised slab for Matthew
Knightley dated 1561; il Anthony Herbert, p. 213.
ESp ntd churchwardens' accts 1530's:
Item layde owt at Aster for the makynge of the
sepulture light and for the roundyll with other wax
bought at the Tyme nedefull iiijs. iiijd.
Item to the clarke for the wachynge the sepulture ijd.
Item for the sepulker lyght and other waxe nedeful to
the use of the churche vs.
1535:
in primis for the wax and makynge of the sepulke and
wachynge of the same and expenseys vjs. xd.
1546:
Item paid to the clerke for watshyng of the sepultear
ijd.
1554:
payd for watchinge of the sepulcre ijd. [Skillington]

GARTHORPE, St Mary
?ESp/tomb; 2 recesses in N wall of chancel; lower, tomb
recess, has plain, pointed arch; centered directly above
it, smaller niche with trefoiled & cusped pointed arch
with crocketing & finial under plain triangular gable
with finial; flanking pinnacles with head stops; c. 1300;
il Nichols, Le 2, Pt. 1, fig. 2 opp. p. 192. [Bloxam,
"ESp"]

LANGLEY, St Mary (Benedictine Convent)
ESp* ntd inv 1485:
A schete for ye sepulchre.
Viij paynteyd clothys grete and smale for ye auter and
ij for ye Sepulchre and ij for ye ends of ye same j of
blake with veleur for ye rege and ij of rede silke for
ye bowys. [Walcott, "Langley"]

LEICESTER, St Martin
ESp* ntd churchwardens' accts 1492:
For keeping the Sepulchre and . . . the long altar 8d.
to the clerk.
1544:

more oing to ye Chirche the same day by Henry
maybley for the sepulcre lyght xs.
1545-6:
Item for thered for ye sepulcre ij yere id.
1547:
Sold to Rychard Raynford the Sepulcre light waying iij
score and xv li., at iijd. ob. a li. xxjs. xd. ob.
1553-4:
gatherers for the sepulcars lyght
 John busshe
 William rechardson
1554-5:
Item received of John busshe & William richardson for
sepulcre lyght iiijs.
Item received of William odam for old det for the
sepulcre lyght vijs. viijd.
Item pd to Iohn Molp for tymber & for makynge of the
sepulcre vs.
Item paid for naylles for the sepulcre iiijd.
Item paid for the sepulcre lyght iiijs.
Item paid to Iohn barbour for payntyng the sepulcre &
a clothe for our ladys aulter xxijd.
gatherers of sepulcre lyght
 Iohn Sutton barbor
 Will Ward mercer
1557-8:
Gatherars for the sepulcher's lyght for the same yere
Richard Chettell & Vyncent Tompson & remains in ther
hands--iiijs. jd. ob. & xj tappers. [North, *St Martin's*]

LUBENHAM, All Saints
 ?ESp; large recess with pointed arch in N wall of chan-
 cel; arch has cusping that terminates in heads, crock-
 ets, & finial; octagonal turrets flank arch; early 14c.
 [VCH 5]

MELTON MOWBRAY, St Mary
 ESp* ntd churchwardens' accts 1546:
 Item getheryd for sent purker lyght vijs. ob.
 Item peyd to Wylliam Green for makyng of sent pulker
 wax ijs.
 1547 or 1548:
 Item received of Clement Gils for the sepulcher case
 viijs. vjd.
 1553:
 Item payd to Thomas pyckryng the xxiiij daye of
 Marche for makyng of the sepulcre and other things the
 same tyme ijs. iiijd.
 Item payd for neles for the sepulcre id.
 1557-8:
 Item paid for ij pond & a haffe of wax for ye sepulkar
 lyght iijs. iiijd. [North, "Melton"]

ROTHLEY, St John Baptist or St Mary
ESp* ntd will of Bartholomew Kyngston inscribed on his
tomb, dated 1486, in N aisle:
AND ij <SERGES OF> WAX TO BE BRENT AT HIS
DERGE AND MESSE & AFTYR YAT TO <BREN> AFOR YE
SEPULKER IN TYME OF PACE. [Watts]

LINCOLNSHIRE (Ls)

ADDLETHORPE, St Nicholas
ESp* ntd churchwardens' accts 1543:
Item recevyd for ye sepullcer lyghte gatheryd in ye
cherche 2s. 2d.
1544:
Item resavyd upon Paull's day for sepulcre lyght 2s.
1545:
Item pryes paid for wax to ye sepulcare lyght 2s.
1555:
Item for a pound of wax for the sepulcre 14d.
Item for the makyng of the same wax 7d.
Item for the sepulcre 10d.
1556:
Item for mendynge a forme at ye sepulcre 4d.
Item gevene by ye towne to the sepulcre lyght 2s.
[Dudding, "Addlethorpe"]

ALGARKIRK, SS Peter & Paul
?ESp; square-headed recess in chancel N wall now with
doors; Dec; church restored in 1850's. [Alexander, Ls]

ASHBY-DE-LA-LAUNDE, St Hybald
ESp* ntd inv 26 April 1566:
Item our sepulcre--broken and burned Anno ij
Elizabethe. [Peacock, English Church Furniture]

ASHBY JUXTA HORNCASTLE (WEST ASHBY), All Saints
ESp* ntd Comm inv 1566:
Item one crismatorie cruyttes one crosse one pixe one
canabe one vale one sepulcre ar cutt and putto other
vses. [Peacock, "English Church Furniture"]

ASWARDBY (ASWARBY), St Denis or St Helen
ESp* ntd inv 29 April 1566:
Item one sepulcre broken in peces and defaced and
burnte. [Peacock, English Church Furniture]

AYLESBY, St Lawrence
?ESp; early 14c recess with sunk quadrant molding in N
wall of chancel; 2nd niche above. [Alexander, Ls;
Pevsner]
ESp ntd Comm inv 1566:

Item owr sepowlker was defaysede by the sayde chorche wardens. [Peacock, "English Church Furniture"]

BARKSTON, St Nicholas
ESp; plain arched recess in N wall of chancel; c.1300. [Alexander, Ls]
ESp ntd inv 26 April 1566:
a sepulcre of lattes . . . [was] defaced about three yeres past, . . . & sold at Christemas last. [Peacock, *English Church Furniture*]

BARROW-ON-HUMBER, Our Lady or Holy Trinity
?ESp/aumbry; small square opening in N wall of chancel; 13c. [Alexander, Ls]

BARROWBY, All Saints
ESp* ntd inv 8 April 1566:
Item one sepulcre broken in peces. [Peacock, *English Church Furniture*]

BASTON, St John Baptist
ESp* ntd inv c.1566:
Item one sepulcre broken & defacid by Master Vycar & the cloth defacid by william Cope. [Peacock, *English Church Furniture*]

BEESBY, St John Baptist
ESp* ntd inv 25 April 1566:
Item a sepulcher--brent Anno ij Elizabeth by the aforesaid church wardens. [Peacock, *English Church Furniture*]

BELLEAU, St John Baptist
?ESp; 2 recesses in N wall of chancel, both square-headed; one above the other; 14c; incorporated into 19c rebuilding. [Alexander, Ls]

BELTON (Isle of Axholme), All Saints
ESp* ntd inv 22 April 1566:
Item a sepulker with litle Jack--broken in peces one year ago but litle Jack was broken in peces this yeare by the said churchwardens. [Peacock, *English Church Furniture*]
Citing Ridley, *Works* (1841), p. 265, Peacock suggests that "litle Jack" refers to pyx (sacrament contemptuously called "Jack in a box").

BENINGTON, All Saints
?ESp; low segmental-arched recess in N wall of chancel to W of 2 round arched openings without bases; 14c. [Alexander, Ls]

BILLINGBOROUGH, St Andrew
ESp* ntd inv 14 March 1565:
Item . . . a sepulcre clothe . . . --sold to Hughe
Tyngle of the said parishe anno domini 1565 by the said
churchwardens defaced. [Peacock, *English Church
Furniture*]

BITCHFIELD, St Mary Magdalene
ESp* ntd inv 21 March 1565:
Item a sepulker--broken and burnt Anno domini 1563
William Boroughe and William Askew churchwardens.
[Peacock, *English Church Furniture*]

BLYTON, St Martin
ESp* ntd inv 20 April 1566:
Item a sepulker of wainscot--Taken from the Church by
the vicar and remayneth in his house as wee suppose.
[Peacock, *English Church Furniture*]

BONBY, St Andrew
ESp* ntd inv 26 April 1566:
Item a sepulker and a crose--broken in peces iiij a year
a go the said Michill and Totter being churchwardens.
[Peacock, *English Church Furniture*]

BOSTON, St Botolph
ESp* ntd Comm certificate dated 20 August 1552 listing
goods sold by mayor & burgesses of Boston:
Item a Sepulchre with the appurtenances xxvis. viijd.
[Peacock, *English Church Furniture*]

BOTTESFORD, St Peter's Chains or St Peter
?ESp; double recess in N wall of Early English chancel;
both arches with dogtooth moldings & now fitted with
doors; 2 further arched openings without moldings in E
wall of chancel; chancel restored 1630 & 1857. [Alexan-
der, *Ls*; Pevsner]

BRATOFT, SS Peter & Paul
?ESp; recess with Dec moldings in N wall of chancel;
14c. [Alexander, *Ls*]
ESp ntd Comm inv 1566:
Item a sepulker sold to Peter bowland whome maid an
ambre of the said sepulker in anno domini 1566 Thomas
Dawson & Richard wryght church wardens. [Peacock,
"English Church Furniture"]

BRAUNCETON, All Saints
ESp* ntd inv April 1566:
Item a sepulcre broken in peces and geven to the pore
this yere. [Peacock, *English Church Furniture*]

BROUGHTON, St Mary
Fragments of canopies, carved & painted, found under floor of church in 1871, possibly belonged to ESp* or sedilia. ["Broughton"]
ESp* ntd inv 8 April 1566:
a sepulker cloth [and other items] . . . sold to Roger Marflet of the said parishe Thomas Jonson william watson & Peter dent of the said parishe this yeare by the said churchwardens and what they have done with theim wee knowe not. [Peacock, *English Church Furniture*]

BURTON COGGLES, St Thomas Becket
ESp* ntd inv 21 March 1566:
Item the sepulcre--was burnte in melting lead for to mend our churche. [Peacock, *English Church Furniture*]

BURTON-ON-STATHER, St Andrew
?ESp; low arched recess with ballflower molding in N wall of chancel; 14c. [Alexander, *Ls*]

CASTLE BYTHAM, St James
?ESp; large recess in N wall of chancel containing tomb chest with crocketed ogee panels; arch has openwork cusping & ballflower molding; ogee gable. [Pevsner]
ESp* ntd inv 18 March 1565:
Item one sepulcre--which we haue made a communion table of. [Peacock, *English Church Furniture*]

CLAXBY PLUCKACRE, St Andrew
ESp* ntd Comm inv 1566:
Item a sepulker with ij wodden candelstickes--broken this yeare by the churchwardens nowe beinge. [Peacock, "English Church Furniture"]

CLAYPOLE, St Peter
?ESp/aumbry; recess with ogee arch in N wall of chancel; crockets, finial, & flanking buttresses with pinnacles; iron hinges for door. [Sutton]

COATES (BY-STOW), St Edith
ESp* in N wall of chancel had sculpture of Christ rising from grave; badly damaged. ["Coates"]

COLSTERWORTH, St John Baptist
ESp* ntd 18 March 1565:
Item a sepulker one vestment one banner--sold to certain of the parishners Anno vjto Elizabeth Simon Meares and Myles Darbie churchwardens which is defaced. [Peacock, *English Church Furniture*]

COVENHAM ST. BARTHOLOMEW, St Bartholomew
ESp* ntd inv 26 April 1566:
Item a sepulker--sold to Robert South Anno primo
Elizabeth who defacid it. [Peacock, *English Church
Furniture*]

COVENHAM ST. MARY, St Mary
?ESp; Dec recess in N wall of chancel; arch of recess
with cusping & sub-cusping; ogee gable; 14c.
[Pevsner]

CROXTON, St James
ESp* ntd inv 30 April 1566:
Item a sepulker--whearof is made a shelf for to set
dishes on. [Peacock, *English Church Furniture*]

CUMBERWORTH, St Helen
ESp* ntd Comm inv 1566:
Item the sepaulker with the herse and the table that
stood over the hygh allter--deffaced and sollde by John
donyngton and Rychard page cherchewardons that now
is. [Peacock, "English Church Furniture"]

DENTON, St Andrew
ESp* ntd inv 6 April 1566:
Item one sepulcre--sold to Johnne orsonn and he haith
made a presse therof to laie clothes therein. [Peacock,
English Church Furniture]

DORRINGTON, St James
ESp* ntd inv 26 April 1566:
Sepulcre was broke & sold to the said william Storre and
Robert Cappe who have made a henne penne of it.
[Peacock, *English Church Furniture*]

DOWSBY, St Andrew
ESp* ntd inv 21 April 1566:
Item a Sepulker--geven to a poore woman fyve year
agoo who brent it. [Peacock, *English Church Furniture*]

EAST KIRKBY, St Nicholas
Remains of ?ESp; fragments of relief mounted together on
N wall of chancel include frieze of naturalistic foliage,
pair of trefoil arches, pinnacles, & panel with 3 half-
length female figs; each is frontal & supports round
ball-like object (?spice jar) with both hands; between
them large 4-petaled flowers; ledge with basin 8 1/2" in
diameter projects directly below figs who must be 3 holy
women; Bloxam suggests basin for offering called
creeping silver made in connection with Adoration of
Cross. Fig. 45.

EWERBY, St Andrew
Esp* ntd inv 27 April 1566:
Sepulcre--was broken in peces aboute sixxe yeres last
past. [Peacock, *English Church Furniture*]

FISHTOFT, St Guthlac
?ESp; blocked double-arched opening in N wall of chan-
cel; part of 13c remodeling of 12c chancel. [Alexander,
Ls]

FOLKINGHAM, St Andrew
?ESp; small square-headed opening in N wall of chancel;
13c. [Alexander, *Ls*]

FRAMPTON, SS Mary & Michael or St Mary
?ESp/tomb; chest in recess in N wall of chancel; wavy
pattern on chest; Dec; ?ESp, sedilia, & priest's doorway
all have crocketed ogee gables, buttress shafts, & fini-
als. [Alexander, *Ls*; Pevsner]

FULLETBY, St Andrew
ESp* ntd inv 24 April 1566:
Item one pix one sepulker one paire of old Sensors and
the Rood with a paire of Clappers Lackinge. [Peacock,
English Church Furniture]

GOXHILL, All Saints
?ESp; small arched recess in N wall of chancel; 13c but
recut. [Alexander, *Ls*]

GREAT COATES, St Nicholas
?ESp/tomb*; brass, now in chancel floor, to Sir Tho
Barnardiston (d. 1503); includes his wife & children;
figs kneel, scrolls issue from mouths of parents; in-
cludes representation of Resurrection. [Heales, "ESp";
Pevsner]

GREAT GRIMSBY, St Mary
ESp* ntd churchwardens' accts 1411-2:
Et datum ad lumen sepulcri hoc anno vid. de
consuetudine. [Gillett]

GREATFORD, St Thomas Becket
?ESp; triangular headed opening in N wall of chancel;
chancel 13c with 14c additions. [Alexander, *Ls*]
ESp* ntd inv 4 March 1565:
Item the frame of the sepulcre broken yet remayninge
the clothe for the neither parte of the altare servinge
for the same. [Peacock, *English Church Furniture*]

GREETHAM, All Saints
ESp* ntd Comm inv 1566:

Item a sepulchre brokne and burned anno ij^{do}
Elizabeth. [Peacock, "English Church Furniture"]

GUNBY ST. NICHOLAS, St Nicholas
 ESp* ntd inv 18 March 1565:
 Item . . . a sepulker [and other items] . . . Remainith
 in our parishe church of Gunbie. [Peacock, *English
 Church Furniture*]

GUNBY, St Peter Apostle
 ESp* ntd inv 30 April 1566:
 Item one rood with a sepulker--sold to Sir Henrie
 Banister Anno primo Elizabeth by the said
 churchwardens. [Peacock, *English Church Furniture*]

HABROUGH, St Margaret
 ESp* ntd inv 30 April 1566:
 Item a Sepulker--sold and defacid this yeare. [Pea-
 cock, *English Church Furniture*]

HACCONBY, St Andrew
 ?ESp/tomb; Perp recess with 4-centered arch for
 founder's tomb between chancel & N chapel. [Alexander,
 Ls; Pevsner]

HAGWORTHINGHAM, Holy Trinity
 ESp* ntd inv 26 April 1566:
 Item a sepulker--sold which is defacid Anno ij Aprilis.
 [Peacock, *English Church Furniture*]

HAITHER (?HAYDOR), St Michael
 ESp ntd inv, c.1566:
 Item . . . one sepulcre cloth [and other items] . . .
 defaced yesterdaie beinge the vijth of Aprill 1566 and
 sold to Sir Leonerd Towne vicare Symond Jenkinson and
 William Smythe. [Peacock, *English Church Furniture*]

HAREBY, SS Peter & Paul
 ESp* ntd inv 18 March 1566:
 Item one crose of wood and ij candlestickes of wood and
 a sepulcre--which our parsonne haith burned the crose
 and candlestickes were burned and the sepulcre the
 said parsonne haith made a presse of. [Peacock, *English
 Church Furniture*]

HARLAXTON, SS Mary & Peter
 ESp* ntd inv 9 April 1566:
 Item [various vestments] . . . and one sepulcre [cloth]
 and one vaile sold to Mr. blewitt sens candlemas last
 past 1565 and he haithe defaced and cut theim in peces
 and made bed hanginges thereof and cusshinges.
 Item one sepulcre sold to Mr. blewitt and he haith

broken yt in peces. [Peacock, *English Church Furniture*]

HEALING, SS Peter & Paul
ESp* ntd Comm inv 1566:
Item one crose clothe and a baner clothe and sepowlker clothe ij corprorsses--deffaysed and sowlde to theys men Jhon nallir and Jhon hell by wylliam bordis chorchewardis and the Reste of owr pares.
Item the sepowlker--was cotte and mayd a fryme for a commewneon taybell. [Peacock, "English Church Furniture"]

HECKINGTON, St Andrew Large
ESp in N wall of chancel near E corner part of Dec chancel with tomb, sacristy, double piscina, & triple sedilia, built by Rich de Potesgrave, rector 1308-49, chancery clerk & chaplain to Edward II; elaborate relief carving centers on triangle-headed recess for use in Easter ceremonies; lowest stage of ESp treated like front of tomb chest, divided into 4 panels of equal width, each carved with sleeping soldier under trefoiled, crocketed, steeply pointed gable with finial; soldiers badly damaged; spandrels of their panels covered with leafy foliage in shallow relief; upper parts of ESp divided vertically into 3 parts by 4 buttresses that rise to full height of monument; center, containing recess, corresponds to 2 of soldier panels below; intermediate zone of ESp rises from horizontal slab of tomb chest & consists of 2 reliefs under canopies flanking recess; relief to L made up of one holy woman & angel, both with flowing drapery; panel to R of recess contains another angel & holy woman; in R jamb of recess, a smaller figure, crouching; could this be Mary Magdalene? Higher zone above gables of relief panels & recess filled, on sides, with foliage in higher relief; above recess, standing on its very large finial, the risen Christ; angels kneel, facing him, on slanted sides of triangle-headed recess; probably they once held censers; Christ framed in steeply pointed crocketed gable, with large head stops, presumably angels, at its lower corners; finial of upper gable reaches to cornice; from sides, parapets slant upward to meet gable; their undersides curved; their shape suggests flying buttresses, so that architectural framework of ESp resembles cross-section of 3-aisled church; between these dividers & cornice, foliage richly luxuriant; small figs on underside of cornice include mermaid & figs playing single & double flutes; whole monument about 10' in height & 5'6" in width; recess 2'8" in width & 1'8" in depth; 14c; plaster cast of ESp included in Great Exhibition at Crystal Palace in 1851. **Fig. 50.**

HOLYWELL, St Wilfrid
 ESp* ntd inv 21 March 1565:
 Item one sepulcre of wood--burned. [Peacock, *English
 Church Furniture*]

HONINGTON, St Wilfrid
 ESp in former arch to Norman (N) chapel has 3 pinnacles
 & sculpture of feathered angels; late Dec. [Alexander,
 Ls; Pevsner]

HORBLING, St Andrew
 ESp; lunette in wall of N transept with relief of Resur-
 rection; Christ, visible from knees up, rises from tomb
 chest paneled with 4 1/2 pierced quatrefoils in circles;
 Christ bare-chested & bearded; his arm reaches out to
 kneeling fig on his R, perhaps angel; to his L fig
 crouching under curve of lunette; traces of paint; now
 all faces hacked away & much other damage; below are
 tomb chest & large recess, but neither seems related to
 this relief, which may be part of ESp, wooden com-
 ponents of which sold at Reformation.
 ESp ntd inv 18 March 1565:
 Item the sepulcre--was sold to Robert lond and he saith
 he haith made a presse therof. [Peacock, *English
 Church Furniture*]

HOUGH-ON-THE-HILL, All Saints
 ESp* ntd inv 26 April 1566:
 Item on crismatorie and a sepulchre--takne away by Mr.
 larke. . . . [Peacock, *English Church Furniture*]

IRNHAM, St Andrew
 ESp/founder's tomb; tomb of Sir Geoffrey Luttrell (d. 23
 May 1345) apparently used also as ESp; formerly stood
 under easternmost arch of arcade dividing N aisle from
 chancel but removed to E end of N aisle in restoration
 of 1858; chest has Sutton & Luttrell arms; canopy of 3
 bays with nodding arches; vaults of canopy pierced;
 one has boss in form of bat's head with ribs of vault as
 its wings; surfaces rich with foliate carving; top has
 crenellations & little hanging canopies; center finial
 represents Virgin & Child; L finial, Crucifixion; style
 of carving compared to Percy Tomb or to Lincoln
 school; il Evans, *1307-1461*, Pl. 77b; Woolley, "Ns & Ls
 ESp," Pl. IV.

KELBY, St Andrew
 ESp* ntd inv 8 April 1566:
 Item a sepulker clothe--sold to Robert Harrie of the
 said parishe this yeare by the aboue namid
 churchwardens defacid. [Peacock, *English Church
 Furniture*]

KIRKBY-CUM-OSGODBY, St Andrew
?ESp/aumbry; double recess in chancel with polygonal
shafts. [Pevsner]
ESp ntd Comm inv 1566:
Item our Sepulchre and our clappes--brokne and made
awaie anno ij^{do} Elizabethe. [Peacock, "English Church
Furniture"]

KIRKBY UNDERWOOD, St Mary & All Saints
ESp* ntd inv 21 March 1565:
Item one sepulcre--burned. [Peacock, *English Church
Furniture*]

KIRKSTEAD, St Leonard
ESp/recess in N wall of chancel discovered in restoration
of early 20c. ["St Leonard's"]

KIRTON-IN-LINDSEY, St Andrew or SS Peter & Paul
Sepulchre guild ntd 1498 will of Wm Blyton referring to
Guild of Holy Sepulchre. [Peacock, "Kirton-in-Lindsey"]

LANGTOFT, St Michael
?ESp; elaborate recess in N wall of Early English chan-
cel; chancel substantially restored in 19c. [Alexander,
Ls]

LEVERTON, St Helen
ESp* ntd churchwardens' accts 1495:
Received de executori walteri Buschy pro sepulture &
omnibus altare ecclesia vijs. ijd.
1498:
Resseuyd of Wylliam poldertofte of the Sopulcur lythe
vjs. viijd.
1516:
Resseuyd of Thomas Ratforth & gynkyn watkyngson of
ye sepulchyr lyth xiijs. iiijd.
1537:
Payd for iiij li. of wax to the sepulckayr and for
makyng of the same wax 2s. 7d.
1549:
[Resseuyd] of Christopher Busshe for sepulchre lights
6s. 10d.
1555:
for maykkyng of the sepulkkure howysse iijd.
for paynttyng of a clothe for the saym ijs.
for feycheyng of the sepulkcure clothe frome the
paynters att boston ijd. [Peacock, "Leverton"; P.
Thompson, *Boston*]

LINCOLN, Cathedral, St Mary
ESp in sanctuary N of high altar, freestanding, between
2 pillars separating sanctuary from N aisle; entire

monument made up of 6 bays of equal height & width,
each with its own gable; 3 easternmost form ESp, those
to W presumably tomb, though for whom not known;
possible association with Remigius, builder of early
Norman cathedral; monument designed as low tomb chest
behind supports for canopy; supports divide front into
6 squarish panels, 3 of ESp proper carved with sleeping
soldiers in relief; each soldier with shield, & naturalis-
tic foliage behind him; faces hacked away; above, nar-
row slab of tomb chest plain; ESp separated from tomb
by vertical wall, beautifully carved with naturalistic
foliage, leaving 3 bays on each side; interior end walls
similarly carved; underside of canopy fan vaulted with
earliest fan vaults in England; gables have pierced
trefoil cusping, crockets & finials; c.1300. Figs. 37-38.
ESp ntd 1389 Guild Certificate of Guild of Resurrection:
Twenty round wax lights shall be kept burning round
the body of our Lord lying in the sepulchre, from
Easter eve till the time of Resurrection on Easter Day,
each wax light weighing a pound and a half. [Toulmin
Smith, *Gilds*]
15c inv:
Item j ymago christi de argento deaurato aperta seu
vacua in pectore pro sacramento imponendo tempore
resurreccionis stans super vj leones et habet unum
birellum et unum diadema in posteriore parte capitis et
Crucem in manu pondere . . xxxvij unc.
Inv 1536:
In primis a Image of owr savyour sylver and gylte
stondyng opon vj lyons voyde yn the breist for the
sacrament for Estur day havyng a berall before and a
diademe behynde with a crose yn hand weyng xxxvij
unces.
Item a whyte stenyd cloth of damaske sylke for the
sepullcour with the passyon and the Resurreccion of
owr lord.
Inv 1548:
Ex pro rep<ar>acione: ecclesie: Item an Image of our
Saviour silver and guilt standing uppon 6 Lions void in
ye brest for ye Sacrament for Easter day, haveing a
berall before, and a Diademe behind with a Crosse in
hand, weighing xxxvij unces.
Item a whyte stenyd cloth of damaske sylke for the
sepullcour with the passyon and the Resurreccion of
owr lord.
Inv 1557:
white steyned clothe of damaske sylke for the
sepulchre.
Certificate of Ornaments to Queen's Comm 1566:
Sepulcres--j mencioned hereafter.
Alter clothes--j for the sepulcre wrought with Images
Now remayning in the olde revestrie j alterstone

['black' interlined] a Sepulcre a . . a crosse for
candelles called Judas crosse and other Furniture
belonging to the same Sepulcre, the pascall with the
Images in Fote belonging to the same Sepulcre and a
candlestike of wodde. [Wordsworth, "Inv Lincoln"]

LINCOLN, Holy Cross Church in Wykford
ESp* ntd guild certificate 1389 stating that Guild of St
Sepulchre (founded ?1376) funded [number illegible]
square candles burning round ESp as at St Martin [see
next entry]. [Westlake]

LINCOLN, St Martin
ESp* ntd guild certificate 1389 stating that Guild of
Resurrection funded annually:
24 square candles and 4 mortuary candles round the
Sepulchre, of which 4 square and 4 mortuary candles
burn from the Burial to the Resurrection, when all are
lighted in honour of the Burial and Resurrection and
for the safety of our souls, living and dead. [Westlake]

LINCOLN, St Michael on Hill
ESp* ntd guild certificate 1389 stating that Guild of
Corpus Christi founded in honor of Jesus Christ, his
body & blood, the Holy Sepulchre, etc. Guild provided
13 square candles round ESp on day of "Preparation" &
3 round candles burning continuously from day of Pre-
paration to Resurrection. [Westlake]

LINCOLN, St Paul (?St Paul-in-the-Bail)
ESp* ntd Comm inv 1566:
Item our Sepulchre--brokne in peces and sold to our
parsoone nowe beinge the said time. [Peacock, "English
Church Furniture"]

LITTLE BYTHAM (BYTHAM PARVA), St Medard
ESp/founder's tomb; segmental-arched recess in N wall of
chancel at NE corner; steep triangular pediment with
crocketing on outer side; hollow molding on inner side
of pediment has one ball flower at apex and 8 on either
side; moldings & segmental arch both rest on shoulders
of projecting corbel busts to either side; heads of busts
support bases of pedestals for images; outer moldings
die into inner edges of pilasters to E & W; below, to
either side, ledge with termination of dragon on E, 2
mutilated animals on W; E pinnacle broken off; W re-
mains; il Keyser, "Little Bytham," fig 4.
ESp* ntd inv 21 March 1565:
Item . . . one sepulker--broken and defaced anno
domini 1565 Thomas Blissit and William wallice
churchwardens but certaine of theis thinges weare made
awaie ij year a go so that no one popishe ornament of

all remanith but is vtterlie defacid broken in peces and put to prophane use. [Peacock, *English Church Furniture*]

LITTLE STEEPING, St Andrew
ESp* ntd 1524 will of Wm Austyn:
Also for making of two Sergs that stands in the high quere before the Sacrament in the churche of litill Stepyng iiijd. alway to be paid at Ester, also two tapers on the high quere of litill Stepyng and they to be made every yeare of vj lb. wax a pece, xij lb. both, and every oon of the said Tapers to burne before the Sepulcre from good fryday to Ester day morning that Resureccon be done. [W. H. Smith]

LOUTH, St James
ESp* ntd churchwardens' accts 1516:
Memorandum of Saynt Leuke day the Evangelist that I John Cawod laid all thes bokys and with oder dyvers ewidence in the rode lofte in a new ambre wich our lady gild paid for 6s. 8d. The yer of our lord Gode Millmo ccccxvj.
Also .j. boke of acomtt of Sepulcure light. [Dudding, *Louth*]

MAREHAM-ON-THE-HILL, All Saints
?ESp; low arched recess in N wall of chancel; probably 14c but church heavily restored in 1804. [Alexander, *Ls*]

MARKBY, St Peter or St Mark
?ESp; square-headed opening in N wall of chancel; late medieval. [Alexander, *Ls*]
ESp* ntd inv 25 April 1566:
Item a sepulker--sold to william Badge the same tyme who haithe made necessaries thereof for his house. [Peacock, *English Church Furniture*]

MARKET DEEPING, St Guthlac
ESp* ntd inv 1565:
Item one sepulker a crosse amd the holie water stockes--sold to hughe Bushe of Deeping aforesaid now decessid Anno domini 1563 by the said churchwardens. [Peacock, *English Church Furniture*]

MINTING, St Andrew
ESp* ntd inv 30 April 1566:
Item our Rood Loft a sepulchre and our clappes with all other suche ymplements--defaced and put to prophane vse primo elizabeth. [Peacock, *English Church Furniture*]

MOULTON, All Saints
 ?ESp with ogee arch in N wall of chancel; 14c. [Pevsner]

MUMBY, St Peter or St Leonard
 ESp* ntd inv 1548:
 oon clothe of gren silke ijs belonging to the sepulcre
 oon paynted clothe xxd. to be hanged vpon the wal
 behynd the sepulcre oone sepulcre clothe xijd. [Foster,
 "Inv 1548"]

NAVENBY, St Peter
 ESp in N chancel part of Dec chancel including tomb,
 sacristy, piscina with double drain, & triple sedilia,
 commissioned by Wm de Herlaston, rector 1325-9, royal
 clerk & chaplain; ESp, by same sculptor as Heckington
 ESp, has vertical format; height 7'; below, 3 soldiers,
 all standing & now headless; one leans against side of
 panel as though sleepy; above them, horizontal slab
 forms floor of recess nearly 3' high by nearly 2' wide;
 top of recess trefoiled, enframed by cinquefoil in relief
 & ogee arch with crocketing & large leafy finial; pin-
 nacles from sides reach to cornice, framing sides of
 ogee, on which stand figs. of angel & 3 holy women.
 Fig. 36.

NEWTON, St Botolph
 ?ESp; ogee-headed recess with ballflower decoration in N
 wall of chancel. [Alexander, Ls]
 ESp* ntd inv 29 March 1566:
 Item one sepulcre and one Judas candlestick--sold to
 Adame bas who haith broken the same in peces. [Pea-
 cock, English Church Furniture]

NORTHORPE, St John Baptist
 ?ESp; low arched recess in N wall of chancel; 13c.
 [Alexander, Ls]

NORTH WITHAM, St Mary
 ?ESp; plain champfered low-arched recess in N wall of
 chancel; 13c-14c. [Alexander, Ls]
 ESp ntd inv 18 March 1565:
 Item one sepulcre--sold to ffraunces flower by the
 whole consent of the whole parishe the said Peter
 broughton beinge churchwarden at that tyme anno 1560
 which haith made a presse therof. [Peacock, English
 Church Furniture]

OSBOURNBY, SS Peter & Paul
 ESp* ntd inv 1 April 1566:
 Item the sepulcre clothe give by the towneshippe to
 Richard Sodbie &c and the sepulcre is burned. [Pea-
 cock, English Church Furniture]

OWMBY, SS Peter & Paul
ESp* ntd inv 12 April 1566:
Item one sepulcre broken in peces in Anno primo
Elizabeth and a communion table made thereof. [Pea-
cock, *English Church Furniture*]

PICKWORTH, St Andrew
ESp* ntd inv 1 April 1566:
Item a sepulker--sold to Robert Cook our parson Anno
domini 1565 who defacid it. [Peacock, *English Church
Furniture*]

RAITHBY-BY-SPILSBY, Holy Trinity
?ESp; Dec recess with low arch, cusped and molded, in
N wall of chancel; church mostly rebuilt by G. G. Scott
in 1873. [Alexander, *Ls*; Pevsner]

RAND, St Oswald
?ESp; Dec recess with low arch & ballflower moldings in
N wall of chancel. [Alexander, *Ls*]

REDBOURNE, St Andrew
?ESp; Dec recess, low in N wall of chancel, with ogee
arch, molded & cusped. [Alexander, *Ls*; Pevsner]

RIGSBY, St James
ESp* ntd inv 1548:
ij bannar clothes with other trashe with owld clothes for
the sepulcre. [Foster, "Inv 1548"]

RIPPINGALE, St Andrew
ESp* ntd inv 29 March 1566:
Item the roode loft taken doune and distroyed and made
awaie with all the tabernacles and all others as the
sepulcre and herse lightes with all the bookes of
papistrie rent and burned anno 1561. [Peacock, *English
Church Furniture*]

ROPSLEY, St Peter
?ESp; Dec recess with low arch in N wall of chancel;
c.1300. [Alexander, *Ls*; Pevsner]

ROXBY, St Mary
?ESp; Dec square-headed recess, now with doors, in N
wall of chancel. [Alexander, *Ls*]

SCOTTON, St Genewys or St German
?ESp; low arched recess in N wall of chancel; 13c.
[Alexander, *Ls*]

SKELLINGTHORPE, St Lawrence
ESp* ntd Comm inv 1566:

Item banner clothes and a sepulker clothe--sold to Roberte Frithe who hathe defacid theim. [Peacock, "English Church Furniture"]

SKIDBROOKE, St Botolph
?ESp; square-headed recess in N wall of chancel; 14c-15c. [Alexander, Ls]

SKILLINGTON, St James
ESp* ntd inv 8 April 1566:
Item Clappers Iudaces and a sepulker--made awaie and broken in peces Anno primo Elizabeth. [Peacock, English Church Furniture]

SOMERBY (OLD SOMERBY), St Mary Magdalene
ESp* ntd inv of goods given by Sir Tho Cumberworth, Kt, to Chapel of Holy Trinity in Somerby Church in 1440:
Item 2 clothes of gold of read and grene with all the honourments for the sepulcre and for our obetes & 2 of white cloth of gold.
Also ntd inv 21 April 1566:
Item a sepulker--was sold to Henrie Leveret in the fyrst or second yeare of the Quenes Majestie yat now is who defacid. [Peacock, English Church Furniture]

SOUTH COCKERINGTON, St Leonard
?ESp; Dec niche with projecting base in N wall of chancel. [Alexander, Ls]

SOUTH WILLINGHAM, St Martin
ESp* ntd inv 30 April 1566:
Item one sepulcre broken in peces and defaced. [Peacock, English Church Furniture]

SOUTH WITHAM, St John Baptist
ESp* ntd inv 18 March 1565:
Item iij banner clothes with a sepulcre clothe . . . sold to Thomas wymberley for ijs. viijd. aboute a fortnighte sens by harrie hodson and Iohnne Croftes churchwardens and he haith broken and defacid the same.
Item one sepulcre--broken and defaced. [Peacock, English Church Furniture]

SPRINGTHORPE, SS George & Lawrence
ESp* ntd inv 8 April 1566:
Item one sepulcre burnte 1561. [Peacock, English Church Furniture]

STALLINGBOROUGH, SS Peter & Paul
ESp* ntd inv 1 May 1566:

Item a sepulker--defacid whearof wee made a bear
[bier] to carrie the dead corps and other thinges.
[Peacock, *English Church Furniture*]

STAMFORD, St Mary
?ESp; 2 low ogee headed tomb recesses, almost identical,
in Chapel of Corpus Christi Guild [N of chancel];
another arch now incorporating 3-light NE window of
chapel has paneled tomb chest at base; this composition
15c; chapel 14c. [Alexander, *Ls*]

STEVENBY, Church
ESp* ntd inv 18 March 1565:
Item . . . one sepulcre . . . and as for the sepulcre is
broken and defaced. [Peacock, *English Church
Furniture*]

STICKFORD, St Helen
ESp* ntd inv 30 April 1566:
Item a sepulker--sold a year a go and defacid by william
Est. [Peacock, *English Church Furniture*]

SUTTERTON, St Mary
ESp* ntd churchwardens' accts 1525 referring to ESp
light. [Peacock, "Sutterton"]

SWATON, St Andrew or St Michael
ESp* ntd inv 18 March 1565:
Item one sepulcre--Burned and defaced and put to
prophaine vse. [Peacock, *English Church Furniture*]

SYSTON, St Mary
ESp* ntd inv 10 April 1566:
Item one pix one pax and a sepulker--broken in peces
and defacid the said tyme by the said churchwardens.
[Peacock, *English Church Furniture*]

TALLINGTON, St Lawrence
ESp* ntd inv 18 March 1565:
Item one sepulcre and the roode lofte--burnte by
Roberte Broune and Robert Ibbes churchwardens Anno
1560. [Peacock, *English Church Furniture*]

THORPE-ON-THE-HILL, St Michael & All Angels or All Saints
ESp* ntd inv 7 April 1566:
Item two vestmentes a sepulcre clothe two banner
clothes and a crosse clothe sold to william Cressie about
a moneth sens 1565 which was defaced before he
boughte them.
Item one sepulcre defaced and broken in peces. [Pea-
cock, *English Church Furniture*]

THURLBY, St Firmin
?ESp; square-headed opening divided by central shaft
with stepped edge in N wall of chancel; 13c. [Alexan-
der, Ls]
ESp ntd inv 31 March 1566:
Item the sepulcre was brent for the glasier, by theis
churchwardes since this lent. [Peacock, *English Church
Furniture*]

ULCEBY, St Nicholas
?ESp; 2 crudely cut openings, one above the other, in N
wall of 13c chancel. [Alexander, Ls]

USSELBY, St Margaret
ESp* ntd Comm inv 1566:
Intem [sic] the sepulcre and sepulcre cloyth--was
burned and defaced Anno primo Elezabyth John wrawby
Edward conyngam churchewardons. [Peacock, "English
Church Furniture"]

WADDINGHAM, SS Mary & Peter
ESp* ntd inv 11 April 1566:
Item one sepulcre broken in peces and defaced. [Pea-
cock, *English Church Furniture*]

WAINFLEET ST MARY, St Mary
ESp* ntd 1527 will of Robt Barret:
Item to the Sepultum lyght in the churche of oure lady
in Waynflete viiid. [Heanley]

WELTON-LE-MARSH, St Martin
ESp* ntd inv 30 April 1566:
Item a sepulker--defacid Anno primo Elizabeth by the
aforesaid churchwardens. [Peacock, *English Church
Furniture*]

WEST RASEN, All Saints
ESp* ntd inv 29 April 1566:
Item the sepulchre and the clothe--brokne and sold this
yeare.
Item a sepulcre--stóllen out of our church anno primo
Elizabeth. [Peacock, *English Church Furniture*]

WIGTOFT, SS Peter & Paul
ESp* ntd churchwardens' accts 1545:
Memorandum that John Nebyle and John Butler, Alder-
men of the Sepulcre lyght in Anno domini
M.CCCCC.XLV., Anno Henry VIII., xxxvj., have
delyvered by the paryshoners to the use of the seid
lyght, 9s. 7d. And also be it remembred that ther is at
this day fyve score and twoo pounde waxe in the seid
lyght. [Heales, "ESp"; Feasey, "ESp"]

WILLOUGHBY, St Helen or St Andrew
ESp* ntd 1415 will of Wm Wynluff & 1416 will of Jn Bardenay with bequests to ESp lights. [Gibbons]

WINTERINGHAM, All Saints
?ESp; 2 recesses in N wall of 13c chancel; one is 7'2" in width; to E of it, another 2' 1" in width; former has segmental arch, latter pointed; smaller could have been ESp. [J. T. Fowler, "Winteringham"]

WINTERTON, All Saints
ESp* ntd inv 30 April 1566:
Item the Iewes light the pascall post the sepulcre the maydens lighte were burned in the Anno 2⁰ Elizabeth. Item one sepulcre clothe of lynnen which was sold to Richard Glanforthe and he haith defaced. [Peacock, *English Church Furniture*]

WINTHORPE, St Mary
ESp* ntd inv 30 April 1566:
Item a Sepulcre--broken Anno primo vel ij^do Elizabethe. [Peacock, *English Church Furniture*]

WOOLSTHORPE-BY-BELVOIR, St James
ESp* ntd inv 1 April 1566:
Item one sepulcre broken in peces and defaced by the fall of the steple. [Peacock, *English Church Furniture*]

WRANGLE, SS Peter & Paul, or St Peter, or SS Mary & Nicholas
ESp* ntd Comm inv 1566:
Item a sepulchre and our Judasses--brokne in peces and made awaie the same time. [Peacock, "English Church Furniture"]

LONDON (Lo)

LONDON, Diocese of
ESp ntd Article 57 of Bishop Ridley's Articles of 1550 for London Diocese:
or whether there be any sepulchre on Good Friday? [Frere, *Visitation* 2]
Also ntd Item 10 of Bishop Ridley's Injunctions for London Diocese 1550:
That none maintain . . . sepulchres . . . or any other suchlike abuses, and superstitions, now taken away by the King's grace's most godly proceedings. [Frere, *Visitation* 3]
Anonymous MS. summarizing ecclesiastical events refers

to Bishop Bonner's injunctions:
1554. This yeare was comaundement gyven, that in all
churchis in London, the sepulcre should be had upp
agayn, and that every man should beare palmes, and
goo to shrifte. [Nicols, *Narratives*, quoting Harley MS.
419, f. 131]

All Hallows Barking
?ESp/tomb; chest tomb with canopy in N chancel chapel
of St Nich; chest, on molded base, has quatrefoil pan-
els on ends & front; plain slab supports 2 octagonal
shafts & 2 responds against back wall on which rest
canopy; front of canopy treated as 2 very depressed
arches, cusped; above them decorative frieze including
Holy Name, then frieze of quatrefoils, & finally cornice
of Tudor flowers; underside of canopy has fan vault-
ing; back wall has brass to Jn Croke (will dated 1477,
proved 1484) kneeling at desk & wearing fur-trimmed
tunic & fur-lined alderman's mantle (sons kneel with
him); facing him brass of wife, Margaret (d. 1490),
shown as widow, kneeling with 5 daughters; Croke &
wife each have scrolls issuing from mouth; only few
letters of inscriptions remain; tomb of Purbeck marble;
il Lo C C Survey 15, Pls. 81, 84, 85. [Norman, "All
Hallows"]
?ESp/tomb; chest tomb in S chancel chapel also ap-
propriate for ESp; may be tomb of Sir Robt Tate re-
moved from Royal Lady Chapel; chest, on molded base,
paneled with 3 squares containing quatrefoils with
shields, set diagonally; canopy with flat arch rises
above plain slab; very shallow canopy has frieze of
quatrefoils & cresting of Tudor flowers; back wall had
brasses of man, woman, 3 sons, 4 daughters, now all
missing; brass of Resurrection & scrolls remain; brass,
10 1/2" x 11", shows Christ with bannered cross step-
ping from tomb around which soldiers sleep; Christ
surrounded by rays of light; scrolls read, "<Ego re-
surgam et in carne mea videbo> te Ihesum deum
salvatorem meum," and "Qui Lazarum ressusitasti a
monumento fitidum dona nobis requiem." Brass il Lo C C
Surv 15, p. 72.
ESp ntd inv 1452:
a resurreccion of siluer and ouergilt with a birell for
the sacrament weying of troye weght .iiij lb. vj vnces.
Item for the sepulcre ij longe peces of blu velewet
embrouded with sterres of gold of cipres/ iiij quarters
and .ij. smale peces of the same sute/ and .ij. clothes
hangers of blue tartaryn with sterres of gold.
Item iiij kerchiefs of plesauance for the same.
Item j celour stevned with the Trinitee for the
sepulcre.
Inv 1512:

Item a Resurieccion with a tombe. I crossye and a
scryne all syluer and gyltte liii onces di.

SEPOWLKER CLOTTHES & BANNERS

Item. ij sepulker cloytthes of blewe sarssynet with noli
me tangere.
xij pendantes of Red bokeram & ij longe standerdis of
Red bokeram with ij syluer lyons & a square banner of
bokeram with the Kynges armes & xii square banners
and pendantis.
iiij banner cloytthes for crossys & a good banner
cloytth of the trynete of sylke.
viij peces of blew welvett with starrys of gold a havtter
cloth of above & beneth panyed with Red (& grene
cloth) of gold and a havlter passe of the same with ij
curtens of sursenet of Red and grene. [Lo C C Surv
12]

All Hallows, Bread Street
ESp* ntd Comm inv 1552 listing goods sold 1549-50:
Receuede of thomas Rowe for the Rowde vayle the
sepulcher cloth both stayned and the lenon vayle of old
Rotton diaper xvs.
Receuede for the bordes with a frynge for the sepulcer
viijs. [Walters, Lo Churches]

All Hallows Great
ESp* ntd Comm inv 1552 listing goods sold 1549-50:
ffyrst the sepulchre Chest that stode in the Quere sold
for xxs. [Walters, Lo Churches]

All Hallows, Lombard Street
ESp* ntd Comm inv 1552 listing goods sold since 1547:
Item the saide Henrie ffisher paide for iiij pillers of
carved worke which were of the Sepulker iijs. iiijd.
[Walters, Lo Churches]

All Hallows, London Wall
ESp* ntd churchwarden's accts 1456:
Also paid for ye waaste and making of thre tapris to ye
sepulcre ijs. iijd.
1458:
Also payde for the makynge and the Waste of iij Taprys
to the sepultur ijs. iijd.
1469:
Item Resceyued of the parson toward the makyng of ye
sepulcre iiijs.
Item Resceyued for the olde sepulcre iijs. iiijd.
Item rescevued of the parisshyoners toward the makyng
of the Sepulcre that is to sey of William Boteler iiijd. of
John Hardyng iijs. iiijd. of Symond Pratte ijs. of John

Newman xxd. of William Condy xxd. of Nicholas Cale
xxd. of John Sistokke xijd. of William Cace xijd. of
matchyng is wvf xijd. Richard Trent iiijd. Richard
Barbour ijd. walter may iiijd. John Abraham iiijd.
William Godale iiijd. William hayward ijd. John Gilbert
iiijd. Kateryn Grene iiijd. Item of Gey Condy vjs. viijd.
thomas cherscey xijd. laurance Webe iiijd. Nycolas
Santlowe iiijd. John lambe xijd. John Coghnat iiijs.
Ryc Wyfelde iiijd. Wyll pudsay iiijd. Cateryne Kendale
iijd. John Cagge jd. John Browne iiijd. John Bole iiijd.
thomas hvnt ijd.
Item paide for makyng of the Sepulcre xliiijs.
Item paide for payntyng of the same sepulcre ixs.
Item paid for wast and makyng of ye tapers of ye
sepulcre iijs. ijd.
Item for Iren and hokes to the Sepulcre xvjd.
Item for Curteyn Rynges to the same vjd.
1475:
Item Resseyuid At Ester for sepulcre light xxd.
Item paid for the waste of the sepulcre light for ye
wexechaundeler ijs. ixd.
1476:
Item resseveid for the sepulcre lyght xvijd.
Item for the Sepulcore lyth and sthandardis ijs. ijd.
ob.
1481-2:
Item payed for water & Coles and Watching of the
Sepultur iiijd.
1487-8:
Item paied to the Waxchaundeler for the last yere that
is to say for ij lb. of Judas candill and for ij Standerds
and for the Beme lyght and iiij tapers for the Sepulcur
and for a taper of a lb. for the ffunt xijs. xd.
1499-1500:
Item to the parish Clerk for brede and ale at ye same
tyme to watche the Sepulcre iijd.
1508-10:
Item payd for a taper of a li. for tobrune be the
sepullcer viijd.
Item payd for naylis for the sepullcer jd.
Item payd for a taper of a li. for the sepullcer viijd.
?date:
Item of Sepulcre lyght receyvyde iiijs. xjd.
1527:
Item Ressavyd for the Sepulter lythe xiijd. ob.
1528:
Item Ressavyd for the Sepulkers tappers iijs. ijd.
1529:
Item Ressavyd for the sepulkere tappers iijs. viijd.
Item payd the waxe chawller for judasse candelle & to
standerds and the crosse kandelles & the sepulker lyte
& the garnyssheynge of the torches vjs. viijd.

1530:
Item gatheryd for the sepulcre lyght xd.
Item payde for brede and dryncke for them that wachyd
the Sepucre jd.
?date:
Item payd to the Clarke for watchynge of the Sepovlker
iiijd.
Item payd for a di. li. tapper for Sepullcre iijd. ob.
[Welch, *Allhallows*]

All Hallows Staining
ESp* ntd churchwardens' accts 1521:
Paid for a Image of ye resurreccion ixs. ijd.
1553-4:
Received for the sepoulkar lyght, as it apperyth by ye
gatheryng boke ijs. vd.
Item for stoofe and makeng a fframe for the sepoulkar
lyght, and a pesse for to sett the paskall on iijs. iiijd.
[Also frequent references to "Sepolekar Lyght," etc.]
[Povah]

St Alban, Wood Street
ESp* ntd Comm inv 1552:
 ffor the Sepulcre
Item ij cloathes of purple and tawney taffata lyned with
blue Canwys.
Item ij cloathes moare of the same.
Item iij vallances for the Sepulchre. [Walters, *Lo
Churches*]

St Alphege, London Wall
ESp* ntd churchwardens' accts 1528:
Paid to ij men for watching of the sepulcre vijd.
1534:
Paid for watching the sepulcre iiiid.
1536:
Paid to ye copersmyth for making a thing which stands
in God Amyty's brest at Ester viiid.
Paid for making God Amyty's Cotte iiijd.
Inv 1536:
Item A payntyd clothe the which hanges behynde the
sepukur.
Item viii paynted clothes & a pylow that longs
sepulcure.
Item a cotte for the resurexione at ester of rede sylke.
1545:
Paid for settyng up of ye Sepulcre and mendyng of ye
same viijd.
Paid for watching of the Sepulcre ixd. [Carter]

St Andrew Holborn
ESp* ntd lightwardens' accts 1477-8:

Item to the clerk for colis to watche the Sepulcre iiijd.
[Barron & Roscoe]

St Andrew Hubbard
ESp* ntd churchwardens' accts 1458-60:
Item, Cartynge awey dungge and Rovbous at diuers
tymes and amendvng of a deske and for the amendyng
of the Sepulcre tymbre and makyng clene of the
churchawe xvid. ob.
1469-72:
Item, for dressyng of a Candelstik to the Resureccion
iiijd.
1474-6:
Item, paied for Coles for watchyng of the sepulcre for
ij yere iiijd.
[Payments for ale, bread, & coals for watchers of ESp
noted frequently from this year until 1546, & from 1552
to 1558.]
1480-2:
Item, paid to a mason for taking oute of a Stone, and
setting in of the bace of the Resurreccion that the
tabernacle stondeth vpon iiijd.
Item, paid to the kerver for making of the bace xxijd.
Item, for a Coffyn to laye in the Crossis and mendyng
the fframe vjd.
1483-5:
Item, paid for the payntyng of the tabernacle & makyng
of a new fote that the Resurreccion stondyth on iijli.
iijs. iiijd.
Item, paid to John Mudley for peyntyng of the clothe
afore the resureccion ijs. viijd.
1491-2:
Item, paid ffor a hoke to the sepulcre and ij plattes
iiijd.
1493-4:
Item, paid ffor mendyng of the frame of the sepulcre
ijd.
1499-1502:
Item, paid for pynyss for the sepulcre & the Aulters
jd.
1510-1:
Item, paid for makyng of iij sepulture Tapers of xviij
lb. the lb. makyng ob. Summa ixd.
1522:
Item, Receyued gadryd on good fryday toward the
Sepulcre iiijs.
Item, paid for the sepulcre viijs. iiijd.
1536-7:
Receuyd for to yers for the Sepulker lyght at ester
tyme xxiijs. viijd.
[Entries of sums received for ESp light noted regularly
until 1546.]

Item, for the Sepulker tapers vijs. viijd.
Item, for xij tapers for the Sepulkerlyght viijs.
1552-4:
Item, Recevyd for the sepulcre lyght iiijs. viijd.
Item, for watchynge the sepulcre iiijd.
Item, leyd ovt for the sepulcre lyght vjs.
1554:
Resevyd for the sepulture lyght for ij yeres xxvijs.
viijd.
155?:
Item, paid for settyng vp the sepulture xijd.
Item, paid for nayles vnto the same iijd.
Item, paid for a xj tapers for the sepulture xjs.
Item, payde to the clarke ffor watchyng the sepulture
xijd.
Item, paid for the frame of the sepulture xjs.
Item, paid for the payntyng of the sepulture xs.
Item, paid for the watchyng of the sepulture xijd.
Item, paid for cole for those that watche the sepulture
iiijd.
?1556-8:
Resevyd for the Sepullkar light for ij yeres xxiijs.
vijd.
Paid for whaching the Sepullcar lyght viijd.
Paid for wachyng the Sepulcar xijd.
Paid for the Sepullcar lyght xjs. [Crosthwaite]

St Andrew Undershaft
ESp* ntd Comm inv 1552:
Item iij Borders for the sepulcar A sepulcar clothe.
Sold 1550-1:
Sold to Sowche . . . a sudary "that hanged by the
Sepulchre," 2d. [Walters, *Lo Churches*]

St Antholin
ESp* ntd Comm inv 1552:
one olde Sepulchre clothe of fustyan stayned. [Walters,
Lo Churches]

St Benet Fink
ESp* ntd Comm inv 1552 listing goods sold 1549-51:
Sold to Thomas Worlyche . . . two old fringes for the
Sepulchre, 8d.
Sold to John Wilcocks . . . the timber of the
Sepulchre, 5s.
Sold to Thomas Kychen, a sepulchre cloth of silk,
1s. 2d. [Walters, *Lo Churches*]

St Benet, Gracechurch Street
ESp* ntd Comm inv 1552 listing items sold 2 October
1550:
Sold to James Morley . . . all the clothes for the

sepulchre, 14s. [Walters, *Lo Churches*]
Also ntd churchwardens' accts 1553:
Paid for ye ffoote of ye sepulchre, and for a desk for
ye high aulter, 8s.
Paid for wax used about the sepulchre Easter Day 7s.
Paid for a sacke of coales to watch the aforesaid
sepulchre 1s. 3d.
1556:
Paid for making the sepulchre agaynst Easter 5s.
Inv 1560:
A Sepulchre with ii carpets. [Malcolm 1]

St Benet, Paul's Wharf
ESp* ntd Comm inv 1552 listing items sold 1548-9:
Item sold to Robert ffanne [?] the Sepulcre and
allablaster [sic] Images & other broken Images xxijs.
[Walters, *Lo Churches*]

St Botolph Aldersgate
ESp* ntd Guild of Corpus Christi founded 1374 with
purpose of maintaining 13 wax lights burning about
ESp; guild later became Brotherhood of Holy Trinity;
entry in guild book, c.1450, traces history:
Gode bretheren and susteren, it is forto weten and
knowen that the bygynnynge of this bretherhode of
grete deuocion, euery man paynge a peyny for to fynde
xiij. taperes aboute the sepulchre of Christe at Estre in
the chirche of seynte Botulphe with-oute Alderesgate in
Loundon. After that, throughe more gretter deuocion
and sterynge unto the worschippe of god it was yturne
in to a fraternite of the holy Trynyte nought with
stondynge the fvndynge euery yere the mayntenynge of
the forsayde xiij. tapers of the whiche bretherhode
these were ther.
Entry of c.1450:
Also ther ben ordeyned xiij. tapers of wex and euery
taper of six pounde of wex with dysches of pewere
accordynge therto ffor to brenne aboute the sepulcre on
estres eue and estres day also longe as the maner es in
holychurche. [Westlake]

St Botolph, Billingsgate
ESp* ntd Comm inv 1552 listing items sold 1549-50:
Item to Richard Whaberley & the goodman fanne . . . a
valence of buckeram aboute the Sepulchre. [Walters, *Lo
Churches*]

St Catherine Coleman
ESp* ntd Comm inv 1552 reporting ?1548 inv:
Item a sepulker clothe.
Sold 1550:
Item A sepulker clothe of lynnyn. [Walters, *Lo*

Churches]

St Catherine Cree
ESp* ntd Comm inv 1552 reporting 1547 inv:
Item lxijli of waxe of the Rood lyght and the Sepulcre.
Sold 1547-8:
In primis Solde to Symon Burton the xxv daye of
Decembre lxijli of waxe of the Roode lyght and the
Sepulcre lyght at iiijd. the pounde xxs. viijd. [Walters,
Lo Churches]

St Catherine's Hospital (near Tower of London)
ESp* ntd inv 1546:
 In the vtter Chamber over the vestre
Item the tymbre of the Sepulchre and the cros for the
Candelstickes ijs.
Item olde paincted clothes for the same iiijd. ["Some In-
ventories"]

St Christopher-le-Stocks
ESp* ntd inv 1488:
Item--ij Clothes for the sepulchre, oon with the Passion
and the other steyned full of whyte leves. [Freshfield,
"St Margaret-Lothbury"]

St Dionis Backchurch
ESp* ntd Comm inv 1552 listing items sold 1550:
Item soulde to Thomas Sharpe j peace of ryghte
[?whyghte] cloth of golde yat wente abowte ye
sepoulter conteynyng ij yardes quarter and halfe at
xjs. iiijd. yarde sore dropyd with wex xxvjs. viijd.
[Walters, *Lo Churches*]

St Dunstan-in-the-East
ESp* ntd Comm inv 1552 listing goods sold 1549-50:
Item in the therd yeere of owre sayde Soveraign Lordes
Raign the sayde William Anstye then beinge vpper
warden toke into his handes . . . A Sepulture Cloth
of bawdkyn.
Also ntd Comm inv 1550:
Item viij Banners some of Sylke stayned and some of
Lynnyn stayned That that longeth to the Sepulture and
for good ffrydaye.
Item a Sepulture Cloth of Cloth of golde.
Item a shete to laye in the Sepulture.
 Hangynges
Item ij Aulter Clothes stayned for aboue and beneth for
Ihesus Aulter one of Ihesus and another of the
Sepulture with Curtyns with Aungelles. ["St. Dun-
stan's"; Walters, *Lo Churches*]

St Edmund, Lombard Street
ESp* ntd Comm inv 1552 listing items sold 1549-50:
Item to hym [John Royse] an iron chest olde and the
sepulcher for vjs. viijd. [Walters, *Lo Churches*]

St Faith by St Paul's
ESp* ntd Comm inv 1552 listing items sold 1551-2:
Item . . . a frame of a Sepulchre. [Walters, *Lo
Churches*]

St George, Botolph Lane
ESp* ntd Comm inv 1552 listing items sold 1551:
The same day to Jhon Churley . . . sertyne ollde
canvas which was wonte to be abowte the sepullchre
with iiij banar staves. [Walters, *Lo Churches*]

St Gregory-by-St Paul's
ESp* ntd Comm inv 1552:
Item a clothe of Redd Damaske for the Sepulchre. [Wal-
ters, *Lo Churches*]

St Helen Bishopsgate (Benedictine Convent)
ESp/tomb in N wall of nun's choir (N aisle of church);
now high on wall because floor lowered; front of base,
recessed in wall, divided into 6 round-headed panels
with cusping; these open to provide squint from sacris-
ty; marble slab with molded round edge forms top of
chest; above this square-headed recess with foliate
cornice & cresting of Tudor flowers; soffit of recess in
shape of 4-centered arch, elaborately paneled, as are
side walls; finishing surface of back wall, presumably
inscribed plate, now missing; heraldry identifies this as
tomb of Johane Alfrey, whose will of 1525 asks that she
be buried in choir:
under a tumbe in the walle stonding before the image of
Saint Helyn whereuppon the Sepulcre of our Lord hath
ben yerely used to be sett. And for the same cause
specially I will that the said tumbe be newe made by
myn executors . . . a stone to be laide upon the grave
of my late husbonde William Ledys making mencion who
lyeth buried under the same stone . . . a table
conteyning thre ymages . . . the Trinitie to be in the
myddes . . . our Lady to be on the right side of the
same Trinitie . . . saint Kateryn to be on the left side
. . . and the same table to be fastened upon the walle
bitwene my said tumbe and the ymage of Saint Helyn.
Il Lo C C Surv 9, Pls. 61, 68; RCHM 4, Pl. 69.
[Lo C C Surv 9]

St James, Garlickhithe
ESp* ntd churchwardens' accts c.1555:
Setting the sepulture 4d. [Norman, "St James"]

St John Zachary
ESp* ntd 1531 will of Dame Eliz Reed asking to be buried:
at the north ende of the highe awter there before the Image of saint John in a tombe by me thereto ordeyned, which tombe doth serve at Esther tyme for the botom of the Sepulcre of our Lorde Jesu Criste. [McMurray]

St Lawrence Jewry
ESp* ntd Comm inv 1552:
Item one cloth of blew veluet that went abowt the sepulcer. [Walters, *Lo Churches*]

St Leonard, Eastcheap
ESp* ntd 1501 will of Hugh Brown, citizen & grocer of London leaving:
to the Church of St leonard a cross of silver and gilt with a foot thereto all gilt, and therin being over the crucifix a round box of gold with a piece of the holy cross therein closed, made crosswise to the entent that every Christen body is bound to honour and worship God . . . and on every Goodfriday and Esterday in the morning at the Resurrection of the said cross to be occupied at the creeping of the cross, also that the said cross shall yearly be laid by and with the blessed sacrament in the sepulchere on every Goodfriday, to the great honour of God, and for the great dignity and preciositie of the same cross. [Woodruff, *Sede*]

St Leonard, Foster Lane
ESp* ntd Comm inv 1552 including items sold 1551-2:
Item of a goldsmyth in wodestrett for the sepulchre vjs. viijd. [Walters, *Lo Churches*]
Also ntd inv 1555:
xvi. tapers for the sepulchre light weing xxiiij li. vjs. viijd. [Walcott, "Gleanings"]

St Margaret, Lothbury
ESp* ntd Comm inv 1552 listing items sold 1549:
Item the vallance of the Sepulcer with stooles & other pyces for xiijs. viijd.
Sold to Robert Madder, purser in Lad Lane, . . . the sepulchre cloth £4. [Walters, *Lo Churches*]

St Margaret Moses
ESp* ntd Comm inv 1552 listing items sold 1551:
Sold to Mr. Gonne: . . . the wainscot above the sepulchre, 1s. 6d.
Sold to Mr. Howland: four green curtains for the sepulchre, 3s. 4d. [Walters, *Lo Churches*]

St Margaret, New Fish Street
ESp* ntd Comm inv 1552 listing goods sold 1550:
Sold to Thomas Huscam, two curtains of green and red
Bruges satin for the sepulchre, 2s. 8d.
1551:
Sold to Harry Wallis: . . . a sepulchre cloth of red and
green Bruges satin with fringe of silk, 7s. 4d. [Walters, *Lo Churches*]

St Margaret Pattens
ESp* ntd inv 1470:
Item a Grete cloth of Tapestri werke for to hang uppon
the Walle by hynde the Sepulcur.
Item a steyned Cloth of Sepulcur werke with the
Ressurreccion. the Passyon. and with other werkis.
Inv 1486:
Item a noder crosse for the Sepulcur havyng relikes
therin by our said master parson iiijs.
Inv ?1511:
Item twoo Angelles for the Sepulcre. [Hope, "Inv St Margaret"]
Also ntd churchwardens' accts 1524:
Peceived for the Sepulchre tapurs at Estur iis.
viij 1/2d.
Paid ffor brede and drynk for them that wached ye
sepulcre iid.
Paid to them that wached the sepulcre xd.
Received for the sepulcre tapurs at Estur iis. viii 1/2d.
["S. Margaret"]
Ntd Comm inv 1552 listing goods sold 1547-51:
Item xij Curtyns greate & small with the blak valance
that servyd for the Sepulcre iijs. [Walters, *Lo Churches*]

St Martin, Ludgate
ESp* ntd Comm inv 1552:
Item a clothe of gold that was about the Sepulcre.
Sold 1547:
In primis the coverynge of the Sepulcre vs.
Sold 1551:
Item Solde to John lacye and Robert shankes . . . A
broche which stode vpon ye Image brest that was borne
about vpon Easter daye gylt. [Walters, *Lo Churches*]

St Martin Outwich
ESp* ntd Comm inv 1552 including inv 1547:
Item ij peses of tymbre that belonged to the sepulcre.
Sold 1550:
To James Chapman, two pieces of timber from the
Sepulchre, 6d. [Walters, *Lo Churches*]

St Martin Pomerey
ESp* ntd 1478 will of Sir Rauf Verney:
My body to be buried in the Church of St Martyn
pomerey in Irmongerlane of London, that is to wite, in
the Toumbe standing under the sepulcre betwene the
Quere and our lady Chapell of the same Church.
[Heales, "ESp"]

St Mary Abchurch
ESp* ntd Comm inv including inv of 1541:
Item v yardes di. of red tartran for the sepulcre.
Sold 1550:
Item to him [John Mynors] certein olde sarcenet whiche
hanged about the Sepulcre iiijs.
Item more to him certein old red silk which hanged
about the saide Sepulcre vjs. viijd. [Walters, *Lo
Churches*]

St Mary Aldermary
ESp* ntd Comm inv 1552:
Item a Banar cloth of the sepolker.
In the grett chyste
Item one grett payntyd cloth with the sepulker. [Wal-
ters, *Lo Churches*]

St Mary-at-Hill
ESp* ntd churchwardens' accts 1426-7:
ffirst payd for the sepulcre for diuers naylis & wyres &
glu ixd. ob.
Also payd to Thomas Ioynour for makynge of the same
sepulcre iiij s.
1428-9:
Also for ij carpenters mendyng the sepulcre a day &
more xijd.
1429-30:
Also for mendynge of the sepulcre xvjd.
1479-81:
Wecchyng of the sepulcre.
Item, payd to the Clerke and paris for mete and
drynke, for wechynge of the Sepulcre, with othir
bysynes done in the Church at diverse tyme3 by the
space of this accompte, xxiijd.
Item, for Colis to the churche, & frankencence, in
wechyng of the sepulcre, & at othyre tyme3 of the yere
by the same space, ijs. vjd.
1483-5:
Item, for wachyng of the Sepulcre, and in expences of
bred & ale to William paris for ij° yer, xijd.
1487-8:
Item, to William paris for wachchyng of the sepulcre,
for swepyng of the chirch, and for meate and drynke,
vijd.

1489-90:
Item for nayllis for the Sepulcre, jd.
Item for wachchyng of the sepulcre, to paris, vjd.
1490-1:
The Costys in the Queer.
Item, for settyng vp of the sepulcre & for nayllis, ijd.
ob.
1491-2:
Coustes of the quere.
Item, for wachyng of the sepulcre at estere, xd.
1492-3:
The Costys of the quere.
Item, for tayntyrhokes and ffor wachyng of the
sepulture, xijd.
Item, to parvs for takyng downe of the supulture, ijd.
1493-4:
Item, payd to parys and Raynolde bull for watchynge
of the sepulture, vjd.
1494-5:
Item, for j quarter Coles at Ester, vd.
Item, for the sepulker nailes, ob.
Item, for watchyng of the Sepulker, iiijd.
Summa ixd. ob.
1496-7:
Item, Receuud at Estir for the waste of iiij tapers
brennyng abowte the sepulture, whiche tapers ware of
the yeft of William Proyne. Summa iijs. ixd.
1498-9:
Item, for the wachyng of the Sepulchre and the
chirche, to iiij men, xijd.
Item, for bred & ale to them that watchyd Summa vjd.
Item, for a lampe & for tentyr hookes to the Sepulcre
jd. ob.
1502-3:
Payd to the Clerke & sexteyn & to watson ffor mete &
drynke, from godfrydaye to Estyr eve at nyght xd.
1504-5:
payde for naylles for the sepullcre, and spentt in the
Chyrche ijd. ob.
1509-10:
Paid for disseplynyng Roddis & nayles for the sepulcre
ijd.
1512-3:
paid for nayles for the Sepulcre jd.
paid for a Carpenter to set up the Sepulcre iiijd.
1516-7:
paid [for] brede, mete & drynk, & for wachyng of the
sepulcre good fryday tyll Estur day xvd.
1517-8:
paid for a wayneskot for the Sepulcre xd.
paid for a Newe bourde and nayles for the sepulcre
iiijd.

1518-9:
paid to a smyth for hokes & staplis for the iiij Angelles
on the sepulcre and a clape of Iron on the Rood lofte
vjd.
1519-20:
Item, paid for drynke at the takyng downe of the
sepulcre jd.
1527-8:
paid for an eln of fyne lynnyn clothe to amend the
sepulture clothe wherat it was eiton with rattes xijd.
paid to a bedmaker for mending & Sowing the same
xijd.
paid to Mr. wolf for payntyng & renewing the Images in
the same clothe vs.
1529-30:
paid for iiij Tapurs for the Sepulcre more then was
gadred of the parissheners xiijd.
1539-40:
Payed ij men for watchyng ye sepullcre ij nyghtes xvjd.
[Littlehales]
Comm inv 1552:
Item A stayned clothe that went abovt the Sepulture.
[Walters, *Lo Churches*]
1553:
delyuered [to the Commissioners] a stayned Cloth yat
went about ye Sepultev3
to be kept to ye vse of the same Church. . . .
Item, more in the Roud loft; a long Chist with the
fframe of the Sepvllevr in yt.
1556-7:
Item payd for ij reedes to lyght the sepulture vjd.
1559:
Payd for takyng down ye sepulcure xijd. [Littlehales]

St Mary Colechurch
ESp* ntd Comm inv listing goods sold 1547-8:
Soulde more by the sayde churche wardeins . . . the
Couer of the sepulker.
Inv 1552:
Item A frame of Irron for the sepulker. [Walters, *Lo
Churches*]

St Mary-le-Bow
ESp* ntd Comm inv 1552 including inv 1547-8:
Item a Sepulchre clothe very olde.
Sold 1550:
Item solde to Mr. Ellyott xxx peces of Streamers and a
Sepulchre clothe very olde praysed alle at xvs. [Wal-
ters, *Lo Churches*]

St Mary Magdalene, Milk Street
ESp* ntd Comm inv 1552:

Item . . . a parte of the sepulcre cloth of stayned
wurke. [Walters, *Lo Churches*]

St Mary Woolnoth
ESp* ntd churchwardens' accts 1539:
Item receyved more of the Master and Wardens of
Merchint Tayllors for ij tapers thoon of vij lb. and the
other of v lb. to brenne about the Sepulture in this
Church at Ester ijs. iiijd.
Item paid for a quarter of Coles against Ester vid.
Item paid for watching of the sepulture viijd. [Brooke &
Hallen]
Comm inv 1552:
Item a Shryne for the Sepulture coverid with cloth of
tyssue. [Walters, *Lo Churches*]
Accts 1554:
Item paied for a new quarter for the seputure and for
settinge up of the frame of it and takinge of it downe
to Standbacke xijd.
Item paied to White for watching of yt viijd. [Brooke &
Hallen]

St Matthew, Friday Street
ESp* ntd churchwardens' accts 1547-8:
Receuyed of Mr. Mounslo for a sepulker sold within the
tyme of this accompt iij li. iijs. iiijd.
Receyued of Mr. Beche for ij curtyns whiche hong
about the sepulker sold within the tyme of this accompt
ixs.
1554-5:
Paid for waxe all the yeare and the sepulkar and judas
candelles xxiijs. vijd.
1556-7:
Payd the ssexten ffor watchynge the ssepulkar too
nyytts xijd.
1557-8:
Paid for ij pantyd Clothes for the Sepulcre ijs.
Paid for a poude [sic] of candylls watchyng candylles
iiijd.
Paid to Rechard for watchyng the sepulcre ij nyghts
xijd. [Simpson, "St Matthew"]

St Michael Bassishaw
?ESp* ntd Comm inv 1552 listing goods sold 1549:
Item solde to John Norden . . . a cloth that hang ouer
the tombe. [Walters, *Lo Churches*]

St Michael, Cornhill
ESp* ntd will of Jane, Viscountess Lisle, 21 Nov 1500:
And my body to be buried in the parish church of
Seynt Mighell upon Cornhull in London, under the
sepulcre of our Lord there in the tombe where the body

of Robert Drope late my husband lyeth buried, on
whose soule Jesus have mercy.
Also that the wardeyns of the said church for the tyme
beyng shall yerely in the vigill of Ester putte XIIJs.
IIIJd. parcell of the said yssues and profitts in a box
under lok and key therein to be kept and reserved to
and for the reparacon new making and gilding when
nede shall be & contynuance as well of the Sepulcre of
our Lorde with in the said church which late was made
att coste and charges of my said husband Robert
Drope.
Also the Sexton for the tyme beyng of the said churche
to give his attendance yerely at said obite, and to
provide and see the keeping of the lights, and to see
also att all tymes requisite that the aforesaid sepulcre,
and werks upon the rodeloft be covered and kept from
hurt, for his labour IIs. VIIJd. [Woodruff, *Sede*]
Also ntd 1517; Sir Wm Capell devised dwelling house of
late Jane, Viscountess Lisle, to parson &
churchwardens, for, among other uses, repair & gilding
of ESp erected by Robt Drope, her 2nd husband.
[Brabrook, "St Michael's"]
Also ntd churchwardens' accts 1554:
Paide for the Sepulker Lyghte at Easter & for the
Pascall & for the Tenebar candles xvijs. vjd.
Item paide to a Carpentar and his man to sett up a
cloeth in the belfreye of the x Commandemetes and of
the scripture at the requeste of Mr. Guntter and other
and for makynge of frame of the Sepulker and a crosse
for Judas Candles & for other faultes in the Churche
iiijs.
Paide for quarters vj penynaylles & ij penynaylles & for
trasshe iiijs.
Paide for hookes & staples to the same fframe js.
1555:
Paide for nayles aboute the sepulcre jd.
Paide for a reede to light the sepulcre ijd.
Paide to the Joyenar for makinge the Sepullcre the
Paskall and the Tenebars to the same xvs.
Paide for makinge of ten tapers for the Sepullcre being
in every taper ij lis. of wax iijs. iiijd.
1556:
Paide for tackes for the Sepulker ijd.
Paide to George Reinolds for wex for the sepulker and
wast of the same xs.
1557:
Paide for trashes for the sepulker jd.
Paid to the waxchandler at Ester for wast and for the
tapers about the sepulcre ixs xd.
1558:
Paid to the goodman Stafford for half the sepulkare
light as doth apper bye a bill iiijs.

1559:
Paide to the Joynere for lowsinge of the Sepulcre iiijd.
[Overall]

St Michael Queenhithe
ESp* ntd Comm inv 1552 listing goods sold 1549:
Item Solde to Thomas Clunet the sepulker Dore of blew
velvet. [Walters, *Lo Churches*]

St Mildred, Bread Street
?ESp* ntd Comm inv 1552 listing goods sold 1549-50:
Item to Mr. Gaywood an Image of the Resurrection and
a vestyment of blewe starres xxs. xd. [Walters, *Lo
Churches*]

St Nicholas Cole Abbey
ESp* ntd Comm inv 1552:
Item a Sepúlker clothe stayned with the resurreccyon
and one fruntlet wyth aungelles.
Item a clothe of red wyth the assencyon on yt to lay on
the sepulture. [Walters, *Lo Churches*]

St Nicholas Olave
ESp* ntd will of Sir Jn Saron (d. 1519):
prest and parson of St Nicholas Oluff in Bred Street,
London . . . [who asked to be buried] in the quer on
the left side of Maister Harry Willows, sometime parson
of the said Churche, or before Seynt Nicholas, with a
littell tombe for the resurrection of Ester Day. [Feasey,
"ESp"]

St Olave, Old Jewry
ESp* ntd Comm inv 1552 including 1547 inv:
Item a owlde shette belongyng to the sepulker.
Sold 1551:
to Thomas molt [?] one old Shete which servid for the
Sepulcher and one old paynted clothe lyned with canvas
at iijs. iiijd. [Walters, *Lo Churches*]

St Olave, Silver Street
ESp* ntd Comm inv 1552:
Item [?] pillers of the Sepulchre with. . . .
Sold 1549:
Item a stayned [curtain] for the Sepulchre solde to
Mathewe wod for iijs. iiijd.
Sold 1550:
Item for ij paynted postes and a ledg with holes for the
Sepulchre iiijs. [Walters, *Lo Churches*]

St Paul's Cathedral
ESp* ntd 1245:
Casula bendata rubeo et purpura ponitur per annum ad

Pascha super sepulchrum.

Also ntd inv 1402:

Item una Crux cristallina pro corpore Christi imponendo et deferendo in festo ejusdem Corporis Christi et Paschae, cum corona argentea deaurata supposita et impressa diversis margaritis, cum pede et hasta argenteis, valoris ad minus xx librarum sterlingorum. [Simpson, "Two Inv"]

Also ntd Comm inv 1552:

Item two riche clothes for the garnishinge of the Sepulchre.

Item two other smaller clothes for the Sepulcher of nedle worke one of them of the Sepulchre & thother of the resurrection. ["Inv S. Paul's"; Walters, *Lo Churches*]

?FSp ntd will of Sir Rich Rede of Pedeborne, 27 March 1559; proved 5 July 1576:

I gyve unto the Cathedrall churche of St Paule, in london, my litle embrodered Cloath wroughte with the Resurrection of our Saviour Christe Jesus, whiche I think was first made to hange aboute the middest of an Altare, about or beneathe, in the feast daye of the Resurrection. [Heales, "ESp"]

St Peter, Paul's Wharf

ESp* ntd Comm inv 1552 including an earlier ?undated inv:

Item ij clothes of silke bawdkyn for the sepolcre. [Walters, *Lo Churches*]

St Peter-upon-Cornhill

ESp* ntd Comm inv 1552 including inv 1546:

In primis belonging to the quier

Item a psalter boke cheyned vnder the sepulchre

The churche Jewelles

 Lacking [in margin] Item a picture for the resurrection on ester day with an owche of siluer and guilt in the brest.

Clothes for the sepulchre

 In primis a palle of red damaske for the sacrament vpon corpus christi day frenged about with venice golde and red silke and iiij painted staves their to belonging.

 Item a steyned cloth with a crucyfix, mary and John with mary magdalyn and St. James.

 Item a stayned cloth with the Image of Christ peter James and John with a scripture *surrexit dominus vere*.

 Item a steyned white clothe with a crucifix mary and John spotted with bloudde with the holy gost ouer his hed.

 Item a stayned clothe with ij Aungelles and twoo

scriptures.
Item a white clothe imbrodered with diuers armes.
Item a steyned clothe of the burying of our lorde
with Image of three maryes.
Item iij red frontelles steyned with armes of golde
with frenge of silke.
Item ij crosse staves of tymbre thone guilt with
golde the other with sylver.
Item an Image vpon a crosse of tree for good
friday.
Item a myter of white silke garnished.
Item a standerd of Tree painted with a crowne of
golde for the Pascall.
Item iiij chestes in the vestry ij gret and ij smalle.
Item a crosse of Tymbre with a staffe for lent.
Item a clothe of ray silke of dyvers colours for the
crysmatory.
Item a crosse staff of copper and guilt.
Item a newe Paynted clothe of the resurrection.
Item a stayned clothe to St. vrsele.
Item ij quisshens of red saye lyned with red
lether.
Item xij Pillowes corded with silke.
Sold 1550:
Item a cloth that wont to hange about the sepulchre.
[Walters, Lo Churches]

St Peter, West Cheap
ESp* ntd inv 1431:
Item j canapy steyned with iiij staves and iiij boles of
golde and iiij faynes and j clothe for the sepulcre
steynede, p's. xxvjs. viijd.
Item j hersse for the sepulcre and iiij aungels thereto,
p's. iiij li. [Simpson, "Inv St. Peter Cheap"]
Inv 1518:
Item iij Images for the Resurrexion.
Also ntd churchwardens' accts 1521:
Item for pynnys for the sepulcore ijd.
1527:
Item payd for watchyng of the sepulcre & for pynnys &
naylls and other necessaryes to hange up the clothe and
for watchyng apon good frydaye and on Ester Evyn,
xiijd.
Item payd a Reward to Ambros Barkar's servante for
lendynge of the clothe that henge abowte the sepulcre
by consent was droppyd with candyll, ijs. iiijd.
1529:
for pynnys for the sepulcre clothe.
1532:
Item paid for watchyng on goode frydaye & on Easter
Evyn & for drynke for the watchers, xijd. [Simpson,
"St Peter Cheap"]

Comm inv 1552 including inv 1547-8:
Item ij frenges for the sepulcre of blak bokeram
paynted. [Walters, *Lo Churches*]
1555:
Item payde to the carpenter for mendyng of the
sepulcre, xxd.
Item for watchynge the sepulchre at easter and for
brede and drynke for them that watched, ijs.
Item for ij sakks of coles for the watchmen and to make
ffyer withall on Easter Eve, xviijd. [Simpson, "St Peter
Cheap"]

St Stephen, Coleman Street
 ESp* ntd inv 1466:
 JUELIS
Item the resurrecionn of our lorde with the avyse in
hys bosum to put the sacrament therein.

 LATON
Item anothir grete branche be for the Resurrecion in
the [sic] with v smalle branches ther onn.

 PEVTUR
Item xxij'ti disshes for the sepulcure
Canapeys [in margin]
Item j canape steyned with a sonne of golde to henge
ouer the sepulcure at estir.
Sepulcure [in margin]
Item j sepulcure ouer gyldyd, with j frame to be set
onn with iiij postes and cryste there to.
Item iiij trestelles to haue the sepulture downe with iiij
ironys to bere ht vp with.
Item iiij Angelles for to be set on the postes with iiij
sences ij gyldyd and ij not gyldyt.
Item, iiij grete angelles to be set on the sepulcure with
dyuers smale angelles.
Item ij steyned clothes with the apostolles and the
prophetes bettyn with golde with the crede.
Item viij barres bettynn with golde to be set abowte the
sepulcure with dyuers small pynons.
Item iiij knyghtes to be set onn the postes be for the
dore.
Item j angylle to be set in the dore.
Also ntd inv 1542:
Item v. banners for the sepulture.
Item a hangyng stayned for the sepulture.
Item a clothe to drawe ouer the sepulture.
And an Image of the Resurrection. [Freshfield, "St
Stephen"]
Comm inv 1552 including goods sold 1549-50:
Sold to John Shrieffe . . . the stained hangings for the
sepulchre, 5s. [Walters, *Lo Churches*]

St Stephen, Walbrook
ESp* ntd churchwardens' accts ?1476:
Item pay pur Nayles and poyntes pur le sepokeyr
canope iijd.
1482:
Item pay on Estron evyn, to William breyt, and to Rays
man pur wetchyng of the sepulcur viijd.
1483:
Item payd to the Clerkys when they wachyd the
sepulker ffor ther drynke and bred iiijd.
Item payde to ye Clerkeys at ester Anno secundo for
coleys water and Ale and Candel when they wacheyd
the sepolker xd.
1507-8:
Payed to Buttre Smyth, ffor mendyng of the Sepulkar
and of the Candylstyke that Johan exuyng taper
stondyth in xviijd.
1510-1:
Item payde for naylles for the sepulcre jd.
Item payde for the watchyng of the sepulcre and for
brede and ale viijd.
Item payde for coles to watche with alle iiijd.
1518-9:
Item payd for hokes and nayls ffor the sepulker, and
the hye Awter, and ffor wachyng viijd.
1522-3:
Item ffor watchynge of the sepulcre and drinke xd.
1525-6:
Item paid for wachyng of the sepulker and Drynk viijd.
1526-7:
Item payde for watchynge the sepulcre viijd.
Item payde for bred and drynke for them that watchyd
viijd.
1527-8:
Item for the watching of the Sepulchre viijd.
Item paid for Drynk and brede for them that waatchyd
the Sepulchre iiijd.
1529-30
Item paid to the sexton, for hys dynner and for
wachyng with a noder man vjd.
Item paid mor to iij men, for wachyng of the sepulcur
all nythe and brede and drynk xd.
1534-5:
Item to the sexton, for wachyng of the sepulker iiijd.
Item for bryde and alle, for thym that wacheys the
sepulker vjd.
Item for chandylles wan thaye wachyed ijd. ob.
1536-7:
Item for Candell for watchyng of the Sepulcre ijd.
Item paide to theym that watched for ij nyghtes xijd.
Item for brede and ale for theym iiijd.
1554-5:

Item payd to the carpenter for dressing the sepulcre
and pascall, with a Deske afore the organs xvjd.
1556-7:
paid to the Sexten and Another man for watchyng of
the Sepulkar js. vjd.
Inv 1558:
Item a faire Sepulcre house, Carved.
1558-59:
Item receued of the parishe for the sepulker lyght xs.
viijd.
Paid to John sexton, for Watchyng the sepulker xijd.
[Milbourn, "St. Stephen's"]

St Swithin, London Stone
ESp* ntd Comm inv 1552:
Item a Sepulcre cloth of changeable silke. [Walters, *Lo
Churches*]

St Thomas of Acon, Chapel of, Mercers' Hall
?ESp*; life-sized stone statue of dead Christ on bier
found in 1954 beneath floor of chapel; Evans & Cook
suggest it may have been part of tomb of Tho, Earl of
Ormond (d. 1515) who asked to be buried in Chapel of
St Tho of Acon:
on the north side of the high altar, where the
sepulture of Almighty God was used yearly to be said
on Good Friday, as the sacrament would rest on his
body, to the ghostly relief and comfort of his soul
under the altar.
Style of statue consistent with this date; over bier of 3
transverse beams lies mantle, once painted purplish
crimson over white undercoat, on which rests body;
Evans & Cook suggest this is Pilate's mantle, rather
than grave clothes, usually white; 2 inscriptions on
mantle: "HVMILIAVIT SEMETIPSVM FACTVS OBEDIEVS
VUQVE AD MORTEM: MORTEM AVTEM CRVCIS. PAVLVS
EPTS AD PHILIPPENS"; "*IN PACE* FACTVS EST LOCVS
EIVS," latter being antiphon used in *Depositio; titulus*
at Christ's head, which rests on crown of thorns; one
thorn imbedded in flesh above L eye; although R arm,
L hand, & both feet missing, it is possible to determine
that L arm lay across body, while R lay straight at
side; fig bearded with long flowing hair; enough paint
remains to demonstrate that entire composition was fully
painted: loincloth & teeth, white; hair, reddish brown;
tongue & wounds in R side, red; L side of monument
apparently against wall; if this fig intended for
ESp/tomb, it is unique surviving example of its type;
may be translation into stone of frequent practice, on
Continent, of using wooden fig of Christ in Easter
rituals, although lack of portability changes function of
fig & is reminiscent of Continental Entombments; sculp-

tor may have been French, or working under French
influence; length 6'5 1/2" x width 2'3"; il Evans and
Cook, Pls. XXI-XXIII.

MIDDLESEX (Mid)

CHELSEA, St Luke
?ESp/tomb; altar tomb without inscription on N wall of
15c chancel. [Lysons 2]

ENFIELD, St Andrew
?ESp/chest tomb with later canopy at E end of chancel
between chancel & N chapel; stone chest painted &
paneled on long sides with 4 diagonal cusped panels
enclosing shields; brass on marble slab of woman in
gown with fur trim & mantle with coats of arms; brass
canopy, crocketed; inscription & evangelist symbols (3
missing); tomb of Joyce Charlton (d. ?1446), wife of
Sir Jn Tiptoft; painted stone canopy (c.1530) has 4-
centered arch with straight top & cusped, paneled sof-
fit; tomb il RCHM, Pl. 58; brass il Stephenson,
"Notes," p. 228.

HACKNEY, St John
ESp/tomb; canopied chest tomb of Christopher Urswyck
intended for use as ESp; formerly in church of St
Augustine, where it was against N wall of chancel; slab
with Urswyck's fig in brass, shield, & black-letter in-
scription lay on floor in front of tomb; inscription in
back of recess--ANNO DOMINI 1519 CHRISTOPHORO
VRSWYK RECTORE MIA--indicates that Urswick, Dean
of Windsor & Rector of Hackney, who died 24 March
1522, erected monument during his lifetime; now in NE
vestibule of St John's against S wall; chest front pan-
eled with 3 cusped quatrefoils enclosing shields, 2 with
MIA (=Misericordia) & one with arms of Urswyck; brass
effigy of priest in choir vestments with doctor's cap in
molded slab on top of chest; portion of black letter
inscription reads: "hic sepultus carnis resurreccionem in
aduentu christi expectat"; back of recess paneled under
canted 4-centered arch; top has horizontal cornice with
cresting of Tudor flowers; octagonal attached shafts on
jambs flank recess; il RCHM London 5, Pl. 94; Williams,
"Bishop," figs. 1-2.

HARLINGTON, SS Peter & Paul
ESp/tomb; monument originally canopied chest tomb with
recess for use as ESp; stood in N chancel; tomb of
Gregory Lovell, lord of the manor (d. 1545) & wife
Anne Bellyngham, apparently erected during her life-
time as inscription leaves her date of death blank; after
Jan. 1857 tomb dismantled; chest has disappeared; slab

that was top of chest now set in S wall of chancel; it
had brasses of man in armor & woman in close cap,
inscription, & 3 coats of arms; inscription, now miss-
ing, identified Gregory Lovell & Ann, his wife; upper
part of monument (width about 4' x height 5'3") now on
modern slab in N chancel has 4-centered arch under
square head, elaborately decorated with foliate span-
drels, quatrefoil frieze, & cornice of fleur-de-lis alter-
nating with initials IHS; soffit of arch has cusped pan-
eling; back wall of recess below canopy contains smaller
recess (width 1'1 1/2" x height 1'5"), also with 4-
centered arch under square head, as well as indents
for 3 brasses; il RCHM, Pl. 141; Bond, *Chancel*, p.
231; Wilson, opp. p. 26 (present condition) & opp. p.
30 (drawing in Society of Antiquaries library showing
former condition). [Garratt]

SOUTH MIMMS, St Giles
?ESp/tomb; canopied chest tomb against N wall of chan-
cel; side & ends paneled; canopy, supported by 4
baluster-shaped supports resting on floor, has 4-
centered arch under square head; soffit paneled;
cornice Renaissance in style; possibly to Henry Frowyk
(d. 1527); il RCHM, Pl. 164.

STANWELL, St Mary
ESp/tomb*; canopied chest tomb of Tho de Windsor stood
in N chancel; canopy was 4-centered under straight top
with cornice made up of band of quatrefoils; brasses in
back wall of recess had man in civilian dress, lady,
with children behind them, all kneeling; in center brass
with subject, possibly Resurrection; coat of arms above
each effigy, scroll below each, 10 other scrolls scat-
tered about; stood against N wall of chancel; removed
to N aisle in 1830; broken up when that aisle rebuilt in
1863; some fragments remain; drawing il Longmate, fig.
3 facing p. 993. [Heales, "Stanwell"; VCH 3]
FSp* ntd 1479 will of Tho de Windsor, proved 1485:
my body to be buried in the north side of the quer of
the chirch of our Lady of Stanwell, afor the ymage of
our lady, wher the sepultur of our Lord stondith;
wherupon I will ther be made a playne tombe of marble
of a competent hight to th'entent that yt may ber the
blissid body of our Lord and the sepultur at the time
of Estre, to stond uppon the same, and with myne
Armes and a scriptur convenient to be sett aboute the
same tombe by thadvyse of myne executors and
overseers underwretyn. . . . I will that after my
monethes mynd doone and fynysshed, iiij tapers be
delyvered to the Chirchwardens of the seid chirch of
Stanwell, to th'entent that they kepe the seid iiij
tapers, that is to sey, ij of them to brene yerely as

long as they will endure aboute the sepultur of our
blissid lord, at the tyme of Estre. [Heales, "Stanwell"]

STEPNEY, St Dunstan & All Saints
?ESp/tomb of Sir Henry Colet (d. 1510), twice mayor of
London, on N side of chancel; recess has paneled back;
top of monument has cusped pendant arches & quatre-
foiled parapet; in Colet's will of 1503 he asks to be
buried "at Sepulchre" before St Dunstan, i.e., on N
side of chancel. [Gough; Pevsner]

WESTMINSTER, Royal Household
ESp* ntd 1547 inv of "Ornaments of The Vestry of King
Edward VI., late Henry VIII.'s":
Item oone olde clothe of white damaske to hange by the
Sepulchre with three pilgrames enbrowdered with
pellicans.
Stuff late the duke of Norffolk:
Item oone clothe for the sepulchre of crimson vellet
embrodered with Jhesus & the picture of the
resurreccon containing iij peces.
Item three peces of purple vellet for the Sepulchre
enbrodered with Rooses and flower de luces of playne
clothe of golde conteyning x yardes di lyned with blewe
Damaske fringed with A narrowe fringe of purple Silke.
[Hope, "Colours"]

WESTMINSTER, St Margaret
ESp* ntd churchwardens' accts 1485:
[Paid men to] wache the sepulcre, eche of them at iijd.
a night. [Bardwell]
1520:
For setting up of God's house and taking it down again.
[Feasey, "ESp"]

WESTMINSTER, St Martin-in-the-Fields
ESp* ntd churchwardens' accts in which sums gathered
for ESp light & payments for watching ESp occur regu-
larly from 1525-48 & 1552-9.
1526:
Item paid at Ester to lewys Deoff for the Sepulcre
light, & for makyng of the Roode light, & for the
makyng of iij tapers, as apperyth by a bill xxs. viijd.
1528:
Item for pyns for the Sepulcre ob.
Item payd to the Wexe Chaundeler for makyng of the
Sepulcree light & for the pascall & for makyng of the
Roode light and for Candill And for iiij newe Torches
And for newe wexe & other waxe makyng agaynst
Easter As by his bill apperith lvijs. iijd.
1534-5:
Item paied for pyns for the Sepultur jd.

1535-6:
Item paid for pyns for the Sepultur jd.
1536-7:
Item Paid for pynnes and poynte for the sepulcre ijd.
1537-8:
Item payde for the wast of v lbs. iij quarter of wax
wastid and spent about the sepulcre aft at Ester iijs.
ixd.
Item payd for the makying of the sepulcre Light ijs.
vjd.
Item paide for ij lb. of wax for tapers for the sepulcre
xvjd.
Item payde for pynnes and poyntes for the sepulcre
ijd.
Item paide for the makyng of the Sepulcre Lights at
Ester with great Lights and midle Lights with dyuerse
tapers as it dothe appere by a bill thereof maide xvijs.
ixd.
6 April 1540:
The copy of william russells byll of the sepulchre light.
Memorandum the syxt day of Apryll in the xxxj[ti] yere
of the reigne of our soueraigne lord kyng Herry the
viij[th], witnessith that I william Russell of the towne of
westminster in the countie of middlesex waxchaundeler,
have the stok of wax for the Sepulchre light of seynt
martens in the ffeld, xv[th] tapers, euery of them,
weying iiij ll. the pece, and summa of the weight of the
same tapers iij score pounde, And also the said Russell
hath resceyued the day and yere afore wrytten, ij
tapers for the said sepulcher weying ij ll.
1545-6:
Item payd for pynnes and poyntes for the Sepulcre ijd.
Item payd for v li. of wax for the Sepulcre ijs.
Item payd for xij li. of wax to the Pood Lyght and
Sepulcre iiijs. ixd.
1546-7:
Item payed for pynnes and poyntes aboute the Sepulcre
ijd.
Item payed for the gatheryng of the Sepulcre light &
for the gathering of ye Clarke & sexten wages for this
first quarter ijs. ijd.
1547-8:
Item payed ffor pynnes and poynts aboute the Sepulcre
ijd.
1552-3:
Item paide ffor a fframe for the sepulture and for Judas
Crosse, and for the Paschall & for cordes Platters,
ffrynge, nayles & other necessaries aboute the same
vjs. vijd. ob.
Item payde for xxiiij[ti] pound iij quarters of wax for the
sepulture and paschall lyght and for ye fonte Taper and
sysys for Judas crosse after xd. ye .li. xxs. vijd. ob.

1556-7:
Item to the Clerke for watchinge of the Sepulchre, &
for naylls to dresse yt xxd.
1557-8:
Item paide to the waxchaundeler for makynge of
xxxj lli. of wax for ye Sepulchre vs. ijd.
1558-9:
Item paide ffor mendynge of the Sepulchre, and wyers
ffor the paskall ijs. vjd. [Kitto]

WESTMINSTER, St Peter's Abbey
ESp* ntd inv of goods taken at Dissolution:
Sepulchre Clothes.--A greate cover of bedde called a
sepulcher cloth of nedle worke.
Sepulchre clothes and other.--the ffyrste of gold with
scouchyns enbrothered with the Batelle of Rowncyvalle.
Lent Stuff.-- . . . a steynyd clothe to cover the
sepulcre with the Trinite and ij clothes for Peter and
Paule. [Walcott, "Inv Westminster Abbey"]

WESTMINSTER, St Stephen
ESp* ntd medieval accts:
a sepulchre cloth of cloth of gold with red fygury and
blew tynsyn lxs. [Walcott, "Gleanings"]

NORFOLK (No)

BACONSTHORPE, St Mary
?ESp; 4-centered arch on N side of chancel; chest pan-
eled with 3 round arches enclosing ogee arches with
crocketing & finials; arch above base has crocketed
ogee gable; crenellations at top; Perp; 14c; il Cautley,
No, p. 162. [Cox, *No* 1; Pevsner, *NE No*]

BLAKENEY, St Nicholas
?ESp on N wall of Early English chancel near priest's
door; Victorian canopy. [*ArchJ*, 46 (1889), 448; Pevs-
ner, *NE No*]

BRISLEY, St Bartholomew
?ESp/crypt; door on N of chancel gives access to crypt
at E end of chancel. [Cautley, *No*]

CARLETON ST PETER, St Peter
?ESp/recess in N wall of chancel opened in restoration of
1897; has inscription from 1557 Geneva NT. [Pevsner,
NW & S No]

CASTON, Holy Cross
?ESp; enlarged sill of Win N2 thought to have been plan-

ned for ESp; Perp. [Barnes, *Caston*]
ESp ntd 1510 will of Tho Coleyn of Gryston:
And I will the seid Robert and his heyrs shall yerly
fynde a tapur of iij li. waxe before the sepultur of our
lord in Caston. [Harrod, "Extracts"]

DICKLEBURGH, All Saints
?ESp; paintings on N wall of chancel E of monument to
Le Grys family; one, showing Christ bearing cross,
restored; other, Christ rising from tomb. [Gough]

DRAYTON, St Margaret
ESp* ntd inv of archdeacon of Norwich 1368:
quatuor panni linei pro sepulcro, dicti keverchefs.
[Watkin, *Inv*].

EAST DEREHAM, St Nicholas
?ESp contemporary with other fittings of 13c chancel.
[Cautley, *No*]

EAST HARLING, SS Peter & Paul
?ESp/tomb; canopied chest tomb of Purbeck marble in
wall between chancel & N chapel; shields on front of
chest; brass from slab missing; underside of canopy
vaulted; sides of canopy paneled with niches for figs;
top has frieze with shields & fleur-de-lis; tomb of Sir
Wm Chamberlain (d. 1462); il Bond, *Chancel*, p. 222;
Cautley, *No*, p. 157.

EAST RAYNHAM or RAYNHAM, St Mary
ESp/tomb; tomb chest with canopy in N chancel; chest
paneled with shields; 4-centered arch frames panelled
recess; this monument specified in will (9 Nov 1499), of
Eleanore, second lady & widow of Sir Roger Townsend,
Justice of Common Pleas under Henry VIII, asking that
new tomb be made for her & her husband in NE part of
chancel by high altar, before image of Our Lady; upon
tomb was to be "cunningly graven a Sepulchre for
Easter Day." Pevsner says monument is over-restored.
[Bloxam, "ESp"; Pevsner, *NW & S No*]

ELSING, Priory of St Mary (Austin Canons)
ESp* ntd Comm inv 1538:
iiij frenges for an alter and sepulcre vjs. [Walcott, "Inv
Dissolution"]

ERPINGHAM, St Mary
ESp* ntd Comm inv 1552:
Item a Clothe for the Sepulcher of Sylke valued at ijs.
viijd. [Walters, "Inv No"]

GORLESTON, St Andrew
ESp; large recess with cusped & sub-cusped ogee arch,
crockets, & buttresses in N chancel chapel; painting of
Throne of Grace Trinity (damaged by 19c cleaning) on
back wall, angel censing to either side; background
diapered; much use of gold; below large figs, unidenti-
fied; shield on each side of arch, one with Trinity
banner, other with Instruments of Passion; 14c. [Bate-
ley; Pevsner, NE No]

GREAT WITCHINGHAM, St Mary
ESp* ntd churchwardens' accts 1557:
To Thomas Smyth for ye sepulchre cloths xvid.
Ntd inv ?1558:
Item, the sepulcher tymber. [Bolingbroke, "Reformation"]

GREAT YARMOUTH, St Nicholas
ESp* ntd churchwardens' accts 1463:
For mending an Aungel standing on the Sepulcher.
1464:
For a new House to put the Sepulcher in.
1506:
For dressing the Sepulcher & watching the Sepulcher.
[Galloway & Wasson]

HARPLEY, St Lawrence
?ESp/tomb; arched recess in N wall of chancel above
chancel steps & just E of sacristy door; depressed
pointed arch within square head; width 5'10"; Perp;
opposite it, low side window; il engraving Jones,
"Harpley Church," p. 22. [Cautley, No]

HINGHAM, St Andrew
?ESp/tomb; canopied chest tomb of red stone for Tho,
Lord Morley (d. 1435), in N chancel reaching full
height of wall; chest has shields; brasses from slab
missing; high recess with tracery on back wall; 10 figs
kneel at base of this recess; buttresses carved with
small figs; above recess fig of Christ seated under
canopy &, on top of buttresses, Annunciation; il Pevs-
ner, NW & S No, Pls. 42b & 43; Cautley, No, p. 156.

HOUGHTON ST GILES or HOUGHTON-IN-THE-HOLE, St Giles
ESp* ntd inv of archdeacon of Norwich 1368:
Item iij pecie flamioli in una pecia pro sepulcro Domini.
[Watkin, Inv]

HUNSTANTON, St Mary
?ESp/tomb; canopied chest tomb to Henry Le Strange (d.
1485) in N chancel; front of chest has panels with star,
lozenge, & quatrefoil; back & side walls of recess pan-
eled; white marble canopy has 4-centered arch under

frieze of shields in cusped quatrefoils; over-restored
according to Pevsner. [Cox, *No* 1; Pevsner, *NW &
S No*]

HUNWORTH, St Lawrence
ESp* ntd 1506 will of Jn Colyns:
Item to the sepulcre lyght of Hunworth, vjd. [Harrod,
"Extracts"]

KELLING, St Mary
Small ?ESp in N chancel in form of recess with 4-cen-
tered head under ogee arch; paneling on base & span-
drels; pinnacles & crenellated cresting; nearby in NE
corner of chancel, remains of shaft, perhaps support
for statue of angel; ?ESp similar to that at Bacons-
thorpe; il Cautley, *No*, p. 162. [Pevsner, *NE No*]

KING'S LYNN, St Nicholas
?ESp; rectangular niche in N wall of chancel encloses
half-fig of angel; Pevsner says too small for ESp.
[Pevsner, *NE & S No*]
ESp ntd guild certificate 1389 stating that Guild of St
Tho of Canterbury provided 16 lb. candle at ESp.
[Westlake]

KNAPTON, SS Peter & Paul
?ESp; large Perp recess in N chancel resembles
"blocked-up doorway," according to Brickhill. [Cox,
No 1]

LITCHAM, St Andrew or All Saints
ESp* ntd 1507 will of Julian Stede:
I bequeth to the church of Lutcham aforeseyd a
coverlyte of colowr grene and blew for the herse. Item
I will that Custance, my daughter, shall have the
kepyng of my hyves with benne both of the v that
long to the church and of myn awn; and for to kepe
with the wax of the seyd benne a lyte afore the image
of sent Erasme, and another lyte afore the ymage of
sent Nicholas, and the iijd afore the ymage of the
Crucifix on the Rode, and a Tapur afore the sepulcre
at Estern, as long as it pleasyth God to kepe the seyd
benne. [Harrod, "Extracts"]

LITTLE BITTERING (BITTERING PARVA), St Peter
ESp* ntd list of goods removed by ?Comm 1547:
Item the sepulker with all necessaryes to that
belongyng. [Walters, "Inv No"]

LODDON, Holy Trinity
ESp* ntd churchwardens' accts 1556:
Item for menddyng of the seppoulker iiijd.

Item payd to Hethfelld for makyng of the Sepulker
tymber and bord vjs. vjd. [Copeman]

LONG STRATTON, St Michael
ESp* ntd Comm inv 1552:
[Erased:] stained linen altar cloth, two surplices, and
two rochets, vail cloth and sepulchre cloth. [Walters,
"Inv No"]

NARBOROUGH, All Saints
?ESp/tomb*; brasses to Sir Jn Spelman (d. 1545) & wife
Elizabeth in N chancel; they kneel facing each other
below square brass panel of Resurrection; Christ, fron-
tal & holding cross-staff, steps with one leg out of
chest tomb surrounded by sleeping soldiers; scroll from
man to Resurrection reads, "Jesu, fili Dei, miserere
mei," & from wife, "Salvator <Mundi> memento mei";
long inscription below identifies figs. [Blomefield 6;
Pevsner, NW & S No]

NEW BUCKENHAM, St Martin
?ESp/tomb; chest under 4-centered arch in N chancel;
chest plain; back wall of recess had brasses, now miss-
ing. [Pevsner, NW & S No]

NORTH CREAKE, St Mary
?ESp; recess of Early Dec style in N wall of chancel;
arch cusped & subcusped; gable with openwork tracery,
crockets, & large finial; pinnacles at each end; very
similar to ESp at Stanton St John, Os; "sumptuous tho,
alas, over-restored," according to Pevsner; later than
1301 construction of chancel. [Compton, "Creke"; Pevs-
ner, NW & S No]

NORTHWOLD, St Andrew Large
ESp in N wall of chancel, badly mutilated; plinth, worn,
supports frieze of blind tracery panels & quatrefoils;
above this, wide buttresses with niches flank panel
forming top of tomb chest carved in relief with 4 sleep-
ing soldiers in variety of poses separated by little
trees; just above slab toward E end, very small cinque-
foiled niche, possibly for Deposition of Host; back wall
of recess paneled; each panel has rib-vaulted canopy,
forming niches on 2 levels; these must once have been
filled with statuary; above, rows of small panels,
pierced; top truncated, probably once had enclosing
arch; 12' in height x 9' in width; late 15c; il Bond,
Chancel, p. 240; Cautley, No, p. 163; det. of 2 sol-
diers, Gardner, EMS, fig. 343; McGill, opp. p. 120.
[Evans, 1307-1461; Pevsner, NW & S No]

NORTON SUBCOURSE, St Margaret or St Mary

?ESp/chest tomb under low ogee arch in N chancel.
[Keyser, "Day's Excursion"; Pevsner, *NW & S No*]

NORWICH, Cathedral Priory (Benedictine)
 ESp* ntd *Depositio, Elevatio,* & *Visitatio* in Customary of
 1277-1370, Cambridge, Corpus Christi College MS. 465:

<Depositio>

Cum*que omnes* adorauer*int* sacer*dos* c*um* m*in*istris
deferat cruce*m* ad sepul*c*r*um* cantando A*nt*iphonam.
 In pace *in* idipsu*m* <dormiam et requiescam>.
Deinde
 Caro mea <requiescet in spe>.
Datoq*ue* thure & clauso sepul*c*ro cantet*ur.*
*Respon*sorium
 Sepulto Do*m*ino <signatum est monumentum; vol-
 ventes lapidem ad hostium monumenti; ponentes
 milites qui custodirent illud>.
Postea lauent man*us* ep*iscop*us & ministri. Deinde duo
sacerdotes induti stol*a* & casula & *con*uersi cu*m*
candelabris & thure *post* eos ep*iscop*us & dyaconus in
.casul*is* venient ad locum vbi posit*us* fuerit corpus
do*m*i*ni*. [f. 62V; **fig. 19**]

<Elevatio>

In nocte pasche ad mat*ut*inas.
Anteq*uam* pulsentur ad m*at*utinas: Secretar*ius* excitabit
ep*iscop*um & Priorem. & quosdam de senioribus. Oui
ablutis manibus & induti albis: Venient ad sepulcrum.
& thurificato crucifixo ab ep*iscop*o: erigant eum &
stabunt *in* sol*i*to loco ep*iscop*o incipiente .*antiphonas.*
 Christus resurgen*s* <ex mortuis iam non moritur,
 mors illi ultra non dominabitur. Quod enim vivet,
 vivet Deo, alleluia, alleluia>.
 Consurgit Chr*istus* <tumulo, victor redit de
 baratro, tyrannum trudens vinculo, et reserans
 paradisum>.
&
 Crucem sanc*tam* <subiit qui Infernum confreget,
 accinctus est potentia, surrexit die tertia, alle-
 luia>.
&
 Surrex*it* do*m*inus <qui pro nobis pependit in
 ligno, alleluia>.
Hiis peractis dicat Sacerdos Versum.
 Dicite *in* nationibus <quia Dominus regnavit in
 ligno, alleluia>.
&
 Do*min*us vobiscum.
& or*ationem.*

Deus qui pro nobis filium tuum <Crucis patibulum
subire voluisti, ut inimici a nobis expelleres
potestatem concede nobis famulis tuis ut resur-
rectionis eius graciam consequamur>.
Statim post hec: accensis omnibus cereolis &
pulsantibus omnibus signis: accedant omnes ex more in
chorum & faciant trinam orationem & simul cum eis illi
qui iam induti sunt. Prioribus superius stantibus
scilicet apud altare sicut stare solent cotidie ad missas.
Eodem etiam ordine stabunt ad totas matutinas. [f. 65V;
fig. 20]

<Visitatio>

Dum legitur iii. lectio eant se preparare tres marie cum
magna reuerencia in deuotione. Finitoque Responsorio
intrent chorum. [f. 66r; fig. 20; cf. Lipphardt, No.
411]

ESp also ntd records indicating Prior paid 10s. annually
for wax taper before ESp. [Blomefield 4]

NORWICH, St Andrew
ESp* ntd Comm inv 1552 listing items in church on 15
Feb 1548:
Item the ordynaunce of the sepulcre prised at vs.
Item a sepulcre clothe of redde tissewe xxs.
Sold after 15 Feb 1548:
Item soulde to Thomas Crane . . . a Sepulchre cloth of
redde tissewe at xxs. [L'Estrange]

NORWICH, St Etheldreda
ESp* ntd accts of cellarer of Norwich Cathedral 1376:
Paid for making the Sepulchre, and the wages of
workmen for four days, 2s. [Harrod, "Goods and
Ornaments"]

NORWICH, St John Baptist Timberhill
ESp* ntd 1479 will of Jn Erpyngham leaving gift:
to the light burning before our Lord's sepulchre in
Easter time.
Also ntd churchwardens' accts c.1555:
for fitting up the Sepulchre 3d. [Blomefield 4]

NORWICH, St Julian
ESp* ntd inv of archdeacon of Norwich 1368:
Item aparatus pro sepulcro, ex collacione eiusdem
[Alicia de Hemgrave]. [Watkin, Inv]

NORWICH, St Leonard, Priory of (dependency of Cathedral
Priory)
ESp* ntd inv 1452-3:

Item diversi panni pro sepulcro steyned cum hystoria
Resurrectionis. [Bensly]

NORWICH, St Mary Coslany
ESp* ntd will of Henry Toke (d. 1465) providing:
a candle to burn before the Holy Sepulchre, from Good
Friday to the Resurrection, as the use and custom is,
of 5 l. weight. [Blomefield 4]

NORWICH, St Mary in the Fields, College of
ESp* ntd 1458 will of Wm Martyn who "gave a sum of
money to make the sepulchre of our Lord."
[Blomefield 4]

NORWICH, St Mary Less
ESp* ntd 1474 will of Jn Baly who gave to church:
two laton candlesticks of 4 marks, and two wax tapers
to put in them, weighing 5 pounds a taper, to burn
about the herses in the church, and at Easter about
the sepulchre. [Blomefield 4]

NORWICH, St Peter Mancroft
ESp* ntd early 16c inv:
Item an ymage of silver of our Saviour with hys
woundes bledyng his vesture gilte with a litle pixe for
the sacrament uppon the breste and a diadem silver &
gilte · pond₃ lviij unces di with a crose & the fote of
the worke [right margin: saviour.].
Item steyned cloithes complet for the sepulter of
dyverse colours & ymagery with crounes of gold & lyith
uppon the ij shelfe bi the wyndows with lent
vestmenttes.
Item a grene crose with iiij evangelistes gilte for ester
morow in the resurrection. [Hope, "St Peter Mancroft"]

ORMESBY ST MARGARET, St Margaret
?ESp in N chancel; arch cusped & subcusped; traceried
spandrels; Dec but recut. [Pevsner, NE No]

PLUMSTEAD, St Michael
?ESp*; traces of vaulted & canopied structure. [Cautley,
No]

PORINGLAND, All Saints
ESp* ntd Comm inv 1552:
Item . . . stayned hangynge for Sepultre. [Walters,
"Inv No"]

RAVENINGHAM, St Andrew
?ESp/tomb; canopied tomb recess in S wall of chancel;
arch with foliated cusping & subcusping; crocketed
gable with cusped pointed trefoil inside & finial; Pevs-

ner suggests it may have been moved from N side, as
its form is that of founder's tomb combined with ESp;
church restored in 1885 & 1898; early 14c. [Cox, No 2;
Pevsner, NW & S No]

REEPHAM, All Saints
ESp* ntd inv of archdeacon of Norwich 1368:
j pannus steyned pro sepulcro. [Watkin, Inv]

ROYDON, St Remigius
?ESp; low recess in N wall of Dec chancel, much re-
stored. [Pevsner, NW & S No]

RUNCTON HOLME, St James
ESp* ntd 1416 will of Edmund Habirgent leaving to
church:
a purple cloth for covering the sepulchre, and a fine
linen cloth for wrapping the body of our Lord. [Wil-
liams, "No Churches"]

SALLE, SS Peter & Paul
ESp* ntd will of Tho Ryghtwys (d. 24 Feb 1480) leaving
12d. to ESp light.
Also ntd will of Margaret Ryghtwys (d. 1500) leaving
12d. to ESp light. [Parsons]

SCOULTON, Holy Trinity
?ESp; wide recess with round head in N wall of chancel;
depth 2'; sill has 5 round holes, equally spaced, each
7" deep & 5" in diameter; function unclear; 13c. [Caut-
ley, No; Pevsner, NW & S No]

SHINGHAM, St Botolph
?ESp; small arched recess in N wall of chancel. [Caut-
ley, No]

SHIPDHAM, All Saints
ESp* ntd churchwardens' accts 1511-67 with yearly pay-
ments for watching ESp light.
Also ntd 1519:
Item payd [for] to Ihon symud for makyng of ye
sepulcyr jd.
1528:
Item payd for settyng vp of the sepulker & takyng
doun iiijd.
1529:
Item payd for the Sepulker settyng vp & doun iiijd.
1531:
Item for Iohn Hunttman for settyng vp & takyng doun
of sepulker iiijd.
1532:
Item for sethtyng vp & takyng doun of the sepulker

iiijd.

1533:

Item for the takyng down of the Sepulker iiijd.

1534:

In primis to ye grauer for ye Sepulker xiijs. iiijd.

Item to Iohn Wynsent for fechyng home of ye Sepulker & hes careg ijs.

1539:

Item payd to john barne for eryne warke for the Sepulker viijs. jd.

Item for makyng of the Sepulker cloth vjd.

1543:

Item payd to Roberd Barne for mendyng ye Irnys of the sepulcre iiijd.

1554:

Item payde for makyng ye sepulcre xjd.

1557:

payde for making the sepulcre & for nayles & lime & pinning in of the same xxxvs. ijd.

1558:

Receyts

ffirste Receyued of Thomas Cubbes towarde the paynting of ye Sepulchre iijs. iiijd.

Costs

Item for paynting the sepulcre xxjs. [Galloway & Wasson]

SOUTH CREAKE, St Mary Virgin
 ?ESp; plain recess in chancel. [Cautley, No]

SUTTON, St Michael
 ESp* ntd 1504 will of Robt Dengayn, rector, leaving 6s. 8d. to repair ESp. [Williams, "No Churches"]

SWAFFHAM, SS Peter & Paul
 ?ESp/tomb; low recess in N wall of chancel with cusped Tudor arch; battlements above; front of chest has shields with Trinity & symbols of Passion; effigy of priest in recess not made for it; ?15c. [Cox, No; Pevsner, NW & S No]
 ESp ntd will of Tho Rame (d. 1494) who gave £4 to make a new "sepulkyr." [Cattermole & Cotton]
 Also ntd churchwardens' accts 1509:
 Item payed to Rychard Lawes for makyng of the stage of palmesondaye & settynge vp on the Sepulcur & for odther warkys don vijd.
 1514:
 Item payed to Rychard lawes for settyng vpon the stage & the sepulcur iiijd.
 1519:
 Item payed to Richard lawes for settyng vp on the stage & the Sepulcur iiijd. [Galloway & Wasson]

TASBURGH, St Mary
?ESp/tomb; chest tomb in S wall of chancel has niche at back as if for Deposition. [Cautley, No]

TERRINGTON ST JOHN, St John
?ESp; plain monument in chancel. [Cautley, No]

TILNEY ST LAWRENCE, St Lawrence
ESp* ntd guild certificate 1389 stating that guild of St Lawrence funded 3 candles for ESp. [Westlake]
Also ntd 15c guild certificate mentioning wax lights: circa sepulchrum ad festum Pasche. [Firth]

TITCHWELL, St Mary
?ESp/tomb; low recess in N wall of chancel. [Pevsner, NW & S No]

TIVETSHALL, St Margaret
Plain ESp in chancel. [Pevsner, NW & S No]

TOTTINGTON, St Andrew
ESp* ntd will of Jn Hey, vicar (d. 1502), who left money to repair new sepulchre & St Peter's tabernacle. [Gough]

TRUNCH, St Botolph
?ESp; sill of Win N2 dropped as if to serve as base of ESp. [Brickhill]

WATTON, St Mary
?ESp/aumbry; simple square recess in N wall of chancel. [Cautley, No]

WEST BRADENHAM, St Andrew
?ESp; recess with crocketed arch & flanking pinnacles in chancel. [Cautley, No]

WHITLINGHAM, St Andrew
ESp* ntd 1484 will of Wm King:
one taper of a pound weight, to burn before the sepulchre of our Lord Jesus Christ at Easter, in Whitlingham church. [Blomefield 4]

WIGGENHALL ST MARY MAGDALENE, St Mary Magdalene
ESp* ntd guild certificate 1389 stating that newly founded Guild of St Mary Magdalene funded 6 candles at ESp. [Westlake]

WILTON, St James
?ESp; large ogee-headed recess in N chancel. [Pevsner, NW & S No]

NORTHAMPTONSHIRE (Nm)

ABINGTON, SS Peter & Paul
?ESp/aumbry in N wall of chancel; plastered over. [VCH 4]
ESp ntd 1501 will of Jn Wright:
To the sepulchre light ij stryke of barley.
Also ntd 1528 will of Wm Wynton:
To the sepulcre xijd.
Also ntd 1528 will of Jn Hollis. [Serjeantson & Longden]

ALDERTON, St Margaret
ESp* ntd 1490 will of Wm Caumvyle:
Lego lumini sancti sepulchri iijs. iiijd.
Also ntd 1528 will of J. Mayoo:
To the sepulcre light ijs.
Ntd 1559 will of Robt Holman:
To the sepulcre a pounde of wax. [Serjeantson & Longden]

ASHBY ST LEDGERS, SS Mary & Leodgare
ESp* ntd 1514 will of Jn Stormyn:
Lego lumini sepulchri viijd.
Also ntd wills of Wm Tomson, 1524, & J. Hollis, 1558.
[Serjeantson & Longden]

ASTON-LE-WALLS, St Leonard
?ESp/tomb; recess with cinquecusped arch in N chancel;
c.1300. [Pevsner]

AYNHO, St Michael
ESp* ntd 1523 will of Nich Hanslap:
To the sepulcre light a quarter of barley.
Also ntd 1533 will of Sir Edward Wollse. [Serjeantson & Longden]

BADBY, St Mary
ESp* ntd 1500 will of Tho Bodyngton:
Luminibus sepulchri iiij modios ordei.
Also ntd 1530 will of J. Hawntyn:
To the sepulchre light xijd. [Serjeantson & Longden]

BARBY, St Mary
ESp* ntd 1503 will of Alexander Calcott:
Lumini sepulchri iiijd.
Also ntd 1517 will of W. French. [Serjeantson & Longden]

BARNACK, St John Baptist
?ESp; plain arched recess in N wall of chancel opposite

sedilia; chancel c.1300-10. [VCH 2]

BENEFIELD, St Mary
ESp* ntd 1522 will of Jn Gun:
To ye lyght of ye sepulcre a cowe or xiijs. iiijd.
Also ntd 1523 will of Nich Fezant. [Serjeantson &
Longden]

BLAKESLEY, St Mary
ESp* ntd 1522 will of Joan Nansicles:
To the sepulcr lyght, to the torches & to the bells
halffe quarter of maslyn & a quartyr barley. [Serjeant-
son & Longden]

BLISWORTH, St John Baptist
ESp* ntd 1514 will of Jn Wodell:
To the sepulture light ij strike of barle. [Serjeantson &
Longden]

BODDINGTON, St John Baptist
ESp* ntd 1506 will of Rich Bland, rector:
Lego pro le selyng chori et fabricacioni sepulchri x li.
[Serjeantson & Longden]

BOUGHTON, St John Baptist
ESp* ntd 1528 will of Robt Twecton:
To ye sepulker lyghte one stryke of barley.
Also ntd wills of Robt Martyn, 1535, & Joan Twyckton,
1557. [Serjeantson & Longden]

BOZEAT, St Mary
ESp* ntd 1521 will of Rich Everton:
To the sepulchre lyght a schyppe.
Also ntd 1521 will of Rafe Aberge:
To the sepulchre light one bushell barley.
Ntd 1528 will of T. Luatt:
To the sepulcre a yewe & a lambe. [Serjeantson &
Longden]

BRADDEN, St Michael
ESp* ntd 1523 will of Sir W. Salvyn, parson of Bradden:
To the sepulcre light ijs. to by a schepe with.
Also ntd will of T. Smyth, c.1525:
To the sepulcre lighte a bullocke.
Also ntd 1543 will of T. Goodman:
I gyve unto the sepulker lyght a browne cowe of the
value of xijs. the whych cowe I wyll schulde be sett
unto one pore man my nebur and he to pay yerely for
the same cowe and callffe unto the churchewardyns apon
mydlent Sunday yerely xxd. [Serjeantson & Longden]

BRAFIELD-ON-THE-GREEN, St Lawrence
ESp* ntd 1529 will of Robt Proopp:
To the sepulchre lvghte ij stryke of barley.
Also ntd 1531 will of Wm Hasylwood. [Serjeantson &
Longden]

BRAMPTON ASH, St Mary
ESp* ntd 1545 will of Robt Gray:
To the sepulcure light viijd. [Serjeantson & Longden]

BRAMPTON-CHURCH (CHURCH BRAMPTON), St Botolph
ESp* ntd 1511 will of Wm Cosby:
To the sepulker light twoo strickes of malt.
Also ntd 1521 will of Tho Algode:
To Saynt Pulcre lyght iiijd.
Also ntd 1528 will of Rich Cosby:
To ye sepulcre light one tapur. [Serjeantson &
Longden]

BRAUNSTON, All Saints
ESp* ntd 1516 will of Nich Sabyn:
To the sepulchur lyght xijd.
Also ntd 1524 will of T. Mosley. [Serjeantson &
Longden]

BRIGSTOCK, St Andrew
ESp* ntd bequests for repair of ESp including gift of
2-year-old bullock. [J. Cox, "Parish Churches Nm"]

BROUGHTON, St Andrew
?ESp/aumbry at E end of N wall of chancel; restored.
[VCH 4]
ESp ntd 1500 will of Sir Jn Chese, rector:
To the sepulcre light ij liberi waxe unmade.
Also ntd 1521 will of T. Bound. [Serjeantson &
Longden]

BUGBROOKE, St Michael
ESp* ntd 1504 will of Rich Smyth:
Luminibus sepulchri quatuor modios ordei.
Also ntd wills of T. Bull, 1514; Stevyn Hawke, 1521; &
W. Smyth, 1522:
To the sepulcr lyght xijd.
Ntd 1528 will of J. Freeman of Kislingbury:
To the gyldyng of the sepulture of Bugbroke xxd.
[Serjeantson & Longden]

BULWICK, St Nicholas
ESp* ntd wills of W. Beyment, 1522; Nich Goodyer, 1526;
& Rich Cleydon, 1527. [Serjeantson & Longden]

BURTON LATIMER, St Mary
ESp* ntd 1523 will of Wm Plowright:
To ye makyng of a new sepulchre xiijs. iiijd. [Serjeant-
son & Longden]

BYFIELD, Holy Cross or St Helen
ESp* ntd 1509 will of Rich Heynes:
To the sepulcre light an ewe.
Also ntd 1522 will of Jn Clifton:
To ye sepulcre and to ye torches a londe of barly of a
long furlong.
Also ntd 1529 will of Alice Cleydon:
To the sepulcre lygth one hyve. [Serjeantson &
Longden]

CASTOR, SS Kyneburgha, Kyneswitha, & Tibba
?ESp/recess with low arch in N wall of 13c chancel near
E end. [VCH 2]
ESp ntd guild certificate 1389 stating that Guild of
Corpus Christi (founded 1376) provided 13 lights to
burn about ESp from "day of Preparation" to time of
Resurrection. [Westlake]
ESp lights also ntd wills of J. Kempster, 1522, & Robt
Curteys the elder, 1544. [Serjeantson & Longden]

CHACOMBE, SS Peter & Paul
ESp* ntd 1524 will of J. Barret:
To ye sepulchre light an hewe. [Serjeantson &
Longden]

CHARWELTON, Holy Trinity
ESp* ntd 1535 will of Sir Jn Grendon:
To the sepulchre light xijd. [Serjeantson & Longden]

CHELVESTON, St John Baptist
?ESp/aumbry; small rectangular recess near E end of N
wall of chancel. [VCH 4]
ESp ntd 1521 will of W. Bynge:
To the mayntening of the sepulchre lyght.
Also ntd 1547 will of Rich Lawe. [Serjeantson &
Longden]

CHIPPING WARDEN, SS Peter & Paul
ESp* ntd 1510 will of Heue Francis:
To the sepulcre a londe of berly provydyd that the
church men shall sowe the iij lands [those left to Our
Lady, Rood, & ESp] for the treme [term] beforsayd at
their own proper costs and charge.
Also ntd 1547 will of W. Harrys:
To the sepulcre light a shepe. [Serjeantson & Longden]

CLOPTON, St Peter
ESp* ntd 1530 will of T. Hart:
To the sepulchre light xvjd. [Serjeantson & Longden]

COGENHOE, St Peter
?ESp; 3 aumbries in middle bay of N wall of chancel
forming one composition; 2 below, 20" x 13", plain &
rectangular, that above, 27" x 16", has pointed tre-
foiled head below hood mold; all rebated for doors;
early 13c. [VCH 4]
ESp ntd wills of Henry Cocks, 1530, & Morys Bell,
1546. [Serjeantson & Longden]

COLD HIGHAM, St Mary or St Luke
ESp* ntd 1552 will of J. Brawnson:
To the sepulchre light on shepe. [Serjeantson &
Longden]

COLLINGTREE, St. Colomba
?ESp/aumbry; rectangular recess in N wall of chancel
beneath Win N2. [VCH 4]

CORBY, St John Baptist or St Peter
?ESp/tomb; large recess with crocketed gable in chancel.
[Pevsner]
ESp ntd 1522 will of Rich Alambe:
To the sepulchre light xijd. [Serjeantson & Longden]

COTTERSTOCK, St Andrew (Collegiate)
ESp; small arched recess in N wall of chancel; early 14c.
[VCH 2]
ESp ntd 1523 will of W. Broughton:
To the sepulchre light halfe a seme of barley. [Ser-
jeantson & Longden]

COTTESBROOKE, All Saints
ESp* ntd 1528 will of T. Myllner:
To the sepulture light iiijd.
Also ntd wills of T. Waren, 1529; Rich Cradock, 1538;
& Rich Wallpull, 1540. [Serjeantson & Longden]

COTTINGHAM, St Mary Magdalene
ESp; large recess low in N wall of chancel has shafts &
moldings; c.1300. [Pevsner]
ESp ntd 1395 will of Ralph Crophull, rector:
To the high altar . . . a coverture for the sepulchre.
Also ntd 1522 will of H. Drake:
To the sepulcre light xijd. [Serjeantson & Longden]

COURTEENHALL, SS Peter & Paul
?ESp; double aumbry with plain pointed heads cut from
one stone in N wall of chancel W of Win N2 (blocked).

[VCH 4]

CRANFORD ST JOHN, St John
ESp* ntd 1537 will of Rich Selby:
I bequeth to the makyng of the sepulcre of Seynt
John's vjs. viijd. [Serjeantson & Longden]

CRANSLEY, St Andrew
?ESp/tomb; low recess with moldings under Win N2;
c.1300-30. [VCH 4]
ESp ntd 1516 will of Tho Hunt:
To the preparyng & furnyschyng of the sepulcur x
hewe schype . . . that the increase of them may be to
the supportacion of the same.
Also ntd 1521 will of Tho Berde:
To the sepulcre lyght iijs. iiijd.
Ntd will of Tho Walter, c.1528:
To the gyldynge of the sepulcre xxs.
Sepulchre Guild ntd 1530 will of Tho Houghton:
To the bretherhed of the sepulcre of Cransley xijd.
Ntd 1537 will of Robt Lad:
To the brotherhed of the sepulcre light xvjd. [Ser-
jeantson & Longden]

CRICK, St Margaret
ESp* ntd 1529 will of Wm Jonys:
To the sepulcre lyght xijd. [Serjeantson & Longden]

CULWORTH, St Mary
ESp* ntd 1528 will of Rich Graunt:
To the reparacon of the sepulchre.
Also ntd 1530 will of Alys Graunt:
To the makyng of the sepulchre ijs.
Ntd churchwardens' accts 1531:
Item ffor ye workmanshyp ffor ye sepulchre lyght vjs.
xjd. [Serjeantson & Longden]

DALLINGTON, St Mary
ESp* ntd 1521 will of Jn Browne:
To ye sepulchre ij stryke of barley.
Also ntd 1537 will of Jn Nune:
To ye sepulche light one pound of wax. [Serjeantson &
Longden]

DAVENTRY, Holy Cross
ESp* ntd 1500 will of Rich Whyte:
To the sepulcre lyght iiijd.
Also ntd 1541 will of Roger Lache:
To the sepulcre light six pounds of waxe.
Ntd 1547 will of Rich Blowre. [Serjeantson & Longden]

DEENE, St Peter
ESp* ntd 1532 will of Js Wyatt:
To the kepyng . . . tapers of the sepulcre light ijs.
[Serjeantson & Longden]

DENFORD, Holy Trinity
ESp* ntd 1504 will of Henry Rayne:
To the sustentacon of the sepulcre lyght v rodes of
medow. [Serjeantson & Longden]

DESBOROUGH, St Giles
ESp* ntd 1522 will of Robt Wright:
To ye makyng of a new sepulcre xijd.
Also ntd 1528 will of J. Smart:
To the sepulchre light iiijd. [Serjeantson & Longden]

DUSTON, St Luke or St Mary
ESp* ntd 1522 will of Rich Curtesse:
To the sepulcre light a wether schepe.
Also ntd 1526 will of Jn Palmer. [Serjeantson &
Longden]

EARLS BARTON, All Saints
ESp* ntd 1530 will of Henry Dowsse. [Serjeantson &
Longden]

EAST CARLTON, St Peter
ESp* ntd 1513 will of Philip Page:
To ye sepulture light dim. li. of wax. [Serjeantson &
Longden]

EAST HADDON, St Mary
ESp* ntd 1504 will of Joan Hions:
Lumini sepulchri iiijd.
Also ntd wills of Robt Traves, 1515; Tho Buttlyr, 1529;
& W. James, 1529. [Serjeantson & Longden]

EASTON MAUDIT, SS Peter & Paul
?ESp/aumbry; rectangular double recess in N wall of
chancel; c.1320. [VCH 4]
ESp ntd 1497 will of Jn Hotofte:
Lego lumini sepulchri unam acram terre arabilis in
campis de Boseyate apud Lythewell.
Also ntd 1523 will of Symon Roche:
To the sepulcre light halfe a pownd of wax. [Serjeant-
son & Longden]

EASTON NESTON, St Mary
ESp* ntd 1513 will of Simon Hobson:
To the sepulcr lyght a stryke of barley. [Serjeantson &
Longden]

EASTON-ON-THE-HILL, All Saints
ESp* ntd 1514 will of Blosum:
To Seynt Pulturys lyght iiijd. [Serjeantson & Longden]

ECTON, St Mary Magdalene
ESp/tomb; arched recess originally at E end of 13c chancel; chancel lengthened in 17c, at which time doorway cut through part of recess; doorway now blocked & recess restored. [VCH 4]
ESp ntd 1531 will of Jn Leverich:
To the sepulchre lyght a quarter of malt.
Also ntd wills of Robt Farrowe, 1534, & Catherine Hensman, 1537. [Serjeantson & Longden]

EDGCOTE, St James or St Mary
ESp* ntd 1516 will of T. Austin:
To the sepulcure ly3ght and bells in Ochcott a acre of barly. [Serjeantson & Longden]
Also ntd 1450 will of Joan Buckland:
ffirst, I beqweth to the Churche of oure lady of Ochecote . . . Item, a grene appariell for the Auter, that is for to say, Reredose and frontell powdred with golde, & ij Rydelles of Grenetarteryn; Item ij smale peces of the same sewte for the Sepulcre. [Clark, Lincoln]

ETTON, St Stephen
?ESp; small arched opening (height 8 1/2" x width 5 1/2") in NE angle of chancel, rebated for door; opens into larger, plastered recess; may have been for deposit of Host in Easter rites; 13c. [VCH 2]

EVERDON, St Mary
ESp; low ogee-headed recess in N wall of chancel opposite sedilia; early 14c. [Pevsner]
ESp ntd 1510 will of Edw Abbott:
Sustentacioni cereorum sepulcri iij busshells of wheat.
Also ntd 1512 will of J. Ewan:
To the reparacon of the sepulchre torches.
Ntd 1520 will of Rich Tarre:
To the sepulcr lyghte viijd.
Ntd 1522 will of J. Buckebe:
To ye reparacon of ye sepulcre light a buschell of barley and a strike of whete. [Serjeantson & Longden]

FARTHINGHOE, All Hallows or St Michael
ESp* ntd 1470 will of Wm Catur:
Lego luminari sancti sepulchri ij modios brasii.
Also ntd 1532 will of J. Phillips:
To the sepulcre light one shippe when he is shorn. [Serjeantson & Longden]

FAXTON, St Denis
ESp* ntd 1557 will of Humfrey Garryte:
To the sepulcher lyght in the chapell of Faxton my best
ewe with her lame. [Serjeantson & Longden]

FINEDON (THINGDON), St Mary
ESp* ntd 1556 will of Alice Wallis.
Sepulchre Guild ntd 1510 will of Rich Langley:
To the sepulcre yeld of Thynden a bushell of malt.
[Serjeantson & Longden]

FLORE, All Saints
?ESp. [Cox & Harvey]
ESp ntd wills of Agnes Baw, c.1514, & Joan Leyke,
c.1525. [Serjeantson & Longden]

GAYTON, St Mary
?ESp/tomb; chest under ogee arch between chancel & N
chapel; chest with ogee-headed panels; on chest, oak
fig of knight, cross-legged, possibly Sir Philip de
Gayton (d. 1316); arch with buttresses & finial. [Pevs-
ner]
ESp ntd 1499 will of Tho Chapelen:
Lego sepulchro unum modium ordei.
Also ntd 1510 will of T. Farman:
Ad sustentacionem luminum sancti sepulchri unum
modium ordii.
Also ntd 1516 will of J. Hunt:
To the sepulchre ij stryke of barley. [Serjeantson &
Longden]

GEDDINGTON, St Andrew or St Mary Magdalene
ESp* ntd 1515 will of Rich Thorne:
To the sepulture ij wether schepe.
Also ntd 1517 will of J. Comford:
To ye sepulker lyght ijd.
Also ntd 1528 will of Nich Veyssacorley:
To the sepulchre iiij wethers.
Ntd 1536 will of T. Freman:
I bequethe to the use of the church the oolde sepulcher
there. [Serjeantson & Longden]

GLAPTHORN, St Leonard
?ESp/aumbry; square recess in N wall of chancel;
c.1250. [VCH 2]
ESp ntd 1520 will of J. Waren:
To Sevnt Pulcre lyght viijd.
Also ntd 1521 will of Rich Atkyn. [Serjeantson &
Longden]

GRAFTON REGIS, St Mary
ESp* ntd 1539 will of Nich Woolfe:

To the sepulchre light xxd.
Also ntd 1544 will of Js Waddyngton:
Unto the sepulcare xijd. [Serjeantson & Longden]

GRAFTON UNDERWOOD, St James
ESp* ntd 1531 will of Robt Perryman:
To the sepulchre light ij stryke of barley. [Serjeantson
& Longden]

GREAT BILLING, St Andrew
ESp* ntd 1512 will of Rich Fisher:
To the sepulture lyght iijs. iiijd.
Also ntd 1514 will of Jn Wisman:
To the meyntenyng of ye sepulture lytte half a quarter
of barley.
Also ntd 1537 will of Jn Dawkyns:
To the sepulker iij shepe. [Serjeantson & Longden]

GREAT BRINGTON, St. Mary
ESp* ntd 1514 will of Jn Peyntelyng:
To ye sepulture lyght vjd.
Also ntd 1522 will of Sir Jn Spencer, kt:
To be buried in the chancel of Brynkton church afore
the image of our blissed Lady and there my executours
to make a tombe for me as nygh to the walle as they
canne behynde the sepulture.
Also ntd will of Jn Saulbryge, c.1531. [Serjeantson &
Longden]

GREAT CREATON, St Michael
ESp* ntd 1521 will of T. Skynner:
To the sepulcr lyght a stryke of barley. [Serjeantson &
Longden]

GREAT DODDINGTON, St Luke (formerly St Nicholas)
ESp/aumbry; tall, rectangular recess with trefoiled head
& hood mold in N wall of chancel at E end; had door;
from c.1290-1300 when chancel was lengthened. [VCH 4]
ESp ntd will of Nich Scarks, c.1537.
Also ntd will of Agnes Wells, 9 Nov 1559:
To the sepulker light ijd. [Serjeantson & Longden]

GREAT HARROWDEN, All Saints
ESp* ntd 1510 will of H. Robyns:
To the sepulcre lyght xijd.
Also ntd 1522 will of Jn Hanche. [Serjeantson &
Longden]

GREAT HOUGHTON, Assumption
ESp* ntd wills of J. Burnell, 1512, & Tho Symson, 1532.
[Serjeantson & Longden]

GREAT OAKLEY, St Michael
ESp* ntd will of Robt Jolew, c.1516:
To the lyghts of the sepulcre in the said chapell of
Saynt Michael xxd.
Also ntd will of Rich Dekon, c.1521:
To the sepulcher xijd.
Also ntd will of Jn Bull, c.1526:
To the sepulchre vjs. viijd. in money or catell. [Ser-
jeantson & Longden]

GREAT WELDON, St Mary
ESp* ntd 1515 will of R. Smyth:
To the sepulture lyght ij strykes of malt. [Serjeantson
& Longden]

GREEN'S NORTON, St Bartholomew or St Lawrence
ESp* ntd 1512 will of T. Wynkyn:
To the sepulcr light xijd.
Also ntd 1514 will of Henry Nycolls:
To the sepulture lyght j stryke of barley.
Also ntd 1515 will of Evan ap Gryffith. [Serjeantson &
Longden]

GRENDON, St Mary or St James
ESp; small plain tomb chest in arched recess below Win
N2; width 5'6" x depth 2'; Dec; chancel rebuilt c.1360-
80. [VCH 4]
ESp ntd 1514 will of Jn Petyt:
To ye sepultur lyght a quarter of barley. [Serjeantson
& Longden]

GUILSBOROUGH, St Etheldreda
ESp* ntd 1504 will of Roger Belcher:
Lumini sancti sepulchri unam ovem. [Serjeantson &
Longden]

HANGING HOUGHTON, Church (?St Mary)
FSp* ntd 1499 will of Jn Kyng:
Lego ad reparacionem sepulchri Domini iijs. iiijd.
Also ntd 1499 will of Tho West:
I bequeth to the payntyng of the sepulchre.
Also ntd 1530 will of Jn West:
To the sepulchre lyght viijd.
Also ntd 1536 will of Wm Palmer. [Serjeantson &
Longden]

HANNINGTON, SS Peter & Paul
ESp; small arched recess in N wall of chancel E of rec-
tangular aumbry; church late 13c. [VCH 4]
FSp ntd 1535 will of T. Lomney. [Serjeantson &
Longden]

HARDINGSTONE, St Edmund
ESp* ntd 1501 will of Tho Freeman:
Lumini sepulchri duos modios ordei.
Also ntd 1530 will of Jn Wold:
to the mayntenance of the sepulcre light iiijd.
Also ntd 1532 will of Alexander West:
To the mayntenance of the light of the sepulchar oone
shippe. [Serjeantson & Longden]

HARGRAVE, All Saints
?ESp/tomb; plain recess with 2-centered arch in N wall
of chancel; church 1200-50; much rebuilt. [VCH 4]

HARLESTONE, St Andrew
ESp* ntd will of Rich Tekyn, c.1512:
To the sepulcre light a stryke of malte.
Also ntd 1519 will of Wm Peton.
Also ntd 1535 will of Tho Avery:
To the sepulker lyght ijs. To the seid lyght ij pownd
of waxe ye pryse xvjd. [Serjeantson & Longden]

HARPOLE, All Saints
ESp* ntd wills of T. Bonne, c.1512; Alice Thorpe, 1526;
& H. Jeffes, 1526. [Serjeantson & Longden]

HARRINGWORTH, St John Baptist
ESp* ntd 1523 will of W. Dunmow:
To the supportacion of the sepulcr lyett xijd. [Ser-
jeantson & Longden]

HELLIDON, St John Baptist
ESp* ntd will of Rich Haresse, c.1526:
To the reparacion of the sepulcher howse. [Serjeantson
& Longden]

HELMDON, St Nicholas or St Mary Magdalene
?ESp/aumbry; recess with ogee head in N wall of Dec
chancel. [Pevsner]
ESp ntd 1523 will of W. Jelyion:
To the sepulchre light one quarter of barley to ye
encreasyng ye stocks of ye foresaid light.
Also ntd 1529 will of T. Howll:
To the makyng of a newe sepulchre in the church of
Sent Nicolas in Helmyden xxd.
Also ntd 1530 will of W. Colls:
To the makyng of the sepulchre iiij stryke of barley.
[Serjeantson & Longden]

HELPSTON, St Botolph
?ESp; 3 recesses with trefoiled heads in N wall of chan-
cel opposite sedilia & about same size, rebated for
doors; chancel rebuilt beginning 1280-1300. [VCH 2]

HIGHAM FERRERS, St Mary Virgin
?ESp/tomb; chest under arch between chancel & Lady
Chapel to N has brass for Lawrence St Maur, rector of
Higham Ferrars & canon of Hereford (d. 1338), but
intended for member of House of Lancaster as indicated
by bees painted on canopy; chest has panels enclosing
shields; brass shows standing fig of deceased under
ogee arch; small side panels of saints; above ogee,
strip of 5 figs, center of which is seated Christ re-
ceiving soul held in napkin by angels; brass il Pevs-
ner, p. 249. [VCH 3]
ESp ntd 1506 will of Maryon Thorpe:
To the sepulchre light vjs. viijd.
Also ntd 1521 will of Robt Pipewell. [Serjeantson &
Longden]

HOLCOT, St Mary & All Saints
ESp* ntd 1501 will of Jn Whyte bequeathing 3s. 4d. to
ESp light of Holcote Church. [McGregor]

HOLDENBY, All Saints
ESp* ntd will of W. Randall, c.1512:
To the sepulcr lyght a stryke of malt.
Also ntd 1516 will of W. Seybot:
To Sent Pulkar lyght viijd.
Ntd 1522 will of Tho Stawnton. [Serjeantson & Longden]
Ntd 1531 will of Tho Robins. [Cox, *Parish Churches
Nm*]

HORTON, St Mary
ESp* ntd 1509 will of Jn Launden:
To Seynt pulcre light a pound of wax. [Serjeantson &
Longden]

IRCHESTER, St Katherine
?ESp; niche with straight-sided pediment enclosing
quatrefoil near NE corner of chancel; ledge or bowl
below, now at floor level, but floor has been raised 2
feet; hole in wall at back of niche has suggested use
for baking altar breads; use as ESp also possible; could
bowl be offering basin for "creeping silver"? 13c. [VCH
4]
ESp ntd 1500 will of Jn Jeffrey:
Lumini sepulchri iijs. iiijd.
Also ntd 1526 will of H. Goodwyn. [Serjeantson &
Longden]

IRTHLINGBOROUGH, St Peter
ESp/tomb; recess below N window of chancel; segmental
arch has trefoiled cusping; end 13c. [VCH 3]
ESp ntd 1531 will of Rich Mayle:
To the sepulchre light viijd.

268 NORTHAMPTONSHIRE

Also ntd 1536 will of W. Reeve (proved 1557):
To Sainte Pulcres lights too busshells of malte.
Sepulchre Guild ntd 1545 will of Rafe Smyth:
To Saynt Pulcur gylde halfe a quarter of barley.
There was also a Resurrection Guild, possibly same as
ESp Guild, ntd 1517 will of Jn Bloffyld:
I bequeth ij schep to the Resurrection gyld.
Also ntd 1522 will of Jn Smith:
To the broders of the Resurrection gylde for the use of
the same iijs. iiijd.
Also ntd 1522 will of Jn Ward:
To the use and yncresse of the gylde of Resurrecyon
xxd. [Serjeantson & Longden]

ISHAM, SS Peter & Paul
?ESp/aumbry; rectangular recess with splayed jambs &
head in N wall of chancel. [VCH 4]
ESp ntd will of T. Stephyn, c.1529:
To every tapar longyng to the sepulkar iiijd.
Also ntd 1544 will of J. Croxson:
To the maintenynge of the tapers aboute the sepulcher
xijd. [Serjeantson & Longden]

ISLIP, St Nicholas
ESp* ntd 1522 will of Jn Castleton:
To ye sepulcre light ij strike of barley.
Also ntd 1531 wills of Jn Nicholls & Jn Olyver. [Ser-
jeantson & Longden]

KELMARSH, St Denis
ESp* ntd 1498 will of Jn Calyffe:
Lego lumini sepulchri duas oves.
Also ntd 1498 will of Symon Wellys:
Lego iij oves sepulchro ecclesie de Kellmersh. [Serjeant-
son & Longden]

KETTERING, SS Peter & Paul
ESp* ntd 1493 will of Robt Whytlyng:
Lumini sepulchri ijs.
Also ntd 1535 will of Rich Tailor, priest:
To the sepulchar light of Keteryng to be about my
hearsee iijs. iiijd.
Ntd 1542 will of Eliz Ansty:
To the sepulcre light iijs. iiijd.
Ntd 1547 will of Margaret Ireland:
To the sepulcre lighte iiijd. [Serjeantson & Longden]
Sepulchre Guild ntd 1522 will of J. Ayer, 1522, & T.
Lawford, 1524.
Also ntd 1540 will of J. Warner:
To the brotherhed of the sepultur light xxd. [Serjeant-
son & Longden]

KILSBY, St Faith
Wooden ESp once belonged to this church; Bloxam (1882) reported it was in Snittersfield Vicarage, Ws; it disappeared in 1920's; form of coffer with sides carved in relief, excepting one long side which must have been intended to face wall; top modern; R end panel with Trial before Pilate: Christ in long tunic & with bound hands, Pilate in tunic, hooded mantle, & close-fitting cap, 2 soldiers, only one distinguishable as in 14c armor, & fig in civil costume; opposite end with Bearing of Cross: Christ again in long tunic, accompanied by woman & soldier; long side with 3 panels; from L, Deposition, partly destroyed; Resurrection: Christ, with cross-staff, stepping from tomb surrounded by soldiers; Hortulanus; Bloxam compares style to alabasters & dates chest to 1380-1400; chest 3'9" in length x 1'3" in width x 1'9" in height; panels 13" x 11". Il Chas. J. Hunt, "Old Chests," *TrBAS*, 20 (1895), 80.
ESp ntd 1521 will of T. Bathman:
To the sepulcr xvjd.
Also ntd 1535 will of Robt Cowley:
To the sepulchre light xijd.
Also ntd 1540 will of Robt Redull. [Serjeantson & Longden]

KINGSTHORPE, St John Baptist
?ESp/aumbry; small trefoiled recess in N wall of chancel at W end opposite 13c trefoiled piscina. [VCH 4]

KISLINGBURY, St Luke or SS Peter & Paul
ESp* ntd 1510 will of T. Wilkys:
To the sepulcr light xijd.
Also ntd 1532 will of T. Constable:
To the sepulchre a stryke of barley. [Serjeantson & Longden]

LAMPORT, All Saints
ESp* ntd 1521 will of Robt Smyth:
To the sepulcr too shepe.
Also ntd 1533 will of Rich Rateclyff:
To the sepulchre light oon pownd waxe. [Serjeantson & Longden]

LILFORD, St Peter
ESp* ntd 1511 will of Robt Warden:
To the sepulcre light j stryke of malt.
Also ntd 1517 will of H. Howlyff:
To the sepulcre lyght ijd.
Ntd 1541 will of Robt Curtys:
To the sepulkar iiijd.
Sepulchre Guild ntd 1519 will of Robt Hall:
To the sepulcr gyld ij qr of barley.

Ntd 1522 will of J. Bene of Achurch:
I bequeth to the mayntenyng of ye yelde of ye sepultur
in Lylford xvjd. [Serjeantson & Longden]

LITCHBOROUGH, St Martin
ESp* ntd 1536 will of J. Nell:
To the sepulchre light xijd. [Serjeantson & Longden]

LITTLE ADDINGTON, St Mary
ESp* ntd 1528 will of J. Browne:
To the sepulchre light [?one] shipe. [Serjeantson &
Longden]

LITTLE HARROWDEN, St Mary
ESp* ntd wills of Rich Gybbes, 1524, & Wm Samuel,
1529. [Serjeantson & Longden]

LITTLE HOUGHTON, St Mary Virgin
ESp* ntd 1499 wills of Tho Clipesham, 1499, & Js Tatam,
1529. [Serjeantson & Longden]

LODDINGTON, St Andrew or St Leonard
ESp* ntd 1513 will of Robt Tansor:
To ye sepultur light a schepe.
Also ntd 1515 will of J. Clarke. [Serjeantson &
Longden]

LONG BUCKBY, St Gregory
ESp* ntd 1521 will of Ellen Lyne:
To the sepulcre lyght a stryke of barley.
Also ntd 1522 will of Elyn Gyfford:
To Seynt pulcre lyght iiijd.
Also ntd wills of W. Alexander, 1526, & T. Coke, 1528.
[Serjeantson & Longden]

LOWICK, St Peter
?ESp/aumbry; recess in N wall of chancel; 13c. [VCH 3]
ESp ntd 1479 will of Jn Martyn, rector:
Item lumini sancti sepulchri quatuor quarteria brasii.
Also ntd 1497 will of Jn Hudson:
Item campanis xxd. et luminari sancti sepulchri xxd.
[Sackville, "Lowick"]
Ntd 1513 will of Henry Pynchbeke:
To the sepulcr lyght j stryke of barley.
ESp Guild ntd 1512 will of W. Rige:
To the sepulcr gyld off Lufweke ijd. [Serjeantson &
Longden]

LUDDINGTON-IN-THE-BROOK, St Andrew (St Margaret since 1791)
ESp* ntd 1519 will of Sir Jn Pollard, parson of the par-
ish of Lollyngton:
I bequeth x bee hyvys to meynteyn the sepulture

lyght, which x bee hyves shall be in custody of ye
church wardens.
Also ntd 1555 will of T. Barones. [Serjeantson &
Longden]

LUTTON, St Peter
 ESp*; paneling on N wall of chancel E of doorway pre-
 sumably marks place of ESp*; 4-centered arch encloses
 6 cinquefoil-headed panels; 2 center panels stop halfway
 down, leaving blank square of 1'6" with plain ashlar
 plinth below; may have formed permanent locus for
 ESp. Il VCH 2, opp. p. 582. [VCH 2]
 ESp ntd 1511 will of Rich Alward:
 To the sepulcr light iiij stryke of barley.
 Also ntd 1514 will of Agnes Felde:
 To the holy sepulture ij stryke of barley. Item I will
 yat ye best cow, after ye principall be taken, be de-
 lyvered unto Walton to ye kepe of ye holy sepulture yn
 ye same chyrch for to fortyfy and maynten ye same
 lytts. [Serjeantson & Longden]

MARHOLM, St Guthlac or St Mary
 ESp/tomb; chest & canopy of marble in NE chancel for
 Sir Wm Fitzwilliam; brasses of Sir Wm (d. 1534) & wife
 kneeling on back wall; scrolls from their mouths read:
 "prohibere nephas." [VCH 2]
 ESp ntd 1522 will of Rich Wildbor:
 To ye rode light & sepulcre light a sem barley. [Ser-
 jeantson & Longden]

MARSTON ST LAWRENCE, St Lawrence
 ?ESp; Dec. [Pevsner]

MAXEY, St Mary or St Peter
 ?ESp/tomb; chest under ogee-arched recess in N chan-
 cel; chest front elaborately paneled with 2 blank shields
 in cusped circles; slab plain; back of recess has panels
 containing blank shields; underside of ogee cusped &
 subcusped; spandrels filled with quatrefoils under
 square head with crenellations; elsewhere in church,
 black letter inscription to Tho Anable (d. 1402) which
 says that he had "hunc tumilum" made; may refer to
 monument described above; il Bond, Chancel, p. 221.
 [Sweeting; VCH 2]

MEARS ASHBY, All Saints
 ESp* ntd 1516 will of Wm Parker:
 To maynten the sepulcher tapur iiijd.
 Also ntd 1517 will of Sir Jn Goodwyn, vicar:
 To the sepulchr there a tapur of ij pownd of waxe and
 erely iiijd. to meynteyn the seyd tapur.
 Also ntd 1519 will of Jn Tayler:

To the sepulcre light ij strike of barley.
Also ntd 1539 will of Joan Wede:
I wyll that yf Thomas Croxon do injoye my house called
Brownes house to hys owne use that than the sayed
Thomas Croxton shall paye to the mayntayng of the
sepulcre lyght xxs.
To the sepulcre guylde one stryke of malte.
Sepulchre Guild also ntd 1523 will of Wm Alman:
To the sepulcre gylde on tolfat of barlye. [Serjeantson
& Longden]

MIDDLETON CHENEY, All Saints
ESp* ntd 1534 will of Robt Tailor:
To the light of the sepulchre oone strike of barley.
[Serjeantson & Longden]

MILTON MALZOR, St Helen or Holy Cross
?ESp/aumbry; pointed recess with wide chamfer in N
wall of chancel; modern door. [VCH 4]
ESp ntd 1518 will of Robt Stewynnys:
To the sepulcur lyght a cowe.
Also ntd wills of Jn Belling, 1526, & Wm Harbord, 1532.
[Serjeantson & Longden]

MORETON PINKNEY, St Mary
ESp* ntd 1526 will of Tho Collis:
To the sepulcre lighte j shepe.
Also ntd 1527 will of T. Brayles:
To the sepulchre xijd.
Also ntd will of Robyns, c.1531:
To the sepulchre a tapir of oone pownde of waxe. [Ser-
jeantson & Longden]

MOULTON, SS Peter & Paul
ESp* ntd 1516 will of Owyn Jefferson. [Serjeantson &
Longden]

NASEBY, All Saints
ESp* ntd 1523 will of H. Belhost:
To the sepulcr light xxd.
Also ntd 1529 will of Myles Roos:
I gyve all my hyves of bees to maynten the rode lyȝth
and the sepulture lyȝth. [Serjeantson & Longden]

NETHER HEYFORD, SS Peter & Paul
ESp* ntd 1544 will of Rich Warner:
To the sepulture light iiijd.
Also ntd 1545 will of Symon Barby:
To the mayntaining of the sepulture light vjs. viijd.
Ntd 1547 will of J. Lekins. [Serjeantson & Longden]

NEWBOTTLE, St James
ESp* ntd 1514 will of Sir T. Thelwall:
Ad sustentacionem luminis sancti sepulchri iiijd. [Ser-
jeantson & Longden]

NEWNHAM, St Michael
ESp* ntd 1510 will of Nich Sumerfeyld:
To the sepulchre ij bushell of barley.
Also ntd 1515 will of T. Goodman:
To the sepulcur lyth viijd. [Serjeantson & Longden]

NEWTON BROMSWOLD, St Peter
ESp; pointed recess in E bay of N chancel; arch on
shafts with molded capitals; width 6'; arch springs at
3'6"; recess, depth 8 1/2"; once deeper; 13c church
rebuilt in 14c. [VCH 4]
ESp ntd 1511 will of J. Pere:
To the sepulcar lyght on buschell barle.
Also ntd 1535 will of J. Burton:
To the sepulchre xijd.
Also ntd 1557 will of E. Dawson:
To sepulcher light a pownde of wax or els a torch.
[Serjeantson & Longden]

NORTHAMPTON, Holy Sepulchre
ESp* ntd 1543 will of Jane Harrod:
To the sepulcre lyght too pownds of wax.
St Sepulchre Guild ntd 1476 will of Simon Balle:
Lego fraternitati sancti sepulchri xxs.
Also ntd 1510 will of Wm Quarrior:
To the fraternytie of Seynt sepulcre in the church of
Seynt sepulcre xijd. [Serjeantson & Longden]

NORTHAMPTON, St Giles
ESp* ntd 1474 will of Jn Butcher mentioning ESp light.
Also ntd 1521 will of Wm Chauntrell. [Serjeantson &
Longden]

NORTHAMPTON, St Mary
ESp* ntd will of Tho Pemberton, 1539, & W. Dyckyns,
1546, mentioning FSp light. [Serjeantson & Longden]

NORTON, All Saints
ESp* ntd 1469 will of Wm Syre:
Lego luminari sepulchri iijs. iiijd. [Serjeantson &
Longden]

OLD (or WOLD), St Andrew
ESp* ntd 1490 will of Andrew Lodyngton:
Lumini sancti sepulchri unam ovem.
Also ntd 1519 will of E. Arnold:
To the sepulcre a hekefor [heiffer].

Ntd 1519 will of W. Arnold:
To the lygt of the sepulcr a scheppe.
Ntd 1519 will of Jn Arnold:
To the sepulcr every yer xijd. to be payd on passyon
Sunday as long as my father in lawe lyffs, & after hys
deyth I gyffe a kowgh to the meyntenyng of the seyd
sepulcr lyght.
Ntd 1529 will of H. Garrad:
To the sepulchre lyght one hyve.
Ntd 1544 will of Edward Martin, parson of Wold:
Item a taper of xvjd. to be continnually burnynge befor
ye blessyd sacrament at masse tyme, and a cow to
maynteyne the same; the sepulchars wardyns schall so
guyde yt that they have allway a bredar. The resydewe
left of the gayns to go to the torches & the sepulcher.
[Serjeantson & Longden]

ORLINGBURY, St Mary
ESp* ntd will of J. Heitton, 1536.
Sepulchre Guild ntd 1515 will of Jn Freeman:
To the sepulcre gyld one hyve.
Also ntd 1518 will of Jn Smyth:
To the lyghts of the sepulcar gylde ij strykes of
barley.
Ntd 1533 will of T. Wallis. [Serjeantson & Longden]

ORTON, All Saints
ESp* ntd will of J. Pye, c.1512:
To the sepulcr off Orton a schyppe. [Serjeantson &
Longden]

OVERSTONE, St Nicholas
ESp* ntd 1510 will of Jn Luke:
To the sepulture lyght half a quarter of malt. [Ser-
jeantson & Longden]

PAULERSPURY, St James
ESp* ntd 1534 will of Robt Dixe:
To the sepulcre light xxd. [Serjeantson & Longden]

PEAKIRK, St Pega
?ESp/aumbry; square recess rebated for door in N wall
of chancel. [VCH 2]
ESp ntd 1528 will of T. Chapman:
To the sepulchre light.[Serjeantson & Longden]

PETERBOROUGH, St John Baptist
ESp* ntd churchwardens' accts 1469:
Item Soluerunt for kepyng of the Sepulkyr lyth ijd.
1488:
In solutis Willelmo Man pro certis tabulis pro le Sapulcre
iijd.

Et solutis Georgio Cowper pro emendacione Sepulcri [et]
aliorum defectuum in ecclesia ijs.
1504-5:
Item payd for mendyng of the Sepulcre and for A pece
of tymber and for dressyng of ye organes xvd.
1505-6:
Item payd for makyng of A key to the Coffer of ye
Sepulcre ijd.
12 April 1506:
Memorandum that it remayneth in the hondes of Petre
Chayney of Petrebroughe V^{xx} and xiij li. of wex of the
Sepulture lite with xvjs. of money and he to make the
stok good at the Fest of Ester when the Sepulture shall
be sett vp and he to paye for the wast and the monay
that ys gethered to remayne to the Churchis behoue.
4 April 1507:
Sepulture lyght. 5 li. vs.
Memorandum that there remayneth in ye handys of Petre
Chaynye of Peterbrought V^{xx} and xij li. wax of ye
Sepulture lyght with xxixs. viijd. of mony and he to
make the stok gvd att ye feste of Ester when the
Sepulture shall be sett vp And he to pay for ye waste
and the monye that ys gethered to remayne to ye
Chyrchys behoue [afterwards deleted].
8 April 1509:
there remaynys in ye handes of John Ayer and Wauter
Morton xviijs. of ye sepulture lyght [deleted].
1514:
Memorandum that remayneth In the hands off John Eyr
and Water Morton all thynges reconyd and a compted
off the sepultur lyght the xxv^{th} day off May In the
sext yere off the Reyne off Kyng Harry the $viij^{th}$
vjs. xd.
Also the forseid John and Watur havyng In stoke to be
houeffe of ye sepulture lygth xls.
Item in waxe $iiij^{xx}$ li. and they to set yt vp at zester
off ther cost and carge And the gadryng that they
gadder at zester to be kepe to the Increste off ye seid
lygth [afterwards deleted].
Memorandum that Peter Edward hath Reseued to the
bryge be the handes off John Eyre and Water Morton
off the en crese and gadryng off the sepulture lygth
the xxij day off Aprell the sext yere off kyng Henry ye
$viij^{th}$ viijs. ixd.
1522-3:
Memorandum the same yer that Water morton mayd
acount and delyuered for the sepulcre leyth xxxvs.
vjd.
1537-8:
Item that I Thomas Marzott haes resewyd of Robert
Tocke Alexsander Hedlay Robert Browne for the
sepulker lyght xls.

Item be yt had In rememberans that I Thomas Marzott
of Peterborow haes resewyd of Robert Toche and Jhon
broune foller xxxij tabars for the sepulcar lyght the
whyche tabars do wey iiij schowre powndes of wax and
vj and the seyd Thomas for to make the seyd xxxij
tabars Ageyn ester next cummyng for to ber the wast
of the seyd lyght and the seyd Thomas schall delywer
to the cherche of Peterborow the seyd iiij schore
powndes of wax and vj A geyn whan he schall be call A
pon.
1538-9:
Item payde to Thomas Skarlett and Peter Peykoke for
kepyng of the seypullker at ester xiiijd.
1539-40:
Item payde for the sepulker lyghte wachyng xiiijd.
1554-7:
In primis to pay for the Sepulture vjs.
Item wax to the Sepulture xvjd.
Item wax to the Sepulture xxd.
1564:
Reseived off mr. bayle for ye sepulcher iijs. iiijd.
[Mellows]

PIDDINGTON, St Mary
ESp* ntd 1485 will of Wm Keyser:
Sustentacioni luminis sepulchri ecclesie de Peddyngton
xij denarios annuatim percipiendos per prepositos
ejusdem ecclesie.
Also ntd 1524 will of Robt Norman:
To the sepulchre lyght one stryke of barley.
Also ntd 1526 will of Wm Reynolds. [Serjeantson &
Longden]

PITSFORD, St Mary
ESp* ntd 1513 will of Wm Lawndon:
To ye sepulture lyght xxd.
Also ntd wills of Robt Cowper, 1514, & Robt Salwarke,
1528. [Serjeantson & Longden]

POLEBROOK, All Saints
?ESp/aumbry; rectangular recess in N wall of 13c chan-
cel covered by paneling in 1930. [VCH 3]
ESp ntd 1531 will of W. Tripshall:
To the sepultur light one ewe. [Serjeantson & Longden]

POTTERSPURY, St Nicholas
ESp* ntd 1526 will of Joan Freeman:
To the sepulchre light xijd. [Serjeantson & Longden]

PYTCHLEY, All Saints
ESp* ntd 1477 will of Margaret Isham:
To the releyf of the lyghts about the sepulchre of our

Lorde vjs. viijd.
Also ntd 1519 will of J. Yong:
To the sepulcr iiij stryke of barley.
Also ntd 1522 will of J. Gybbys.
Sepulchre Guild ntd will of Joan Atwellys:
To the sepulcre guylde xxd. [Serjeantson & Longden]

RAUNDS, St Peter or St Mary
ESp/aumbry; large rectangular recess in N wall of chancel between Wins N2 & N3; chancel 1240-60, altered in 15c. [VCH 4]
ESp ntd 1546 will of Tho Plowright, vicar of Raunds:
To be buryed betwene ye sepulcre foytt & ye marble stone before ye auntentecall [high] aulter in Rands. . . . To ye sepulcre lyght for my dewe yat is accustomyd xiijs. iiijd.
Sepulchre or Resurrection Guild ntd 1496 will of Jn Wales:
Lego ad fraternitatem resurrectionis vjs. viijd.
Also ntd 1512 will of Gered May:
To the fraternite of the sepulchr a quarter of malt.
Ntd 1529 will of Joan Rawson:
To ye Resurrectyon gylde for a diner vjs. viijd.
Ntd 1531 will of Jn Benett:
To the sepultur gyld in Raunds for my father & my mother, my sellff & my wif to be made brother & syster of the said guyld iiij quarters of barley. Item I bequeth to the said gyld my tenement or howsse the qwich I dwell in & a closse lyeng in Northende . . . the said gyld to have thes for evermore.
Ntd 1535 will of H. Diall:
I guyf & bequethe for to make a dyner for the brethren & sisterne of the Resurretion guylde iiijs. [Serjeantson & Longden]

RINGSTEAD, St Mary
Sepulchre Guild ntd 1513 will of Agnes Lyle:
To the sepulcr yeld iiij stryk of barley. [Serjeantson & Longden]

ROADE, St Mary
ESp* ntd 1510 will of T. Goldyng:
Lumini sepulcri dimidium libre cere.
Also ntd 1522 will of T. Grene:
To the Sente Pulcare lighte xij. [Serjeantson & Longden]

ROTHWELL, St John Baptist (Convent)
ESp* ntd Comm inv 1538:
a sepulture of waynescott ijs. [Walcott, "Inv Diss"]

ROTHWELL, St Saviour or Holy Trinity
 ESp* ntd 1521 will of Robt Watts:
 To the sepulchre iij shyppe.
 Also ntd 1538 will of Jone Stabulls:
 To the sepulcre lyght xijd.
 Also ntd wills of Tho Page, 1540, & Eden Whyt, 1558.
 [Serjeantson & Longden]

RUSHDEN, St Mary
 ESp* ntd 1520 will of J. Wedon:
 To the sepulcr lyght xxd.
 Also ntd 1542 will of Tho Spery:
 To the lygtes of the sepulcre & the torchis iijs. iiijd.
 [Serjeantson & Longden]

RUSHTON, All Saints
 Ntd 1556 will of H. Rose:
 To the sepulchre lyght viijd. [Serjeantson & Longden]

RUSHTON, St Peter
 ESp* ntd 1499 will of Agnes Sawyer:
 Ad lumen sepulchri viijd.
 Also ntd 1520 will of Jn Tresham, esq.:
 To be buried in the chancell by the sepulcr in the
 parysh church of Seynt Petur. [Serjeantson &
 Longden]

SCALDWELL, SS Peter & Paul
 ESp* ntd 1496 will of K. Benett:
 Lumini sepulchri unam ovem.
 Also ntd 1510 will of J. Colet:
 To the sepulchre light a schepe.
 Also ntd 1513 will of J. Wodford. [Serjeantson &
 Longden]

SPRATTON, St Andrew or St Luke
 ?ESp/tomb; chest with paneled sides enclosing quatrefoils
 with blank shields under easternmost arch of N chancel
 arcade; formerly held wooden effigy; 15c. [VCH 4]
 ESp ntd will of J. Parnell, c.1510:
 To Sent Pulcre lyght iiijd.
 Also ntd 1521 will of Rich Parker:
 To ye sepulcre lyght a schepe.
 Also ntd 1521 will of W. Keybur. [Serjeantson &
 Longden]

STANFORD ON AVON, St Nicholas
 ESp* ntd 1500 will of Henry Willyams:
 I bequeth my coverled to the use of the sepulcre.
 Also ntd 1508 will of Basilla Laxton:
 Item sepulcro in eadem ecclesia unum lynthyamen.
 Also ntd 1537 will of Rich Cave, esq.:

And if there be any wax saved yerely that then I will
it be gyven to the sepulcre there to be to the mendyng
of the tapers there spent at Easter. [Serjeantson &
Longden]

STANWICK, St Lawrence
ESp* ntd 1529 will of Js Curtys:
To the sepulchre light xijd.
Also ntd 1539 will of Sir Jn Harrison. [Serjeantson &
Longden]

STAVERTON, St Mary
ESp* ntd 1521 will of Rich Cokys:
To the sepulcre lyght xijd.
Also ntd wills of Robt Abbey, 1522, & Rich Smyth,
1536. [Serjeantson & Longden]

STOKE ALBANY, St Botolph
?ESp/tomb; low recess with trefoiled cusped arch in
chancel; c.1300. [Pevsner]

STOKE BRUERNE, St Mary Virgin
ESp* ntd 1526 will of Robt Bounde:
To the sepulchre light xxd.
Also ntd 1529 will of Robt Kingston:
To the sepulcre light ij bee hyves.
Also ntd 1540 will of Tho Clare. [Serjeantson &
Longden]

STOKE DOYLE, St Rombold
Sepulchre Guild ntd 1496 will of Jn Brasebrygg:
Gilde sepulchri Domini unam mappam deauratam. [Ser-
jeantson & Longden]

SUDBOROUGH, All Saints
?ESp/tomb; recess with nearly segmental arch in N wall
of chancel. [Pevsner]
ESp ntd 1527 will of T. Ball:
To the sepulcre light xxd.
Sepulchre Guild ntd 1528 will of T. Long.
Also ntd 1523 will of W. Norton:
To the sepulcr gyld viijd.
Also ntd 1528 will of Sir T. Pull:
To the sepulkar gylde xxd. [Serjeantson & Longden]

SULGRAVE, All Saints or St James
ESp* ntd 1510 will of Rich Wright:
For the sepulcre light xld.
Also ntd 1518 will of T. Myller:
To the sepulture one scheppe. [Serjeantson & Longden]

SUTTON, St Giles or St Michael (Chapel to Castor)
ESp* ntd 1545 will of J. Fysher:
To the sepulcher light xijd. [Serjeantson & Longden]

SYRESHAM, St James or St Nicholas
ESp* ntd 1528 will of T. Kenersley:
To the mayntenans of ye sepulture lightt in the church
of Syersham ij kyne the churchwardens to have the
ordering of the said kyne. To the same sepulture xiij
li. of waxe. [Serjeantson & Longden]

SYWELL, SS Peter & Paul
?ESp/aumbry; recess in N wall of chancel. [VCH 4]
ESp ntd 1512 will of Sir Harry Boterell:
To the sepulcr iijs. iiijd.
Also ntd 1518 will of W. Mannyng:
To the sepulcr lyghts halfe a quarter of barley.
Ntd 1530 will of W. Witmall. [Serjeantson & Longden]

TANSOR, St Mary
?ESp/aumbry; square recess in N wall of chancel. [VCH
2]
ESp ntd 1527 will of J. Rickman:
To the sepulchre iiijd.
Also ntd 1529 will of Robt Diccons:
To the sepulchre lyght viijd. [Serjeantson & Longden]

THORPE MALSOR, All Saints or St Leonard
ESp* ntd 1510 will of W. Davy:
To the sepulchre xijd.
Also ntd 1521 will of Robt Osborne:
To the sepulchre ij stryke of barley.
Also ntd 1528 will of W. Alderman:
To the sepulcre a heyford [heiffer].
Also ntd 1528 will of Tho Woodford. [Serjeantson &
Longden]

TITCHMARSH, St Mary
?ESp/aumbry; recess with trefoiled head in N wall of 13c
chancel; similar to piscina opposite; restored. [VCH 3]
ESp ntd 1514 will of Alys Sexton:
To ye sepulture lyght a stryke of barley.
Also ntd 1521 will of Robt Dene. [Serjeantson &
Longden]

TOWCESTER, St Lawrence
ESp* ntd 1519 will of Robt Knott:
Lego lumini sepulchri iiijd.
Also ntd 1521 will of Robt Hawke. [Serjeantson &
Longden]

TWYWELL, St Nicholas
?ESp; 3-part structure in N wall of chancel; at floor
level low recess with segmental arch on attached shafts;
recess 6'10" in width x 3'3" in height; resting on
square head of recess, double aumbry, rectangular
openings rebated for doors; above this sloping surface
with book rest, presumably Gospel desk; pinnacles once
rose at corners; aumbries & desk 4' in height x 4'4" in
width; late 13c; il VCH 3, opp. p. 251; Bond, *Chancel*,
p. 226.

UFFORD, St Andrew
?ESp/aumbry; square recess in N wall of chancel under
Win N2; chancel c.1300. [VCH 2]

WADENHOE, St Giles or St Michael
ESp* ntd will of Jn Goodrich, c.1525:
To the lighte off the sepulchre ij strykes of barley.
Also ntd 1526 will of J. Abron:
I bequeth to the mendyng of the sepulchre & the light
there xxd. [Serjeantson & Longden]

WAKERLEY, St John Baptist
?ESp/tomb; chest with paneled sides under shallow 4-
centered arch with tracery; c.1500; adopted as tomb to
Rich Cecil (d. 1633); il Keyser, "Seaton, Wakerley,
Wittering," fig. 22.

WALGRAVE, St Peter
?ESp/aumbry; pointed recess in N wall of 14c chancel.
[VCH 4]
ESp ntd 1521 will of W. Wede:
To the sepulchre lyght a hyve with beys.
Also ntd 1530 will of H. Carter:
To the mayntenyng of the sepulcre light iiijd.
Ntd 1530 will of T. Kyng. [Serjeantson & Longden]

WAPPENHAM, St Mary
ESp* ntd 1510 will of J. Collens:
I bequeth to the sepulcre lyght. . . .
Also ntd 1537 will of W. Fote:
To the sepulchre light & the rode light iiijd. [Serjeant-
son & Longden]

WARKTON, St Edmund
Sepulchre Guild ntd wills of Symond Craft, 1523; Lionel
Awstell, 1527; Robt Atton, 1528; & Agnes Picheley,
c.1530. [Serjeantson & Longden]

WARMINGTON, St Mary
?ESp/tomb; large chest in N wall of chancel beneath Win
N2; dowel holes at corners; top 10'7" x 4' x 9" thick;

chamfered on underside. [VCH 3]
ESp ntd 1513 will of H. Aborne:
Luminibus sancti sepulchri dimidium quarterii ordei.
Also ntd wills of Js Pakeman, c.1518; J. Baxter, 1521;
& Rich Patman, 1529. [Serjeantson & Longden]

WATFORD, SS Peter & Paul
ESp* ntd 1521 will of J. Sabyn:
To foure lyghts in the chyrch of Watford, that ys to
say the sepulcr lyght, the rode lyght, our Lady lyght
& the lampe, to every of them xijd.
Also ntd 1522 will of Nich Naseby:
To the sepulcre light iiijd. & a stryke of barley.
Also ntd 1531 will of W. Sabyn. [Serjeantson &
Longden]

WEEDON, SS Peter & Paul or St Peter
ESp* ntd 1501 will of Jn Campion:
Lego sepulchro Christi libram cere.
Also ntd 1522 will of T. Lynell:
To the sepulcre ly3t viijd.
Ntd will of T. Campyon, c.1528.
Ntd 1539 will of E. Billing:
Towards the mainteynynge of the lights about the
sepulchre xijd. [Serjeantson & Longden]

WEEDON LOIS, St Mary
ESp* ntd 1497 will of Henry Ward:
Ad reparacionem sepulchri ij modios ordei. [Serjeantson
& Longden]

WEEKLEY, St Mary
Sepulchre Guild ntd 1496 will of K. Clypsham:
Lego gilde sepulchri iij modios brasii.
Also ntd 1522 will of J. Lawforth:
To the gyld of the sepulcr lyght iij schepe.
Ntd 1524 will of Margaret Lawford:
To the sepulcer gyld a shippe & a be hyve.
Ntd will of J. Hunt, c. 1529:
To the sepulkar gyld iiijd.
Ntd 1546 will of Nich Pinson:
To be made a broder of the sepulchre gilde the same
money [xs.]. [Serjeantson & Longden]

WELLINGBOROUGH, All Saints
ESp/aumbry in N wall of chancel built 1300-50. [VCH 4]
ESp ntd 1518 will of Wm Fisher:
To the sepulture vjs. viijd.
Also ntd 1524 will of Wm Clendon:
To ye sepulchre lyght viijd.
Also ntd 1557 will of Jeffrey Fisher.
Sepulchre Guild ntd 1521 will of George Wyllymott:

Lego fraternitati sepulcri ijd. [Serjeantson & Longden]

WELTON, St Andrew or St Martin
ESp* ntd 1528 will of R. Ingland:
To the sepulker light ijd.
Also ntd 1531 will of J. Gybbs. [Serjeantson &
Longden]

WEST HADDON, All Saints
ESp* ntd 1521 will of J. Freman:
To the sepulcr lyght xijd.
Also ntd 1526 will of Elizabeth Warren.
Ntd 1530 will of E. Morkote:
To the iij lyghts in the sayd church yt is to say our
lady lyght, to the rode lyght & the sepulchre light to
every one of them j stryke of barley [Serjeantson &
Longden]

WESTON FAVELL, St Peter
?ESp/aumbry; square-headed recess in N wall of chancel.
[VCH 4]
ESp ntd wills of Wm Arkwryth, 1517, & Lawrence Praty,
1521. [Serjeantson & Longden]

WHILTON, St Andrew
ESp* ntd 1521 will of W. Langton:
To the sepulcr lyght of Wylton viijd. [Serjeantson &
Longden]

WHISTON, St Mary
ESp* ntd 1523 will of Jn Dobbe:
To the sepulcr lyght ijs. [Serjeantson & Longden]

WHITTLEBURY, St Mary
ESp* ntd 1514 will of W. Schoowle:
To ye sepultur lyght half a quarter barley.
Also ntd 1530 will of Jn Lambert:
To the sepulcher a cow.
Also ntd 1539 will of R. Roberds:
To the sepulcre lyghte xijd. [Serjeantson & Longden]

WICKEN, St John Evangelist
ESp* ntd will of Humphrey Wells, c.1529:
To the sepulcre lightt xviijs. [Serjeantson & Longden]

WILBARSTON, All Saints
Sepulchre Guild ntd 1502 will of Robt Ashwell:
Lego gilde sepulchri duo quarteria brasii. [Serjeantson
& Longden]

WILBY, St Mary
ESp* ntd wills of W. West, 1517, & Agnes Robonet, 1522.

284 NORTHUMBERLAND

[Serjeantson & Longden]

WINWICK, Holy Trinity or St Michael
ESp* ntd 1521 will of Rich Plakytt:
To ye chyrch of Winwick to ye Rode lyght & to ye
sepulcr lyght iiijd. [Serjeantson & Longden]

WOLLASTON, St Mary
ESp* ntd 1517 will of W. Roberts:
To the sepulcre light vjs. viijd.
Also ntd 1528 will of J. May:
To the sepulchre light vjd.
Also ntd 1557 will of Jn Packe:
To the torches & to the sepulcre lights xijd.
Sepulchre Guild ntd 1526 will of J. Aberne:
To the sepulcre brotherhood ij stryk of barley.
Also ntd will of Rich Agutter, c.1533:
To the sepulture brotherhod xxd. [Serjeantson &
Longden]

WOODFORD (BY THRAPSTON), All Hallows or St Mary
ESp* ntd 1517 will of Agnes Grome:
To ye sepulcar a schepe. [Serjeantson & Longden]

WOODFORD HALSE, All Saints or St Mary
ESp* ntd 1518 will of Alice Smyth:
A charpett to the crose for to lye on the sepulcur.
[Serjeantson & Longden]

WOOTTON, St George Martyr
ESp* ntd wills of Jn Grene, 1483, & Tho Wold, 1532.
[Serjeantson & Longden]

NORTHUMBERLAND (Nt)

BAMBURGH, St Aidan
?ESp/aumbry in N wall of chancel; pointed arch, tre-
foiled; opposite sedilia & piscina of same shape; church
probably after 1221. [Pevsner]

FELTON (FENTON), St Michael
ESp* ntd will of Margaret Newby, 16 June 1531:
also to the sepultur vs. [*Test Ebor* 6]

STAMFORDHAM, St Mary
?ESp/aumbry; recess with pointed trefoiled head in N
wall of chancel; similar in form to piscina, but some-
what smaller; late 13c. [Pevsner]

TYNEMOUTH, Priory (Benedictine)
?ESp; deep, arched recess in N wall of chancel.
[Pevsner]

WIDDRINGTON, Holy Trinity
?ESp; 2 recesses in N wall of chancel opposite sedilia;
chancel of mid 14c. [Pevsner]

NOTTINGHAMSHIRE (Ns)

ARNOLD, St Mary
ESp of Hawton-Heckington type in N wall of chancel; all
sculpture missing; below, tomb chest with 4 ogee-
headed niches for soldiers; on top of chest, large re-
cess in center flanked by smaller niche on each side;
all 3 ogee-headed with crockets & finials; flanking
niches cusped; recess cusped & sub-cusped; diaper
pattern in form of 4-petaled flower in spandrels; above
recess, large niche with triangular head; flanking it 2
smaller recesses at lower level, ogee-headed; buttresses
between niches have large finials that extend to
straight cornice; to W of this, tomb recess with chest
having same diaper pattern as ESp; presumably donor's
tomb as at Hawton; sedilia & double piscina opposite;
mid 14c; il Wooley, "Ns & Ls ESp," Pl. VIII; Sympson,
opp. p. 291.

BLYTH, SS Mary & Martin (Benedictine Priory)
ESp* ntd will of Agnes de Harwood (d. 1390):
Item lego sepulcro in ecclesia de Blith j zonam cum
argento harnesatam. Item lego ad id ij. monilia. [Test
Ebor 1]

EAST MARKHAM, St John Baptist
?ESp/tomb; chest for Sir Jn Markham (d. 1409) in N
chancel; shields in niches on front of chest; no effigy;
slab has inscription. [Briggs]

EAST RETFORD, St Edmund or St Swithin
ESp* ntd will of Edmund Talbot, Esq., 11 August 1496:
To the same church, for the sepulcre, the covering
that they have there of grene velvett with myne armes
theruppon, and a paynted clothe to be above it.
[Clay, North Country Wills]

FLEDBOROUGH, St Gregory
4 fragments of ESp now built into N wall of chancel
near E end; largest found turned upside down & in use
as doorstep at back door of rectory; original ESp
smaller & probably simpler version of Heckington-Hawton

type; one fragment seems to be top part of rectangular
panel with Resurrection; it shows upper half of frontal
fig of Christ, haloed, both arms raised, L presumably
blessing & R, with drapery over it, holding cross-staff;
flanking Christ, smaller figs of angels, one to his L
censing & one to his R with hands ?folded; another
panel has 3 ogee niches, trefoiled & crocketed, each
containing sleeping soldier in chain mail; 2 blank
shields suspended by straps in spandrels; ?14c. Figs.
48-49.
ESp ntd will of Sir Rich Basset of Fledborough, 15 June
1522:
If I dye within xxti myles of Fledburgh, my body to be
beriede at the north ende of the hy-altar in the
churche of Fledburgh, where the sepulcre is usid to be
sett of Good Fridaye. [*Test Ebor* 5]

HAWTON, All Saints
ESp is part of whole chancel interior of Ancaster stone
in Dec style; N wall unified composition under one
cornice includes door to former N chapel, founder's
tomb, & ESp; slim buttresses with pinnacles rise to
cornice & provide sub-divisions; ESp in 3 horizontal
divisions; lowest, tomb chest with 4 niches having tre-
foiled-ogee heads & hanging knops to each cusp; canopy
of each arch with crocketing & finial; in each niche one
sleeping soldier, wearing basinet, sleeveless surcoat
over hawberk of chain mail, each with sword or spear &
leaning on heater-shaped shield charged with dragons &
profile heads; background, spandrels, & finials have
foliate carving; line of molding under flat member serv-
ing as top of chest provides square head for each sol-
dier niche; buttresses rise from front edge of chest
top, creating 3 vertical ogee-headed openings, center
having width of 2 of soldier panels below; these 3 bays
have 4-part vaults with large bosses; approximately 2'
from front of slab to back wall, which has small recess
& carving in relief of figs of Christ, holy women, &
angels; crocketed ogee-headed recess of about 8" in
depth, framed by arch of L bay; to R of it, Christ with
R knee raised as if stepping through tomb slab, L foot
below level of recess; R hand raised in blessing; L
holds staff; drapery over L shoulder covers lower body
& legs, exposes wound in R side from which blood
flows; head now broken; to Christ's L are 3 holy
women, one nearest him kneeling, facing him, her
hands covered by her drapery, R hand & arm lifted;
head broken away; behind her & framed by arch of R
bay, 2 standing figs, holding spice boxes & partially
turned away; on each end wall, angel; both angels
kneel, wings uplifted, hands and feet bare; all these
figs in shadow; jambs of central niche formed of 3

clustered columns; above ogee arches framing this
level, at either side, angled forms like flying but-
tresses; in center, triangular gable over finial of ogee
projects into top band of relief sculpture which shows
Ascension, divided into 3 groupings by pinnacles of
vertical buttresses; to each side, 3 figs, standing &
looking up, some with hands folded in prayer, some
holding books; above each group, half-angel with scroll
emerges from stylized clouds in cornice; in center,
Christ's footprints on large finial that divides 6 figs
around it into 2 groups of 3; one of these, shod, may
be BVM; all others barefoot; one closest to center on
R, gesturing upward with R hand, is St Peter holding
large key in L hand; above them, band of stylized
clouds, & disappearing into clouds some drapery, lower
legs, & feet (broken away) of Christ, flanked by cens-
ing half-angels; all backgrounds covered with foliage
except that at level of Ascension, effectively left plain
to suggest gulf between heaven & earth; 12' in height.
Plaster cast of ESp was in Ecclesiastical Court of Crys-
tal Palace. Adjoining tomb recess, with cusped & sub-
cusped ogee arch, possibly for Sir Robt de Compton,
lord of manor at Hawton (d. 1330); badly damaged ef-
figy of cross-legged knight under recess. Figs. 39-42.

HOCKERTON, St Nicholas
 ?ESp; niche in N wall of chancel. [Pevsner]

LAXTON, St Michael
 ?ESp/small niche with tracery on N wall of chancel; no
 figural sculpture; low side window opposite; early 14c.
 [Gill, "St Michael's"; Pevsner]

NEWARK-ON-TRENT, St Mary Magdalene
 ESp/tomb; monument for Tho Mering (d. 1500) between
 chancel & N aisle; on choir side, 4-centered arch over
 chest; toward aisle side, treated as 2 bays filled with
 5-light transomed openings; crenellations at top. [Pevs-
 ner]
 ESp ntd will of Tho Mering of Newark, 13 August 1500:
 To be beried in the north partie of ye qwere, by twix
 the two pillors next ye altar, as at ye tyme of Estur itt
 is used to sett ye sepulcur of Jhesu Criste. [Test
 Ebor 4]
 Also ntd will of Jn Mering, 16 June 1541:
 And at Ester the saide Thomas Meringes landes shall
 fynde fyve tapours for the sepulture, every tapour to
 be of vj li. a pece, and to burne the spacie of xijth
 days. [Test Ebor 6]

NORMANTON-ON-SOAR, St Mary or St James or St John
 ?ESp/recess in N wall of chancel. [Baylay]

NOTTINGHAM, St Mary
ESp* ntd 1505 will of Tho Warner:
My Executors to sell all my gardens in St Mariegate
Nottingham for dearest and dispose in pious uses for
St. Mary's church and especially for one candle to
burn in the church and one for the Easter Sepulchre
according to custom. [Wadsworth]

RATCLIFFE-ON-SOAR, Holy Trinity
ESp/founder's tomb low on N wall of chancel; part of en-
semble including sedilia & piscina all of end 13c. [Gill,
"Radcliffe"]

SIBTHORPE, SS Peter & Paul or St Peter (Collegiate)
ESp on N wall of chancel discovered in 19c when tomb
of 1590 in front of it was removed; below, low tomb
recess with segmental arch; centered above this, small
niche under ogee arch for use in *Depositio*; flanking
niche on either side, 2 small panels with ogee cusped
heads, each containing relief of sleeping soldier; these
wearing chain mail, sleeveless surcoats, & basinets &
having spears & heater-shaped shields charged with
grotesque faces; faces hacked away, except for one
whose helmet covers his face; above central niche,
steeply pointed triangular gable with spiral crockets &
finial; inside gable, standing on finial of lower arch,
risen Christ; he blesses with R hand, holds long cross-
staff with banner in L; wounds in side & feet visible;
below him, 2 angels with censers; half-figs with folded
hands serve as stops at lower corners of gable; paint-
ing modern; 14c. **Fig. 44.**
ESp ntd Ordinances for Sibthorpe College, 1342-3:
2 tapers are directed to be burned in the chancel by
the sepulchre of our Lord from the ninth hour of Good
Friday til after the end of the service of the Resurrec-
tion on Easter day. [Serjeantson & Longden]

SOUTHWELL, Cathedral, St Mary Virgin
?ESp*; 5 sedilia & piscina in panel to E of pulpitum;
not in original position; close in style to sedilia & pis-
cinae at Hawton, Heckington, & Navenby, all dating
c.1330. Thompson is convinced that they stood
originally in 2nd bay of S arcade, on S side of high
altar, probably forming part of composition including
stone screen behind altar & screen on N side in which
there was tomb or permanent recess for ESp; c.1330-40.
[Thompson, "Southwell"]

WEST BRIDGFORD, St Giles
?ESp/tomb; low canopied arch in N wall of new N chapel;
moved from N wall of chancel when church was extended
in 1898; now has cross-legged knight under it; in 1896

J. T. Godfrey described inscription, now missing,
reading "Christ is risen" on arch; 14c; much restored.
[Watson]

WILLOUGHBY-ON-THE-WOLDS, St Mary & All Saints or All
Saints or St Peter
ESp* ntd will of Rich Girton, 15 May 1524:
Also I gif to the light called Sepulcre light a yowe and
a lame, in Willoughby church. [Test Ebor 5]

WORKSOP, SS Mary & Cuthbert (Priory)
ESp* ntd will of Sir Chas Pilkington leaving 5 marks for
repair of ESp at Worksop. [Wooley, "Ns & Ls ESp"]

OXFORDSHIRE (Os)

ARDLEY or ARDLEIGH, St Mary
ESp/tomb; recess in N wall of chancel, cusped, with
shield on each cusp; words "Non est" on finial; 14c.
[VCH 6]

ASTON ROWANT, SS Peter & Paul
?ESp/tomb; recess in N chapel; Dec; 14c. [VCH 8]

BAMPTON or BAMPTON-PROPER, St Mary
ESp/tomb; recess in E chapel of N transept; triangle-
headed recess cusped & sub-cusped; crocketed pedi-
ment with ball flowers rests on 2 brackets: head of
queen on N & king on S; above queen a small monster,
above king, a priest; flanking pilasters have tops
broken off; 1320-50; il Keyser, "Bampton," figs. 17 &
18.
ESp in N wall of chancel E of doorway to sacristy
reaches full height of wall; no fig sculpture remains;
ESp breaks through Norman string course molding;
consists of 2 large recesses, one above the other,
under paneled canopy; lower recess somewhat taller
than upper, both have very flat arches, cinquecusped &
subcusped; tiny blank shields in spandrels of lower
arch; crocketed gable of upper arch in form of triangle
with slightly curving concave sides which interpenetrate
2 rows of trefoil-headed niches in panels to form crys-
talline effect; these niches may well have contained
figs; traces of red paint remain on moldings & upper
panels; perhaps lower recess for donor's tomb & upper
for ESp or, as Keyser suggests, lower for ESp, upper
for representation of Resurrection; late 15c. Fig. 13.

BANBURY, St Mary
ESp* ntd 1502 will of Jn Barret:

to the building of a new sepulchre in the said church
£4. [Weaver & Beardwood]

BICESTER, St Eadburg
Esp* ntd 1498 will of Wm Staveley:
to be buried in the chauncell ther the sepulture is set
within the parishe churche of Burcestre. [Weaver &
Beardwood]

CHARLBURY, St Mary Virgin
ESp* ntd Chantry Certificate 1548:
Stocke in cattall not presed in 3 kyne and 28 shepe.
Memorandum that the said catall was gyven to the
mayntenance of 3 lampe lyghts Roode lvght and
Sepulcre light there for ever. [Graham, *Chantry Os*]

CHARLTON-ON-OTMOOR, St Mary
?ESp; plain recess in N wall of chancel opposite sedilia &
piscina; 14c. [VCH 6]

CUDDESTON, All Saints
ESp; recess at E end of N wall of 15c chancel. [VCH 5]
ESp ntd Comm inv 1552:
Item 3 paynted clothes for the sepulchre. [Graham,
Chantry Os]

DORCHESTER, SS Peter & Paul
?ESp; Christ rising from tomb with sleeping soldiers
below sculpted on main boss of reticulated window at E
end of N aisle (Win N3); Evans suggests that altar
below window used for ESp; N aisle probably begun
1225; remodeled 1293. [Evans, *1307-1461*; VCH 7]
ESp ntd Comm inv 1552:
Item 2 pawlys and a sepulcre clothe. [Graham, *Os*]

DUCKLINGTON, St Bartholomew
?ESp/tomb; recess with ogee arch cusped & subcusped,
vines along outer curve, heads in vines & on cusping,
called tree of Jesse; 14c; il Crossley, *ECM*, Pl. 70.

HAMPTON-POYLE, St Mary
ESp* ntd 1498 will of Dame Kateryne Reed:
To the sepulture lighte of the same churche 3s. 4d.
[Weaver & Beardwood]

HANDBOROUGH, SS Peter & Paul
?ESp in chancel; Norman. [R. Bailey]

HORSEPATH, St Giles
ESp* ntd Comm inv 1552:
Item a peynted lynen cloth for the sepulcre and an
other whyte of dyaper. [Graham, *Os*]

LEWKNOR, St Margaret
?ESp; recess part of rebuilt chancel of early 14c includ-
ing priest's doorway & piscina; all have crocketed
canopies; recess has pointing hand carved on arch;
effigy in recess not intended for it. [VCH 8]

MARSTON, St Nicholas
ESp* ntd churchwardens' accts ?1541:
Item Harry Nycholl for the sepulcre lyght ijs. vjd.
Item Phylyp Fys and John Harper reseved of Rychard
Harwell and Thomas Nycholls for the sepulcre lyght
vjs. xd.
Jhon Harper for the sepulcre lyght iijs.
1557:
Paid for the sepulcre and the paschall stocke iijs.
Item for the wax for the sepucre fonttaper and
roodlight xs. [Weaver & Clark]

MERTON, St Swithin
?ESp/aumbry; ogee-headed niche in N wall of chancel,
height approximately 2 1/2'; crockets, finial, & pin-
nacles at sides to height of finial; depth approximately
18"; 14c. [VCH 5] **Fig. 29.**

NORTHMOOR, St Denis
ESp* ntd 1508 will of Jn Byrd:
To the Sepulcre light twenty pounds of wax to a
stokke, soo that it be not lessyd. [Weaver &
Beardwood]

OXFORD, Cathedral, Christ Church (formerly St Frideswide)
ESp* ntd *Depositio* in Missal of 1384, Munich Staatsbib-
liothek MS. clm. 705:

<Depositio>

Deinde finitis vesperis exuat sacerdos calicem &
assumens secum unum de prelatis in superpellicio
reponat crucem in sepulcro. deinde corpus domini
scilicet in pixide incipiens ipse solus istud
Responsorium.
Estimatus sum <cum descendentibus in lacum, factus
sum sicut homo sine adjutorio, inter mortuos
liber>.
genuflectendo cum suo socio. quo incepto: statim
exurgant similiter fiat in Responsorio.
Sepulto domino <signatum est monumentum, vol-
ventes lapidem ad hostium monumenti; ponentes
milites qui custodirent illud>.
Chorus prosequatur cum suo versu. genuflectendo per
totum tempus usque in finem seruicij. Responsorium.
Estimatus sum cum descendentibus in lacum. factus

sum sicut homo sine adiutorio inter mortuos liber.
versus
　Posuerunt me in lacu inferiori in tenebrosis & in
　umbra mortis. Factus <sum sicut homo sine ad-
　jutorio, inter mortuos liber>.
Deinde incensato sepulcro & clauso ostio: incipiat idem
sacerdos *Responsorium*.
　Sepulto *domino.*
Chorus *prosequatur* cum suo *versu* Responsorium.
　Sepulto *domino* signatum est monumentum uoluentes
　lapidem ad ostium monumenti. ponentes milites qui
　custodirent illud.
versus
　Ne forte ueniant discipuli eius & furentur eum &
　dicant plebi surrexit a mortuis. ponentes <milites
　qui custodirent illum>.
Item sacerdos *antiphonam.*
　In pace in idipsum.
Chorus *respondet*
　dormiam & requiescam.
Sacerdos *antiphonam.*
　In pace *factus* est locus eius & in syon habitatio
　eius.
Sacerdos *antiphonam.*
　Caro mea requiescet in spe.
Ad istas tres *antiphonas* genuflectant duo *predicti*
sacerdotes *continue.* Hijs finitis reinduat sacerdos
casulam & *eodem* ordine quo accessit in *principio*
seruicij cum *diacono* & subdiacono & ceteris ministris
abcedat. Exinde ardebit continue unus cereus ad minus
ante sepulcrum *usque* ad *processionem* que fit in
resurreccione *dominica* in die pasche. ita *tamen quando*
dum *Benedictus* canitur & cetera que sequuntur *in*
sequenti nocte extinguantur & in *vigilia* pasche *dum*
benedicitur *nouus* ignis usque accendatur *cereus*
paschalis. [f. 97V; **fig. 21**; cf. Lipphardt, No. 412]
Also ntd inv 19 May 1545:
A clothe for the sepulcre iijs. iiijd.
a sepulcre of woode and a dexte of woode for the
Gospeller xxd. [Walcott, "Inv Diss"]

OXFORD, Magdalen College Chapel
　ESp/tomb; small vaulted recess on N side of altar has
　tomb of founder of college; inv of furniture belonging
　to chapel indicates recess originally built for ESp.
　[Bond, *Chancel*]
　ESp ntd college records 1486-7:
　Solutum Iohanni White pro fabricacione sepulture erga
　pascha xijd.
　1536-9:
　Solutum pro carbonibus combustis in sacrario per
　custodes sepulchri et per pueros in festis hyemalibus

ijs. [Alton]

OXFORD, Queen's College Chapel
ESp ntd 1422 will of Roger Whelpdale, bishop of Carlisle, 1419-22:
Volo quod lectus meus, jam de novo steynet, cum toto apparatu camerae, liberetur capellae collegii Reginae, pro diebus magnis, et potissime pro tempore Paschali, pro sepulcro Dominico, altari, et lateribus capellae. [*Test Ebor* 3]

OXFORD, St Martin
ESp* ntd churchwardens' accts 1554, when ESp was purchased.
1559: watch kept at ESp on Good Friday.
1560: church still possessed part of ESp. [VCH 4]

OXFORD, St Mary Virgin
ESp* ntd frequently in medieval records. [Clark, *Wood's Oxford*]
ESp* ntd as restored in churchwardens' accts 1553. [VCH 4]

PIDDINGTON, St Nicholas
?ESp in form of pointed recess of about 3' in height low in N wall W of Win N2; shafts of Purbeck marble with foliate capitals carry arch with trefoil cusping & 3 angels on either side; another angel at point of arch; early Dec style; Lamborn suggests recess came from abbey of Bonhommes at Ashridge; c.1300. **Fig. 28.**
ESp ntd bequest of 12d. to sepulchre light in 1544. [VCH 5]

PIRTON or PYRTON, St Mary
ESp* ntd churchwardens' accts 1554:
Item naylys about the sepuker jd. [Weaver & Clark]

STANTON-HARCOURT, St Michael
?ESp; pedestal of shrine of St Edburg from Priory of Austin Canons at Bicester, presumably brought here at time of dissolution of monastery; placed in N chancel on base of different period for use as ?ESp; very fine work of early 14c; Purbeck marble shrine stands on slender fenestrated pillars supporting 2-arched canopy, ogee arches cusped & crocketed; small figs of Evangelists stand in niches at angles; 12 heraldic shields in spandrels; flat top on which feretory of shrine would have rested; il Lamborn, "Stanton"; Bond, *Chancel*, p. 225.

STANTON ST. JOHN, St John Baptist
?ESp; ogee-headed arch, crocketed & cusped, in N wall

of chancel; may be reset; no slab or effigy; 14c.
[VCH 5]

SWYNECOMBE, St Botolph
ESp* ntd will of Tho Carter, 4 August 1550:
My bodye to be buryed in the parishe churche of
Swynecombe aforesaid, at the high aulter ende, where
the Sepulcre was accustomyd to stonde. [Heales, "ESp"]

THAME, St Mary
ESp* ntd churchwardens' accts 1462-3:
Item for nayles for ye sepulker ob.
?1463-4:
Item we payde for makyng of ye sepulcre & for a logge
to rere ye tabul xxiiid.
1464:
Item we have payde to Thomas flynt Wakyng in ye
Chirche at Esterne id.
1465:
Item we payde for makyng of ye sepulcre at estern ob.
[Ellis]
Ntd 1506 will of Walter Pratte:
to the light of the holy sepulchre six pounds of wax.
[Weaver & Beardwood]
Churchwardens' accts 1520:
Item received of the lyghtmen of the sepulchre iii li.
1523:
In the hands of Robert Mortymer & Geoffrey Stockdale
to the use of the sepulcre vi li. iiijs. iiijd.
Item payed to Christofer Myxbury for keping of the
yarnaments and chevelers for the Resurrection played in
the Church of Thame xvjd.
1550:
Item for the hangyngs belongyng unto the sepulcure
sold to William Bekyngfeld xlvjs. viijd.
1552:
Item for makyng the Judas and ye sepulcre iijd.
Item for ij tapers for the sepulcre xxijd.
1556:
Item for pack thred occupied about ye sepulcrye jd.
1557:
paid for naile in settynge upe the sepulcrye jd. [Lee,
Thame]
Comm inv 1552 includes list of goods sold within
previous 5 years:
Item the hangynges of the sepulcre of sylk. [Graham,
Os]

WITNEY, Nativity of BVM or St Mary
ESp* ntd Lambarde's Dictionarium written in late 16c,
published in 1730:
In the Dayes of ceremonial Religion they used at

Wytney to set foorthe yearly in maner of a Shew, or
Enterlude, the Resurrection of our Lord and Saviour
Chryste, partly of Purpose to draw thyther some
Concourse of People that might spend their Money in
the Towne, but cheiflie to allure by pleasant Spectacle
the comon Sort to the Likinge of Popishe Maumetrie; for
the which Purpose, and the more lyvely thearby to
exhibite to the Eye the hole Action of the Resurrection,
the Preistes garnished out certein smalle Puppets,
representinge the Parsons of *Christe*, the Watchmen,
Marie, and others, amongest the which one bare the
Parte of a wakinge Watcheman, who (espiinge *Christ* to
arise) made a continual Noyce, like to the Sound that is
caused by the Metinge of two Styckes, and was therof
comonly called *Jack Snacker* of *Wytney*. [W. Lambarde]

RUTLAND (R)

ASHWELL, St Mary
?ESp; round-arched recess in N wall of chancel opposite
sedilia; T's incised on soffit may refer to Tuchet family;
3 small niches within recess; one on inner face of each
jamb & one in center of back of recess; all have pointed
arches with crockets & finials; recess width 7'; depth
15 1/2"; 15c. [VCH 2]

EGLETON, St Edmund
?FSp; 4-centered arched recess in N wall of chancel
below Win N2; late Perp. [Keyser, "Little Bytham &
Egleton"; VCH 2]

EXTON, SS Peter & Paul
ESp/tomb; chest tomb with plain top. [Kite, "Devizes"]

SEATON, All Hallows or All Saints
?ESp/aumbry; pointed recess at E end of N wall of 13c
chancel. [VCH 2]

SHROPSHIRE (Sh)

ACTON BURNELL, St Mary
?ESp/aumbry; trefoil-headed recess in N wall of chancel;
late 13c. [VCH 8]

BILLINGSLEY, St Mary
?ESp/tomb; chest in recess in N wall of chancel; chest
paneled with blank arches, cusped; recess has cinque-
cusped arch under crocketed gable, pierced; early 14c.

[Pevsner]

LUDLOW, St Lawrence
ESp in N wall of chancel contains monument of Sir Robt
Townshend, Chief Justice of the Marshes (d. 1581).
[Weyman]
ESp ntd churchwardens' accts 1540:
Item, payd to Thomas Hunt for mendynge of the crofer
for ye sepulcre vjd.
Item, payd for borde nayle and lathe neale for the same
cofer ijd.
Item, payd unto Croket for mendynge of a bare for the
sepulcre ijd.
Item, payd for nayles, cordes, and pynys to the
sepulcre vjd.
Item, payd for colis agaynst Chrystmas, Ester,
Whytsontyd, and Alhalontyd, to sense with and to
wecche the sepulcre iiijd.
1541:
Item, payde for smale cordes to the sepullcre iiijd.
Item, for pessynge on of the pellers of the sepullcre
ijd.
Item, for tackes and pyns to the sepulcre and for
whyte ynkle to the awbes iiijd. ob.
1542:
Item, for pyns and tackes for the sepulcre ijd.
Item, in cordes to draw the clothe before the highe
alter in Lent, and for lynes to the sepulcre vd.
1543:
Item, for nayles to the sepulcre ijd.
1544:
Item, for nayles and pyns to the sepullcre ijd. ob.
1545:
Item, for nayles and tackes to the sepulcre ijd.
1546:
Item, for nayles and tackes to the sepulcre ijd.
1547:
Item, payde for pynnes and nayles to the sepulcre iijd.
1548:
Item, for nayles and pynnes to make the sepulcre iiijd.
1554:
Item, for naylz and pynnez to the sepulcre vd.
1555:
In great tackes to dresse the sepulcer iijd.
Paid to Thomas Season, for makynge the sepulcre, and
takynge downe the clothe over the roode, and pyns and
tackes xvjd.
Paid to John Blunt for the tymber of the sepulcre, and
his helpe to the makynge of the same vjs.
Paid to Steven Knyght, for makynge of viij. rynges and
viij. staples and a hoke of yron for the sepulcre xijd.
Paid to William Powes, for a tapur for the sepulcur

vjd. ob.
1555-6:
Paid for ij. tapers of j. li. for the sepulcre xijd.
Item, in pyns and in whypcorde for the sepulcure ijd.
ob.
Paid to the sayd Thomas [Season] for dressynge of the
sepulcre xijd.
Item, to William Benson for j. c. of tackes to the
sepulcur ijd.
1556-7:
Item, for tacke nayle and borde nayle for the sepulcre,
to Rychard Kerver vd.
Item, for pynes for the same jd.
Item, for whipcoord to draw the curten of the same ijd.
Item, to him [Thomas Season] for iij dayes worke in
settynge up the sepulcre xvijd.
Item to hym for makynge and kervinge the image for
the resurrexcion xvijd.
Item, to hym [William Powis] for ij. lyttle tapers for the
sepulcre ijd.
Item, to hym for makynge the toppe of one of them
anewe after hit was burnt out in the sepulcre jd.
1557-8:
Paid him [Thomas Season] for mendynge the sepulcre
ijs.
Paid for settinge up of the cepulcre viijd.
1559:
Payd for nayles to sett up the sepulcre iijd.
Payd for pynes to pyne clotes about ytt jd.
Payd Thomas Season in fulle recompense of the ymage
of the resurrexcon xviijd.
Payd Thomas Season for hangynge up of the sacrynge
belle in the hie chauncelle, and for a claspe of iron set
apon the frame of the sepulcur ijd.
Payd Thomas Season for makynge of the sepulcur and
for takynge ytt downe xxd.
Payd to William Powis for makynge of the pascalle and a
tapor over the sepulcre weyinge xiij li. and a half xijs.
iiijd. [Wright, Ludlow]

SHREWSBURY, St Mary
 ESp* ntd Comm inv 1552:
 Item, a stened clothe for the sepulker. [Hunter, "Inv
 Shrewsbury"]

STOTTESDEN, St Mary
 ?ESp/tomb; arch with clustered shafts under NE window
 (Win N2). ["Ecclesiological Notes"]

TONG, St Bartholomew (Collegiate)
 ESp* ntd 1451 will of Wm Fitzherberd:
 Item to the new sepulchre of the church of Tonge

iijs. ivd. [J. Auden]

WORFIELD, St Peter
ESp* ntd churchwardens' accts 1503:
Item Recepti intra parrochianos pro ymagine
resurrectionis xxd.
Item pro labore circa sepulcrum domini Thome tremnande
vd.
Item pro thimiamate & pro lotione canopi fontis et pro
clavis circa sepulcrum domini iijd.
1507:
Item thome tremnande pro reparacione sepulcri et
luminum eiusdem xvjd.
1519:
Item for mendyng ye tapers of ye sepulter iiijs. viijd.
1520:
Item for peyntyng ye Resurrexionem ijs. iijd.
1526:
Item for wax for ye paskalle & to make ye lyght a
bowte ye sepulcure iiijs. ixd.
1529:
In primis for makyng ye pascalle & ye tapers on ye
sepulchre & for candylles at ester iijs. iijd.
1534:
Item for makynge ye paskalle ye processionalles and ye
tapers a bowte ye sepulcure iiijs.
1554:
Item payd for . . . of the . . . lyghtes for the
sepulcre of the same vs.
1554-5:
Item for hookis and buccalles to the sepulcre and
amend' the fformis ijd.
1558-60:
In primis payde for the making of theaster lyght and
the tapers abowte the sepulture xs. [Walters, "Wor-
field"]

WROXETER, St Andrew
?ESp; recess with pointed, trefoiled arch with ballflower
decoration in N wall of chancel. [Pevsner]

SOMERSET (So)

AXBRIDGE, St John Baptist
·ESp* ntd churchwardens' accts 1572 indicating sale of
ESp cloth. [Robinson 1]

BADGWORTH, St Congar
?ESp/tomb; recess in N wall of chancel with large crock-
eted cinquefoiled ogee arch of 14c; stonework entirely

renewed except one terminal head of woman. [Eeles, "Badgworth"]

BATH, St Michael
ESp* ntd churchwardens' accts 1391:
Pro cero empto circa sepulchrum ixs pro cero et factura.
1425:
Item de jd. ob. pro hemmynge vestis sepulcri.
1427:
Et de ijs. jd. soluti pro cera paschali et sepulcri domini empta erga Pascha.
1439:
Et de xijd. pro j cera facta ante sepulcrum.
1459-60:
Et pro x libris et dimidio cere de novo emptis pro lumine thrabe et pro le Fonte tapere et pro cera Sepulcri et pro Jurnale empto, precium libre vjd. cum factura earundem vs. iijd.
1461-2:
Et pro j tapere cere coram Sepulcro continenti ij libras xijd.
1468-9:
Et pro ij cereis emptis pro Sepulcre continentibus iiij lib. precium libre vijd. ob., ijs. vjd.
1485-6:
Et pro cera empta cereis fontis et sepulcri Domini nostri Jhesu Christi erga festum Pasche iijs. vijd. ob.
1490-1:
Et pro custodiendo sepulcri domini nostri Jhesu. Christi in festo Pasche jd.
1541-2:
of iiijd. for wachynge ye sepulcare.
1556-7:
xijd. for ij bordys for ye sepulker.
viijd. for wachenge the sepulkere. [Pearson]

BRIDGWATER, St Mary
ESp* ntd pre-Reformation churchwardens' accts:
Soluti Willelmo Bedeman pro custodia luminis sepulcri domini in festo pasche viijd. [F. Weaver, "Bridgwater"]

BURRINGTON, Holy Trinity
ESp/tomb; stone relief probably once back wall of recess found in 1908 beneath S window of chancel; represents resurrected Christ with cross-staff, flanking him angels swinging censers toward him, & kneeling beneath censers facing Christ 2 figs, one male & one female, probably donors; both have hands raised in prayer; length 3'4"; height 1'10" at L end, rising to 2'8" at R end; mutilated; now in wall of chancel; mid 14c; il Horne, "Burrington," opp. p. 277.

CURRY RIVEL, St Andrew
?ESp; 6 arched recesses in N wall of N chapel; 4
westernmost tomb recesses; others smaller; 2nd from E
with trefoil-cusped pointed arch & plain slab may be
ESp; 14c. [Saunders]

DUNSTER, St Gregory or St George
?ESp/tomb; chest on N side of chancel has quatrefoils
enclosing shields; 4-centered arch above has leafy
carving in spandrels; 16c; much restored; upon it much
earlier effigies of Sir Hugh Luttrell (d. 1428) &
Catherine Beaumont, his wife (d. 1435). [Eeles, "Dun-
ster"; Pevsner, S & W So]

EAST QUANTOXHEAD, St Mary
?ESp/tomb; chest for Hugh Luttrell (d. 1522) paneled
with shields under cusped arches; 4-centered arch
above has paneled soffit & large cresting. [Eeles, "Luc-
combe"; Pevsner, S & W So]

GLASTONBURY, Abbey
Fragment of ESp (now in Yeovil Museum) consisting of
relief of 2 soldiers, presumably about half of lower
portion of ESp; 2 sleeping figs represented, one sitting
& one reclining, both wearing high pointed basinets,
large camails over chest & shoulders, cuissarts, &
greaves with long-toed sollerets; short jupons with wide
sleeves worn over armor; one holds spear & shield; axe
by side of other; Christ's R foot rests on L arm & side
of reclining soldier; some color remains; ground painted
green & sprinkled with white flowers with red centers;
early 15c. [Cumings]

GLASTONBURY, St John
ESp* ntd inv 1418:
j lecto de Worsteed cum testar broided pro sepulcro.
Inv 1421:
j lecto de Worsteed cum testar broyded pro sepulcro.
Inv 1428:
j lecto de worsted cum testar broided pro sepulcro.
Also ntd churchwardens' accts c.1470:
Et solutum pro custodia sepulcri.
1499:
In pictura unius valans pro sepulcro per Johannem
Fawkyswell xviijd.
1500:
In regardis datis pro lumine Cepulcri custodiendo ad
festum pasche ijd.
In clavibus emptis pro cepulcro et reparacione unius
albe ijd.
1553-4:
Item solutum Andreo Alam pro custodia sepulcri vjd.

[Daniel]

HUTTON, St Mary
?ESp/tomb; black marble chest slightly recessed in N
wall of chancel & grooved at front edge as if for in-
scription; front of chest plain; freestone canopy with
4-centered arch & blank shields in apex & spandrels;
gray stone forming back wall of recess (26" x 32 1/2")
has brasses of kneeling figs: Tho Payne (d. 1528) in
armor, wife Eliz, 8 sons, & 3 daughters, as well as 4
shields; 2 shields & central plaque, probably of Trini-
ty, missing; il back with brasses, Connor, Pl. III.
[André, "NE So"; Pevsner, N So]

LUCCOMBE, St Mary
?ESp/tomb; chest stood against N wall of chancel near E
end; has been moved to several locations within church;
sides carved with two tiers of square panels with large
leaves; early 16c. When moved in 1895, one section
which was richly carved was copied and included in
reconstructed monument; original put away for preser-
vation. [J. Cox, "So ESp"; Eeles, "Luccombe"]

MILVERTON, St Michael
ESp of chest tomb type in N chancel; paneled with
squares enclosing big leaves; 1500-50. [J. Cox, "So
ESp"]

MONKSILVER, All Saints
ESp of chest tomb type in N chancel; sides paneled with
7 niches of 2 lights each that have tall crocketed
gables; buttresses between panels. [Pevsner, S & W
So]

NORTH CHERITON, St John Baptist
?ESp/tomb; recess under depressed arch low in N wall of
chancel; to W of it, stone bracket; recess length 6-7';
depth 2'; height 4'; ntd in 1869. [S. Baker, "ESp"]

PENDOMER, Church (dedication unknown)
?ESp; large recess in N wall of chancel; cusped with
angels carved on cusps, now damaged; cresting above
carried by male figures; effigy below doesn't belong to
it; early 14c. [Pevsner, S & W So]

PILTON, St John Baptist
ESp/recess in N wall of Perp chancel has carving of head
of Christ in pastoral crook. [J. Cox, "So"; Pevsner, S
& W So]
ESp ntd report of "Kye" (cow) wardens in church-
wardens' accounts 1507:
Alloc. for the makyng of the sepultur taper ijs. ixd.

Inv 1508 (checked in 1539 & 1544):
Item a clothe for the sepulcre steyned.
Accts 1517:
Item for j tapeyr bey fore ye sepultar xxd. ob.
1521:
Item payde to John Pleyter for mendyn of vestmentes
and makyn of a canopy for ye sepulcor xvjd. [Hob-
house, *Church-Wardens' Accts*]

PITMINSTER, SS Andrew & Mary
ESp* ntd 1534 will of Wm Cutbull:
Sepulcre light iiijd. [F. Weaver, "Some Early Wills"]

PORLOCK, St Dubritius
2 ESp of tomb chest type of same general design; more
coarsely carved, & presumably earlier, removed to S
porch; later, of late 15c, along N wall of chancel in E
corner & carved only on S & W sides; both carved with
quatrefoils, in center one sacred heart, pierced hands,
& feet; il Bond, *Chancel*, p. 230. [Collinson; J. Cox,
"So ESp"]

PORTBURY, St Mary Virgin
?ESp/chapel; stone chapel with ribbed pointed barrel
vault just outside chancel; reached through passage
from N aisle; no traces of altar or piscina; Perp. [An-
dré, "NE So"; Pevsner, *N So*]

SELWORTHY, All Saints
ESp of chest tomb type; stood for some time in church-
yard & much decayed; now in N chancel; series of
quatrefoil panels on one side & end; later stone with
name & date 1777 inserted in middle of side, suggesting
re-use as tomb monument; length 5'5"; width 2'; height
1'8"; late 15c. [J. Cox, "So ESp"; Eeles, *Selworthy*]

STAVORDALE, Stavordale Priory (Augustinian Canons)
?ESp in chancel; 15c. [Pevsner, *N So*]

STOGURSEY or STOKE COURCY, St Andrew
ESp* ntd churchwardens' accts 1523, which reported
receipt of gift from 2 sailors who were:
Cornysse men for the syzthe of the sepulcur. [Feasey,
"ESp"]

TAUNTON, St Mary Magdalene
?ESp/tomb; chest now in churchyard carved with quatre-
foils under cusped arches; late 15c. [Pevsner, *S & W
So*]
Sepulchre Guild ntd 1534 will of Johannes Rowdall:
fraternitatibus summe crucis et sancti sepulchri viijd.
[Weaver, "Some Early Wills"]

Guild also ntd Comm document 1548 recording apportion-
ments made of revenues of 3 chantries:
And that lvis. iiiid. hathe ben yerelie payd to the
poore people of thirtene Almeshouses in Taunton out of
the late ffraternytie of the Sepulchre in Taunton.
[Symonds]

TINTINHULL, St Margaret
ESp* ntd churchwardens' accts 1439-40:
Item pro vij lb. cere pro le pascal taper, et aliis cerulis
ecclesie ad sepulcrum et alibi iiijs. vijd. [Hobhouse,
Church-Wardens' Accts]

WELLOW, St Julian
ESp/tomb; shallow recess in N wall of Hungerford Chapel
contains chest with quatrefoils on front; recess has
4-centered arch; inscription on ledge: "For love of Jesu
and Mary's sake/ Pray for them that this lete make";
cleaned in restoration of 1951. ["Wellow"; Pevsner, *N
So*]

WELLS CATHEDRAL
ESp* indicated by image of type used in Easter rites
given to Wells Cathedral by Cardinal Beaufort:
Unam vmaginem argenteam deauratam, resurrectionis
Dominicae, stantem super viride terragium amilasatum,
habentem birillum in pectore, pro corpore Dominico
imponendo; ponderis Trojani octuaginta et quindecim
uncias. [Heales, "ESp"]
ESp ntd *Elevatio* in Wells Ordinal of early 14c (Lambeth
MS. 729, p. 32) which is simplified version of Sarum
Elevatio of same period:

ORDO PROCESSIONIS DIEI PASCHE AD MATUTINAS

In die Pasche ante matutinas omnes Clerici in
superpelliciis accedant ad altare et duo excellentiores
presbiteri in superpelliciis et in capis sericis prius
incensato sepulchro cum magna veneratione corpus
dominicum et crucem inde tollant, et super altare
deponant excellentiore presbitero inchoante antiphonam,
et finita antiphona, et processio solito modo dicat
excellentior sacerdos versum deinde orationem. Qua
finita incensent corpus, et altare, et sic recedant,
deinde incohentur matutine post campanarum
pulsationem. [Reynolds, *Wells*]

WINSFORD, St Mary Magdalene
ESp of chest tomb type on N side of chancel; plain. [Jos
Morris, "ESp"]

YATTON, St Mary
ESp* ntd churchwardens' accts 1446-7:
Item yreseived of the parasche to the sepulcur, clare
xviijs. vd.
1447-48:
Item y payde vor the sepulcur kloth xxixs. viijd.
1448:
Memorandum for makyng of the sepulkyr tre xxd.
1461-2 (for 1460-1):
for a clothe to the sepulkyr xxvjs. viijd.
1465:
we paid at wakyng at sepulcure ijd.
1466:
for ale to menne wakyng at the sepulcure iiijd.
1468:
to J. Harnell for ij nygts wakyng the sepulcur ijd.
1471:
to iij men to wake at the sepulcure iiijd.
1490:
for makyng of the sepulcure and the cafe [?cave] iijd.
1507-8: mention of ESp.
1521:
Payd for wakyng ye sepulcre ob.
1554:
for makyng of ye sepulcre viijd. ob. [Hobhouse,
Church-Wardens' Accts]

STAFFORDSHIRE (St)

AUDLEY, St James
?ESp/tomb; recess with ogee arch & crocketing in N wall of
chancel opposite sedilia & piscina; Dec. [Pevsner]

ENVILLE, St Mary Virgin
?ESp/founder's tomb; recess in N wall of chancel; 11c;
church restored 1872-5. [J. Cox, "So ESp"]

GNOSALL, St Lawrence (Collegiate)
?ESp; semi-circular recess in N wall of chancel; part 13c,
part 14c. [VCH 4]

LICHFIELD, Cathedral, SS Mary & Chad
Possible reference to ESp in Statutes from time of Hugh,
Bishop of Lichfield 1188-98, in revision of 13th or 14th
century:
Item in nocte Natalis representacio pastorum fieri consueuit
et in diluculo Pasche representacio Resurreccionis dominice
et representacio peregrinorum die lune in septimana Pasche
sicut in libris super hijs ac alijs compositis continetur.
Et prouidere debet quod representacio pastorum in nocte
Natalis domini et miraculorum in nocte Pasche et die lune

in Pascha congrue et honorifice fiant. [Young 2]

LICHFIELD, Diocese of
ESp ntd Bishop Bentham's Injunctions for Coventry & Lich-
field Diocese 1565:
and that you do abolish and put away clean out of your
church all monuments of idolatry and superstition, as . . .
sepulchres which were used on Good Friday. [Frere, *Injunc-
tions* 3]

NORBURY, St Peter
?ESp/founder's tomb; large recess with cinquefoiled arch in N
wall of chancel; cinquefoils further trefoiled & carved with
human heads & foliage clusters; crocketed gable with finial
& flanking buttresses with pinnacles; recess contains stone
effigy with modern paint, length 6'8"; fig of member of
Botiler family, c.1290; VCH 4 nevertheless says "no doubt"
recess used as ESp. Il drawing, VCH 4, p. 157.

TENBURY, St Mary
?ESp/tomb; recess in N wall of chancel with elaborately
crocketed canopy contains 13c effigy (length 3'); recess
probably later in date. [Cossins, "1912"]

SUFFOLK (Sf)

ACTON, All Saints
?ESp/tomb; chest under arch between chancel & N chapel;
slab had foliated cross; arch on either side of wall crock-
eted & cusped with ogee gable & pinnacles; Dec. [Cautley,
Sf; Pevsner]

AMPTON, St Peter
ESp* ntd 1530 will of Jn Cleris:
to the sepulcre light in Ampton church, to continew for
evyr, too melche nete [milk cows] to be leten by the
churchwardens for the tyme being, and halfe part of the
mony comyng yeerly of the letage of the sayd nete to go
to the fyndyng of the seyd light, and the other half to bye
another melche neete, so that the stoke may evyr be
renewyd and encresyd, and the mony comyng of the letage
of every and all thes seme nete to go to mayntenance of
the sayd light to contynew perpetuall. [Tymms, *Bury*; A.
Page]

BADINGHAM, St John Baptist
?ESp/tomb; chest under tall recess in N wall of chancel;
chest has 7 panels, 4 with shields; much of recess now
blocked; cresting at top has shields & helmets carved in
stone; for member of Carbonell family, possibly Sir Jn (d.

1423); wall-shafts with brackets flank monument; c.1400.
[Cautley, *Sf*; Pevsner]

BARDWELL, SS Peter & Paul or SS Mary & Paul
?ESp/aumbry; small recess in N chancel cut of one block of
stone. [Cautley, *Sf*]
ESp ntd records of Guild of St Peter 1513-4:
Memorandum, that John Bete, John Balley, and Robart
Baxtar, wax men of the sepulker lyte hat made a Cownte
on sainte Petyrs day the a postyll for the vth yere of King
Herry the viii, & than remaynyng in their hands xviis. xid.
Memorandum, that John Bete [and] John Balley are chosyn
to be sepulker men ffor the yere that ys ffor to Come; the
seyde John John and Robart hathe made ther a counte, and
they have delyuered to Robart Baxter and Wylliam goolde
xvs. vid.
Item, they haue Resseived in wax in the weyke xx/iiii li.
viii [=88 lbs.].
1525-6:
Memorandum, that John Sefferey and Wylliam Golde,
sepulkyr men, hath made ther a counte on sant markys day
for the xvii yere of kyng herry the viiith and soo ther
remayneth in ther hands xxxiiid.
1532-3:
Gardiani Sancti sepulcri.
Robertus Burdewes et Thomas Seelot Elegerunt Custodes
Sancti sepulcri luminis octauo die Maii Anno regni regis
Henrici viiiui xxiii, ad quem diem predicti Gardiani
Receperunt de vltimis Gardianis, videlicet, Johannis Seffrey
et dicti Roberti Burdewes ixs. xid.
Item, Receperunt de Nouis Gardianis in eadem diem ffyve
score et xiiiio ceram cum lez weyke.
1533-4:
Memorandum, that the sepulcur men Thomas Syllet, Robert
Burdws hathe made theyr cownte on the sonday aftyr newe
yere in the xxvth yere of Kynge herry the viiith, all
expencis a lowyd remaynyth in there handys xiiis. iiii 1/2d.
1534-5:
Memorandum, that the sepulkyr men Tomas Syllott, Robert
Burdws, hathe made there a Counte one the sunday after
Twellthe, in the xxvi yere of Kynge harry the viiith, and
all expenses alowyd and so remaynythe stylle in there
handys xiiiis. vid.
1535-6:
Memorandum, that the sepulkyr men Tomas Syllott and
Robert beete hathe made there a Cownte one the v day of
marche in xxvii yere of Kynge harry the viii, alle exspensus
alowyde, and so remaynythe still in there handys of the
sayde Thomas Syllott and Robert beete viiis. vd.
1536-7:
Memorandum, that the sepulkyr men, Tomas Selott and
Robert Beete, hathe made there acounte one the viite day

of january in the xxviiiti yere of Kyng harry the viiite,
halle exspensus alowyde, and so remaynyth stylle in there
handys of the seyd tomas selott and Robert beete
vis. ix 1/2d.
1537-8:
Memorandum, Receyved by the hands of Robert Bete and
Thomas Syllot, sepulcur men, in the xxix yer of the rege of
kynge Henry the [end of entry].
1536-7:
Johannes Cage et Willelmus Doo Elegerunt Custodes sancti
sepulcri luminis decimo die mensis marcii in anno regni
regis henrici octaui vicesimo octauo, ad quem diem predicti
Gardiani Receperunt de vltimis Gardianis, videlicet, Roberto
Bete et Thoma Syllot viiis. et vd.
Item Receperunt predicti noue Gardiani in eadem die.
Item received of wax at that tyme in the wyke iiii skore
pounds and xi.
1538-9:
Anno regis henrycy octaui tricesimo, vicesimo die mensis
februarii, iohannes Cage et willelmus Beet, luminis sepulcri
Gardiani, fecerunt Compotum die et mense predicto, et
remanet in manibus suis xv 1/2d.
1538-9:
Memorandum, that in the yere of our lord god, anno
millesimo CCCCCXXXVIII in the XXXti yere off the rege
of our most Suffren lord kynge henry the viiite, and in the
xxti day of ffebruarii, Wee John Cage and William Doo,
Wardens of the sepulcur lyte, made ther a cownte in the
day and yere above wretyn, and all thyngs cowntyd and
alowyd ther remaynyth in the hands of the a forseyd John
and William xv 1/2d.
1543-4:
Memorandum, that the seconde day of marche in the xxxvt
yere of the reign of our soueraign lord Kynge henry the
viiith Jhon Cage, and William Doo, wardens of the sepulchre
light of sayncte peters in Bardewell, made ther accompt for
fowr yere laste paste before the date hereof, and all
receyts and deductions accompted and allowed, the same
wardens were dectures vnto the churche iis. xd., the wiche
sum the[y] paid incontynently after the accompt made.
Newe wardens elected for the nexte yeare folowynge,
William Sefferay and Jhon Weste.
Imprimis, delyuered in to ther hands of mony remanynge of
the laste accompt iis. xd.
1544-5:
Memorandum, that the sepulcre men Wyllyam Sefferay, John
West, hathe made these account one the xxiiity daye of
february in the six an thyrty yere of Kynge henry the
viiith, hall expenses alowyd, and so Remayneth styll in the
hands of them xviiid.
1545-6:
Memorandum, that the sepulcre men William Sefferey and

John West hathe made their acounte one the last day of
february, in the seuen an thyrty yeare of Kynge Henrye the
eygth, delyuered into the hands of Robert bete and goodwyn
Iue, the churche wardens and sepulcre men newly chosen
for the yere folowyng, and so delyuered into ther hands of
mony, xviiid. [Warren, "Gild"]
Also ntd will (?date) leaving:
a pightle in Caldwelle meadow to find and maintain the
Sepulchre light. [Redstone, "Chapels"]

BARHAM, St Mary
?ESp/tomb; low marble chest under canopied recess in N
wall of chancel; slab has indent of brass of knight in ar-
mor; border inscription & shields also missing; slender shafts
topped with pinnacles support crocketed canopy; cusping of
canopy in form of angels with shields; spandrels of canopy
carved with relief of oak sprays & boars; possibly tomb of
Rich Booth, whose family used boar symbol and who mar-
ried into Oke family; late 14c. [Birch]

BARROW, All Saints
?ESp/tomb; recess in N wall of chancel with canopy has
small brasses on back & long inscription to Sir Clement
Heigham (d. 1570); perhaps ESp reused. [Cautley, *Sf*]

BELTON, All Saints
?ESp/tomb; low recess with cusped ogee arch in N wall of
chancel; Dec; 14c. [Pevsner; Cautley, *Sf*]

BLYTHBURGH, Holy Trinity
?ESp/tomb; canopied chest on N side of chancel within thick-
ness of wall; chest decorated with 3 cusped quatrefoils
enclosing shields; brasses formerly on slab; side walls of
recess with niches & paneling; flat canopy with ribbed sof-
fit has large cresting; Purbeck marble; monument for Sir Jn
Hopton (d. 1489); il Cautley, *Sf*, p. 232. [Pevsner]

BOXFORD, St Mary
ESp* ntd 1456 will of Wm Sampson, Sr, who left 53s. 4d. to
make new ESp:
to hold the altar sacrament in Easter week.
Also ntd churchwardens' accts 1557:
Item payd for making the sepulchre xviijd.
Item payd for tymber & boord for them both [ESp &
church gates] xxijd. [Northeast]

BUNGAY, St Mary
ESp* ntd churchwardens' accts 1523:
Item paid for the Repacion of the Sepulker ageynst goode
fryday. xd.
1537:
Item on to Wylliam Bode for waschyng the sepulker clothes

iijd.
1554:
Jtem for Wettching the Sepulture viijd.
1558:
Memorandum ther was received by Mr. Sudborn,
Churchreve, at the buriall of Mrs. Harvye, for certayne
tapers of ye sepulture light yat were then occupied, xxd.
Memorandum Jtem the xxviij of Marche, in Anno 1557, the
parishners Did alowe and paye to John codd the elder, for
certayn charge that he hadd paid for the churchreves, for
making the rode, the hoest, ye Sepulture, and for xxxiij li.
of waxe for the Sepulture, for the pixt & pixt clothe, the
holy water stoppe, and the Sencers, vi li. [G. Baker]

BURES, St Mary
 ?ESp/tomb; chest under arch in N chancel; chest decorated
 with shields; indent for canopied brass on slab; large angel
 corbels for arch; said to be tomb of first Sir Wm Walde-
 grave. [Barker, W Sf; Pevsner]
 ESp ntd 1410 will of Sir Rich Walgrave mentioning Bache-
 lors' & Maidens' Lights around ESp. [Redstone, "Extracts"]

BURGATE, St Mary
 ESp; high pointed arch enclosing shallow recess in N wall of
 chancel W of door to sacristy. [C. Manning]

BURY ST. EDMUNDS, St Mary
 ?ESp* ntd 1463 will of Jn Baret (d. 1467):
 Item I wil yeerly be payd viijd. for viij. tapers stondyng at
 the grawe of resurreccion gylde that they be lyght eche
 yeer at my dirige and messe.
 ?ESp ntd 1504 will of Anne Barett:
 Item I wyll that an honest priest and a queerman shall syng
 for my soule . . . by the space of xxti yeerys, in the
 churche of our Lady in Bury aforseid, at the Resurreccion
 aughter. . . . Item I wyll that myn executours shall by a
 messbook suffycyent, with all other thyngs necessary for a
 prist to syng messe yn, with curteyns and aughter clothes
 necessary, which messebook, chalys, vestment, and othyr
 stuff I wyll it shall remayn at the Resurreccion aughter
 aforseid to the woorshyppe of God as longe as yt may
 endure. [Tymms, Bury]

CHEVINGTON, All Saints
 ESp* ntd 1475 will of Robt Paman leaving cow to provide
 6d. yearly for the common light of ESp & 6d. to provide
 one wax candle of 10 lbs. for ESp. [Tymms, "Chevington"]

COCKFIELD, St Peter
 ?ESp/tomb; chest with 4 shields in N wall of chancel under
 canopy of 3 steep gables decorated with quatrefoils; arches
 beneath gables cusped & subcusped; buttresses with pin-

nacles between gables & flanking monument; piscina &
(formerly) sedilia in same style; chancel early 14c; formerly
mutilated & whitewashed; heavily restored in late 19c; il
Babington, Pl. III; Cautley, *Sf*, p. 232. [H. Barker, *W Sf*;
Pevsner]

CODDENHAM, St Mary Virgin
?ESp*; monument to 18c donors named Gardemau placed in
space once probably locus of ESp. ["Coddenham"]

DENNINGTON, St Mary
ESp* ntd will of Lady Bardolph, wife of chamberlain to
Henry VI, who left:
a purple gown with small sleeves to adorn the easter
Sepulchre there. [Feasey, "ESp"]

DRINKSTONE, All Saints
?ESp*; base of pulpit appears to be former tomb chest or
ESp; decorated with circles with mouchettes; early to mid
14c. [Pevsner]

EARL STONHAM, St Mary
?ESp; plain recess in N wall of chancel. [Cautley, *Sf*]

EAST BERGHOLT, St Mary Virgin
ESp recess in N wall of chancel discovered in 1828 when Jn
Constable put up memorial to his wife & her grandparents;
bricked up & rediscovered c.1922; back wall has well-
preserved painting of Resurrection; Christ, with halo &
black hair, wearing loincloth & cope, steps from tomb with
R leg, L still inside; R hand raised in blessing; L may hold
cross-staff; plaster ground was painted red, now pink, &
empty space filled with large leaf decoration in black line;
recess about 4'4" in length; 2'6" in height; 9" in depth, once
deeper; mid 15c. ["E Bergholt"]

ERISWELL, St Peter
?ESp; double recess in NE corner of Dec chancel; 2 openings
with rebated jambs; each has compartment reaching below
sill; molded jambs surround whole & once supported arch of
canopy above; possibly ESp combined with reliquary cham-
bers; 14c. [H. Barker, *W Sf*; Cautley, *Sf*]
ESp ntd will of Wm Lawrence, 22 Oct 1515:
Item, I give to the Sepulchre light, 12d. [Donnan, "Eris-
well"]

EXNING, St Martin
?ESp/tomb; large chest on N side of chancel; had brass on
top; Perp. [H. Barker, *W Sf*]

EYE, SS Peter & Paul
ESp* ntd 1531 will of Robt Thrower the elder:

SUFFOLK 311

Item I bequethe to the sepulchre lyght and to the maryed men's lyght, xijd.
Also ntd 1540 will of Jone Mason:
I gyve to the mayntenance of the sepulchre lyght in Eya church, ij li. of waxe.
Ntd 1540 will of Jn Permenter:
to the reparacions of the husbandmen's lyghte of the sepulchre, yn the sayde parryshe of Eye, vid. [Creed]

FRESSINGFIELD, SS Peter & Paul
ESp* ntd will of Rich Bohun (d. 1496), who gave 6s. 8d. to the sepulchre light.
Also ntd 1504 will of Nich Bohun, who gave 6s. 8d. to the sepulchre light. [R. Simpson]

GAZELEY, All Saints
?ESp/aumbry; canopied niche in N wall of chancel has crock-eted arch with flanking pinnacles. [Cautley, Sf; Pevsner]

GREAT ASHFIELD or ASHFIELD MAGNA, All Saints
ESp* ntd will of 5 June 1460, leaving to ESp a candle of 2 lbs. of wax to burn at Easter. [Redstone, "Extracts"]

GREAT BRADLEY or BRADLEY MAGNA, St Mary
ESp* ntd chantry certificate 1546 indicating 1/2 acre of meadow given to church, donor unknown, yearly value 2s., profits to be used for 3 lights in ESp. [Redstone, "Chap-els"]

GREAT HORNINGSHEATH or HORRINGER, St Leonard
ESp* ntd 1464 will of Simon Criste leaving 3s. 4d. to wax light of ESp. [Tymms, "Horringer"]

GREAT LIVERMERE or LIVERMERE MAGNA, St Peter
?ESp; N wall of chancel has outline of recess; Perp; 15c. [Pevsner]

GRUNDISBURGH, St Mary
ESp* ntd chantry certificate 1546 indicating profits from lands in tenure of Robt Jenour used for ESp light, annual income 2d. [Redstone, "Chapels"]

HADLEIGH, St Mary
?ESp; arched recess in N wall of chancel; paneled & trac-eried vaulting; Late Perp; ?16c. [Cautley, Sf; Pevsner]
ESp ntd 1480 inv:
Item a red Cloath of gold wrought with Aes of gold for ye Sepulchre.
Item an Angel painted for ye Sepulchre.
item a Super-Alter for ye Sepulchre.
Inv 1545:
Item, one Hanging of red silk for ye Sepulcher. [Pigot]

HALESWORTH, St Mary
ESp* ntd 1512 will of Wm Fysk asking to be buried within
holy sepulchre of church of Halesworth. [Suckling 2]

HARKSTEAD, St Mary
?ESp; small recess with buttresses, cusped & crocketed
gable, finial, & flanking pinnacles; 14c. [Cautley, *Sf*; Pevs-
ner]

HAWSTEAD, All Saints
ESp* ntd 1480 will of Tho Rede:
to the light of the sepulchre in the seyd cherche j cowe of
the beste.
Also ntd 1503 will of Andrew Sparke directing his wife to
give:
the best cowe that she shall have at her decease to help to
maintain the sepulchre light. [Tymms, "Hawsted"]

HOPTON-BY-LOWESTOFT, St Mary
ESp* ntd chantry certificate 1546 indicating that 3 roods of
land in Hopton given by unknown donor yielded 6d. per year
for ESp light. [Redstone, "Chapels"]

HORNHAM MAGNA, St Mary
ESp* ntd chantry certificate 1546:
Clyncole close in Thornham, put in feoffment by Jn
Dunche, for light before ESp & for anniversary. Yearly
value 1s. 7d. [Redstone, "Chapels"]

HUNDON, All Saints
ESp* ntd chantry certificate 1546 indicating lands in Hunden
given to church, profits of 11s. 8d. to be used for ESp
light. [Redstone, "Chapels"]

HUNTINGFIELD, St Mary
ESp recess in N chancel now holds chest tomb for Jn Paston
(d. 1575); back wall of recess has 15c painting (now indis-
tinct) of Christ enthroned & adoring angels below. [Caut-
ley, *Sf*]
ESp ntd 1534 inv:
Item, iij. clothys off sylke ffor the sepulker. [Woodward]

ILKETSHALL, St Lawrence
?ESp; small plain arched recess in N wall of chancel. [Caut-
ley, *Sf*]

IPSWICH, St Lawrence
ESp* ntd churchwardens' certificate 1547:
Ornaments we have sold on cope and a shryne or sepulcure
of tymber & gylt with ye tabernacle of ye same for ix li.
[Muskett, "Church Goods in Sf"]

IPSWICH, St Margaret
 ESp* ntd Comm inv 1552:
 Item in thands of Edmunde Wythepowle Esquyer one
 sepulcre Clothe & iij valancs of Redde velvett. [Muskett,
 "Church Goods in Sf"]

IPSWICH, Priory of Holy Trinity
 ESp* ntd inv of 24 August 1536:
 Item dyuerse steyned clothes for the Sepulcure at iiijs
 [signed by the prior]. [Muskett, "Church Goods in Sf"]

IXWORTH THORPE, All Saints
 ESp* ntd 1504 will of Thome Pakenham:
 To the sepulkyr lyght vj hyves of beene to pray ffor me
 and my wyffe in ye comon sangered, and the beene to be
 sett in the ynd of lanys. [Tymms, "Ixworth"]

KEDINGTON, SS Peter & Paul
 ESp* ntd 1542 will of Tho Barnardston the elder:
 my body to be buryed in the Churche of Kedyngton,
 undernethe the sepulker. [Almack]
 Also ntd chantry certificate 1546 indicating that 3 acres of
 land yielding 22d. yearly had been left to obit & ESp light.
 [Redstone, "Chapels"]

KETTLEBASTON, St Mary
 ?ESp/tomb; recess with ogee arches in N wall of Dec chan-
 cel. [Pevsner]

LACKFORD, St Lawrence
 ?ESp/tomb; low plain arched recess in N wall of Dec chan-
 cel, opposite sedilia. [Cautley, Sf; Pevsner]

LITTLE WENHAM, All Saints
 ?ESp/tomb; chest in recess with heavy, square-headed canopy
 in N wall of chancel; Late Perp; 16c. [Pevsner]

LONG MELFORD, Holy Trinity
 ESp/tomb chest for Jn Clopton (d. 1497) beneath very flat
 arch open between N chancel & N (Clopton) chantry chapel;
 chest of Purbeck marble carved with cusped quatrefoils
 enclosing shields; plain slab; flat ogee arch molded & crock-
 eted; on chapel side, tomb flanked by recessed seats; above
 arch, rows of traceried panels on wall with heraldic shields
 of Clopton family, & above these 12 canopied niches; on
 soffit of arch, painting of Resurrected Christ & figs of Jn
 Clopton, wife, & children; Christ, with cross-staff in L
 hand, grasps with his R edge of his red mantle, lined in
 green; wounds in side, hands, feet visible; drops of blood on
 forehead; above his halo, banderole with words "omni qui
 vivet et credit in me non morietur in aeternum." Painting
 of Christ il Gibson, p. 115.

ESp ntd 1494 will of Jn Clopton:
I will that suche clothes of velwet, wyth alle maner
braunches, flowres, and alle maner oder stuffe that I have
sette abowte the Sepulture at Ester, as well the grene as
the red, I yefe and bequeth it alwaye to the same use of
the sepulture.
Ntd churchwardens' inv 1529 [in hand of c.1540]:
An Altar Cloth of Blew Damask with Garters upon the
same, the gift of Mr. John Clopton, with all such cloths of
silk as belongeth to the Sepulcre.
Memorandum 6 April, 1541--
There was given to the Church of Melford, two stained
Cloths, whereof the one hangeth toward Mr. Martyn's Ile,
and the other to be used about the Sepulchre at Easter
time, and also a Red Coverlet for a Forecloth to the High
Altar.
Inv 1547:
Two Clothes of purple velwet for the Sepulcre.
Two Clothes of grene, braunched, for the Sepulcre, of Say.
One halfe yerde of clothe of golde and one yerde of whyte
Sypers braunched, for the Sepulcre.
Syx peces of blew damaske for the same, of the gowne of
a gentlewoman.
Inv 1553:
Item: one aulter clothe of blew damaske, with garters upon
the same, of the gyft of Mayster John Clopton, with all
such clothes of sylke as longeth to the sepulcure.
Inv 1553:
Memorandum that the syxt day of Apryll in the yere of
oure Lorde God, MCCCCCXLIIII ther was gyfn to the
churche of Melford two stayned clothes, wherof the one
hangeth toward Mr Martyn's Yle, the other to be usyd
about the Sepulcre at Ester tyme, and also a rede coverlet
for superclothe to the high Altre: by Mayster John
Cawndysh, prest.
Churchwardens' accts 1554-5:
To the joyner for makyng of the sepulcre and for foure
standes for to bere upp the canape clothe iis.
1555:
Payde to Beryes and others for watchyng of the Sepulcre
viiid.
To John Grys for goyng of errunts, and watchyng the
Sepulcre xvid.
1559:
For watchyng of the Sepulcre xvid.
For strybyng [striking] of the Sepulcre lyght iis.
For vi li. waxe for ye sepulcre lyghte iiiis. vid.
To Peter Elys for iiii li. waxe bowght by hym at Burye for
the sepulcre lyght iiiis. [Parker, *Long Melford*]
Description from mid-16c account of Roger Martin:
In the Quire was a fair planted [painted] frame of timber,
to be set up about Maunday Thursday, with holes for a

number of fair tapers to stand in before the sepulchre, and
to be lighted in service time. Sometimes it was set
overthwart the Quire before the Altar, the sepulchre being
alwaies placed, and finely garnished, at the north end of
the High Altar; between that and Mr. Clopton's little
chappel there, in a vacant place of the wall, I think upon a
tomb of one of his ancestors, the said frame with the
tapers was set near the steps going up to the said Altar.
Lastly, it was used to be set up, all along by Mr. Clopton's
Ile, with a door, made to go out of the rood loft into it.
[*Gentleman's Magazine*, 146, Pt. 2 (1830), 206]

MELLIS, St Mary Virgin
 ?ESp; recess in N wall of chancel; chest below has 5 niches,
 each with canopy; badly damaged. [Cautley, *Sf*]

METFIELD
 ESp ntd chantry certificate 1546 noting that Tho Grene put 3
 acres of land in feoffment for ESp light for 99 years &
 longer if laws of land permit. [Redstone, "Chapels"]

MILDENHALL, SS Andrew & Mary
 ESp* ntd 1488 will of Robt Pachett:
 ad factura noue Sepulcre in ecclesia de M. xxd. [Tymms,
 "Mildenhall"]
 Also ntd churchwardens' accts 1555:
 Item payd to Jones ye carpenter for makyng of ye hers for
 the sepulter. vs.
 Item payd to Thomas Cook for ye sepulter and for bordes
 and tymber for the same. viijd.
 Item payd to father oxford for hangyng up of the vayle and
 settyng up of the sepulter and [?takyng] of the sepulter
 and for the smalle lyne for the vayle. xxd.
 Item payd for two posts for the sepulter. xijd.
 1556: ESp set up.
 1558: ESp set up. ["Extracts"]

RATTLESDEN, St Nicholas
 ?ESp/aumbry; recess in N wall of chancel with hinge hooks &
 rebated for door; grooves for shelf; arch under crocketed
 gable; engaged columns support pinnacles; opening height
 42" x width 17 1/4"; 14c. [Cautley, *Sf*; Pevsner]

RICKINGHALL INFERIOR, St Mary
 ESp* ntd chantry certificate 1546 indicating 3 roods of ar-
 able land & piece of meadow, yearly value 5s., given to
 church, profits to be used for obit & light before ESp.
 [Redstone, "Chapels"]

SANTON DOWNHAM, St Mary
 ?ESp/tomb; plain low recess in N chancel; 13c. [Pevsner]

SHELLEY, All Saints
?ESp/tomb chest in N wall of chancel; late Gothic. [Pevsner]

SINGTON, St Edmund
ESp* ntd 1531 will of Margaret Smith leaving cow for ESp
light. [Redstone, "Extracts"]

SOUTH ELMHAM, St Margaret
?ESp; small arched recess in N wall of chancel; base with
paneling & tracery; canopy with crocketing & pinnacles.
[Cautley, *Sf*]

SNAPE, St John Baptist
?ESp; very plain recess in N wall of chancel. [Cautley, *Sf*]

STANNINGFIELD, St Nicholas
?ESp/tomb; chest for Tho Rokewode (d. 1520) under seg-
mental arch in N wall of chancel; chest decorated with
quatrefoils enclosing shields; plain slab; cresting over arch
has shields; ?early 16c. [Pevsner]

STOKE-BY-CLARE, St John Baptist (Collegiate)
ESp* ntd inv 1534:
Item A sepulcre famyd in tymber. [Hope, "Stoke"]

STOWMARKET, SS Peter & Mary
ESp* ntd wills mentioning "common light" before ESp.
Also ntd 1533 will of Tho Cosyne leaving 8 combs of malt
to Bachelors' light before ESp. [Tymms, "Stowmarket"]

STRADBROKE, All Saints
?ESp; tall Perp niche with canopy in N wall of chancel;
soffit has trellis vault; ?15c. [Pevsner]

STRADISHALL, St Margaret
ESp* ntd will leaving 1/2 acre in Crowchemeadow to find
light before ESp. [Redstone, "Extracts"]
Also ntd chantry certificate 1546 indicating profits of 6d.
annually yielded by 1/2 rood of meadow went to ESp light.
[Redstone, "Chapels"]

TRIMLEY, St Martin
ESp* ntd chantry certificate 1546 indicating profits of 6d.
per year from land in tenure of Wm Smith used to pay for
watching ESp. [Redstone, "Chapels"]

WALBERSWICK, St Andrew
ESp* ntd churchwardens' accts 1454:
Item for Watchyng of the Tapers in ester, nyth viijd.
1457:
Item payd to the clarke kepyng off the candells de sepulcre
vid.

1463:
Item payde to ye clarke for watcheynge at Esterne and
clenseynge of ye candolstycks iijs. xd.
In primys Payde to Wylliam Alkocke for clensynge of the
ymagis and mendynge of the funte and the sepucre iijs.
iiijd.
Item paid to William Alkok onward in party of payement for
ye herse a bowt ye sepulcre vjs. viijd.
Item payde ffor the herse of the sepukeur in party of
payment ijs.
Item payd for irn to ye sepukure xvjd.
1473:
Item payd to ye same Edmund ffor watchyng off ye hers at
Estyrn xijd.
1474:
Item payd to ye same Edmund for watcheng off ye hers
xijd.
1477:
Item payd to Edmunde Wryte ffor watchyng of ye hers and
skoryng of ye canstelys xvjd.
1478:
Item payd to john meyyr for watchyng of ye hers and
skoryng of ye canstelys xd.
1479:
Item pay to J Mayer for watchyng of ye Sepulcr xjd.
[Lewis]
Also noted ?undated list of items kept in loft over porch:
The Lamide for the sep.
And the cloth for the sepulture steyned.
All the wax appertevning to and for the sepulture
remayned. [Gough]

WASHBROOK, St Mary
 ?ESp; blank ogee arch with pinnacles in N wall of chancel
 opposite sedilia & piscina. [Pevsner]

WETHERSDEN, St Mary
 ?ESp; recess in N wall of chancel similar to 14c piscina
 with cusped ogee arch. [Cautley, Sf]

WINGFIELD (SOUTH), St Andrew (Collegiate)
 ?ESp/tomb; chest with canopy in N wall of chancel for
 Michael de la Pole, first Earl of Suffolk (d. 1415), has
 wooden effigies of deceased & wife; arch cusped & crock-
 eted; flanking buttresses with pinnacles. [Cautley, Sf; Evans
 & Cook]

SURREY (Sr)

ADDINGTON, St Mary
 ?ESp/tomb*; chest for Jn Leigh formerly in recess in N wall

of chancel near E end, later removed to make room for
monument of Archbishop Howley; chest has disappeared, but
marble slab with brasses now set in chancel floor; figs
(height 2'2") of Jn Leigh (d. 1503) & wife Isabel Harvey (d.
1544); Leigh wears long gown trimmed with fur & with deep
sleeves bordered in fur; his hair long & hands joined in
prayer; wife, also praying, wears long belted gown & kennel
headdress with embroidered border; below them, group of 5
children added later, probably after death of mother; scroll
from Leigh's mouth reads: "Deus misereatur mihi et
benedicat nobis"; from wife's: "Illuminet vultum tuum super
nos et misereatur mihi"; at head of stone, lozenge with
crest, coat of arms, & motto "Expectamus Resurrexionem";
brass strip around border has inscription, & at corners,
Evangelist symbols; brasses il Stephenson, "List," p. 37.
[Leveson-Gower, "Leigh"; VCH 4]
ESp* ntd Comm inv 1552:
Item a sepulker clothe. [Daniel-Tyssen]

ALFOLD, St Nicholas
?ESp/tomb; 4-centered arch over splayed opening in N wall
of chancel now open to vestry; 15c. [VCH 3]

ASHTEAD, St Giles
ESp* ntd Chantry Certificate 1548:
Sepulcre light usede and mayneteyned within the parisshe
churche of Aysshested with yerely revenues gyven to that
use for ever whiche are worth in landes by yere vjd.
[Craib, "Sr Chantries"]

BANSTEAD, All Saints
ESp* ntd 1489 will of Nich Tayloure:
To find a candle of 4 lbs. to burn before the sepulchre on
Good Friday annually for ever in the said church, one cow
and 3 ewes. [Sr Wills]

BARNES, St Mary
ESp* ntd Comm inv 1552:
sold by William Hauht and George Adams one old sepulcre
for ij.s. ij.d.
Also ntd certificate of accounts 1552:
Receivid of John Mysplaye for one olde sepulchre solde to
hym by the consent of the parishe ijs. vjd. [Daniel-Tyssen]

BLETCHINGLEY, St Mary
?ESp; arched recess in N wall of chancel near E end; dis-
covered during restoration of church in 19c; stone slab
modern. [VCH 4]
ESp ntd churchwardens' accts 1519:
For making the Easter light 2s. 4d.
for watching the sepulchre 4d. [Leveson-Gower, "Bletching-
ley"]

1546-52:
Item to Brande for watchyng the sepulcre viijd.
Item to Brande for watchyng the sepulcre viijd.
Item to John Brande for watching of ye sepulcre iiijd.
[Craib, "Bletchingley"]

BURSTOW, St Bartholomew
?ESp; recess below sill of NE window (Win N2) has 2 tre-
foiled openings & molded jambs under square head; E part
of chancel 15c. [VCH 3]

BYFLEET, St Mary Virgin
?ESp; plain, square recess below Win N2 in early 14c chan-
cel. [VCH 3]
ESp ntd Comm inv 1552:
Item j sepullchre clothe. [Daniel-Tyssen]

CAMBERWELL, St Giles
?ESp/tomb*; table-tomb with tester-canopy formerly set
against & partly recessed into N wall of chancel opposite
sedilia; chest paneled with quatrefoils; slab of gray marble
in back wall had brasses which still survive of Jn Scott (d.
1532), baron of exchequer, wife Eliz, groups of 4 sons & 7
daughters; Scott (in armor) & wife kneel on tasseled cush-
ions at prayer desks on which lie open books; they face
panel which may have been Trinity; tomb probably destroyed
1715; drawing of tomb il Johnston, "Old Camberwell," fig.
2; brasses il ibid., fig. 3; Lysons 1, opp. p. 77.

CARSHALTON, All Saints
?ESp/tomb; chest for Nich Gaynesford (d. 1498) formerly in]
chancel, now in S chapel; chest, of Purbeck marble, has
plain slab with molded & sunk edge; on wall above it when
it was in chancel, & now in chapel, another Purbeck slab
with brasses, originally enameled; above, at far right, brass
of Throne of Grace Trinity, now lost; facing this, Nich
Gaynesford in armor, bareheaded, kneeling on mound cov-
ered with grass & flowers, holds up hands in prayer; behind
him 4 sons & then his wife kneeling at desk with book &
folding hands in prayer; she wears dark-red gown, necklace,
& butterfly headdress; original gilding survives on desk,
head, & shoulders; behind her were children, now gone;
monument made before death of either husband or wife, as
dates of death left blank & costumes of time before 1490.
Brass il Lysons 1, opp. p. 128; Stephenson, "List," opp. p.
28. [Waller, "Carshalton"; VCH 4]
ESp ntd Comm inv 1549:
Item a peynted clothe for the sepulcre. [Roberts]
Also ntd Comm inv 1552:
Theise parcelles underwrytten were embesyled and brybed
awaye owt of the same churche sense the first yere of the
reigne of our said soverayne Lord the king. . . . Item a

peynted clothe for the sepulcre. [Daniel-Tyssen]

CHEAM, St Dunstan
ESp* ntd Comm inv 1549:
Item, a sepulcre cloth steyned. [Roberts]
ESp ntd Comm inv 1552:
Item a sepulcre cloth steynyd. [Daniel-Tyssen]

CHESSINGTON, St Mary Virgin
?ESp/aumbry; recess with rebated jambs for door at NE
corner of 13c chancel; hanging hook for door & groove for
wooden shelf. [VCH 3]
ESp ntd Comm inv 1549:
Item, a scepulture cloth staynyd. [Roberts]

CLAPHAM, Holy Trinity
ESp* ntd Comm inv 1552:
Item diverse stayned clothes and stooles for the sepulchre.
Item diverse old steyned and painted clothes for the doing
of ceremonyes lately used in the churche. [Daniel-Tyssen]

COMPTON, St Nicholas
?ESp/tomb; chest recessed in N chancel; chest, paneled with
quatrefoils, beneath 3-light window (N2) contemporary with
it; late 15c. [André, "Compton"; VCH 3]

COULSDON, St John
ESp* ntd Comm inv 1549:
Item, one sepulker cloth payntyd.[Roberts]

CRANLEIGH, St Nicholas
ESp/tomb*; chest of Sussex marble in N chancel demolished
in restoration of 1845; had brasses to Robt Hardyng, gold-
smith, alderman and sheriff of London & of Knowle in par-
ish of Cranleigh (d. 1503), his wife, & child, all kneeling &
with scrolls issuing from their mouths; that of Harding
reads: "Have mercy Jhesu in honour of thy gloriovs
resvrreccion"; of his wife: "And grant vs the merite of thy
bytter Passion"; & of child, "Accipe parentes, et infantem,
bone Christe." These faced brass of Resurrection showing
bearded Christ in loincloth stepping from lidless chest
tomb; he has long hair & plain halo; holds long cross-staff
with banner in L hand & blesses with R; all his wounds
bleed; soldiers in armor & helmets sleep at 4 corners of
tomb; brasses now in chancel pavement; tomb before de-
struction il Brooks, Sepulchre of Christ; brass of Resurrec-
tion il Stephenson, "Monumental Brasses in Sr," p. 193;
Heales, "Cranley" opp. p. 36. [Bingley, "Cranleigh"; VCH 3]

CROWHURST, St George
?ESp/tomb; chest with quatrefoil panels enclosing shields on N
side of chancel; Purbeck marble slab has brass to Jn

Gaynesford (d. 1450); Gaynesford, in plate armor, rests feet on lion; low pointed arch of canopy cusped & subcusped, enclosed in crenellated square head; il French, "Crowhurst," between pp. 42 & 43. [VCH 4]

EPSOM, St Martin
ESp* ntd Comm inv 1549:
Item, a sepulcre cloth. [Roberts]

EWELL, St Mary
ESp* ntd Comm inv 1549:
Item, a painted cloth for the scepulture. [Roberts]

FARLEIGH, St Mary
ESp* ntd inv 1549:
Item the lentelclothe and the sepulcars clothe. [Daniel-Tyssen]
Also ntd Comm inv 1552:
Item a sepulcre cloth of party rede and grene sylke. [Roberts]

FRENSHAM, St Mary Virgin
?ESp/tomb*; chest with canopy formerly in N chancel, partly blocking lancet window; removed when lancet reopened so that only shafts & pinnacles from flanking buttresses remain; below it, shelf with arched recess; early 14c. [J. E. Morris, Sr; VCH 2]
ESp* ntd Comm inv 1552:
Item j shete for the sepullcher. [Daniel-Tyssen]

GREAT BOOKHAM, St Nicholas
ESp* ntd Comm inv 1549:
Item, the sepulcre cloth. [Roberts]

GUILDFORD, Blackfriars
ESp* ntd inv at dissolution 1538:
The Vestrey: Item the vppar part of the sepulcre woode. [C. Palmer, "Friar-Preachers"]

GUILDFORD, Holy Trinity
ESp* ntd churchwardens' accts 1509:
For watchynge of the sepulkar viijd.
1514:
Item to the sexten for watching of the sepulchre both for day and night, viijd. [Guildford & Russell]
Also ntd Comm inv 1552:
Item a stayned cloth to hang afor the sepulchre. [Daniel-Tyssen]
Also ntd 1558 inv:
Item a sepulchre.
Item a cloth painted for the sepulchre.
Item eleaven litle streamers to deck the sepulchre and

paschall. [Guildford & Russell]

HORLEY, St Bartholomew
?ESp* ntd churchwardens' accts 1540-60:
Item payd for watchyng to father mongar iiijd. [Bax]

KINGSTON UPON THAMES, All Saints
?ESp of early 16c in N wall of chancel; remade in 19c for
vicar's tomb; probably replaced earlier ESp/tomb in N wall
of N (Trinity) chapel for Clement Mileham (d. 1496); chan-
cel opened directly into chapel through large arch; chapel,
renovated as memorial chapel of 5th Surrey Regiment, now
reached through modern wooden screen from chancel; chest
has paneling of quatrefoils enclosing plain shields; 4-
centered arch above has traceried spandrels under square
head; groove cut through moldings on both sides approxi-
mately 15" above base of recess possibly to accommodate
wooden frame of ESp; 15c or early 16c. [Johnston, "Kings-
ton"; Morris, *Sr*; VCH 3]
ESp ntd 1487 will of Jn Dawson:
Ten shillings to buy 2 torches in honour of the Resurrection
of the Lord to be used at Easter in the church of
Kyngston. [*Sr Wills*]
Also ntd churchwardens' accts 1513-4:
For thred for the resurrection 1d. [Lysons 1]
1521:
mending of the sepulcre, 11d. [Heales, "Kingston"]
1529-30:
For bread and ale for the watchers of the sepulture 4d.
[Lysons 1]
1535-6:
Item for Coles at Cristmas for the quyer and at Ester when
they watchid the sepulture iiid. [MacLean, *Sr*]

LAMBETH, St Mary
ESp* ntd churchwardens' accts 1504-5:
Receyved' of the Sepulcre light'.
[List of 63 names follows with sums varying from 16d. "of
Sir William' Willoughby' knyght'" to 1d. from Robert Gran-
don & Rauf Cotlond.]
Item paied' for watching of the Sepulcre light' to .ij.
persones vjd.
Item paied' for brede ale and coolys viijd. ob'.
Item paied' for the makyng of the sepulcre light' xiijs.
1514-5:
Item Receyved For sepulcre' lyghtt' xiijs.
Item payd For watcheres off the sepulcre' iiij nyghttes and
For meytt' and drynke to the watcheres xviijd.
Item payd For the sepulcre' lyghtt xiijs. xjd.
1515-6:
Item Receyved off Sir John a leghe for the sepulcre'
lyghtt' For iiij yeres iiijs.

Item Receyved off the sepulcre' lyghtt' xxs.
Item For a quarttere coles to the watcheres off the sepulcre' vjd.
Item For watchynge off the sepulcre' viijd.
Item For the maykyng off xv sepulcre' tapers weyng iiij[xx] li. and x vijs. vjd.
Item For xj li. d. wayste off the same tapers vs. ixd.
1516-7:
Item Receyved off the sepulcre' lyghtt' xiijs. iiijd.
Item payd to the men that' watched the sepulcre' lyghtt xijd.
Item For makynge the sepulcre' lyghtt' vs. vjd.
1517-8:
Item Receyved off the sepulcre' lyghtt' xiijs. ixd.
Item payd to the watcheres off the sepulcre' xvjd.
Item payd to the sekesten for the watchynge off the sepulcre' iiijd.
1518-9:
Receyved of the parreyssoners for the Scepulker lyte xjs. vijd. ob.
Item payd for wachemen to the scepulker xijd.
Item for ij smalle raylys for the scepulker iiijd.
Item for ij smalle bolttes of yern to the scepulker ijd.
Item for brede and drynke to the wachemen iijd.
Item payd to Eduarde browne in parte of payment for the scepulker lyte and the rode lyte xxiijs. iiijd.
1519-20:
Receyved and gaderd' bee the schurche wardayns for the scepoulker lyte xvjs.
payd to iiij men to watche the scepoulker xijd.
payd for brede and alle for the wache men' ijd.
1520-1:
Item Receyved off the sepulcre' lyghtt' ixs. ob.
Imprimis for Wachyng' off the Sepulker xijd.
Item to the Sexten' and Wachemen' for brede and ale vjd.
Item for Colys vjd.
Item paide for the Sepulker light' xjs. iiijd. ob.
Item paid' to the wachyng' off Sepulcre xijd.
Item paid' for makyng' off the Sepulcre and the pascall' xijs.
Item for Brede and Aylle' vjd.
1521-2:
Item Receyved off the sepulcre lyghtt' ixs. vijd. ob.
Item for maykyng and wayst' off x tapers for the sepulcre lyghtt' xs. iiijd.
Item For ij men' that watched' the sepulcre' ij nyghttes xijd.
Item For brede and drynke for the ij men' that' watched' the sepulcre and for Wylliam sexton' for ij nyghttes vjd.
Item For a quartter off Coolles for the men that' watched' the sepulcre' vjd.
1522-3:

Item Receyved off the sepulcre lyghtt' ixs. vijd. ob.
Item payd' For the wayst' off viij li. wex' off the tapers
off the sepulcre' lyghtt' and for xxxij li. maykyng vijs.
viijd. [Drew]
Comm inv 1552:
Item a sepulcre clothe.
[Sold] Item a sepulcre clothe for xxs. [Daniel-Tyssen]
1551-2:
Item gatheryd at ester to the sepulker lyeghte ijs. viijd.
1552-3:
Item gathered in the Churche at ester to the sepulker
lyeght viijd.
1551-7:
Item gatherid to the sepulker lyeght vjs. viijd.
Item paid to the waxechaundler for making of xiij tapers
for the sepulker lieght every taper wayyng thre powndes
Summa vjs. vjd.
Item paid for wast of the said tapers iijs. viijd.
Item paid for pynnes for the sepulker clothe jd.
Item paid to ij men for wacching of the sepulker xxd.
Item paid for ij wachemen to wache the sepulker xvjd.
Item paid for bred and drynk for the said wacchmen iiijd.
Item paid to the waxe chaundler for making of the sepulker
lyeghte ayenst ester in the foresaid yere xs.
Item paid to ij men for wacching of the sepulker at ester
xvjd.
Item paid for bredd and drink for them ijd.
Item paid to the waxchaundler . . . for making of xij
tapers for the sepulker.
1570:
Item for a sepulcre Clothe solde to Mr Olyver St John of
white sarscenett not received xxs. [Drew]

LEATHERHEAD, SS Mary & Nicholas
?ESp; wide, arched recess in N wall of chancel; much re-
stored; chancel c.1320. [VCH 3]
ESp ntd Comm inv 1549:
Item, a staned cloth of the passion of Christ for the
sepulture. [Roberts]

LITTLE BOOKHAM, Church (dedication unknown)
ESp* ntd Comm inv 1549:
Item, sepulcre clothe. [Roberts]

LONG DITTON, St Mary
ESp* ntd Comm inv 1549:
Item, ij paynted clothys for the sepulcre. [Roberts]

MERSTHAM, St Catherine
ESp* ntd Comm inv 1552:
Item also they sold the sepulcher and a wold chest to
Robart Best xxd. [Roberts]

MITCHAM, SS Peter & Paul
ESp* ntd Comm inv 1552:
Item sold to John Bowland an old paynted sepulcre clothe
for ijs. viij.d. [Daniel-Tyssen]

NEWINGTON, St Mary
ESp* ntd Comm inv 1552:
Item ij sepulcre cloths of silk. [Daniel-Tyssen]

OXTED, St Mary
?ESp with molded jambs & drop arch N wall of chancel at E
end; traces of color remain; 13c. [VCH 4]

PEPER HAROW, St Nicholas
?ESp/tomb; monument to Lady Johanna Adderley (d. 18
November 1487); chest tomb in N wall of chancel under
ogee niche; back wall has brass of Lady Adderley in wid-
ow's dress kneeling at prayer-desk in front of representation
of Trinity: Father with crucifix, parts enameled in red &
blue; Lady Adderley holds rosary in folded hands; over her
head "Ihesu Mercy--Lady helpe"; brass cross on floor of
chancel marks place of her burial; kneeling fig il Heales,
"Peper Harow," opp. p. 34. [VCH 4]

SEND, St Mary
ESp* ntd Comm inv 1552:
Item a sepulcre cloth paynted. [Daniel-Tyssen]

SHALFORD, St Mary
ESp* ntd 1488 will of Wm Palmer:
The said church shall have a 'stok' which is in my hands,
viz. 24s. for finding a light before the sepulchre--12 tapers.
[Sr Wills]

SHERE, St James
ESp* ntd Churchwardens' accts 1515:
Received 10s. towards the Sepulchre light. [Manning & Bray
1]

SOUTHWARK, St Margaret
ESp* ntd churchwardens' accts 1445:
Also peid for Image of the resurreccion with the plate of
syluer xls.
1450:
Also peyd for Colys brede and Ale for Watchyng of the
Sepulcre vjd.
1451:
Also peyd for Naylis to the Sepulcre ijd.
Also peyd for Colys brede and Ale for watchyng of the
Sepulcre vijd.
1453:
Also receuyd for the Sepulcre xiijs. iiijd.

Also peid for lawne to the Sepulcre vs.
Also peid for lyre [?lyne] to the Sepulcre vd.
Also peid for hokis pynnys and corde to the Sepulcre vjd.
Also peid for Colis and Ale to watch the Sepulcre vd.
1454:
Also peid for hokis pynnys & corde vjd.
Also peid for brede and ale to watche the Sepulcre iiijd.
1455:
Also peid for brede and Ale to watche the Sepulcre ijd. ob.
1457:
Payed for paper ob., & for watchyng of the sepulker
iiij ob. . . . vd.
1458:
Item payed for brede, ale and colis for watchyng of the
Sepulcre vd. ob.
1460:
Item payd for brede and Ale at the watchyng of the
Sepulcre iijd.
1462:
Item paide for brede, Ale and Colis to watche the Sepulcre
vjd.
Inv 1485:
Item ij blev cortyns [to] draw afore the sepulture.
Item a lytyll Cortyn of grene sylke for the hede of the
sepulture.
Item iij Cortyns of lavnde to draw afore the sepulture on
the ester halydays.
Item iij steyned Clothys with the passyon & the
Resureccyon to hangg about the sepulture on good fryday.
Item vj angelles of tre gylt with a tombe to stande in the
sepulture at Ester.
Item iiij long Crestes & iiij short for to sett the lyghtes
abovte the sepulture on good fryday, peynted Rede with
yrons to the same. [J. Collier]

SOUTHWARK, St Saviour (Collegiate; formerly church of Monastery
of St Mary Overy)
 ?ESp* ntd Comm inv 1552:
 Item ij peaces of silver knoppis which was in the brest of
 the ymage of the Resurrection. [Daniel-Tyssen]

STOKE D'ABERNON, St Mary
 ESp/tomb of Sir Jn Norbury (d. 1521); arch which formed
 canopy of tomb stands in N wall of chancel between chan-
 cel & Norbury chantry; slat, 4-centered arch has foliated
 spandrels & embattled cornice; paneling of trefoil-headed
 arches on return faces of arch & jambs; chest tomb no
 longer extant. [Johnston, "Stoke"]

STREATHAM, St Leonard
 ESp* ntd Comm inv 1549:
 Item, the hanggynges that was a bowght the sepulture of

sylke and damaske solde to Jamys Revell for xiijs. iiijd. and
the mony therof bestowed upon the whittyng of the church.
[Roberts]
Also ntd churchwarden's accts 1548-50:
sould by them and by the assent of the paryshe a canepe
clothe paynted and the sepulter hanggynge of damaske and
sylke the pryce xvtyns. [Daniel-Tyssen]

SUTTON, St Nicholas
ESp* ntd 1484 will of Alice Stuard:
Nicholas [Broke] and Emota his wife [daughter of de-
ceased] shall find annually at a suitable time--each of them
whilst they live--one candle weighing 12 li. of wax to burn
before the sepulchre in the church of Sutton. [Sr Wills]

THORPE, St Mary
ESp* ntd 1486 will of Wm Pynnok:
To the light of the Holy Sepulchre in the said church one
measure of corn. [Sr Wills]
Also ntd Comm inv 1552:
Item j cloothe for the sepullchre. [Daniel-Tyssen]

WALTON-ON-THAMES, St Mary
ESp* ntd Comm acct to Crown of church goods left in
charge of churchwardens 1552:
Item a sepulcre cloth white and red satten. [Daniel-Tyssen]

WANDSWORTH, All Saints
ESp* ntd churchwardens' accts 1545-6:
Item of parishe for the sepulcre lyghte ijs. xd.
Item for watchinge the Sepullcre at easter ijs.
1546-7:
Receuyd for smale Candills on Easter Daie in the Mornynge
at the Resurrection the sum of viijd.
Item gatheryd of the paryshe ffor the sepulcre lyght vs.
Item for quarter colles at Easter for the watche vjd.
Item for watchinge the Sepullchre ij nights ijs.
1548-9:
Jtem Receuyd for broken tymber and waynskot and the
sepullcre of the churche xiiijs. iiijd.
1553-4:
Item paide for brengyn down the sepullcer ijd.
Item paide for watcheng of the sepullcor ijs.
1554-5:
Jtem paide to the Goodman Edwyn for the sepullcor viijs.
Jtem paide for watchen of the Sepullcor ijs.
Jtem paide for vij li. of new waxe and makynge of v li. of
olde waxe for the Sepullcor vijs.
1555-6:
Resavyd more of the parishe towarde the Sepullcer lyghte
iijs. viijd.
Paide for Watchynge of the Sepullcor ijs.

Paide for xv li and a halfe of new waxe for the Sepullcer
And the pascall xvs. vjd.
1556-7:
Jtem payd ffor waxchyng off ye Seypullker ijd.
1557-8:
Jtem payd to Robart Newyngton ffor a days work on ye
sepokkar xd.
Jtem payd for araffter ffor ye sepokkar iijd.
Jtem paid ffor watchyng ye see pokkar at Estter the Som
ijs.
Jten paid ffor nayles ffor to mend ye sepokure ijd.
Jtem paid to ye waxe chaunler ffor ye sepokare lythe and
ffor and the waste of the paskaulle ixs. viijd. ob.
1558-9:
Jtem paid ffor carryng doune ye waxe to ye Chanler for ye
sepoker ijd.
Jtem paid ffor watchyng the sepoker ijs.
Jtem paid to ye waxe Chanlar ffor ye sepokar lyght and ye
pascall xiijs. jd. [Davis]

WARLINGHAM, All Saints
ESp* ntd 1485 will of Wm Stephyn:
Item. I bequeth iii li. wex for the tapers before the
sepulcure in the parich chirch of Warlingham forseyde. [Sr
Wills]

WEYBRIDGE, St Nicholas
ESp* ntd Comm acct to Crown of church goods left in
charge of churchwardens 1552:
Item a vestment and a sepulcre cloth for the communion
table. [Daniel-Tyssen]

WIMBLEDON, St Mary
ESp* ntd Comm inv 1552:
Item ij clothes of cors clothe of gold for the sepulchre.
Ntd Comm accts, rendered to Crown, of church goods
left in charge of churchwardens:
ij scepulcre clothes and ij alter clothes of silk for the
communyon table. [Daniel-Tyssen]

WITLEY, All Saints
?ESp/tomb; chest under easternmost arch of arcade between
chancel & N chapel; top of tomb has brasses dated 1525 to
Tho Jones, "which Thomas was one of the Sewers of the
Chamber to our Soverayne lorde Kynge Henry VIII," wife
Jane, 3 sons, & 3 daughters; 15c. [Johnston, "Witley"; VCH
3]

WOTTON, St John
ESp* ntd Comm inv 1552:
Item a sepulchre clothe. [Daniel-Tyssen]

SUSSEX (Sx)

ALFRISTON, St Andrew
?ESp; recess with ogee arch in chancel; c.1360. [Pevsner]

AMBERLY, St Michael
?ESp/aumbry in N wall of 13c chancel. [Heales, "ESp"]

ARDINGLY, St Peter
?ESp/aumbry with pointed head & rebated jambs in N
wall of chancel near E end; 14c. [VCH 7]

ARLINGTON, St Pancras
ESp* ntd churchwardens' accts 1467-9:
Et ijd. soluti pro factura luminum ante Sepulchrum.
1474-8:
Et ijd. soluti pro factura iiij libratarum sere ardentis ante
Sepulchrum Domini Jhesu Christi.
1477-9:
Et xvijd. soluti pro factura luminis Sepulcri Domini tempore
parasseve.
Et xvd. soluti pro emendacione iiij tapers et factura luminis
sepulcre et aliorum luminum infra ecclesiam. [Salzmann]

ARUNDEL, Church of Holy Trinity (Collegiate)
?ESp/tomb; canopied tomb of Earl Tho Fitzalan (d. 1524) in N
chancel; mixture of Gothic & Renaissance styles. [Pevsner]
ESp ntd inv 1 Oct 1517:
Item ij auterclothes of white damaske enbrowdid with
emmys crowned the over cloth with a myddell pane of rede
velvett enbrowdid with an Image of our lady with iij copys
of the same sewte and a hoole vestiment for preest diacon
and subdiacon of the same sewte with all the apparell.
Item a sepulcre of dyverse peces of the same sewte of the
whiche oon pece is enbrowdid with a close tombe and an
other with the resurrection.
item ij Cusshyn bebris of whit damaske enbrowdid with
Emmys crowned Sewed to the Sepulcre clothe.
Item a sepulcre of goldsmythes worke the grounde rede and
blew pale.
Item a rede canopie of cloth of gold for corpus Christi day
square longyng to the rede sepulcre. [Hope, "Arundel"]

BEPTON, St Mary
?ESp; niche in N wall of chancel near E end contains dam-
aged tomb slab; cinquefoil pointed arch under crocketed
triangular gable enclosing trefoil; c.1300. [Pevsner; VCH 4]

BERWICK, Church (dedication unknown)
?ESp/founder's tomb; recess with large Dec canopy in N wall
of chancel; cusped pointed arch under triangular canopy
with finial; 14c. [Pevsner]

BOSHAM, Holy Trinity
?ESp/tomb; canopied chest in N wall of chancel; chest with quatrefoiled panels; pointed cinquefoiled arch above, standing on triple shafts with molded capitals & bases; effigy of woman on slab does not belong to tomb; late 14c or early 15c; il Clinch, p. 69. [VCH 4]

BOXGROVE, Boxgrove Priory
ESp* ntd will of Luke Poynings, Lord St John, 5 June 1376: Lego . . . corpus meum ad sepeliendum in ecclesia conventuali Prioratus de Boxgrave Cicestrensis Diocesis in sinistra parte ejusdem ecclesie ubi sepulchrum Domini die pascensi solet. [Rice, Transcripts 4]

BROADWATER, St Mary
?ESp/tomb of Tho West, 5th Lord de la Warr (d. 1525) in wall on N side of chancel; Caen stone; flat slab is plain; sloping sides & back of recess once painted & gilt; sculpted coat of arms in center of back; canopy with 3 cusped ogee arches & large finials; Renaissance details in bands of foliated ornament; much restored; il Harrison & Leeney, p. 125. [Burges]

BURY, St John Evangelist
ESp* ntd will of Jn Higens, 30 Sept 1539: My body to be buried within the chirche of Bury within the chauncell wher the sepultur verelie standith. [Rice, Transcripts 1]

CHICHESTER, Cathedral
ESp* ntd will of Agnes Wulgar of St Mary in Foro, 23 Oct 1523:
I geue and bequeth to the Hyghe Altar of the Cathedral Church of Chychester a standyng pece doble gylte, with oken leves, to the entent to stand upon the said Alter [at] princypall festes, at [sic] upon the Sepultor at Ester. [Rice, Transcripts 1]
ESp ntd inv 1562:
A Sepulchre cloth of branched velvet embroidered with images. [Peckham, "Chichester 1562"]

CHICHESTER, St Peter Less
ESp* ntd will of Jn Bartelott, 6 Nov 1487:
To the church of St. Peter the less a candle weighing 8 lb., such as I used to find for the Easter Sepulchre. [Peckham, "Some Chichester Wills"]

CHIDDINGLEY, Church (dedication unknown)
ESp* ntd will of Wm Jeffray, 20 Aug 1543:
I will to have a taper of iiij powndes of wax, to berne before the Sepultur, the space of vij yeres next after my deceasse, within the same church.

Also ntd will of Wm Lyttelton, vicar of Chiddingley, 1 Oct
1558:
my bodye to be buryed within the Chauncell at the northe
syde under the sepulcre. [Rice, *Transcripts 2*]

COCKING, Church (dedication unknown)
?ESp/tomb; recess in N wall of chancel; length 3'6" x depth
1'3"; plain slab under depressed trefoil-headed ogee arch
with foliate finial; flanking pinnacles spring from head
stops, one of which was replaced in 1896; c.1290-1300; il
Johnston, "Cocking," fig. 9. [VCH 4]

COOMBES, Church (dedication unknown)
ESp* ntd will of Robt Palyngham, 31 May 1477:
Lego in sustentacionem perpetuam unius cerei, ponderantis
tres libras cerei, ad ardendem circa sepulchrum Domini
nostri Jesu Christi in die Paracephes ad festum Pasche, vjs.
sterlingorum. [Rice, *Transcripts 2*]

COWFOLD, St Peter
ESp* ntd churchwardens' accts 1473-4:
In manibus Walter Dunstall a stok pris viijs. de legato
Johannes Dunstall pro sostyne a taper aput sepulcrum
perpetuum. [Otter]

EASEBOURNE, St Mary
?ESp/chest; tomb with canopy in N chancel under arch of
arcade flanked by screen; plain chest; modern supports for
high canopy with ogee arch, cusped & subcusped; tracery in
soffits under heavy square cornice; altered in 18c to funer-
ary monument; now restored; late 14c. [Pevsner; VCH 4]
Fig. 52.

EAST GRINSTEAD, St Swithin
ESp* ntd will of Henry Duffylde, 28 March 1523:
I will that the Sepulcre in the church of Estgrensted shalbe
gilted and paynted after the best maner and the payment
therof to ryse of my landes that I have gevyn to my
children, by equall porcions according to the valour of every
landes so gevyn to my children. [Rice, *Transcripts 2*]

ETCHINGHAM, God, SS Mary & Nicholas
ESp* ntd will of Rich Petter, 12 June 1527:
I bequeth a cowe to fynde a tapre burnyng before Our Lady
in the saied chapell continually excepte in the tyme of
Easter, and then to burne before the Sepulture. [Rice,
Transcripts 2]

FITTLEWORTH, St Mary
ESp* ntd will of Wm Tanner, 17 Feb 1538:
I bequethe to Fyttylworth Churche iij shepe matris to
mayntyn a taper of wax before ye Sepulcar. [Rice, *Tran-*

scripts 2]

FORD, St Andrew
?ESp/relic shrine; round headed niche in N wall of early
Norman chancel & contemporary with it; jambs & head
splayed; opened 1879; width 1'4 1/4"; height 3'8 3/4"; 2 1/2'
from floor; c.1100; il Johnston, "Ford," p. 124.

FRAMFIELD, St Thomas Becket
?ESp/aumbry*; small trefoil-headed niche formerly in N wall
of chancel. [Hoare]

GLYNDE, Church (dedication unknown)
ESp* ntd will of Robt Morley, 10 April 1514:
My body to be buried within the quere there, on the north
syde, where as the Sepulcre is accustumed to stande, in the
wiche place I wyll a Tombe of marble to be made, with my
picture and myn armes garnisshid theron, with a vawte
rysing up by the wall, comyng over the same stone of
marble, so that at Easter tyme the Sepulcre maye be there
sett to thonour of allmyghty god. [Rice, *Transcripts* 2]

HAMSEY, St Peter
ESp/tomb; canopied table tomb in N wall of chancel very
similar to Selmeston; chest, on base, has 3 panels of cusped
quatrefoils enclosing blank shields; plain slab; polygonal
columns support flat 4-centered arch of canopy; above,
frieze of quatrefoils & elaborate cornice; Tudor flowers in
both. Il Rice, "Hamsey," p. 55. [VCH]
Tomb has no inscriptions, but identified as one built for
Edward Markewyk in accordance with instructions in his
will of 12 November 1534, proved 22 May 1538:
my body to be buried in the Parishe Church of Hampsey
before the Image of Saint Peter in the Chauncell there.
. . . I will that my executours shall ordeyn and make one
Tombe of Stone to be leyde uppon me with an Image and
scripture there graven, whereuppon the Sepulcre may be
sett. [Rice, *Transcripts* 2]

HERSTMONCEUX, All Saints
?ESp/chest tomb with very high canopy in wall between N
chancel & N chapel; arch open to both; chest has paneling
of cusped quatrefoils; 2 alabaster effigies of men in armor
on slab which has brasses; canopy has cinquefoiled arches
with traceried spandrels; above, frieze of quatrefoils on
each side, & rich cornice with shields on chancel side;
canopied niches adjoin tomb in E wall of both chancel &
chapel; main part of tomb with flat top of 1450-80 probably
built by Rich Fenys (d. 1484) or Robt Rynes (d. 1451) &
probably stood in center of chancel free of wall; presumably
moved to comply with will of Tho Fenys, Lord Dacre (d.
1533), at which time ends blocked up and some additions

such as cornice made. Ray has shown that effigies on this
tomb not Dacres, but probably Hoos brought from Battle
Abbey at time of Dissolution in 1538 which were perhaps
purchased by executors of Dacre's will. Il Ray, "Herstmon-
ceux," opp. p. 38. [VCH 9]
ESp ntd 1531 will of Tho Fenys, Lord Dacre:
And my body to be buried in the parishe church of
Herstmounceux in the North side of the high awter there
where the Sepulcre is used to be made And one Tombe
there to be made and ordeyned convenient for the making
and setting of the said Sepulcre And apparell to be made
and bought for the said Sepulcre at my cost and charge in
the honour of the most blessed sacrament and my Savior
Jesu Crist. And I will that myn executours geve towarde
the light of the seid Sepulcre oon hundred pounds of wax to
be made in Tapers of tenne pounds oon pece to bren
abought the said Sepulcre after the maner as the custome
is nowe used to bren aboute the same. [Ray, "Herstmon-
ceux"]

HORSHAM, St Mary Virgin
 ESp/tomb; canopied tomb of Tho Hoo (d. 1486) erected soon
 after his death; Purbeck marble; canopy heavily restored in
 16c. [Windrum]

ICKLESHAM, All Saints (now St Nicholas)
 ?ESp/aumbry; plain arched recess in N wall of chancel.
 [Churton; VCH 9]

ISFIELD, St Margaret (formerly St Mary)
 ?ESp in N wall of chancel under Win N2; 14c. [Godfrey]

ITCHINGFIELD, St Nicholas
 ?ESp/aumbry; recess with plain arch & abaci in N wall of
 rebuilt chancel; Norman. [Pevsner]
 ESp ntd will of Jn Michell of Horsham, 1 July 1520:
 I will that Richard myn eldest sonne and heier apparaunt
 kepe within the churche of Hechyngfeld iij tapers, that is
 to saye, one taper before the Ymage of Our Lady, a nother
 taper before the Ymage of Seint Ursula, and the iijde
 before the Ymage of Saint Erasmus, and a nother taper
 before the Sepulcre at Easter tyme, and after that tyme to
 stande before the Image of Saint Cristofer; and these iiij
 tapers to be soo maynteyned and kept by the space of xxxj
 yeres from the tyme of my decesse.
 Also ntd will of Rich Mychell of Warnham, 26 Nov 1524:
 I will that Henry my eldest sonne [and heir] apparent kepe
 within the church of Hechingfeld four tapers, that is to
 say, oon taper before the Image of Our Lady, another taper
 before the Image of Saint Ursula, the thirde taper before
 the Image of Saint Erasmus and the fourth taper before the
 Sepulcre in Ester tyme, and after that tyme to stande

before the Image of Saint Cristofer, and these my tapers to
be so maynteyned and kept by the space of xxxjti yeres in
perfourmaunce and fulfilling of the last will and testament
of John Mychell of Stamerham, my fader. And yf hit
fortune the said Henry my sonne to dye before the said
xxxjti yeres ended, then I will that Thomas my sonne kepe
and maynteyn the said tapers the residue of the said yeres
not ended, as in the last will of my said fader more playnly
apperith. [Rice, *Transcripts* 3]

KINGSTON BUCI, St Julian
?ESp/tomb for member of Lewknor family in N wall of chan-
cel; similar to monuments at Hamsey & Sittingbourne; fire-
stone; very flat arch of canopy has ogee with vertical
paneling above; soffit of canopy vaulted with panels de-
corated with roses, crowns, & pomegranates; in center
under arch small reliefs of Resurrection with sleeping sol-
diers in helmets surrounding Christ rising; relief of Pietà
to W & Trinity to E; all reliefs damaged; late Perp; early
16c; il Grayling, "Kingston," p. 57. [Pevsner]

LANCING, St James Less
?ESp; ogee-arched recess in N wall of chancel. [Pevsner;
VCH 6, Pt. 1]

LEWES, St Andrew; St Michael
ESp* ntd St Andrew's churchwardens' accts 1524-5:
Item for whacvng off the Sepollker iiijd. [repeated annual-
ly].
1529-30:
For the karpenter for mendyng of the holes for the
sepulchre leyte iiijd.
Item payd to Leowe for mendyng of the Beme of the
sepelker leyte iiijd.
[In 1546, St Andrew's was united with St Michael's; by
1548, St Michael's only]
1553-4:
Item to brete for makynge of ye sepulcer ijs.
Item to brete for makynge of ye forme yat ye sepulker
tapers stode on ijd. [Whitley, "Lewes"]

LITLINGTON, Church (dedication unknown)
?ESp/tomb recessed in N wall of chancel; 15c. [Godfrey]

MAYFIELD, St Dunstan
ESp* ntd will of Tho Symms, vicar, 15 Dec 1500:
Lego sepulchro in ecclesia de Maghfeld predicta zonam
meam optimam. [Rice, *Transcripts* 3]

MOUNTFIELD, All Saints
ESp* ntd will of Joan Bennet of Whatlington, 28 Dec 1542:
To ye church of Monfeld, a mylyd towell for the sepulcre.

[Rice, *Transcripts* 3]

ORE, St Helen (in ruins)
?ESp/tomb; recess in N wall of chancel between 2 windows; cinquefoiled arch under plain, pointed gable; width 5'5"; 13c. [VCH 9]

OVINGDEAN, St Wulfram
?ESp/aumbry; plain recess in N wall of 12c chancel. [VCH 7]

RACTON, Church (dedication unknown)
?ESp/tomb; canopied chest tomb of Caen stone against N wall of chancel; chest has 3 multifoiled panels with shields, arms of Gunter impaling Cooke; elaborately carved canopy has 4-centered arches, initials I. G. intertwined with foliage, some Italianate features; back wall of recess has relief of Resurrected Christ in cope with morse holding crossstaff with banner; kneeling man & woman flank him; man in armor, wearing tabard, accompanied by 4 sons in civilian dress; woman, with kennel headdress, has 2 daughters; scrolls from hands of principal figs not inscribed; may be tomb of Hugh Gunter (d. c.1520) or Jn Gunter (d. 1557); tomb earlier than 1557; il Arnold, "Racton," opp. p. 1. [Pevsner; VCH 4]

ROGATE, St Bartholomew
ESp/aumbry; recess with pointed arch in N chancel. [VCH 4]
ESp ntd will of Tho Adene, 1 Oct 1541:
I wyll to Jhon Adene one cow to ye yntent that he schall mayntayne one taper of vj li. of wax wherof my executor schall delyver vj li. of ye seyd wax before Ester next cumyng. And yat the seyd Jhon Adene schall yerly after that tyme mayntayne the seyd taper of vj li. of wax yn ye seyd churche of Rogat before ye Sepultur for ever. And yf ye seyd Jhon Adene do not mayntayne or cause to be mayntaynd ye seyd taper dilyngently as yt ys above seyd that then I wyll ye churchewardens of Rogat schall put ye Stoke yn to sum yndyfferent mens handes to be maynteynyd and contynued for ever. [Rice, *Transcripts* 4]

ROTHERFIELD, St Denys
ESp* ntd inv 1509:
v Stayned clothis for the sepulchre.
Inv 1558:
iij sepulker clothys.
Inv 1567:
ij sepulchre clothes. [Goodwyn]

SALEHURST, St Mary
?ESp; recess with cinquefoiled head in N wall of chancel; blank shield above; chancel c.1250. [VCH 9]

SELMESTON, St Mary
?ESp; recess very similar to Hamsey, with depressed arch, very flat, & cresting in N wall of chancel; late Perp; ?16c. [Pevsner]

SELSEY, ?St Mary
ESp* ntd will of Jn Red, 10 Feb 1518:
To the mayntaynyng of a taper that I geve befor the Sepulcre oon ewe. [Rice, Transcripts 4]
Also ntd chantry certificate 1546:
Farm of one cottage and one garden adjoining the same containing a fourth part of one rood of land called "Bedehous" for the maintenance of a light before the sepulchre 8d. [Ray, Sx Chantry Records]

SHIPLEY, St Mary
ESp/aumbry in N wall of early 12c chancel.
ESp ntd will of Rich Hunt, 31 March 1535:
I will ther shalbe gevyn xiijs. iiijd. or els a cowe worth xiijs. iiijd. to be for a stocke which shall kepe a tapre to burne yerly before the Sepulcre in Shipley churche and all the yer after to burne before the Image of Our Lady. [Rice, Transcripts 4]

SINGLETON, St John Evangelist
ESp/tomb; chest with flat canopy against N wall of chancel; front of chest & underside of canopy paneled; cresting of 4-leaved flowers; carving badly damaged; 15c or 16c. [VCH 4]
ESp ntd will of Rich Heberden, 20 Oct 1479:
Lego ecclesie parochiali de Singylton unam vaccam ad inveniendum unum serum ardentem annuatim coram Sepulcrum a die Parascive usque post Resurrexcionem. [Rice, Transcripts 4]

SLAUGHAM, St Mary
?ESp/tomb; canopied chest in N wall of chancel for Rich Covert (d. 1547) & 3 wives; chest paneled with tracery surrounding shields, now fitted with modern brasses; canopy has flat Tudor arch with pendant keystone & rests on octagonal shafts with concave sides; cornice above frieze of quatrefoils; back of recess has brasses (reset) of Covert & 3 wives; Covert, in armor, kneels on cushion placed on tiled pavement; wives behind him; all face small brass of Resurrection that shows Christ rising from tomb surrounded by sleeping soldiers. [VCH 7]

SLINDON, St Mary
?ESp*; canopied tomb with very flat 4-centered arch & wooden effigy of man in armor formerly in N wall of chancel; destroyed for arch to organ chamber. [Jackson; VCH 4]

SOMPTING, St Mary
?ESp/tomb; canopied tomb of poor workmanship in N wall of
chancel, with shield of Goldsmiths' & Saltfishmongers'
Companies, must be that referred to by Rich Burré in his
will of 3 Aug 1527:
I will my body to be beryed in my tumbe in the chaunsell
of the church of Sowntyng. [André, "Sompting"; Lower,
"Burré"; Pevsner; VCH 6, Pt. 1]

STOUGHTON, St Mary
ESp* ntd will of Tho Cripps, 25 July 1530:
To the Sepulcre Light xxd. [Rice, *Transcripts* 4]

TANGMERE, St Andrew
ESp* ntd will of Roger Carpenter, 9 Oct 1521:
For the mayntenawnce of a taper to the Sepulcre iiij
busshells of barley. [Rice, *Transcripts* 4]

TELSCOMBE, St Lawrence
ESp* ntd will of Alice Ryckewater, 14 April 1557:
I beqweth xviijd. to bye a pound and dimidium of waxe to
brene before the Sepulcre.
Also ntd will of Julian Ryeward, 25 Nov 1558:
I bequethe vjs. viijd. and a pound and half of wax to fynd
to taper to burn yerly befor the sepultur. [Rice, *Tran-
scripts* 4]

THAKEHAM, SS Peter & Paul
ESp/tomb for Jn Aspley (d. 1507) in N wall of chancel under
Win N2. [Godfrey]
ESp ntd will of Jn Apsley, 14 May 1507:
My body to be buried in suche tyme as it shall please God
to call me oute of this transitory world in the chauncell of
Thakeham at the north ende of the high aulter where the
sepulcre ys wonte to stand and there to have a fayre stone
in the honour of God and to be leyde the hyer for the
sepulcre as myn executours can thinke moost convenyent
and if I dye witin the shire of Sussex. [Rice, *Transcripts* 4]

TICEHURST, St Mary Virgin
ESp* ntd will of Jn Hamond, 10 Feb 1485:
I bequeth toward the making of the sepulture in the seid
church of Tyseherst xxs. so that it be made on thesside the
Fest of Estre which shalbe in the yere of our Lord
MlCCCClxxxvij and if the said sepulture be nott made on
thissyde the seid fest then I bequeith the said xxs. to the
house of Chanons of Combewell in the said countie to pray
for my sowle. [Rice, *Transcripts* 4]

TREYFORD, St Mary
ESp* ntd will of Jn Aylwen, 14 March 1545:
I will that ther be kept one stock of bese for to mayntayne

a taper befor the Sepulcar yerly. [Rice, *Transcripts* 4]

TROTTON, St George
?ESp/tomb; chest in NE corner of chancel; paneled with
tall, narrow niches; edge of slab carved to represent swags
of linen drapery; top of Purbeck marble slab plain; probably
tomb of Sir Roger Lewknor (d. 1478) who asked to be
buried:
in a marble tombe which I ordeyned there beside the high
Auter. [Rice, *Transcripts* 4; VCH 4]

TWINEHAM, St Peter
ESp* ntd will of Rich Staplegh, 31 Oct 1546:
I bequeth to the Sepulcre of Twyneham a taper of iij li.
wex and then I will a cowe price xs. to be delyvered by
myne executor to the yerely meyntenunce of the said taper
and every yere to renewe the same taper a li. [Rice, *Tran-
scripts* 4]

UPMARDEN, St Michael
ESp* ntd will of Nich Paye, 25 Feb 1522:
Lego Sancto Sepulcro de Upmerdon predicta unam vaccam
in stipite que nunquam morietur. [Rice, *Transcripts* 4]

WARMINGHURST, Holy Sepulchre
ESp* ntd will of Rich Brigger, 15 March 1534:
I bequeth unto ye same church j heyfer of ij yere age to
be set to hyre at the dyscrecion of ye church wardens and
parysheneres to mayntene a tapur before ye Sepulcre and
other necessarys aboute ye church. [Rice, *Transcripts* 4]

WEST GRINSTEAD, St George
ESp* ntd will of Wm Parson, 1 Apr 1535:
I geve and bequeth unto the churche of Saynt George afore
sayd, toward the Sepucre Clothe xijd. [Rice, *Transcripts* 2]

WESTHAMPNETT, St Peter
?ESp/tomb; canopied chest in E bay of N wall of chancel;
chest has multifoiled paneling; canopy with very flat Tudor
arch; underside of canopy & ends of recess paneled; back
wall of recess has brasses of Rich Sackville, wife Eliz, son,
& daughter, centered on Trinity; Sackville in furred gown
kneels at faldstool; one son behind him; Eliz wearing kennel
headdress, similarly kneels; one daughter behind her;
Trinity, badly damaged, shows Father in vestments, Son
wearing loincloth; c.1535. [VCH 4]
ESp ntd will of Sir Wm Tawk, kt, 6 July 1375:
lego praefate ecclesie iij vaccas et xx muttones . . . ad
inveniendum inde et sustentandum ij torticia ardentia cotidie
in eadem ecclesia ad levationem corporis christi ac etiam
ad inveniendum . . . cereum Isabelle quondam uxoris mee
super trabem que [est] coram cruce ac ad inveniendum

. . . annuatim unum cereum ij li. cere continuo ardentem
ad sepulcrum de hora sepulture domini in diem boni veneris
usque horam resurrectionis domini in die paschali. [Rice,
Transcripts 4]

WEST TARRING, St Andrew
ESp* ntd churchwardens' accts 1517-45 & 1552-9 during which
time payments for watching of ESp occur regularly.
1558:
Item for mendyng ye sepulcry vijd. [Pressey, "W Tarring"]

WEST WITTERING, SS Peter & Paul
?ESp; 2 canopied chest tombs in N chancel; now both against
N wall; formerly E at right angles to other; both to mem-
bers of Earnley family; earlier, to W, thought to be Wm
Earnley's tomb for his first wife (d. before 1538); purely
Gothic in style; front of chest has panels of shields alter-
nating with figs of saints: George & dragon; female fig with
building, perhaps Barbara; ecclesiastic; St Roche & dog;
inscription on chamfer of slab; canopy has Tudor arch;
recess with relief of Resurrection: Christ with cloak &
rayed halo, both forearms broken off; soldier in armor to
his R falling to ground; above him fig with pike & perhaps
angel; 2nd tomb probably for Earnley (d. 1545) by his sec-
ond wife; front of chest has narrow panel of Renaissance
decoration in relief at either end framing large panel of
Annunciation; at L angel approaches Mary with scroll; above
to R of angel, head of God Father in cloud sends rays of
light with his L hand toward large pot of lilies just R of
center; small fig of Christ with arms outstretched as though
crucified on three lily stems; to R of this Virgin kneels
before desk with open book, hands folded in prayer; curtain
behind her closes scene; canopy above has very flat Tudor
arch in square head, framing relief on back wall of resur-
rected Christ flanked by members of Earnley family;
Christ, frontal, with rayed halo, wears loincloth & points to
wound in side with R hand; L forearm broken; to his R man
kneels at prayer desk, facing Christ, in armor, tabard, &
cape; 2 boys kneel behind him; above these 3, scroll reads
"By . . . crosse & passyon"; opposite him, woman in kennel
headdress kneels; one girl behind her; scroll issuing from
her hand reads, "delyver us Lord Jhesus cryst"; both tombs
have initials W. E. Latter il Crossley, *ECM*, p. 126. [Hild-
burgh; VCH 4] **Fig. 54.**
ESp ntd will of Tho Love, 10 Apr 1543:
I geve to Wylliam Hoskyn my sonne ij yewes shepe toward
the mayntenaunce of a tapre of iij li. before the Sepulcre
at Easter. [Rice, *Transcripts* 4]

WARWICKSHIRE (Ws)

ANSLEY, St Lawrence
ESp; N chapel; nail head dec. [Davidson & Alexander]

ARLEY, St Wilfrid
?ESp/tomb; arched recess in chancel under NE Win (Win N2), sill of which is raised considerably to accommodate it; segmental pointed arch under restored hood mold with crockets & finial detached from wall above splay of window sill; 14c; contains effigy of different date. [Cossins, "Excursions . . . 1900"; Pevsner; VCH 6]

ASTON-BY-BIRMINGHAM, SS Peter & Paul
?ESp/tomb; effigy on alabaster tomb probably for Sir Wm Harcourt of Maxstoke (d. 1482 or later); tomb possibly originally against N wall, probably in Erdington (S) chapel. [Chatwin 1 & 2]
ESp ntd 1471 will of Sir Wm Harcourt (proved 1494): my body to be buried in the holy sepultur in the church of Astone in the diocese of Couentry and Lichfield in the chapell of the south syde of the same church. [Chatwin 4, Addenda]

BEAUDESERT, St Nicholas
?ESp/aumbry E of Win N2; simple in form; 14c or earlier. [Davidson & Alexander; VCH 3]

BILTON, St Mark
?ESp/tomb recess in N wall of chancel below & W of Win N2; ogee arch cusped & subcusped; leafy spandrels; hood mold has crockets & finial; floor level has been raised, obscuring lower portion of recess; red sandstone; mid 14c. [Bird; Bloxam, "ESp"; Pevsner; VCH 6]

COLESHILL, SS Peter & Paul
?ESp/tomb; tomb of Sir Simon Digby against N wall of chancel against E end; on top of chest, lifesize alabaster effigies of Sir Simon & wife.
ESp ntd will of Sir Simon Digby (d. 1520) whose tomb stands in NE corner of chancel; his burial to be: in the Chauncell of the Churche of Colshull underneth the Sepulchre. [Chatwin 3]

COUGHTON, St Peter
?ESp/tomb; chest under E arch on N side of chancel; sides have cusped panels enclosing brass shields; on slab are brasses of Sir George Throckmorton (d. 1552), in armor, & wife Katherine Vause; below their feet, 8 sons & 11 daughters; Throckmorton in armor; chest, 9' in length, of gray marble; c.1530-40. [Pevsner; VCH 3]

COVENTRY, Diocese of
ESp ntd Bishop Bentham's Injunctions for Coventry & Lichfield Diocese 1565:

and that you do abolish and put away clean out of your church all monuments of idolatry and superstition, as . . . sepulchres which were used on Good Friday. [Frere, *Visitation* 3]

COVENTRY, Holy Trinity
ESp ntd Constitutions of 1452:
Also he [the first deacon] schall wache ye sepulcur on Astur evyn tyll ye recurreccion be don, then he and hys ffellow schall take downe ye lenttyn clothys abowte ye Awter, and affore ye rode.
[The second deacon] shal wache ye sepulcur on gode fryday all nyght.
ESp ntd inv of 21 January 1559:
Item ii peyntted clothes ffor ye seypoulkur. [Sharp, *Illustrations* . . . of Holy Trinity Church, 1818]

COVENTRY, St John Bablake (Collegiate)
ESp* ntd accounts for 1469 indicating that Jn Kerver was paid 26s. 9d. for making ESp; ESp sold to Henry Moore for 13s. 4d. in 1551. [Sharp, *Bablake Church*, 1818]

CUBBINGTON, St Mary
?ESp/tomb beneath & to W of Win N2; segmental, pointed arch in N wall of chancel over low recess; 13c-14c; restored 1855. [Bloxam, "ESp"; Pevsner; VCH 6]

LADBROOKE, All Saints
?ESp; badly mutilated recess in N wall of chancel below Win N2; early 14c. [VCH 6]

LONG ITCHINGTON, Holy Trinity
?ESp; arched recess in N wall of chancel; arch pointed & trefoiled under triangular gable with crocketing & floriated finial; from head stops at sides rise pinnacles with floriated finials; late 13c. [Bloxam, "ESp"; VCH 6]

NEWTON REGIS, St Mary
?ESp/tomb; recess in N wall of chancel; length 6'2"; segmental pointed arch; in recess, slab or coffin lid of fine gray sandstone with very low relief of long cross; trefoil head of cross contains half-fig of priest in Mass vestments under crocketed gable; above 2 small angels hold napkin with small nude fig (soul of priest) with dove above; 2 angels kneeling below to either side of cross have censers; at foot of cross, Agnus Dei; probably for Jn de la Warde or Worde, rector; both recess & slab c.1320. Slab il Bloxam, "Sepulchral . . . Warwicks," p. 8; Chatwin 4, Pl. XII; Davidson & Alexander, fig. 49. [VCH 4]

ROWINGTON, St Lawrence
ESp* ntd 1502 will of Jn Hill, bailiff of Rowington:
Also I will that the Guardians aforesaid before the
festival of the Nativity shall keep and maintain certain
waxen lights in the Church of Rowington aforesaid viz.
one of wax before the principal shrine called the Rode
lights, and three of wax on the Pascal day before the
Sepulchre burning during Easter Even at every Pascal
festival and for this expense shall receive 6s. 8d.
[Notices Ws 2]

SOLIHULL, St Alphege
ESp* ntd churchwardens' accts 1534-5:
item received for easter boxe and sepulchre light xxs.
item paid to the sexton for watching ye sepulchre lyght
iid.
item paid for xii lb waxe for Sepulchre lyght viis.
[Davidson & Alexander]

STRATFORD-UPON-AVON, Holy Trinity
?ESp/tomb; chest for Dean Tho Balshall (d. 1491) in N
chancel; Balshall's will asked that he be buried in tomb
"of my ordaining on the north part on the chancel";
chest, of white sandstone, has relief scenes in canopied
niches between pinnacled buttresses on ends & front; 2
scenes on W end: arrest of Christ & another too defaced
to recognize; on front, from W to E, scourging with
Christ tied to pillar; Bearing of Cross; Crucifixion;
Entombment; & 3 women at tomb; E end has ?Hortulanus
& Road to Emmaus; all these reliefs badly mutilated;
hollow molding of gray marble slab has letters "ihs" &
"th" repeated at intervals; presence of Passion
sequence suggests tomb meant to be used as ESp; il
Bond, Chancel, p. 223. [Davidson & Alexander; VCH 3]

WARWICK, St Mary (Collegiate)
ESp in N wall of chancel; this wall paneled between main
shafts with blank niches having trefoiled & cusped ogee
arches with Perp traceried paneling above; 3 of these
panels recessed with vaulted space in thickness of wall
vaulted for ESp; 15c. [VCH 8] Fig. 34.

WARWICK, St Nicholas
ESp* ntd churchwardens' accts 1550-1:
item receyved of Edmond Wryght for the seypulcur & vj
bannar clothys & other olde peynttyd clothys vs.
1553-5:
Item payd to Edmund Wryght ffor the sepirclor iijs.
iiijd.
Item payd to Thomis payne ffor waching the sepulcur
lyght iiijd. [Savage, Churchwardens' Accts]

WITHYBROOK, All Saints
ESp in N chancel E of arch to N chapel had been hacked
off flush with wall & walled up; discovered in 1848;
paneled tomb chest had reliefs of soldiers; plain slab
with sinking, possibly for effigy; on back wall of
recess relief of 2 soldiers in plate armor of mid 15c
flanking frontal angel; soldiers much mutilated; when
recess opened, arcading of tomb chest painted red;
ground at back of arch also red & embellished with
white & blue leaves; soffit of 4-centered arch was azure
sprinkled with white stars; grounds have faded to
gray; arch width, 33 inches; small doorway at back of
niche to N chapel; c.1450. Il Cossins, "Excursions
. . . 1914," p. 48; Davidson & Alexander, fig. 48.
[Bloxam, *Ecc Arch*; VCH 6]

WOLVERTON, St Mary
?ESp/tomb; recess with pointed arch reset in modern N
wall of chancel; human heads form stops for hood-
mold; early 14c; il *Notices Ws* 2, p. 79. [VCH 3]

WOOTTON WAWEN, St Peter
?ESp/tomb; N side of chancel, near E end, altar tomb
with slab of black marble; on slab brasses of Jn
Harewell (d. 1505) & wife Anna; below his effigy, 5
sons; below hers, 5 daughters. [Cossins, "Excursions
. . . 1905"]

WESTMORLAND (Wt)

CROSBY RAVENSWORTH, St Lawrence
?ESp/tomb; chest between N (Threlkeld) chapel &
chancel; chamfered base; fluted & reeded sides; 3 blank
shields on each long side; plain marble slab; perhaps
for Sir Lancelot Threlkeld (d. 1512); il RCHM, Pl. 94.

LONG MARTON, SS Margaret & James or St Margaret
ESp in N wall of chancel, as well as piscina & sedilia,
built c.1350; Win N2 added above ESp c.1450. [Cory]

WILTSHIRE (Wl)

AMESBURY, St Melorius (Priory of Order of Fontevrault)
?ESp/doorway; tall arch with openwork cusping &
crocketed gable; Pevsner describes as "substitute"
for ESp; c.1300. [Pevsner]
ESp ntd 1542 will of Nico Chamber:

Also I give to the attiring of the sepulchre on Good
Friday a pall embroidered in gold and silk with the
borders of silk and fringe. [His wife Agnes is to take
charge of it & repair it if necessary.] [Ruddle]

CHITTERNE, St Mary
?ESp/tomb; recess in N Win with ogee arch rising
against window opening; flanking shafts have flat tops
to support images or candles; height approximately 3';
?14c. [Pevsner]

COLERNE, St John Baptist
ESp/tomb; recess with moulded arch in N wall of N
chapel; c.1300. [Pevsner]
ESp ntd chantry certificate 1548-9:
For the sepulchre light out of Churche mede, iiijs.
iiijd. [Walcott, "Inv Wl"]

DEVIZES, St Mary
ESp* ntd wills of Wm Smyth (c.1436) & son Tho Smyth
(1460) leaving tenements in Devizes & in South Broom:
for the maintenance of three Sepulchre Tapers and the
Font Taper, and also that an Obit should be celebrated
annually in the above church to pray for the Souls of
the Father and Mother of the said Thomas, as also for
the Soul of himself.
Also ntd churchwardens' accts ?1500:
to iiij men for keeping of the Sepulchre ij nights xiijd.
for the making of the Sepulchre and taking down ijd.
Item for a board to the Sepulchre ijd. [Kite, "Devizes"]
1527:
For watchyng of the sepulcre and for pynnys and
naylls and other necessaryes to hange up the clothe &
for watchyng upon good fryedaye and on Ester Evyn
xiijd.
Payd a Reward to Ambros Barkars servant for mendyng
of the clothe that henge abowte the sepulcre by consent
was droppyd with candyll ijs. iiijd.
1533:
To the carpenter for mendyng of the sepulcre xxd.
For watchynge the sepulcre at easter and for brede and
drynke for them that watched ijs.
For ij sakks of coles for the wachmen to make fyer with
all on Easter Eve xviijd. [J. Cox, Chw]
1557:
for the Sextane watching at the Sepulcre iiijd. [Kite,
"Devizes"]

EDINGTON, Monastery of Bonhommes, Church
?ESp* ntd inv of gifts to chapel of Holy Sepulchre in
Edington Church given by Wm Wey (d. 1476):
Thes be goodys of Master William Wey, ys yefte to the

chapel made to the lykenes of the sepulkyr of owre
Lord at Jerusalem.
Furst as for the avter an her, and a canvas, iiij auter
clothys wrowt, ij auter clothys playne, ij tuellys for the
stagys, iiij tuell ordeynyd to wypeyn. Also ij clothys
of blw bawdkyn. Also ij clothys of oworke stayned, in
that one ys owre Lorde wyth a spade in hys Hande in
that other ys owre . . . [half a line scratched out].
Also iij other right wele staynyd clothys of oworke; in
the furst ys a crvcyfyxe in the myddys; in the secvnde
oure lady yevying owre Lorde sowke; in the therde ys
the assumcyvn of ovre blessyd Lady. Also ij other
clothys of lynclothe wyth thre blac crossys in eche of
hem.

Off Vestymentis.

Fvrst a peyre of vestymentis of grene, the orfray rede.
Also a peyre of red vestymentys of the flex of red
velwet, orfray red sylke. Also a peyre of grene vesty-
mentis of bawdkyn with byrdys of golde, the orfray of
red bawdkyn. Also a peyre of vestymentis of whyte
bustyan, the orfray of grene. Also bysyde theot ij
aubys and ij amyse and ij gerdelys.

Off Corporas.

Fvrst iiij corporas clothes. Also iiij corporas casys, the
fvrst of clothe of golde wyth Jaochym and Anna; the
secvnde of blak selke wrowte; the thryde of whyte
bustyan; the fowrthe of grene wyke.

For the hangying of the sepulkyr
wythowte and whythyn.

Furst ij cvrteynys of blw bokeram. Also a clothe
stayned wyth the tempyl of Jerusalem, the Movnte of
Olyvete, and Bethleem. Also a chalyse, selvyr and
overgelde, weyeng . . . unses, made fast wyth a vyse
of selvyr in the fote. Also iij peyre crwetys of pewtyr.
Also iij dysches of pewtyr. Also a paxbrede with a
crwcyfyxe. Also the vernakyl and a crucyfyx in pawper
closyd to bordys, the wheche came fro Jerusalem. Also
a relyquary of box in the wheche be thys relyks. A
ston of the Movnte of Calvery, a stone of sepulkyr, a
stone of the hyl of Tabor. A stone of the pyler that
ovre Lord was stowrchyd too. A stone of the plase
wher the crosse was hyd and fvnde. Also a stone of
the holy cave of Bethleem. Also a sacryng bel halwyd,
wryt aboute "Jhesus Johannes pyt ney". Also ij priketis
of latyn. also ij stondyng candylstykys of latyn. Also a
quayer of paper wyth the peyntyng of owre Lorde ys
passyvn. Also ij pylwys of sylke.

Other goodys longyng to the <se>pulkyr.

Furste a clothe stayned wyth thre Maryes and thre
pilgremys. Another wythe the aperyng of owre Lord
Cryste Jhesu vnto hys moder. Also a mappa Mundy.
Also a mappa of the Holy Lond wyth Jerusalem in the
myddys. Also ij levys of parchement, on wyth the
tempyl of Jerusalem, another wyth the holy movnte of
Olyvete. Also a dex keveryd wyth blakke and thereupon
the bokys; one of materys of Jerusalem, the second
folio. *To every bayok.* Another of Synt Anselme ys
worke the second fo. *Meditacio vii.* Another de vita
Sanctorum Patrum, the second fo. *rat amicus abbatis.*
Also a stone in the whech ys the depyne of the
morteyse of ovre Lordys crosse. Also iiij qwystenes
ordeyned to the sepukyr.

Other thyngys of the Holy Land mad in bordys.

Fvrst in a borde byhynde the qveer the lengthe of oure
Lorde ys sepulkyr wyth the hythe of the dor, the
brede of the dore, the lengthe of our Lordys fote, the
depnes of the morteyse of the crosse, and rvndenys of
the same. Also by the clokke howse of the sepulker of
ovre Lorde wyth too howses at the endys of the same.
Also in the chapterhowse ther be thre thyngs, the
chapel of Caluery made in bordys; the Cherch of Beth-
leen made wyth bordys; the Mownte of Olyuete, and the
Vale of Josaphath made wyth bordys.
My wyl is that thes afore wret be nat alyened fro the
chapel of the Sepulke, nether fro the holy monastery of
Edyngdon. [Smith & Cunnington]

GREAT CHEVEPELL, St Peter or SS Peter & Paul
?ESp/tomb; recess in N wall of chancel; height about 3';
early 13c. [Kite, "Devizes"; VCH 10]

HANNINGTON, St John Baptist
ESp* ntd chantry certificate 1548-9:
for the Sepulchre light out of the Sepulchre half [feeld]
ijd. [Walcott, "Inv Wl"]

MARLBOROUGH, White Friars (Carmelite)
ESp* ntd inv taken at suppression, 1538:
Item a hangyng of sylke for ye sepulchre ijs. [Clarke-
Maxwell]

MERE, St Michael
ESp; arched recess in N wall of chancel at floor level;
rubble masonry; width 3'9"; height 1'10" to springing;
height 3'9" to apex; depth 1'1"; arch of radiating
rubble stones; slightly pointed. [Ponting, "Mere"]

ESp ntd churchwardens' accts 1556:
Item for makvng of iiijer pynnes for the Sepulchre iiijd.
1558:
Item for nayles and pynnes • for the Sepulchre.
[Baker, "Mere"]

PURTON, St Mary
?ESp/tomb in chancel; extensively restored. [Pevsner]

SALISBURY, Cathedral, St Mary
ESp* ntd in reference to *Depositio* in 4 consuetudinaries
of Use of Sarum collated by Frere:
The Old Register of Sarum, 1250-1300, Diocesan
Registry Office;
Dublin Troper, c.1300, Add. MS. 710, Cambridge Uni-
versity Library;
Bodleian MS. 443 (2384), early 14c;
Harl. MS. 1001, early 14c, British Library.
De Officio Thesaurarii.
Praeterea in die parasceues post repositum corpus
domini in sepulchro, duo cerei dimidie libre ad minus in
thesauraria tota die ante sepulchrum ardebunt. [Frere,
Use of Sarum 1; cf. Lipphardt No. 415] [Although not
all these texts include the words "in thesauraria,"
RCHM Salisbury views the one that does as the best
text.]
Depositio also ntd in 6 customaries of Use of Sarum col-
lated by Frere:
Oxford, Corpus Christi College, MS. 44, end of 14c;
Salisbury Cathedral, MS. 175, end of 14c;
British Library, Harl. MS. 2911, 15c;
British Library, Arundel MS. 130, 15c;
Bodleian Library, Rawlinson A. 371 (15450), 15c;
Bodleian Library, Jones MS. 59 (8967), 15c.
Notandum quod a die parasceues ardebit continue unus
cereus ad minus ante sepulcrum usque ad processionem
que fit in resurreccione dominica in die pasche. [Frere,
Use of Sarum 1; from Rawlinson MS.]
Quando amoueri debent sepulchrum et magnus cereus
paschalis. Die ueneris in ebdomada pasche ante missam
amoueatur sepulchrum. [Frere, *Use of Sarum* 1; cf.
Lipphardt, No. 415]
RCHM notes that location of ESp in treasury is consis-
tent with itinerary of procession with cross from ESp on
Easter morning in *Elevatio* from Consuetudinary
?12c-early 13c.
Also ntd Treasurer's inv c.1214-22:
Item, velum unum de serico supra sepulchrum. [RCHM]

Ntd *Depositio* in Missal of c.1264, Manchester, John
Rylands Library, MS. Lat. 24:
Deinde exuat sacerdos casulam & assumens secum unum

de prelatis reponat crucem in sepulchro cum corpore
dominico incipiens Responsorium.
 Estimatus sum <cum descendentibus in lacum, factus
 sum sicut homo sine adjutorio, inter mortuos
 liber>.
Deinde incensato sepulchro et clauso; incipiat
Responsorium.
 Sepulto domino <signatum est monumentum,
 volventes lapidem ad hostium monumenti; ponentes
 milites qui custodirent illud>.
Antiphona
 In pace in idipsum <dormiam et requiescam>.
Antiphona.
 In pace factus <est locus eius, et in Sion habitatio
 eius>.
Antiphona
 Caro mea requiescet <in spe>.
[f. 94V; fig. 22; cf. Lipphardt, No. 418). Virtually
identical text in 13c Missal, Paris, Bibl. d'Arsenal, MS.
135, f. 89r, which adds later antiphon:
 Quamdiu Corpus Domini ibi fuerit, lumen ante
 supulchrum ardeat. [Lipphardt, No. 416]

Ntd Depositio in Gradual of c.1275, British Library
Add. MS. 12194, p. 104:
Deinde exuat sacerdos casulam et assumens
secum unum de prelatis reponat crucem in
sepulcro cum corpore dominico incipiens
Responsorium
 Sepulto domino <signatum est monumentum;
 volventes lapidem ad hostium monumenti; ponentes
 milites qui custodirent illud>.
Antiphona
 In pace in idipsum <dormiam et requiescam>.
Antiphona
 In pace factus est <et in Sion habitatio eius>.
Antiphona
 Caro mea requiescet in spe.
[Frere, Graduale Sarisburiense; Lipphardt reports that
his text No. 417 comes from this manuscript, but it
does not: it is taken instead from the Processional
edited by Henderson.]

Ntd Elevatio in 15c Ordinal, British Library, Harl. MS.
2911:
In die pasche ante matutinas & campanarum pulsationem
conueniant clerici ad ecclesiam & accendantur omnia
luminaria per totam ecclesiam | Duo excellentiores
presbiteri in superpelliciis cum ceroferariis & thuribulis
& clero ad sepulcrum accedant & incensato prius
sepulcro cum magna veneracione statim post
thurificatione videlicet genuflectione corpus domini cum

priuatim super altare deponatur.
Illis accipientibus crucem de sepulcro incipiat
excellentior persona antiphonam.
christus resurgens <ex mortuis iam non moritur,
mors illi ultra non dominabitur. Quod enim vivet,
vivet Deo, alleluia, alleluia>.
cum qua eat processio per hostium presbiterii australe
incedens & per medium chori regrediens cum predicta
cruce de sepulcro assumpta inter duos sacerdotes
predictos super eorum brachia venerabiliter portata
cum thuribilis & ceroferariis precendentibus ad unum
altare ex parte ecclesie boriali choro sequente habito
non mutato excellioribus precedentibus. corpore vero
dominico super altare in pixide dimisso sub thesaurarii
custodia qui illud statim in pixide dimissum in
tabernaculo dependeat & tunc pulsentur omnes campane
in classicum. [ff. 42v-43r; figs. 23-24]

Ntd Depositio and Elevatio in Breviary printed in Venice
in 1483:

<Depositio>

Hac feria .vi. in die parasceue in aurora accedant duo
clerici & honeste faciant sepulchrum domini in sinistra
parte altaris quod omnino non amoueatur usque ad .vi.
feriam in hebdomada pasche ante primam de die videlicet
ante missam.
Finitis his vesperis exuat casulam sacerdos & assumens
secum vnum de prelatis in superpelliciis & reponent
crucem primo in sepulchro: deinde corpus dominicum
videlicet in pixide: incipiens ipse solus sacerdos hoc
responsorium.
 Estimatus sum <cum descendentibus in lacum,
 factus sum sicut homo sine adjutorio, inter mortuos
 liber>.
cum genuflectione cum socio suo: quo responsorio
incepto surgant: similiter facient in isto responsorio:
 Sepulto domino <signatum est monumentum;
 ponentes milites qui custodirent eum>.
Chorus totum responsorium prosequatur cum suo versu.
genuflectendo per totum tempus usque in finem seruitii.
Deinde incensato sepulchro et clauso ostio incipiat
sacerdos vt supra dicitur. Responsorium
 Sepulto domino.
Chorus prosequit totum Responsorium cum suo versu
usque in finem. Item solus sacerdos incipiat
Responsorium
 In pace in idipsum.
Chorus:
 Dormiam et requiescam.
Item sacerdos Responsorium.

In pace factus est locus eius.
Chorus.
 Et habitatio eius in syon.
Item sacerdos
 Caro mea
Chorus.
 Requiescat in spe.
Et ad istam antiphonam genuflectent duo presbiteri sic
finiti omnibus istis recedent omnes.

<Elevatio>

in die pasche ante matutinas & campanarum pulsatio.
conueniant clerici ad ecclesiam & accendantur luminaria
per ecclesiam. Duo excellentissimi presbyteri in
superpelliciis cum ceroferariis. & thuribilis. & populo
circumstante ad sepulchrum accedant & incensato prius
sepulchro cum summa ueneratione videlicet genuflectendo
post thurificationem corporis domini pixidem deponent
super altare. Item illis accipientibus crucem de
sepulchro clero & populo interim genuflectionibus &
crucem adorantibus excellentior persona alta voce
incipiat antiphonam.
 Christus resurgens ex mortuis iam non moritur
 mors illi vltra non dominabitur quod enim viuit
 viuit deo alleluia alleluia.
Versus
 Dicant nunc iudei quomodo milites custodientes
 sepulchrum perdiderunt regem ad lapidis positionem
 quare non seruabant petram iusticie: aut sepultum
 reddant aut resurgentem adorant nobiscum
 dicentes. Quod enim viuet <vivit Deo, alleluia,
 alleluia>.
Tunc omnes campane in classicum pulsentur: & sic cum
summa veneratione deportetur crux ad locum vbi
prouisum fuerit clero canente predictam antiphonam quo
facto dicitur versus
 Surrexit dominus de sepulchro.
Versus
 Qui pro nobis pependit in ligno alleluia.
Oratio.
 Deus qui pro nobis filium tuum crucis patibulum
 subire voluisti: vt inimici a nobis expelleres
 potestatem: concede nobis famulis tuis vt in
 resurrectionis eius gaudiis semper viuamus. Per
 eundem <Cristum Dominum nostrum>.
[STC 15795, sigs. M9^{r-v}, N2^{r-v}; cf. Lipphardt, No.
420 (Depositio only)]

Ntd Depositio in Processionale ad Usum Sarum printed
by Richard Pynson in 1502:

<Depositio>

Finitis versibus exuat sacerdos casulam & sumens
secum vnum de prelatis in superpelliciis discalciati
reponant crucem propter cum corpore dominico in
sepulcrum incipiens ipse solus hoc Responsorium
Estimatus sum genuflectendo cum socio suo, quo incepto
statim surgat similiter: fiat in Responsorio Sepulto
domino. Chorus totum Responsorium prosequatur cum
suo versu Genuflectendo per tempus usque ad finem
seruicii Responsoria vt sic.
 [With musical notation] Estimatus sum
chorus prosequatur
 cum descendentibus in lacum factus sum sicut homo
 sine adiutorio inter mortuos liber
versus
 Posuerunt me in lacu inferiori in tenebrosis & in
 vmbra mortis. Factus
Dum pridictum [sic] Responsorium canitur cum suo
versu predicti duo sacerdotes thurificent sepulcrum quo
facto & clauso ostio incipiat idem sacerdos hoc sequens
Responsorium
 [With musical notation] Sepulto domino signatum est
 monumentum Uoluentes lapidem ad ostium
 monumenti
 Ponentes milites qui custodirent illud.
Versus
 Ne forte veniant discipuli eius et furentur eum et
 dicant plebi surrexit a mortuis. Ponentes
Sacerdotes dicant antiphonam
 [With musical notation] In pace
chorus prosequatur sic.
 in idipsum dormiam & requiescam
Sacerdotes antiphonam
 [With musical notation] In pace factus est
chorus prosequatur
 locus eius et in syon habitacio eius
Sacerdotes antiphonam
 [With musical notation] Caro mea
Chorus prosequatur
 requiescit in spe.
Ad istas tres antiphonas genuflectent predicti duo
sacerdotes continue Hiis finitis ordine seruatis [?]
reinduat sacerdos casulam, eodem modo quo accessit in
principio seruicii cum diacono & subdiacono & ceteris
ministris abcedat. Exinde continue ardebit unus
cereus ad minus ante sepulcrum usque ad processionem
que fit in resurrectione dominica in die pasche ita tamen
quo dum psalmus Benedictus canitur & cetera que
sequuntur in sequenti nocte extinguatur similiter &
extinguatur in vigilia pasche dum benedictur nouus
ignus. [ff. 64ʳ-65ʳ]

Ntd reference to preparation of Host for ESp in Missal
printed in Paris by F. Regnault in 1526:
Feria .v. in cena domini.
Ponantur a subdyacono tres hostie ad consecrandum:
quarum due referuentur in crastinum: vna ad
percipiendum a sacerdote. reliqua vt ponatur cum cruce
in sepulchro.
Missal has usual text of Depositio, adding at conclusion:
Exinde ardebit continue vnus cereus ad minus ante
sepulchrum usque ad processionem que fit in
resurrectione dominica in die pasche. ita tamen quod
dum psalmus Benedictus canitur. & cetera que
sequuntur in sequenti nocte extinguatur. Similiter
extinguatur in vigilia pasche dum benedicitur nouus
ignis usque dum accendatur cereus paschalis .xxxvj.
pedes continentes in longitudine. [STC 16205, ff. lxxiV,
lxxiiir]

Ntd Elevatio in Breviary printed in Paris by F.
Regnault in 1531:
In die sancto pasche ante matutinas et ante
campanarum pulsationem conueniant clerici ad ecclesiam
et accendantur luminaria per totam ecclesiam. Tunc duo
excellentiores presbyteri in superpelliciis cum duobus
ceroferariis & duobus thuribulis & clero ad sepulchrum
accedant: & incensato a predictis duobus presbyteris
prius sepulchro cum magna veneratione: videlicet
genuflectendo: statim post thurificationem corpus
dominicum super altare priuatim deponant: iterum
accipientes crucem de sepulchro: choro et populo
interim genuflectente incipiat excellentior persona
antiphonam
 Christus resurgens.
Et chorus prosequatur totam antiphonam sic,
 ex mortuis iam non moritur: mors illi vltra non
 dominabitur: quod enim viuit viuit deo alleluia
 alleluia.
Et tunc dum canitur antiphona, eat processio per
ostium australe presbyterii incedens & per medium chori
regrediens cum predicta cruce de sepulchro inter
predictos duos sacerdotes super eorum brachia
venerabiliter portata: cum thuribulis et ceroferariis
precedentibus per ostium presbyterii boreale exeundo:
ad unum altare ex parte boreali ecclesie choro sequente:
habitu non mutato minoribus precedentibus. ita tamen
quod predicti duo excellentiores in fine processionis
subsequantur corpore dominico super altare in pixide
dimisso et sub thesaurarii custodia: qui illud statim in
predicta pixide in tabernaculo deponat et tunc pulsentur
omnes campane in classicum. [STC 15830, f. cxxvV]

SALISBURY, Hospital of the Holy Trinity
ESp* ntd inv 1418:
In capella vnum pannum pro sepulchro staynatum.
Inv 1436:
Item vnum staynyd cloth pro sepulchro pretij xld. [T.
Baker, "Trinity Hosp"]

SALISBURY, Most Holy & Blessed Trinity (Dominican)
ESp ntd inv taken at suppression, 1538:
In the chapell bi ye quere.
Item an olld chest & a frame for ye sepulchre.
Item a bere & a forme. [Palmer, "Black Friars Wl"]

SALISBURY, St Edmund (Collegiate)
ESp* ntd churchwardens' accts 1443-6:
Willielmo Ovynge pro factura le Taperis pro cepultura
deservienda & pro cerae erga festum Pasche Anno xxiij
Regis H. vjti iiijs.
1462-3:
Et in factura xxxij lb. in staplis & barris ferreis pro
sepulcro luminis de ferro proprio ijs. viijd.
Et carpentar' facienti postem sepulcri cum mearemio ad
idem vid.
Et in pictura diuers' necessariorum circa sepulcrum
iiijd. Et in lotione iiij albarum ij tuell' & j lynthianium
pro sepulcro cum emendacione vnius albe dirupte vijd.
1468-9:
Et in vno homine conducto pro labore suo circa
Sepulchrum videlicet Petro Joynor in toto xxd.
Et in candelis emptis et expentendis circa opus predicti
sepulcri jd.
Et Johanni Smythe pro xvj lib ferri occupat' circa
sepulchrum ijs. vjd.
Et eidem Johanni Smythe pro labore suo in operacione
proprii stauri ecclesie circa sepulchrum occupat' xijd.
Et Johanni Russhe Turner pro factura xllvij pynys de
Beche & Asshe ad standum supra sepulcur' pro cera
ibidem ardente xviijd.
Et Willielmo Eglys mason pro labore suo circa Sepulcur'
vid.
1472 inv:
Item ij palles of cloth of goolde for the sepulcre with te
of Raynes.
1476-7:
to William Kerver for the makyng' of a newe Sepultur'
vjs. viijd.
for the beryng' of the same to the Church' iiijd.
1477-8:
Et soluti pro ferramento de nouo empto pro firmacione &
factura de la Sepultur' ibidem xiijs. iiijd.
1510-1:
Et de jd.--pro jc Splintr' pro sepulcro domini hoc Anno

empt'.
Undated:
for a c pynnes for the Sepulture jd.
1523-4:
pynys for the sepulcre ijs. iiijd.
1538-9:
pynnes for the sepulcre jd.
1553-4:
Sawyng' of the tymber that went a bowte the Sepulcer
xd.
stapelles and lockes for the Sepulcer and Verylles for
the canapy staves iijs.
Nycholas [burges] for the watchyng' of the Sepulcer ij
nightes vijd.
makyng' of the Sepulcer vis. viijd.
ij peces of tymber xd.
a pound' of glewe ijd.
a pece of tymber iiijd.
payntyng' of the Sepulcer ijs.
cords ijd.
pynnes ijd.
nayles ijd. ob.
Robert martyn for dressyng' of the Sepulcer viijd.
1556-7:
drynke for them that dyd dresse the Sepulker ijd.
Nycholas burges for watchyng the Sepulker vjd.
1557-8:
watchyng' of the Sepulker vjd.
Setting' vpp of the Sepulker ijd.
pynnes to pyn the Sepulker jd. [Swayne, *Sarum*]

SHORNCOTT, All Saints
?ESp/aumbry; wide, low-arched recess with cinquefoiled
head in N wall of chancel between Win N2 & N3; width
3'; height 1' 9" to springing; depth 10 1/2"; sill 4'
above present floor; later insertion in Norman wall.
[Ponting, "1892"]

STEEPLE ASHTON, St Mary
ESp* ntd inv of 1542:
Item of grene sylke and sepulchere clothe. [Lukis]

WORCESTERSHIRE (Wr)

BADSEY, St James
ESp ntd churchwardens' accts 1534:
Item payyd for ye peyntyng of ye sepulcer clothe
xiiijd. [Wadley, "Badsey"]

BREDON, St Giles
ESp/founder's tomb; recess of white stone in N wall of
chancel contains plain blue coffin-shaped stone; seg-
mental pointed arch of recess has pierced cusping &
sub-cusping; arch surrounded by hollow molding with
large ballflowers joined by twining stem; surrounding
this a triangular pediment with trefoil under point of
pediment; outer side of pediment has crocketing, behind
which slanting sides of canopy cut to imitate over-
lapping tiles; finial & pinnacles of flanking pilasters
broken off; canopy has traces of red decoration;
1300-20; il Keyser, "Bredon," fig. 9; VCH 3, opp. p.
288. [Pevsner]

CHADDESLEY-CORBETT, St Cassyon
?ESp; richly molded niche in N wall of chancel. [J. S.
Walker]

GREAT HAMPTON, St Andrew
Wooden ESp in form of chest with paneled & traceried
sides; length 4'3"; width 2'; height 3'; 15c; formerly in
this church; present location unknown. [Bond,
Chancel]

HALESOWEN, SS Mary & John Evangelist or St John Baptist
ESp ntd churchwardens' accts 1487-8:
item for xviij li of wax at ixd. a li for the sepulter
light and the Fstur taper xiijs. v[d.]
item payed to Thomas Hipkes for makyng of the tapurs
to the sepultore vjd.
1488-9:
item for tentur hokes atte sepulter jd.
1496-7:
item Reseyvyd upon Ester day to ye ester taper & ye
sepulcur lygth.
1497-8:
item resevyd upon ester day to ye Ester tapur & to ye
sepulcur lvgth xjs. vjd.
1527-8:
item payd to Richard Harrysone for wagheyng of ye
sepullcur two Nyghts iiijd.
1541-2:
item payd to Raffe Swyfte for mendyng of the sepulcur
at aster vjd. [Somers]

HANBURY, St John Baptist
ESp ntd Comm inv 1552:
a sepulker of wainscotte. [Walters, "Inv Wr"]

TENBURY, St Mary
?ESp; canopied recess in N chancel E of doorway to
vestry; contains chest of which front has 5 trefoil-

headed panels; recess with cinquefoiled head under
gabled & crocketed canopy; head of canopy with pierced
trefoil; flanking pilasters with gabled & finialed
pinnacles; c.1300; now contains 13c miniature effigy of
knight found in rubbish in 1814. Il VCH 4, opp. p.
368. [Pevsner]

WORCESTER, Cathedral, Christ & Blessed Virgin Mary
ESp* ntd diary of Bishop Blandford, 1548:
March 25th, being Palm Sunday, no palms hallowed, nor
cross borne on Easter eve; no fire hallowed, but the
paschal taper, and the font. On Easter day the Pix,
with the sacrament in it, was taken out of the
sepulchre, they singing "Christ is risen," without
procession. On Good Friday, no creeping to the cross.
1549:
No sepulchre, or service of sepulchre, on Good Friday.
[Green, Worcester 2]

WORCESTER, Diocese of
ESp ntd both in Articles & in Injunctions of Bishop
Hooper for Gloucester & Worcester dioceses 1551-2:
that none of you maintain . . . sepulchres pascal.
That you exhort your parishioners and such as be
under your cure and charge for the ministry of the
church, to take down and remove out of their churches
and chapels, all places, tabernacles, tombs, sepulchres,
tables, footstools, rood-lofts, and other monuments,
signs, tokens, relics, leavings, and remembrances,
where such superstition, idols, images, or other provo-
cation of idolatry have been used. [Frere, Visitation 3]

WORCESTER, Grey Friars
ESp* ntd undated inv:
The Quere a payre off organs a frame for ye
sephulcher a crose with a staffe a lampe
hangyng. . . . [Walcott, "Inv Worcester Cathedral"]

WORCESTER, St Clement
ESp* ntd Comm inv 1552:
a payntid clothe for the Sepulcre. [Walters, "Inv Wr"]

WORCESTER, St Helen
ESp* ntd churchwardens' accts 1520:
Item paid for wachinge of the light abowte the Sepulcre
ijd. [Amphlett]
Also ntd Comm inv 1552:
a hanging for the Sepulcre of buckram. [Walters, "Inv
Wr"]

WORCESTER, St John Baptist-in-Bedwardine
ESp* ntd Comm inv 1552:

iij curteynys wyche wosse for ye sepulcure. [Walters, "Inv Wr"]

WORCESTER, St Michael's-in-Bedwardine
ESp* ntd churchwardens' accts 1543:
Item paid for tacketts, pynnes and threydde to dress the sepulcer ijd. ob.
1545:
Item for the Rode light and sepulter light vijs. jd.
Item for the dressyng of the sepulter iiijd.
1546:
Item for dressyng of the Sepulture at Easter iiijd.
1547:
At Ester for the sepulte lyght, the pascall lyght, the lampe light, with the fonte taper.
Item payde for iij Tapers for the sepulter for makynge of xij li. waxe vjd.
Item payde for the wast of the said iij Tapers vjd.
Item for nayles and pynnes for the Sepulter on Palme Sonday and wyer for the Curteynes for the Sepulter at Ester ijd.
Item for corde for the sacrament and thryd for the sepulcre jd.
Item for nayles to the same ob.
1548:
Item payed for pynnes and Nayles for the dressyng of the Sepulter at Easter jd. ob.
Item payed for the makynge of a tapur to sett on the Aulter at Easter before the Sepulter iiijd. ob.
Item [receaued] for an Ares coueryng which was used to the sepulter sold to Mr. Bland vjs. viijd.
Item [receaued] for ij frames and the endes of the high alter and the frame of the sepulter xvjd.
1555:
Item for the sepulcre ijd.
Item paid to Nycholas for the sepulcre ijs.
Item for Nayles for the sepulcre And coles on Ester even jd.
1561:
An Inventorie of soche goodes as remayne to the churche vse . . . the sepultre without a hedd.
[Amphlett]

WORCESTER, St Swithin
ESp* ntd Comm inv 1552:
A note of that that is sold by me William Longley ij broderid clothes for the Sepulcres vijs. viijd.
ij yardes of chaungeable Silke that was aboute the Sepulcre vs.
ij borders that war aboute the sepulcre iiijd. [Walters, "Inv Wr"]

YORKSHIRE (Ys)

ALDBOROUGH, St Andrew
?ESp*; mutilated fig of Roman soldier, head resting in L
hand, built into wall near S door in 1870. [Twycross-
Raines]

BARDSEY, All Saints
?ESp/tomb; chest in N wall of early 14c chancel under
flat arch open to 17c N chapel; plain slab; near it,
small square-headed window, trefoiled, opens to N
chapel; chancel restored. [Glynne; Pevsner, Ys W
Riding]

BATLEY, All Saints
ESp* ntd 1509 will of Jn Copley:
To one vyse makyng on Estur daie in the mornyng to
the sepulcre iijs. and iiijd. [Test Ebor 5; Sheard,
Batley]

BEVERLEY, Minster, St John Evangelist & St Martin
Reference in 13c to ESp "ex parte aquilonari." [Glynne]
Percy Tomb probably intended for use as ESp; low plain
chest with high, extremely ornate canopy stands in
chancel N of high altar, between a chancel pier and
spiral stair leading to top of screen; tomb, at right
angles to screen, carved on both N aisle & chancel
sides; possibly for either Eleanor Percy (d. 1328) or
for Idoine Percy, in which case it must have been
erected before her death in 1365; dark marble tomb
chest that formerly stood on present base removed in
restoration of 1825 (see Dawton, Pl. XLIV); indent of
brass, now missing, drawn by Carter in 1791 shows fig
under canopy; canopy, of magnesian limestone of
Tadcaster, flanked by buttresses; it has on each face
nodding ogee arch under steep triangular gable; ogee
arches cusped & subcusped, with all surfaces richly
carved; choir side: major cusps have lady & 3 knights
with shields, possibly Lady Percy and her husband;
secondary cusps have St Michael & dragon; Virgin,
seated & crowned, adored by angels; opposite Virgin,
Christ blessing, also seated, crowned, with angels;
points of cusps all have half-figs of angels, some
musical; finial of ogee, projected forward by nodding of
arch, has seated fig of Christ receiving the soul of the
deceased in a cloth; straight gable behind has
exuberant crocketing & 2 projecting brackets that
support figs of angels holding Instruments of Passion;
on aisle side, all 4 major cusps filled with soldiers &
secondary cusps all angels; projecting finial has seated
Christ exposing wound in his side; behind him on
gable, censing angels in mouchettes; reclining poses of

soldiers in cusps reminiscent of sleeping soldiers at
tomb; 1340-50. Fig. 51; see also illustrations in Dawton,
Pls. XLIV-LVI; Evans, *1307-1461*, Pl. 79; Prior &
Gardner, figs. 25, 370, 394.

BEVERLEY, St Mary
Broken fragments from ESp* now in priest's room: 3 pin-
nacles carved in relief with pointed niches; 2 square
panels with flowing blank tracery, both under cornice
with small flowers; 2 panels with tops of lights in blank
tracery, corners filled with cusped trefoils; one piece
of ?base with cusped quatrefoils & graffito signature of
Ivo de Raughton, architect; consecration cross on 3rd
pier from E in chancel suggests location; form may have
been similar to Lincoln; 1320-5. Fig. 55.
ESp ntd will of Cecily Leppington, 12 Dec 1526:
Also I bequeath to the said kirke my best over-see bed
called the Baptest os an ornament to the sepulcre of
oure Saviour Christe Jhesu at the fest of Ester.
[*Test Ebor* 5]

BISHOPTHORPE, St Andrew
ESp* ntd will of Wm Wright, 20 May 1500:
I witt to my parish kirke on old stok of bees with a
swarm, to ye upholdyng of a serge of v pond before ye
sepulcre. [*Test Ebor* 4]

BOLTON (-BY-BOWLAND), SS Peter & Paul
?ESp; fragment of arched recess in N wall of chancel.
[Pevsner, *Ys W Riding*]

BRANDESBURTON, St Mary
?ESp; crocketed ogee niche with groining in N wall of
chancel near E corner; Perp. [Glynne; Pevsner, *Y & E
Riding*]

COWTHORPE, St Michael
?ESp; wooden chest with gabled canopy; front of chest
has 6 blank panels with segmental arches, cusped &
subcusped, flowers in spandrels & large flowers on
points of major cusps; L end paneled like front; R end
& back plain; posts at 4 corners support gabled canopy
with pierced cresting of leaves & Tudor flowers; similar
cresting at base of canopy on front & ends; arched
braces from posts to underside of canopy decorated
with floral motifs & blank shields on L end & front;
gables at ends with crocketing & finials; placement of
decoration indicates that L end & front planned to be
visible, therefore ESp intended for NE corner of chan-
cel; now in NW corner of nave; length about 5' x width
2 1/2' x height 7'; 15c. Fig. 27.

EASBY, St Agatha
?ESp/tomb; recess in N wall of chancel; several iron
eyelets in wall by recess possibly medieval & intended
for fastening ESp frame. [VCH: Ys N Riding 1] Fig.
30.

EAST GILLING, Holy Cross
ESP/tomb; recess with pointed segmental arch and
quatrefoil decoration in N wall of chancel under Win N2;
slab has effigy in sunk relief; late 13c. [VCH: Ys N
Riding 2]

FEATHERSTONE, All Saints
ESp* ntd Comm inv 1552:
sepulcre howse. [Page, *Inv York*]

HARPHAM, St John of Beverley
ESp/tomb between chancel & (N) chantry of Our Lady;
alabaster chest tomb, sides paneled with blank shields;
slab on top (length 6'5" x width 3'5") incised with figs
of Sir Wm de St Quinton (d. 1349) & wife (d. 1382 or
1384); tomb from date of wife's death; fig of Sir Wm in
mixed armor of mail & plate; wife dressed as widow;
figs under double canopy; heads rest on pillows, hands
clasped in prayer; border inscription; tomb slab il
Stephenson, "Harpham," Pl. I.

HEDON, St Augustine
ESp* ntd churchwardens' accts 1396-98:
Et soluti pro emendacione formelle et j. sepulcri, xij.d.
temp. Henry VI:
et alterius ymagine pro Corpore Christi deferendo
tempore Resurreccionis ex precepto maioris.
c.1453-4:
Et in clavis emptis pro sepulchro, ob.
1483-5:
Paynter emendanti pictoram ymaginis Resurreccionis
Domini erga Pascha hoc anno.
1545-56:
Item, for wodde and colles on Pasche nyghtt to Kellett
iiij.d.
Item, to Kellett for wachynge the churche that nyghtt
iiij.d. [Boyle]

HOVINGHAM, All Saints
ESp* ntd will of Lancelot Stapilton, 1 Feb 1538:
Also I chardge myne executors the day of my buriall to
lett be borne about my bodie xiijth serdges, xij of them
a pounde of pece, and the xiijth of thre pounde, in the
worshipe of the Father, the Sone and the Holie Gost,
and that serdge to be burned afor the sacrament, and
the other xij serdges to be burned in like maner afor

the sacrament and the sepulcre, every ij serdges at ons
so long as they last, and that if the proctor or the
prest clame any of them, then I will that voue here
none, but light them at youre pleasure where you list.
[Test Ebor 6]

KINGSTON ON HULL, St Mary Lowgate
ESp* ntd will of Johanna Fitlyng, 2 Aug 1440:
Volo quod unus pannus meus aureus cum nigro
fundamento imperpetuum custodiatur per custodes
fabricae dictae capellae ad ornamentum sepulchri Domini
in Festo Paschali. [Test Ebor 2]

KIRKBY-IN-CLEVELAND, St Augustine
ESp* ntd 1457 will of Tho Aleby, rector:
Item lego fabricae cujusdam sepulcri noviter faciendi
vjs. viijd.
Item lego pro coopertura ejusdem sepulcri quemdam
pannum de serico. [Test Ebor 2]

KIRKBY WISKE, St John Baptist
?ESp; arched recess in N wall of chancel; arch trefoiled
under crocketed gable with large finial; flanking
pilasters with gabled & crocketed finials; plain slab;
chest has band of foliage on chamfered upper edge;
14c; near it head bracket, also of 14c, that could have
been used as support for image or light; whole recess
largely restored; il VCH: Ys N Riding 1, opp. p. 180.

METHLEY, St Oswald
ESp* ntd will of Wm Smith, 13 May 1539:
Also I will that Elizabeth my doughter shall fynde one
candill afor the sepulcre of oure Lorde, and one Candle
to be afor the blisside sacrament enduringe hir lif if
she shalbe of suche power. [Lumb]

MYKYLL USBURNE, Church
ESp ntd will of Randall Ward, 29 Jan 1559:
Item I gyffe to ye churche ij. buschells of barlye . . .
bestowed at ye dyscrecon off ye churchewardons and
sett uppe a candell before ye sepulcrur every ʒere to
be prayed for. [Raine, Richmond]

OWSTON, All Saints
?ESp; arched recess with crocketed gable in N wall of
chancel; arch has cusping; 1290-1330. [Brickhill]

PATRICK BROMPTON, St Patrick
ESp/tomb; recess in N wall of chancel; arch trefoiled and
cusped, flanking crocketed pinnacles; much restored;
?14c. [VCH: Ys N Riding 1]

PATRINGTON, St Patrick
ESp in N wall of chancel E of N door; a vertical monu-
ment of type found in Ls & Ns; whole composition
flanked by 2 buttresses topped with finials that rise to
cornice; lowest level treated like front of tomb chest; 3
ogee-headed niches with crockets and finials frame 3
sleeping soldiers, each with pointed basinet & heater-
shaped shield; soldier to W has lion on his shield, one
in center a boss, & third instruments of Passion; slab
above them forms floor of plain rectangular recess full
width of ESp; then shelf which serves as Christ's tomb;
he is in a sitting position with one leg thrown over
edge of tomb, knees bent; head turned to face viewer;
he has long, curly hair; an angel on each side of him
swings a censer; above this relief another plain recess,
higher than first, topped with a cusped ogee arch with
finial rising to the cornice; possibly separate recesses
were for cross & Host; c.1330-39. Fig. 47.

RICHMOND, St Mary Virgin
ESp* ntd 1433 will of Margaret Blackburn which asks
that 8 wax candles of 16 lb. each burn at her funeral:
Et alii duo eorumdem tortis maneant ecclesiae parochiali
Sanctae Mariae Virginis in Richemond ad comburendum
ibidem die Paschae tempore Resurrectionis Domini nostri
Jhesu Cristi dum durare poterunt. [Test Ebor 2]

SCARBOROUGH, St Mary
ESp* ntd inv 1434:
Et duos pannos de serico stragulato pro sepulcro
domini. Unum pannum lineum cum rubio serico
borduratum ad sepulcrum. [Hope, "Scarborough"]

SEATON-ROSS, St Edmund
ESp* ntd will of Ralph Elwick, 2 May 1531:
also vjs. viijd. to fynd one light afor sepulcor and so
to bedysposed as my executors thynkes the best to be
doyn. [Test Ebor 6]

SHEFFIELD, SS Peter & Paul
ESp* ntd churchwardens' accts 1558:
Item paid for a clothe to ye Sepulcers house
conteynynge xii. yards at viiid. ye yerd viiis.
Item paid to Hugh Paynter for payntynge ye Sepulcre
clothe iiiis.
Item paid for settinge uppe of ye Resureccion viid.
[Hunter, Hallamshire]

SHERIFF HUTTON, St Helen & Holy Cross or St Helen
ESp ntd inv 1524:
Item Baner clothis for the sepulkyr of sylke.
Wax belongyng to the sepulcre lyght [list of names

4

follows; next to each: "ij pounds wax"].
Churchwardens' accts ?1554:
payd for mendynd the sepullcre iiid. [Purvis]

SKECLYNG (?SKEFFLING, St Helen)
ESp* ntd will of Eliz Hatfield, 19 May 1509:
Ecclesie parochiali meae j ares-bed, ea intentione quod
quolibet anno die obitus mei cooperuerit super sepulcrum
meum et mariti mei, et ad ornamentum sepulcri Domini
tempore Paschali et Sacramenti, dum valet et durabit.
[Test Ebor 5]

THORNTON STEWARD, St Oswald
?ESp/tomb; recess with pointed segmental arch in N wall
of chancel; hood has carved heads at apex &
headstops; 14c. [Pevsner, Ys N Riding]

WHITKIRK, St Mary
ESp* ntd will of Alvered Manston, 6 June 1439:
Item volo et ordino quod quolibet die Passenae
[?Parasceues] in honore Domini nostri Jhesu Christi et
quinque vulnerum ejus, ordinentur quinque librae cerae
in candelis ad ardendum ante sepulcrum in ecclesia
predicta, et xvd. ad solvendum eodem die pauperibus,
et hoc pro termino quinque annorum proxime post
mortem meam sequencium. [Test Ebor 2]

YORK, All Saints, North Street
ESp* ntd 1407 will of Wm de Vescy leaving 8 lb. wax for
candle for ESp.
Also ntd 1429 will of Jn Reresby leaving 6d. to ESp
light. [Raine, Med Y]
Also ntd 1433 will of Margaret Blackburn who asks that
8 wax candles of 16 lb. each burn at her funeral:
volo quod duo remaneant ecclesiae parochiali Omnium
Sanctorum in Northstrete in Eboraco ad comburendum
ibidem annuatim die Paschae tempore Resurreccionis
Domini nostri Jhesu Christi dum durare poterunt.
[Test Ebor 2]
Also ntd 1442 will of Margaret Gateshead leaving bed of
"ruby say" embroidered with Vernicle to ESp.
Also ntd 1444 will of John Sharpe mentioning light at
ESp. [Raine, Med Y]

YORK, Diocese of
ESp ntd Item 15 of Injunctions of Archbishop Edward Lee
for York Diocese c.1538:
Nevertheless they may still use lights in the rood-loft,
and afore the Sacrament, and at the sepulchre at
Easter, according to the King's Injunctions. [Frere,
Visitation 3]

YORK, Holy Trinity, Goodramgate
 ESp* ntd 1433 will of Margaret Blackburn which asks
 that 8 wax candles of 16 lb. each burn at her funeral:
 Et alii duo eorumdem tortis maneant ecclesiae parochiali
 Sanctae Trinitatis in Curia Regis Ebor. ad comburendum
 inibi, modo et forma predictis [i.e., tempore
 Resurreccionis Domini nostri Jhesu Christi in die
 Paschae, dum durare poterunt, annuatim]. [Test Ebor
 2]
 Also ntd churchwardens' accts 1557. [Benson, "Holy
 Trinity"]

YORK, Minster, St Peter
 Chapel of St Mary & All Angels, popularly known as St
 Sepulchre's, founded in late 1170's by Archbishop Roger
 as separate structure in precincts of Archbishop's
 Palace and with door to N aisle of Minster; chapel
 enlarged under Archbishop Melton in 1333; door to nave
 may date from this time rather than earlier; chapel had
 its own resident body of canons; building no longer
 extant; may have been used as ESp for cathedral;
 devotion to it indicated by 1398 will of Johannus Wawan:
 Item lego fabricae capellae Sancti Sepulcri xj l. vjs.
 viijd. [Test Ebor 1]
 ESp* ntd Depositio in Manuale insignis Ecclesiae Ebora-
 censis printed by Wynkyn de Worde in 1509:

 In die parasceue

 Tandem adorata cruce baiulent eam duo presbiteri ad
 locum sepulcri vbi prelatus eam suscepit incipiendo
 antiphonam.
 [With musical notation] Super omnia ligna
 cedrorum tu sola excelsior in qua vita mundi
 pependit in qua christus triumphauit et mors
 mortem superauit in eternum.
 antiphonam.
 [With musical notation] In pace in idipsum dormiam
 et requiescam.
 antiphonam.
 [With musical notation] Habitabit in tabernaculo tuo
 requiescet in monte sancto tuo.
 antiphonam.
 [With musical notation] Caro mea requiescet in spe.
 Tunc presbiteri flexis genibus ponentes crucem in
 sepulcro et thurificent eam & postea incipiant:
 [With musical notation] Sepulto domino signatum est
 monumentum ponentes milites qui custodierunt
 illud.
 [STC 16160, sig. lv^r-v]

 Also ntd Depositio & Elevatio in Processionale completum

per *totum anni circulum*. Ad usum celebris ecclesie
Eboracensis, printed in ?Rouen by J. Gachet in 1530:

<Depositio>

In die parasceue.
Tandem adorata cruce baiulant eam duo presbyteri
ascendentes per partem aquilonarem chori usque ad
sepulcrum et ibi sacerdos incipiat antiphonam.
[With musical notation]. Super omnia ligna cedrorum
tu sola excelsior in qua vita mundi pependit in qua
christus triumphauit et mors mortem superauit in
eternum.
antiphonam.
[With musical notation] In pace in idipsum dormiam
et requiescam.
antiphonam.
[With musical notation] Habitabit in tabernaculo tuo
requiescet in monte sancto tuo.
antiphonam.
[With musical notation]. Caro mea requiescet in
spe.
Postea executor officii genuflectens ponat crucem in
sepulchro et thurificet eam et rectus incipiat et chorus
finiat.
[With musical notation] Sepulto Domino signatum
est monumentum ponentes milites qui custodierunt
illud.
[ff. 34ᵛ-35ʳ]

<Elevatio>

In die sancto pasche.
Sequitur missa in ecclesiis parochialibus in die pasche in
aurora pulsatis campanis ad classicum congregato clero
et populo flexis genibus dicitur oratio dominicalis &
postea sacerdos thurificet sepulchrum et proferatur
sacramentum cum imagine cum corona spinea incipiatur
Responsorium
 Christus resurgens.
quod cantetur circa fontem cereis precedentibus.
 [With musical notation] Christus resurgens ex
 mortuis iam non moritur mors illi vltra non
 dominabitur. Quod enim viuit viuit deo. Alleluya
 alleluya.
Versus
 Dicant nunc iudei quomodo milites custodientes
 sepulchrum perdiderunt regem ad lapidis positionem
 quare non servabant petram iusticie aut sepultum
 reddant aut resurgentem adorent nobiscum
 dicentes. Quod <enim vivit, vivit Deo, alleluia,
 alleluia>.

[With musical notation]
Te deum laudamus te dominum confitemur.
Te eternum patrem: omnis terra veneratur.
Tibi omnes angeli: tibi celi et vniuerse potestates.
Tibi cherubin et seraphin: incessabili voce
proclamant.
Sanctus. Sanctus. Sanctus. Dominus deus sabaoth.
Pleni sunt celi et terra: maiestatis glorie tue.
Te gloriosus: apostolorum chorus.
Te prophetarum: laudabilis numerus.
Te martyrum candidatus: laudat exercitus.
Te per orbem terrarum: sancta confitetur ecclesia.
Patrem immense maiestatis.
Venerandum tuum verum et unicum filium.
Sanctum quoque paraclytum spiritum.
Tu rex glorie christe.
Tu patris sempiternus es filius.
Tu ad liberandum suscepturus hominem non
horruisti virginis vterum.
Tu deuicto mortis aculeo: aperuisti credentibus
regna celorum.
Tu ad dexteram dei sedes: in gloria patris:
Iudex crederis: esse venturus.
Te ergo quesumus famulis tuis subueni: quos
precioso sanguine redemisti.
Eterna fac cum sanctis tuis: in gloria numerari.
Saluum fac populum tuum domine: et benedic
hereditati tue.
Et rege eos et extolle illos usque in eternum.
Per singulos dies: benedicimus te.
Et laudamus nomen tuum in seculum: et in seculum
seculi.
Dignare domine die isto sine peccato nos custodire.
Miserere nostri domine: miserere nostre.
Fiat misericordia tua domine super nos:
quemadmodum sperauimus in te.
In te domine speraui non confundar in eternum.
Versus.
Resurrexit dominus. Sicut dixit vobis.
Oratio.
Presta quesumus omnipotens deus vt in
resurrectione domini nostri iesu christi cum
omnibus sanctis percipiamus portionem. Qui tecum
viuit et regnat Deus. Per omnia secula.
Deinde osculetur cuppa in qua est sacramentum primo a
sacerdote et postea a populo.
[STC 16251, ff. 38ᵛ-41ʳ; Lipphardt, No. 425, but the
source is incorrectly identified by him as a Manual and
Processional of 1509.]

YORK, St Crux
ESp* ntd 1483 will of Joan Gillyot:

I give my best girdle of blue silk ornamented with
silver for the worship and beautifying of the Sepulchre
of our Lord set up each year in St Crux church.
[Raine, *Med Y*]

YORK, St Helen
ESp* ntd 1506 will of Jn Johnson:
to ye light of Seynt Pulcre iiijd.
Also ntd 1508 will of Hew Syngliton:
vj li. wax to sepulchre light. [Raine, *Med Y*]

YORK, St John Evangelist, Ousebridge
ESp* ntd 1433 will of Margaret Blackburn which asks
that 8 wax candles of 16 lb. each burn at her funeral:
Et alii duo eorumdem tortis maneant ecclesiae parochiali
Sancti Johannis Evangelistae ad finem pontis Use in
Eboraco ad comburendum ibidem tempore Resurreccionis
Domini nostri Jhesu Christi in die Paschae, dum durare
poterunt, annuatim. [*Test Ebor* 2]
Also ntd 1441 will of Alice Grymmesby providing 4d. for
candle before ESp for each of 10 years. [Raine, *Med Y*]

YORK, St Lawrence
ESp* ntd 1464 will of Rich Haukesworth leaving 2s. to
maintain light before ESp from Maundy Thursday to
Easter Sunday. [Raine, *Med Y*]

YORK, St Mary Bishophill Senior
ESp* ntd 1489-90 will of Wm Grundall leaving painted
cloth with image of St Geo for its adornment "in die
pascivae et paschali tempore." [Raine, *Med Y*]

YORK, St Mary Castlegate
ESp* ntd 1472 will of Agnes Davyson leaving 12d. for
maintenance of ESp.
Also ntd 1526 will of Eliz Welburne leaving 12d. to her
own candle burning before ESp:
to refresh it so long as it shall last, and then it is to
be burned out for her soul's sake, her husband's soul &
all Christian souls. [Raine, *Med Y*]

YORK, St Michael-le-Belfrey
ESp* ntd 1471 will of Rich Tong. [Raine, *Med Y*]

YORK, St Michael, Spurriergate
ESp* ntd churchwardens' accts 1538:
[1/2d. for pack-thread for] Seynt Pulcher candyll.
Mending the sepulchre house ntd 1541.
1545:
[1/2d. for pack-thread to bind St] Pulchers candyll.
[Raine, *Med Y*]
1546:

Paid for Pake thred for bynding of St Pulcur Candylls
1/2d.
Paid for whyt Thred to the Parysh Clark for sewyng of
Seynt Pulcure Howse and the Vestements id.
Paid to John Carver for a day and di. mendyng of
Seynt Pulcure Howse and for helping of ye Angells'
Wyngys, and the Stawyls in the Churche, and for di.
Day helping of the Hamerrys [aumbries] in the Church
1s. [Heales, "Easter Sepulchres"]
In 1547, ESp seems to have been put away under lock
and key along with figures of saints. [Davidson &
O'Connor]

YORK, St Nicholas, Mickelgate
ESp* ntd 1471 will of Rich Tong:
Volo quod executor meus inveniet et sustentabit
candelam meam vocatam Sepulcre-candell, in custodia
Johannis Belamy, ponderantem iiij. li. cerae, sumptibus
meis propriis et expensis, annualiter combusturam coram
sepulcro Domini in festis Paschalibus in ecclesia mea
parochiali secundum usum ac laudabilem consuetudinem
civitatis Ebor. durante termino vij. annorum post diem
sepulturae meae. [Test Ebor 3]

SELECTED BIBLIOGRAPHY

Abbreviations

AASR	*Associated Architectural Societies Reports and Papers*
ACC	Alcuin Club Collections
Ant	*The Antiquary*
AntJ	*Antiquaries Journal*
Arch	*Archaeologia*
ArchA	*Archaeologia Aeliana*
ArchCt	*Archaeologia Cantiana*
ArchJ	*Archaeological Journal*
BdHist	*Bedford Historical Record Society Publications*
BkBuOsAJ	*The Berks, Bucks and Oxon Archaeological Journal*
BlGArch	*Bristol and Gloucestershire Archaeological Society*
CAS	Cambridge Antiquarian Society
CASTr	*Cambridge Antiquarian Society Transactions*
ChmS	Chetham Society
ChNWLSArch	Chester and North Wales Architectural, Archaeological and Historic Society
CompD	*Comparative Drama*
CsHuArch	Cambridgeshire and Huntingdon Archaeological Society
CuWtAnt	Cumberland and Westmorland Antiquarian and Archaeological Society
DbArch	Derbyshire Archaeological and Natural History Society
DoArch	*Dorset Natural History and Archaeological Society*
DR	*Downside Review*
DvAssn	*Devonshire Association*
DvCoN&Q	*Devonshire and Cornwall Notes and Queries*
EA	*East Anglian*
EccsTr	*Ecclesiological Society Transactions*
EHtArch	*East Hertfordshire Archaeological Society*
ERAntsTr	*East Riding Antiquarian Society Transactions*
EsArch	*Essex Archaeological Society*
EsR	*Essex Review*
HaFC	*Hampshire Field Club and Archaeological Society Papers and Proceedings*
JBAA	*Journal of the British Archaeological Association*

369

LaCsAnt	Lancashire and Cheshire Antiquarian Society
LeArch	Leicestershire Architectural and Archaeo-
	logical Society
LoMidArch	London and Middlesex Archaeological Society
LsN&Q	Lincolnshire Notes and Queries
MalS	Malone Society
MiA	Midland Antiquary
MP	Modern Philology
N&Q	Notes and Queries
NoArch	Norfolk Archaeology
PTS	Publications of the Thoroton Society
RBu	Records of Buckinghamshire
Rel	The Reliquary
RORD	Research Opportunities in Renaissance Drama
ShArch	Shropshire Archaeological and Natural History
	Society
SfIArchP	Proceedings of the Suffolk Institute of
	Archaeology and Natural History
SoArch	Somerset Archaeological and Natural History
	Society
SoDoN&Q	Somerset and Dorset Notes and Queries
SrAC	Surrey Archaeological Collections
SxAC	Sussex Archaeological Collections
SxN&Q	Sussex Notes and Queries
TrBAS	Transactions of the Birmingham Archaeo-
	logical Society
TrHSLaCs	Transactions of the Historic Society of
	Lancashire and Cheshire
WlArch	Wiltshire Archaeology and Natural History
WrArch	Worcestershire Archaeological Society
WNFC	Woolhope Naturalists' Field Club
YAJ	Yorkshire Archaeological Journal

Adams, H. T. "Silchester Church: Description of the Plates," BkBuOsAJ, 33 (1929), 105-11.

Alexander, Jennifer. Lincolnshire Art (Exclusive of Lincoln): A Subject List, Early Drama, Art, and Music, Reference Ser. Kalamazoo: Medieval Institute Publications, forthcoming.

Almack, Richard. "Kedington alias Ketton, and the Barnardiston Family," SfIArchP, 4 (1864-74), 123-82.

Alton, R. E. "The Academic Drama in Oxford: Extracts from the Records of four Colleges," Collections V. MalS, 1959. Pp. 29-95.

Amphlett, John. ed. The Churchwardens' Accounts of St. Michael's in Bedwardine, Worcester, from 1539 to 1603. WrHS. Oxford, 1896.

Anderson, A. Whitford. "Notes on the Churches of Hertford-shire," *EccSTr*, 6 (1906-10), 73-80, Pls. 1-5.

André, J. Lewis. "Compton Church," *SrAC*, 12 (1894-95), 1-19.

_____. "Ritualistic Ecclesiology of Northeast Somer-set," *ArchJ*, 56 (1899), 144-58.

_____. "Sompting Church," *SxAC*, 41 (1898), 7-24.

Angus-Butterworth, Lionel Milner. "The Monumental Brasses of Cheshire," *LaCsAnt*, 55 (1940), 81-106.

"Archbishop Wareham's Visitation in the Year 1511," *British Magazine*, 31 (1847), 538-51, 637-52.

Arnold, Frederick H. "Racton Church," *SxAC*, 23 (1871), 1-19.

Arnold-Forster, Frances. *Studies in Church Dedications*. London: Skeffington and Son, 1899. 3 vols.

Atchley, E. G. Cuthbert F. "Mediaeval Parish-Clerks in Bristol," *EccSTr*, 5 (1901-05), 107-116.

_____. "On the Mediaeval Parish Records of the Church of St. Nicholas, Bristol," *EccSTr*, 6 (1906-10), 35-67.

_____. "Some Documents relating to the Parish Church of All Saints, Bristol," *ArchJ*, 58 (1901), 147-81.

_____. "Some Inventories of the Parish Church of St. Stephen, Bristol," *EccSTr*, 6 (1906-10), 161-84.

_____. "Some More Bristol Inventories," *EccSTr*, 9 (1922-23), 1-50.

Auden, J. E. "The College of Tong," *ShArch*, 3rd ser., 6 (1906), 199-216.

Babington, Churchill. "Materials for a History of Cockfield," *SfIArchP*, 5 (1875-86), 195-252.

Baigent, Francis Joseph. "On the Church of St. John, Winchester, and the Paintings Discovered on the North Wall," *JBAA*, 9 (1853), 1-14.

Bailey, F. A. ed. "The Churchwardens' Accounts of Prescot, 1523-1607," *TrHSLaCs*, 92 (1940), 133-201.

_____. *The Churchwardens' Accounts of Prescot, Lanca-*

shire 1523-1607. Record Society of Lancashire and Cheshire, 104. Prescot, 1953.

Bailey, John Eglington, ed. *Inventories of Goods in the Churches and Chapels of Lancashire*. ChmS, 107, 113. 1879-88.

Bailey, Robert C. S. "Hanborough Church," *BlGArch*, 47 (1925), 153-65.

Baker, Gray B. "Extracts from Churchwardens' Books--Bungay, St. Mary, Suffolk," *EA*, 1 (1858-63), *passim*; 2 (1864-66), *passim*; 3 (1866-68), *passim*.

Baker, S. O. "Easter Sepulchre," *SoDoNQ*, 1 (1890), 150.

Baker, Thomas H. "The Churchwardens' Accounts of Mere," *WlArch*, 35 (1907-08), 23-92.

_____. "The Trinity Hospital, Salisbury," *WlArch*, 36 (1909-10), 376-412.

Bardwell, William. *A Brief Historical Narrative of the Royal Church and Parish of St. Margaret the Martyr, Westminster*. London, n.d.

Barker, H. R. *West Suffolk, Illustrated*. Bury St. Edmunds: F. G. Pawsey, 1907.

Barker, Joseph. "Notes on Kingsland Church," *WNFC*, 1890, pp. 43-48.

Barnes, A. S. "Eton in Catholic Days," *DR*, 16 (1897), 215-30.

Barnes, John S. *A History of Caston, Norfolk*. Orpington, Kent: Barnes, 1974.

Barnes, W. Miles. "A Brief Historical and Descriptive Sketch of the Churches in the Rural Deanery of Dorchester," *DoArch*, 12 (1891), 36-70.

_____. "Church Goods, Dorset, 1552," *DoArch*, 25 (1904), 196-274; 26 (1905), 101-59.

Barron, Caroline M., and Jane Roscoe. "The Medieval Parish Church of St. Andrew, Holborn," *London Topographical Record*, 24 (1980), 31-60.

Bately, John. "Gorleston Church," *JBAA*, 36 (1880), 435-41.

Bax, Alfred Ridley. "On the Early Churchwardens' Accounts of Horley, 1507-1702," *SrAC*, 8 (1881-83), 243-54.

Baylay, A. M. Y. "The Church at Normanton-on-Soar," *PTS*, 14 (1910), 9-15.

Bell, Patricia, ed. *Bedfordshire Wills 1480-1519*. BdHist, 45. Bedford, 1966.

Bellairs, G. C. "Hallaton Church and the Recent Discoveries There," *LeArch*, 7 (1888-92), 218-22.

Bennet, E. K. "Cheveley Church," *SfIArchP*, 1 (1849-53), 237-49.

Bensly, W. T. "St. Leonard's Priory, Norwich," *NoArch*, 12 (1895), 190-227.

Benson, George. "Holy Trinity Church, Goodramgate," *AASR*, 30 (1909-10), 641-54.

Benton, G. Montagu. "Essex Wills at Canterbury," *EsArch*, n.s. 21 (1933-34), 234-69.

Beresford, J. R. "The Churchwardens' Accounts of Holy Trinity, Chester, 1532 to 1633," *ChNWLSArch*, n.s. 38 (1951), 95-172.

Bethell, W. Wood. "Hawkesbury Church," *BlGArch*, 13 (1888-89), 10-15.

Bidlake, W. H. "The Architect's Rambles through South Lincolnshire," *TrBAS*, 15 (1888-89), 20-26.

Bingley, A. H. "Monument of Robert Hardyng in St. Nicholas' Church, Cranleigh," *SrAC*, 37 (1927), 101.

Binney, J. Erskine. *The Accounts of the Wardens of the Parish of Morebath, Devon., 1520-1573*. Exeter: James G. Commin, 1904.

Birch, H. W. "Some Suffolk Church Notes--Barham," *EA*, n.s. 6 (1895), 177-82.

Bird, W. Hobart. *Old Warwickshire Churches*. London: E. J. Burrow, 1936.

Blair, Lawrence. *A List of Churchwardens' Accounts*. Ann Arbor: Edwards, 1939.

Blomefield, Francis. *An Essay towards a Topoyraphical History of the County of Norfolk*. London: W. Miller, 1805-10. 11 vols.

Bloxam, Matthew H. "On Easter Sepulchres," *AASR*, 11

374 BIBLIOGRAPHY

(1871-72), 67-82.

_____. "On Offertory Boxes," *AASR*, 1 (1850-51),
13-23.

_____. *The Principles of Gothic Ecclesiastical Architec-
ture*, 11th ed. London: Bell and Sons, 1882. 2 vols.

_____. "On Some of the Sepulchral Monuments of War-
wickshire," *TrBAS*, 5 (1874), 1-20.

Bolingbroke, Leonard G. "The Reformation in a Norfolk
Parish," *NoArch*, 13 (1898), 199-216.

Bond, Francis. *The Chancel of English Churches*. London:
Oxford Univ. Press, 1916.

Borenius, Tancred, and E. W. Tristram. *English Medieval
Painting*. Florence: Pantheon, 1926.

Borrowman, Robert. *Beckenham Past and Present*. Beckenham,
1910.

Box, K. Dixon. *Twenty-four Essex Churches*. Letchworth:
Essex Countryside, n.d.

Boyle, John Roberts. *The Early History of the Town and Port
of Hedon*. Hull and York: A. Brown and Sons, 1895.

Brabrook, Edward W. "St. Michael's Church, Cornhill,"
LoMidArch, n.s. 4 (1918-22), 376-89.

Braybrooke, Richard. *The History of Audley End to which are
appended notices of the town and parish of Saffron Walden*.
London: Samuel Bentley, 1836.

Brickhill, A. A. "The Easter Sepulchre Recess at St. Mary's
Church, Stockport," *LaCsAnt*, 32 (1914), 238-42.

Briggs, A. E. "East Markham Church," *PTS*, 11 (1907), 11-19.

Broadley, A. M. "Loders Church, Dorset," *SoDoN&Q*, 7
(1900-01), 23-25.

Brooke, J. M. S., and A. W. Cornelius Hallen. *The Transcript
of the Registers of the United Parishes of St. Mary Woolnoth
and St. Mary Woolchurch, Haw*. London: Bowles and Sons,
1886.

Brooks, Neil C. *The Sepulchre of Christ in Art and Liturgy*.
University of Illinois Studies in Art and Literature, 7, No. 2.
Urbana, 1921.

"Broughton," *AASR*, 28 (1905-06), x-xii.

Bruce, John. "Extracts from Accounts of the Churchwardens of Minchinhampton, in the County of Gloucester, with Observations thereon," *Arch*, 35 (1853), 409-52.

Brushfield, T. N. "The Church of All Saints, East Budleigh, Part II," *DvAssn*, 24 (1892), 219-358.

Buckland, W. E. "Notes and Jottings about Sutton Bonington," *PTS*, 29 (1925), 133-69.

_____. *The Parish Registers and Records in the Diocese of Rochester*. Kent Archaeological Society, Records Branch, 1. London, 1912.

Burges, W. "The Tomb and Helm of Thomas La Warre, in the Church at Broadwater, Sussex," *ArchJ*, 36 (1879), 78-87.

Bushell, William Done. *The Church of St. Mary the Great, the University Church at Cambridge*. Cambridge: Bowes and Bowes, 1948.

Caiger-Smith, A. *English Medieval Mural Paintings*. Oxford: Clarendon Press, 1963.

Carter, Pierson Cathrick. *History of the Church and Parish of St. Alphage, London Wall*. London, 1925.

Cattermole, Paul, and Simon Cotton, "Medieval Parish Church Building in Norfolk," *NoArch*, 38, Pt. 3 (1983), 235-79.

Cautley, H. Munro. *Norfolk Churches*. Ipswich: Norman Adelard, 1949.

_____. *Suffolk Churches and their Treasures*, 5th ed. Woodbridge, Suffolk: Boydell, 1982.

Chambers, E. K. *The Mediaeval Stage*. London: Oxford Univ. Press, 1905. 2 vols.

Chancellor, Frederick. *The Ancient Sepulchral Monuments of Essex*. London, 1890. 2 vols.

_____. "Essex Churches V. All Saints', Purleigh," *EsR*, 2 (1893), 82-96; "VII. St. Mary the Virgin, Great Leighs," 205-23; "XIV. St. John the Apostle and Evangelist, Little Leighs," 4 (1895), 146-57; "XVI. St. Andrew's Hornchurch," 5 (1896), 18-40.

Chatwin, Philip B. "Monumental Effigies in the County of Warwick," *TrBAS*, 47 (1921), 35-88; 48 (1922), 136-68; 49

(1923) 26-53.

Chitty, Herbert. "The Winchester College Bells and Belfries," *HaFC*, 9 (1920), 37-80.

"Churchwardens' Accounts of the Parish of S. Margaret Pattens, London," *Sacristy*, 1 (1871), 258-62.

Churton, Theodore T. "Icklesham Church," *SxAC*, 32 (1882), 105-22.

Cirket, A. F. *English Wills, 1498-1526*. In *BdHist*, 37 (1957).

Clark, Andrew. "Great Dunmow Church Antiquities, 1526-1546," *EsR*, 21 (1912), 141-50.

_____, ed. *Lincoln Diocese Documents, 1450-1544*. EETS, o.s. 149. London, 1914.

_____, ed. *Survey of the Antiquities of the City of Oxford composed in 1661-6 by Anthony Wood*. Oxford Historical Society, 17. Oxford, 1890.

Clark, H. Adams. *A History of the Parish Church of St. Giles*. Beaconsfield, 1961.

Clark-Maxwell, W. G. "The Fall of the Friars' Houses and Alien Priories in Wilts," *WlArch*, 30 (1897), 20-34.

Clarke, H. Adams. *A History of the Parish Church of St. Giles*. Beaconsfield, 1961.

Clay, John William. *North Country Wills*. Surtees Soc., 116. Durham, 1908.

Clay, William Keatinge. *A History of the Parish of Landbeach*. CAS Octavo Publications, 6. Cambridge, 1861.

_____. *A History of the Parish of Milton in the County of Cambridge*. CAS Octavo Publications, 11. Cambridge, 1869.

_____. *A History of the Parish of Waterbeach*. CAS Octavo Publications, 4. Cambridge, 1859.

Clinch, George. *Old English Churches*. London: L. U. Gill, 1902.

Clopper, Lawrence M., ed. *Chester*. Records of Early English Drama. Toronto: Univ. of Toronto Press, 1979.

Clutterbuck, Robert Hawley. *Notes on the Parishes of Fyfield, Kimpton, Penton Mewsey, Weyhill and Wherwell*. Salisbury:

Bennett Brothers, 1898.

"Coates-by Stow," *JBAA*, n.s. 27 (1921), 41.

Cobbe, Henry. *Luton Church Historical and Descriptive.*
London: G. Bell and Sons, 1899.

Collier, I. C. "The Churchwardens' Accounts of St. John the
Baptist, Winchester," *Rel*, 17 (1876-77), 81-85, 155-57, 219-24.

Collier, J. Payne. "St. Margaret's Southwark," *British Maga-
zine*, 32 (1847), 481-96, 638-50; 33 (1848), 1-16, 179-84.

Compton, C. H. "Creke, Norfolk: Its Abbey and Churches,"
JBAA, 46 (1890), 201-20.

Connor, Arthur B. "Monumental Brasses in Somerset, Part
XIV," *SoArch*, 90 (1945), 70-81.

Cook, G. H. *Mediaeval Chantries and Chantry Chapels.* Lon-
don: Phoenix House, 1947.

_____. *The English Mediaeval Parish Church.* London:
Phoenix House, 1954.

Copeman, James. "Autographs of Sir Miles Hobart and Anthony
Hobart," *NoArch*, 2 (1849), 61-69.

Cornelius, C. Fryer. "Mediaeval Effigies and Other Sepulchral
Memorials in the Parish Churches within a Ten-Mile Radius of
Newton Abbot," *DvAssn*, 83 (1951), 217-34.

Cornish, Robert, ed. *Kilmington (Devon) Churchwardens'
Accounts, 1555-1608.* Exeter: W. Pollard, 1901.

Cory, J. A. "Historical Account of Long Marton Church, as
shewn by its Masonry," *CuWtAnt*, 5 (1881-82), 169-73.

Cossins, J. A. "Excursions in the year 1900," *TrBAS*, 27
(1901), 1-15.

_____. "Excursions in the Year 1905," *TrBAS*, 31
(1905), 1-21.

_____. "The Excursions of the Year 1912," *TrBAS*, 38
(1912), 48-62.

_____. "The Excursions of the Year 1914," *TrBAS*, 40
(1914), 31-52.

Cotton, Charles. "Churchwardens' Accounts of the Parish of
St. Andrew, Canterbury, from A.D. 1485 to A.D. 1625,"

ArchCt, 32 (1917), 181-246; 33 (1918), 1-62; 34 (1920), 1-46; 35 (1921), 41-108; 36 (1923), 81-122.

_____, ed. *The Canterbury Chantries and Hospitals*. Kent Archaeological Society, Kent Records, 12 (Supplement). Ashford, 1934.

Cotton, William. "Inventories of Church Goods, *temp*. Edward VI," *Notes and Gleanings*, 3 (1890), 60-62, 104-05, 155-156; 4 (1891), 112, 177-79; 5 (1892), 1-2, 87-88.

Cowper, J. M. *Accounts of the Churchwardens of St. Dunstan's, Canterbury, A.D. 1484-1580*. London: Mitchell and Hughes, 1885.

Cox, Edward W. "Notes on Halsall Church," *TrHSLaCs*, 48 (1896), 233-40.

Cox, John Charles. *Churchwardens' Accounts from the Fourteenth Century to the Close of the Seventeenth Century*. London: Methuen, 1913.

_____. *English Church Fittings, Furniture and Accessories*. London: Batsford, 1923.

_____. *Hampshire*, 6th ed., revised by Philip M. Johnston. London: Methuen, 1929.

_____. *Norfolk*. London: George Allen, 1911. 2 vols.

_____. *Notes on the Churches of Derbyshire*. Chesterfield: Palmer and Edmunds, 1875-79. 4 vols.

_____. "The Parish Churches of Northamptonshire illustrated by wills, *temp*. Henry VIII," *ArchJ*, 58 (1901), 113-32.

_____. "Some Somerset Easter Sepulchres and Sacristies," *DR*, 42 (1924), 84-88.

_____ and Alfred Harvey. *English Church Furniture*, 2nd ed. London: Methuen, 1908.

_____ and W. H. St. John Hope. *The Chronicles of the Collegiate Church or Free Chapel of All Saints, Derby*. London: Bemrose and Sons, 1881.

Crabbe, George. "Merton Church and Hall," *NoArch*, 6 (1864), 304-13.

Craib, Theodore. "Bletchingley Churchwardens' Accounts, 1546-1552," *SrAC*, 29 (1916), 25-33.

_____. "Church Goods in Hampshire A. D. 1552," *HaFC*, 7, Pt. 3 (1916), 67-98; 8, Pt. 1 (1917), 1-39.

_____. "Church Goods in Hampshire in A. D. 1549," *HaFC*, 8, Pt. 3 (1919), 336-49; 9, Pt. 1 (1920), 92-98.

_____. "Surrey Chantries," *SrAC*, 25 (1912), 3-32.

Creed, Henry. "The Church of St. Peter and St. Paul, Eye," *SfIArchP*, 2 (1854-59), 125-48.

Cresswell, Beatrix F. *The Edwardian Inventories for the City and County of Exeter*. ACC, 20. London, 1916.

_____. *Exeter Churches*. Exeter: J. G. Commin, 1908.

_____. *Notes on the Churches of the Deanery of Kenn, Devon*. Exeter: J. G. Commin, 1912.

Crossley, Frederick H. *English Church Monuments A.D. 1150-1550*. London: Batsford, 1921.

_____. "On the Importance of Fourteenth Century Planning in the Construction of the Churches of Cheshire," *ChNWLSArch*, n.s. 32 (1937), 5-52.

_____. "Medieval Monumental Effigies Remaining in Cheshire," *TrHSLaCs*, 76 (1924), 1-51.

Crosthwaite, John C., ed. "Ancient Churchwardens' Accounts of a City Parish," *British Magazine*, 31 (1847), 241-50, 394-404, 526-37; 32 (1847), 30-40, 144-57, 272-82, 390-99; 33 (1848), 564-79, 664-77; 34 (1848), 16-33, 171-87, 292-307, 395-409, 524-33, 674-81; 35 (1849), 50-57, 178-86.

Cumings, Syer. "Holy Sepulchre of Glastonbury Abbey," *JBAA*, 19 (1863), 145-48.

Dalton, John Neale. *The Collegiate Church of Ottery St. Mary*. Cambridge: Cambridge Univ. Press, 1917.

_____, ed. *Ordinale Exon*. (Exeter Chapter MS. 3502 collated with Parker MS. 93). Henry Bradshaw Society, 37. London, 1909.

Daniel, W. E. "Churchwardens' Accounts, St. John's, Glaston-bury," *SoDoN&Q*, 4 (1894-95), 89-96, 137-44, 235-40, 281-88, 329-36, 379-81.

Daniel-Tyssen, J. R. "Inventories of the Goods and Ornaments of the Churches in the County of Surrey in the Reign of King Edward VI.," *SrAC*, 4 (1869), 1-189.

380 BIBLIOGRAPHY

Davidson, Clifford. *Drama and Art*. Early Drama, Art, and Music, Monograph Ser., 1. Kalamazoo: Medieval Institute Publications, 1977.

_____ and Jennifer Alexander. *The Early Art of Coventry, Stratford-upon-Avon, Warwick, and Lesser Sites in Warwickshire*. Early Drama, Art, and Music, Reference Ser., 4. Kalamazoo: Medieval Institute Publications, 1985.

_____ and David E. O'Connor. *York Art*. Early Drama, Art, and Music, Reference Ser., 1. Kalamazoo: Medieval Institute Publications, 1978.

Davis, Cecil T. "Early Churchwardens' Accounts of Wandsworth, 1545 to 1558," *SrAC*, 15 (1900), 80-127; "1558 to 1573," 17 (1902), 135-75.

Dawton, Nicholas. "The Percy Tomb at Beverley Minster: The Style of the Sculpture," *Studies in Medieval Sculpture*, ed. F. H. Thompson. Occasional Papers, n.s. 3. London: Society of Antiquaries, 1983. Pp. 122-50.

Day, E. Hermitage. "The Edwardian Inventories for Leicestershire," *AASR*, 31 (1911-12), 441-70.

Day, W. I. Leeson. *Holsworthy*. DvAssn. Parochial Histories of Devon, 2. 1934.

Dickin, Edward Percival. "Embezzled Church Goods of Essex," *EsArch*, n.s. 13 (1915), 158-71.

Dolan, Diane. *Le drame liturgique de Pâques en Normandie et en Angleterre au Moyen-Age*. Paris: Presses Universitaires de France, 1975.

Donnan, William H. *History of Eriswell*. [Elveden,] 1956.

Drew, Charles, ed. *Lambeth Churchwardens' Accounts 1504-1645 and Vestry Book 1610*. Surrey Record Society, 40, 43-44, 47. 1940-50.

Du Boulay Hill, A. "Fledborough Church," *PTS*, 11 (1907), 1-9.

Dudding, Reginald C. "Addlethorpe and Ingoldmells Churchwardens' Accounts," *LsN&Q*, 17 (1922-23), 151-80.

_____. *The First Churchwardens' Book of Louth 1500-1524*. Oxford: Oxford Univ. Press, 1941.

Dugdale, William. *Monasticon Anglicanum*. London: Longman, Hurst, Rees, Orme, and Brown, 1817-30. 6 vols.

Duncan, Leland L. "Ecclesiological Notes Respecting the
Deanery of Shoreham, Kent," *ArchCt*, 23 (1898), 134-49.

_____. "The Parish Churches of West Kent, their
Dedications, Altars, Images, and Lights," *EccSTr*, 3 (1891-95),
241-98.

_____. *Testamenta Cantiana: West Kent*. Kent Archaeo-
logical Society, Extra Vol., Pt. 1. London, 1906.

Dymond, Robert. "The History of the Parish of St. Petrock,
Exeter, as shown by its Churchwardens' Accounts and Other
Records," *DvAssn*, 14 (1882), 402-92.

"Easter Sepulchre in East Bergholt Church, Suffolk," *AntJ*, 2
(1922), 385.

"Ecclesiological Notes," *The Ecclesiologist*, 6 (1846), 30, 234.

Eeles, Francis C. "Badgeworth Church," *SoArch*, 91 (1946),
16-22.

_____. *The Church of All Saints, Selworthy*. Taunton:
Barnicott and Pearce, 1929.

_____. "Dunster Church," *ArchJ*, 107 (1950), 117.

_____, ed. *The Edwardian Inventories for Buckingham-
shire*. ACC, 9. London, 1908.

_____. "Luccombe Church," *SoArch*, 77 (1931), li-lvii.

Ellis, W. Patterson. "The Churchwardens' Accounts of the
Parish of St. Mary, Thame," *BkBuOsAJ*, 7 (1901-02), *passim*;
20 (1914-15), *passim*.

Evans, Joan. *English Art 1307-1461*. Oxford: Clarendon Press,
1949.

_____ and Norman Cook. "A Statue of Christ from the
Ruins of Mercers' Hall," *ArchJ*, 111 (1954), 168-80.

Evelyn-White, C. H. *The Churches of Cambridgeshire and the
Isle of Ely*. London: George Allen, 1911.

Everett, A. W. "Easter Sepulchre in Throwleigh Church,"
DvCoN&Q, 20 (1938-39), 267-69.

"Extracts from Churchwardens' Books--No. 2. Mildenhall,
Suffolk," *EA*, 1 (1858-63), 185-87, 198-99.

Farmiloe, J. E., and Rosita Nixseaman. *Elizabethan Church*

wardens' Accounts. BdHist, 33. Streatley, 1952.

Feasey, Henry John. *Ancient English Holy Week Ceremonial*. London: Thomas Baker, 1897.

Feasey, Henry Philibert. "Curiosities of and in our Ancient Churches," *Ant*, 36 (1900), 22-26.

_____. "The Easter Sepulchre," *Ecclesiastical Review*, 32 (1905), 337-55, 468-99.

_____. "Salmeston Grange," *Ant*, 39 (1903), 264-70.

Ferguson, R. S. "The Monuments in Carlisle Cathedral," *CuWtAnt*, 7 (1883), 259-70.

Fielding, Cecil H. *Memories of Malling*. West Malling, 1893.

Finn, Arthur, ed. *Records of Lydd*. Ashford, 1911.

Firth, Catherine B. "Village Gilds of Norfolk in the Fifteenth Century," *NoArch*, 18 (1912-14), 161-203.

Fishwick, Henry. "Inventories of Goods in the Churches and Chapels of Lancashire," *Chetham Miscellanies*. ChmS, n.s. 47 (1902), 1-29.

Forsyth, William H. "Easter Sepulchre," *Metropolitan Museum of New York Bulletin*, 3 (1945), 163-65.

_____. *The Entombment of Christ*. Cambridge: Harvard Univ. Press, 1970.

Foster, C. W. "Inventories of Church Goods, A.D. 1548," *AASR*, 34 (1917-18), 27-46.

Foster, J. E., ed. *Churchwardens' Accounts of St. Mary the Great, Cambridge*. CAS Octavo Publications, 35. Cambridge, 1905.

Fowler, J. T. "The Parish Church of All Saints, Winteringham," *AASR*, 30 (1909-10), 1-10.

Fowler, Joseph. "Sherborne All Hallows Church Wardens' Accounts," *SoDoN&Q*, 23 (1939-42), 189-94, 209-12, 249-52, 269-72, 289-92, 311-14, 331-34; 24 (1943-46), 6-8, 25-28, 40-43, 66-68, 80-85, 101-06, 121-25, 161-66, 285-88, 300-04; 25 (1947-50), 7-11, 23-30, 55-60, 64-68, 83-87, 105-09, 122-26, 169-74, 187-89, 206-10, 226-29, 257-62, 268-69, 287-93; 26 (1955), 6-10, 21-24, 49-54.

Fowler, Joseph T. *Extracts from the Account Rolls of the*

Abbey of Durham. Surtees Soc., 99-100, 103. Durham, 1898-1900.

_____. *The Rites of Durham*. Surtees Soc., 107. Durham, 1903.

Fowler, R. C. "Church Goods of Essex," *EsArch*, n.s. 10 (1909), 228-36.

_____. "Inventories of Essex Monasteries in 1536," *EsArch*, n.s. 9 (1906), 280-92, 330-47, 380-400.

French, George Russell. "A Brief Account of Crowhurst Church, Surrey, and its Monuments," *SrAC*, 3 (1865), 39-62.

Frere, Walter Howard. *Graduale Sarisburiense*. London: Quaritch, 1894 [facsimile of British Library MS. Add. 12194].

_____. *The Use of Sarum*. Cambridge: Univ. Press, 1898. 2 vols.

_____, ed. *Visitation Articles and Injunctions of the Period of the Reformation, III: 1559-1575*. ACC, 16. London: Longmans, Green, 1910.

_____. *The Winchester Troper*. London: Harrison and Sons, 1894.

_____ and Langton E. G. Brown. *The Hereford Breviary*. Bradshaw Soc., 26. London, 1904.

Freshfield, Edwin. "Some Remarks upon the Book of Records and History of the Parish of St. Stephen, Coleman Street, in the City of London," *Arch*, 50 (1887), 17-57.

_____. "On the Parish Books of St. Margaret-Lothbury, St. Christopher-le-Stocks, and St. Bartholomew-by-the-Exchange, in the City of London," *Arch*, 45 (1888), 57-123.

Galloway, David, and John Wasson, eds. *Records of Plays and Players in Norfolk and Suffolk*. Collections, XI. MalS, 1980-81.

Gardner, Arthur. *English Medieval Sculpture*, rev. ed. Cambridge: Cambridge Univ. Press, 1951.

Garry, Francis N. A., and A. G. Garry. *The Churchwardens' Accounts of the Parish of St. Mary's, Reading, Berks, 1550-1662*. Reading: Edward J. Blackwell, 1893.

Garratt, Thomas. [Harlington and Cranford], *EccsTr*, 6 (1906-10), xxi-xxvii.

Gibbons, Alfred. *Early Lincoln Wills.* Lincoln: James Williamson, 1888.

Gibson, Gail McMurray, "Long Melford Church, Suffolk: Some Suggestions for the Study of Visual Artifacts and Medieval Drama," *RORD*, 21 (1978), 103-15.

Gill, Harry. "Radcliffe-on-Soar. Holy Trinity Church," *PTS*, 28 (1924), 10-26.

_____. "St. Michael's, Laxton," *PTS*, 28 (1924), 96-105.

_____. "Woodborough Church," *PTS*, 12 (1908), 7-19.

Gillett, E. E. "An Early Churchwarden's account of St. Mary's, Grimsby," *Architectural and Archaeological Society of the County of Lincoln, Reports and Papers*, n.s. 6 (1955), 27-36.

Gilmore, G. D., ed. "Two Monastic Account Rolls," *BdHist*, 49 (1970), 19-55.

Giraud, F. F. "On Goods and Ornaments at Faversham Church, A.D. 1512," *ArchCt*, 18 (1889), 103-13.

Glasscock, J. L., ed. *The Records of St. Michael's Parish Church, Bishop's Stortford.* London: Elliot Stock, 1882.

Glynne, Stephen R. *Notes on the Churches of Cheshire,* ed. J. A. Atkinson. ChmS, n.s. 32. 1894.

_____. *Notes on the Churches of Lancashire,* ed. J. A. Atkinson. ChmS, n.s. 27. 1893.

Godfrey, W. H. "Sussex Church Plans: XXIV.--Litlington," *SxN&Q*, 4 (1932-33), 236-37; "XLII.--St. Mary (now called St. Margaret) Isfield," 6 (1936-37), 241-42; "LI.--SS. Peter & Paul, Thakeham," 8 (1940-41), 12-13.

Goldberg, P. J. P. "The Percy Tomb in Beverley Minster," *YAJ*, 56 (1984), 65-74.

Goodwyn, Canon. "An Old Churchwardens' Account Book of Rotherfield," *SxAC*, 41 (1898), 25-48.

Gough, Richard. *Vetusta Monumenta,* III. 1780.

Graham, Rose, ed. *The Chantry Certificates for Oxfordshire and the Edwardian Inventories of Church Goods for Oxfordshire.* ACC, 23. London, 1920.

_____. *The Chantry Certificates and the Edwardian Inventories of Church Goods.* Oxfordshire Record Society, 1.

Oxford, 1919.

Grayling, Francis. "The Churches of Sittingbourne and Milton," *ArchCt*, 23 (1898), 150-60.

_____. "Kingston Buci Church," *SxAC*, 61 (1920), 53-60.

Green, Valentine. *The History and Antiquities of the City and Suburbs of Worcester*. London, 1796. 2 vols.

Greenstreet, James. "Early Kentish Wills (A.D. 1442 to 1467)," *ArchCt*, 11 (1877), 370-87.

Gregory, R. S. "St. Andrews, Much Hadham," *EHtArch*, 2 (1902-04), 135-39.

Guildford, G. W., and J. Russell. *Guildford: A descriptive and historical view of the county town of Surrey*. London: Longman, 1845.

Guildhall Library. *Churchwardens' Accounts of Parishes within the City of London. A Handlist*, 2nd ed. London, 1969.

Haines, Walter. "Stanford Churchwardens' Accounts (1552-1602)," *Ant*, 17 (1888), 70-72, 117-20, 168-72, 209-13.

Hanham, Alison, ed. *Churchwardens' Accounts of Ashburton, 1479-1580*. Devon and Cornwall Record Society, n.s. 15. 1970.

Harrison, Frederick, and O. H. Leeney. "The Church of St. Mary, Broadwater," *SxAC*, 74 (1933), 98-130.

Harrod, Henry. "Extracts from Early Norfolk Wills," *NoArch*, 1 (1847), 111-28, 255-72.

_____. "Goods and Ornaments of Norwich Churches in the Fourteenth Century," *NoArch*, 5 (1859), 89-121.

Hart, Charles J. "Old Chests," *TrBAS*, 20 (1894), 60-94.

Haslewood, Francis. "Notes from the Records of Smarden Church," *ArchCt*, 9 (1874), 224-35.

_____. "Smarden Church," *ArchCt*, 14 (1882), 18-34.

Heales, Alfred. "The Brasses in Peper Harow Church," *SrAC*, 7 (1880), 34-43.

_____. "The Church of Stanwell, and its Monuments," *LoMidArch*, 3 (1865-69), 105-32.

_____. "Cranley," *SrAC*, 6 (1874), 21-56.

_____. "Early History of the Church of Kingston-upon-Thames, Surrey," *SrAC*, 8 (1881-83), 13-156.

_____. "Easter Sepulchres; their Object, Nature, and History," *Arch*, 42 (1869), 263-308.

Heanley, Robert M. "The Will of Robert Barret, of Wainfleet," *LsN&Q*, 3 (1892-93), 46-50.

Henderson, W. G., ed. *Manuale et Processionale ad Usum Insignis Ecclesiae Eboracensis.* Surtees Soc., 63. Durham, 1874.

_____. *Missale ad Usum Percelebris Ecclesiae Herfordensis.* 1874.

_____. *Processional ad usum insignis et praeclarae Ecclesiae Sarum.* Leeds, 1882.

Herbert, Albert. "The Church of St. Peter, Little Claybrooke," *LeArch*, 12 (1921-22), 198-200.

Herbert, Anthony. "Architectural Notes on All Saints Church," *LeArch*, 18 (1934), 250-54.

Hildburgh, W. L. "An Alabaster Table of the Annunciation with the Crucifix: a Study in English Iconography," *Arch*, 74 (1923-24), 203-32.

Hoare, Henry Rosehurst. "Notes on the Church of St. Thomas à Becket, Framfield," *SxAC*, 4 (1851), 291-304.

Hobhouse, Edmund. *Church-Wardens' Accounts of Croscombe, Pilton, Patton, Tintinhull, Morebath, and St. Michael's, Bath.* Somerset Record Society, 4. 1890.

Hockaday, F. S. "Ashleworth: Ecclesiastical Records," *BlGArch*, 48 (1926), 275-86.

Hodgson, J. F. "On 'Low Side Windows'," *ArchA*, n.s. 23 (1901), 42-235.

Hope, W. H. St. John. "Ancient Inventories of Goods Belonging to the Parish Church of St. Margaret Pattens in the City of London," *ArchJ*, 42 (1885), 312-30.

_____. "The Architectural History of the Cathedral Church and Monastery of St. Andrew at Rochester," *ArchCt*, 23 (1898), 194-328.

_____. "On the English Liturgical Colours," *EccSTr*, 2 (1886-90), 233-72.

_____. "Inventories of the College of Stoke-by-Clare taken in 1534 and 1547-8," *SfIArchP*, 17 (1919-21), 21-77.

_____. "Inventories of the parish church of St. Peter Mancroft, Norwich," *NoArch*, 14 (1901), 153-240.

_____. "On an Inventory of the Goods of the Collegiate Church of the Holy Trinity, Arundel, taken 1st October, 9 Henry VIII. (1517)," *Arch*, 61 (1909), 61-96.

_____. "Inventory of the parish church of St. Mary, Scarborough, 1434; and that of the White Friars or Carmelites of Newcastle-on-Tyne, 1538," *Arch*, 51 (1888), 61-72.

_____ and Cuthbert Atchley. "An Inventory of Pleshy College, 1527," *EccSTr*, 8 (1917-20), 160-72.

Horne, Ethelbert. "Burrington Church," *SoDoN&Q*, 17 (1921-23), 277-78.

Howard, F. E., and F. H. Crossley. *English Church Woodwork*. London: Batsford, 1917.

Hunter, Joseph. *Hallamshire*. London: Lackington, Hughes, 1819.

_____. "Inventories of the Church Goods in the Town of Shrewsbury at the Time of the Reformation," *ArchJ*, 12 (1855), 269-74.

Hussey, Arthur. *Kent Obit and Lamp Rents*. Kent Archaeological Society, Records Branch, 14. 1936.

_____. "Milton Wills (Next Sittingbourne)," *ArchCt*, 47 (1935), 177-88.

_____. "Notes on Faversham Abbey from Parishioners' Wills proved at Canterbury," *Ant*, 42 (1906), 51-56.

_____. "Reculver and Hoath Wills," *ArchCt*, 32 (1917), 77-141.

_____. "Sittingbourne Wills", *ArchCt*, 41 (1929), 37-56; 42 (1930), 37-56.

_____. *Testamenta Cantiana: East Kent*. Kent Archaeological Society, Extra Vol., Pt. 2. 1907.

Hutchins, J. *The History and Antiquities of the County of*

Dorset, 3rd ed., ed. W. Shipp and J. W. Hodson. London, 1861-74; rpt., 1973. 4 vols.

"Inventory and Sale of Goods, etc., St. Peter's, Cornhill, temp. Henry VIII. and Edward VI.," *Ant*, 33 (1897), 278-83, 312-15, 331-37.

"Inventory of the Ornaments of S. Paul's Cathedral in 1552," *The Ecclesiologist*, 17 (1856), 197-205.

Isham, A. "The Antiquities of Weston Turville," *RBu*, 2 (1863), 242-53.

Jackson, T. G. "Some Account of Slindon Church," *SxAC*, 19 (1867), 126-33.

Jeavons, S. A. "The Church Monuments of Derbyshire. The Sixteenth and Seventeenth Centuries. Part I," *DbArch*, 84 (1964), 52-80, Pls. I-XVI.

Johnston, Philip Mainwaring. "The Church of Witley and Thursley Chapel-of-Ease," *SrAC*, 18 (1903), 80-95.

_____. "Cocking and Its Church," *ArchJ*, 78 (1921), 174-204.

_____. "Ford and Its Church," *SxAC*, 43 (1900), 105-57.

_____. "Old Camberwell: I.--The Church of St. Giles," *LoMidArch*, n.s. 3 (1914-17), 123-84.

_____. "The Parish Church of All Saints, Kingston-upon-Thames," *JBAA*, n.s. 32 (1926), 229-47.

_____. "Stoke d'Abernon Church," *SrAC*, 20 (1907), 1-89.

Jones, Mrs. Herbert. "Notes on Harpley Church," *NoArch*, 8 (1879), 17-38.

Kelke, W. Hastings. "The Sculptured Monuments of Buckinghamshire, prior to the Sixteenth Century," *RBu*, 3 (1870), 8-23.

Kemp, T. "Warwick Registers," *TrBAS*, 45 (1919), 1-21.

Kerry, Charles. *A History of the Municipal Church of St. Lawrence, Reading.* Reading, 1883.

Keyser, Charles E. "An Architectural Account of Bredon Church, Worcestershire," *JBAA*, n.s. 18 (1912), 1-12.

_____. "An Architectural Account of the Churches of Buckland, Hinton Waldrist and Longsworth," *BkBuOsAJ*, 12 (1906-07), 97-107.

_____. "An Architectural Account of the Churches of North Moreton, Brightwell, Little Wittenham and Long Wittenham," *BkBuOsAJ*, 15 (1910), 65-73.

_____. "An Architectural Account of the Churches of Sparsholt and Childrey," *BkBuOsAJ*, 11 (1905-06), 81-90, 97-107.

_____. "An Architectural Description of Bampton Church, Oxfordshire," *JBAA*, n.s. 22 (1916), 1-12.

_____. "A Day's Excursion Among the Churches of South-East Norfolk," *ArchJ*, 64 (1907), 91-109.

_____. *A List of Buildings in Great Britain and Ireland Having Mural and Other Painted Decorations*, 3rd ed. London: His Majesty's Stationery Office, 1883.

_____. "Notes on the Churches of Aldermaston, Padworth, Englefield and Tidmarsh," *BkBuOsAJ*, 17 (1911-12), 2-11, 33-43, 65-76, 97-107.

_____. "Notes on the Churches of Boxford, Abingdon, Ashbury, Uffington and Longcot," *BkBuOsAJ*, 16 (1910-11), 2-8, 34-40, 65-71.

_____. "Notes on the Churches of Frilsham, Yattendon, Ashampstead, Hampstead Norreys and Aldworth," *BkBuOsAJ*, 21 (1915-16), 4-9, 33-39, 65-71, 97-108.

_____. "Notes on the Churches of Fyfield, Besselsleigh, Appleton, Cumnor, Wootton and Sunningwell," *BkBuOsAJ*, 23 (1917-18), 1-8, 33-41, 70-86.

_____. "Notes on the Churches of Hanney, Lyford, Denchworth and Charney Bassett," *BkBuOsAJ*, 19 (1913-14), 2-10, 33-37, 65-70, 97-103.

_____. "Notes on the Churches of the Lambourn Valley," *BkBuOsAJ*, 27 (1922-23), 114-36.

_____. "Notes on the Churches of Little Bytham and Egleton," *JBAA*, n.s. 19 (1913), 45-54, 75-83.

_____. "Notes on the Churches of Ruscombe, Shottesbrooke, Waltham St. Lawrence and Hurst," *BkBuOsAJ*, 25 (1919-20), 3-18, 49-62.

_____. "Notes on the Churches of Seaton, Rutlandshire, and Wakerley and Wittering, Northamptonshire," *JBAA*, n.s. 23 (1917), 1-22.

_____. "Notes on the Churches of Stanford-in-the-Vale, Hatford and Shellingford and the Chapels of Goosey and Baulking," *BkBuOsAJ*, 20 (1914-15), 1-9, 33-37, 65-72, 97-102.

_____. "Notes on the Churches of Sutton Courtenay, Appleford, Drayton and Milton," *BkBuOsAJ*, 22 (1916-17), 33-42, 64-70, 97-109.

_____. "A Visit to the Churches of Barnsley, Bibury, Aldsworth, Winson, Coln Rogers, and Coln St. Denys," *BlGArch*, 41 (1918-19), 171-204.

King, H. W. "Ancient Wills (No. 3)," *EsArch*, 3 (1865), 75-94.

_____. "Excerpts from Ancient Wills," *EsArch*, n.s. 1 (1878), 165-78; n.s. 2 (1884), 359-76.

_____. "Inventories of Church Goods, 6th Edw. VI." *EsArch*, 4 (1869), 197-234; 5 (1873), 116-35, 219-42, 273-80; n.s. 1 (1878), 5-32; n.s. 2 (1884), 165-88, 223-50; n.s. 3 (1889), 36-63.

Kite, Edward. "The Churches of Devizes," *WlArch*, 2 (1855), 213-56, 302-32.

Kitto, John V. *St. Martin-in-the-Fields: The Accounts of the Churchwardens 1525-1603*. London: Simpkin, Marshall, Kent, Hamilton, 1901.

Knowles, David, ed. and trans. *The Monastic Constitutions of Lanfranc*. London: Thomas Nelson and Sons, 1951.

Lambarde, Fane. "The Easter Sepulchre in Faversham Church," *ArchCt*, 41 (1929), 107-13.

Lambarde, William. *Dictionarium Angliae Topographicum et Historicum: An Alphabetical Description of the Chief Places in England and Wales*. London, 1730.

Lamborn, E. A. Greening. "Suum cuique," *N&Q*, 188 (1945), 158-61.

_____. "Stanton Harcourt Easter Sepulchre," *Country Life*, 29 May 1942, pp. 1048-49.

Lawrance, Henry, and T. E. Routh. "Military Effigies in Nottinghamshire before the Black Death," *PTS*, 28 (1924), 114-37.

Layard, Nina Frances. "Notes on St. Mary the Virgin, Codden-
ham," *SfIArchP*, 17 (1919-21), 127-34.

Lee, Frederick George. *The History, Description, and
Antiquities of the Prebendal Church of the Blessed Virgin Mary
of Thame*. London: Mitchell and Hughes, 1883.

_____. "St Mary's, Ashendon, Bucks.," *RBu*, 1 (1858),
134-38.

Leighton, Wilfrid. "Trinity Hospital," *BlGArch*, 36 (1913),
251-87.

L'Estrange, J. "The Church Goods of St. Andrew and St. Mary
Coslany, in the City of Norwich," *NoArch*, 7 (1872), 45-78.

Leveson-Gower, Granville. "Bletchingly Church," *SrAC*, 5
(1871), 227-74.

_____. "Further Notes," *ArchCt*, 21 (1895), 83-86.

_____. "Inventory of Church Goods at Edenbridge"
ArchCt, 21 (1895), 115-17.

_____. "Notes on Edenbridge," *ArchCt*, 21 (1895),
109-14.

_____. "Notices of the Family of Leigh of Addington,"
SrAC, 7 (1880), 77-124.

Lewis, R. W. M. *Walberswick Churchwardens' Accounts A.D.
1450-1499*. Walberswick, 1947.

Lightfoot, W. J. "Notes from the Records of Hawkhurst
Church," *ArchCt*, 5 (1863), 55-86.

Lipphardt, Walther. *Lateinische Osterfeiern und Osterspiele*.
Berlin: Walter de Gruyter, 1975-81. 6 vols.

Littlehales, Henry, ed. *The Medieval Records of a London City
Church*. EETS, o.s. 125, 128. London, 1904-05.

Livett, G. M. "Nettlestead Church: Architectural Notes,"
ArchCt, 28 (1909), 251-77.

Lloyd, A. H. "Melbourn Church," *CAS Proceedings*, 29
(1926-27), 50-66.

Lloyd, Iorwerth Grey, "The Parish Church of Cliffe at Hoo,"
ArchCt, 11 (1877), 145-57.

Lomas, S. C., ed. *The Edwardian Inventories for Huntingdon-*

shire. ACC, 7. London, 1906.

London Survey Committee. *Survey of London.* London: London County Council, 1900- .

Longmate, B. [Letter of 26 June 1793,] *Gentleman's Magazine,* 63 (1793), 993.

Longstaffe, W. H. D. "The Screen and Chancel Arrangements of Darlington Church," *ArchA,* n.s. 7 (1876), 240-56.

Lower, Mark Antony. "Notes on the Wills Proved at Consistory Courts of Lewes and Chichester," *SxAC,* 3 (1850), 108-16.

_____. "The Tomb of Richard Burre in Sompting Church," *SxAC,* 19 (1867), 180-84.

Loyd, L. H. "The Churchwardens' Accounts of Wing, Co. Bucks," *JBAA,* 44 (1888), 51-59.

Lukis, William C. "Documents from the Parish Register of Steeple Ashton, Wilts.," *Transactions of the Cambridge Camden Society* (1843-45), pp. 292-96.

Lumb, George Denison. *Testamenta Leodiensia.* Thoresby Society Publications, 19. Leeds, 1911-13.

Lysons, Daniel. *The Environs of London.* London, 1792-96. 4 vols.

Maclean, John. "Chantry Certificates, Gloucestershire," *BlGArch,* 8 (1883-84), 229-308.

_____. "Inventories and Receipts for Church Goods in the County of Gloucester, and Cities of Gloucester and Bristol," *BlGArch,* 12 (1887-88), 70-113.

MacLean, Sally-Beth. *Chester Art.* Early Drama, Art, and Music, Reference Ser., 3. Kalamazoo: Medieval Institute Publications, 1982.

_____. *Surrey Art.* Early Drama, Art, and Music, Reference Ser. Kalamazoo, Medieval Institute Publications, forthcoming.

Mackeson, H. B., and W. A. Scott Robertson. "Hythe Churchwardens' Accounts in the Time of Henry IV," *ArchCt,* 10 (1876), 242-49.

Majendie, Lewis A. "The Dunmow Parish Accounts," *EsArch,* 2 (1863), 229-37.

Malcolm, James Peller. *Londinium Redivivium*. London: John Nichols and Son, 1802-07. 4 vols.

Manning, C. R. "Notice of Burgate Church, Suffolk: Its Architecture, Monuments, &c.," *SfIArchP*, 1 (1849-53), 208-17.

Manning, Owen, and William Bray. *The History and Antiquities of the County of Surrey*. London: John White, 1804-14. 3 vols.

Marshall, George. "Some Account of the Churches of Vowchurch, Turnastone, St. Margaret's, Urishay, and Peterchurch," *WNFC* (1916), pp. 93-105.

Martin, Alan R. "The Church of Cliffe-at-Hoo," *ArchCt*, 41 (1929), 71-88.

Masters, Betty R., and Elizabeth Ralph, eds. *The Church Book of St. Ewen's, Bristol, 1454-1584*. BIGArch Publications, Records Section, 6. 1967.

Mayo, C. H. "The Church of Wooton Glanville," *DoArch*, 21 (1900), 211-17.

Mayo, Charles. *A History of Wimborne Minster*. London: Bell and Daldy, 1860.

McGill, G. H. "The Easter Sepulchre at Northwold," *NoArch*, 4 (1855), 120-32.

McGregor, Margaret. *Bedfordshire Wills proved in the Prerogative Court of Canterbury 1383-1548*. BdHist, 58. 1979.

McMurray, William. *The Records of Two City Parishes*. London: Hunter and Longhurst, 1925.

Mee, Arthur. *Buckinghamshire*. London: Hodder and Stoughton, 1940.

_____. *The Counties of Bedford and Huntingdon*. London: Hodder and Stoughton, 1939.

Mellows, W. T., ed. *Peterborough Local Administration: Parochial Government before the Reformation*. Northamptonshire Record Society, 9. 1939.

Mercer, Francis B. *Churchwardens' Accounts at Betrysden 1515-1573*. Kent Archaeological Society, Records Branch, 5, Pt. 3. 1928.

Micklethwaite, J. T. "Parish Churches in the Year 1548," *ArchJ*, 35 (1878), 372-98.

Milbourn, Thomas. "The Church of St. Stephen Walbrook,"
LoMidArch, 5 (1877-81), 327-402.

Mills, A. D. "A Corpus Christi Play and Other Dramatic
Activities in Sixteenth-Century Sherborne, Dorset," *Collections
IX*. MalS, 1977. Pp. 1-15.

"Monument in Ivinghoe Church Supposed to Commemorate Henry
de Blois, Bishop of Winchester," *RBu*, 1 (1858), 77-80.

Morris, Elizabeth Florence. "Hunsdon Church," *EHtArch*, 2
(1902-04), 46-56.

Morris, Joseph E. *Surrey*. London: George Allen and Sons,
1910.

_____. "Easter Sepulchres," *N&Q*, 187 (1944), 126-28;
193 (1950), 46-49, 488.

Morris, Percy. "Exeter Cathedral: A Conjectural Restoration of
the Fourteenth Century Altar-Screen," *AntJ*, 23 (1943),
122-47.

Moule, H. J. "Easter Sepulchre," *SoDoN&Q*, 1 (1890), 149-50.

Muskett, J. J., ed. "Cambridgeshire Church Goods," *EA*, n.s.
6-10 (1895-1904), *passim*.

_____. "Church Goods in Suffolk," *EA*, n.s. 1-4
(1885-92), *passim*.

Nash, W. L. *The Church-Wardens' Account Book for the Parish
of St. Giles, Reading*, Pt. 1 (1518-46). Reading, 1881.

"Newark and District Excursion," *PTS*, 4 (1900), 21-74.

Nicholls, J. F., and John Taylor. *Bristol Past and Present*.
Bristol: J. W. Arrowsmith, 1881-82. 3 vols.

Nichols, John. *The History and Antiquities of the County of
Leicester*. London: J. Nichols, 1795-1815. 4 vols.

Nichols, John Gough, ed. *Narratives of the Days of the
Reformation*. Camden Soc., 77. London, 1859.

Norman, Philip. "All Hallows Barking," *EccSTr*, 5 (1901-05),
99-106.

_____. "The Church of St. James, Garlickhithe,"
EccSTr, 6 (1906-10), 68-72.

North, Thomas. *The Accounts of the Churchwardens of S.*

Martin's, Leicester 1489-1884. Leicester: Samuel Clark, 1884.

_____. "Accounts of the Churchwardens of Melton Mowbray," *LeArch*, 3 (1874), 180-206.

Northeast, Peter, ed. *Boxford Churchwardens' Accounts 1530-1561*. Suffolk Record Soc., 23. Woodbridge, 1982.

Notices of the Churches of Warwick. Warwickshire Natural History and Archaeological Society. Warwick: Henry T. Cooke, 1847-58.

Oliver, Edmund Ward. "Notes from Ruckinge Wills," *ArchCt*, 13 (1880), 231-36.

Orme, Nicholas. "The Dissolution of the Chantries in Devon, 1546-8," *DvAssn*, 111 (1979), 75-123.

Otter, W. Bruere. "Churchwardens' Accounts of the Parish of Cowfold," *SxAC*, 2 (1849), 316-25.

Ouvry, Frederic. "Extracts from the Churchwardens' Accounts of the Parish of Wing, in the County of Buckingham," *Arch*, 36 (1855), 219-41.

Overall, William Henry, ed. *The Accounts of the Churchwardens of the Parish of St. Michael, Cornhill, in the City of London*. London: A. J. Waterlow, 1871.

Owst, Gerald R. *Literature and Pulpit in Medieval England*, 2nd ed. Cambridge, 1961.

P. ["Letter,"] *Gentleman's Magazine*, 66 (1796), 840-43.

Page, Augustine, "Ampton Church," *SfIArchP*, 1 (1849-53), 190-98.

Page, William. *The Inventories of Church Goods for the Counties of York, Durham, and Northumberland*. Surtees Soc., 97. Durham, 1897.

Page-Turner, F. A. "The Bedfordshire Wills and Administrations Proved at Lambeth Palace and in the Archdeaconry of Huntingdon," *BdHist*, 2 (1914), 3-59.

Palmer, C. F. R. "The Friar-Preachers, or Blackfriars, of Guildford," *Rel*, n.s. 1 (1887), 7-20.

_____. "The Black Friars of Wiltshire," *WlArch*, 18 (1879), 162-76.

Palmer, W. Mortlake. "Churchwardens' Bills or Returns for the

Deanery of Barton, Cambridgeshire, for Michaelmas, 1554,"
CsHuArch, 5 (1937), 257-65.

_____. "The Village Gilds of Cambridgeshire,"
CsHuArch, 1 (1900-04), 330-402.

Parker, John. *The Early History and Antiquities of Wycombe in Buckinghamshire*. Wycombe: Butler and Son, 1878.

Parker, William. *The History of Long Melford*. London, 1873.

Parsons, Walter Langley Edward. *Salle: The Story of a Norfolk Parish*. Norwich: Jarrold and Sons, 1937.

Peacock, Edward. "Churchwardens' Accounts of Saint Mary's, Sutterton," *ArchJ*, 39 (1882), 53-63.

_____. "English Church Furniture, A.D. 1566," *LsN&Q*, 14 (1916-17), 78-88, 109-16, 144-51, 166-73.

_____. *English Church Furniture, Ornaments and Decorations, at the Period of the Reformation*. London: John Camden Hotten, 1866.

_____. "Extracts from the Churchwardens' Accounts of the Parish of Leverton, in the County of Lincoln," *Arch*, 41 (1867), 333-70.

_____. "Kirton-in-Lindsey: Churchwardens' Accounts, etc." *Ant*, 19 (1889), 18-22.

_____. "On the Churchwardens' Accounts of the Parish of Stratton, in the county of Cornwall," *Arch*, 46 (1880-81), 195-236.

Pearson, C. B. "The Churchwardens' Accounts of the Church and Parish of S. Michael without the North Gate, Bath, 1349-1575," *SoArch*, 23 (1877), 1-28; 24 (1878), 29-52; 25 (1879), 53-100; 26 (1880), 101-38.

Peckham, W. D. "Chichester Cathedral in 1562," *SxAC*, 96 (1958), 1-8.

_____. "Some Chichester Wills, 1483-1504," *SxAC*, 87 (1948), 1-27.

Peter, Richard, and Otto Bathurst Peter. *The Histories of Launceton and Dunheved*. Plymouth: W. Brendon and Son, 1885.

Pevsner, Nikolaus, ed. *The Buildings of England*. Harmondsworth: Penguin, 1951- . Multi-volume series.

Phear, John B. "Molland Accounts," *DvAssn*, 35 (1903), 198-238.

Piccope, G. J., ed. *Lancashire and Cheshire Wills and Inventories from the Ecclesiastical Court, Cheshire.* ChmS, 33, 51, 54 (1857-61).

Pigot, Hugh. "Hadleigh: the Town, the Church, and the Great Men who have been born in or connected with the parish," *SfIArchP*, 3 (1860-63), 1-290.

Pilkinton, Mark. "The Easter Sepulchre at St. Mary Redcliffe, Bristol, 1470," *EDAM Newsletter*, 5 (1982), 10-12.

Plaisted, Arthur H. *The Manor and Parish Records of Medmenham, Buckinghamshire.* London: Longmans, Green, 1925.

Plomer, Henry R. *The Churchwardens' Accounts of St. Nicholas, Strood.* Kent Archaeological Society, Records Branch, 5, Pt. 1. 1915.

Ponting, C. E. "Notes on the Churches visited in 1892," *WlArch*, 27 (1893), 15-41.

_____. "The Parish Church of S. Michael, Mere," *WlArch*, 29 (1896), 20-70.

Povah, Alfred. *The Annals of the Parishes of St. Olave Hart Street and All Hallows Staining.* London: Blades, East, and Blades, 1894.

Pressey, W. J. "The Churchwardens' Accounts of Heybridge," *EsArch*, n.s. 22 (1935-38), 28-36.

_____. "The Church Wardens' Accounts of West Tarring," *SxN&Q*, 3 (1930-31), 18-21, 42-45, 77-80, 108-112, 145-49, 179-84, 209-14, 240-45; 4 (1932-33), 9-14, 46-49.

_____. "The Churchwardens' Book of St. Mary, Chelmsford," *EsR*, 47 (1938), 120-28, 198-203.

Prior, Edward S., and Arthur Gardner. *An Account of Medieval Figure Sculpture in England.* Cambridge: Cambridge Univ. Press, 1912.

Processionale ad Usum Sarum. Richard Pynson, 1502; rpt. Clarabricken, Ireland: Boethius Press, 1980.

Purvis, J. S. "The Churchwardens' Book of Sheriff Hutton, A.D. 1524-1568," *YAJ*, 36 (1944-47), 178-89.

398 BIBLIOGRAPHY

Raine, Angelo. *Mediaeval York*. London: John Murray, 1955.

Raine, James, ed. *The Priory of Coldingham*. Surtees Soc., 12. London, 1841.

_____. *Wills and Inventories from the Registery of the Archdeaconry of Richmond*. Surtees Soc., 26. Durham, 1853.

Raines, Francis Robert. *A History of the Chantries within the County Palatine of Lancaster*. ChmS, 59-60. 1862.

Ray, John E., "The Parish Church of All Saints, Herstmonceux, and the Dacre Tomb," *SxAC*, 58 (1916), 21-64.

_____, ed. *Sussex Chantry Records*. Sussex Record Soc., 36. Cambridge, 1930.

Redstone, V. B. "Chapels, Chantries and Gilds in Suffolk," *SfIArchP*, 12 (1904-06), 1-87.

_____. "Extracts from Wills and Other Material showing the History of Suffolk Churches, Chantries, and Guilds," *SfIArchP*, 23 (1937-39), 50-78.

Rendell, Gerald H. "Church of St. Mary, Dedham," *EsR*, 29 (1920), 1-13.

Reynolds, Herbert Edward. *Wells Cathedral: Its Foundations, Constitutional History, and Statutes*. 1880.

Rice, R. Garraway. "Parish Church of St. Peter, Hamsey," *SxN&Q*, 2 (1928-29), 52-55.

_____. *Transcripts of Sussex Wills*. Sussex Record Soc., 41-43, 45. 1935-40.

Rickert, Margaret. *Painting in Britain: The Middle Ages*, 2nd ed. Baltimore: Penguin, 1965.

Roberts, R. A. "Church of St. Botolph, Lullingstone," *ArchCt*, 16 (1886), 99-113.

_____. "Churches in Romney Marsh," *ArchCt*, 13 (1880), 408-87.

_____. "Further Inventories of the Goods and Ornaments of the Churches in the County of Surrey in the Reign of King Edward the Sixth," *SrAC*, 21 (1908), 33-82; 22 (1909), 69-104; 23 (1910), 30-60; 24 (1911), 1-39.

_____. "Minster Church, Thanet", *ArchCt*, 12 (1878), 167-76.

_____. "Preston Church next Faversham," *ArchCt*, 21
(1895), 126-34.

Robinson, W. J. *West Country Churches*. Bristol: Bristol Times
and Mirror, 1914-16. 4 vols.

Rock, Daniel. *The Church of our Fathers*. London: John
Hodges, 1905. 4 vols.

Roe, Fred. *Ancient Coffers and Cupboards*. London, 1903.

Rose-Troup, Frances. "Bishop Grandisson: Student and Art
Lover," *DvAssn*, 60 (1928), 239-75.

Routledge, Charles F. "St. Martin's Church, Canterbury,"
ArchCt, 22 (1897), 1-28.

Rowe, J. Brooking. *A History of the Borough of Plympton
Erle*. Exeter: James G. Commin, 1906.

Royal Commission on Historical Monuments. [Inventories.]
Multi-volume series.

Royston, Peter. "Orton Longueville Church," *JBAA*, n.s. 5
(1899) 97-105.

Ruddle, C. S. "Notes on Amesbury Church," *WlArch*, 31
(1900), 29-32.

Rye, Walter. "Norfolk Church Goods," *NoArch*, 7 (1872),
20-44.

Sackville, S. G. Stopford. "Notes on Lowick Church," *AASR*,
17 (1883-84), 55-76.

"St. Dunstan's in the East, London," *Ant*, 31 (1895), 15-21.

"St. Leonard's Church, Kirkstead," *JBAA*, n.s. 21 (1915),
81-83.

Salzmann, L. F. "Early Churchwardens' Accounts, Arlington,"
SxAC, 54 (1911), 85-112.

Sandars, Samuel. *Historical and Architectural Notes on Great
Saint Mary's Church, Cambridge*. CAS Octavo Publications, 10.
1869.

Saunders, G. W. "The North Chapel of St. Andrew's Church,
Curry Rivel," *SoArch*, 61 (1915), 31-53.

Savage, Richard, ed. *The Churchwardens' Accounts of the
Parish of St. Nicholas, Warwick, 1547-1621*. Warwick, [1890].

Scott, Sir G. Gilbert. "Brabourne Church," *ArchCt*, 10 (1876), 1-9.

Scott, J. Oldrid. "Cowden Church, Kent," *ArchCt*, 21 (1895), 81-86.

Sekules, Veronica. "A Group of Masons in Early Fourteenth-Century Lincolnshire: Research in Progress," *Studies in Medieval Sculpture*, ed. F. H. Thompson. Occasional Papers, n.s. 3. London: Soc. of Antiquaries, 1983. Pp. 151-64.

Serjeantson, R. M. "The Will of Roger Benetheton, 1438-9," *BdHist*, 4 (1917), 1-3.

_____ and H. Isham Longden, "The Parish Churches and Religious Houses of Northamptonshire: Their Dedications, Altars, Images and Lights," *ArchJ*, 70 (1913), 217-452.

Sharp, Thomas. *Bablake Church, Coventry.* Coventry, 1818.

_____. *Illustrations of the History and Antiquities of Holy Trinity Church.* Coventry, 1818.

Sheard, Michael. *Records of the Parish of Batley.* Worksop: Robert White, 1894.

Simpson, R. J. "Notes on Fressingfield Church," *SflArchP*, 3 (1860-63), 321-30.

Simpson, W. Sparrow. "Churchwardens' Accounts for the Parish of St. Matthew, Friday Street, in the City of London, from 1547 to 1603," *JBAA*, 25 (1869), 356-81.

_____. "Inventory of the Vestments, Plate, and Books, Belonging to the Church of St. Peter Cheap, in the City of London, in the Year 1431," *JBAA*, 24 (1868), 150-60.

_____. "On the Parish of St. Peter Cheap, in the City of London, from 1392 to 1633," *JBAA*, 24 (1868), 248-68.

_____. "Two Inventories of the Cathedral Church of St. Paul, London, dated respectively 1245 and 1402," *Arch*, 50 (1887), 439-524.

Skillington, S. H. "Medieval Cossington," *LeArch*, 18 (1934-35), 203-54; 19 (1935-37), 275-92.

Smith, Brian S. "Little Waltham Church Goods, c. 1400," *EsArch*, ser. 3, 1 (1961-65), 111-13.

Smith, D. U. Seth, and G. M. A. Cunnington, "An Inventory of Gifts to the Chapel of the Holy Sepulchre that was at

Edington," WlArch, 55 (1953-1954), 161-64.

Smith, G. LeBlanc. "Some Churches in the Teign Valley, Devon," Rel, n.s. 13 (1907), 73-96.

Smith, Joshua Toulmin. English Gilds. EETS, o.s. 40. London, 1870.

Smith, W. H. "Inhabitants of Lincolnshire Villages in the 16th Century," LsN&Q, 5 (1896-98), 19-23.

Smyttan, G. H. "On the Church and College of Sibthorpe in Nottinghamshire," AASR, 3 (1854-56), 82-88.

"Some Inventories, with Notes," Rel, n.s. 4 (1890), 150-62.

Somers, Frank, ed. Halesowen Churchwardens' Accounts (1487-1582). WrHS. London, 1957.

Stephenson, Mill. "An Incised Alabaster Slab in Harpham Church," ERAntsTr, 10 (1902), 25-26.

_____. "A List of Monumental Brasses in Surrey," SrAC, 25 (1912), 33-100; 26 (1913), 1-80.

_____. "Monumental Brasses in Surrey," EccsTr, 3 (1891-95), 186-94.

_____. "Notes on the Monumental Brasses of Middlesex," EccsTr, 4 (1896-1900), 221-33.

Stooks, Charles Drummond. A History of Crondall and Yately. Winchester: Warren and Son, 1905.

Suckling, Alfred I. The History and Antiquities of the County of Suffolk. London, 1846-48. 2 vols.

Surrey Wills. Surrey Record Soc., 17. 1921.

Sutton, A. F. "Claypole Church," PTS, 15 (1911), 9-12.

Swayne, Henry James Fowle. Churchwardens' accounts of S. Edmund and S. Thomas, Sarum, 1443-1702, with other documents. Wiltshire Record Society, 66, Pt. 1. 1896.

Sweeting, W. D. "Maxey Church and Parish," JBAA, n.s. 5 (1899), 106-21.

Sydenham, John. The History of the Town and Country of Poole. Poole: Sydenham, 1839.

Symonds, Henry. "Edward VI and Somerset Chantries," SoDoN&Q, 19 (1927-29), 12-14.

Sympson, E. Mansel. "Notes on Easter Sepulchres in Lincoln-shire and Nottinghamshire," *AASR*, 23 (1895-96), 290-96.

Taylor, E. S. "Notices of the Church of Martham, Norfolk, Previous to its Restoration in 1856," *NoArch*, 5 (1859), 168-79.

Taylor, Henry, and R. D. Radcliffe. "Notes on the Parish Church of Halsall" *TrHSLaCs*, 48 (1896), 194-232.

Testamenta Eboracensia, ed. James Raine and John W. Clay. Surtees Soc., 4, 30, 45, 53, 79, 106. Durham, 1836-1902.

Thompson, A. Hamilton. "The Cathedral Church of the Blessed Virgin Mary, Southwell," *PTS*, 15 (1911), 15-62.

_____. "The Chapel of St. Mary and the Holy Angels, otherwise known as St. Sepulchre's Chapel, at York," *YAJ*, 36 (1944-47), 63-77.

_____. "Church Architecture in Devon," *ArchJ*, 70 (1913), 453-94.

Thompson, Canon. *The History and Antiquities of the Collegiate Church of St. Saviour (St. Marie Overie), Southwark*. London: Elliot Stock, 1904.

Thompson, Pishey, *The History and Antiquities of Boston*. Boston: John Noble, Jr., 1856.

Tolhurst, J. B. L., ed. *The Barking Ordinale*. Henry Brad-shaw Society, 66. 1927.

Tristram, Ernest W. *English Wall Painting of the Fourteenth Century*. London: Routledge and Kegan Paul, 1955.

_____. *English Medieval Wall Painting*. London: Oxford Univ. Press, 1944-50. 2 vols.

Tymms, Samuel. "Chevington Church," *SfIArchP*, 2 (1854-59), 434-38.

_____. "Hawsted Church," *SfIArchP*, 2 (1854-59), 1-9.

_____. "Horringer Church," *SfIArchP*, 2 (1854-59), 430-34.

_____. "Mildenhall Church," *SfIArchP*, 1 (1849-53), 269-77.

_____. "Stowmarket Church," *SfIArchP*, 2 (1854-59), 248-56.

_____. "Wills and Extracts from Wills Relating to Ixworth and Ixworth Thorpe," *SfIArchP*, 1 (1849-53), 103-20.

_____, ed. *Wills and Inventories from the Registers of the Commissary of Bury St. Edmunds and the Archdeacon of Sudbury*. Camden Soc., 49. London, 1850.

Twycross-Raines, G. F. "Aldbrough Church, Holderness," *ERAntSTr*, 23 (1920), 28-33.

Vallance, Aymer. "Cranbrook Church Inventory, 1509," *ArchCt*, 41 (1929), 57-68.

_____. "Eltham Churchwardens' Accounts," *ArchCt*, 47 (1935), 71-102.

_____. "Lydden Church," *ArchCt*, 43 (1931), 1-27.

VCH: see Victoria County Histories

Venables, Edmund. "Annals of the Church of St. Mary the Great, Cambridge," *CAS Octavo Publications*, 10 (1869), 61-97.

Victoria County Histories of the Counties of England, gen. eds. William Page *et al*. 1900- . Multi-volume series.

Wadley, Thomas P. "Extracts from Churchwardens' Accounts at Badsey, co. Worcester," *MiA*, 1 (1882), 31-40.

_____. *The Great Orphan Book and Book of Wills*. BlGArch. Bristol, 1886.

Wadsworth, F. Arthur. "The Parish Churches and Houses of Friars of Nottingham, their Chapels, Gilds, Images, and Lights," *PTS*, 22 (1918), 75-113.

Wainwright, Thomas. "Bridport Churchwardens' Accounts, A.D. 1556," *SoDoN&Q*, 8 (1902-03), 120-22.

Walcott, Mackenzie E. C. "Church Goods and Chantries of Derbyshire in the XVIth Century, with Notes," *Rel*, 11 (1870-71), 1-12, 81-88.

_____. "The Early Statutes of the Cathedral Church of the Holy Trinity, Chichester, with Observations on its Constitutions and History," *Arch*, 45 (1877-80), 143-234.

_____. "Gleanings from MS. Inventories," *Rel*, 11 (1870-71), 229-36; 12 (1871-72), 5-8.

_____. "Inventories and Valuations of Religious Houses at the time of the Dissolution, from the Public Record Office," *Arch*, 43 (1871), 201-49.

404 BIBLIOGRAPHY

_____. "Inventories of Church Goods and Certificates of Chantries, temp. Edw. VI., in Worcestershire, from the Public Record Office," *AASR*, 11 (1871-72), 300-42.

_____. "Inventories of Church Goods, and Chantries of Wilts.," *WlArch*, 12 (1870), 354-83.

_____. "Inventories of Framland Deanery, Co. Leicester," *AASR*, 12, Pt. 1 (1873).

_____. "Inventories of the Benedictine Priory of SS. Mary and Sexburga, in the Island of Shepey, for Nuns," *ArchCt*, 7 (1868), 287-306.

_____. "The Inventories of Westminster Abbey at the Dissolution," *LoMidArch*, 4 (1869-74), 313-76.

_____. "Inventory of St. Mary's Benedictine Nunnery, at Langley, Co. Leicester, 1485," *AASR*, 11 (1871-72), 201-06.

_____. "Inventory of Worcester Cathedral," *AASR*, 11 (1871-72), 303-08.

_____. *Sacred Archaeology*. London, 1868.

_____, R. P. Coates, and W. A. Scott Robertson. "Inventories of Parish Church Goods in Kent, A. D. 1552," *ArchCt*, 8 (1872), 74-163; 9 (1874), 266-84; 10 (1876), 282-97; 11 (1877), 409-16; 14 (1882), 290-312.

Walker, Henry Bacheler, and W. L. Rutton. "St. Martin's Church, New Romney: Records Relating to Its Removal in A.D. 1550," *ArchCt*, 20 (1893), 155-60.

Walker, J. Severn. "Ecclesiology of Worcestershire," *AASR*, 6 (1861-62), 223-40.

Walker, John W. "St. Mary's Chapel on Wakefield Bridge," *YAJ*, 11 (1891), 143-68.

Wall, G. W. "St. Helen's Church, Sephton," *TrHSLaCs*, 47 (1895), 37-102.

Waller, John G. "On the the Monuments in Carshalton Church, Surrey," *SrAC*, 7 (1880), 67-76.

Waller, William Chapman. "Inventories of Church Goods. 6 Edward VI.," *EsArch*, n.s. 11 (1911), 90-97, 202-10, 310-20.

Walters, H. B. "The Churchwardens' Accounts of the Parish of Worfield," *ShArch*, ser. 3, 3 (1903), 99-138; 4 (1904), 85-114; 6 (1906) 1-24; 7 (1907), 219-40; 9 (1909), 113-40.

_____. "Inventories of Norfolk Church Goods (1552),"
NoArch, 26 (1936-38), 245-70; 27 (1939-41), 97-144, 263-89,
385-416; 28 (1942-44), 7-22, 89-106, 133-180, 217-28; 30
(1947-52), 75-87, 160-67, 213-19, 370-78; 31 (1955-57) 200-09,
233-98; 33 (1962-65) 63-85, 216-35, 457-90.

_____. "Inventories of Worcestershire Church Goods,
1552," WrArch, n.s. 17 (1940), 11-21; 27 (1950), 47-62; 29
(1952), 38-49; 30 (1953), 54-71; 31 (1954), 20-38; 32 (1955),
38-64.

_____. London Churches at the Reformation. London:
SPCK, 1939.

Ward, J. "Extracts from the Church-wardens Accompts of the
Parish of St. Helen's, in Abington, Berkshire," Arch 1 (1779),
11-23.

Ward, J. H. "Easter Sepulchre," SoDoN&Q, 1 (1890), 148-49.

Warren, F. E. "Gild of S. Peter in Bardwell," SfIArchP, 11
(1900-03), 81-147.

Watkin, Aelred, ed. Inventory of Church Goods temp. Edward
III. Norfolk Record Soc., 19. 1947-48. 2 Pts.

Watkin, Hugh R. Dartmouth. Vol. I: Pre-Reformation.
Parochial Histories of Devonshire, 5. DvAssn. 1935.

Watkins, John. "On the History of Willingham Church," CAS
Proceedings, 9 (1896), 12-20.

Watson, C. H. B. "West Bridgford Church," PTS, 45 (1941),
76-96.

Watts, J. Wallace. "Rothley: The Church," LeArch, 12
(1921-22), 99-120.

Weaver, F. W. "Bridgwater in the Olden Time," DR, 15 (1896),
228-33.

_____. "Some Early Wills at Wells District Probate
Registry," DR, 13 (1894), 273-79; 14 (1895), 10-21.

_____ and G. N. Clark, eds. Churchwardens' Accounts
of Marston, Spelsbury, Pyrton. Oxfordshire Record Soc., 6.
Oxford, 1925.

Weaver, J. R. H., and A. Beardwood, eds. Some Oxfordshire
Wills. Oxfordshire Record Soc., 39. Oxford, 1958.

Webb, E. A., G. W. Miller, and John Beckwith. *The History of Chislehurst*. London: George Allen, 1899.

Welch, Charles. *The Churchwardens' Accounts of the Parish of Allhallows, London Wall*. London, 1912.

"Wellow Murals, The," *SoArch*, 97 (1952), 19-20.

Wells, F. B. "The Church of All Saints, Woodchurch," *ArchCt*, 14 (1882), 344-53.

Westlake, H. F. *The Parish Gilds of Mediaeval England*. London: SPCK, 1919.

Weyman, Henry T. "Ludlow Church and Castle," *WNFC*, 1916, 126-36.

Whitley, H. Michell. "The Churchwardens' Accounts of St. Andrew's and St. Michael's, Lewes, from 1552 to 1601," *SxAC*, 45 (1902), 40-61.

_____. "An Inventory of the Church Goods of Saint Kieran's Church, Exeter, A. D. 1417," *DvAssn*, 43 (1911), 309-18.

Whittemore, P. J. "Monumental brass at Stoke-in-Teignhead Church," *DvCoN&Q*, 33 (1977), 300-03.

Williams, J. F. "A Bishop of Norwich--Who Never Was!" *NoArch*, 33 (1962-65), 56-62.

_____. "Great Hallingbury Churchwardens' Accounts, 1526 to 1634," *EsArch*, n.s. 23 (1942-45), 98-115.

_____. "Some Norfolk Churches and their Old-time Benefactors," *NoArch*, 27 (1939-41), 333-44.

Wilson, Herbert. *Eight Hundred Years of Harlington Parish Church*. Rochester, 1926.

Windrum, Anthony. *Horsham*. London: Phillimore, 1978.

Woodruff, C. Eveleigh. "Extracts from Original Documents Illustrating the Progress of the Reformation in Kent," *ArchCt*, 31 (1915), 92-120.

_____. "Inventory of the Church Goods of Maidstone," *ArchCt*, 22 (1897), 29-33.

_____. "The Sacrist's Rolls of Christ Church, Canterbury," *ArchCt*, 48 (1936), 38-80.

_____, ed. *Sede Vacante Wills*. Kent Archaeological Soc., Records Branch, 3. 1914.

Woodward, B. B. "Churchwardens' Accounts for Huntingfield," *Proceedings of the Society of Antiquaries*, n.s. 1 (1860), 116-19.

Woolaston, Gerald Woods, C. Eveleigh Woodruff, and W. P. D. Stebbing. "St. Leonard's, Deal," *ArchCt*, 49 (1938), 167-88.

Woolley, Ernest, "Irnham, Lincolnshire and Hawton, Nottinghamshire," *JBAA*, n.s. 35 (1929), 208-46.

_____. "Some Nottinghamshire and Lincolnshire Easter Sepulchres," *PTS*, 28 (1924), 67-72.

Wordsworth, Christopher. "Inventories of Plate, Vestments, &c., belonging to the Cathedral Church of the Blessed Mary of Lincoln," *Arch*, 53 (1892), 1-82.

_____. *Notes on Medieval Services in England*. London, 1898.

Worth, R. N. *Calendar of the Tavistock Parish Records*. Plymouth: W. Brendon and Son, 1887.

Wright, Thomas, ed. *Churchwardens Accounts of the Town of Ludlow, in Shropshire*. Camden Soc., 102. London, 1869.

Wynne, M. B. "Wax Candles in Ancient Wills," *Ant*, 36 (1900), 216-17.

Young, Karl. *The Drama of the Medieval Church*. Oxford: Clarendon Press, 1933. 2 vols.

_____. "The Dramatic Association of the Easter Sepulchre," *University of Wisconsin Studies in Language and Literature*, 10 (1920), 5-130.

_____. [Review of Brooks, *The Sepulchre of Christ in Art and Liturgy*], *JEGP*, 21 (1922), 692-701.

Index

Due to the frequency of their occurrence, the following items have not been included in the index: mention of lights for the Sepulchre; gifts of wax or candles to the Sepulchre or Sepulchre lights; gifts of money; Sepulchre watching; provision of food, drink, or coals for watchers; nails, pins, points, or iron for the Sepulchre.

409

false

Quinton, Sir William de, tomb of 41, 360

Rabett, Richard, will of 83
Rame, Thomas, will of 253
Rand, Henry, will of 183
Randall, W., will of 267
Rateclyff, Richard, will of 269
Raughton, Ivo de 359
Rawlynge, Agnes, will of 82
Rawson, Joan, will of 277
Raymond, Thomas, will of 118
Rayne, Henry, will of 261
Raynold, Nicholas, will of 190
Raynold, Richard, will of 83
Red, John, will of 336
Rede, Thomas, will of 312
Reed, Dame Elizabeth, will of 41, 227
Reed, Dame Kateryne, will of 290
Reeve, W., will of 268
Regularis Concordia 19-29, 33-34, 52
Reresby, John, will of 363
Resurrection, play of 59, 90, 294, 295
Reynolds, William, will of 276
Reysley, John, will of 81
Rhabanus Maurus 9
Rickman, J., will of 280
Ridar, Joan, will of 175
Ridley, Nicholas, Bishop 217
Rige, W., will of 270
Rites of Durham 57-58, 129-30
Roberds, R., will of 283
Roberts, W., will of 284
Robins, Thomas, will of 267
Robonet, Agnes, will of 283
Robyns, H., will of 264
Robyns, will of 272
Roche, Symon, will of 261
Rock, Daniel 3
Roger, Archbishop of York 364
Rokewode, Thomas, tomb of 316

Rolff, William, will of 105
Rome, church in 12
Roos, Myles, will of 272
Rose, H., will of 278
Rowdall, Johannes, will of 302
Rowe, John, will of 166
Rudde, John, will of 80
Ryckewater, Alice, will of 337
Rycward, Julian, will of 337
Rydle, Roger, will of 175
Ryghtwys, Margaret, will of 252
Ryghtwys, Thomas, will of 252
Rynes, Robert, tomb of 332

Sabyn, J., will of 282
Sabyn, Nicholas, will of 257
Sabyn, W., will of 282
Sackville, Richard, tomb of 338
Sacrament House 36, 38, 47, 105
St. Anselm 346
St. Barbara 339
St. Catherine 182, 187, 226
St. Christopher 333-34
St. Clement 177
St. Erasmus 333
St. Gall, monastery of 9
St. George 339, 367
St. Helen 226
St. James 46, 235
St. John 17, 41, 46, 227, 235
St. Margaret 181
St. Maur, Lawrence, tomb of 267
St. Michael 358
St. Nicholas 247
St. Paul 6, 244
St. Peter 17, 40, 46-47, 178, 235, 244, 287, 332, 360
St. Riquier, church at 15-16
St. Roche 339
St. Thomas, apostle 44, 46, 168
St. Ursula 236, 333
Sakwyle, Simon, will of 111
Salesbury, Sir John, tomb of 94

ubi mundus adsistere · & placere conspectui tuo · qui con pacre ·

Hæc alternos duos cum oratione · D[omine] ĩ omnis ihu xpe qui tuas

manus mundas propter nos in cruce posuisti · & de tuo sco sanguine

nos redemisti · mitte in me sensum & intellegentiam quomodo habea[m]

ueram penitentiam · & habeam bonam perseuerantiam omnibus dieb[us]

uitæ meæ · amen · Et eam humiliter deosculans · surgat · Deinc

ministerio ni chorus omnis frs eadem mente deuota peragant · Nam

salutato ab abbate ut omnibus cruce · redeat ipse abbas ad sedem sua[m]

usq: dum omnis clerus ac populus hoc idem faciat · Nam quia

ea die depositionem corporis saluatoris nri celebramus usum quo

rundam religiosorum imitabilem ad fidem indocta uulgi ac neofitoru[m]

corroborandam equiparendo sequi libra · cui usum fuerit ul sibi

taliter placuerit hoc modo decreuimus · Sic autem in una parte

altaris qua uacuum fuerit quedam assimilatio sepulchri uelamenq:

quoddam in gyro tensum · quoddum sca crux adorata fuerit depo

natur hoc ordine · Veniant diacones qui prius portauerunt eam ·

& in uoluant eam sindone in loco ubi adornata est · Tunc reportent a

eam canentes antiphonas · In pace in id ipsum · habitabit · ITEM ·

Caro mea requiescat in spe · Donec ueniant ad locum monumento ·

deposita q: cruce · ac si dni nri ihu xpi corpore sepulto · dicant antiph ·

Sepulto dño signatum est monumentu[m] ponentes milites quicusto

direnc eam · In eodem loco sca crux cum omni reuerentia custodiat ·

usq: dominica noctem resurrecionis · Hocce uero ordinentur

dno frs aut tres aut plures si tanta fuerint congregatio · qui ibidem

psalmos decantando excubias fideles exerceant. Quibus peractis egre-
diantur diaconus ac subdiaconus. desacrario cum corpore dni quod
pridie remansit. & calice cum uino non consecrato. & ponant super
altare. Tunc sacerdos ueniat ante altare. & dicat uoce sonora. Oremus
precepas salutaribus moniti. & pater nr. inde. libera nos qs dne usq;
per omnia scla sclorum. Et sumat abbas de sco sacrificio. & ponat
in calicem nichil dicens & communicent omns cum silentio. hoc
expleto. uespertinum officium canat unus quisq; priuatim inloco
suo. Quo peracto. refectorium petant. Surgentes autem amensa
cetera more solito peragant. Crucis uero ueneratione peracta
quibus uacuum. fuerit ministri uel pueri scruat ac balneent.
Sitanta fuerit cohors societatis ut sabbati crastini adhoc non sufficiat.
dies. Completorium uero post collationem unus quisq; inloco suo
stans semotim. ac silenter more canonicorum ut supra diximus de
canon. & consueto more cetera compleat. his uero tribus diebus
in refectorio omnia cum benedictione & in capitulo more solito agantur.

QUALITER DIURNA SIUE NOCTURNA LAUS PASCHALI FESTIUITATE AGAT
Sabbato sco hora nona ueniente abbate in aecclesiam cum fribus
nouus ut supra dictum est afferatur ignis. Posteo uero cereo ante
altare. exillo accendatur igne. Quem diaconus more solito bene
dicens. hanc orationem quasi uoce legentis proferens dicat.
Exultet iam angelica turba celorum. Tunc uoce sublimiore
dicat. Sursum corda. & rel. Finita benedictione. accendatur
alter cereus. & tunc ...luminantur duo cerei. tenentabus duobus

2. *Regularis Concordia*: conclusion of *Depositio*. British Library MS. Cotton
Tiberius A.III, fol. 20r. By permission of the British Library.

3. *Regularis Concordia: Elevatio* and beginning of *Visitatio Sepulchri*. British Library MS. Tiberius A.III, fol. 21ʳ. By permission of the British Library.

cantare. Quem queritis. Quo de cantato fine tenus. respondeant.
In tres uno ore. Ihm nazarenum. Quibus ille. Non est hic surrexit
sicut predixerat. Ite nunciate quia surrexit a mortuis. Cuius
iussimus uoce uertant se illi tres ad chorum dicentes. Alt. resurrexit
dns. Dicto hoc rursus ille residens. uelut reuocans illos. dicat antiph
Venite & uidete locum. hec uero dicens. surgat & erigat uelum.
ostendatq; eis locum cruce nudatum. Sed tantum linteamina
posita. quibus crux inuoluta erat. Quo uiso: deponant turribula
que gestauerant in eodem sepulchro. Sumantq; linteum. & exten
dant contra clerum. ac uelut ostendentes quod surrexerit dns
etiam non sit illo inuolutus. hanc canant antiph. Surrexit
dns de sepulchro. Super ponantq; linteum altari. finita antiph.
prior congaudens pro triumpho regis nri. quod deuicta morte
surrexit. incipiat hymnum. Te dm laudamus. Quo incepto
una pulsantur omnia signa. post cuius finem. dicat sacerdos
uersum. In resurrectione tua xpe. uerbo tenus & mitiq; matu
tinas dicens. Ds in adiutorium meum intende. & a cantore. ilico
inchoetur antiph cum psalmo. Dns regnauit. quia ds misereatur
nri. hoc non cantatur in loco. Sed cum ds df mis adee deluce con
tinuam canonicorum more. Quinque psalmi iure peractis.
cum antiphonis sibi rite pertinentibus capitulo. & iam a pres
bitero uersuq; surrexit dns de sepulchro. ut mos est a puero
dicto. iniuetur antiph in eua angelia. Qua peracta. dicatur
coll. De omnibus scis more solito his septem diebus non canimus

4. *Regularis Concordia*: conclusion of *Visitatio Sepulchri*. British Library MS.
Tiberius A.III, fol. 21ᵛ. By permission of the British Library.

5. *Ordinale Exoniensis: Elevatio.* Cambridge, Corpus Christi College, **Parker MS. 93, fol. 57v.** By permission of the Master and Fellows **of** Corpus Christi College, Cambridge.

6. *Ordinale Exoniensis:* rubrics for Easter Sepulchre. Cambridge, Corpus Christi College, Parker MS. 93, fol. 115r. By permission of the Master and Fellows of Corpus Christi College, Cambridge.

7. *Ordinale Exoniensis*: rubrics for Easter Sepulchre and Depositio. Cambridge, Corpus Christi College,
By permission of the Master and Fellows of Corpus Christi College,

9. *Missale Dunelmense*: conclusion of *Depositio*. British Library MS. Harl. 5289, fol. 177v. By permission of the British Library.

8. *Missale Dunelmense*: beginning of *Depositio*. British Library MS. Harl. 5289, fol. 177r. By permission of the British Library.

10. *Ordinale Berkingense*: beginning of *Depositio*. Oxford, University College MS. 169, p. 108. By permission of the Master and Fellows of University College, Oxford.

11. *Ordinale Berkingense*: conclusion of *Depositio*. Oxford, University College MS. 169, p. 109. By permission of the Master and Fellows of University College, Oxford.

13. *Ordinale Berkingense*: continuation of *Elevatio*. Oxford, University College MS. 169, p. 120. By permission of the Master and Fellows of University College, Oxford.

12. *Ordinale Berkingense*: beginning of *Elevatio*. Oxford, University College MS. 169, p. 119. By permission of the Master and Fellows of University College, Oxford.

14. *Ordinale Berkingense*: conclusion of *Elevatio* and beginning of *Visitatio Sepulchri*. Oxford, University College MS. 169, p. 121. By

15. *Ordinale Berkingense*: continuation of *Visitatio Sepulchri*, Oxford, University College MS. 169, p. 122. By permission of the Master and Fellows of University College, Oxford.

16. *Ordinale Berkingense*: continuation of *Visitatio Sepulchri*. Oxford, University College MS. 169, p. 123. By permission of the Master and Fellows of University College, Oxford.

17. *Ordinale Berkingense*: conclusion of *Visitatio Sepulchri*. Oxford, University College MS. 169, p. 124. By permission of the Master and Fellows of University College, Oxford.

In verbis vbidr partm sunt. Duo etiam sindones duas si Altare pns i
postras hinc inde qui sibi inuicem cohpreutes in modu turantis dist
haut z secum afferant. lecta passione in pinis fiat ora. pro eccella sca
z cete per ordinem. pronuntiante diacono. flectamus genua nisi
pro iuders tm si genuflectant. post ores duo psbtri albis z casu
lis reuestiti crucem uelatam assumant cantantes hos uersus inte
altare. Popule meus. Alii duo in capis nigris de serico stantes.
in medio chori respondeant. Agyos. chor. humilr pstratus
in terram respondeant. Scs. stm duo presbtri. Quia eduxi te. cant
Agyos. chorus scs. stm duo psbi. Quid ultra. cantores Agyos.
chorus scs. hoc finito. epc accedens z crucem cu luielo discoopiens
alta uoce dicat. R. ecce lignu. fineten chorus. R. ecce lignuin. ps.
deus misereat. R. ecce lignu. resp. Jntim epc solus scam crucem
deosculans adoret. deinde psbtri z ceti per ordinem iod fragant.
choro cantante R. sequtes. R. dua cruce. R. Crux fidelis. y. page
ling. reperatur R. Crux. fidel. z sic fiat repeticio in fine uniuscuiusq;
xo. preda. pange lingua. z similr dicat hymnus lustra sex. si no
fuerit sequantur due ae. Du fabricator. R. O admirabile post
ea a sacerdotib; sca crux au hostiu sepulchri deportetu. Hauet
cu uino z aq z liniteo tergatur choro interim submissa uoce can
tante uel prouis lamentante. h R. Tenebre fce sunt. cu xo. R.
ecce uidimus. R. propo filio. R. Dus tanqin. R. Oblatus. R. ecce
quoin. du ponit in sepulchro. cantent. R. In pace inid. R. Caro
mea. epc turificet sepulchru z cruce z accenso uit cereo. claudat
sepulchru. chorus humilr proseqtur. R. Sepulto duo. epc stans
aute sepulchru. solus cantet R. memento mei finetn postea epc
caliat lotis manib; casula induat z corp du ad altare defe
rat z inceuset z cora altari ofessione dca: humili uoce sic ifeat
oremus. populus salutarib; moniti. pr tir. finetn elpr rndeat.
sed libera nos a malo. z c usq; p oia elpr rndeat amen. Hec agn
dei dicatur uer pax accipietur. postea sin sacerdos oi caiut: dicant
vespere. R. calice. z cetere R. cu ps. iur S. R. Cum accepisset. ps. i)

tñc pfñceñs ee eps ʒ faciat ñrñā . ex cū
sius . curges ʒ incipiat . a'. Adorent om̄
tis signa tim . ʒ sic deinū accedant
ad osculanda crucē cū veñ arde . Deinde
ceñ in ordine suo similiter faciant.
Sacd'o' q̄ p̄us tenuit crucē dimittes cū
adorabit . depofita casula stola ʒ alb
suftentabit . Cumq̄ om̄s adorauint
sacd cū m̄iftris deferat crucē ad eccl̄m
cantando . a' . In pace id ipm̄ . Deū caro
mea . ſDetoċ clure ʒclauſo ſepulcro
cantet . pʒ ſepulto dño . Poſtea tan ent
man' eps ʒ m̄iftri . Deū duo sacd diti
ftol ʒ casul ʒ duſi cū candelab's ʒ the
pet eos eps ʒ diac in casul' venient
ad locū ubi poſit fuit corp' . d.ō' . ʒ facto
p̄us thē ab eo : accedētes sac . diſcoopi
ent corp' dō ʒ calicē . ʒ poſtco vino ʒ ca
lice : deferet eps e sacdoulbʒ corp' . ʒ diac
calicē . ſQuos cū p̄ p̄cedētes cantedo
ps . oñ ſcpe m̄ . de . ʒ accedētes ad altare :
ponēt calicē ʒ corp' sup corpalia p̄p̄ra
a diac ʒ coopto calice : ʒcedent . Acedēs
co eps m̄ifter d̄ʒ sup om̄ia . ſPoſtea
faciat . oe . suppliat inclinans se añ
altare . Deū dicat . Confiteor . Et erigēs

19. *Norwich Customary: Depositio*. Cambridge, Corpus Christi College MS. 465, fol. 62v. By permission of the Master and Fellows of Corpus Christi College, Cambridge.

22. *Sarum Missal: Depositio.* Manchester, John Rylands Library MS. Lat. 24, fol. 94[v]. By permission of the John Rylands Library.

23. *Sarum Ordinal: Elevatio.* British Library MS. Harl. 2911, fol. 42ᵛ. By permission of the British Library.

24. *Sarum Ordinal: Elevatio.* British Library MS. Harl. 2911, fol. 43ʳ. By permission of the British Library.

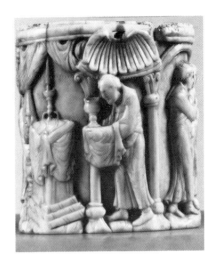

25. Monk approaches altar. Possibly illustration of *Elevatio*. Ivory pyx, Victoria and Albert Museum (268-1867). By courtesy of the Board of Trustees of the Victoria and Albert Museum.

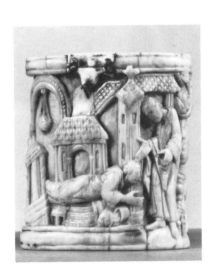

26. Monk prostrate at feet of another. Possibly illustration of Hortulanus scene in *Visitatio Sepulchri*. Ivory pyx, Victoria and Albert Museum (268-1867). By courtesy of the Board of Trustees of the Victoria and Albert Museum.

28. Small recess with pointed arch. c.1300. St. Nicholas, Piddington, Oxfordshire.

27. Wooden Easter Sepulchre. 14th century. St. Michael, Cow-thorpe, Yorkshire. By permission of the Redundant Churches Fund.

30. Simple round-arched recess. St. Agatha, Easby, Yorkshire.

29. Small recess with ogee arch and flanking buttresses. 14th century. St. Swithin, Merton, Oxfordshire.

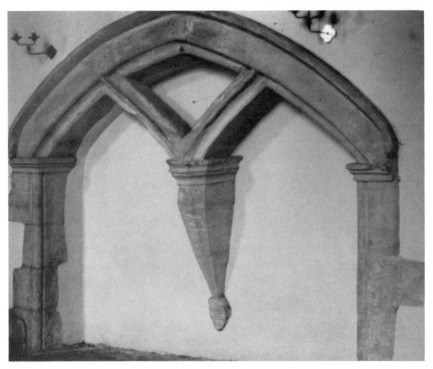

31. Slightly pointed arch with center corbel. Late 13th century. St. Nicholas, Lillingstone Dayrell, Buckinghamshire.

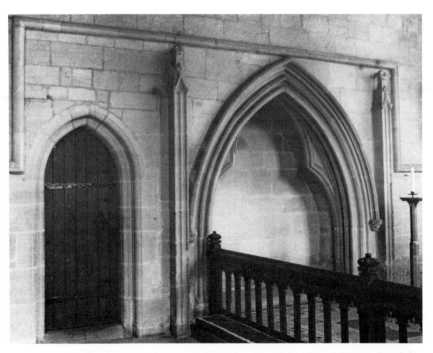

32. Tall, pointed arch with cusping. ?14th century. St. Patrick, Patrick Brompton, Yorkshire.

33. Low, pointed arch over chest with quatrefoils. 14th century. SS. Peter and Paul, Olney, Buckinghamshire.

34. Easter Sepulchre. 15th century. St. Mary, Warwick. Reproduced by kind permission of the vicar and churchwardens of the Collegiate Church of St. Mary, Warwick.

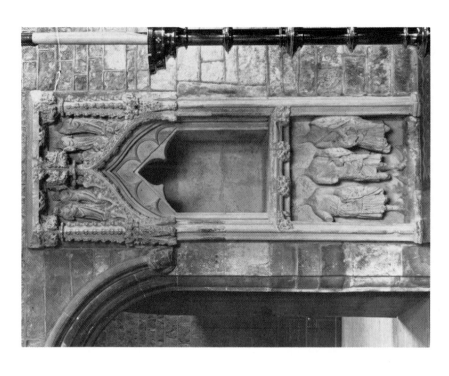

36. Easter Sepulchre. Early 14th century. St. Peter, Navenby, Lincolnshire. By permission of the Royal Commission on the Historical Monuments of England.

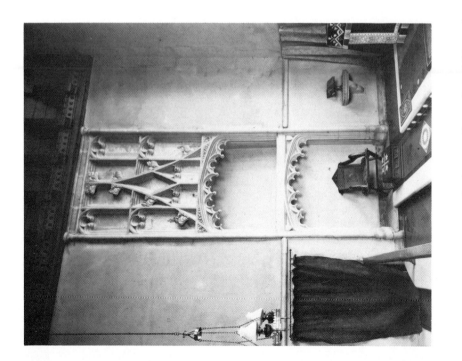

35. Tall structure with perpendicular paneling. Late 15th century. St. Mary, Bampton (or Bampton-Proper), Oxfordshire. By permission of the Royal Commission on the Historical Monuments of England.

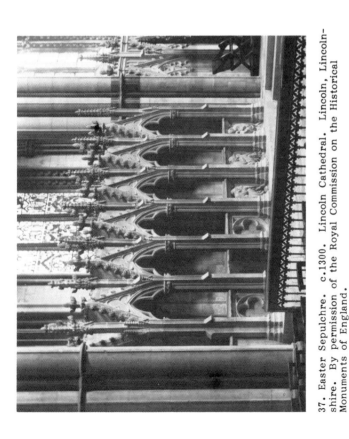

37. Easter Sepulchre. c.1300. Lincoln Cathedral. Lincoln, Lincoln-shire. By permission of the Royal Commission on the Historical Monuments of England.

38. Detail of sleeping soldier from Easter Sepulchre. c.1300. Lincoln Cathedral. By permission of the Royal Commission on the Historical Monuments of England.

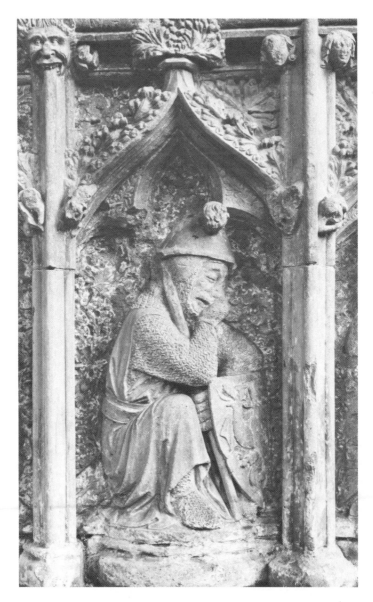

39. Detail of sleeping soldier from Easter Sepulchre. c.1330. All Saints,
Hawton, Nottinghamshire. By permission of the Royal Commission on the
Historical Monuments of England.

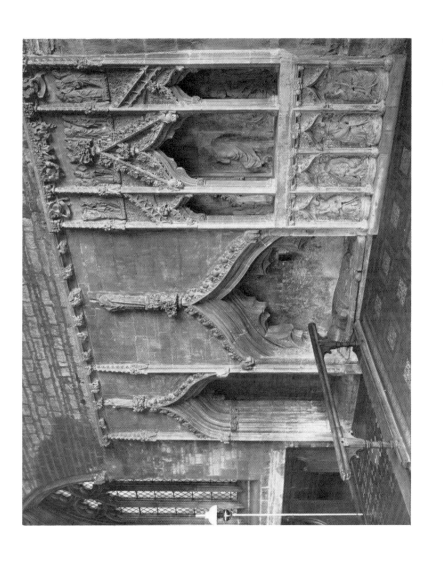

40. North wall of chancel. c.1330. All Saints, Hawton, Nottinghamshire. By permission of the Royal Commission on the Historical Monuments of England.

42. Detail of Ascension (center) from the Easter Sepulchre. c.1330. All Saints, Hawton, Nottinghamshire. By permission of the Royal Commission on the Historical Monuments of England.

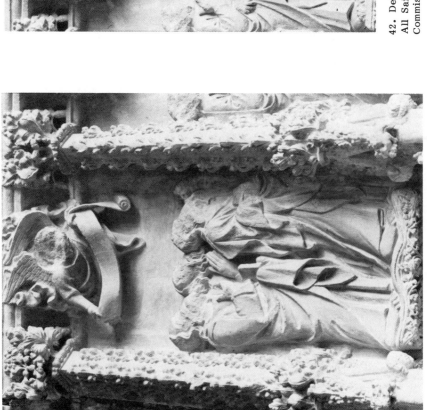

41. Detail of Ascension (left side) from Easter Sepulchre. c.1330. All Saints, Hawton, Nottinghamshire. By permission of the Royal Commission on the Historical Monuments of England.

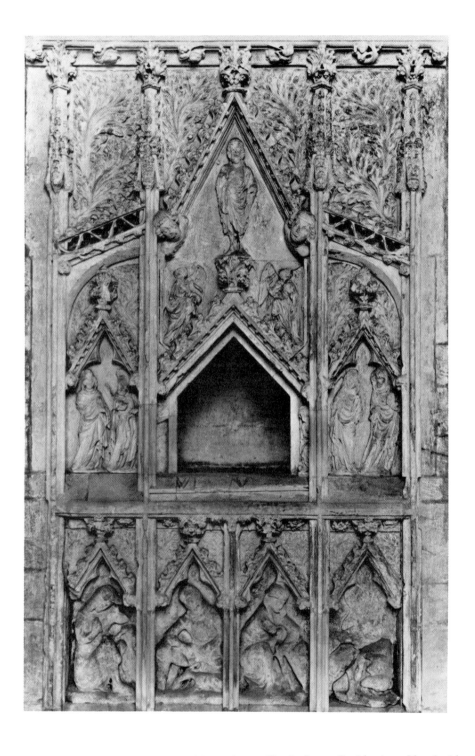

43. Easter Sepulchre. Early 14th century. St. Andrew, Heckington, Lincolnshire. By permission of the Royal Commission on the Historical Monuments of England.

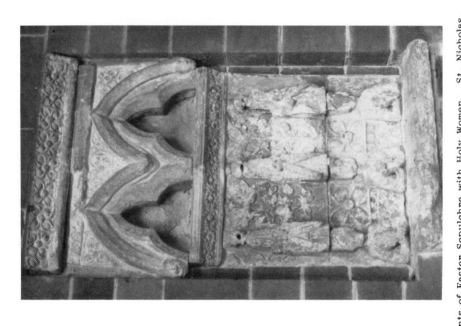

45. Fragments of Easter Sepulchre with Holy Women. St. Nicholas, East Kirkby, Lincolnshire.

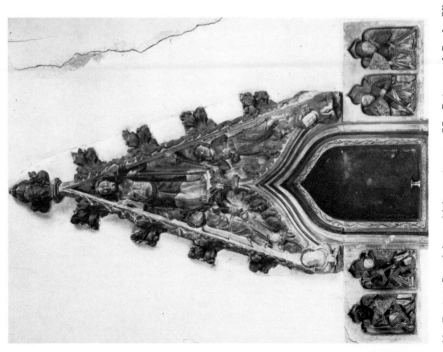

44. Easter Sepulchre. 14th century. SS. Peter and Paul, Sibthorpe, Nottinghamshire. By permission of the Royal Commission on the Historical Monuments of England.

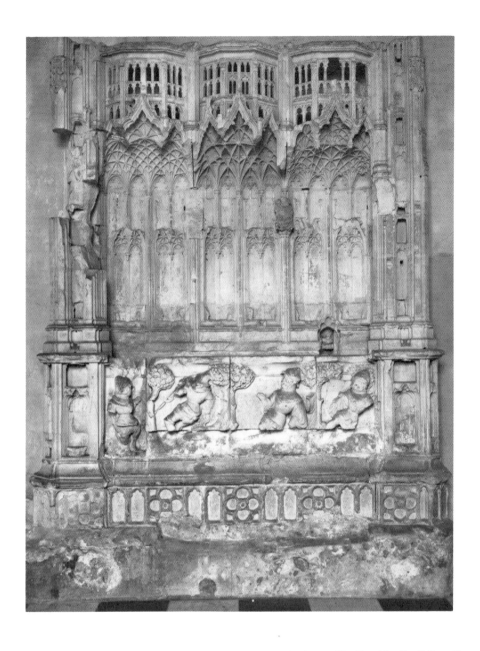

46. Easter Sepulchre. Late 15th century. St. Andrew, Northwold, Norfolk. By permission of the Royal Commission on the Historical Monuments of England.

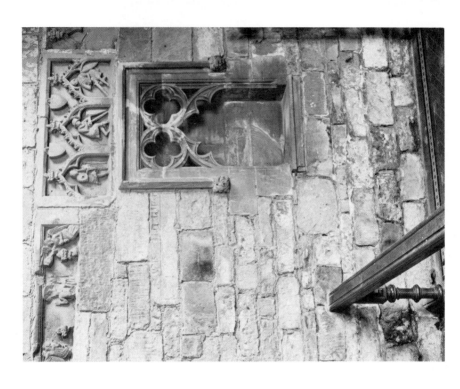

48. Fragments of Easter Sepulchre. ?14th century. St. Gregory, Fledborough, Nottinghamshire. By permission of the Royal Commission on the Historical Monuments of England.

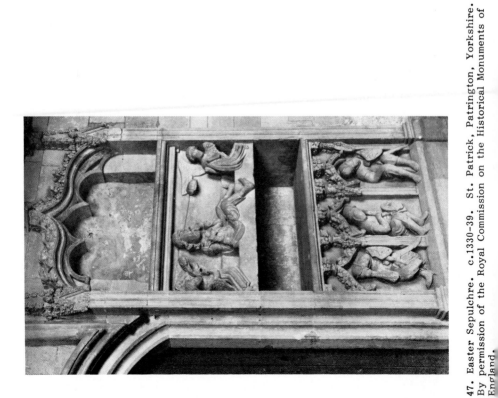

47. Easter Sepulchre. c.1330–39. St. Patrick, Patrington, Yorkshire. By permission of the Royal Commission on the Historical Monuments of England.

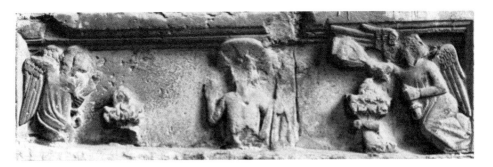

49. Detail of fragments of Easter Sepulchre. ?14th century. St. Gregory, Fledborough, Nottinghamshire. By permission of the Royal Commission on the Historical Monuments of England.

50. Resurrection from Easter Sepulchre. St. Andrew, Horbling, Lincolnshire.

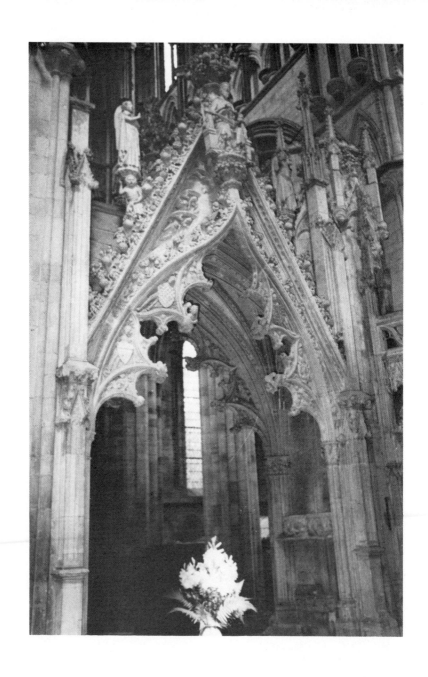

51. Percy Tomb. c.1336-40. Beverley Minster, Yorkshire.

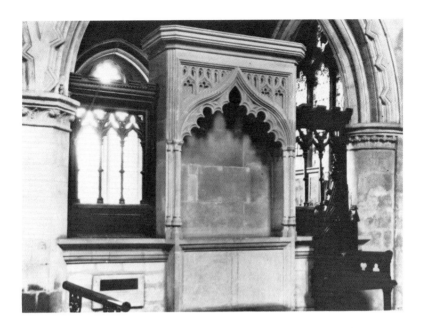

52. Easter Sepulchre combined with tomb. Late 14th century. St. Mary, Easebourne, Sussex. By permission of the Royal Commission on the Historical Monuments of England.

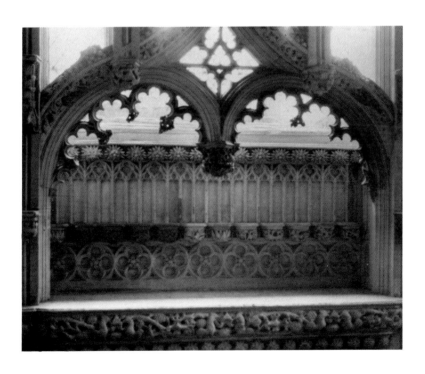

53. Bishop Alcock's Chantry. Late 15th century. Ely Cathedral.

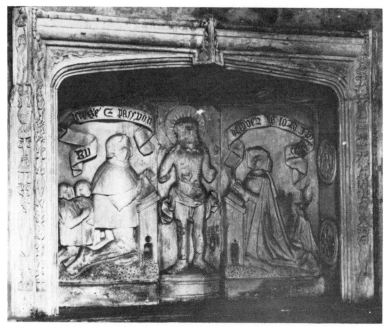

54. Earnley Tomb. 16th century. SS. Peter and Paul, West Wittering, Sussex. By permission of the Royal Commission on the Historical Monuments of England.

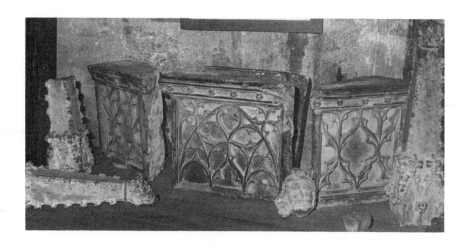

55. Fragments of Easter Sepulchre. St. Mary, Beverley, Yorkshire.